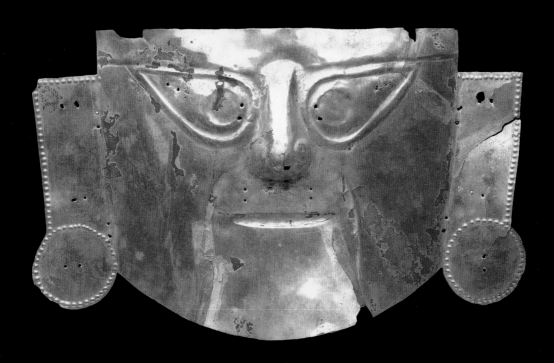

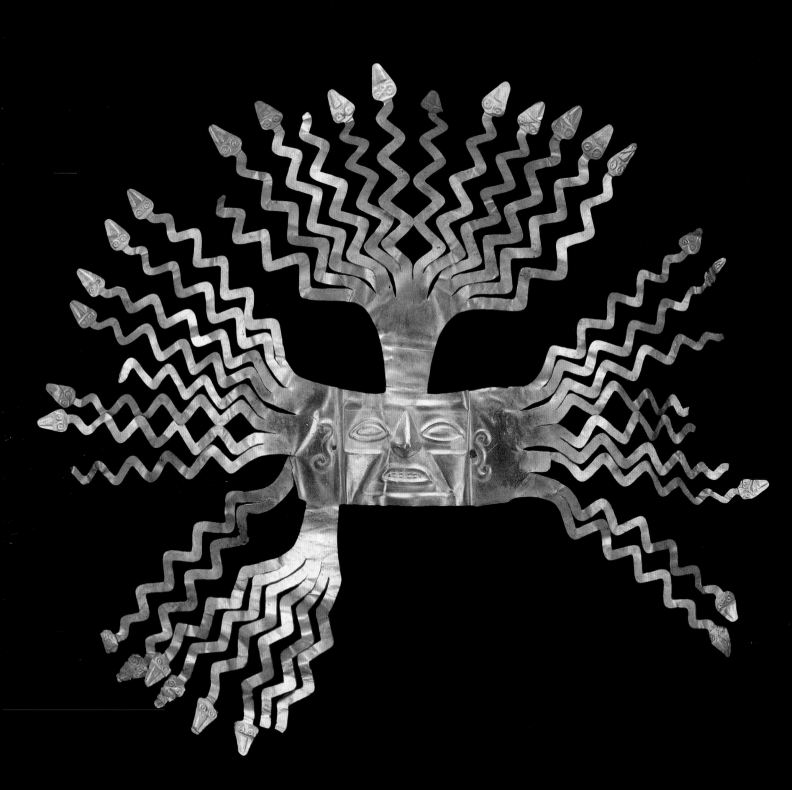

THE ANCIENT
AMERICAS
ART FROM SACRED LANDSCAPES

RICHARD F. TOWNSEND

GENERAL EDITOR

With essays by
Anthony F. Aveni, Elizabeth P. Benson
Elizabeth Hill Boone, J. J. Brody, Richard L. Burger
Beatriz de la Fuente, Mary W. Helms, Alan Kolata
Stephen H. Lekson, Miguel León-Portilla, Colin McEwan
Eduardo Matos Moctezuma, Mary Ellen Miller, Susan A. Niles
Esther Pasztory, Anne Paul, Carlos Ponce Sanginés
Johan Reinhard, Vincent Scully, Rebecca Stone-Miller
Richard F. Townsend, Juan Antonio Valdés, Francisco Valdez
Maarten Van de Guchte, Evon Z. Vogt, Tom Zuidema

THE ART INSTITUTE OF CHICAGO

This book was published in conjunction with the exhibition "The Ancient Americas: Art from Sacred Landscapes," organized by The Art Institute of Chicago and shown at the Art Institute (October 10, 1992–January 3, 1993); the Museum of Fine Arts, Houston (February 4–April 18, 1993); and the Los Angeles County Museum of Art (June 6–August 15, 1993).

Front cover: Ritual figure, Mimbres. Photo: Robert Hashimoto, The Art Institute of Chicago. (Cat. no. 150)
Frontispiece and spine: Sun mask (diadem), La Tolita. (Cat. no. 116)
Page 1: Mask for funerary bundle, Lambayeque. (Cat. no. 122)
Page 5: Mask from incense burner depicting the old deity of fire, Teotihuacan. (Cat. no. 250)
Page 22: Plumed diadem with mask and pendants, Calima. (Cat. no. 28)
Page 374: Mantle with mask motifs, Paracas. (Cat. no. 219)
Back cover: Ritual vessel depicting mask of Tlaloc, Aztec. Photo: Gabriel Figueroa Flores. (Cat. no. 18)

General Editor: Richard F. Townsend
Editor: Elizabeth P. Benson
Managing Editor: Norma Rosso
Copy Editor: Carol Jentsch
Executive Director of Publications: Susan F. Rossen
Senior Production Manager: Katherine Houck Fredrickson, assisted by Manine Golden
Design: Ed Marquand, assisted by Suzanne Brooker, Marquand Books, Inc., Seattle, Washington
Maps: Mapping Specialists Limited
Composition: Paul Baker Typography, Inc., Evanston, Illinois

Printing and binding: CS Graphics, Singapore

The essays by Beatriz de la Fuente, Eduardo Matos Moctezuma, Miguel León-Portilla, Juan Antonio Valdés, and Francisco Valdez were translated from the Spanish by Kathryn Deiss, with assistance from Rafael Chacón.

Copublished by The Art Institute of Chicago, Michigan Avenue at Adams Street, Chicago, Illinois 60603. Tel (312) 443-4962; Fax (312) 443-0849; and by Prestel-Verlag, Mandlstrasse 26, D-8000 Munich 40, Germany. Tel (89) 38-17-09-0; Fax (89) 38-17-09-35.

Distribution of the hardcover edition in the USA and Canada on behalf of Prestel by te Neues Publishing Company, 15 East 76 Street, New York, New York 10021. Tel (212) 288-0265; Fax (212) 570-2373.
Distribution of the hardcover edition in continental Europe by Prestel-Verlag, Verlegerdienst München GmbH & Co Kg, Gutenbergstrasse 1, D-8031, Gilching, Germany. Tel (8105) 21-10; Fax (8105) 55-20.
Distributed in Japan on behalf of Prestel by YOHAN-Western Publications Distribution Agency, 14-9 Okubo 3-chome, Shinjuku-ku, Tokyo 160. Tel (3) 208-0181; Fax (3) 209-0288.
Distribution of the hardcover edition in the United Kingdom, Ireland, and all other countries on behalf of Prestel by Thames & Hudson, Ltd., 30-34 Bloomsbury Street, London WC1B 3QP, England. Tel (71) 636-5488; Fax (71) 636-1659.

©1992 The Art Institute of Chicago

Library of Congress Cataloging-in-Publication Data

The Ancient Americas: Art from sacred landscapes/ Richard F. Townsend, general editor; with essays by Anthony F. Aveni . . . [et al.].
 p. cm.
 Includes bibliographical references.
 ISBN 0-86559-104-0
 1. Indians–Art. 2. Indians–Antiquities.
 3. America–Antiquities. I. Townsend, Richard F.
E59.A7A42 1992
709'.7'0902–dc20 92-21869
 CIP

ISBN of the English hardcover edition (trade edition): 3-7913-1188-3.

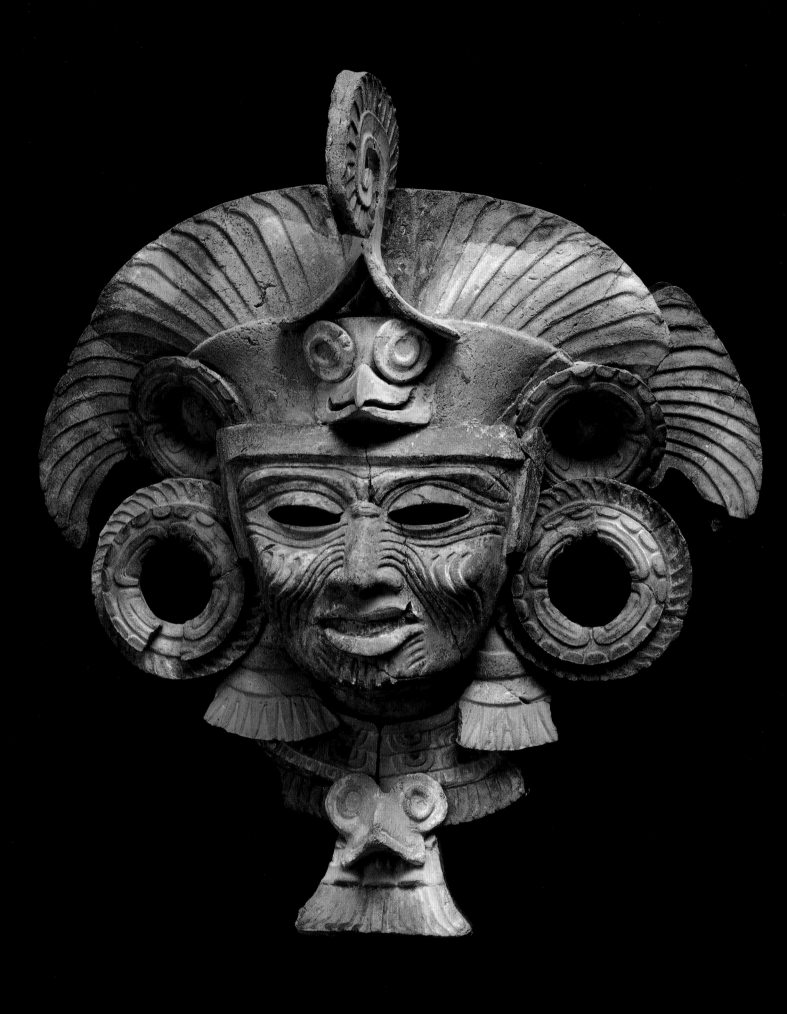

CONTENTS

FOREWORD

A century ago, in 1893, the World's Columbian Exposition was held in the city of Chicago. Expressing the optimism of that era, this international fair celebrated the idea of universal progress, the promise of science and industry, and the seemingly limitless prospect of economic growth and prosperity. The assumptions and values reflected in the organization of this exposition were also evident in the growth of the city and the vast transformation of the man-made environment in the United States during the late nineteenth century. Founded in 1832, Chicago was newly rebuilt after the catastrophic fire of 1871. It developed as a powerful manufacturing and commercial center as the tide of immigrants flowed from Europe and the Atlantic states, across the Midwest, toward California. A process was underway whereby cities, suburbs, factories, farms, and transportation networks were expanding and being organized with increasingly specialized functions. Within twenty-five years, the appearance of the North American landscape was profoundly and permanently changed. In the World's Columbian Exposition, this process was seen as a natural outcome of that spirit of enterprise and free outward expansion that had also marked the voyages of Columbus and others in the European Age of Discovery.

Today, in 1992, the Quincentennial Year is being commemorated in Chicago by an exhibition of far different scope and character. "The Ancient Americas: Art from Sacred Landscapes" examines a central theme of Amerindian art and culture, concerning the deep-seated, unifying idea of the integration of society and nature. The Art Institute of Chicago has organized this exhibition in cooperation with national museums in Mexico, Guatemala, Colombia, Ecuador, Peru, Bolivia, and Chile, as well as with museums and collections in the United States and Europe. The project is presented in a time of profound and pivotal global change in the physical, economic, political, technological, and aesthetic environments. While the impetus of exploration continues in the inhospitable reaches of the solar system, we have also seen pictures of the earth from the moon taken by astronauts. We know that we live on a planet of limited resources, and we perceive a widening abyss between human existence and the delicate networks of life in the biosphere. This is also a time when the peoples of countless communities,

long thought to have been subsumed or absorbed by larger nations or empires, are again voicing their old traditions and asserting their cultural identity and origin as we move toward the twenty-first century. In this decade of passage, The Art Institute of Chicago affirms its fundamental educational mission to bring to broad public attention ideas and languages of form that will extend our concept of art and its purposes, in communicating the deepest human values and aspirations.

The idea of the "Ancient Americas" project was proposed to me by Dr. Richard F. Townsend in 1987. With funding from the National Endowment for the Arts, he embarked in that year on travels to Latin America to explore the notion of this exhibition with museum directors, scholars, and cultural officials. Strong favorable response from these countries and from museums and scholars in the United States and Europe led to an international planning conference at The Art Institute of Chicago in October 1988. This conference was supported by the National Endowment for the Arts and the National Endowment for the Humanities. From the outset, the overarching aim of this project was to bring to a new and wider public an understanding of the significance of the arts, thought, and history of the first civilizations of the Americas and their descendants today. Reflecting the recent interpretive work of art historians, archaeologists, and ethnologists, as well as scholars in related disciplines, the exhibition and book occasioned by it focus on ways that ancient communities perceived their connections with the earth, the sky, and the waters. Still unfamiliar to many, the spectacular arts of Amerindian civilizations were sometimes surrounded by myths and rites of intense and fearsome life-and-death drama. Yet, we find within their protean variety a widely shared notion of humankind as an active participant in the process of annual renewal, and the concept of cities and temples designed as places of dialogue with the deified forms of the landscape. The essays in this book outline the shape of an ancient body of knowledge, transmitted through the visual arts and oral tradition, which held the earth as a giver of life, a framework of order, and an inspirer of song. By calling this theme to public attention, we seek to incorporate a cultural history that reaches far beyond the first encounter of European and Amerindian peoples in 1492, and to present

ideas and images that may usefully point to a more meaningful and habitable future. To reach traditional and new, expanded museum constituencies in the United States and Latin America, we are accompanying the exhibition project with an innovative international educational program, in addition to this book.

The Art Institute is delighted to be cooperating in the presentation of this exhibition with the Museum of Fine Arts, Houston, and the Los Angeles County Museum of Art. I would like to thank Director Dr. Peter Marzio and former Director Dr. Earl A. Powell III, for their cooperation and support, which has assured that this exhibition will be experienced by a broad public across the United States. To many colleagues and friends in Latin America, who have so generously participated in the formation of this complex project, we owe a special debt of gratitude. For their indispensable support and expressions of interest, I particularly wish to thank Carlos Salinas de Gortari, President of Mexico; Alberto Fujimori, President of Peru, and Jaime Paz Zamora, President of Bolivia. In the initial stages of the exhibition, the directors of cultural institutions in various countries were especially helpful in launching our project: Carlos Valencia Goelkel, former Director, Instituto Colombiano de Cultura, of Colombia; José M. Jaramillo Breilh, former Director of the Instituto del Patrimonio Cultural of Ecuador; Marta Regina de Fahsen, former Vice-Minister of Culture and Sports of Guatemala; Fernando Cabieses, former Director, Instituto Nacional de Cultura of Peru; Carlos Urquiso Sossa, former Director of the Instituto Nacional de Arqueología of Bolivia; and Enrique Florescano, former Director of the Instituto Nacional de Antropología e Historia of Mexico. All of these individuals contributed significantly to the realization of the project in the discussions held during the 1988 planning conference in Chicago, as well as subsequently in their respective countries. In Mexico, the counsel and help given by Victor Flores Olea, former President of the Consejo Nacional para la Cultura y los Artes, and by current President Rafael Tovar y de Teresa, have been critical to the development and successful outcome of the project. The gracious participation of Luis F. Capurro Soto, Director, Archivos, Biblioteca Nacional de Chile of Chile, helped to complete the exhibition display with loans from the southernmost outposts of high civilization in ancient South America. Many more participants from the United States, Latin America, and Europe to whom we are most grateful are named by Richard F. Townsend in the Acknowledgments on the following pages.

I wish to acknowledge the generous financial support given to the five-year project by the National Endowment for the Arts, the National Endowment for the Humanities, and the Federal Indemnity Program. It is no exaggeration to say that the concept would have been stillborn without early commitment by these enlightened government agencies. We also owe special thanks to the Rockefeller Foundation, the J. Paul Getty Trust, the Sara Lee Corporation, and American Airlines. Without their commitment, an undertaking of this magnitude would clearly have been beyond our reach.

Finally, I would like to personally thank Richard F. Townsend and his able and talented staff for the intelligence and persistence, over half a decade, to transform the discoveries and theories at the forefront of Amerindian archaeology and art history into an exhibition, a publication, and an educational program that have a comprehensible and compelling message for scholar and layman alike, in this the Quincentennial Year of the encounter of European and Amerindian cultures.

James N. Wood, *Director*

ACKNOWLEDGMENTS

The question of understanding a new, unfamiliar, cultural and geographic setting has deep personal roots for me, from the time in 1947 when my parents moved from the United States to Mexico to write and illustrate children's books. This marked the beginning of travels to monuments and landscapes that reflect that country's extraordinary history and scenic presence. These acknowledgments therefore begin with my parents, Charles Townsend and Ellis Credle. My first encounters with the remains of past civilizations have always seemed inextricably linked to the shapes of the earth and the annual change from the dry to the rainy seasons. The years I have spent in travel and research since then have led from the United States Southwest to Peru and Bolivia, and are the basis of the approach that underlies this exhibition and book.

The development, over six years, of "The Ancient Americas: Art from Sacred Landscapes" has been a cooperative undertaking by people from many nations. Reflecting this experience, these acknowledgments include high government officials and museum personnel, teachers, colleagues, and many others who expressed their support and goodwill in myriad conceptual, practical, and hospitable ways. The opportunity to meet and work with these talented and generous individuals has been profoundly meaningful, continually reminding me of the importance of friendship and the universal, positive impulse to build constructive connections between our diverse communities. These lines of thanks strive for what is probably impossible: to embrace all who have contributed to the formation of this cultural endeavor, even though space does not allow me to include a full list.

In 1987, The Art Institute of Chicago received a letter from Ruth Berenson, of the National Endowment for the Arts, eliciting ideas for projects for the 1992 Quincentennial Year. My proposal for an international exhibition addressing the ancient relationship of society and nature was enthusiastically endorsed; to her, and to William P. Glade of the United States Information Agency and Marsha Semmel of the National Endowment for the Humanities, I owe special thanks. Positive discussions followed with scholars, museum directors, and cultural officials in many countries. I reiterate here my personal thanks to all those named by The Art Institute of Chicago's President and Director, James N. Wood, in his foreword; many more played critical roles in the development of this project.

In Mexico, we are especially thankful to Fernando Solana, Secretary of Foreign Relations, Javier Barros Valerio, Undersecretary of Foreign Relations, and Alfonso de Maria y Campos, General Director of Cultural Affairs. Jorge Alberto Lozoya, Technical Secretary of the President's Cabinet, offered strong support from the outset, and Consul Alejandro Carrillo Castro, in Chicago, and former Cultural Attaché Argentina Terán were also unfailingly helpful. Warm expressions of gratitude go to the Director of the Consejo Nacional para la Cultura y las Artes, Rafael Tovar y de Teresa, and former Director Victor Flores Olea; to Oscar González, National Coordinator of Special Projects and Cultural Exchanges; and to Miriam Kaiser, Director of International Exhibitions, and her assistant, Cecilia Chávez. Roberto García Moll, Director of the Instituto Nacional de Antropología e Historia (INAH), kindly received us on many occasions. Mario Vásquez Rubalcava, National Coordinator of Museums and Exhibitions, offered welcome counsel on the installation during his visit to Chicago. I am very grateful to Marí Carmen Serra Puche, Director of the National Museum of Anthropology; my long-standing friend and colleague Felipe Solis Olguín, Aztec Curator; and Marcia Castro Leal, Olmec Curator and Commissioner for the "Ancient Americas" exhibition. Eduardo Matos Moctezuma enthusiastically approved the participation of the Museo del Templo Mayor. At the Museo de las Intervenciones, Director Mónica Cuevas and Conservator María Luisa Franco helped us, as did Consuelo Maquevar, Director of the Museo del Virreinato in Tepotzotlán, and former Director Manuel Verumen. I am grateful to Roberto Gallegos, Director of the archaeological zone of Teotihuacan. Also to be thanked are the Governor of Veracruz, Dante Delgado Rannauro; and, at the Universidad Veracruzana, Rector Salvador Valencia Carmona, General Coordinator Félix Báez Jorge, and Director of Research José Velasco Toro. At the Museo Arqueológico de Xalapa, Director José Luis Melgarejo Vivanco courteously conducted us through the astonishing exhibit. Julio César Javier Quero, Director of the Instituto de Cultura de Tabasco, enlightened me on the educational programs of regional museums. Beatriz de la

Fuente, of the Instituto de Investigaciones Estéticas, was an especially effective and friendly supporter, as was Miguel León-Portilla, Mexican Ambassador to UNESCO. Jorge Huft's knowledge of architecture and love of travel made our visits to Mexico delightful.

The first to endorse Guatemalan participation were Marta Regina de Fahsen, former Vice-Minister of Culture and Sports, and Dora Guerra de Gónzalez, Director of the Museo Nacional de Antropología, who was most helpful in discussing pieces for the exhibition with me and with essayists Juan Antonio Valdés and Mary Ellen Miller. My visits to Guatemala were also fruitful because of the cooperation of Karl H. Krause Forno and Flavio Rojas Lima, former Vice-Ministers of Culture and Sports; former Minister Roberto Obarrio; the present Minister, Autulio Castillo Barajas; Vice-Minister, Eduardo Meneses Coronado; and Miguel Alvarez and Beatriz Diaz de Soto, former and present Directors, respectively, of the Instituto de Antropología e Historia de Guatemala. In Chicago, I am grateful to Consul José Luis Aparicio.

Clemencia Plazas, Director of the Museo del Oro del Banco de la República, and Lina María Peréz de Gaviria, of the Instituto Colombiano de Cultura, attended the planning conference and continued to provide generous assistance with the Colombian segment of our show. The staff members of the Museo del Oro provided us with meaningful counsel and publications concerning their educational endeavors. I appreciate the assistance of Carlos Valencia Goelkel, former Director of the Instituto Colombiano de Cultura; the reflections of Germán Arciniegas, Chief of the Colombian Commission for the Five-Hundredth Anniversary festivities; and the observations of Luis Dúque Gómez, Director of the Instituto Nacional de Antropología. My conversations in Bogotá with Gerardo Reichel-Dolmatoff, of the University of California, Los Angeles, helped to focus on the Tairona culture in the exhibition and publication. My thanks also go to the vivacious Carolina Valencia, who worked so creatively at The Art Institute of Chicago in the formative period of this exhibition; in 1986–87, she taught an Art Institute course that became a first model for the "Ancient Americas" educational program; I would also like to thank Hernando Valencia and Hernando Valencia, Jr. The project received expressions of support from

Ambassador Victor Chaux Mosquera. In Chicago, Consul Alvaro Cabrera assisted in processing the Colombian agreements.

In Ecuador, my initial conversations with María del Carmen Zaldumbide, former Director of the Museos del Banco Central in Quito, were instrumental in affirming the cooperative relationship established at our planning conference with José Jaramillo Breilh, former Director of the Instituto Nacional del Patrimonio Cultural. My first trip there was cut short by the earthquake of 1988, but the warmth of subsequent communications more than made up for the interrupted initial contact. Rodrigo Pallares Zaldumbide, the present Director of the Museos del Banco Central, and Olaf Holm, Director of the Museo Antropológico del Banco Central in Guayaquil, worked to ensure the loan of pieces never before displayed abroad. Curator Rosangela Adoum was fundamental in administering these loans. I am most grateful to Sergio Durán Pitarque, Vice-Director of the Museos del Banco Central; Alfonso Ortíz Crespo, former Director of the Instituto de Patrimonio Cultural; and María Silva, former Head of the Department of Archaeology, Anthropology, and History, within that institution. Consul Ivan Aulestra in Chicago was also helpful.

Hermilio Rosas la Noire, Director of the Museo de Antropología in Lima, was unfailingly supportive of the exhibition concept from our first conversation in 1988; his courtesy and patient guidance were indispensable. Federico Kauffmann Doig, Director of the Instituto de Arqueología Amazónica, enthusiastically offered hospitality, as well as ideas and practical help in first shaping the project. The commitment of Francisco Iriarte Brenner, former Director of the Patrimonio Cultural Monumental de la Nación, was fundamental in securing the required approvals; Pedro Gjuranovich, Director of the Instituto Nacional de Cultura, endorsed our later presentations. Luis Nieri Galindo, whose deep interest in the ancient cultures of his homeland are reflected in the splendid books published by his institution, the Banco de Crédito del Peru, was steadfast in his support. Fernando Cabieses, former Director, Instituto Nacional de Cultura, played an especially positive and meaningful role in advancing the project in Lima. Thanks are also due to Isabel Larco Hoyle, Director of the Museo Arqueológico; Rafael Larco

Herrera; Rosa Amano, Director of the Museo Amano; and Walter Alva, Director of the Museo Bruning, Lambayeque. Betty Benavides ensured project continuity with highly effective help, advice, and friendship. Special acknowledgment is owed our friend Mariella Agois, who, as a graduate assistant at The School of the Art Institute of Chicago, helped to prepare the first project proposals submitted to the National Endowments. We are grateful as well to Jaime Cacho Sousa, Undersecretary of Tourism and Cultural Affairs in the Ministerio de Relaciones Exteriores; and Consul Carlos Gonzalez, and former Consul Mariano García Godos in Chicago.

The goodwill and cooperation of our Bolivian colleagues led to some of the most rewarding experiences in the preparation of the exhibition. Never before has there been the opportunity to present to a broad public major works from the archaeological site of Tiwanaku. From 1988 on, Carlos Ponce Sanginés, Director of the Centro de Estudios Tiwanaku, was generous with his knowledge and enthusiasm. Oswaldo Rivera Sundt, former Director of the Instituto Nacional de Arqueología, was unfailingly and exceptionally helpful in the years that followed; his profound belief in the history of his homeland gave his friendship and commitment to the project a special intensity. I am also indebted to Enrique Gonzáles Ayres for his friendly support. Julio César Velásquez Alquizaleth, Director of the Museo Nacional de Arqueología, was unfailingly courteous and generous. Gonzalo Iñiguez Vaca Guzmán, Director of the Museo de Metales Preciosos Precolombinos, enthusiastically guided me in selecting works from that exceptionally fine collection, and provided admirable assistance with our subsequent requests and visits. Former Minister of Education Enrique Ipiña Melgar; the current Minister, Edim Céspedes, and Mario Beldoya Ballivián, Director of the Instituto Boliviano de Cultura, warmly endorsed Bolivian participation, as did Waldo Michel Villamor, Subdirector, Ministerio de Educación y Cultura, and Federico Calero Deheza, Subdirector, Dirección Nacional de Turismo. Susana Seleme, Private Secretary to the President, was most gracious. I also extend thanks to Pedro Querejazu, former Director of the Museo Nacional de Arte; to Rita Solar de Aramayo, President, Amigos de los Museos; and to Mario Mercado, for enlarging my understanding of the artistic heritage of La Paz. Lupe Rivera was an especially responsive ally; her positive outlook, sense of humor, and strong sense of friendship helped to communicate the intent of the project and gain the support of many. To Valeria Paz, who volunteered at the Art Institute, I owe affectionate thanks.

Our exhibition project in Bolivia was aided immeasurably by the directors of one of the most important and significant archaeological projects in the Americas: the excavations at Tiwanaku. Led by Oswaldo Rivera, of the Instituto Nacional de Arqueología, and Alan Kolata, of the University of Chicago, these investigations have underscored the fundamental importance of that ancient city in Andean history. Our visits to the site and its satellite settlements are among my most memorable experiences, and the loan of newly excavated works calls attention to the ongoing process of recovery and interpretation. In Chile, Miguel Giannoni Cervellino, Director of the Museo de Atacama, endorsed the loan of rare Inca figurines, which accompany a similar set from the Museo Nacional de Historia Natural in Santiago.

During the past five years of steady work, we received invaluable help from a number of scholars. Alan Kolata's warm friendship and recommendations facilitated the essential connection between the Art Institute and Bolivian institutions. Johan Reinhard generously provided unique pictures and information from his South American discoveries. David Carrasco, of the University of Colorado at Boulder, gave us information on Amerindian myth and religion that we incorporated into our exhibition presentation. My 1988 meeting with J. J. Brody took place at the remote archaeological site of Three Rivers, where petroglyphs incised on boulders portray ancient connections between man, spirit, and nature. Mary Ellen Miller, of Yale University, made a crucial visit to Guatemala to work on the selection of exhibition objects. Christopher Donnan of UCLA provided an introduction to Walter Alva, Director of the Museo Bruning. Tom Zuidema, of the University of Illinois-Champaign-Urbana, undertook a long journey to Colombia and Ecuador to begin the process of selecting works for the exhibition.

Curator Diana Fane, of The Brooklyn Museum, helped to secure especially rare objects, as did Elizabeth H. Boone, Director of Dumbarton Oaks Center for Pre-Columbian Studies. Curator Charles Stanish, of the Field Museum of Natural History, most generously offered excellent pieces from this institution's extensive collections, as did Rosemary Joyce of the Peabody Museum of Archaeology and Ethnology at Harvard University, and Curator Craig Morris and his assistant Barbara Conklin of the American Museum of National History. Pamela Hearne, Keeper at the University Museum of Archaeology and Anthropology at the University of Pennsylvania, kindly helped to identify works of special interest, as did Curator Nancy Rosoff of the National Museum of the American Indian. Curators Robert Stroessner and Gordon McEwan offered a tour of the collections of The Denver Art Museum and provided invaluable assistance. Cameran Castiel, Exhibition Officer of the National Gallery of Art, Washington, D.C., dispensed welcome advice. Gail Martin and James Reid guided us to important textiles for the exhibition. Michael Kan, Deputy Director of The Detroit Institute of Arts, facilitated a late loan request; and Evan H. Turner, Director of the Cleveland Museum of Art, and Curator Margaret Young responded most supportively to our needs. Assistant Keeper Elizabeth Carmichael of the British Museum endorsed the loan of major objects. Dr. Gerhard Baer, Director of the Museum für Völkerkunde, Basel, approved our request for an exceptional Aztec piece. Allen Wardwell, first curator of Primitive Art at The Art Institute of Chicago, provided expertise in evaluating our loan list for Federal Indemnity, as did Stacy Goodman, of Sotheby's. In Chicago, Bibiana Suarez, formerly of the School of the Art Institute, was invaluable in finding Mariella Agois, Laura González, and Norma Rosso, staff members without whom this project would never have been realized. The financial contribution of Gilda and Hank Buchbinder helped make possible the 1988 planning conference.

Many dedicated employees of the U.S. Foreign Service aided the exhibition in innumerable ways in our embassies abroad. In Mexico, Ambassador John Negroponte and Cultural Attaché John Dwyer were extremely helpful. A special expression of friendship and gratitude is extended to Bertha Cea, adviser to the Cultural Attaché; her lively interest and thought-

ful support were indispensable at all stages of the project. In Guatemala, I am grateful to Cultural Attaché Joan McKniff and James and Sandra Brady; in Ecuador, Jerome Oeten offered welcome suggestions; in Peru, I am indebted to Cultural Attachés Charla Saylor Hatton, Melvin Carraga, and Carol Wilder. In Bolivia, I wish to thank Ambassador and Mrs. Edward Rowell, Ambassador Robert S. Gelbard, and Ambassador Richard C. Bowers; USIA officer Robert J. Callahan; and Cultural Attachés Roy Glover, Thomas R. Carmicheal, Thomas Mesa, and Kimberly King. An expression of gratitude goes to Cultural Attaché Inez Kerr in Chile. These and many other Foreign Service staff members ably facilitated our numerous communications.

At The Art Institute of Chicago, the staff of the Department of Africa, Oceania, and the Americas must be at the head of the list of those I wish to thank. Their spirit of cooperation, creative input, and ability to orchestrate complex tasks under conditions of extreme pressure were deciding factors in the outcome of the project. Joanne Berens designed the workspace that was to become our headquarters. Mariella Agois patiently typed the original project proposals. Rafael Chacón and Laura González arranged the 1988 conference and worked tirelessly for two more years on all aspects of organization. Linda Morimoto enthusiastically assisted with the conference and much correspondence. Preparator Jacqueline Johnson undertook with aplomb the management of loan lists and installation schedules and assumed a critical role in the handling and installation of the works of art in the show. Anne King, our department secretary, kept the multiple functions of our office in order and maintained the pressured schedule of appointments and typing with an unvarying calm and sense of humor. Charmaine Picard admirably and efficiently performed a range of exacting tasks. Pablo Helguera and Carlos Fuentes assisted with translation and correspondence, and volunteers Adam Jolles and Mary McVicker were also most helpful.

The arrival of Norma Rosso and Colin McEwan in 1989 signaled the creation of a new management structure that permitted exceptionally efficient coordination of this undertaking. Ms. Rosso's sphere of activities included supervising the book and the educational program, as well as overseeing correspondence and translation. Mr. McEwan's work as an archaeologist in South America gave him the expertise to negotiate arrangements and to travel and meet with our project partners abroad. His creative thought is woven into many aspects of this project. Ms. Rosso and Mr. McEwan collaborated on the innovative teaching kits to be disseminated in the United States and in Latin America. I am profoundly grateful to them for the intelligence, perseverance, and imagination with which they saw to their myriad and, at times, overwhelming responsibilities. The project's realization and success is due, in large part, to the heroic and exceptional effort made by them and my staff.

There are many to thank on the extraordinary staff of the Publications Department for the production of this book, beginning with the wise and tactful Susan F. Rossen, Executive Director. The fine eye and rigorous, constructive suggestions made by Katherine Houck Fredrickson; the everlasting patience and meticulous craftsmanship of copy editors Carol Jentsch and Manine Golden; and the computer skills of Cris Ligenza and Bryan Miller: all ensured the book's high quality.

Elizabeth P. Benson edited the catalogue essays with the intellectual rigor and knowledge gleaned from a lifetime of experience in the pre-Columbian field; she was ably assisted by Mary Glowacki. Photographers Dirk Bakker, Justin Kerr, Kent Bowser, Flor Garduño, and Gabriel Figueroa Flores undertook arduous travel schedules to obtain many of the splendid illustrations. I am grateful to the catalogue essayists, listed on the title page and table of contents, for their illuminating contributions. Kathryn Deiss translated the Spanish essays into English with admirable perspicacity. Elizabeth de la Ossa and her group worked diligently and sensitively to translate the massive English manuscript into Spanish. I also wish to thank Deborah Morrow and Jack Meyers of the J. Paul Getty Trust for their unflagging support of a Spanish edition and valuable suggestions when the going got rough, as well as Tomás Ybarra-Frausto and Roberta Arthurs of the Rockefeller Foundation. My thanks also go to Michael Maegraith of Prestel Verlag, Munich, for his unwavering interest in the project. Last, but not least, I wish to acknowledge the exceptional talent and eye of the book's designer, Ed Marquand, and the hard work of his gifted staff.

I am particularly grateful to James N. Wood, President and Director of The Art Institute of Chicago, for his friendship, thoughtfulness, and quiet encouragement during the conceptualization, preparation, and presentation of the "Ancient Americas." This project could never have been realized without the involvement and support of many others at this museum, too numerous to name here. I deeply appreciate the expertise and contributions of Dorothy Schroeder, the pragmatic Assistant Director for Exhibitions and Budget; Mary Solt, Executive Director of Museum Registration; William R. Leisher, Executive Director of Conservation; Larry Ter Molen, Executive Vice President for Development and Public Affairs; and Mary Jane Keitel, Director of Government Affairs and Foundation Relations, and Eileen Harakal, Executive Director of Public Affairs. Special thanks also go to Reynold Bailey and his art installation crew; and to Barbara Hall, Suzie Schnepp, Robert Hashimoto, John Molini, and Emily Romero. In the Department of Museum Education, I would like to thank Executive Director Ronne Hartfield, as well as Toni Contro, who provided the link to a large and enthusiastic staff and, through them, to audiences both within and without the museum. Celia Marriott and her staff prepared excellent audiovisual materials; and Lyn DelliQuadri and her talented assistants designed the fine exhibition graphics. The opportunity to work with architect John Vinci in designing the installation in Chicago was a distinct pleasure. My gratitude is also expressed to Gina Jannotta, President of the Woman's Board of The Art Institute of Chicago, and to all the supporting members.

In conclusion, I give my warmest thanks to my wife, Pala Jacqueline, whose eye as an artist, abiding interest, and creative approach to the theme of the project, as well as her unwavering personal support, have been a primary source of strength in transforming my original vision of the "Ancient Americas" into reality.

Richard F. Townsend, *General Editor*

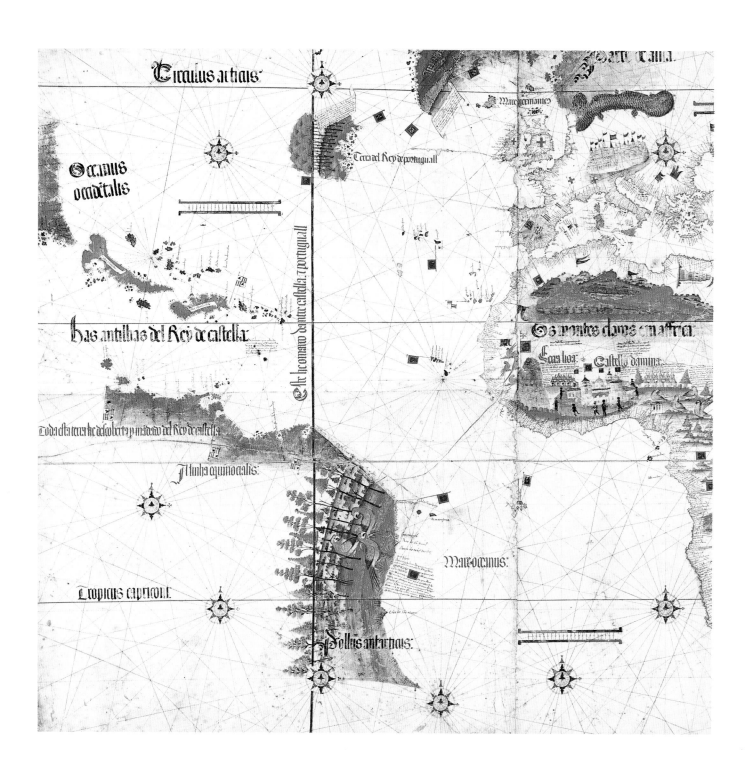

Circulus articus·

Oceanus occidentalis

Terra del Rey de portuguall

Mare germanicus

Has antilhas del Rey de castella

O mar he oceano sanc̃ entre castella· z portuguall

Os pontes claros en affrica

Cam boa· Castello damina·

Toda esta terra he descoberta p manãdo del Rey de castella

Linha equinocialis·

Mare oceanus·

Tropicus capricorni·

Pollus antarticus·

THE ENCOUNTER OF CULTURES

The variety of meanings attributed to the landing of Christopher Columbus on October 12, 1492, on the small island that he baptized San Salvador, now known as Samana Cay, derives from the historical consequences of that event. Had Columbus and his companions disappeared in a confrontation with the natives, or if, for some other reason, the news of his "discovery" had never reached Europe, his landing would have had little significant consequence. As it happened, 1492 marked the beginning of one of the most extraordinary cultural encounters recorded in history. The peoples of Europe and the Americas, who until then had been living in isolation from one another, engaged in a series of dramatic confrontations from which the indigenous Amerindian populations suffered the deepest trauma. The "destruction of the Indies," as decried by Fray Bartolomé de las Casas, was almost achieved by the early sixteenth century, particularly in the Caribbean islands, where Spanish colonization began (see figs. 1, 2). On the other hand, a complex process was started, in which migration, settlement, confrontation, and adaptation played dominant roles in the vast new cultural syntheses that were to take place in the Americas.

Confrontational and Traumatic Encounters

The word "encounter" accurately describes the cultural process that was unleashed. In English, Spanish, and French, the words *encounter*, *encuentro*, and *rencontre*, respectively, carry a set of connotations that go beyond a mere meeting of things or persons. On the one hand, *encounter* denotes "confrontation, conflict, clash between men who engage in battle"; on the other, it signifies "meeting face to face, contact, and fusion."[1]

These two aspects of the process began to take place with the European penetration into a world of many and diverse peoples. The intrusion of Spaniards, Portuguese, French, and English disrupted the lives and cultures of native populations that had been established for millennia, resulting in severe dislocations and, in some cases, complete annihilation. From a European point of view, the encounter was described as "discovery and conquest"; but, for indigenous populations, it meant invasion and the imposition of foreign values and beliefs (see fig. 3). The well-known, universal drama of conquest and expansion by a small but powerful elite was to be repeated in the arena of the New World on a scale never seen before and with a distinct profile (see figs. 4, 7).

Ancient Confrontations and Global Encounter

Europeans had recorded the numerous confrontations and wars of conquest that had transpired between them. The Spaniards knew that the ancient inhabitants of the Iberian peninsula were conquered first by the Romans. Later, many other conquests took place in Spain, such as those carried out by the Goths and the Arabs. Elsewhere, the Gauls and the Germans were conquered by the Romans, and, much later, the Celts were overrun by the Anglo-Saxons in the British Isles. William the Conquerer's subjugation of England is another significant example.

Indigenous populations of the Americas were also aware of their own internal conflicts. Areas of ancient Mexico and Guatemala, as well as Tahuantinsuyu in the modern Andean countries of Peru, Bolivia, and Ecuador, did not lack wars of conquest. Imperialistic campaigns were initiated by the

Fig. 1 Cantino planisphere. Lisbon, 1502. Illuminated manuscript on vellum leaves. Biblioteca Estense, Modena. Cuba, the east coast of Florida, the Antilles, and northwestern South America appear to the left on this chart, which was drawn before the Spanish voyages to Central America and Mexico.

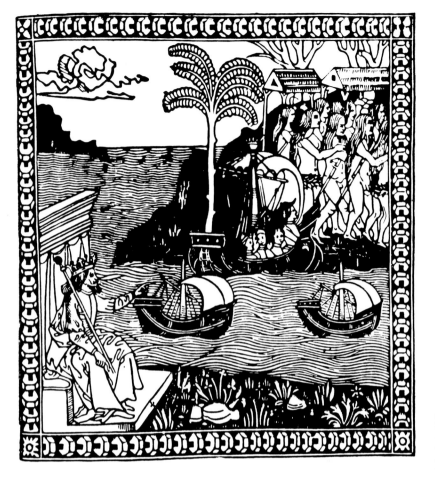

Aztec as well as the Incas; these ultimately ended with the domination and subsequent conversion of other groups into vassal states that paid tribute on a regular basis.

There was one great difference, however, between these experiences of war and conquest and the events that ensued in the western hemisphere after 1492. Before 1492, there had been hostile, as well as positive, encounters between the peoples of a single continent, and, to some degree, between cultures that did not differ radically from one another. Even those confrontations or conquests instigated by Europeans toward the states of North Africa or the closest regions of Asia were directed at people whose existence and way of life were to some degree familiar. But the penetration of what was a "New World" to the Europeans brought them face to face with people who were wholly unknown to them, presenting unimaginable encounters of inter-hemispheric, if not global, dimensions.

The peoples of these two worlds—the "Old" (Europe, Asia, and Africa) and the "New" (America)—had lived in isolation from each other since prehistoric times and had created their own distinct cultural traditions and cosmologies. Never had either Europeans or indigenous Americans come

Tenochtitlan.

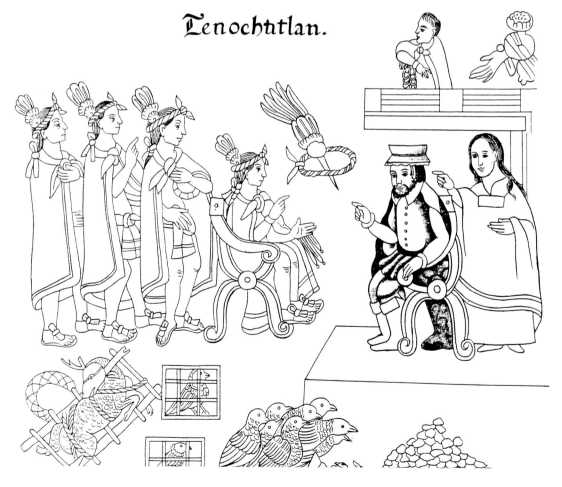

into contact with people who were so radically different. It was not so much that they considered each other suspect, but that, in principle, these "others" had no proper place in their respective visions or concepts of the world. Not only Europeans, but also Asians and Africans, were soon to arrive in the New World. For the indigenous Americans, the encounter with these wholly unknown races was a cataclysmic experience.[2]

Encounters Attempting Reconciliation and Understanding

In the midst of the conflicts that ensued as the conquest of the Americas proceeded, there were attempts to reconcile with and understand those who were being subjected to European culture and beliefs (see fig. 5). Men who were shaped by Renaissance humanism found much to admire among Amerindian societies. They saw them as living almost in a "natural" state, in which there was "neither yours, nor mine." Peter Martyr Anghiera, for example, gathered as much information as possible in his *De Rebus Oceanis et Novo Orbe* (1516), a book that excited widespread interest with its descriptions of faraway lands. In his famous *Utopia*, Sir Thomas More was inspired by the accounts given by Peter Martyr about the New World, as well as by other news that he was able to obtain concerning its urban life. The writers Francis Bacon and Tomaso Campanella, in *Atlantis* and *City of the Sun*, respectively, also recorded their admiration for Amerindian society. Others, among them the artist Albrecht Dürer, expressed great fascination with objects recently shipped from the new lands, which included works of gold and silver, embroidered textiles, and feathered mantles in rich colors (see fig. 6). While in Brussels in 1520, Dürer was able to examine pieces sent by Cortés from Mexico to the Emperor Charles V. He wrote in his diary:

> There I saw the things brought to the Emperor from the new land of gold: a sun made of gold one braccia [probably the Italian *braccia*, meaning one arm's length, not the maritime *braza*, meaning one fathom] wide, and a moon, all of silver, of the same size..., as well as all types of arms used there, harnesses, blowguns, wonderful shields, strange garments, bedcovers, and all types of wonderful things made for human use. And it was all so beautiful that it would be a marvel to see even better things.... And I have never seen anything in my whole life that has cheered my heart as much as these things. In them I found wonderfully artistic things and admired the subtle genius of the men from these strange lands.[3]

If so much interest about the Americas was aroused simply by such news and a few objects sent back to Europe, direct contact with the indigenous populations had an even more profound impact on the friars and civil administrators who were educated at universities such as Salamanca in Spain and the Sorbonne in France. These learned men felt deeply motivated to understand the beliefs, moral principles, and general culture of the newly conquered peoples. The indictment of what came to be known as the "destruction of the Indies" is due to figures such as Fray Antón de Montecinos on the island of Santo Domingo and Fray Bartolomé de las Casas in Mexico and Guatemala.[4] Las Casas, as well as Fray Andrés de Olmos and the great Fray Bernardino de Sahagún, conducted major ethnographic and historical investigations that resulted in the recovery of at least part of the great cultural legacy of ancient America. Thanks to their efforts, as well as to those of modern archaeologists, the civilizations of these ancient peoples themselves are now providing a new form of cultural encounter.

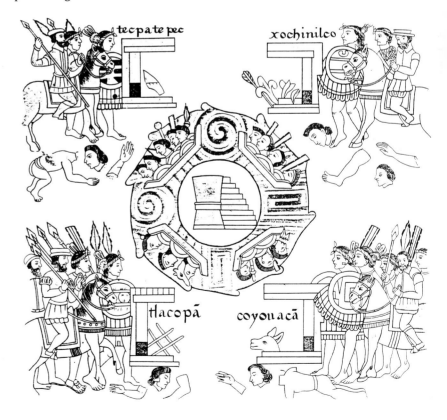

Fig. 4 The siege of Tenochtitlan. From *Lienzo de Tlaxcala*, Mexico, Axtec, 1500/1600. Photo: *Artes de Mexico*, vol. 51/52, 1964, p. 42. The island capital is symbolized by a stepped pyramid in Lake Tetzcoco. The Spaniards and their Tlaxcalan allies approach from mainland cities.

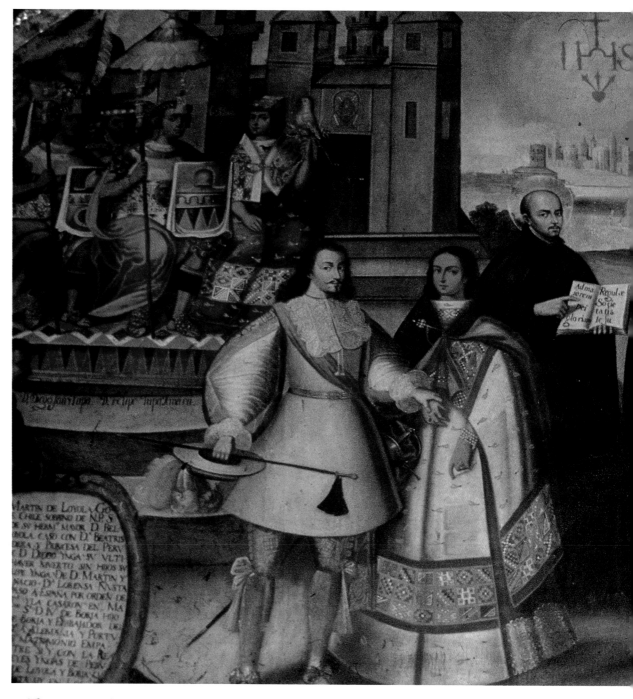

Fig. 5 Unknown artist. The marriage of Don Martín de Loyola and the Inca Nusta Beatriz (detail). Peru, Cuzco, Church of La Compañía, 1680/1700. Oil on canvas. Photo: Teresa Gisbert. The colonial Inca nobility and the Jesuits formed a religious, political, and economic alliance.

The process of recovery does not depend entirely upon archaeological excavation, early Colonial ethnographic reports, or the deciphering of ancient inscriptions or early Colonial texts in languages such as Maya, Nahuatl, Quechua, and Aymara.[5] In the Western Hemisphere, nearly forty million Indian descendants of those who forged the early civilizations have preserved much of their living heritage in language, art, and religious belief. In spite of the continuing injustices that have been added to the traumas of the first European conquest and colonization, these Indians have begun to act again as cultural and political creators. Their living presence and ancient heritage enrich the multicultural and multiethnic reality of the American nations.

A New Form of Encounter

Five hundred years after Columbus first met the inhabitants of remote Samana Cay and began the wave of migrations that marked the end of the independent, aboriginal nations, we are beginning to understand the patterns of Amerindian culture and history. Scholars and public alike are learning to appreciate the aesthetic and symbolic values of the indigenous art and architecture of these ancient civilizations. In the light of this history, The Art Institute of Chicago has organized an exemplary project. The idea of marking

the fifth centenary of Columbus's encounter with the Americas by presenting an exhibition of ancient Amerindian art as an approach to the fundamental theme of humanity and nature is a major step on the way to new forms of cultural understanding. An extraordinary ensemble of works of art from different civilizations allows for aesthetic appreciation of a diversity of artistic accomplishments and for an understanding of cultural evolution through time. The Mesoamerican section includes Olmec objects created around 800 BC; objects from the Classic period of Teotihuacan and the Maya, between about 1 and 750; and Aztec works of the fifteenth and early sixteenth centuries.

These illustrate interactions effected through trade, warfare, and tribute systems, as well as through the critical sphere of religious and artistic expression. Mesoamerican culture also diffused to what is now the United States Southwest, as well as to Central America. Farther south, in the Andean region, another world of civilizations was characterized by similar dynamic interactions in economic, political, and religious life. The world view of these peoples was manifested in a powerful synthesis found in the architecture and sculpture of the sacred precinct of Chavín, which date to sometime between 900 and 200 BC; in the intricate figures on Paracas mantles, about 200 BC; and throughout a long succession of ensuing cultures, which included the Nazca and Moche, and, later, Chimú, on the desert coast; the great highland capital of Tiwanaku on the Bolivian Plateau; and, finally, the Inca empire.

While each of the cultures included in the "Ancient Americas" exhibition and book produced a unique artistic expression, each also reflects, at the deepest level, a view of humankind's place in a world in which society was an integral part of the structure and processes of nature. The idea of sacred geography, with its animate and inanimate forms and seasonal phenomena engaging every important social and individual activity, was a pervasive unifying theme of Amerindian civilization. The "Ancient Americas" project explores this cosmovision in its various forms of expression and underlines the fundamental role of art and architecture as means of communication. To suggest the structure and functions of this basic relationship, works of art in the exhibition are displayed with photomurals of temples and cities in their respective sacred landscapes. The viewer is thus introduced to the dialogue that once existed between the social and natural orders. Within this shared world view, the symbolic systems of diverse cultures illustrate the myths, cosmologies, and rituals by which the workings of ancient life were regulated.

The exchange of ideas and symbols was surely a major aspect of cultural encounter in ancient times. This is a field for future research, along with the evidence of migrations, conquests, trade, and agriculture that have long been the subject of archaeological investigation. How far did those exchanges and contacts extend? Did direct dialogue exist between the major zones of civilization—that is to say, Mesoamerica and the Andean region? Which intermediate areas

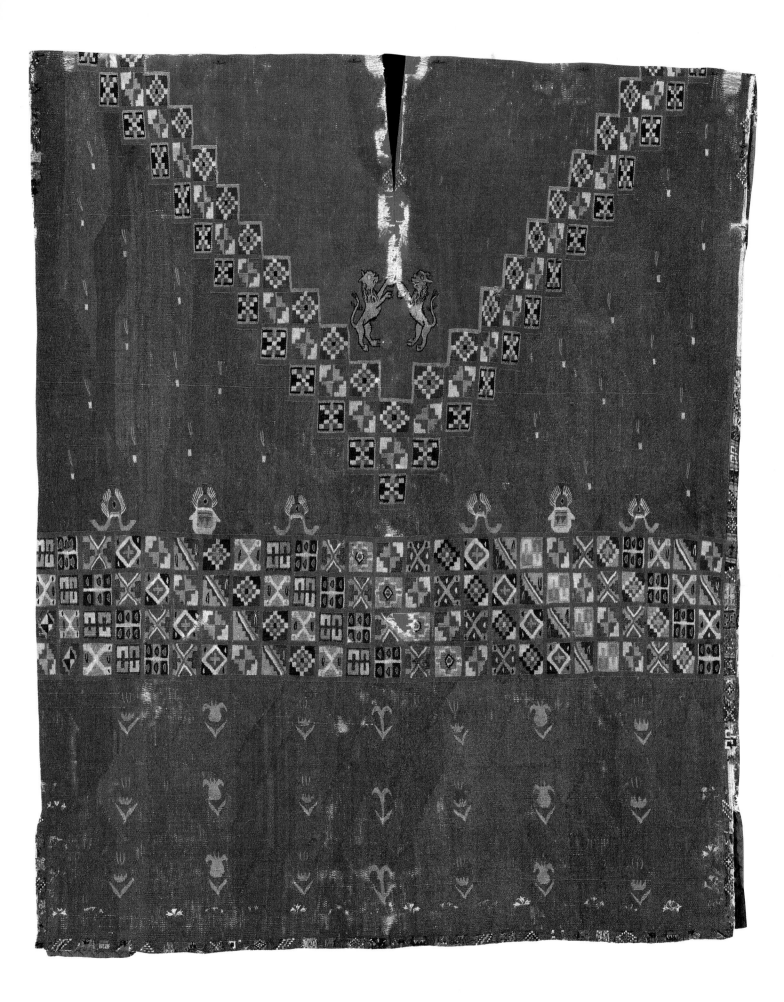

were affected by or contributed to the long, complex process of cultural encounter? Will it ever be possible to observe the whole universe of ancient Amerindian cultures, from Alaska to Tierra del Fuego, not as a summation of isolated entities, but in the fullness of their interactions over the centuries?

The "Ancient Americas" project opens the door to a new domain of cultural exchange experienced by the scholars and researchers whose efforts and contributions, stemming from a variety of intellectual perspectives, have made this exhibition and book possible, and by the many people who will see its contents and consider their meaning. Many descendants of the ancient Americans, some of whom live in the large metropolitan areas of the United States, as well as guests from Mexico and Central and South America, will come face to face with their ancestral artistic creations and images of sacred geography, as testimony of the first great intellectual and aesthetic tradition developed in this hemisphere. Thousands of men and women of Latin American *mestizo* roots, the living carriers of the seeds of encounter, will be able to appreciate a dimension of their own inheritance that has remained mostly mysterious. Americans of African, Asian, and European descent will also participate in this discourse. In experiencing the integrated vision of space, art, and culture in pre-Columbian society, they will have the opportunity to realize that the Americas contained civilized societies of great cultural depth and complexity, whose history is part of our common patrimony throughout the hemisphere.

In this fashion, the anniversary of Columbus's landing half a millennium ago becomes an opportune moment to participate in a new way, as if in a symphony with different tempos and rhythms, in the long process of migration, settlement, conflict, and exchange

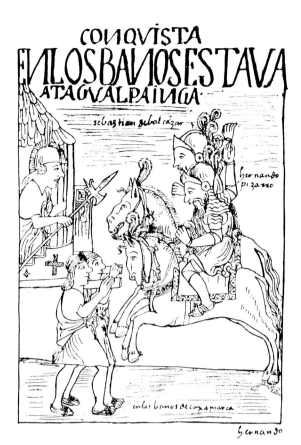

that is the characteristic, if not essential, trait of the Americas. The perception of new forms of cultural encounter will be an incentive for approaching the ancient legacy of the American continent. The art and vision of the world of those who, living in isolation from Europe and the Orient for millennia, created extraordinary cultures, are ever more widely understood and valued. As an ancient Nahuatl poet expressed it, the encounter of cultures must become "flowers and songs that intertwine."[6] The arts and voices of ancient Amerindian civilization transcend the trauma of conquest, continuing to creatively affect the ongoing transformation of culture.

Fig. 6 Textile. Peru, Inca, 1523/50. Camelid wool and cotton. Private collection. Photo: Don Tuttle. The Spanish arms of León are symbolized by rampant lions embroidered on a tunic of traditional Inca design. By such means, new allegiances were proclaimed and acknowledged in sixteenth-century Colonial Peru.

Fig. 7 Hernando Pizarro's cavalry assaults the Inca ruler Atahualpa at Cajamarca. Peru, 1532. Photo: Guaman Poma, 1986, p. 382.

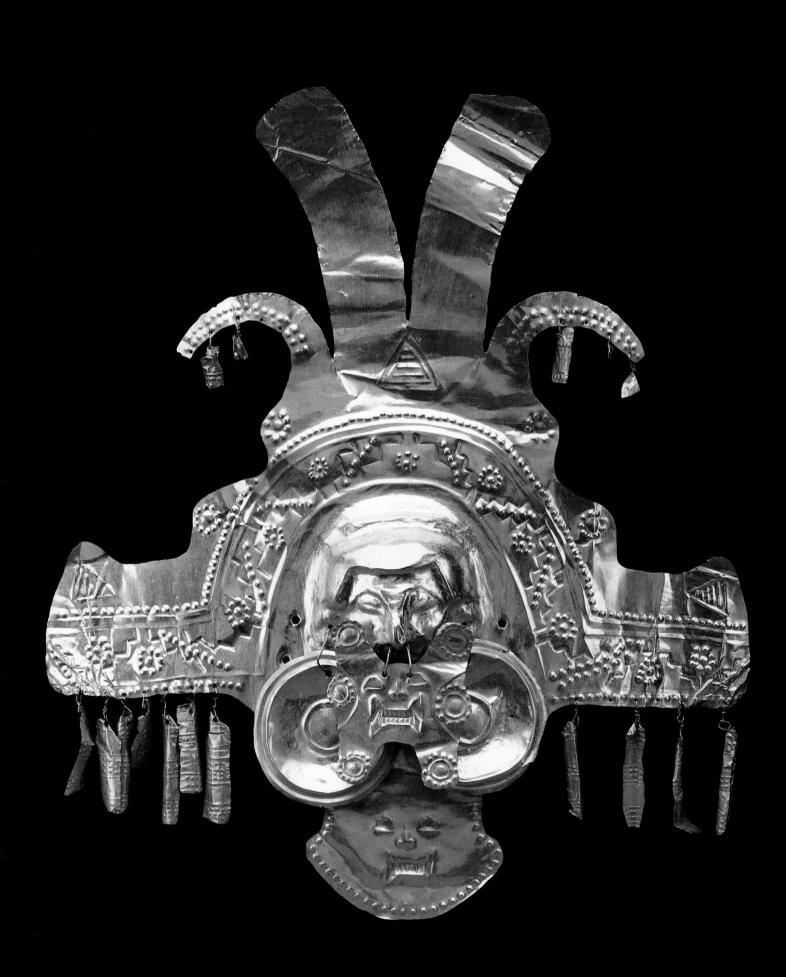

PRINCIPLES AND THEMES

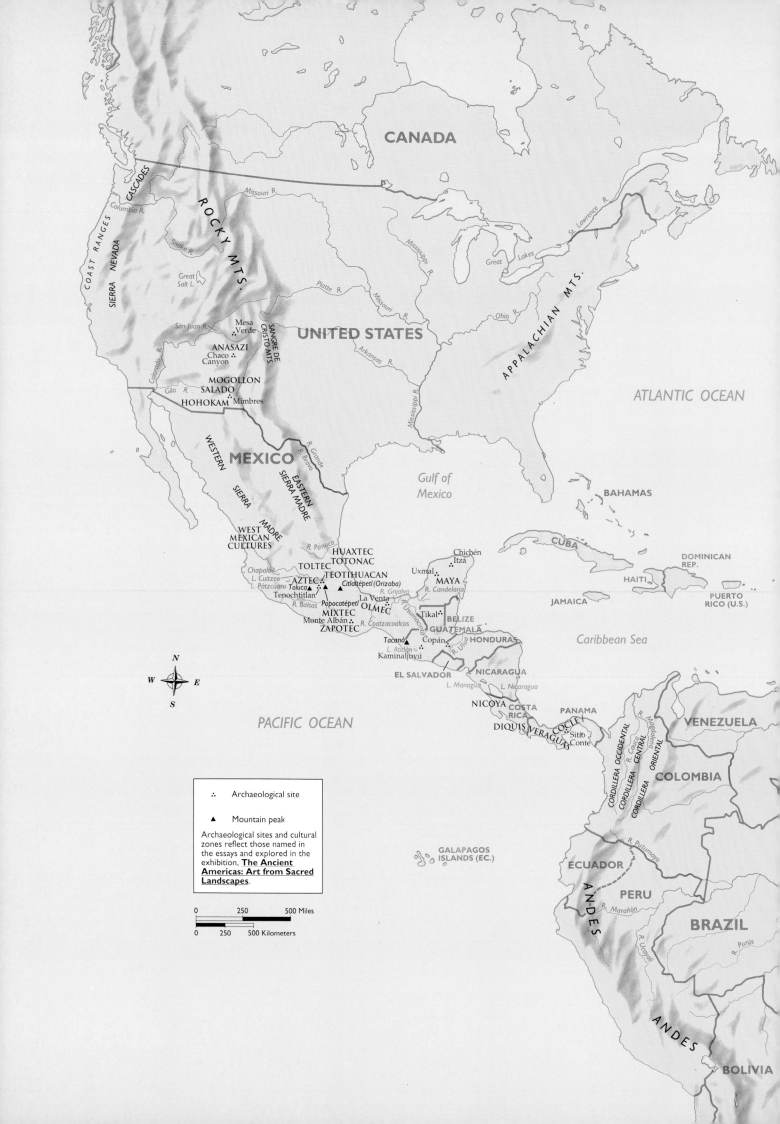

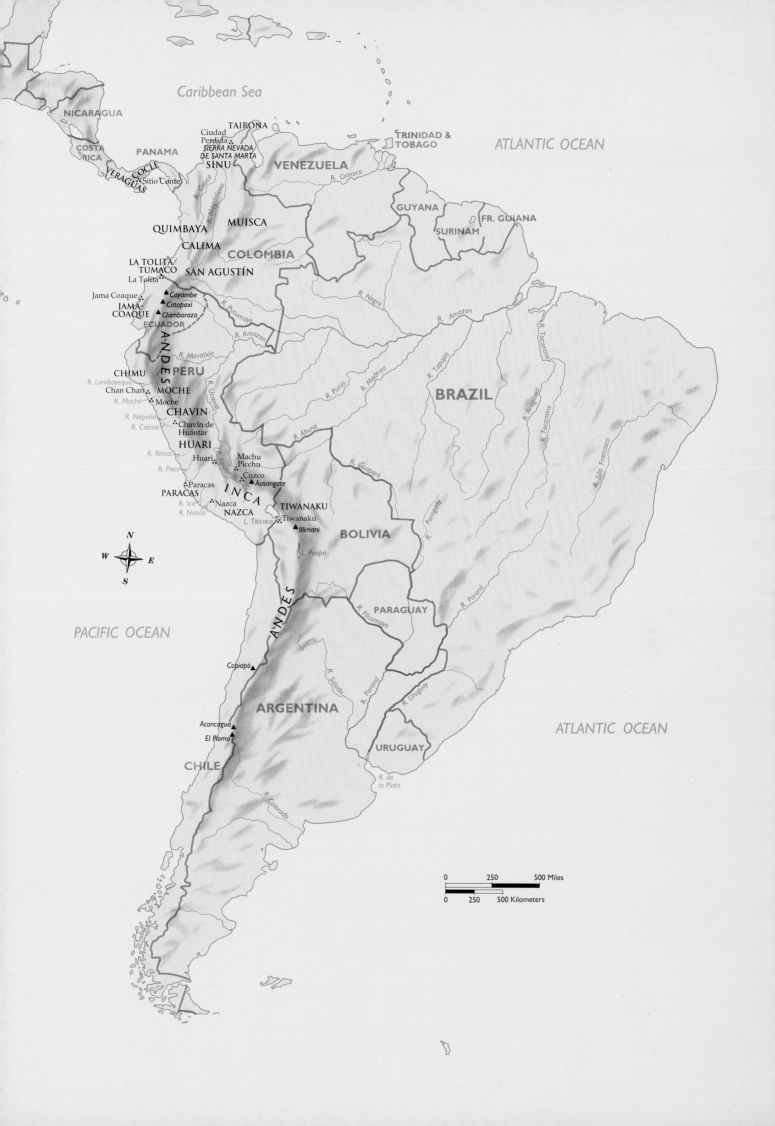

Caribbean Sea

ATLANTIC OCEAN

NICARAGUA

COSTA RICA

PANAMA

VERAGUAS

COCLÉ

Sitio Conte

TAIRONA

Ciudad Perdida

SIERRA NEVADA DE SANTA MARTA

SINÚ

VENEZUELA

TRINIDAD & TOBAGO

R. Orinoco

QUIMBAYA

MUISCA

CALIMA

COLOMBIA

GUYANA

SURINAM

FR. GUIANA

LA TOLITA/ TUMACO

SAN AGUSTÍN

R. Cauca

R. Magdalena

R. Putumayo

R. Negro

R. Amazon

La Tolita

Jama Coaque

JAMA-COAQUE

Cayambe

Cotopaxi

Chimborazo

ECUADOR

R. Amazon

ANDES

R. Marañón

PERU

R. Napo

R. Amazon

R. Purús

R. Madeira

R. Tapajós

R. Tocantins

BRAZIL

R. Araguaia

R. Tocantins

CHIMU

Chan Chan

R. Lambayeque

MOCHE

R. Moche

Moche

CHAVIN

Chavín de Huántar

R. Nepeña

R. Casma

HUARI

R. Rimac

Huari

R. Pisco

Machu Picchu

R. Huallaga

Cuzco

Ausangate

INCA

R. Ucayali

R. Guaporé

R. São Francisco

Paracas

PARACAS

R. Ica

Nazca

R. Nazca

NAZCA

TIWANAKU

L. Titicaca

Tiwanaku

Illimani

BOLIVIA

R. Paraguay

R. Paraná

L. Poopó

PACIFIC OCEAN

N

W E

S

ANDES

PARAGUAY

R. Pilcomayo

R. Paraná

R. Salado

R. Paraná

R. Uruguay

Copiapó

ARGENTINA

ATLANTIC OCEAN

Aconcagua

El Plomo

URUGUAY

R. de la Plata

CHILE

R. Colorado

0 250 500 Miles

0 250 500 Kilometers

	3000 B.C.		2500 B.C.		2000 B.C.		1500 B.C.		1000 B.

ARCHAIC DESERT HU

SOUTHWEST UNITED STATES

EARLY

WEST MEXICAN CULTURES

OLMEC

MESOAMERICA

VALDIVIA

MACHALILLA

CHORRERA

LA TOL

CENTRAL AMERICA AND
NORTHERN ANDES

ANDES

CHA

GENERAL CHRONOLOGY

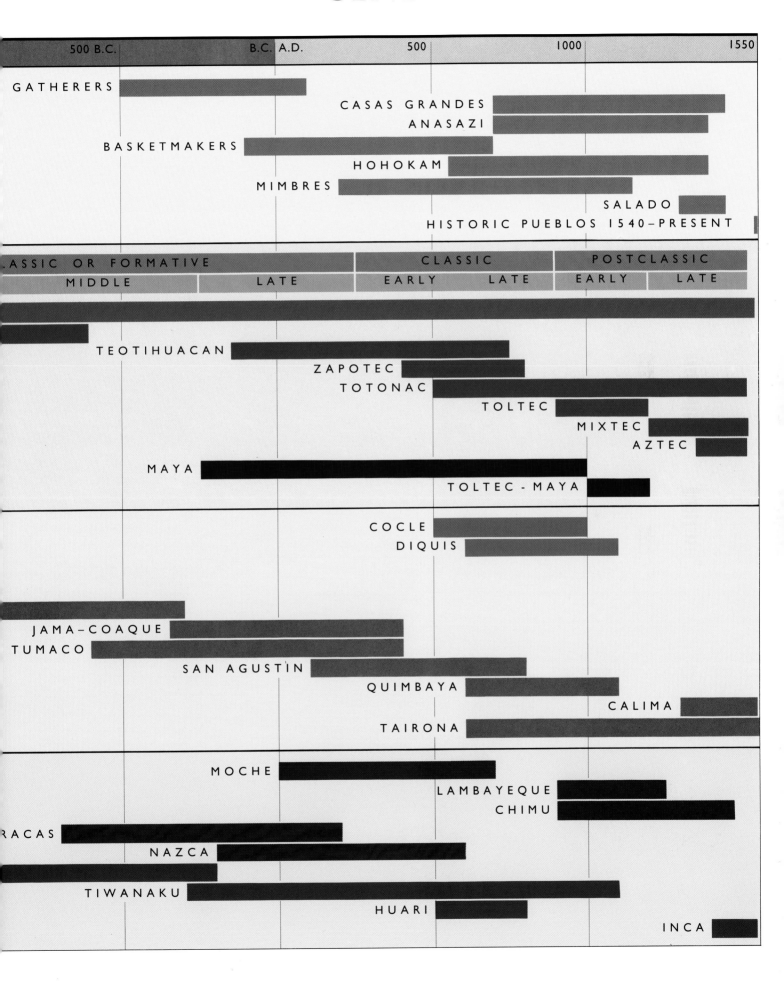

| | 500 B.C. | B.C. A.D. | 500 | 1000 | 1550 |

GATHERERS

CASAS GRANDES
ANASAZI
BASKETMAKERS
HOHOKAM
MIMBRES
SALADO
HISTORIC PUEBLOS 1540–PRESENT

CLASSIC OR FORMATIVE | CLASSIC | POSTCLASSIC
MIDDLE | LATE | EARLY | LATE | EARLY | LATE

TEOTIHUACAN
ZAPOTEC
TOTONAC
TOLTEC
MIXTEC
AZTEC
MAYA
TOLTEC - MAYA

COCLE
DIQUIS

JAMA–COAQUE
TUMACO
SAN AGUSTIN
QUIMBAYA
CALIMA
TAIRONA

MOCHE
LAMBAYEQUE
CHIMU
PARACAS
NAZCA
TIWANAKU
HUARI
INCA

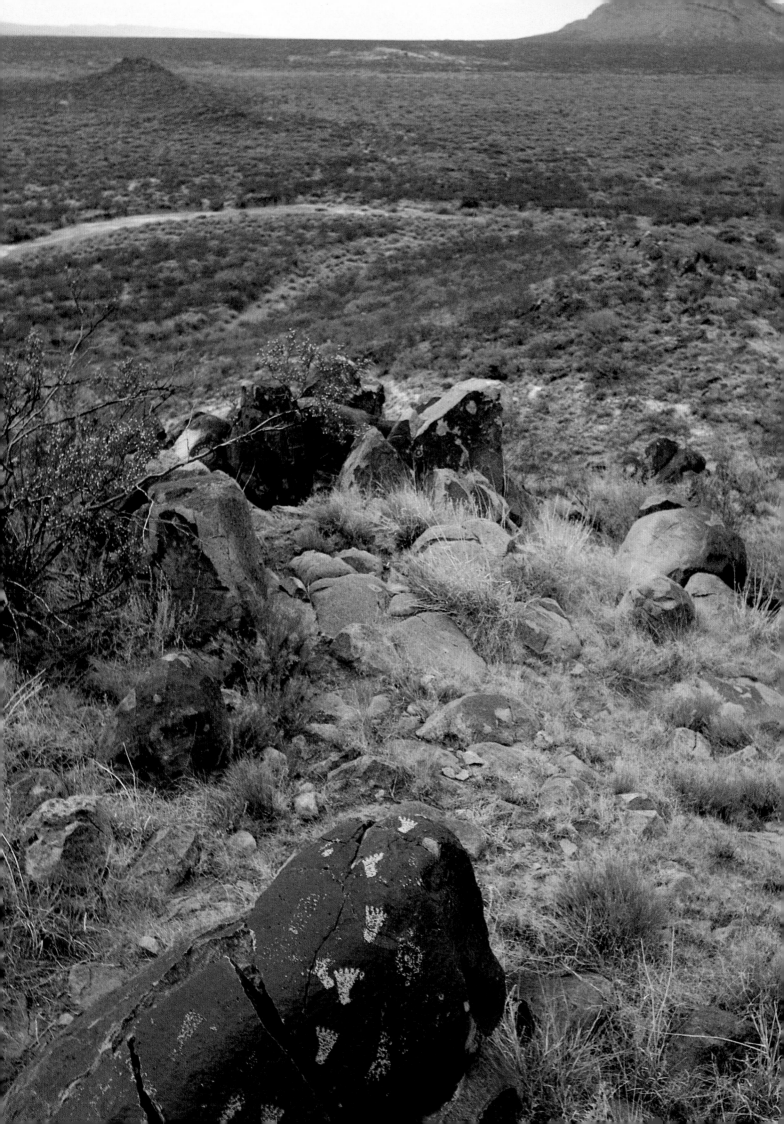

RICHARD F. TOWNSEND

LANDSCAPE AND SYMBOL

On a clear, sunlit day in 1925, the psychologist Carl Jung stood by the small river that runs through the middle of Taos Pueblo, New Mexico. Writing later about this experience, Jung described silent, blanket-wrapped figures on the flat roofs of the adobe buildings, absorbed by the sight of the sun, and by the peaks of the Sangre de Cristo range rising above the sweeping plateau (see Scully essay in this book, fig. 5). An elderly Indian spoke unexpectedly from behind the visitor: "Do you not think that all life comes from the mountain?" Jung continued:

> A glance at the river pouring down from the mountain showed me the outward image that had engendered this conclusion. Obviously all life came from the mountain, for where there is water, there is life. Nothing could be more obvious. In his question, I felt a swelling emotion connected with the word "mountain," and thought of the tale of secret rites celebrated on the mountain. I replied, "Everyone can see that you speak the truth."[1]

This conversation could just as well have taken place fifteen hundred years ago in the Ritual Way at Teotihuacan, Mexico, or at the beginning of the first millennium BC in the sacred precinct at Chavín de Huántar in the Andes of Peru (see Pasztory essay in this book, fig. 6; see also Burger essay in this book, fig. 1). For the image of the sun, the mountain, the waters of life, and the community embedded in the natural environment stands at the center of the oldest religions of the American hemisphere. At archaeological sites extending down the entire length of the continent, the layout of cities, the placement of monuments, and diverse systems of signs and symbols speak of an ancient dialogue with the forms of life seen in the surrounding landscape. "The Ancient Americas: Art from Sacred Landscapes" is addressed to this deep-seated intellectual and artistic domain, which flourished long before the voyage of Columbus and continues to the present day.

The essays in this book are addressed to a series of symbolic and aesthetic traditions, each with its own range of expression. The diversity of styles presents an astonishing spectrum of visual languages, widely known and admired today at dozens of major restored archaeological ruins and in museums throughout the Americas and Europe. Yet, the meaning of ritual scenes and the depictions of mythical or historical events belong to a world that seems inaccessible and alien to many. Similarly, the relationships between architecture, sculpture, and the natural environment may often appeal to the eye, yet their significance remains enigmatic. In recent years and particularly during the past decade, new inquiries by scholars from various disciplines have focused on the interpretation of Amerindian art and architecture, in an effort to understand the deeper structures of visual expression and the patterns of thought and world view they portray. These researches have begun to disclose a theme widely shared among many early cultural and social traditions. The arts are informed by an underlying order that derives from the way the landscape was perceived, used, and translated symbolically. The idea emerges of human societies organized as an integral part of the structures and rhythms of nature. This principle is seen in the monuments of sophisticated urban civilizations, as well as in the arts of agricultural villagers and also of

Fig. 1 Petroglyph of mythical journey. New Mexico, Mimbres, Three Rivers, 700/1150. Photo: Richard Townsend.

hunting tribes, whose roots lead back to the unknown edge of paleolithic culture.

The beginnings of human life in the Americas are rooted in a remote time, perhaps fifteen thousand years ago or more, when nomadic bands of hunting people first crossed the Bering Straits from Siberia to Alaska. Over the millennia, a long series of migrations reached into every environment, from the Arctic Circle down the ranges of mountains and across the plains and plateaus, following rivers through forests and pampas to arrive eventually at the windswept, uttermost point of South America. The first paleolithic bands traversed an open terrain of the most varied climates and topographic features, gleaning their livelihood according to the seasonal availability of animals and plants. It was not until about 8000 BC that a long, gradual, and profound transformation began in central Mexico with the first domestication of maize, squash, and beans. Similar developments in Peru were marked by the domestication of root crops, beans, cotton, llamas and alpacas, and the exploitation of fisheries along the Pacific coast. In the wet humid forests of the Amazon and elsewhere in the tropics, cultivation began along river banks. The earliest forms of agriculture remained closely linked to an economy of hunting and gathering, and spread slowly in barely perceptible ways at first. But as small plots of land were managed for cultivation year after year, the ancient habits of seasonal migration began to give way to more permanent settlements. These were followed by villages and the growth of more complex communities that led to the formation of city-states, localized kingdoms, and eventually to powerful imperial domains. It is acknowledged by archaeologists that civilization originated independently in the Americas, apart from the two other primary locations in Mesopotamia and China. The process of development in the Americas never followed an even course, but evolved in spasmodic patterns in vastly different regions. The archaeological ruins of towns, temples, and agricultural works reflect a wide range of economic, social, and cultural adjustments to immensely varied natural environments. The descendants of these ancestral populations are living throughout the Americas today. In many Amerindian communities, ancient ways continue to play a fundamental role in shaping intellectual, aesthetic, and economic life. These peoples carry histories and cultural outlooks that represent thousands of years of human achievement. The commemorative events of 1992 present an opportunity to acknowledge this early and ongoing stratum of civilization in the western hemisphere.

The "Ancient Americas" book and exhibition rest upon an assumption that the basic ideas giving rise to monumental art and architecture were already present in seminal form long before the development of complex societies. No people, however economically simple, rudimentary in social organization, or geographically isolated, has lacked a way to account for the origins of the world, the organization and rhythms of the natural environment, and the place of humankind within the larger cosmological system. Since paleolithic times, the habitats of hunting bands and nomadic tribes were articulated with paths, places, and particular features that were perceived to be charged with special meanings. Mountains, caves, springs, groves, or certain places overlooking the sea might be identified with the mythic events of a remote creation time, with the deeds of ancestral heroes and totemic creatures, or with the dwellings of powerful deities and spirits. Such sites might be distinguished with rock paintings, petroglyphic carvings, or small portable objects to signal

their unusual significance (see fig. 1). Networks of such special places defined tribal domains in terms of what has often been called a sacred geography.

The marking of time was also an integral activity in the formation of a sacred geography, for the regular movement of celestial bodies was as important to the early hunter-gatherers as it was for the later seed-planting peoples. At special periods in the annual cycle, such as the change from the dry to the rainy season or the eve of animal migrations, people would congregate at special locations to renew their spiritual and economic bonds with the deified forms of the land, the sky, the plants and animals, and the ancestral spirits, and to recount their legends and epic histories. Remembrance and renewal were intertwined in these ritual times of seasonal and social passage. The pragmatic business of obtaining food went hand in hand with the making of a culturally meaningful habitat, and human activities were regulated by a sense of periodicity and cyclic recurrence. In this way of life, economic, religious, and historical actions were never separated, but were fused in a manner of perceiving and using the landscape. The creation of sacred geographies was thus an immemorial activity that did not depend on the formation of highly complex, stratified societies or the appearance of priestly specialists. It existed in the most rudimentary societies, as well. From this point of view, elaborate works of art and architecture cannot be seen as the mere outcome of economic necessity, utilitarian purpose, the availability of surplus wealth, or the special needs of a social elite. Rather, they are projections of profoundly human experiences and needs: to account for the genesis of the peoples and their world; to explain the underlying order of nature;

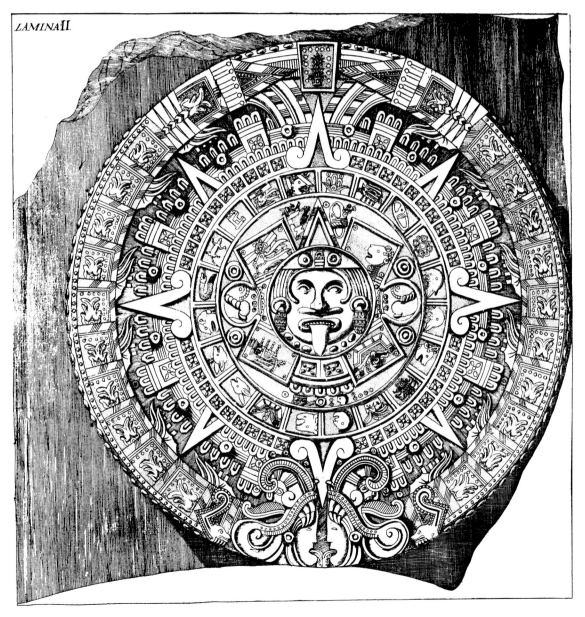

Fig. 3 The first archaeological drawings of the Aztec "Calendar Stone," 1792. Drawing: León y Gama, 1990, pl. 2.

and to conduct the pattern of individual and communal life in accord with the annual seasons. The arts presented here reflect these ancient concerns as they were transmitted and developed by agricultural civilizations in North, Central, and South America before the great European migration. The range of materials and techniques and different aesthetic expressions remind us of a long process of cultural history and provide a means to approach the imagination and intellect of Amerindian civilization. In that mode of thought and perception, the visual arts participated in an ongoing colloquy between the

present, an immense body of information has been formed on all aspects of Amerindian life. Scholars, missionaries, soldiers, explorers, and colonial officials, as well as the intelligentsia of countless Amerindian communities, have participated in an ongoing endeavor to portray and evaluate the cultural history of the continent's first inhabitants. The ideas expressed in this book and exhibition are built on perceptions and lines of thought that stem from this collective inquiry.

The motivations and interests of the first Spanish authors varied immensely. Hernán Cortés wrote letters to Emperor Charles V,

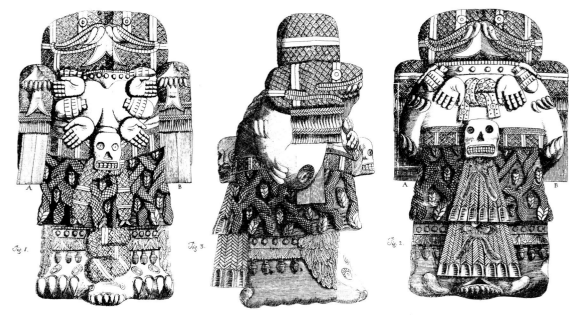

Fig. 4 The first archaeological drawings of the Aztec colossal Coatlicue, 1792. Drawing: León y Gama, 1990, pl. 1.

seen and unseen orders of life, and formed part of actions directed to the vital exchange and cyclic renewal of all living things.

The Beginnings of European Inquiry

The European concern to describe and explain the native peoples of the Americas began with the Spanish expeditions and colonization in the early sixteenth century. As the existence of a vast continent between Europe and Asia was recognized after 1492, and the contours and landscapes of the hemisphere gradually became apparent, questions immediately arose concerning the origins and existence of its native populations. Who were the inhabitants of these regions? Where had they come from? What was their history? What could be said of their laws, governments, and systems of social organization? What were their religious beliefs, and what did their monuments signify? As in other instances of European colonization, exceptional individuals took pains to record what they saw and learned. From that time to the

describing in considerable visual detail the land, the cities, and the peoples he encountered on his expedition to Mexico (1519–21). His political aim was to justify his role in leading the Aztec conquest. But Cortés emerged as much more than a successful military commander, for his later work was devoted to achieving a colonial economy and society with the Indians under the protection of the monastic orders and the Spanish state. Bernal Diáz del Castillo wrote an extraordinary day-to-day account of the great adventure of his youth as a soldier in Cortés's expedition. *The True History of the Conquest of Mexico* includes vivid eyewitness impressions of the Aztec capitol and the surrounding cities and regions. The Dominican friar Bartolomé de las Casas described with outrage the destruction of indigenous society in the first Caribbean colonies, arguing successfully for legislation that considered Indians as rational human beings and established a coherent policy of Church and Crown to defend the native populations. The Franciscan

friar Bernardino de Sahagún learned the Nahuatl language and interviewed members of the Aztec intelligentsia over twelve years, amassing information on all aspects of their life and history for his encyclopedic *History of the Things of New Spain* (see fig. 2). Later in the sixteenth century, Fray Diego Durán wrote *Book of the Gods and Rites and the Ancient Calendar*, describing with unusual sensitivity the rich visual and symbolic field of Aztec religious belief and practice. Bishop Diego de Landa drew upon personal observations, a complete command of the Maya language, and information from three principal natives of royal lineage to create his *Relación* of sixteenth-century Maya life and society in Yucatán. Fray Pedro Cieza de León, Fray Domingo de Betanzos, Bernabé Cobo, and others produced more abbreviated accounts and chronicles of the Incas and their neighbors in the Andes of Peru. Yet these and related descriptive works, however detailed and often admiring, were ultimately aimed at the extirpation of Amerindian religious life. In Mexico, especially, the works of the sixteenth-century friars reflected a powerful intellectual and spiritual movement intended to serve the process of Christianization and the creation of a new utopian society in the colonial possessions. By the late sixteenth and early seventeenth centuries, historians of mixed Spanish and Indian descent such as Hernando Alvarado Tezozomoc and Fernando de Alva Ixtlilxóchitl were preparing eloquent ethnohistorical chronicles from native oral traditions and pictorial manuscripts. Writing in Spain, the Inca Garcilaso de la Vega compiled a chronicle of his mother's people. Felipe Guaman Poma de Ayala portrayed, in a remarkable series of drawings and texts, Inca history and customs, as well as life in early colonial Peru (see León-Portilla essay in this book, fig. 7).

What art historian George Kubler has termed "salvaging Amerindian antiquity"[2] continued in variant form throughout the three hundred years of colonial rule. But by the eighteenth century, the intellectual framework of the Enlightenment was changing European perceptions. Thus, in 1792, the newly discovered Aztec "Calendar Stone" and the colossal Coatlicue, excavated from beneath the main plaza in downtown Mexico City, where they had lain since the destruction of the ritual center of Tenochtitlan by Cortés in 1522, were regarded as archaeological relics. They were published and explained in the light of sixteenth-century ethnohistoric texts by the Mexican scholar Antonio de León y Gama in 1795 (see figs. 3, 4). In no small measure, his approach reflects a growing quest for national identity, which sought to acknowledge and come to terms with the indigenous cultural heritage that had evolved for thousands of years in Mexico before the Colonial period.

Explorations and Excavations of the Nineteenth and Twentieth Centuries

As the early nineteenth century brought on the Wars of Independence and the formation of republics, a new time of international exploration and discovery began to re-evaluate the archaeological monuments of the hitherto closed world of Spanish America.

In the 1840s the publication of William Henry Prescott's classic *History of the Conquest of Mexico* and the *History of the Conquest of Peru*, as well as John Stephen's *Incidents of Travel in Central America, Chiapas, and Yucatan* (illustrated by Frederick Catherwood's *camera lucida* views of Maya ruins), were among the most influential books disclosing to the European and North American public the sophistication and antiquity of Amerindian civilization before the Spanish conquests (see fig. 5). To these must be added Alexander von Humbolt's essays and illustrated books on his explorations, published between 1810 and 1862. These were followed by travel and archaeological exploration accounts written by such men as George Squier in Peru (see fig. 6) and Desiré Charnay in Mexico, the latter of whom

Fig. 5 The Palace of the Governor. Mexico, Uxmal, Yucatán, c. 950. Drawing: Frederick Catherwood, in Stephens, 1963, gatefold.

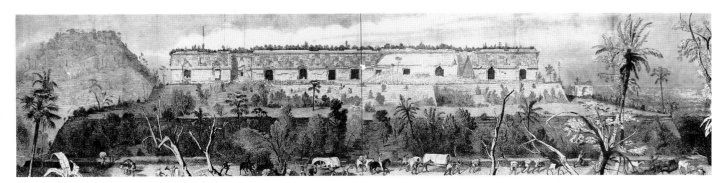

Fig. 6 Inca gateway and Valley of Ollantaytambo, Peru, c. 1450. Stone. Drawing: R. Wand, in Squier, 1877, frontis.

published a remarkably well-illustrated volume, *The Ancient Cities of the New World.*

The archaeological excavations that began toward the end of the nineteenth century and into the early twentieth mapped the location of the most notable sites, and began to chart sequences of layered remains and to classify ancient materials. Alfred Maudslay and Teobert Maler reported and photographed the Maya ruins of Honduras, Guatemala, and Mexico (see fig. 7). Max Uhle laid the foundation of Peruvian archaeology, excavating and drawing plans at the shrine of Pachacamac, the royal compounds of Chan Chan, the Pyramid of the Sun at Moche, as well as other sites of coastal Peru (see fig. 8). Adolph Bandelier wrote ethnographic accounts on the Pueblos of New Mexico, and first interpreted, in a remarkable study, the mythic significance of the ruins on the Island of the Sun in Lake Titicaca, between Peru and Bolivia (see Kolata and Ponce Sanginés essay in this book, fig. 2). Arthur Posnansky was the first to excavate and map Tiwanaku, Bolivia (see fig. 9), a site that has only recently emerged as one of the great centers of Andean civilization. By the 1920s, Julio Tello's archaeological excavations had revealed the temple of Chavín de Huántar to be dated to the early first millennium BC; Manuel Gamio was completing his pivotal archaeological and ethnographic study of human occupations in the Valley of Teotihuacan, Mexico; and Neil Judd's excavations at Pueblo Bonito, New Mexico, had advanced the understanding of cultures ancestral to the modern Pueblo Indians. These and numerous projects by others were milestones in charting the extent and depth of civilization in the ancient Americas.

By the mid-twentieth century, a vast apparatus of foundation and university-sponsored excavations and surveys had identified a sequence of successive cultural phases, beginning with the first hunter-gatherers, the appearance of settled farming communities, and the gradual formation of complex and stratified statelike societies. But little was understood yet about the underlying causes, forces, or historical events that had affected the evolution of Amerindian civilization. During the 1940s and '50s, debate centered on the growing recognition that archaeology should be more than a way of dating and classifying sites and material remains; it should also be a means of recovering and interpreting the whole fabric of cultures and the forces affecting cultural change. Walter Taylor's *A Study of Archaeology*, published in

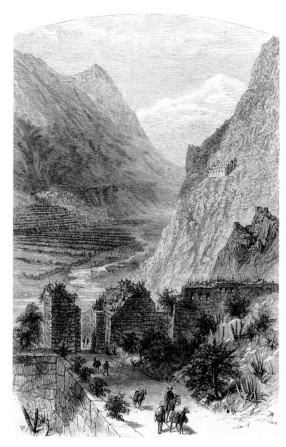

1948, advanced the notion that material remains should be interpreted as evidence of cultural activities in the *context* of environmental and biological data pertaining to prehistoric populations. By 1962, Louis Binford proposed a "new archaeology," calling for the study of artifact assemblages and natural environments as a means of reconstructing extinct cultural systems. Archaeological fieldwork increasingly turned to the problems of explaining the development of civilization in terms of a dynamic network of connections between natural resources, the invention and improvement of agricultural practices and related economic activities that gave rise to settled life, and the gradual emergence of cities and stratified societies with complex military and religious organizations and systems of trade and tribute. This approach was successful in placing emphasis on the relationship of ecological and economic factors and technological innovations as primary agents in determining cultural changes over long periods of time. From this standpoint, art and architecture were regarded as indicators of advanced civilization and manifestations of wealth and authority in the hands of political and religious elites. But the interpretation of these works in terms of symbols and the role of ideas and aesthetics in the development of early civilizations were not yet considered in the out-

line of Amerindian culture developed by mainstream scientific archaeology.

Describing the Aesthetic and Symbolic Domains

Even as explorations were mapping sites and seeking to explain the processes of cultural change, other scholars had begun an inquiry into the aesthetic and symbolic aspects of indigenous life. The first world history of art was written in 1842 by the Prussian Franz Kugler and included a chapter on ancient Amerindian art. His *Handbuch* recognized the independent origins of New World civilizations, an observation that would later be independently confirmed by archaeology. Kugler held that monumentality lies at the root of artistic expression, because of the human need to tie thought to a fixed place by forms that conveyed those thoughts (a premise that foreshadows the idea of symbols and sacred geography explored in the present publication). In Mexico, Manuel Orozco y Berra continued the work of his predecessor, Antonio León y Gama, publishing an important study of Aztec sculpture in the 1870s. During the second quarter of the twentieth century, the educator Alfonso Caso, the art historian Salvador Toscano, and the artist Miguel Covarrubias shaped a course of interpretation that included iconographic and stylistic considerations of art with the information provided by field excavations. Covarrubias was an early champion of the Olmec "mother culture," an outlook strongly expressed in his *Indian Art of Mexico and Central America* (1957) (see fig. 10). This book also reflected the notion that, within Mesoamerica (central Mexico, Guatemala, Belize, and adjacent parts of Honduras and El Salvador), there was a system of ideas that permitted similar meanings to be attached to similar symbols produced by different cultures over long periods of time. This point of view was directly influenced by Paul Kirchhoff's widely accepted view that Mesoamerican civilization could be seen as a unified tradition, with the cultures in its boundaries more closely related to one another than any one of them was to outside cultures.

A more broadly humanistic perspective on Amerindian art was proposed by George Kubler in *The Art and Architecture of the Ancient Americas*, first published in 1952. Kubler called attention to works of art as products of a fundamentally non-rational, aesthetic activity that lies partly outside of culture. From this standpoint, the same process that enters in the creation of a work of art also figures in the way people make choices in the ordering and integration of their lives and in the way culture itself is constructed. Aesthetic activity might therefore be included with ecological and economic factors as one of several principal agents in determining cultural transformation over long periods of time. Recalling Jakob Burkhardt's *Civilization of the Renaissance in Italy*, Kubler remarked on the idea that the creation of a state might be viewed as the outcome of an intellectual and aesthetic process, a process of reflection and calculation, "the State as a work of art."[3] In Peru, as early as the 1930s, the emigré Russian biologist Evgeny Yakovleff identified the species of birds depicted on Nazca ceramic vessels, suggesting that their attributes and properties functioned as components in a system of symbols. Another valuable work was anthropologist John Rowe's imaginative report on the mythic figures carved on the monuments of Chavín de Huántar in Peru (see fig. 11). Rowe explored the likely connection between poetic metaphors of ritual

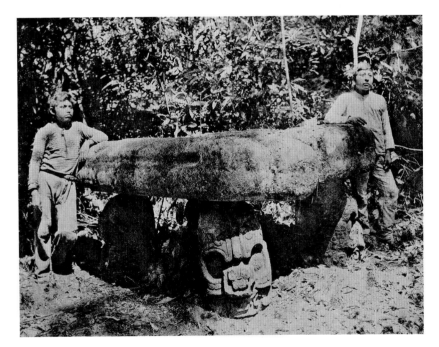

speech and the hybrid images of birds, felines, reptiles, and elaborately costumed human figures—an observation that had widespread implications for exploring the relationship of language and art in other Amerindian traditions.

One of the most significant breakthroughs in the study of the Amerindian past was the deciphering of historical themes in the hieroglyphic inscriptions and figural scenes of Classic Maya monuments. Tatiana Proskouriakoff's articles in the 1960s opened what

Fig. 7 Altar 4. Guatemala, Maya, Piedras Negras, 700/ 800. Stone. Photo: Maler, 1901, pl. 9.

has now become a flood of scholarship devoted to interpreting the inscribed and painted objects, sculptures, and buildings from scores of Maya sites. Texts and images of ancient rulers are now being read as records of dynastic histories and Maya religious cosmology, kingship, and political events from about 250 to about 800. Within the burgeoning field of Maya art studies, the investigations generated by archaeologist Michael Coe must be especially mentioned. Searching for possible connections between scenes painted on ceramic vessels recovered archaeologically from tombs and the mythic adventures of hero-twins described in the early seventeenth-century texts of the Quiché Maya *Popol Vuh*, Coe affirmed a long-lasting pattern of continuity and called attention to the transmission of ideas and the role of religion as a cohesive and dynamic force in Mesoamerican civilization (see fig. 13). Yet, it was the English writer D. H. Lawrence who, with an intuitive sense of poetry, provided an especially evocative glimpse of Amerindian aesthetics and ritual upon witnessing a communal dance at Taos, New Mexico. The men filed out in the plaza, the women following with seed rattles:

> Never shall I forget the utter absorption of the dance, so quiet, so steadily, timelessly rhythmic, and silent, with the ceaseless down-tread, always to the earth's center, the very reverse of the upflow of Dionysiac or Christian ecstasy. Never shall I forget the deep singing of the men at the drum, swelling and sinking, the deepest sound I have heard in all my life, deeper than thunder, deeper than the sound of the Pacific Ocean, deeper than the roar of a deep waterfall: the wonderful deep sound of men calling to the unspeakable depths.[4]

The Search for a Sacred Geography

Since the days of travelers and explorers in the nineteenth and early twentieth centuries, it was noted that the architecture of many archaeological sites visually echoed the shapes of the surrounding land. Tiered pyramids and open plazas repeat the mountains and basins in Mexico, and Inca ruins incorporate natural boulders and other formations of the Andean terrain. In the 1930s, Walter Krickeberg undertook a survey of petroglyphic carvings and sculptures in central highland Mexico and was the first to seriously consider topographic forms in terms of mythic and ritual functions. The originality of his approach went unremarked at the time; yet, it prefigured what has now emerged as a distinct line of inquiry into the relationships of landscapes and symbols. J. Eric Thompson also wrote an exploratory essay on the role of caves in Maya culture. Another important step was taken by ethnohistorian

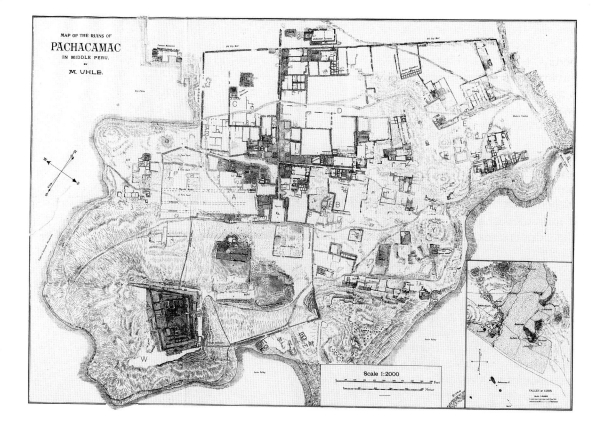

Fig. 8 Plan of the great shrine at Pachacamac on the coast of Bolivia, 500–1532. Drawing: Uhle, 1903.

Doris Heyden when she wrote about the function of caves as ritual sites in ancient and contemporary Indian Mexico. These studies of 1973 and 1976 were linked to the archaeological discovery of a long cave beneath the Pyramid of the Sun at Teotihuacan and the need to explain its possible function. Art historian Stephen Tobriner also wrote a suggestive article on Cerro Gordo as an iconic mountain that probably determined the ritual axis of the city of Teotihuacan (see Pasztory essay in this book, fig. 2). Anthropologist Tom Zuidema's charting of the ritual geography surrounding Cuzco, the Inca capitol, described a system of lines (*ceques*) radiating from the center to a series of shrines and sacred features in the landscape (see McEwan and Van de Guchte essay in this book, fig. 12). This work advanced an understanding of the cycle of agricultural rites and commemorative ceremonies engaging the land and all aspects of life in the Inca state. Another important step in acknowledging the need for deeper examination of the attributes and habitats of animals and the properties of plants in tropical forests was taken by Donald Lathrap. In his essay "The Tropical Forest and the Cultural Context of Chavín," Lathrap considered the imagery of forest species carved on the Tello Obelisk, an icon linked to the temple at Chavín de Huántar in the high Andes of Peru (see Burger essay in this book, figs. 3, 4). The synthesis expressed by the obelisk suggested a critical role for forest cultures in the origins and development of Amerindian civilization.

Inhabited today by some twenty million people, with only a vestige of the rich natural environment that still partly survived one hundred years ago, the Valley of Mexico would now seem an unlikely place to search for evidence of a sacred geography. Yet, within the old core of Mexico City, at sites now enveloped by vast cinderblock suburbs, and at others in the mountains beyond the brown haze, Aztec archaeological ruins have yielded fundamental and detailed information leading directly to the publication and the exhibition it accompanies. My interest in Aztec art took form in the early 1970s while working on a doctoral dissertation, *State and Cosmos in the Art of Tenochtitlan,* under the direction of Tatiana Proskouriakoff at Harvard University. By interpreting the figural imagery and hieroglyphic inscriptions of sculptural monuments from Tenochtitlan and related sites, I realized that the way the Aztec organized their ritual space and urban

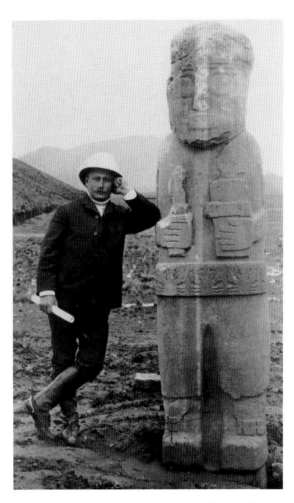

Fig. 9 Arthur Posnansky at Tiwanaku, Peru, 1903. Photo: Posnansky, 1945, fig. 108.

habitat and how they saw themselves in history and myth repeated the way they perceived the overarching order of the natural environment. These researches were continued at the Aztec temple of Malinalco, located in the forested mountains northwest of Mexico City. The temple was conceived as an architectural cave, cut into the living rock of a mountain (see fig. 14). Within this monolithic, circular chamber, the eagle and jaguar seats of Aztec rulership were carved (see fig. 15). Considered in the light of sixteenth-century texts and the work of Krickeberg and Heyden, the monument was revealed to have been an earth temple where Aztec provincial governors took office and where the sacred earth legitimized their rule. In "Malinalco and the Lords of Tenochtitlan" (1982), I also intended to show Malinalco as the provincial expression of a symbolic program developed first at the imperial capital Tenochtitlan, where the Aztec kings assumed office and power. These discoveries led to the idea that certain other landscape features might be represented by Aztec monuments.

In January 1978, I began to search the Valley of Mexico for key sites of a sacred geography. Among many locations visited, the ritual

Fig. 10 Miguel Covar-
rubias's chart proposing
Olmec origins of the rain-
god masks in subsequent
Mesoamerican styles
and cultures. Drawing:
Covarrubias, 1957, p. 62.

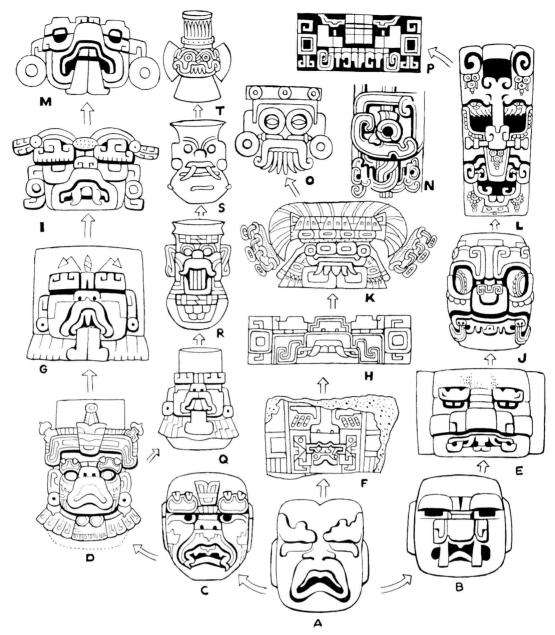

hill of Tetzcotzingo and the temple on Mount Tlaloc appeared to be particularly significant. At Tetzcotzingo, near the city of Tetzcoco (Texcoco) in the eastern Valley of Mexico, King Netzahualcoyotl had commissioned religious and historical monuments during the fifteenth century (see Townsend essay in this book, fig. 12). These shrines, embedded in the mountain, portrayed those aspects of the land and the sky that were perceived to be especially significant. The ritual organization of this "mountain of life" not only echoed the ecological stratification of the great rain-producing mountains of central Mexico; it also showed an essential affinity with the Main Pyramid of Aztec Tenochtitlan. In "Pyramid and Sacred Mountain" (1982), I explored the connections between particular forms of the natural environment and the symbols of urban monuments. Ongoing inves-

tigations at the temple on Mount Tlaloc have deepened this inquiry and are discussed in chapter 3 of the present volume.

These findings were greatly amplified in the early 1980s by the excavation of the foundations of the Main Pyramid of Tenochtitlan in central Mexico City. The extraordinary project was directed by Eduardo Matos Moctezuma, whose subsequent publications and those of his associates disclosed the history of the building in the Aztec state and its complex symbolism. The Main Pyramid stood at the ritual and geographic epicenter of the capital city, at once a man-made symbolic "mountain of life" and the *imago mundi* of the Aztec kingships and world (see Matos Moctezuma essay in this book, fig. 8). The relationships of pyramid, land, and Aztec society were discussed by many scholars in *The Aztec Templo Mayor*, a conference volume

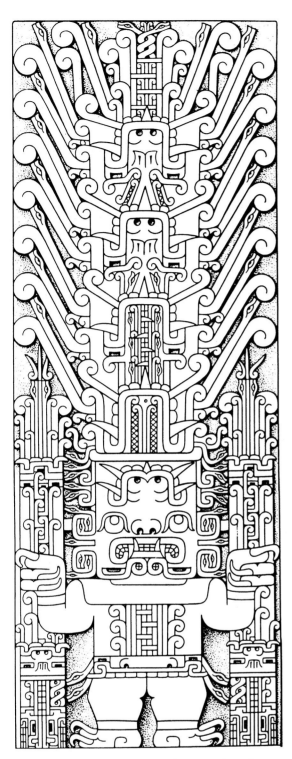

Fig. 11 Raimondi stela. Peru, Chavín, Chavín de Huántar, 900/200 BC. Drawing: After Willey, 1971, p. 46.

cultural civilization of Mesoamerica. It was their aim to declare their own place and identity within a larger framework of concepts, customs, perceptions, and symbols inherited from their predecessors. Most recently, Aztec ceremonial landscape in the Valley of Mexico has been explored by several scholars in a volume edited by David Carrasco. The idea of *ritual landscapes* or *sacred geography* emerged as an ancient principle, transmitted and adapted by a succession of societies over centuries or even millennia. The work in the Valley of Mexico by archaeologists, anthropologists, ethnohistorians, and art historians thus formed a base and a frame of reference for preparing the "Ancient Americas." The notion of sacred geography might well serve as an underpinning for the diverse styles and symbols developed by other cultural traditions, north and south, throughout the continent.

Voices of Cultural Continuity

The patterns disclosed in the Valley of Mexico also showed affinities with ways of thought and ritual symbolism in contemporary Indian societies. Among the many reports of recent decades, three have played a formative role in the "Ancient Americas" project. In the southwestern United States, the archaeological background for the modern Pueblos has been worked out in considerable detail since excavations began in the early twentieth century. Decades of ethnological research have voiced the distinctive ethos and world view of this enduring cultural tradition. The *Tewa World* (1969) by Alfonso Ortiz outlined the religious and social organization of San Juan Pueblo in New Mexico, describing a sacred geography that bears a broad family resemblance to that which would be outlined later in the Valley of Mexico. Far to the south, in the mountains of Chiapas, a long-term anthropological project reported the dynamically vital world view of a Maya Indian community. In *Zinacantan* (1969), Evon Vogt described the circuits of shamanistic healers visiting ancestral shrines on mountains, in caves, by springs, and at other locations around the community center (see Vogt essay in this book). Indian informants described a framework of thought and symbolic action maintained at Zinacantan over a period of almost four hundred years of pressures from Hispanic political and religious institutions. In the remote Andes of Bolivia, Joseph Bastien reported on the religious life of Quechua and Aymara communities. Having served formerly as a priest in a

edited by Elizabeth Boone in 1986; by Matos Moctezuma in *The Great Temple of the Aztecs;* and by Broda, Carrasco, and Matos Moctezuma in *The Great Temple of Tenochtitlan: Center and Periphery in the Aztec World.* They demonstrated that, at this site and others in the Valley of Mexico, economy, religion, history, and art were deeply interwoven in the Aztec world view. They also showed that the Aztecs, a relatively simple immigrant people in the thirteenth century, had adapted themselves to the culture of much older communities deeply rooted in the agri-

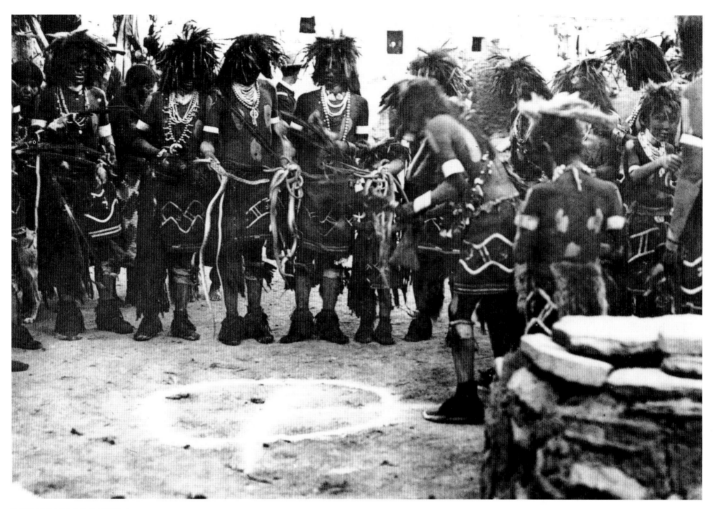

Fig. 12 Ring of sacred
cornmeal. Arizona, Hopi,
Mishognovi, 1901. Photo:
Adam C. Vroman, in Webb
and Weinstein, 1975, p. 101.

neighboring district and noting the tenacious resistance of the Aymara to acceptance of economic and social programs imposed from outside, Bastien returned as an anthropologist to learn of the peoples' bonds with the land and its animals and plants. In *The Mountain of the Condor* (1978), the author described a cycle of reciprocity by which the people ceremonially feed the earth at shrines set in the mountain, in return for the fecundity given to their fields and animals. The snowbound peaks and cold mountain lakes are where the deceased go to reside, and whence the newborn infants are thought to arrive. The people think of themselves and their land in terms of resemblance and analogy: as macrocosm to microcosm, the land is related to the human body and the body to the land.

A Walk Through the Exhibition

The essays in this book and the artistic traditions selected for discussion reflect the constraints of the "Ancient Americas" exhibition. Some three hundred works have been displayed to effectively develop the exhibition theme. Regrettably, in terms of logistics, costs, and the amount of information

that can be reasonably presented to gallery visitors, the number of objects could not be greater. The selection was also influenced to some extent by my personal experience and work in the United States Southwest, Mesoamerica, and the Andean region. As a result, the exhibition and book do not include the remarkable archaeological cultures of North America beyond the United States Southwest, the notable arts of early Costa Rica, Nicaragua, and the Caribbean, or the ancient cultures and arts of the Amazon Basin.

The sequence of fourteen cultural traditions represented here begins with the Mimbres of the southwestern United States. Then follow the arts of Mesoamerican cultures in Mexico and Guatemala: Olmec, Teotihuacan, Maya, and Aztec. The art of ancient Panama is displayed close by that of the Tairona of Colombia and La Tolita/Jama-Coaque from Ecuador. The Andean arts of Peru and Bolivia begin with Chavín and Paracas, continuing with Nazca, Moche, Tiwanaku, and Inca. In addition to these principal ensembles, various works from other cultures are included. In the exhibition, the objects are displayed in distinctive groupings according to culture and geographic area, together

with panoramic photomurals of archaeological sites in their landscape settings. This format invites the viewer to be mindful of a dialogue between small-scale objects, monumental sculptures, architecture, and the natural environment.

The archaeological culture known as Mimbres, dating to about 1000, is counted among the ancestors of the Pueblo peoples who continue to dwell in the broad region stretching from the Rio Grande in New Mexico to the north Arizona plateau. Art historian J. J. Brody describes Mimbres black-and-white-figured ceramics, which were unsurpassed in the Southwest for their bold graphic design and abstraction. Yet, the Mimbres painters, probably women, depicted an appealing, intimate, and often humorous world of animals, humans, and plants.

In the nearby mountainous region, people whose culture is known as Salado left a cache of figures, bound in reed matting and stored in a cave. The human effigies, wooden serpents, and the carved wooden puma are among the most haunting archaeological works from the Southwest. They bear close resemblance to ritual figures and implements still seen and used among the Pueblos today and they testify to the enduring cults of earth and sky (see figs. 12, 16).

The southwestern tradition is also discussed by archaeologist Stephen Lekson, who portrays the brief but extraordinary flowering of Anasazi communities in Chaco Canyon between about 900 and 1175 AD. The architectural ruins of Pueblo Bonito and other "great houses," kivas, and related constructions are shown to be a major cultural synthesis, one of the most remarkable instances of advancement of a complex civilization north of Mesoamerica. Lekson's inquiry also takes us beyond the known facts of chronology to outline the most recent findings on the cultural, social, and artistic achievements at Chaco. To a much greater degree than had been imagined, the siting of monuments, the plan of communal dwellings, the pattern of roadways, and the ritual cycle of seasonal activities suggest the unified role of Chaco as a religious and administrative center for a vast region.

Almost two thousand years before the Mimbres, far from the desert Southwest, the Olmec of southern Mexico were building imposing religious and political centers at La Venta and San Lorenzo. A powerful stone sculptural art was developed to equip pyramid platforms and open plazas with commemorative monuments. Workshops also provided the priestly and political elite with figurines and small-scale objects exquisitely carved in imported greenstone and jade. The Olmec style displays curving planes enveloping massive volumes, and surfaces are often finely incised with linear signs and symbols. Such monuments as the colossal head of a ruler from San Lorenzo and the jadeite mask from Arroyo Pesquero (see de la Fuente essay in this book, figs. 2, 16) portray individuals whose commanding expressions speak of the temporal and religious authority of dynastic rulers. Art historian Beatriz de la Fuente notes in her essay that Olmec art centered on human figures, often associated with symbols of felines (the lords of the earth and the forest) and other real or mythical creatures. The stylized cave mask from Chalcatzingo functioned architecturally as a place of religious communication with the underworld of ancestors, who were intermediaries between the living community and the regenerative forces contained in the land (see de la Fuente essay in this book, fig. 1).

The ruins of the city of Teotihuacan form the largest archaeological site in the Americas. During the first century, a dense agglomeration of settlements was given a regular gridlike plan, determined by the orientation and placement of ritual constructions in relation to significant features of the land and sky. The great Ritual Way was aligned to connect the sacred mountain to the north of the city and the zone of springs and agricultural fields to the south with the central ceremonial buildings. An intersecting roadway running east-west paralleled a line drawn from the city to a point on the west horizon where the constellation Pleiades set to mark the annual renewal of time (see Pasztory essay in this book, fig. 5). The colossal Sun Pyramid, built above an underground cave, surely marked an earth-womb shrine and established an axis to the heavens. Art historian Esther Pasztory points out that Teotihuacan art does not portray individuals or specific historical events. Its subjects belong instead to the richly symbolic but "anonymous" imagery of the cults of deities and of natural forces.

The art of Classic Maya capitals paralleled that of Teotihuacan until the collapse of these civilizations between the eighth and tenth centuries. The young Maize God (see Miller essay in this book, fig. 1) from Copán, in Honduras, is our touchstone for this extraordinary tradition. Art historian Mary Miller discusses this youthful, idealized prince, portrayed as the personification of

new maize. He enacts a theme of a genesis myth in which the first true human beings were fashioned by the creator gods from maize dough, the source of Maya sustenance. Another aspect of Maya art and thought is discussed by archaeologist Juan Antonio Valdés, who traces the beginnings of Maya cosmological imagery to the formative period of architectural sculpture, stelae, and the plans of religious and political capitals.

The brilliant blue-masked water vessel of the rain god, Tlaloc, is a centerpiece of the Aztec section (see Townsend essay in this book, fig. 1). It was among the thousands of offerings recovered archaeologically from the foundations of the Aztec Main Pyramid in downtown Mexico City. As Matos Moctezuma has revealed, only since the excavations has it been possible to interpret the building in terms of its fundamental significance as a symbolic "mountain of life." The mimesis of this urban monument in relation to the rain mountains overlooking the Valley of Mexico is amplified in my essay on the Temple of Tlaloc. As inheritors of age-old obligations, the Aztec rulers made an annual pilgrimage to that mountaintop temple, where sacrifices were offered to set in motion the formation of clouds, the arrival of rain, and the annual renewal of vegetation.

The golden objects and painted ceramics recovered from burials of Sitio Conte were emblems of the chieftains of ancient Panama between 1300 and 1530 (see Helms essay in this book, figs. 1, 4). Anthropologist Mary Helm's essay explains the composite figures depicted on these objects. Anthropomorphic beings display avian, feline, and crocodilian attributes, drawing analogies between the functions of rulers, the organization of society, and the hierarchy of powerful creatures in near and far places of the tropical forest.

The Andes of Colombia were the homeland of many ethnic groups and independent chieftainships. From the first millennium BC, the art of goldsmithing was well developed. As in other regions of South America, gold was not only esteemed for its visual appeal and incorruptibility, but also for its symbolic values. A Tairona figure (see Zuidema essay in this book, fig. 15) cast in gold, using the lost-wax method, speaks of superb craftsmanship and aesthetic accomplishment in a symbolic tradition related to, but distinct from, those of Central America. Anthropologist Tom Zuidema's essay identifies connections between the images of seated human figures and birds, felines, and reptiles associated with the worship of the earth and the sun.

The Tairona were directly ancestral to the Kogi Indians, who continue to preserve their culture and live in this isolated region.

The coastal forests of Manabí Province in Ecuador are traversed by rivers flowing into the Pacific. This was the homeland of cultures with seagoing trade that extended to Central America, Mexico, and Peru. Archaeologist Francisco Valdez sketches the development of the site of La Tolita, from its beginnings on a riverine island in the first century AD to its development as a major ritual center with expanded residential and agricultural districts, and then to its eventual decline in the fourth century, and its lingering functions as an ancestral place of worship. The affinity between the layout of the ceremonial plaza at La Tolita and the U-shaped plans of much older sites on the Peruvian coast far to the south suggests an early cultural diffusion to this northern area. Yet, the selection of some twenty-five works in ceramics and precious metals from La Tolita included here (see frontispiece, p. 2; and Valdez essay in this book, figs. 2, 11) — ceramic figures, vessels, and ceremonial furniture display masks, headdresses, garments and accessories modeled with meticulous detail — shows an integrated vocabulary of forms in a distinctly independent style. La Tolita art not only developed an imagery relating to great animals of prey, but also to forms that pertain to planting and harvest activities. The centerpiece of the ensemble is a golden sun mask (see frontispiece). As the sun rose over the forested hills at certain times of year, the mask was worn in dances and processions to reflect the shimmering light.

Of all the archaeological monuments of Peru, none are more mysterious than those of the Temple at Chavín de Huántar. Beginning about 900 BC and continuing until 200 BC, this ceremonial complex was built in the heart of the Andean cordillera (see Burger essay in this book, fig. 1). Archaeologist Richard Burger recounts the process through which the builders and sculptors of Chavín created an architectural and sculptural vocabulary by synthesizing a "cosmopolitan" style from much earlier traditions developed in distant areas. The sculptural images that adorned the walls allude to animals not native to this mountain location: caymans, jaguars, and crested eagles are primarily Amazon forest dwellers. Composite, monstrous creatures are featured, sometimes in association with marine shellfish, such as *Spondylus* and *Strombus* from the far-away coast of Ecuador, carved, for example, on the

Lanzón, a prismatic stone stela located deep within the subterranean labyrinth in the heart of the temple, and on the Tello Obelisk from a nearby site. Such motifs suggest religious connections with different cosmological levels or regions.

By 400 BC, the symbols developed at Chavín de Huántar were being carried across Peru, on ceramics, textiles, and other items of religious paraphernalia. Their authority inspired the creation of new regional styles and configurations of symbols. In the South Coast, a desert region, painted textiles reflecting the Chavín style were made at Karwa (see Burger essay in this book, figs. 17, 18, 19); and, at nearby Ocucaje, around 500 BC, splendid mantles were embroidered with linear figures arranged in formats that hark back to that formative center (see Paul essay in this book, fig. 3).

In ancient Peru, cloth, clothing, and the excellence of weaving were always held in highest esteem. Paracas mantles are often regarded as unsurpassed in craftsmanship

and aesthetic expression within the four-thousand-year-old Andean tradition of weaving (see Paul essay in this book, fig. 1). Their embroidered figures reflect an elaborate cosmological imagery, depicting the animals and plants of the sea, the desert, and the valleys where farming was precariously practiced. Art historian Anne Paul identifies many species, indicating that their habits and habitats provide a "text" from which to approach the visual metaphors and analogies presented by the complex embroidered figures. Wrapped in images depicting the creatures and rites associated with their homeland, the Paracas chieftains and priestly elite were buried in mantles that affirmed their mythic connections with the network of life in the region.

The South Coast assemblage continues with Nazca textiles and ceramics. In communities bordering the narrow, green valleys that traverse this stark terrain, ceramic artists developed the technology for polychrome wares with the widest range of color

Fig. 13 "Vase of the Seven Gods" (rollout drawing). Guatemala, Maya, 700/800. Ceramic. Drawing: Coe, 1973, p. 109. Opening with a calendar round date, 4 Ahau 8 Cumku (August 12, 3113 BC), the beginning of time for the ancient Maya, this vase painting depicts a scene occurring at the dawn of creation. Seated on his jaguar-throne, God L, Lord of the Underworld and Death, holds court with subordinate deities. In the *Popul Vuh* texts, God L is described as a formidable opponent of the hero twins, to be defeated only through cunning in the human soul's effort to overcome death and exit Xibalbá, the underworld, in the dance of rebirth.

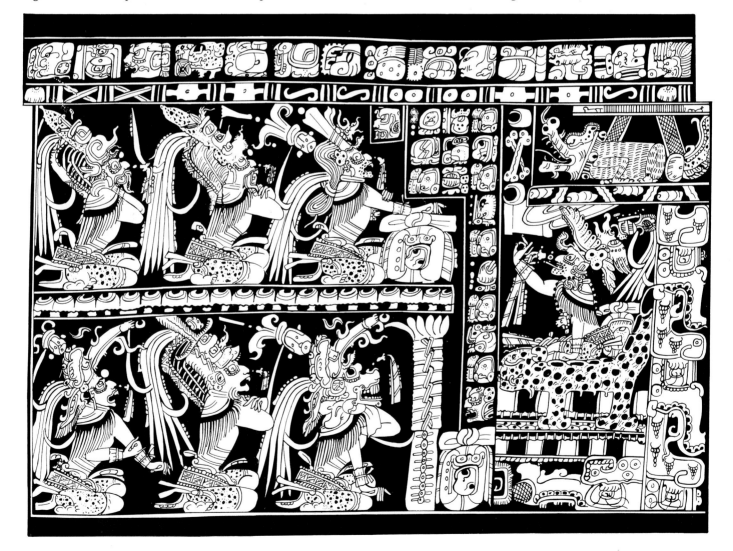

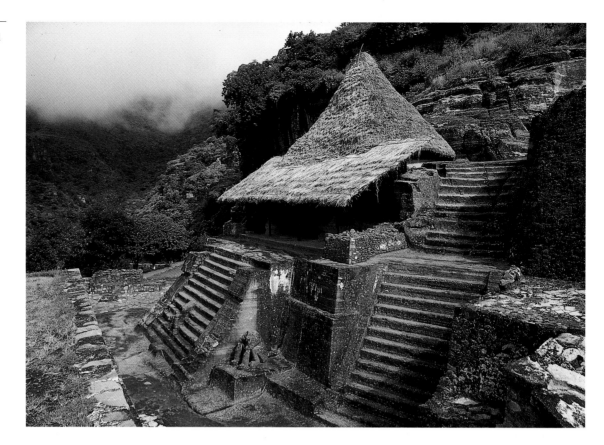

Fig. 14 Cave-temple carved into the living rock of the mountain. Mexico, Aztec, Malinalco, 1500/50. Photo: Richard Townsend.

Fig. 15 Interior view of cave-temple at Malinalco. Photo: Mark Godfrey, ©National Geographic Society. The semicircular bench and floor are carved with eagle and jaguar seats for Aztec military governors. The circular opening in the floor was a receptacle for blood offerings to the earth, legitimizing Aztec rule. The form of the temple recalls the kivas of ancient Southwestern architectural tradition.

in the art of Andean civilization. Spherical, cylindrical, and domelike shapes were covered with figures akin to those of the earlier Paracas mantles (see Reinhard essay in this book, fig. 14). In some instances, the creatures depicted on these vessels are found again, drawn in colossal scale on the surface of nearby deserts, where costumed personages performed rites at critical times of the year; these desert drawings also depict linear diagrams and processional ways (see Reinhard essay in this book, figs. 1, 3). Ethnologist Johan Reinhard describes how these lines point to hills and promontories, converging on features considered sacred by the Nazca. Although the rock and sand mountains may have never seen a drop of rain, some were—and still are—places of worship, for they are regarded as containers of water and are linked symbolically to the peaks of the Andes and to the mother of waters, the sea.

While the peoples of the South Coast remained somewhat isolated, the Moche and their neighbors on the North Coast developed cosmopolitan kingdoms. The essay by art historian Elizabeth Benson outlines the world perceived by Moche artists, from the Pacific Ocean to the coastal valleys and mountain heights to the east. Moche ceramics are remarkable for their sculptural naturalism and lively drawing. They depict everyday life, individual people, architecture, agriculture, warfare, and religious ceremonials and mythical events (see Benson essay in this book, figs. 1, 13, 17). Many scenes on individual vessels belong to larger cycles of images, with well-known characters and familiar narratives of legendary happenings and ceremonial enactments. Moche artists produced some of the most exceptional portraits to have been made in the ancient Americas, where strongly naturalistic visages were rarely a subject of artistic interest.

Long regarded as an isolated religious center, visited only at festival times, the archaeological site of Tiwanaku is now revealed to have been the core of a highly urbanized zone with outlying towns and extended zones of intensive agriculture. Located on the 12,500-foot-high plateau of Bolivia at the southern end of Lake Titicaca, Tiwanaku commanded a vast domain that embraced the snowy cordillera and Amazonian side of the Andes to the east, and the high deserts and narrow river valleys leading down to the Pacific. The idea governing the design of platforms, pyramids, and sunken plazas at Tiwanaku is admirably explained by archaeologist Alan Kolata, who, in association with Carlos

Ponce Sanginés and Oswaldo Rivera, began a new program of excavations there during the 1980s. The religious and political center of the city was designed as a "sacred island," repeating an old Andean archetype of the place where the world was created (see Kolata and Ponce Sanginés essay in this book, fig. 8). In a notable parallel with urban monuments in the Valley of Mexico, Tiwanaku's main pyramid, the Akapana was designed as a sacred mountain.

The "Chunchukala" stela, the colossal head of a commemorative figure, the puma-masked warrior with a trophy head, as well as gold and silver diadems are strongly hieratic and impersonal in style, suggesting an authoritarian "corporate" religion and government in this organized state (see Kolata and Ponce Sanginés essay in this book, figs. 3, 4, 10, 12).

Similar concerns also inform the design of Tiwanaku and Huari textiles. Art historian Rebecca Stone-Miller explains how a language of abstract signs and symbols, referring to animals and human figures, followed prescribed rules of design that allowed for occasional variation (see Stone-Miller essay in this book, figs. 1, 8). These garments, worn by state officials, communicated a system of rank and authority within the specialized and stratified society of Tiwanaku and Huari. Stone-Miller believes that the appearance of design anomalies must reflect, as well, the unknown and unpredictable quality of life in the harsh Andean environment.

The Inca landscape is explored by archaeologist Susan Niles, who reports a variety of manufactured and natural forms ranging from the temples of Cuzco to boulders enshrined throughout the Inca heartland. Sacred sites were known in the Quechua tongue as *huacas*—a term conveying the idea of a living force or energy inherent in all things (see Niles essay in this book, fig. 13). Archaeologists Colin McEwan and Maarten Van de Guchte collaborate in the final essay, disclosing a means by which Inca rulers affirmed the religious and political integration of an immense territory from northern Ecuador to central Chile. Lines radiating from the center of Cuzco, the capital, were routes for processions that would offer human sacrifice on mountaintops and glacial slopes, and at sacred islands or ancient ruins revered by the Inca (see McEwan and Van de Guchte essay in this book, figs. 7, 8). Mythical archetypes formed the script for these enactments, which were designed to confirm the boundaries of empire and to acknowledge sacred

topographical forms and the sites of ancient inhabitants. Performed upon the death of a ruler and the accession of another, the sacrifice offered thanks and began the cycle of renewal.

Art and the Cycle of Renewal

Within the seemingly infinite variety of forms seen in the "Ancient Americas" exhibition and book, there lies an order revealed by the dialogue between land and visual symbol. The task of the artist was to create networks of metaphor and analogy that connected the social and cosmological spheres. The diverse communities to which they belonged did not share a unifying scriptural tradition or doctrine as did Christendom, Islam, or Buddhism; yet, all seem to have participated in an outlook that bound them to their natural environment and its regenerative potential. Words such as *teotl*, in the Nahuatl language of Central Mexico, or *huaca*, in the Quechua tongue of the Andes, are important to any understanding of this ancient world view. *Teotl* means "something sacred," and was used to describe powerful natural phenomena and deities, as well as masks and religious implements and certain types of places and persons of exceptional status. The word *huaca* was employed similarly to characterize mysterious features of the landscape, as well as man-made temples and icons, and even sacred cities or ruins. These terms suggest the notion of life in all things, fixed or mobile, animate and inanimate, seen and unseen. This was not the pantheistic idea of "God in everything," but another form of perception and thought that held human, animal, and all other entities to be inherently charged in greater or lesser degree with a vital and numinous energy.

Basic concepts of space and time dictated the design and activities of the human habitat in the ancient Americas. The horizontal layers of the universe were established by the expanse of the sky, the plane of the earth, and the subterranean regions. Another fundamental spatial division was marked by the sun's path from east to west, and the idea of the center was affirmed by an imaginary axis running vertically from zenith to nadir. Cycles of time were marked by the regular movements of celestial bodies, and the alternation of the dry and wet seasons. The order perceived in the natural world was reflected in the placement of monuments, the orientation of buildings, and the layout of temples and cities, as well as the annual progression of festivals and their corresponding socio-economic activities. Each sector of the cosmic structure was charged with its own special attributes and mythological significance, which art, architecture, and ritual performance were designed to portray. The center was pre-eminently the place of human dwelling: the hearth, the house, the city, and the surrounding zones of cultivation. The most powerful and dangerous forces resided in distant or peripheral places or phenomena: these included thunder, lightning, and dark storms on mountaintops; the shaking of earthquakes from deep below; the heat of the sun; the fecundity of the earth; and the movement of sea-borne tides. Specific forms, such as mountains, caves, springs, lakes, and rivers, as well as forests and agricultural districts, were foci of worship whose manifestations of life were translated in myriad systems of symbols. Certain creatures were assigned important positions connecting the spheres of life in the air, on the land, and in water. By virtue of instincts and powers that they possess but that human beings do not, and because they live apart from the familiar, manufactured center or because of some imagined resemblance, they were deemed to be closer than humankind or other living beings to the most potent elements of nature. The eagle and condor, felines and coyotes, serpents, caymans, and related amphibians were widely acknowledged as mediators and figured as emblems of rulership or as signs of priestly or shamanic authority.

A profound difference between the art of Greco-Roman antiquity and that of the ancient Americas is seen in the treatment of the human figure. In the ancient Mediterranean, the gods were visualized in a way that celebrated and idealized the human figure. In the Americas, human anatomy was almost invariably generalized as the bearer of headdresses, masks, jewelry, and other implements and emblems, which were universally depicted with meticulous precision and attention to every detail. Even when effigy figures were carved as "nudes," they were intended to be periodically dressed in the cult attire appropriate to a given deity or festival. In these civilizations, costume was a principal means of communication, proclaiming in visual metaphors the names and properties of powers and deities, and the attributes and obligation of rulers. When such costumes were worn by performers in agricultural festivals and state occasions, they were seen and "read," while being named and described in

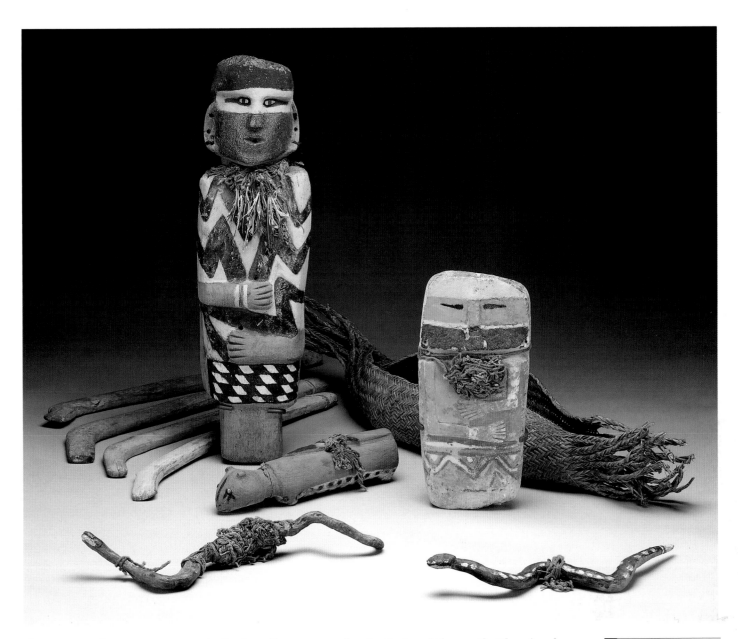

the songs and prayers presented. Oral tradition was critically bound to the visual arts in preserving and transmitting vital knowledge about the origins of the world and humankind, the acts of legendary heroes, and the historical achievements of rulers and their peoples. Elemental forces were summoned at these performances, where kings, nobles, and people danced. Through the cadence of chants, disciplined formations, and display of endurance and vitality, the community was invigorated and sustained and a moral standard was set.

At sacred places along the entire length of the Americas, offerings were made to ancestors, deities, and the forces of nature in re-

turn for the fruits of the earth. The visual arts were fundamental in this intricate fabric of reciprocity, by which the people drew together the living, the dead, ways of subsistence, and the structures and rhythms of the universe. In these respects, the Amerindian nations were engaged in a shared world of belief and symbolism — a kind of *oikoumene*, as it would have been called by the Greeks. This complex relationship of humankind and land was voiced in an overarching religious and aesthetic outlook, in which the men and women of countless communities were — and still are — active participants in the process of nature's renewal.

Fig. 16 Ritual cache figures. New Mexico, Mimbres, Salado region, c. 1350. Stone, wood, cotton, feathers, and pigment. The Art Institute of Chicago. Brilliantly colored and adorned with feathers and string made of cotton, the standing figures are accompanied by wooden snakes, a mountain lion, and other objects that express connections with the earth, the sky, and the subterranean regions. (Cat. no. 150)

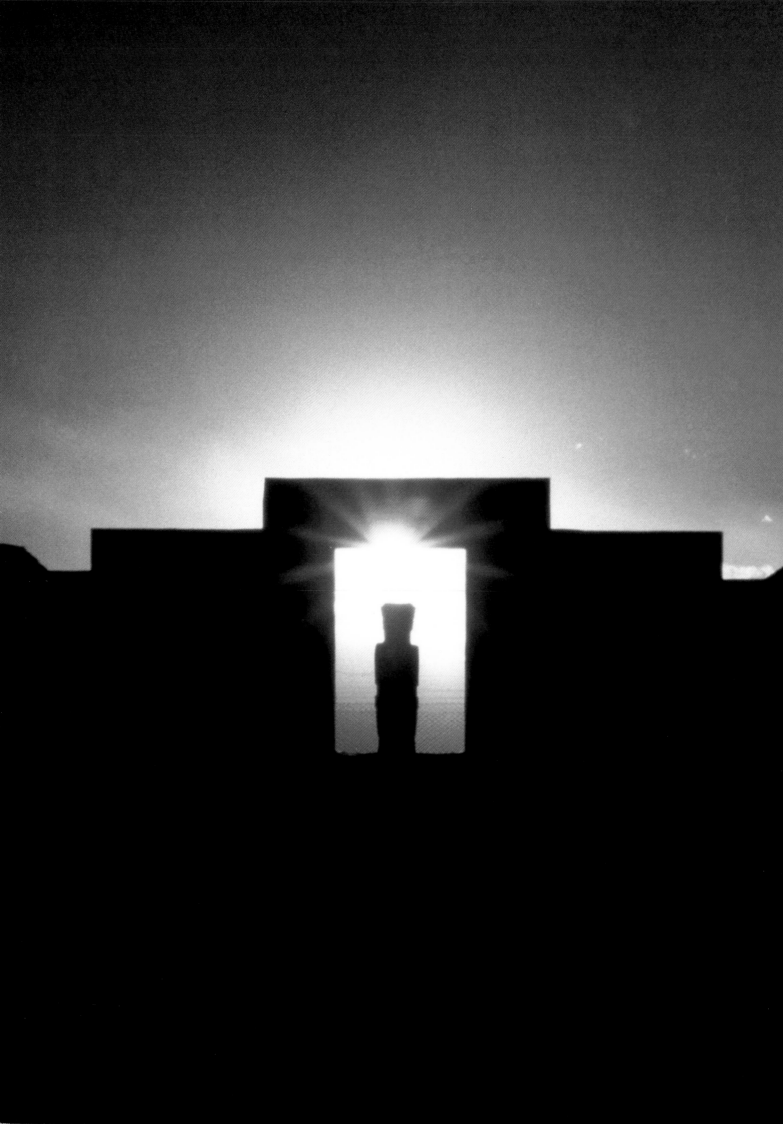

PRE-COLUMBIAN IMAGES OF TIME

What is time? Saint Augustine answered, in effect: if you do not ask me, I know what it is; it is only when I am asked to express it in words that I have a problem. Ideas about time, modes of reckoning it, ways of using it—these form one sphere among a universe of beliefs and customs viewed through the distinctive cultural lenses of diverse indigenous peoples. These ideas differed greatly from the temporal notions held by the Europeans who came to these shores half a millennium ago. The "Ancient Americas" exhibition and book offer the rare opportunity to glimpse myriad Amerindian expressive forms of that entity, time, which so beguiled Aristotle, long before Saint Augustine, and, Albert Einstein, long after him. Time is silently delineated by the annual movement of the sun along the horizon in orientation calendars viewed from canyon walls by native peoples of the southwestern United States (see fig. 5), as it was along the mountain escarpment of the Basin of Mexico (see Matos Moctezuma essay in this book, fig. 2); on the ridges above the Inca capital, Cuzco (see fig. 4); and on the line of the wall and the framing gateway of the Kalasasaya complex at Tiwanaku (fig. 1). We find time's signature precisely written in the painted bark-paper documents (codices) of highland Mexico and Yucatán. It is mythicized in heroic episodes on brightly painted ceramic vessels left in royal funerary offerings, and it is triumphantly celebrated in the ancestor worship depicted on monumental sculptures in parts of the Americas, both north and south, and theatrically dramatized in the interplay of light and shadow in the architecture surrounding Maya ceremonial plazas. A brief excursion through some of these

forms of timepieces leaves us with the impression of a highly imaginative people who saw themselves immersed in a living, numinous, natural world.

Many peoples in Mesoamerica and the Southwest begin their histories with accounts of the time of genesis and the sacred origin of things. A particularly moving narration is presented in the Quiché Maya *Popol Vuh*, or *Book of Counsel*, which speaks of time in terms of a succession of ages. These eras began when the cosmogonic forces "Heart of the Sky" and "Heart of the Earth" created the sky, the earth, and animals and plants, as well as humans and the underworld, in a process of "sowing and dawning." The primordial scene is described as follows:

> Now it still ripples, now it still murmurs, ripples, it still sighs, still hums, and it is empty under the sky. Here follow the first words, the first eloquence: There is not yet one person, one animal, bird, fish, crab, tree, rock, hollow, canyon, meadow, forest. Only the sky alone is there; the face of the earth is not clear. Only the sea alone is pooled under all the sky; there is nothing whatever gathered together. It is at rest; not a single thing stirs. It is held back, kept at rest under the sky.[1]

Following passages name the spirits and creative forces contained within the waters and sky, who meet and join their thoughts and works to conceive of the growth of life:

> "Let it be this way, think about it: this water should be removed, emptied out for the formation of the earth's own

Fig. 1 Ceremonial gate. Bolivia, Tiwanaku, Kalasasaya complex, 400/800. Photo: Johan Reinhard. Aligned with the east-west path of the sun at the equinoxes, this structure formed the backdrop for the annual round of seasonal rituals in Tiwanaku life.

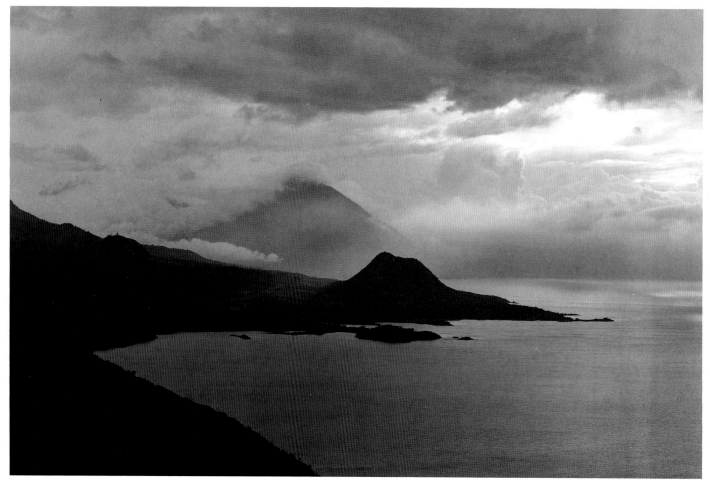

Fig. 2 Lake Atitlán in highland Guatemala. Photo: Dennis Tedlock. The image of the mountains rising from the primordial waters, "like a cloud, like a mist, now forming, unfolding," lies at the center of the Maya creation-myth described in the *Popol Vuh*.

plate and platform, then comes the sowing, the dawning of the sky-earth. But there will be no high days and no bright praise for our work, our design, until the rise of the human design," they said.

And then the earth arose because of them, it was simply their word that brought it forth. For the forming of the earth they said "Earth." It arose suddenly, just like a cloud, like a mist, now forming, unfolding. Then the mountains were separated from the water, all at once the great mountains came forth. By their genius alone, by their cutting edge alone they carried out the conception of the mountain-plain, whose face grew instant groves of cypress and pine [see fig. 2].[2]

This process that started at the beginning of time, initiated a cyclic series of creations and destructions that led eventually to the formation of the present world. In the Maya region and elsewhere in Mesoamerica, the importance of the events of genesis was underlined in commemorative sculpture, monuments that attested to the legitimacy of kings and

their right to rule the world they knew, by tracing their connections to the sacred moment of beginnings.

The origin-time was also held to be sacred in ancient South America. At the Island of the Sun in Lake Titicaca, on the high Andean Plateau between Peru and Bolivia, a major shrine was built around a rock where, according to myth, the sun first rose in the time of creation (see fig. 3; see also Niles essay, and Kolata and Ponce Sanginés essay in this book). The legendary event was recorded in the sixteenth century by the Spaniard Pedro Cieza de León.[3] Long ago, it was said, the earliest, primitive race of people had not seen the sun. They prayed to their gods to relieve their suffering by sending them light. Even as they prayed, the sun rose in great splendor from the Island of Titicaca within the great lake of the Collao (the ancient name of the region). Following this, a creator deity appeared from the south. He made heights out of level plains and springs of water from living rock, and he gave animals and present humankind their existence. This deity was named Tici Viracocha; he was Maker of All Created Things, Beginning Thereof, and Father of the Sun. When the Inca rose to

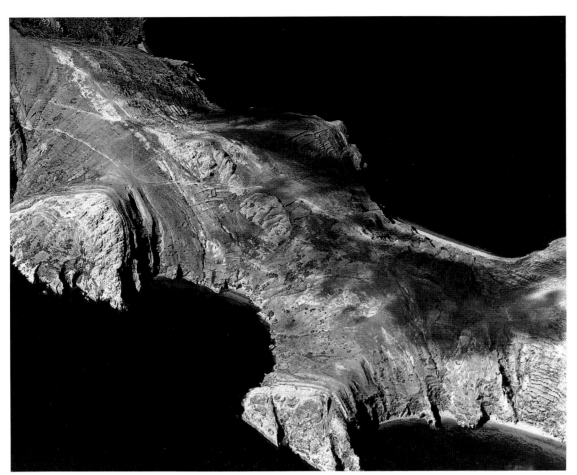

Fig. 3 Island of the Sun in Lake Titicaca, between Peru and Bolivia. Photo: ©Marilyn Bridges 1989. According to ancient myths inherited by the Inca, the rock Titi Kala (on the isthmus at center) was the place where the sun emerged in the original time of creation.

power and conquered this region in the fifteenth century, they appropriated the ancient rock shrine on this island and made annual royal pilgrimages to the site. A variant legend, recorded by the Spaniard Francisco de Betanzos, linked the nearby archaeological site of Tiwanaku with the creation-time events. This city, the center of a civilization that preceded the Inca by over one thousand years, was also venerated as a sacred and ancestral place (see Kolata and Ponce Sanginés essay in this book, figs. 7, 8). At the Island of the Sun, and at Tiwanaku, the Inca contemplated mythical and historical time and laid claim to the grandeur of the past.

On the first page of the *Codex Fejérváry-Mayer* (fig. 7), a Late Postclassic painted-hide document from central Mexico, time envelops a universe in which everything has its proper place. Each quarter of the world, represented by an arm of a "Maltese cross," contains its associated plants, birds, colors, and directional gods; even parts of the human body are assigned a spatial location. The solar disk rises in the eastern arm, at the top of the diagram, while death's jaws lie open in the west (bottom), waiting to receive the dying sun at day's end. Time, the very image of the sun itself, can be reborn only

through human action, which supplies the nurturing blood of sacrifice. Streams of blood connect the creator god, who is armed with spears and a spearthrower at the center, to living entities at the corners of the fourfold universe. The Fejérváry-Mayer diagram represents unified order, incorporating all of the component parts of the universe. It is quite at odds with our scientific cause-and-effect explanation of how things work, which was first developed in Renaissance Europe.

The quadripartite diagram is also a functioning timepiece. Each of the twenty borders enclosing the cardinal and intercardinal segments contains thirteen circular marks. Counting one per day, a two hundred sixty day counterclockwise trip about the periphery of the universe forms an unbroken passage of time in units of the twenty named days of the Mesoamerican calendar. These days are paired with a number ranging from one to thirteen, just as the western world matches the seven-day named sequence with numbered days of the month. This is the Aztec *tonalpohualli* ("count of days"); among the Maya, it is called the *tzolkin*.[4] At each corner of the Fejérváry-Mayer diagram, we read the day-name associated with the first number that begins each consecutive set

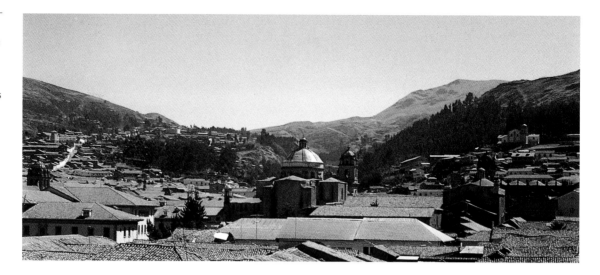

Fig. 4 The west horizon above Cuzco, Peru, from the Inca Temple of the Sun. Photo: Tom Zuidema. The equinox sunset was observed between the ridges at left and center.

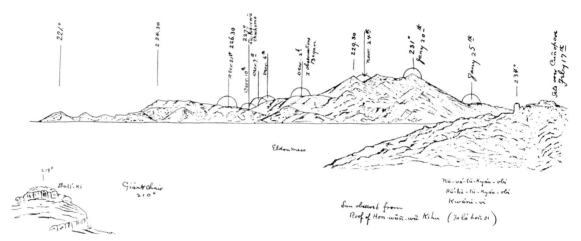

Fig. 5 Sketch of the sunrise horizon, San Francisco peaks, east of the Hopi villages in northern Arizona. Drawing: E. Parsons, 1936, vol. 2.

of thirteen: One Alligator (bottom of upper left column), followed by One Jaguar (bottom of lower left column), then Deer, Flower, Reed, and so on.[5] These twenty day-name symbols are spatially apportioned in four columns of five, each column assigned to one of the four cardinal directions. The columns alternate with blood streams in the narrow spaces between the appendages of the cardinal and intercardinal segments. Each day in this 260-day arrangement carried a particular prognostication. There were (and still are, among some Amerindian peoples) correct days to plant, to marry, to celebrate a rising star. Many of the sacred almanacs in the ancient Mexican codices list the divinatory potentials of the days in this astrologically based temporal cycle.

How did this particular way of recording time, which is unique to Mesoamerica, originate? Surely, the twenty-day count derives from counting on fingers and toes, the foundation for the vigesimally based mathematics known throughout Mesoamerica. And thirteen is the number of layers believed to compose the heavens. Is the *tonalpohualli* simply the result of multiplying two smaller

cycles to create a larger one, as we fold days into months, months into years, and years into centuries, eras, and eons? Its evolution, probably much more complex, may emanate from Preclassic times, when sedentary agricultural peoples first recognized a close correspondence between their own body rhythms and those of their celestial gods. Take the human gestation period and nine cycles of the phases of the moon—both are nearly 260 days long. The female cycle of fertility also mimics the planting cycle. A passage from one of the Aztec chroniclers even links the duration of the appearance of Venus as morning and evening star with the *tonalpohualli*.[6] Finally, there is evidence from the Maya *Codex Dresden* that the *tzolkin* offered a means of predicting eclipses and reading the omens that went with them.[7]

Regardless of culture, discovery is a process wherein the human imagination recognizes a likeness in seemingly diverse aspects of the unknown. Perhaps the single greatest discovery in Mesoamerican timekeeping was the unveiling of nature's magic number, the one that brought together, under the rule of a universal time count, hitherto unrelat-

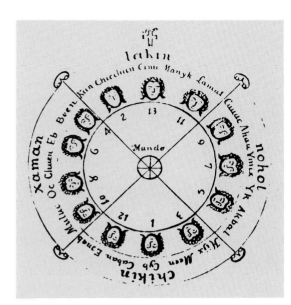

able aspects of a functioning world—Venus and pregnancy, the moon and the body count. The establishment of the 260-day cycle, which can be traced back to the sixth century BC in monumental inscriptions from the Oaxaca Valley, ranks, in its context, with the discovery of the golden mean and the constant of gravitation as hallmarks of human achievement (see de la Fuente essay in this book). It is part of the human quest for unifying principles that reveal intelligible order in a chaotic universe.

Passing from tip to tip of the intercardinal petals of the Fejérváry-Mayer cosmic pattern and making four stops per counterclockwise circuit, we reach at each resting point the day-name of consecutive New Year's days in the year cycle of 365 days.[8] This marks the annual course of the sun; it is subdivided into eighteen months of twenty days each, with a five-day period tacked on. Thirteen such traverses equal fifty-two years as well as seventy-two complete cycles of 260 days. Scholars in the Mesoamerican field call it the Calendar Round, because it binds together two basic temporal cycles, one ritual and the other agricultural. This "binding of the years" is graphically depicted in fig. 8: a rope is drawn taut about a pair of such dates on the Temple of the Plumed Serpents at the ruins of Xochicalco, built in the tenth century. Six centuries later, the Spanish chronicler Bernardino de Sahagún quoted an Aztec saying that, when the cycle was complete, "they put out fires everywhere in the country, cast the statues of their deities into water, disposed of the hearthstones. Everywhere there was much sweeping."[9] Clearly, the completed calendar round signified that time would be renewed. The Aztec marked the completion of a time period by ceremonially tying bundles

of fifty-two reeds, *xiuhmolpilli*, which were also reproduced as stone monuments (see fig. 9). The custom harks back to Teotihuacan, where such representations may be seen in murals dating to around 600 (see Pasztory essay in this book, fig. 1).

In effect, the Fejérváry-Mayer cosmic diagram celebrates the repetitive flow of time that was an integral part of Mesoamerican thought: the day, the passage of the sun along the main axis of the cross; the 260-day biorhythmic cycle, represented by the sequence of dots around the border; the passage of a year, noted by each intercardinal leap; and a bundle of years, about one full lifetime of human experience, indicated by thirteen circulations over the intercardinals. This native American cosmic view portrays time as an entity that contains both direction and spatial ordering. If this seems strange to the Western mind, consider Einstein and the twentieth-century physical relativists who sought the same end, the unification of time and space. Their medium was a set of four-dimensional, abstract mathematical equations rather than the more pictorial form of expression developed by their Amerindian counterparts.

Other written documents stand as testimony to the widespread native American belief in the eternal repetitive flow of events and of time's fourfold division. Even well after the conquest, the quartering of the

Fig. 6 Calendar wheel from *Book of Chilam Balam of Kaua*. Mexico, Yucatán, 1600/1700. Photo: Bowditch, 1910, fig. 64.

Fig. 7 Cosmological diagram. From *Codex Fejérváry–Mayer*, Mexico, Aztec/Mixtec, 1400/1521. Animal hide. Free Public Museums, Liverpool. Photo *Codex Fejérváry-Mayer*, 1971, p. 1.

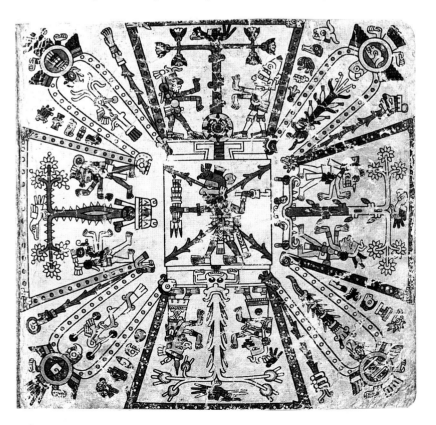

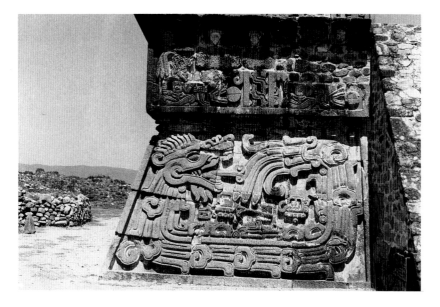

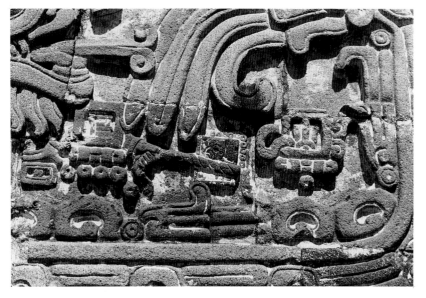

Fig. 8a Temple of the Plumed Serpents. Mexico, Maya, Xochicalco, 900/1000. Stone. INAH–CNCA–MEX, Museo Nacional de Antropología, Mexico City. Photo: Richard Townsend. The plumed serpent with cloud designs symbolizes wind-borne rainstorms, and also stands as an emblem of priestly and royal office.

Fig. 8b Detail of Temple of the Plumed Serpents. A correlation of two regional calendrical systems is shown by a hand extending from a date hieroglyph to rope in another date.

world (labeled "mundo") is still evident in a calendar wheel from the *Book of Chilam Balam of Kaua* (fig. 6). There, we can glimpse the naming and numbering of the days about the horizon, though Jesus Christ, symbolized by the Christian cross, replaces the rising sun in the east, and European-looking faces substitute for the anthropomorphic and zoomorphic figures of pre-European documents. Nonetheless, time's structure remained cyclic, years after the Spanish conquest. Many of these native temporal themes, particularly the fourfold nature of the universe, are traceable in other artifacts in the "Ancient Americas" exhibition and book.

Once thought by the invaders to be the work of the devil, the handful of books that survived the Spanish torch and today reside on public display in museums and libraries were originally intended for priestly eyes only. Native specialists in ritual practice, like the Babylonian astrologers of southern

Mesopotamia, were positioned close to their rulers, who were perhaps their exclusive clients. These royal wise men knew well how to mark the course of time by watching the sky closely. They were the specialists in charge of cultic temples (see fig. 10). Books such as the *Codex Fejérváry-Mayer*, the *Codex Borbonicus*, and others were the divinatory instruction manuals that they once carried from town to town and used to forecast natural events and interpret omens. These wise men were also responsible for invoking the proper incantations, amulets, and formulas needed for setting up a dialogue with the personified forces of the universe, whom the people aided and abetted through temple rituals. The divinatory functions of the manuscripts are outlined in Elizabeth Boone's essay in this book.

In the monumental inscriptions of the ancient civilizations of the Americas, time's image seems tightly focused on the life of the ruler. The message appears to be that dynastic time is sacred time. Among the Maya, a blood tie existed between kings and the forces of nature, a bond formally recognized and relived every time a commemorative monument—a stela, altar, or lintel—was set up in a religious and administrative ceremonial center. In such places, where the powers of gods of time and nature were channeled through the ruler, Maya monuments were time-pillars, serving to emphasize pivotal moments or events—"time's joints," as Shakespeare put it. They celebrated great moments of tension, both civic and natural, that punctuated the normally even, steady flow of time. Would the end of a score of years bring about a holocaust? Might the capture and offering of war victims from a rival city assure the assigned celestial deed? Would the death of a ruler be followed by the successful transfer of authority to his offspring? How could the people be assured that the same source of supreme celestial power, inherent in the old ruler through the penitential blood sacrifice he regularly and publicly made to the deities, would become effective when his son took the throne?

One such moment of tension is depicted on Stela 6 from Piedras Negras (see fig. 11). Stela 6 is among a group of public monuments that superficially resemble gravestones in a cemetery. They were lined up in front of the stairway of Pyramid J-4, fronting the West Group Plaza (fig. 12) at these heavily looted ruins on the Usumacinta River in the rain forest of northwest Guatemala. The figure in the niche is a young ruler (probably a male)

in the conventional posture of one who has just acceded to the throne or is about to do so.[10] He sits in his curtain-draped shrine, which is reached by a ladder and enclosed by a segmented sky-band representing the body of the celestial serpent and the course of the planets around the zodiac. This important personage, who appears elsewhere in the sculpture of Piedras Negras, wears a plumed headdress, ornate earplugs, and a huge breast-plate. All the stelae in the series mark the completion of one year or twenty years. The right half of the hieroglyphic inscription on Stela 6 lists events in the ruler's life and in the lives of his ancestors, but most of the left half is about time alone. Following an introductory glyph, the next five numbers give the position in the Maya Long Count:

> It was nine *baktun* [periods of 144,000 days = 1,296,000 days], twelve *katun* [periods of 7,200 days = 86,400 days], fifteen *tun* [periods of 360 days = 5,400 days], zero *uinal* [a period of 20 days], zero *kin* ["sun" or day] since the last creation.[11]

Thus, the stone marks an event that took place 1,387,800 days after the beginning of the most recent cycle of world creations, calculated by Maya priest/mathematicians to August 12, 3113 BC. The Stela 6 inscription also gives the location of the year-ending event in the Calendar Round: 2 Ahau (the second of thirteen numbers with one of the twenty day names, the *tzolkin* date), 13 Zip (the thirteenth day of the month Zip in the *haab*, the year count). The text then tells the phase of the moon when the lord acceded, the number of the moon in a cycle of six (used to predict eclipses), and the number of days allotted that particular month, possibly even the con-

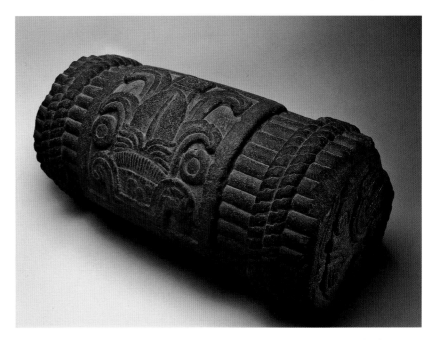

stellation of the zodiac in which the moon was situated. Lintel 3 from this site (see Miller essay in this book, fig. 18) was carved sixty-three years after Stela 6; its dedicatory date reads 9.15.18.3.13 5 Ben 16 Ch'en.

Such monuments display a Classic Maya nobility obsessed with publicly anchoring its genealogy in divine celestial origins. Why were the Maya elite obsessed with detail and precision in the recording of time? Not unlike other cultures who observed celestial activity carefully (e.g., the Chinese, Egyptians, and Babylonians; even Louis XIV was a sun king), the Maya had probably developed an acute sense of the pristine order present in the celestial segment of the natural world and the vast potential for expressing and utilizing it. After all, no cyclic phenomena in nature are as dependable or predictable as those that transpire in the skies. Celestial regularity and continuity serve as excellent metaphors

Fig. 9 *Xiuhmolpilli* commemorative sculpture marking the completion of fifty-two-year cycle. Mexico, Aztec, c. 1508. Stone. INAH–CNCA–MEX, Museo Nacional de Antropología, Mexico City. Photo: Gabriel Figueroa Flores.

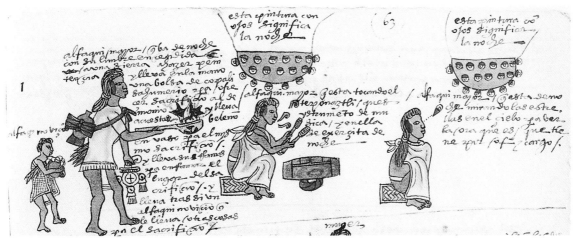

Fig. 10 Priests performing ritual. From *Codex Mendoza*, Mexico, Aztec, Tenochtitlan, c. 1525. *Amate* paper. Bodleian Library, Oxford University. Photo: *Codex Mendoza*, 1938, pp. 92, 93.

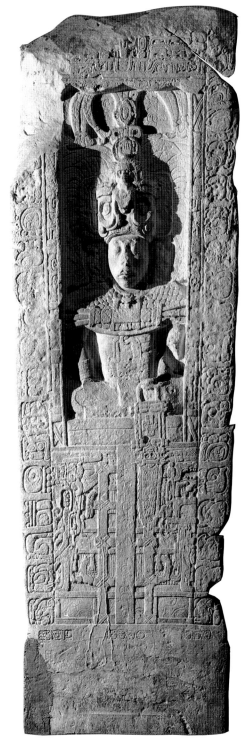

Fig. 11 Stela 6. Guatemala, Maya, Piedras Negras, 600/1000. Stone. Photo: Justin Kerr.

civic, social, and religious needs. The invention of the Calendar Round may have been a way of compromising the old agricultural scheme of lunar reckoning with a more civically oriented solar year. Similar compromises took place in our own calendar, in the time of Caesar and again in the sixteenth-century reforms of Pope Gregory XIII. We are on more secure ground if we recognize that the Maya time system evolved slowly over a long period and was not an overnight invention of a single person. For example, compare the Classic Stela 6 with two Maya time columns that are separated by more than a thousand years: Preclassic Stela 11 from Kaminaljuyú (see Valdés essay in this book, figs. 7, 8), which was erected before the invention of the Long Count, and the Late Classic Stela 17 from Dos Pilas (see Miller essay in this book, fig. 5), which records only the fragmentary remnant of the Calendar Round date "9 Ahau," carved in the upper left panel above the ruler's head.

Classic Maya ceremonial spaces were designed to coordinate time-reckoning and the annual cycle of rituals. They were theaters where celestial and human actions crossed one another. Copán's Temple 22, for example, lies on the north side of an enclosed court (see Miller essay in this book, fig. 8). Built in 703 by the ruler Eighteen Rabbit,[12] this structure was probably used to celebrate his intimate association with the cycle of rain and the annual sprouting of the young corn, personified by the youthful aspect of the ruler himself. Before the assembled throng, he sat in the doorway upon a throne inscribed with hieroglyphs depicting important events in his life. There, he likely performed in public the penitential act of letting blood by inserting the spine of a stingray through the end of his penis. The bicephalic sky serpent carved in high relief over the doorway contains the hieroglyphic symbol of the sun as well as that of Venus, his patron star. Other Copán inscriptions link events in his life with key turning points in the celestial course of this planet. The arrival and departure of Venus, the sun's announcer, were clocked through a unique slotlike window located on the western side of Temple 22. There, the movements of Venus could be carefully monitored, and any connections with other natural phenomena, such as the coming of the rain and the initiation of the maize-planting cycle, could be noted. Largely unknown to modern astronomers until the Maya Venus window was carefully measured and mapped,[13] the period of disappearance of Venus between

for the eternal safeguarding proffered by the Maya rulership to the people. The Piedras Negras ruler, looking out from his niche in Stela 6, seems to be saying to his people: "This was your master's year; here he sits before you, a god of nature and of number manifest, and, through your material and corporeal sacrifice, he will keep the world going round forever." The more specialized and hierarchically structured the state became, the greater the perceived need to devise a universal time system, one that appealed to all

evening star (when it is seen low in the west after sunset) and morning star (when it rises ahead of the sun in the east) changes over the course of the year. Venus has been gone for just a few days when the reappearance event occurs in winter, but it is absent considerably longer, up to twenty days, before it reappears in summer. The Venus Table in the Maya *Codex Dresden*, [14] a recyclable Venus calendar valid for two full Calendar Rounds (104 years), tabulates an average disappearance interval of eight days. This document signals the importance of the morning-star apparition by connecting omens about human, animal, and plant fertility to a variety of Venus aspects. Temple 22 serves as one example of specialized Classic Maya architecture—a stone timepiece that functions as a true astronomical observatory and as a ritual stage for sacred celestial events or manifestations of divine celestial power seen directly through the ruler's participation in a ritual performed at the very moment his personal star passes over his throne.

This time-oriented landscaping—the incorporation of time into the architecture at Copán—has also been discovered in the plans of indigenous America's other great cities: in central Mexico, Teotihuacan (see Pasztory essay in this book, figs. 5, 6) and the Aztec Tenochtitlan (see Matos Moctezuma essay in this book, fig. 4); Tiwanaku in Bolivia (fig. 1); and the Inca capital of Cuzco, Peru (fig. 4). In the Aztec Main Pyramid, time's fundamental axis is a forty-four-kilometer line that symmetrically bisects the central temple and passes over Tlalocan, the mountain home of Tlaloc, god of rain and fertility. The Aztecs believed Tlalocan to be the source of all water, no doubt because, during the rainy season, it is over Tlaloc's house-mountain that dark clouds first gather. The Tlaloc range also serves as an environmental calendar that marks the course of the rising sun during the twenty-day month preceding the equinox and also marks the winter and summer solstices. The Aztec coronation stone of Moctezuma II articulates the connection between Aztec emperors and the eternal, cosmic scheme of things (see fig. 13a-c), following the pattern that had been established in Mesoamerica since Classic Maya times.

In South America, Inca Cuzco was also planned to incorporate time. Cuzco's time axis commenced the planting season, signaled by the passing of the setting sun across a series of pillars erected on the horizon.

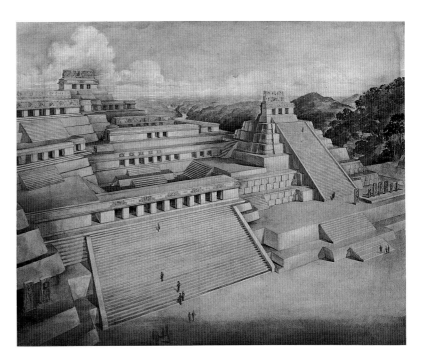

These served to demarcate the planting times according to different altitudes in the vertical ecology of the high-altitude (3,400 meters) Cuzco Valley. According to the Spanish-Inca chronicler Garcilaso de la Vega, the Inca utilized a similar set of pillars at Quito to standardize time in the northern half of their empire. [15]

What are the cultural antecedents for keeping track of time in the landscape, for these orientation calendars that employ neither stylus and tablet nor brush and parchment to record it, where the setting sun does as well as the hands of a clock to provide a framework by which to chart the course of human events? In the Olmec lowlands of Mexico's Gulf coast and among early sites along the coast of Peru, we find buildings hundreds of miles apart with systematic, though rudimentary, celestial orientations. At Lagartero and La Libertad in eastern Chiapas, Mexico, alignments between ruined mounds suggest that, before the ancient Mesoamericans developed their complex calendar, they marked the start of the year by aligning places of worship, one to another, with the extreme annual positions of sunrise and sunset, the June and December solstices. In Peru, the rising point of the Pleiades, the appearance of which designates the start of the year in Inca star lore, may have been a factor in the alignment of ceremonial structures. [16] At Tiwanaku, capital of the great empire that ruled the southern Andes of Peru and Bolivia in the first millennium AD, a principal axis was established to accord with the path of the equinoctial sun (see fig. 1).

Fig. 12 Acropolis showing location of Stela 6. Guatemala, Maya, Piedras Negras, 600/700. Drawing: Proskouriakoff, 1960, p. 462. Courtesy of University Museum, University of Pennsylvania, Philadelphia.

If we have concentrated on the pieces in the "Ancient Americas" exhibition and book that define and quantify time, it is perhaps because our culture, with its emphasis on writing and recording, is predisposed to acknowledge the records of the hieroglyphically oriented Maya and the Aztec. But, given the deep and widespread concern about cyclic time throughout the Americas, it may well be that time was also being celebrated in works of art ranging from the golden effigies of Colombia and Ecuador (see frontispiece, p. 2; see also Zuidema essay in this book, fig. 12), to the Huari and Inca *quipus* from the high Andes, and the solar representations on ceramics and lapidary work in northern South America. Modern ethnologists have extracted a wealth of sky lore from the Carib peoples who still inhabit the remote upper riverine areas of northern South America. Here, the annual life of the sun mirrors the life of the people. Time is the measure of seasonal activities of a social nature, such as marriage and procreation, processes believed to create the seasons and keep them going.[17] Such oral traditions tell about the movement of the sun, moon, and planets among an imaginative array of constellations: the one-legged man (Orion), the wife who cut off his leg (Pleiades), and the mother-in-law who steals fish from her son-in-law's fish trap (Canis Major).

For most cultures of the Americas, time is nature's activity sheet. This brief sketch of how time was, and in many cases still is, expressed through the material works of these indigenous peoples should provide a contrast with the temporal predilections brought over by European invaders and demonstrate one of the difficulties the two cultures had in seeing eye to eye at the moment of encounter. For the Renaissance intruders, nature was becoming a world apart from the human spirit, a world of noninteracting ecospheres, the power of which humanity was destined to harness and control. The Judeo-Christian tradition outlined in Genesis had decreed it, and Francis Bacon would soon boldly restate it. Time as a part of the cosmic scheme had become an entity quite detached from nature, so valuable that it was meted out on mechanical clocks, just as the compass apportioned the directions of space. The European conquerors did not view time as cycles of eternal returns, each harboring within it the seeds of future events, for, as Christians, they believed time marched ahead toward the ultimate second coming, a one-time-only event when the whole world would be judged.

Ideologically, the ancient Americans and the Europeans who confronted them were more than an ocean apart. Given the culture of the conquerors, it is not difficult to understand why they failed to recognize that indigenous peoples also possessed ideas about time and history, that their scheme was based upon ancestor-worship and cyclic time, that their universe was a place in which motives for human action were driven by deeply held beliefs and philosophical speculations as worthwhile to contemplate as those of Saint Augustine. Those ancient beliefs offered the people and those who ruled them a participatory role in a universe undivided by the opposing forces of good and evil. In a unified cosmology of exotic taxonomies and associations that seem incongruent to western thought, they sought to make intelligible through careful observation the nature of the power of spirit present in all animals and elements, rather than reducing them to "separate" zoological, astronomical, and hydrological categories. How unfortunate for us to have misjudged them for so long.

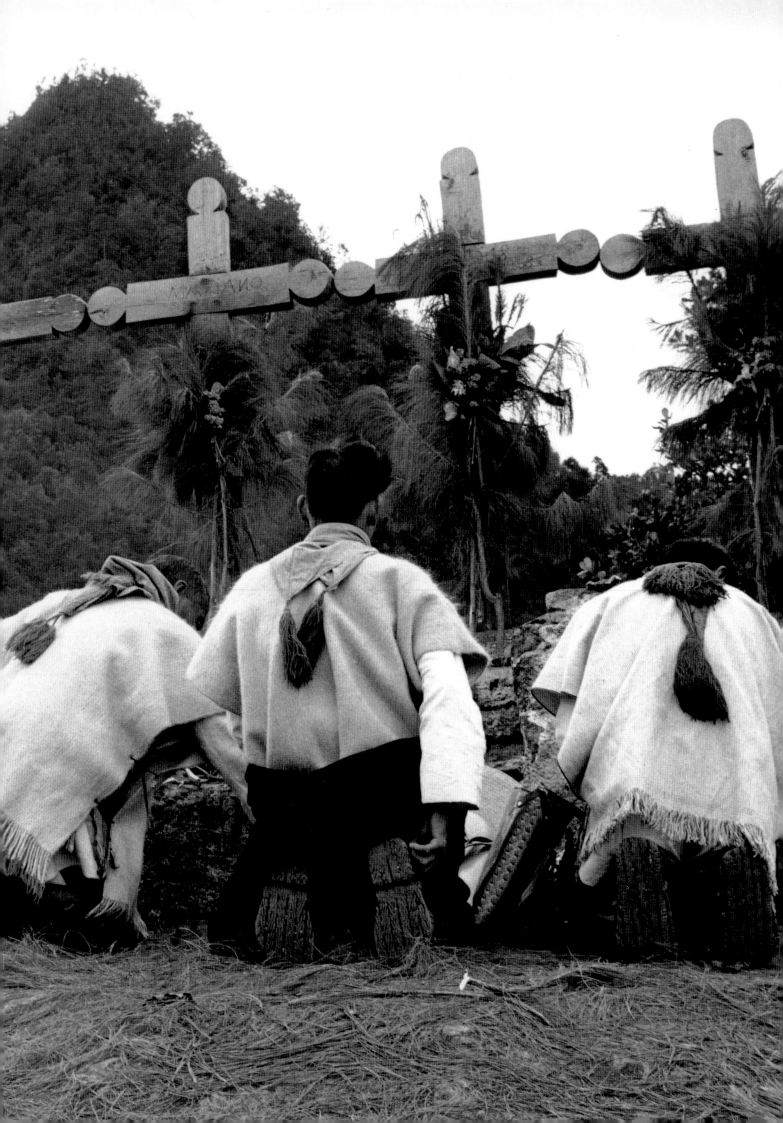

THE PERSISTENCE OF MAYA TRADITION IN ZINACANTAN

The cosmological concepts that shaped the world view of the ancient Maya did not disappear entirely with the Spanish conquest in the sixteenth century. In remote areas of Maya territory, we are still encountering traditional patterns of life that vividly display the intimate relationship between man and nature in the sacred geography and in the concepts of time and space that were central to the cosmovision of the pre-Columbian Maya. We are also discovering how ancient Maya symbols and meanings have become attached to cultural forms introduced by the Spanish, such as Catholic crosses and saints.

On the western edge of the contemporary distribution of the Maya Indians of Mexico, Guatemala, and Belize, the Tzotzil Maya and Tzeltal Maya live in thirty-seven contiguous municipalities in the mountains surrounding San Cristóbal de las Casas in the highlands of Chiapas in southeastern Mexico (see fig. 6). San Cristóbal was founded by the Spanish conquerors in 1528 and served as the political capital of Chiapas until 1892; it continues to be the administrative and economic center of the Chiapas highlands for the descendants of the conquerors.

Zinacantan (population 20,000), where I have engaged in ethnographic field research for the past thirty years, is one of the most colorful and interesting of these Tzotzil Maya communities, especially as its culture maintains many pre-Columbian patterns. The community consists of a ceremonial-political center and twenty-six outlying hamlets, which are located at some two thousand meters elevation, to the west of San Cristóbal. The predominant economic activity is maize agriculture; the crop is cultivated in the highlands near the Zinacanteco homes and on rented fields in the Grijalva River lowlands

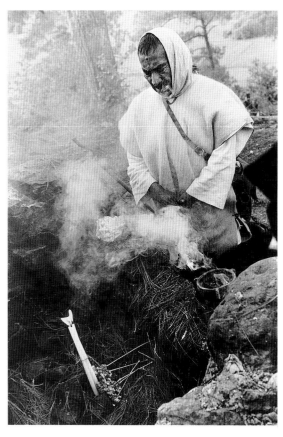

Fig. 1 Shamans pray to the ancestral gods at mountain shrine. Mexico, Maya, Zinacantan. Photo: Frank Cancian.

Fig. 2 Shaman praying with incense. Mexico, Maya, Zinacantan. Photo: Frank Cancian.

to the south. Maize has provided food for the Maya for thousands of years. Increasing numbers of Zinacantecos are becoming merchants and fruit- and flower-growers, as well as wage-workers in nearby Mexican cities. Patrilocal extended families are common, with a father and his sons living in contiguous thatched or tile-roofed houses and bringing their wives in from other families in the same, or a neighboring, hamlet. Each of these extended family compounds has a household cross in the patio between the houses.

Traveling to Zinacantan Center by road or trail from San Cristóbal brings one over a

Fig. 3 Statue of Saint Lawrence with coin necklace. Mexico, Maya, Zinacantan. Photo: John D. Early.

Fig. 4 Shamans praying at cross shrine. Mexico, Maya, Zinacantan. Photo: Frank Cancian.

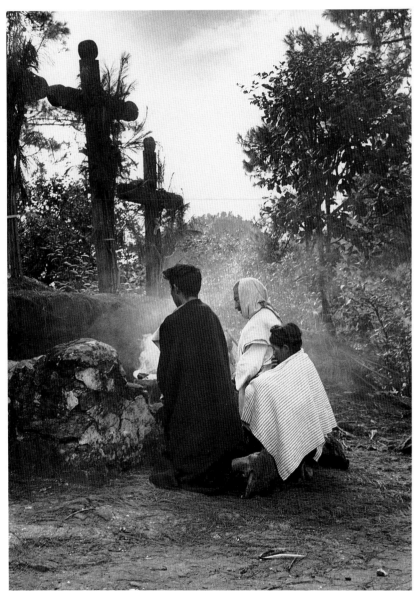

mountain pass into a beautiful valley with many springs and streams. Should one pause and look (with binoculars) at the mountains surrounding the center, or follow trails that lead to these mountains, one would see sets of crosses, both at the foot and on the summits of these mountains, and one would be likely to encounter a Zinacanteco shaman lighting candles, burning copal incense, and praying at one of these cross shrines (see figs. 1, 2, 4). There is such a proliferation of these shrines, along with the household crosses, that, after a few months of preliminary research, I came to the conclusion that I must be studying one of the most Catholic communities in the world.

In the very center of the settlement stand three white-washed churches, each with a cross on top and a churchyard in front with an outdoor cross shrine (see fig. 5). Inside these churches is an extraordinary collection of forty-two statues of saints dressed in ankle-length, flowing robes and capes derived from Spanish colonial styles. The male saints are covered by contemporary Zinacanteco *chamarras* (jackets) and ribbons, and the females by Zinacanteco shawls (see fig. 3).

Across the main street from the principal church, whose patron saint is Saint Lawrence, is the town hall, where the officials (civil, as well as religious) conduct their business. Each of the highest-ranking of them carries some kind of scepter or staff of office while he is marching from place to place or praying at cross shrines (see fig. 11). When the officials are seated on benches, their staffs are placed in racks beside them. (See Miller essay in this book, fig. 18, for a Classic-period Maya lord seated on a bench.)

The church and the town hall, with the main street between them, are parts of a grid pattern of streets and blocks in the Zinacanteco ceremonial-political center. One initially assumes that the grid is laid out according to the cardinal directions in a pattern characteristic, for example, of towns in the midwestern United States, but this is not the case in Zinacantan. Indeed, the grid, reckoned by a compass reading (corrected for magnetic variation) from the center front door of the Church of Saint Lawrence to the patron saint in his central position over the altar, is 115 degrees. When the Maya make maps, they place east rather than north at the top; hence, I speak of this "tilt" (which is found in many contemporary communities and archaeological sites in the Maya area) as being twenty-five degrees south of east.

Sacred Geography

"Sacred geography" concerns the features of the natural environment that are visited and prayed to in the rituals of the Zinacantecos. The most important sanctified features are called *vits* and *ch'en*, meaning "mountain" and "opening in the ground" (i.e., caves and limestone sinks), which provide natural reference points in the world view for a set of crucial binary oppositions: mountain versus cave, up versus down, Ancestral God versus Earth Lord. These binary discriminations function symbolically to differentiate objects and qualities in the universe that are hotter and of higher rank from those that are colder and of lower rank.[1]

The category *vits* includes a variety of natural rises in the landscape, ranging from smallish hills to volcanic peaks, with vertical elevations of over six hundred meters above the surrounding terrain. In each case, they are conceived as being the home of an ancestral god called a Totilme'il in Tzotzil Maya. Totilme'il may be literally translated as "Sir Father, Madam Mother," with the father image always linked to the mother image, indicating that the concept is a unitary one, representing the primordial reproductive pair in the Zinacanteco universe.

The Ancestral Gods are pictured as elderly Zinacantecos who live eternally in their mountain homes, where they convene

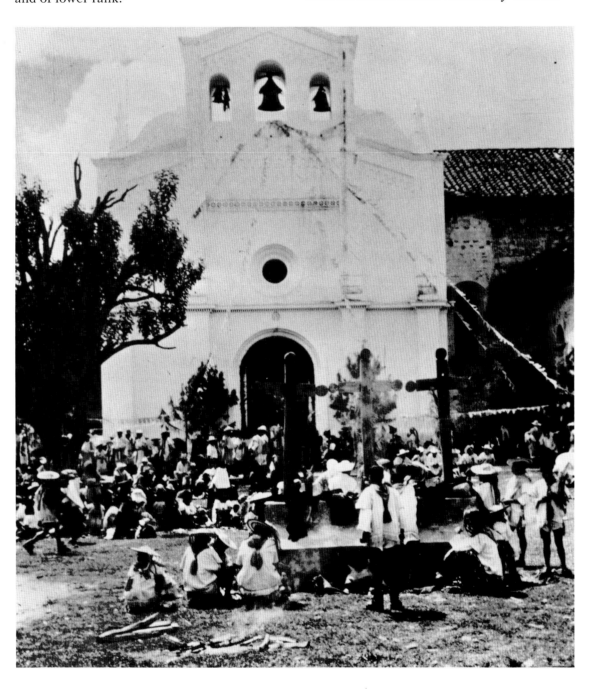

Fig. 5 Church of Saint Lawrence on a fiesta day. Mexico, Maya, Zinacantan. Photo: Frank Cancian.

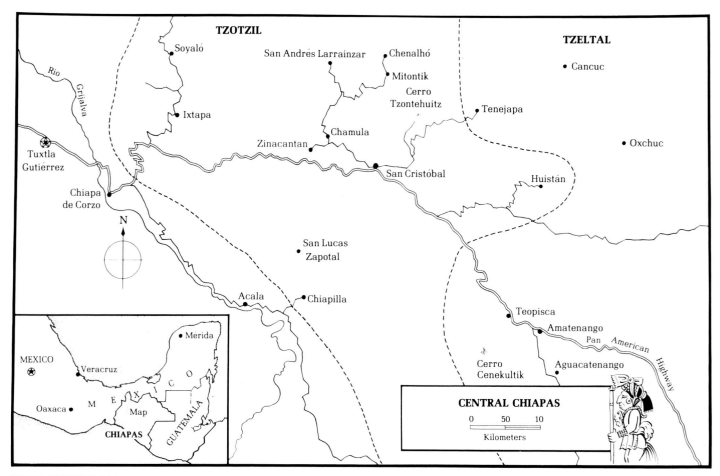

Fig. 6 Map of central Chiapas, Mexico. Drawing: Vogt, 1976.

and deliberate, monitor the affairs of their descendants, and await offerings of black chickens, white candles, copal incense, and cane liquor to sustain them. These gods are both repositories of cultural knowledge and active and jealous guardians of the traditional way of life. They take note of any deviations from the social norms, and they punish deviant Zinacantecos.

The mountain homes of the Ancestral Gods always have cross shrines located at the foot and on the summits (see fig. 1). One or more wooden crosses are set in a cement base, which is constructed on a flat surface, and cement or masonry altars are added in front of the base. When visiting the mountain shrines, the Zinacanteco ritualists light candles and copal incense and pray at the foot of the mountain; then, they climb the steep trail to the summit to repeat the ritual. The prayer at the foot is modeled on the traditional greeting behavior used in approaching an extended family compound; the prayer at the summit is like prayer at the household cross in the patio—indeed, the cross shrine on the summit is conceived to be the house cross for the Ancestral God who lives inside the mountain.

The ritual plants tied to the cross shrine (see figs. 1, 4) invariably include pine-tree tops and bundles of red geraniums: the pine, a symbol par excellence of nature, is near the wild woods, whereas the red geraniums, a quintessential symbol of domesticity and culture, are near the houses of the people. As the candles burn, the gods are consuming their tortillas; as the copal incense smokes, the gods are enjoying their cigarettes, and the ritualists are communicating with their Ancestral Gods (see fig. 2).[2]

The ritual procedures at the steep-sided sacred mountains in Zinacantan, which probably resemble the behavior of the ancient Maya praying and making offerings before stelae at the foot of pyramids and then climbing the steps to pray before the idols in the temples on top (see Valdés essay in this book, fig. 6), indicate an important conceptual relationship between mountains and pyramids among the Maya.[3] We know that pyramids were called by the same word, wits (the Yucatec Maya rendering of vits), by the Classic Maya, and that some were considered to be "mountains" associated with lineage ancestors.[4]

The caves and sinks are channels of communication with the Earth Lord, who lives beneath the surface of the ground and is now pictured as a fat, greedy Mexican landlord who possesses vast quantities of pesos; herds

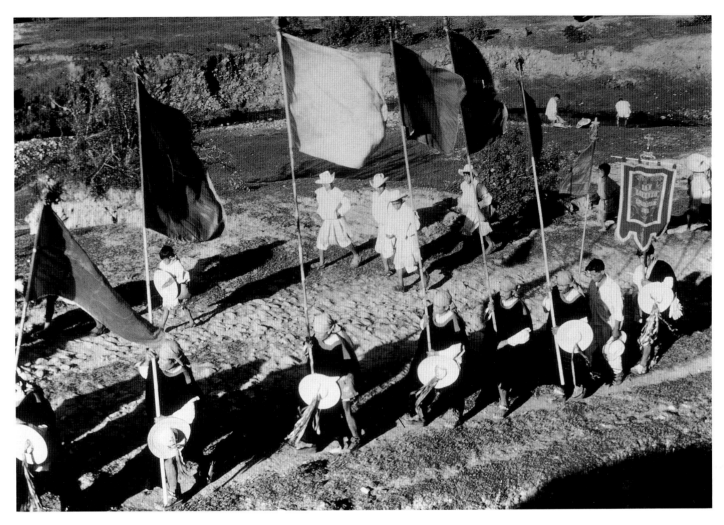

Fig. 7 Procession of *mayordomos* (religious elders). Mexico, Maya, Tzotzil. Photo: Frank Cancian.

of cows, mules, and horses; and flocks of chickens. He owns all the waterholes; he controls the lightning and the clouds, which are conceived as emerging from his caves, rising into the sky, and producing rain for crops; and he claims all the products of the earth as his own. He rides on deer; iguanas serve as blinders for his mount, a snake as his whip, and the shell of the land snail as his powder flask. The gunpowder is used in making sky-rockets and for firing his shotgun, both of which are seen as lightning bolts. Communication with him is regarded with deep ambivalence. The Zinacantecos relate glorious myths about men who have acquired great wealth in money and livestock by going into caves to visit him. But the Earth Lord, who always needs many workers, may capture men's souls and put them to work for endless years. It is clear that this image is derived, in part, from the aboriginal Mesoamerican Earth Lord, who was universally feared in pre-Columbian times.[5]

Communication with the deities and with people who are deceased occurs on a spiritual level that is based upon the Zinacanteco concept of souls. Each person is believed to possess an inner soul, located in the heart and blood, that is installed in the embryo by the Ancestral Gods. This inner soul contains thirteen parts; by losing one or more of them, a person will become ill until a shaman is summmoned to perform a ceremony that will gather up the lost parts of the soul. "Soul loss" occurs when a person quarrels with relatives or mistreats maize, and the Ancestral Gods send a lightning bolt to knock out parts of the soul. Each person's inner soul is shared with an animal-spirit companion, such as a jaguar, ocelot, coyote, or squirrel, for, when the gods install the soul in a human embryo, they simultaneously install the same soul in the embryo of one of these wild animals. A person goes through life sharing this soul with an animal-spirit companion: anything that happens to someone's animal companion (such as getting shot) simultaneously happens to its human counterpart. The animal companions are kept in corrals inside a sacred mountain east of Zinacantan Center, where they are carefully cared for by the Ancestral Gods. If the gods allow an animal companion out of its corral, then its human companion's life is in mortal danger until

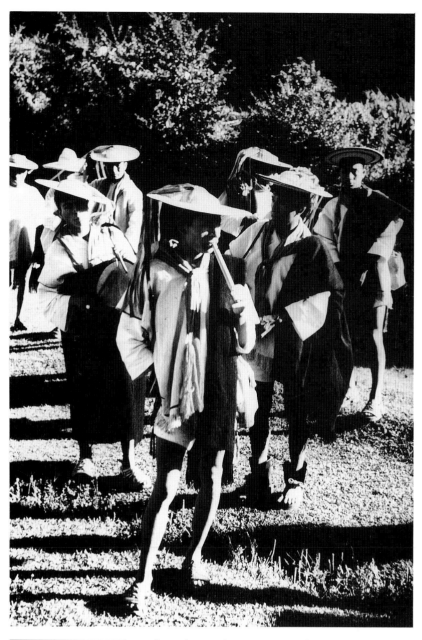

Fig. 8 Drum and flute players for a marching procession of ritualists. Mexico, Maya, Zinacantan. Photo: Frank Cancian.

past, as well as the present structure of the Zinacanteco universe.

Concepts and Symbols of Space and Time

Spatially, the world is perceived as a quincunx, with four corners (held up by gods) and a center, which is located at a small mound in Zinacantan Center called "the Navel of the Earth." There are three layers in the universe: the underworld, this world, and the heavens, or the world above. The surface of the underworld is inhabited by a race of dwarfs who, along with monkeys, were created in the mythological past when the gods attempted to create real men. The quincuncial form is replicated in rituals performed at the four corners and the center of a Zinacanteco house when it is dedicated, shortly after construction. It is also replicated in rituals for the maize field held at its four corners and center, where prayers are offered for rain and good crops.

Time is measured by the daily cycle of the sun around the world, and the path of the sun, from rising to setting, provides the two basic cardinal directions. What we refer to as "north" and "south" are merely "the sides of the path of the sun." The rising sun takes precedence over the setting sun and provides the natural axis for the rank order of gods and people in the cosmos. High-ranking gods and people are invariably seated closer to the rising sun. Ritual processions are always believed to proceed conceptually along the path of the sun, with the lowest-ranking person in front and the highest-ranking ritualist in the rear, closest to the position of the rising sun (see fig. 7). Ceremonial circuits enclosing sacred spaces always proceed counterclockwise, a movement that is produced by facing a sacred space and starting out to the right, with the right hand taking precedence over the left hand. This counterclockwise direction also follows the apparent movement of the tropical sun during the early part of the maize-growing season, from planting time to the first ears of green corn.

The intricate interrelationship of space to time is indicated most vividly in the literal translation of the Zinacanteco words for "sunrise" (*lok'eb k'ak'al*) and "sunset" (*maleb k'ak'al*). Translated literally, these words mean simultaneously "the time when and place where the sun emerges" and "the time when and place where the sun disappears." If I tell a Zinacanteco that I will meet him at *lok'eb k'ak'al*, he will understand both where to be the following

a lengthy curing ceremony is performed by a shaman to round up the lost animal companion.[6]

It is clear that nature, to the Zinacantecos, is not some set of inanimate forces and processes but, endowed with "animism," is very much "alive." Mountains are currently inhabited by gods who are the remote ancestors of the Zinacantecos; the Earth Lord is ever-present just under the feet of the Zinacantecos and may be communicated with via the caves and waterholes. Curious rock formations were once alive and moving about; trees by waterholes were once ancestors who helped find these sources of water. Marvelous transformations take place: ancestors become trees; priests turn into rocks; bats are mice who sprout wings and fly away. An inventory of sacred places in Zinacantan provides a visual tour and reminder of the mythological

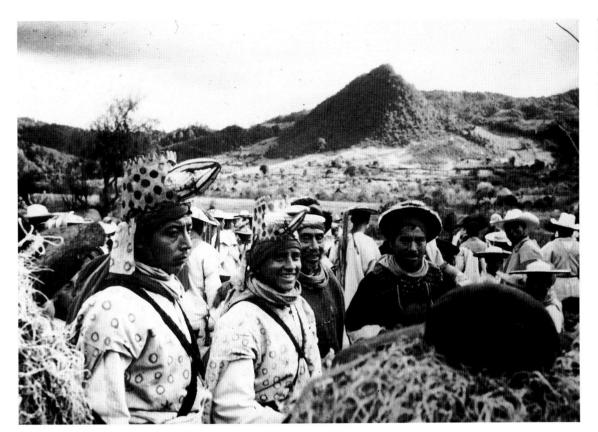

Fig. 9 Two costumed *k'uk'ulch'on* ("plumed serpents") at the fiesta of San Sebastián. Mexico, Maya, Zinacantan. Photo: Frank Cancian.

morning (i.e., at which edge of the village) and when to be there.

Spanish Forms with Maya Meanings

Most of the sacred paraphernalia utilized in contemporary Zinacanteco ceremonies to enact the principles of their cosmovision have Spanish forms, such as crosses, saints, rosaries, mirrors, ribbons, chickens, and batons. A few important ceremonial items have retained their pre-Columbian forms and meanings. The copal incense burned in ancient ceramic censers is found archaeologically and is ubiquitous in contemporary Maya communities. The high-backed ceremonial sandals worn by Zinacantan ritualists; the drums, flutes, and rattles utilized to provide music for processions and ritual dances (see fig. 8); the four colors (red, black, white, and yellow) of maize kernels used in divination by the shamans; and the bamboo staff of the Zinacanteco shaman are all pre-Columbian in form. Special ceremonial characters who appear at the major winter ceremonial, the Fiesta de San Sebastián, in late January, are of particular interest in this connection: for example, *k'uk'ulch'on*, or "plumed serpent," a pair of whom appear for the fiesta and who are obviously the persisting, local manifestation of Quetzalcoatl, or Kukulcán, as this deity was called by the Yucatec Maya (see fig. 9).

Close comparison of the important ceremonial items with the Spanish equivalents reveals that the Spanish forms are replacements for pre-Columbian paraphernalia and structures, and that they have become imbued with symbolic meanings drawn largely from the ancient Maya cosmogram. For example, Catholic churches have clearly replaced pre-Columbian temples, while the images of Catholic saints have substituted for the aboriginal idols kept in the temples. The mirrors that now hang on the saints in Zinacantan replaced the pyrite or hematite mirrors possessed by the Classic Maya. In contemporary Tzotzil, a word for "pupil" or "eye" is *nen sat*, *nen* meaning "mirror" and *sat*, "eye" or "face." This suggests that the mirrors on the Zinacantan saints today, like those adorning many figures in the pre-Columbian iconography, are associated with eyes and that they are a means of seeing into the supernatural world of the gods.[7]

The necklaces worn around the necks of the saints resemble Catholic rosaries, but they are actually composed of coins (some derived from the Colonial period and some modern). These necklaces are kept in sacred bundles on the house altars of the *mayordomos* (ceremonial officials), who take them out periodically and ritually count the value of the coins by moving grains of maize on a reed mat (see fig. 10). Since these necklaces

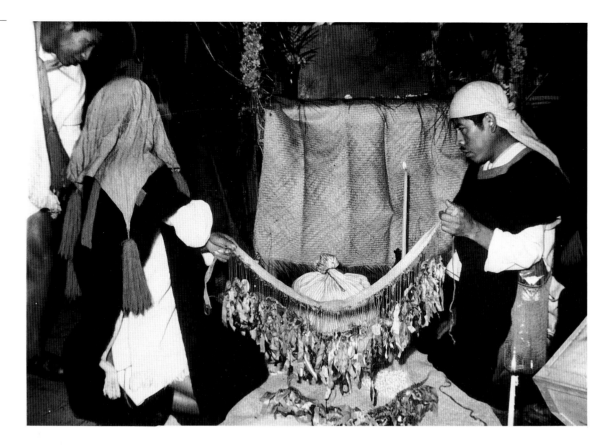

Fig. 10 Ritualists counting coins. Mexico, Maya, Zinacantan. Photo: John D. Early.

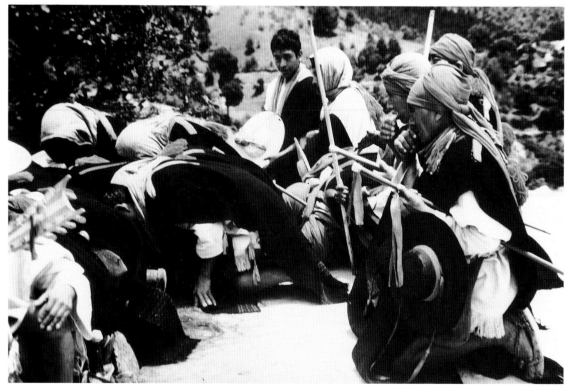

Fig. 11 Zinacanteco religious officials. Mexico, Maya, Zinacantan. Photo: John D. Early.

are not referred to as "rosaries," but are called *'ual* in Tzotzil, which means "necklace" or "month," it is likely that the counting of these saints' necklaces once involved a divining ritual, perhaps for predicting the luck associated with months and/or for multiplying magically two things of high value to the contemporary Zinacantecos: money and maize.[8]

The beribboned Zinacanteco hats closely resemble the elaborate feather headdresses of the ancient Maya (see fig. 12). Chickens offered to the gods in contemporary curing ceremonies are undoubtedly replacements for pre-Columbian turkeys, which are still sacrificed in remote Maya communities in the Guatemalan highlands. The contemporary batons, which, like people, contain inner souls given them by the ancestral gods, replaced the pre-Columbian scepters (see fig. 11).

The Catholic-looking crosses, which also contain inner souls and are a means of communication with the Ancestral Gods inside the mountains, appear to be directly related to the World Tree (closely resembling a Christian cross) of the ancient Maya. A fine example of this pre-Columbian *axis mundi* is carved into the iconography on the sarcophagus lid of Lord Pacal at Palenque (see Miller essay in this book, fig. 19).

All of these sacred items, even the ones that seem most Spanish in form, occupy a significant place in the essentially ancient cosmovision of the Zinacantecos. They all contain an "inner soul," or "vital force," connected to the energy of the rising sun and transmitted to them by the ancestral gods, and all display crucial symbols and images of the intimate relationship of man to nature that persists in this twentieth-century Maya way of life.[9]

Fig. 12 Zinacanteco with ribbons on his hat. Mexico, Maya, Zinacantan. Photo: Frank Cancian.

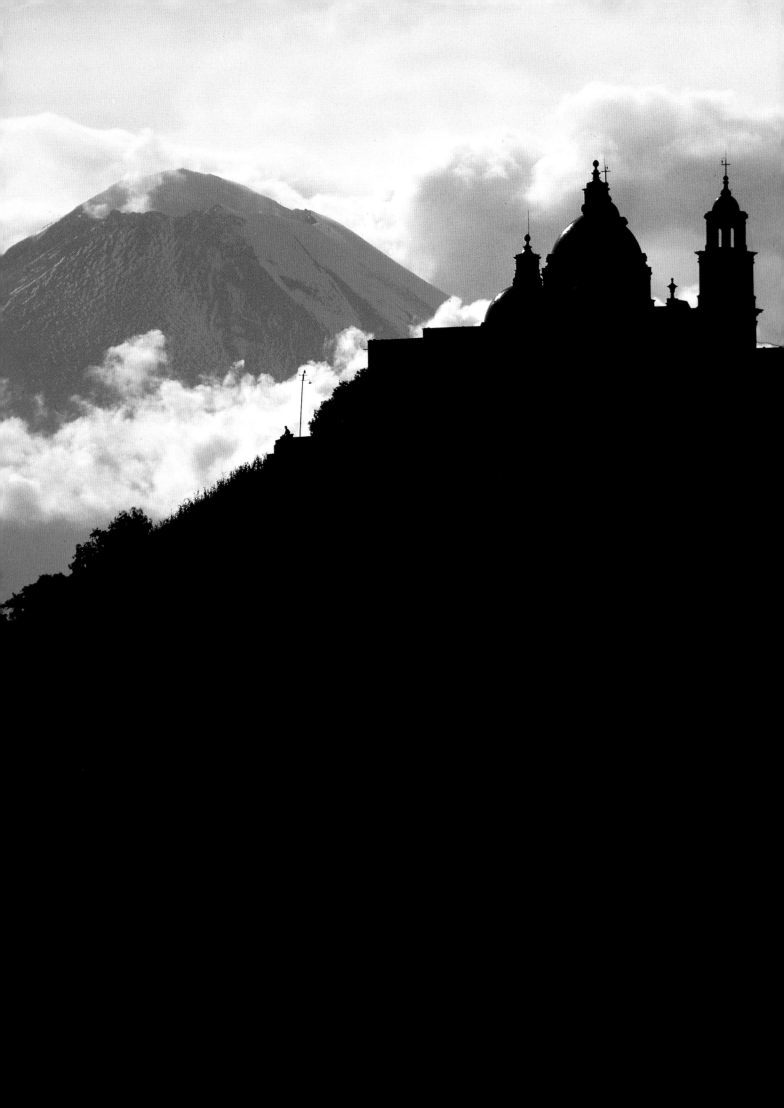

MANKIND AND THE EARTH IN AMERICA AND EUROPE

I hope I will not be misunderstood if I say that the "Ancient Americas" exhibition is, for me, a culmination of my interests over the past thirty-five years and, in one sense, a justification of them. From 1955 until 1963, I studied the relationship between temples and landscape in Greece,[1] while, from 1964 until 1973, I worked on similar problems in the American Southwest and Mesoamerica.[2] In 1975, I began to study French gardens and fortifications of the seventeenth century from the same point of view and was led by them into further interpretations of modern urbanism and the architecture of the nation-state. These topics came to be associated in my mind with the work on French Gothic cathedrals that I had begun between 1946 and 1952 and picked up again in 1975.[3] These studies have resulted in a general book, treating Mesoamerica and the Southwest, Mesopotamia, Egypt, Crete, Greece, Rome, medieval France, late medieval and Renaissance Italy, the France of Louis XIV, Palladio, England and America, and modern urbanism.[4] I list these items, because their sequence can suggest the structure of my thought more effectively than would otherwise be possible in so short a paper.

The first time I saw Greek temples in landscape, at Paestum in south Italy in 1952, it was at once apparent to me that, despite some very perceptive travelers and mythographers, Greek temples had not yet been described by architectural historians in terms appropriate to them. Indeed, an inability to conceptualize or to acknowledge the relationship that has always existed between topography and building in all human cultures has constituted one of the major failures of modern archaeology and architectural history up to the present time. That intellectual blindness derives from the simple arrogance of modern urbanized humanity and has so far prevented it from seeing what it cannot imagine as important to itself. So, pre-Columbian Mexican architecture was normally categorized as purely geometric and antinatural, and its sites were largely ignored, while Greek temples were meticulously dissected and described as if they were all standing in Kansas. Happily, the "Ancient Americas" project shows that Americanist scholarship has abandoned old prejudices far more completely than classical archaeology has yet been able to do and is now prepared to deal with sacred sites in terms of all their relevant forms, which, first and foremost, comprise those of the sacred landscapes themselves.

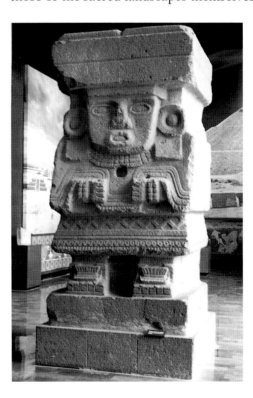

Fig. 1 Profile of unrestored pyramid, surmounted by a seventeenth-century Spanish church. Mexico, Cholula, 1/800. Photo: Mark Godfrey, ©National Geographic Society. The pyramid was once known as Tlachihualtepetl ("man-made mountain"). The volcano Popocatepetl, looming in the background, was formerly worshiped as a natural icon by Indian communities.

Fig. 2 Water Goddess. Mexico, Teotihuacan, c. 200. Stone. INAH–CNCA–MEX, Museo Nacional de Antropología, Mexico City. Photo: Richard Townsend.

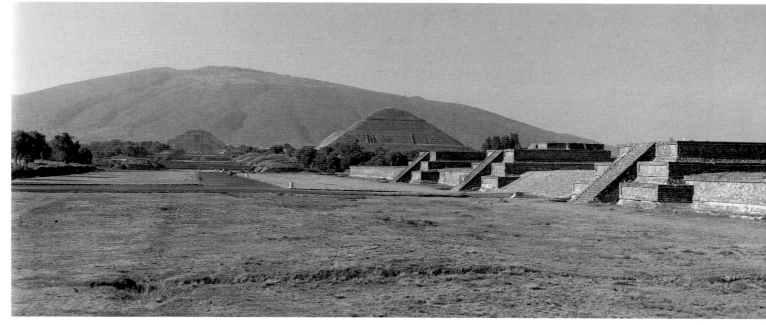

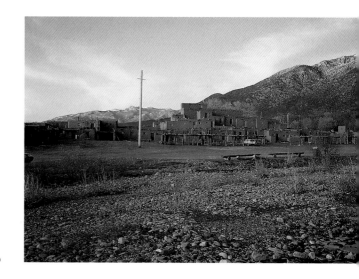

Fig. 3 The Ritual Way of Teotihuacan (also known as Avenue of the Dead or North-South Avenue) running from the "Citadel" precinct past the Pyramid of the Sun to the Pyramid of the Moon. Mexico, Teotihuacan, c. 1–750. Photo: Gabriel Figueroa Flores. Cerro Gordo, the sacred mountain, rises in the distance.

Fig. 4 Facade of the Quetzalcoatl ("Plumed Serpent") Pyramid. Mexico, Teotihuacan, 300/400. Photo: Richard Townsend. The image of the plumed dragon bearing a storm-deity mark on its tail represents a ritual metaphor for powerful windstorms bringing rains from the mountains.

Seen in the context of European-American developments as a whole, Meso-american buildings reflect a characteristi-cally pre-Greek or non-Greek attitude toward landscape forms: they imitate them (see fig. 1). This is also the case in Mesopotamia and Egypt, and, in its way, in Bronze Age Crete as well. The Greeks were the first to break with that tradition. Their temples contrast with the sacred natural forms and introduce into nature the embodiment of human will and desire, of a humanly conceived divinity, dif-fering from the divinity in nature and stand-ing out in contrast to nature's shapes.

Fundamental, of course, is the concept of the sacred mountain, seen in its simplest and purest form at Teotihuacan, Mexico's major ceremonial site, and perhaps the greatest in the Americas (see fig. 3). Its main axis, the so-called "Avenue of the Dead" (also known as the North-South Avenue or the Ritual Way), runs directly toward the Temple of the Moon—so named by the Aztec and perhaps by earlier people—whose profiles echo and condense those of the sacred mountain Cerro

Gordo (or, more to the point, Tenan, "Our Mother of Stone"), which rises behind the temple.[5] So placed, the temple may be re-garded as expressing Mesoamerican human-kind's basic view of itself. It is embedded in nature and integrally part of it, but it is also able, indeed required, to help nature along through the power of its ceremonies—through human sacrifice, primarily. The temple assists the mountain in bringing forth the springs that provide water to the Valley of Mexico. The temple base is compacted in horizontal fractured lines, like those through which the springs of the earth are squeezed. Seen down the length of the avenue, the mountain seems to be pressing down upon the temple with its mass, compressing it into fracture. The Water Goddess in the Museo Nacional de Antropo-logía in Mexico City is a figural description of this condition (fig. 2). A massive block of stone weighs upon her head; it is cleft in the center, just as the mountain is cleft, as the

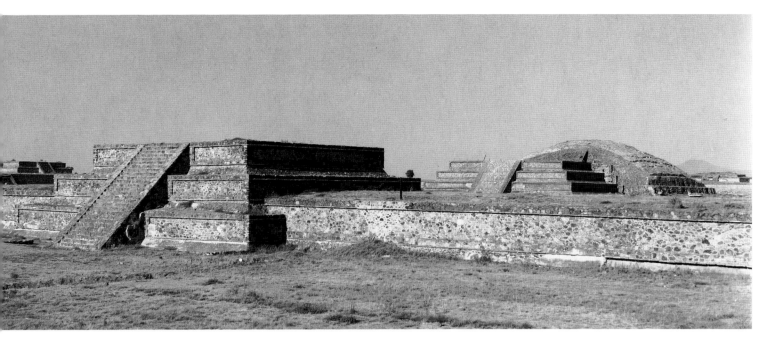

heads of Olmec gods are cleft. Its weight compresses her body, squeezing water from her hands and fracturing her kilt into horizontal fault lines. In this, it precisely reflects the *tablero* (framed tablet) construction of the Temple of Quetzalcoatl, which stands to the right of the avenue at the point where the ceremonial axis begins to plunge into the heart of the site (see fig. 4). This structure, too, is made to seem compressed and fractured, and it is also spurting springs, depicted as plumed serpents (Quetzalcoatl) that spurt from its side, alternating with faces of Tlaloc (god of water and agriculture) and sea shells. Along its staircase, the great serpent (or dragon) heads stand out before the temples and the mountain beyond them, symbolizing the water from the earth and the water from the sky. Other complementary relationships between temples and mountains are obvious enough at Teotihuacan, if we look from the Temple of the Moon back down the axis

of the site, but clearly the major focus is on the mountain mother, Tenan, and her life-giving force.

The same principle guides the placement and formation of the pueblos of the American Southwest, as they can be seen in full ceremonial operation today. Taos remains the most striking example (fig. 5). There, as in all pueblos, the man-made pyramid of North House is asymmetrical in shape, but it still clearly echoes the masses of Taos Mountain, and its fabricated abstraction of the natural forms is still believed to help the mountain give up its water in the never-failing stream that flows down through the center of the plaza. Seen from the side, North House also rises straight up to a typical Pueblo sky altar, echoing and abstracting the shapes of the clouds, so that the dances that take place before it, their drum- and foot-beats built into the set-back forms, are dancing the mountain, dancing the cloud, perhaps affecting the

Fig. 5 The plaza of Taos Pueblo with Taos mountain, New Mexico. Photo: Kent Bowser.

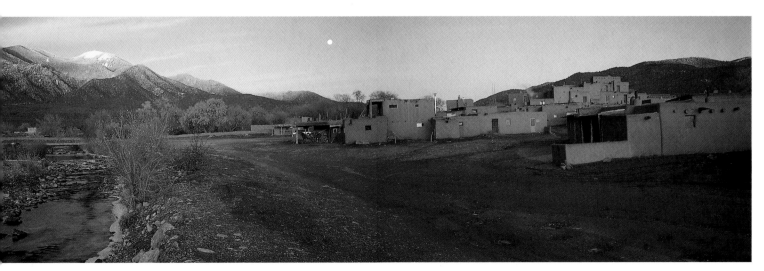

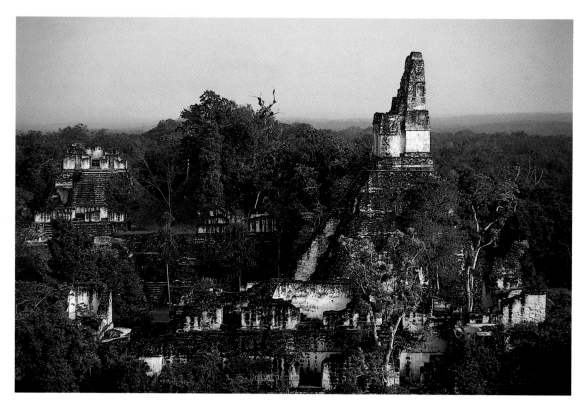

Fig. 6 Aerial view of
Tikal. Guatemala, Maya,
200 BC–AD 800. Photo:
Nicholas Hellmuth.

Fig. 7 Empire State
Building. New York, 1931.
Photo: Vincent Scully, after
a 1939 postcard.

course of nature itself, and drawing all together into a pressure-cooker of power, which the human city has always felt itself to be.

Similar relationships between human ritual and the shapes of the mountains and the buildings can be studied in all the pueblos of the Southwest to this day. As in Mesoamerica, each site displays a particular configuration based on the relationship between natural and man-made forms, but everywhere the basic principle remains the same. Therefore, humble as they are, the pueblos are still functioning cities and powerful ceremonial centers. They can recall for us even the ritual of Aztec Tenochtitlan itself, where the Temple of Quetzalcoatl directly faced the cleft between the Temple of Tlaloc to the left and that of Huitzilopochtli to the right, while the sun rose there at the equinox to drift over behind Tlaloc in the

wet season of agriculture and behind Huilzilopochtli during the dry season of hunting and war, the hunting of men. And out there, on those bearings, are the two greatest mountains of Mexico, Popocatepetl to the left and Ixtaccihuatl to the right, causing the twin temples to resonate to the boundaries of the whole vast landscape.

In all sacred sites, large or small, from Taos to Teotihuacan, the pattern of landscape relationship is fundamentally the same. To the south, at the Classic Maya site of Tikal, it might seem at first that other principles are at work (fig. 6). Temple I, the tomb and monument of King Ah Cacao, and Temple II, the monument of his queen, Lady Twelve Macaw, "look like" those important personages. Temple I stands as a tall, robed figure with a high, crowned head; Temple II stands before it, majestically short and broad, as Lady Twelve Macaw is shown carved on the existing lintel of her temple. Empathetically, we see these buildings as human figures, related to our own. Surely, some of that human imagery was intended by the Maya, sensitive as they were to the beauty of the human body, especially when it was magnificently caparisoned—or in the throes of pain. But it is also clear that the fundamental American principle, that of the imitation of natural forms, is at work at Tikal as well. The temples crowning the bases are of stone and mortar, shaping a narrow, dark, corbel-vaulted interior like a cave. Mounting the steep stairs in tropical heat, one is met at last by the cold,

wet breath of that interior, the very exhalation of its companion clouds. Here, where there are no mountains, the man-made mountain lifts the temple above the houses of the city, above the rain forest of today, so that its roof comb delicately traces the profiles of the clouds (how different from the Southwestern right-angled planes, which accomplish the same end) and its mouth promises their rain. The temples of Tikal become true "skyscrapers," the first in the Americas, and it is little wonder that the American skyscraper architects of the 1920s and '30s consciously adopted their forms (see fig. 7).

In Mesopotamia, the topographical situation was a bit like that of Tikal, in that only the manufactured mountain was physically present, and it rose in the center of the town, connecting earth with heaven. There, however, the mass of the mountain was exaggerated as it loomed above the flat Mesopotamian plain. As at Tikal, the priest-king scaled its stairway to meet the gods in the sky, but here the profiles of the mountain were built out in every dimension to dramatize his progress. He was Gilgamesh, King of Uruk, who battled with the gods for immortality and found it only in the permanence of the vast works of architecture he built for his town. He was the first epic hero, ancestor of Herakles and the rest, and the sacred mountain is heroized, too, as the setting for his exploits and as the symbol of his glory.

The pyramids of Egypt, though clearly inspired by the ziggurats of Mesopotamia, are, in the end, wholly different. Old Kingdom Egypt had no true cities. The pyramids marked the tombs of pharaohs, set out in the desert on the west bank of the Nile. Untouchable, purely visual signs of human immortality, meant to be seen from afar, they supported no temples and were not climbed. From the stepped pyramid of Zoser onward in time, their mass was progressively dematerialized, and they mounted ever more smoothly into the sky, eventually becoming one with it. Zoser's pyramid, as it is seen on the axis fixed by the wall of cobras at the southern end of its courtyard, rises like a weightless staircase (fig. 9); nothing about it suggests three-dimensional mass, as, for example, each face of a Mesoamerican pyramid or a ziggurat is designed to do. Finally, in the true pyramids at Gizeh, all the surfaces disappear into a point and were originally sheathed in blinding white limestone, bright as the very rays of the sun and magnifying their radiance, reflecting it over the whole land of Egypt opening toward the delta below them. The cult at Gizeh was that of Ra, and the function of the pyramid was to ensure the pharaoh's acceptance in the sun boat of that god (see fig. 8). Hence, all the pyramids, oriented exactly to the points of the compass, deploy in echelon behind the figure of the

Fig. 8 Pyramids of Gizeh. Egypt, 3000/1000 BC. Photo: Francis Frith, in Van Haaften, 1980, pl. 11.

Fig. 9 Pyramid of Zoser. Egypt, Saqqarah, 3000/2000 BC. Photo: Francis Frith, in Van Haaften, 1980, pl. 9.

Sphinx, who, bearing the face of the pharoah
Chephren (whose head was steadied by the
hawk in the tomb temple below him), must
look unwinking into the eye of the sun as it
rises eastward across the Nile. He holds the
whole battery steady, aiming at the sun. The
sacred mountain is transformed into light.

In Crete, in the same years of the third
and second millennia BC, the pattern of
natural and manufactured was much more
like that of Mexico and the Southwest. The
sacred mountains were there in nature itself,
each with a special character of its own. At
Knossos, the seat of kingship, Mount Jouctas
rises conical and cleft (fig. 12), a good deal
like the mountain at Teotihuacan. The rela-
tionship of courtyard to mountain at Knossos
is, however, much more like the relationship
common among the pueblos. Puye, an aban-
doned pueblo on Santa Clara's land, is almost
a dead ringer for it (fig. 10). At Knossos, the
northern entrance to the courtyard leads our

eye diagonally across the southern propylon
to the horned cone of Jouctas beyond the
nearer hills. The throne room is directly on
axis with it in the range of buildings on the
right. At Puye, the entrance to the court also
looks diagonally across it along a line of sight
marked by a stair in the far wall and culmi-
nating in the massive bulk of Ts'i-Como, the
Sacred Mountain of the West for the Tewa
people. Visitors to the summer dances at
Puye stand on what were once the flat roofs
of the pueblo, in all likelihood as the spec-
tators stood on the flat roofs of Knossos to
watch the bull dance in the courtyard below
them, with the sacred, horned mountain also
in view.

At Phaistos, where there was no throne
room, the axis of the courtyard runs directly
to Mount Ida, opening its vast horns. There,
in myth, Zeus was born, while, in Jouctas,
which resembles a tholos tomb, he was bur-
ied. Here, as in Mesoamerica, the forms of

Fig. 12 Knossos with Mount Jouctas. Greece, 3000/1000 BC. Photo: Vincent Scully.

nature dominate the sacred kingly sites, and the forms created by humankind are adjusted to them, making the most of their power.

The Greeks changed everything. They inherited the tradition of the sacred mountain, conical, cleft, or horned, and such landscape shapes mark all their sacred sites; but, by the late seventh century BC, the Greeks came to confront the divinity of the earth with a sculptural body wholly different from its own canonical forms. This is the peripteral temple, wherein the columns mask the fact that the *naos*, like all buildings, is a container of space. The columns transform the building into a sculptural body like a Greek phalanx of vertically standing, individual units, like the muscular bodies of men. The old way of imitating nature's forms was entirely abandoned. Human beings now populated the earth with their own fabricated images of divinity. Nature's law was still real and implacable, but it was balanced by the human determination to be special in the world, different from the rest of creation and prepared to challenge its powers.

The temples embody the Olympian gods, each of whom is an individual with a special character. Each temple, though of the same species as the others, is different, as individuals differ. At Paestum, the Temple of Hera, goddess of childbirth, weighs heavily on the land. The Temple of Athena leaps triumphantly above it. The columns of Archaic temples of Apollo have no entasis whatever. Hence, they neither press down, like Hera, nor leap up, like Athena, but simply, as at Corinth, stand steady, disciplined, unshakeable, an image of Greek order in a landscape at whose borders flare the sphinx-mountains and the rocky heights of the goddess. During the Archaic period, all of this culminated at Delphi, Apollo's greatest shrine (fig. 11).

There, his columns (always without entasis, though the present ones are post-classical) confront the vastest and most potent of the old, sacred topographical forms, the horns of the Phaedriades, in which all the earth-shaking power of the goddess is lifted in majesty.

In Athens, under Pericles, the human city at last triumphed over the earth and all her old limits and laws. Just a decade or two earlier, at Olympia, under the enveloping conical hill of Kronos, the father of Zeus, the Greeks had explored, as if for the last time, the character of the old ways. The Periclean rebuilding of the Acropolis of Athens celebrated the breaking of limits. The Parthenon lifts free as an eagle out of its sacred landscape, blazing as white as the pyramids in the sun (fig. 13). In its sculptures, nature consents to the victory of human political life over everything. The human bodies of the Olympians on the east pediment become as grand and "natural" as the body of Hymettos, the sacred mountain that rises before them, to whose horns the old temple at Athena Polias was always oriented. Here, once again, we are led to skyscrapers, in a different way, as if there were only one easy leap in the human consciousness from the victory of Athens over nature to that of, say, Houston, where nature to all intents and purposes ceases to exist, except as a despised enemy coiled to strike in the darkness.

What happened in Roman architecture initiated a kind of interruption, almost two millennia long, in the dialogue between the natural and the manufactured with which humankind had previously been involved. Rome turned inward and elected, at last, to create an ideal universe within, closed off from the natural world and more perfect in terms of human conception than that world

Fig. 13 The Acropolis. Greece, Athens, 500/400 BC. Photo: Walter Hege, in Rodenwaldt, 1957, fig. 2.

could ever be. The greatest of all Roman sanctuaries, that of Fortune at Praeneste, above the coast south of Rome, shows how the pattern of enclosure began to develop. The temple is on a slope. The landscape of Greece is formed by rings of mountains enclosing plains, in which, as in Attica, for example, the solid bodies of the temples stand; but Italy is a long spine of mountains. On their slopes, the major Roman sacred sites lead their waters down to the fields below. We are reminded of Teotihuacan in this aspect. The underlying structure of the temple at Praeneste recalls that of a Mexican temple base, and a ziggurat as well, neither of which the Romans knew. But, like so much else Roman, it is all profoundly non-Greek, or pre-Greek, and, in that ancient tradition, it is concerned with helping nature and invoking her forms. In antiquity, Praeneste was crowned with a Hellenistic colonnade, the Greek overlay on the Roman form. But the colonnade is disposed in a way totally different from that employed in Greek temples. It is intended to create not a body but an environment. For the Romans, the principle of enclosure became everything. For them, the temple was not a sculptural mass but an enveloping fabric, just as the word *templum* means a sacred space rather than a building. So, at Praeneste, one mounts the ramp up the mountain and climbs the axial stairs to arrive at the enveloping hemicycle from which one turns and surveys the world, commanding the landscape like a general. The columns do not mass together to smash, as a Greek phalanx would do; they deploy like the legion to envelop the whole vast view, the entire Mediterranean world, shaping an image

of the empire of Rome. So, in its own way, does the Pantheon, praising, as it does, the perfect universe enclosed by Rome (fig. 14). So does Hagia Sophia, where the universe is transcendentalized into an image of bodiless perfection, formed by the ideal neo-Platonic shapes of circle and square. Who would go outside to wrestle with imperfection and gross matter when a higher reality is here, all fabricated but reflecting a supranatural order through which humanity is protected from nature's deadly laws?

The preoccupation of architecture right through the Middle Ages and into the Renaissance was to build an image of heaven on earth, inside—and, especially in Gothic France, to connect the kingdom with the heavenly order. But, when, toward 1500, humankind began to turn outside again to deal with the landscape on its own terrain, Praeneste was the model. It is the sacred mountain, hemicycled and ramped, which Donato Bramante introduced into the Vatican itself as the culmination of his Court of the Belvedere (fig. 15), balancing its image of pagan antiquity with the ultimate interior space, domed St. Peter's, which he was building at the other end of the courtyard. The same is true at Pirro Ligorio's Villa d'Este and in many other gardens. The Villa d'Este at Tivoli had a Roman model, that of the nearby sanctuary of Hercules Victor. At Tivoli, as at Teotihuacan, the theme is water, which is made to burst out of the slope with pagan abandon (see fig. 16). Everything in the Italian garden deals with the rebirth of the earth as a force, with a delicious new delight in nature's awesome power. It is the foundation of Romanticism and the precursor of the

Fig. 14 Giovanni Panini (Italian, 1676–1759). *Interior of the Pantheon,* c. 1750. National Gallery of Art, Washington, D.C.

VERO DISSEGNO DELI STVPENDI EDEFITII GIARDINI BOSCHI FONTANE
ET COSE MARAVEGLIOSE DI BELVEDERE IN ROMA

Fig. 15 Donato Bramante
(Italian, 1444–1514). Rome,
Belvedere courtyard, 1500/
50. Photo: Courtesy of Yale
University, Department of
History of Art, New Haven,
Connecticut.

Fig. 16 Tivoli Gardens. Italy,
Rome, 1560–75. Photo:
Private collection.

Fig. 17 Aerial view of Versailles. France, 1669–85. Photo: Courtesy of Yale University, Department of History of Art, New Haven, Connecticut.

English Romantic garden, where, however, all terrors were to be muffled in the soft dampness of the English countryside and, finally, in the gentle hedonism of middle-class suburban life.

The French classic garden was totally different and deserves an extended analysis, which it has not yet received in print. The French architects of the seventeenth century regarded themselves as drawing a portrait of the human intelligence on the land. Their theorists called the process *pourtraiture*.[6] At Vaux-le-Vicomte, André Le Nôtre traced the mind of Nicolas Fouquet on the landscape, seeming to draw on a surface as thin as parchment, pushing back the forest, celebrating the will of the liberated individual who shapes and civilizes the earth to his own measure. At Versailles (fig. 17), that individual was the king, and the portrait was that of the France which was himself, the new France of canals and long avenues radiating across the countryside from the king's centralizing person. But *pourtraire* is also *portrahere*, to reveal; the revelation is that of the neo-Platonic geometry of the universe, now drawn on its surface, with the king, man of perfect proportions, connecting France with the cosmic order once more. The vistas extend "indefinitely" from him across the landscape, as if to his vastly extended borders of continental France. Those frontiers were then defended in depth by the citadels designed by the Marquis de Vauban, themselves designed according to principles similar to those that formed the gardens, with flat trajectory lines of sight radiating in similar *étoiles*. It was a brand new structuring of the world, the ultimate classic plan to control nature and to subdue her to the demands of human political life. It created Washington, DC, the ultimate "capital," and modern Paris, the ultimate garden; indeed, it created all of France itself. During the nineteenth century, the railroads all radiated from Paris to Vauban's citadels, like the bastions of one great fortified town or garden, the country as a whole, of which Paris was the heart.

Perhaps no modern nation has formed its institutions and its countryside, its whole way of life, into such an integrated unity, especially in view of the fact that so many factions of class and region lie below the surface, the *pourtrait*. As such, France can stand as the clearest symbol of the relationship of all modern nation-states to nature no less than to human diversity and represents the widest identification so far with the world outside the self that contemporary humanity has seemed able to achieve. It would be ridiculous to pretend that the Amerindian identification was (or is) any broader, but it is different in kind. It recognizes, at least, the indissoluble connection between all living things and, indeed, between everything, animate or inanimate, that forms the cosmos. Obviously, that point of view is especially relevant today, when humankind's political combinations and constructive skills possess the power to destroy the natural world. The Amerindian view binds human beings to the world and holds humanity responsible for the world's continued health. Hence, it seeks not only to draw power from nature but also to enhance nature, if necessary with its blood.

NOTES

Preface: The Encounter of Cultures
Miguel León-Portilla

1. These are the first entries registered in the *Diccionario de la lengua española*, 1984; the *Oxford English Dictionary*, 1979; and the *Dictionnaire de la langue française*, 1988.
2. As shown in León-Portilla, ed., 1983, indigenous texts that take into account the vision of those who were conquered bear witness to this.
3. Dürer, 1925, pp. 34–35.
4. Las Casas's denouncements, now recognized as precursive to the Declaration of the Rights of Man, especially in his *Brevísima relación de la destrucción de las Indias*, would eventually stir up the world's conscience in regard to what had occurred in the New World.
5. The magazine *Tlalocan*, put out by the Universidad Nacional Autónoma de México, publishes reports in a number of indigenous tongues from Mesoamerica and the Southwest United States. As of 1989, eleven volumes with texts in more than fifty languages have appeared in print.
6. Attributed to "Tecayehuatzin, lord of Huexotzinco," in *Cantos Mexicanos*, fol. 9v, Biblioteca Nacional, Mexico City.

Introduction: Landscape and Symbol
Richard F. Townsend

1. Jung, 1976, pp. 41–42.
2. Kubler, 1991.
3. Kubler, 1962.
4. Lawrence, 1976, p. 34.

Pre-Columbian Images of Time
Anthony F. Aveni

1. Tedlock, 1985.
2. Ibid.
3. Bandelier, 1910.
4. *Tzolkin* is a corruption of *ch'ol k'ij* in Quiché dialect, which means the "arranging of the days." See B. Tedlock, 1982, pp. 53, 89.
5. The animals pictured on the objects from many of the nonliterate Amerindian cultures shown in the exhibition and book have calendrical counterparts, though we have little hope of discovering what they were.
6. Nuttall, 1904.
7. *Codex Dresden*, 1989, pp. 51–58.
8. Aztec: *xihuitl*; Maya: *haab*, or "common days" count.
9. Sahagún, 1951–82, bk. 7, p. 25.
10. Proskouriakoff, 1960, p. 462.
11. In this notation, the glyphs for these large units of time were accompanied by a bar-and-dot system of numerals, in which a dot stands for one and a bar for five, symbols that probably originate, respectively, from the fingertip and extended hand employed as tallying devices in a simple body-count system.
12. Modern epigraphers named the ruler Eighteen Rabbit because his name-hieroglyph incorporates the Maya numeral eighteen and a rodentlike head.
13. Closs, Aveni, and Crowley, 1982. This connection between Venus appearances and maize-planting helps to explain why an effigy of the Maize God (see Miller essay in this book, fig. 1) appears on the temple.
14. *Codex Dresden*, pp. 24, 46–50.
15. Garcilaso de la Vega, 1966, p. 117.
16. The Inca called this star group *Collca*, the word also used for a storehouse in which they kept the grain they had harvested the year before.
17. Magaña, 1988, p. 37.

The Persistence of Maya Tradition in Zinacantan
Evon Z. Vogt

1. Vogt, 1981.
2. Vogt, 1976, pp. 44–50.
3. Vogt, 1964; 1969, pp. 594–96; 1990; see also Townsend, 1982; 1987.
4. Stuart, 1987; Freidel and Schele, 1989.
5. Vogt, 1976, pp. 16–17; 1981.
6. Vogt, 1976, pp. 18–19; Watanabe, 1989.
7. See, for example, Greene Robertson, 1985, p. 19, fig. 55, which shows a mirror hanging from the belt of the standing figure on Pier C of House A at the Classic Maya site of Palenque, Chiapas, Mexico; see also Laughlin, 1975, p. 251; Taube, in press.
8. Vogt, 1976, pp. 127–28; Victoria R. Bricker, personal communication, October 29, 1974.
9. Bricker (1989, pp. 231–50) demonstrated that religious traditions occurring in ritual dramas performed in Chamula, a community that borders Zinacantan on the north, have persisted since Maya Classic times, or for fifteen hundred years.

Mankind and the Earth in America and Europe
Vincent Scully

1. The result of this work was Scully, 1962.
2. Scully, 1975.
3. The whole developed into the Mellon lectures of 1982 at the National Gallery of Art, Washington, D.C., and the William Clyde DeVane lectures of 1988–89 at Yale University, New Haven.
4. Scully, 1991. An article of the same title is included in the record of a symposium, *Landscape and Architecture in the Twentieth Century*, held at the Museum of Modern Art, New York, in 1988, which was published as *Denatured Visions: Landscape and Culture in the Twentieth Century*, eds. Stuart Wrede and William Howard Adams (New York, 1991).
5. In Tobriner's luminous article (1972), Cerro Gordo is properly named, and earlier observations of its axial relationship to the "Avenue of the Dead" are noted, whereas Hardoy (1973, pp. 35–74) never mentioned or illustrated this mountain in his elaborate description of walking through the site. In other parts of Mesoamerica, observations on the relationship of site to the environment have been made: see, for example, Hartung, 1971; Heyden, 1976; Townsend, 1979. The selective vision, inconceivable today in Mesoamerican studies, is still the rule, however, in classical archaeology; see, for example, Tomlinson, 1976. I have benefited from conversations with Mary Ellen Miller on this and related topics.
6. See especially Boyceaux de la Barauderie, 1638; A. Mollet, 1651; C. Mollet, 1652.

THE SOUTHWEST

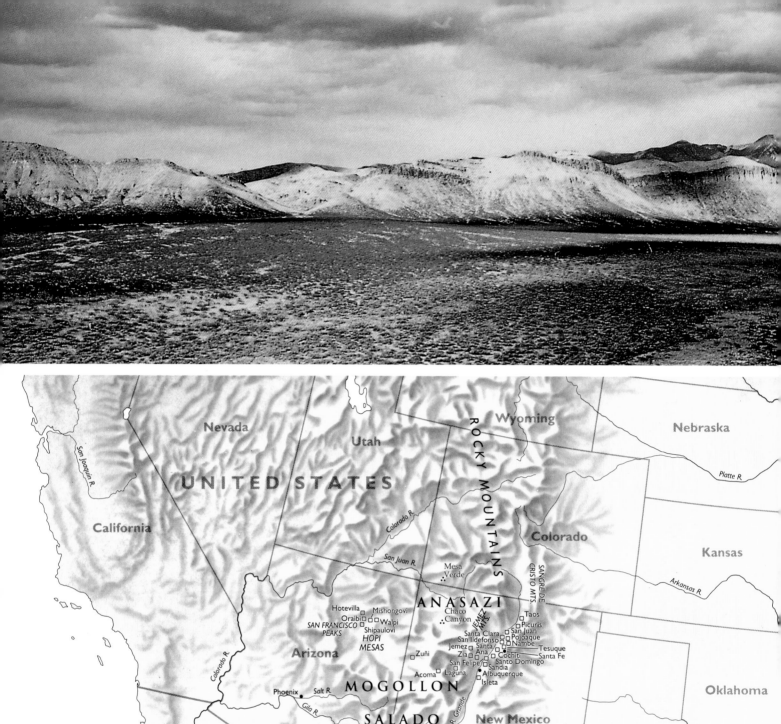

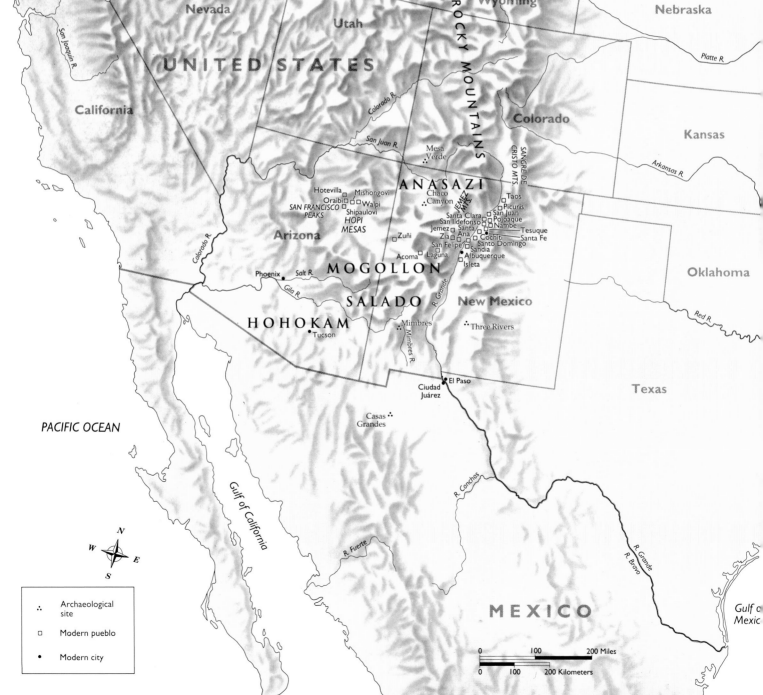

Archaeological site

Modern pueblo

Modern city

Among the diverse areas in the United States where Amerindian peoples carry on their traditions, the Southwest preserves an especially vital connection between the present and past. Pueblo communities along the Rio Grande Valley and scattered across western New Mexico and northern Arizona trace their origins to the Anasazi peoples of the eleventh to the thirteenth centuries, and, even farther back, to an archaic desert culture of hunters and foragers during the first millennium BC. In this vast sunlit region of plateaus and dark mountain ranges, water is ever a preoccupation. Only in summertime do blue-black thunderclouds build up above the forested heights, before the rains sweep down in curtainlike processions. Arroyos and washes become charged with rushing torrents, and the pale red and ocher land suddenly acquires a light green cover. Otherwise, it seldom rains, and only the winter snows can be counted as another source of life-giving moisture. Between 400 and 500, "pit house" villages were supported by early maize and squash agriculture. Later, more elaborate, multiroom structures were built around plazas and distinctive semisubterranean rooms—the ancestral religious kivas. Out of basketry design and the fashioning of early pottery grew the structural principles and geometric regularity that were to govern later artistic traditions. Another important form of expression, deeply rooted in archaic hunting and gathering, was the custom of engraving and painting natural rock surfaces with animal, human, and abstract figures at sites near sources of water and game trails, on ridge tops, and in caves and rock-shelters. The process of imbuing the landscape with meaningful mythic and historical images was well developed, as it was among paleolithic peoples worldwide.

The eleventh through the thirteenth centuries witnessed a cultural florescence that included the construction of multistory communal houses in Chaco Canyon, New Mexico, and throughout the vast surrounding region, as well as the stepped-back, vertically stacked villages within huge concave

rock-shelters at Mesa Verde, in southern Colorado. These are the most visually impressive architectural remains of the town-dwelling Anasazi peoples, but in neighboring districts further south there were important related traditions. The peoples of the Mimbres valley and adjacent mountains developed a unique ceramic art that combines geometric abstractions and lively figures of humans, animals, and composite creatures. The large trading and farming town of Casas Grandes in the desert of northern Mexico maintained links with Mesoamerican cities located far to the south. The complexity of these various societies and the role of religious thought and ritual in maintaining cohesion are the subjects of new debate and revision. By 1300, a profound transformation was underway in the Southwest, as former towns were gradually abandoned and groups migrated to settle anew along the Rio Grande and on the Hopi mesas. At this time, cults developed that were associated with water, fertility, and ancestors, along with religious performances in which participants wore masks and elaborate ritual costumes. These performances show distant affinities with those of the great urban societies of Mexico. This new phase of Southwestern art was grafted onto older regional traditions. The ritual arts of the Pueblos today reflect these layers of history. Dance formations and deep choral singing, secret masked performances, and rites performed at sacred places within the natural landscape respond to the abiding need to call forth water from the depths of the mountains into the sky and down to the waiting animals, people, and plants. The songs and presentations belong to the larger stratum of human history before the visual arts were separated from theater and dance. In this mode of perceiving and signaling what is meaningful, the ancient peoples of the Southwest created a network of symbolic connections that joined humankind and other forms of life with the powerful forces of nature.

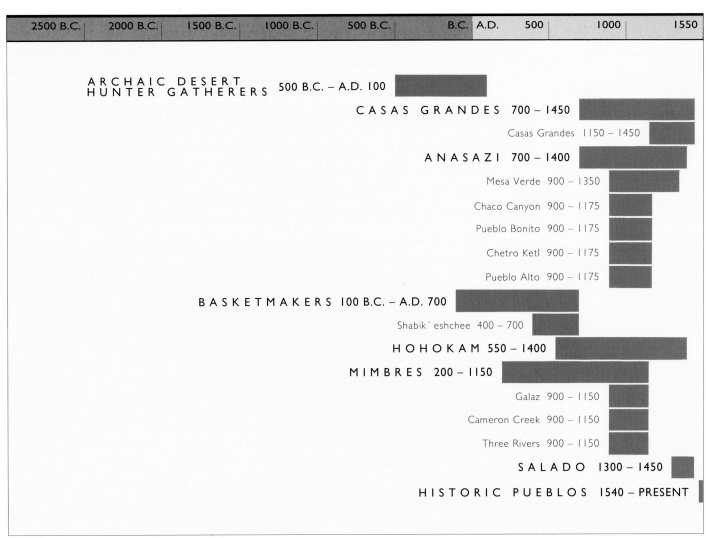

| | 2500 B.C. | 2000 B.C. | 1500 B.C. | 1000 B.C. | 500 B.C. | | B.C. | A.D. | 500 | 1000 | 1550 |

ARCHAIC DESERT
HUNTER GATHERERS 500 B.C. – A.D. 100

CASAS GRANDES 700 – 1450

Casas Grandes 1150 – 1450

ANASAZI 700 – 1400

Mesa Verde 900 – 1350

Chaco Canyon 900 – 1175

Pueblo Bonito 900 – 1175

Chetro Ketl 900 – 1175

Pueblo Alto 900 – 1175

BASKETMAKERS 100 B.C. – A.D. 700

Shabik´ eshchee 400 – 700

HOHOKAM 550 – 1400

MIMBRES 200 – 1150

Galaz 900 – 1150

Cameron Creek 900 – 1150

Three Rivers 900 – 1150

SALADO 1300 – 1450

HISTORIC PUEBLOS 1540 – PRESENT

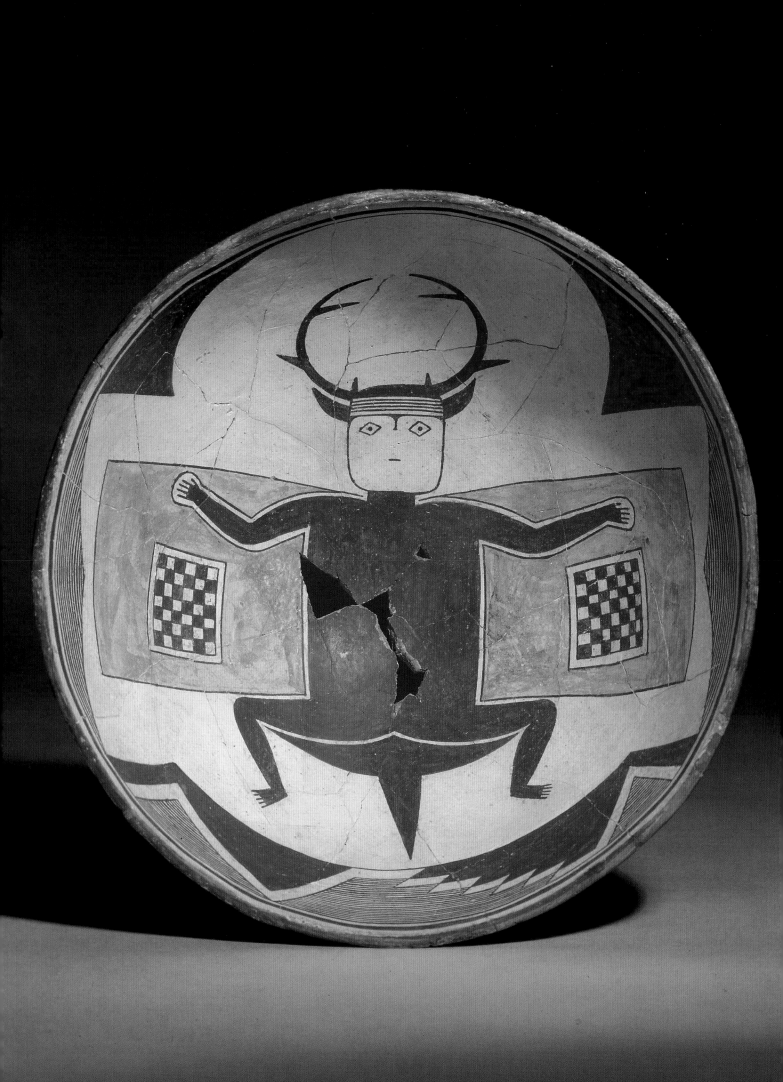

MIMBRES ART: FORM AND IMAGERY

Introduction to Mimbres Classic Painted Pottery

The Mimbres people of southwestern New Mexico belonged to a branch of prehistoric Southwestern culture that we call the Mogollon.[1] From about 200 to 1000, they lived in small pithouse villages that rarely included more than ten or fifteen households. Later, their settlements comprised suites of contiguous rooms that were built around plazas and numbered at most two or three hundred people. As subsistence farmers, they cultivated the river valleys that traversed the arid Sonoran desert and also hunted and gathered wild food. The Mimbres people made no painted pottery until the eighth century; the artistic tradition for which they are famous reached full development during the Mimbres Classic era, from 1000 to 1150. That tradition ended when they abandoned their home region in about 1150, following a lengthy period of economic stress due to drought and depletion of food resources in their desert environment. Rock art that may date to a later period, found at open-air sites far to the east of Mimbres country, shows tantalizing similarities to Mimbres pottery paintings (see figs. 2, 21, 22) and may indicate where some of the displaced population resettled.

About ten thousand Mimbres painted vessels are known, the majority recovered from burial contexts.[2] The designs are painted in black on the white-slipped interior surfaces of bowls that were probably food-service vessels before their conversion to mortuary use by being sacrificed or "killed" (deliberately broken) just prior to burial with the dead. About eighty percent are nonfigurative compositions, complex geometric constructions that often suggest weather phenomena—lightning, clouds, and falling rain. The remainder depict humans (see figs. 1, 5), other animals (see fig. 4), and mythic beings (see fig. 7).[3] Most Mimbres pictures are geometric abstractions, but even those that are representational often incorporate geometric elements (see fig. 3). Some paintings depict narratives, while others illustrate the mundane or the mythological world; some images seem serious, even frightening (see fig. 12), and some are playful. While all subjects may stimulate the imagination and even provide clues to a lost ideology, their visual organization provides a rational constant that links them together. The pictorial means and methods are variations on a single theme of polar opposition: black/white, curved/straight, push/pull, positive/negative, clockwise/counterclockwise (see figs. 3, 8). These

Fig. 1 Bowl depicting man wearing antler headdress. New Mexico, Mimbres, 1000/1150. Ceramic. Collection of Tony Berlant, Santa Monica, California. Photo: Justin Kerr, Courtesy of the American Federation of the Arts, New York. The interplay of representational figures with abstract positive/negative shapes characterizes Mimbres design. (Cat. no. 151)

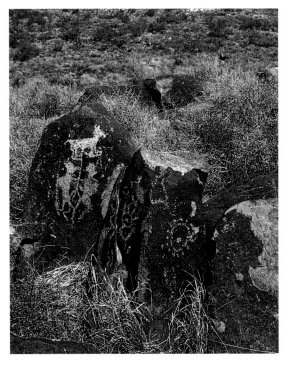

Fig. 2 Petroglyphs. New Mexico, Mimbres, Three Rivers, 1000/1150. Photo: Richard Townsend. These petroglyphs may depict a hunting rite.

Fig. 3 Bowl with abstract animal designs. New Mexico, Mimbres, 1000/1150. Ceramic. Museum of Indian Arts and Culture, Santa Fe. (Cat. no. 159)

Fig. 4 Bowl depicting crane and fish. New Mexico, Mimbres, 1000/1150. Ceramic. Logan Museum of Anthropology, Beloit College, Wisconsin. In this transformational scene, the crane's neck becomes a river filled with fish. (Cat. no. 155)

pairings are matched by images of duality: man/animal, amphibian/snake, black triangles/white rhomboids (see figs. 16, 20). In most instances, the white background on which the images are painted emphasizes their visual and subjective ambiguities; the depicted scenes appear to be occurring in a spatial void.

Mimbres pottery paintings are complicated, tense, and enigmatic. Their figure-ground relationships are in constant flux, creating pictorial illusions, visual puns, counter-rhythms, and multiple symmetries. These ambiguities extend to pictorial content. Both geometric and representational subjects often seem to refer simultaneously to the worlds of everyday experience and myth (see fig. 13). Many appear to be visual metaphors that are especially appropriate for paintings whose ultimate association was with the ancestral dead of a community, who were buried beneath the domestic spaces that continued to be used by the living. Mimbres pottery paintings seem to have mediated between the living and the dead as units of a complex set of expressions that physically and metaphorically reflect the structure of a world view in which time, domestic space, and all of nature constituted a continuum in a balanced universe of oppositions.

Mimbres Classic pottery is especially compelling, even when considered within the larger tradition of Southwestern ceramics. Technically, it differs little from contemporaneous wares of the neighboring Anasazi people; its patterns, motifs, and other design elements are closely related to and sometimes indistinguishable from older traditions of the Anasazi and Hohokam, although the Mimbres intensified Anasazi visual inventions and transformed them into tension-filled abstractions. Mimbres concentration on figurative and narrative subjects is certainly a factor, but the precision and complexity of the design treatment is just as important. Both figurative and nonfigurative paintings often resemble elegantly drawn cryptograms, superbly crafted puzzles layered with hidden meanings.

This art seems the more remarkable when we realize that it was made by part-time artists, probably women, from economically marginal villages of no more than a few hundred residents each. The association of their art with the mystery of death is certainly part of its attraction. We now know of the hardships suffered by the people and the mortuary contexts of their paintings and can interpret them as somehow mediating

between life and death, and between security and insecurity.

This pottery art lay hidden and forgotten for about eight hundred years. Upon its rediscovery, about eighty years ago, it was quickly recognized as a powerful synthesis of several different pictorial, formal, and iconographic traditions of the prehistoric United States Southwest. That evaluation has since been confirmed and reinforced in many different ways.

Mimbres Art in the Modern World

Like other prehistoric Southwestern peoples, the Mimbres had no written language, and they were unremarkable in most material respects. Their villages were small, and, unlike the Anasazi cliffhouses and "great houses" of the northern Southwest, Mimbres buildings have not aged gracefully. Some of the painted pottery made by the Mimbres people had only recently been recovered when anthropologist J. Walter Fewkes was introduced to Mimbres art, late in 1913.[4] E. D. Osborn, an amateur archaeologist in Deming, New Mexico, had sent a letter and photographs of these specimens to the Bureau of American Ethnology of the Smithsonian Institution, where Fewkes was senior ethnologist. Barely six months later, Fewkes was in Deming acquiring specimens for the United States National Museum and investigating ruins of Mimbres villages and their rock-art sites.

Fewkes was sixty-four years old in 1914, and his decision to make the arduous trip could not have been taken lightly. But there were few people more familiar with Southwestern archaeology, and he fully realized the potential significance of the pictures that Osborn had sent. Upon his return to Washington, Fewkes prepared the first of three reports describing Mimbres art and placing it as accurately as possible in archaeological, ethnographic, and historical contexts.[5]

Word about the art spread slowly. At first, only a few people living in southwestern New Mexico were aware of it, and then it became known to a handful of specialists. It only gained a somewhat larger audience about the time of World War II. Early scientific archaeology in the Mimbres country during the 1920s and early '30s was stimulated, in part, by Fewkes's publications, which demonstrated the need to clarify the prehistory of the southern Southwest. A hiatus followed until the late 1960s, when a new, fruitful, and still-ongoing campaign of archaeological investigations began.[6]

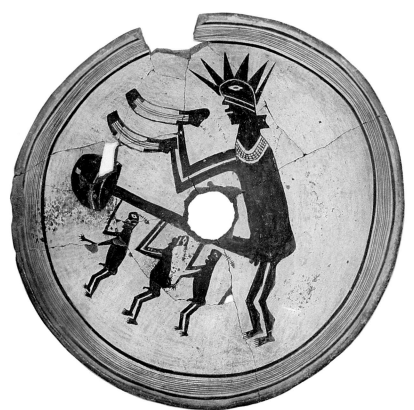

Fig. 5 Bowl depicting ritual fertility clown. New Mexico, Mimbres, Galaz, 1000/1150. Ceramic. Department of Anthropology, University of Minnesota, Minneapolis. (Cat. no. 158)

Small-scale excavation by local amateur archaeologists and pot collectors was superseded by the entirely destructive and sometimes criminal looting of professional pot-hunters that started in the 1960s, when Mimbres art first became a valued commodity on the world art market. Classic Mimbres pottery paintings have an almost universal appeal, which translates into rising market values that are, in turn, the primary cause of the indiscriminate looting and destruction of so many Mimbres archaeological sites. But, whatever kinship may exist between the spirit of Mimbres art and modern artistic values, there are also essential differences. Unlike the fine arts of today, which, almost by definition, are made to be looked at rather than used, Mimbres paintings were utilitarian. In fact, they served two purposes: decorative and symbolic. Thus, Mimbres paintings served social ends far different from those of the art of our own time.

An important quality of Mimbres art is the evident harmony of means and results—the paintings demonstrate an almost-perfect union of medium and message, an indivisibility of form and content. Most are crisply delineated on the carefully prepared interior surface of hemispherical bowls that are otherwise crudely finished. The vessels are portable, and the paintings on them are designed to exploit both the expanse of the picture surface and the absence of top-bottom

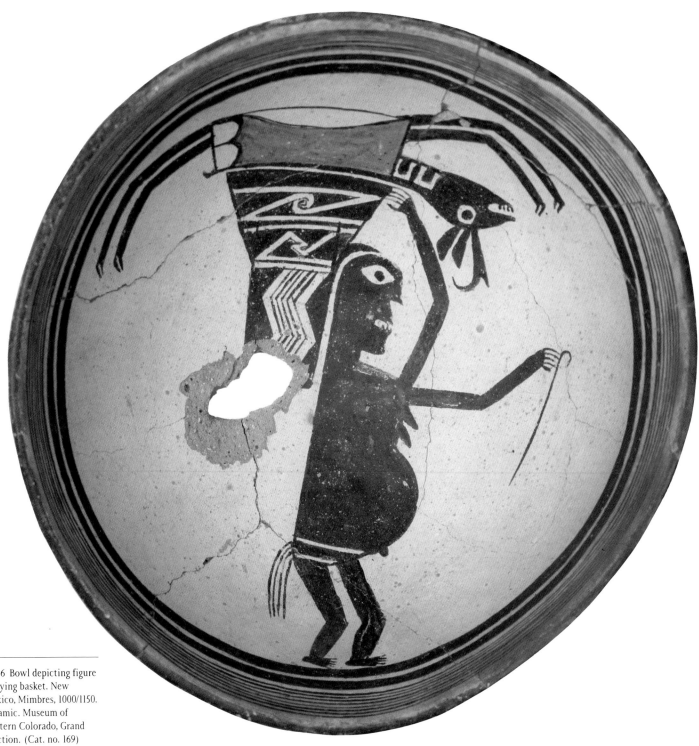

Fig. 6 Bowl depicting figure
carrying basket. New
Mexico, Mimbres, 1000/1150.
Ceramic. Museum of
Western Colorado, Grand
Junction. (Cat. no. 169)

orientation. For technical reasons, Mimbres artists could not easily erase errors and, for all practical purposes, every line and brush mark was there to stay. Absolute confidence that hand, brush, brain, and eye could work as one was required in order for the artists to create their masterpieces.

Today, Pueblo Indians of the Southwest, who count the Mimbres among their many ancestors, still practice ancient pottery-painting methods and can demonstrate the technical logic that is an essential aspect of the harmony of Mimbres art. And, though Mimbres art was lost to humanity for centuries, many of its qualities have been revived and incorporated within the related pictorial structures of contemporary Pueblo Indian art. Eight hundred years may separate modern Pueblo from Mimbres artists, but the relationships are clearly visible.

Mimbres Paintings and the Interpretation of Mimbres Culture

Our understanding of the Mimbres world is largely dependent upon our understanding of its art, but the converse is also true—to understand something of what Mimbres art meant to the Mimbres people, we must know something of the Mimbres world. Theirs was a delicately balanced, semiarid environment with great ecological variety. Originally, they were hunting and gathering people, who subsisted on wild resources. Increasingly, they grew to depend upon agriculture but continued to eat wild foods.

For hundreds of years after village life began, Mimbres people seem to have lived reasonably secure lives in harmony with the environment. But, with growing populations taxing the ecosystem,[7] that balance was lost. Mimbres pottery painting started to take on tense and dynamic qualities at about this time.[8] As though Mimbres Classic art were a prayer or a metaphor for harmony or a mechanism to acquire symbolic control over potentially chaotic conditions, it became most complex and expressive just before the Mimbres region was abandoned.[9] It is tempting to infer a relationship between the simultaneous change in their distinctive art and their departure from their homeland.

We can identify some of the stressful conditions in Mimbres life that occurred at about the time their pottery art achieved its apogee, but there is more to Mimbres art than its reference to subsistence economy. We know that, until the Mimbres lost the harmony with nature they had enjoyed for

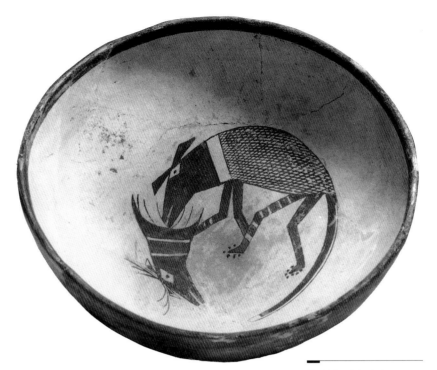

Fig. 7 Bowl depicting masked animal trickster. New Mexico, Mimbres, 1000/1150. Ceramic. Southwest Museum, Los Angeles. (Cat. no. 167)

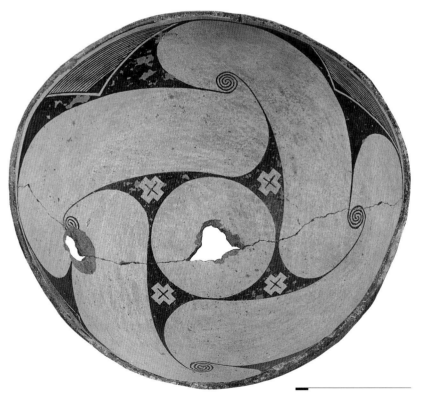

Fig. 8 Bowl with four-part cosmological design. New Mexico, Mimbres, 1000/1150. Ceramic. Museum of Northern Arizona, Flagstaff. (Cat. no. 161)

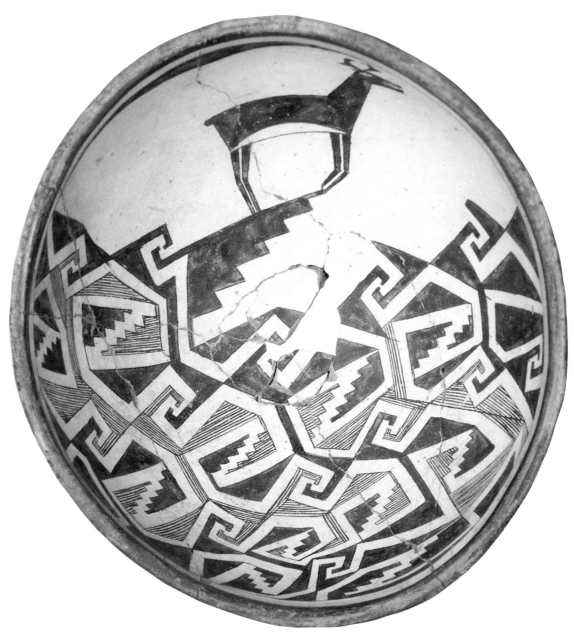

Fig. 9 Bowl depicting antelope on mountain. New Mexico, Mimbres, 1000/1150. Ceramic. Museum of Western Colorado, Grand Junction. (Cat. no. 168)

Fig. 10 Bowl depicting warrior. New Mexico, Mimbres, Swarts Ranch, 1000/1150. Ceramic. Peabody Museum, Harvard University, Cambridge, Massachusetts. (Cat. no. 164)

Fig. 11 Bowl with insect and rabbit designs. New Mexico, Mimbres, 1000/1150. Ceramic. Museum of Northern Arizona, Flagstaff. Photo: School of American Research, Santa Fe. (Cat. no. 162)

centuries, they did not know that this disaster was going to occur. Themes other than overpopulation and a dwindling resource base are featured in their art. Cosmic geography appears to have been an important theme, and, in both organization and imagery, Classic Mimbres art seems to have stated and restated something about the social unity of the Mimbres people, their ethnicity, world view, and mythic and real-world histories and beliefs.

Far more than any other ancient Southwestern people, the Mimbres painted on their pottery recognizable images of real or imaginary animals (see fig. 9), people (see figs. 10, 15), mythic beings (see fig. 11), and events (see fig. 14). Upward of two thousand of their figurative representations are known, and

these provide unique views of the world as seen through the eyes of six or eight generations of people whose thoughts would otherwise be lost to us. Most figurative paintings are superficially less cryptic than the nonfigurative ones and include only a single animal, usually placed in a framed void at the center of a vessel interior. Fewkes, who was a trained naturalist and inclined to conceive of archaeology as "the ethnology of the past," introduced an interpretive approach still followed by most investigators. This approach identifies painted images with real-world animals and then suggests cultural meanings by analogy with historic-era Pueblo Indian practices.[10]

Mimbres artists, however, often deliberately obscured animal identities. On close

examination, many animal pictures show anomalous features such as human feet on a catfish (see fig. 16) or a rattlesnake tail on an amphibian (see fig. 20). Rich visual metaphors obscure clues to mythic traditions that should bear a living relationship to those of modern Pueblo people.[11] There has been some success in establishing such connections, but the meaning of many paintings remains elusive. Some scholars believe they illustrate mythic traditions more like those of Pre-Columbian Middle America than those of the Pueblo Southwest.[12] It is not unusual for a Mimbres painting to be given several equally plausible meanings that are not necessarily mutually exclusive (see fig. 4).[13] The images' cryptic qualities have generated a variety of structural and symbolic interpretations.

Complex narrative pictures on Mimbres pottery may tell of the quality of Mimbres daily life. Elaborately costumed and outfitted individuals, including warriors and priests, appear, as do scenes of hunting (see fig. 14), food- and wood-gathering (see figs. 6, 15), bear-wrestling, planting, childbirth, curing ceremonies and other rituals, swimming, gambling, parrot-training, and, appropriately, pottery-making. Others are concerned with myth, religion, and various ideological themes (see figs. 1, 5, 13). Mythic personages usually combine features of two or more real-world animals. In some instances, these figures interact with one another, with humans, or with other animals. Animals may behave like humans, as in the picture of a long-tailed creature placing a deer mask on its head (see fig. 7). A close look at some of these images reveals that they may depict humans wearing fantastic costumes (see fig. 16).

Most paintings are on the inner surfaces of bowls that range in diameter from about seventeen to twenty-seven centimeters and that are about two-and-a-half times wider than they are deep. All two-dimensional reproductions of the images tend to alter their original visual qualities, especially if, as on a printed page, the vertical axis is made static. In such reproductions, the focal point of a painting often appears to be in the center of its hemispherical picture space, even though it may actually be on the bowl's walls. Other distortions occur when concave bowls are flattened by shadowless photographs taken head-on. These distortions affect our ability to interpret, as well as to appreciate, the paintings. A photograph of a group of figures may show them lying down, when, in fact, they are upright on the wall of a vessel, a position that creates the illusion that the

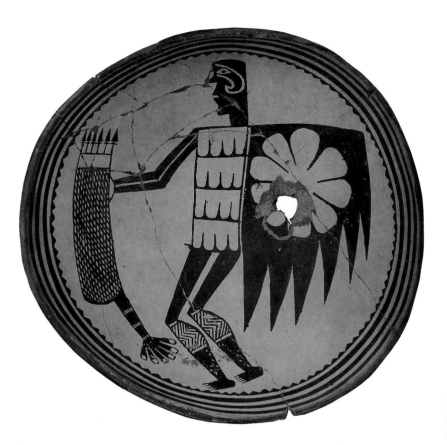

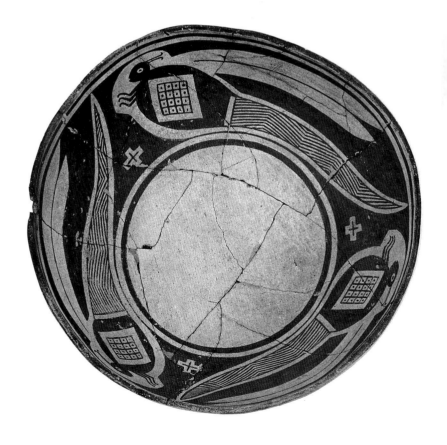

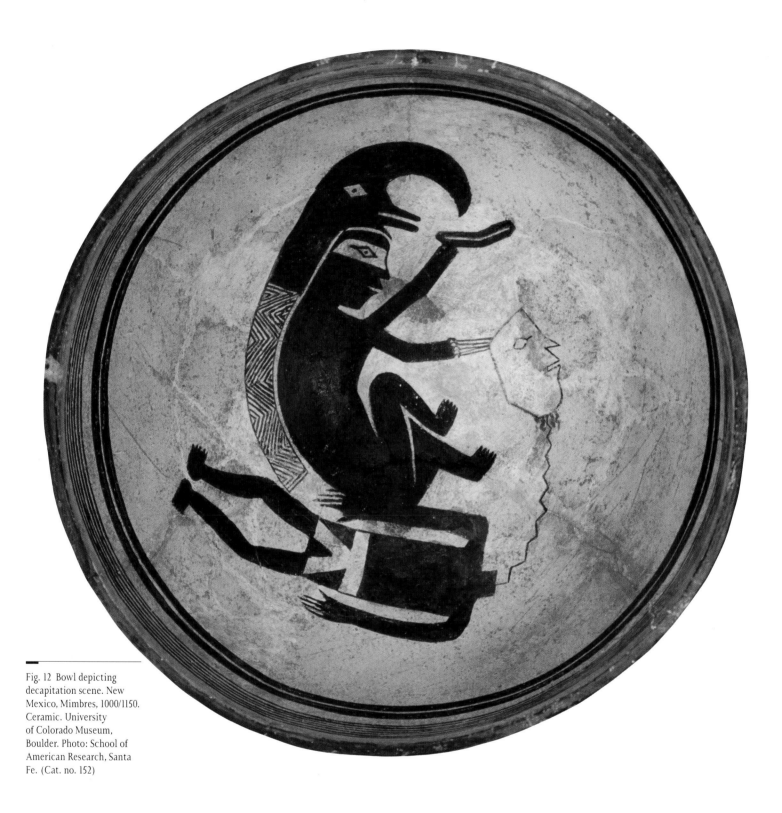

Fig. 12 Bowl depicting
decapitation scene. New
Mexico, Mimbres, 1000/1150.
Ceramic. University
of Colorado Museum,
Boulder. Photo: School of
American Research, Santa
Fe. (Cat. no. 152)

background void may have been intended to represent an interior or a landscape (see fig. 19). Similar distortions occur in nonfigurative paintings. When seen three-dimensionally, these tend to be far more active than static and may suggest abstracted images of such natural phenomena as mountains, clouds, and the night sky. Very rarely, the interpretation of geometric forms as natural ones is confirmed by the inclusion of an animal within geometrically organized space (see figs. 17, 20). Mimbres artists were thoughtful and deliberate, and informed reading of their pottery requires experience with a variety of the specimens themselves.

The rhythms and linear pacing of Mimbres paintings are slow and stately, especially when compared to Hohokam pottery paintings of southern Arizona, from which many Mimbres compositions and animal subjects were derived. But Hohokam spontaneity was modified by Anasazi-inspired geometric logic, intensity of color contrast, and linear qualities, as well as by endless repetition of dualities, hidden images, and inverted symmetries. Conversely, the straightforward geometric logic and linearity of Anasazi art were transmuted by Mimbres hands into a tense language of visual puns and puzzling ambiguities.

Visual puns are the heart and soul of Mimbres paintings. Facing strings of black triangles may combine to create negative patterns of white diamonds or rhomboids (see fig. 18). Long, white zigzag lines race like lightning across a black background, but the white is unpainted—it is the "real" background—and, when the eye focuses on the painted black field, it may see stepped terraces or strings of black triangles that are like hills on a horizon. We do not know which of these mutually interdependent images is the one we are supposed to see.

Similar effects occur in figurative pictures: the white background that frames a black insect may hide the head of a rabbit (see fig. 11), or the tails of two quadrupeds become interlocking spirals which then form a design unit seemingly independent of the animals (see fig. 3). Often, figurative and decorative subjects merge, just as black and white, positive and negative designs do. Few paintings of animals lack the nondescriptive geometric patterns that fill the outlines of the animals' bodies; complex and decorative, some designs may be read as burden baskets, abstracted bird feathers, or stepped terraces that could be mountains, clouds, or altars.

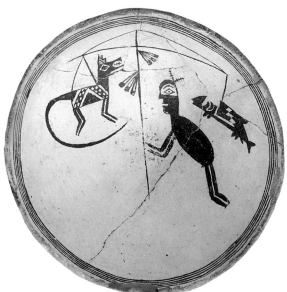

Fig. 13 Bowl depicting ceremonial performer holding staff with animal effigies. New Mexico, Mimbres, 1000/1150. Ceramic. Peabody Museum, Harvard University, Cambridge, Massachusetts. (Cat. no. 165)

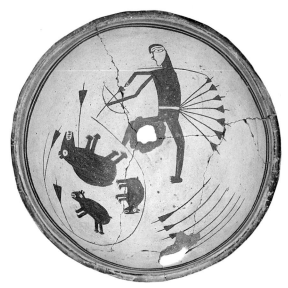

Fig. 14 Bowl depicting bear-hunting scene. New Mexico, Mimbres, Galaz, 1000/1150. Ceramic. Department of Anthropology, University of Minnesota, Minneapolis. (Cat. no. 157)

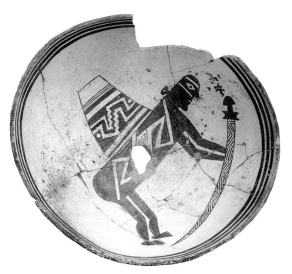

Fig. 15 Bowl depicting figure, basket, and staff. New Mexico, Mimbres, Cienega, 1000/1150. Ceramic. Maxwell Museum of Anthropology, University of New Mexico. Albuquerque. (Cat. no. 156)

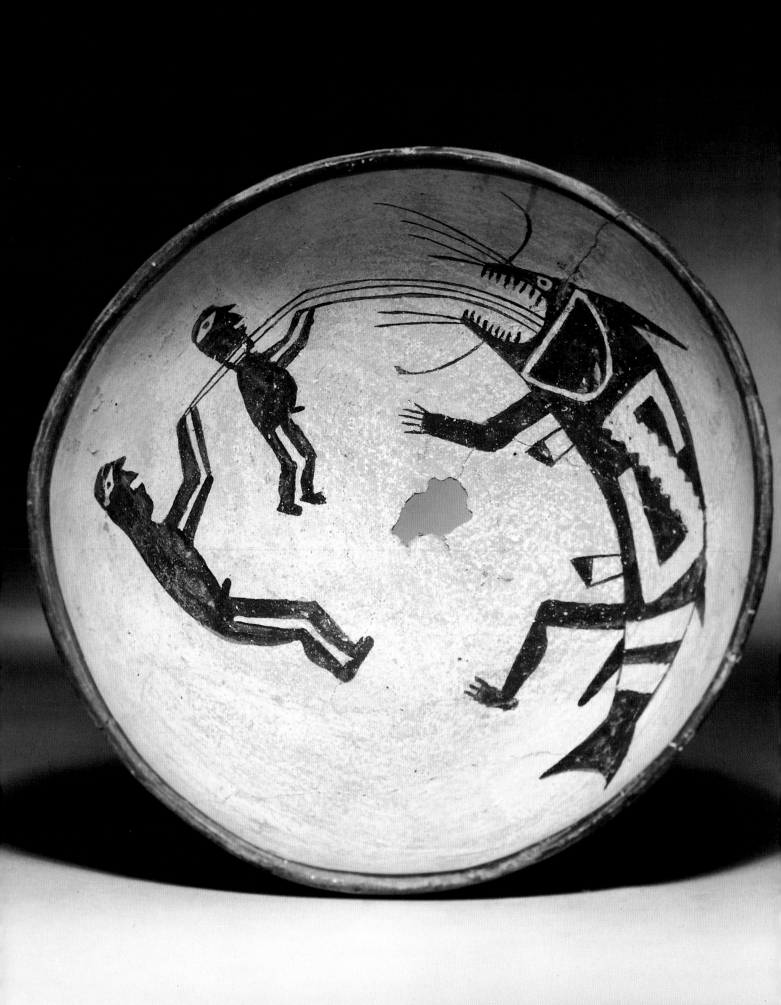

Most Mimbres nonfigurative paintings are organized in four equal sections that rotate around a large, clearly defined, but empty, circular center space. This design can be interpreted in terms of concepts of sacred space that were common in pre-Columbian America and are still held by many modern-day Indians, including Pueblo people. In the view of many Pueblo groups, their community is located at a metaphorical Center Space (or Earth Center), which was sought for and ultimately located by their ancestors after many difficult migrations.[14]

Cosmic geography embraces three dimensions and is always keyed to the very center of the Pueblo home and to four earth-bound directions. This center and the four directions are symbolized in many ways in both daily and ritual life. In the real world, the center may be located within a protective series of quartets of sacred mountains, caves, springs, and shrines, all oriented to the cardinal directions and referring to the sky above and the earth below. There are parallel structures in the nonhuman and mythic worlds. Thus, the common structuring of Mimbres nonfigurative pottery painting may be read as simply another means of representing sacred geography. Each bowl, circumscribed by a framing line, may have been conceived as a map of, or a prayer about, an orderly, bounded world. Abstract geometry may also represent aspects of these sacred beliefs.

There is ethnographic support for this argument. At Zuni Pueblo, early in this century, prayer plumes for shrines were made only by men. Women painted harmoniously balanced, geometric motifs on their pottery to serve as visual prayers in the same way as prayer plumes functioned.[15] It did not matter that the vessels remained utilitarian, or even that they were sold to non-Indians. The designs on Zuni vessels, like those on Mimbres pottery, often suggest feathers and feather constructions. Prayer plumes made of feathers are thought to carry prayers skyward. Analogy with Zuni concepts increases the probability that Classic Mimbres designs were imbued with symbolic meaning. Such designs, made by women and common even on utilitarian objects, would have been a constant reminder of the structure and harmony inherent in the natural world and of the unity of mankind with the cosmos. On the other hand, most surviving Mimbres art created by men is rock art, often far removed

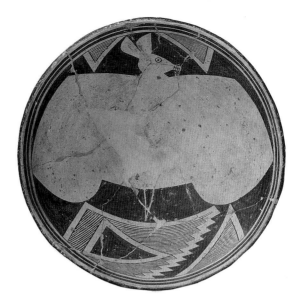

Fig. 16 Bowl depicting two figures and large fish. New Mexico, Mimbres, 1000/1150. Ceramic. University of Colorado Museum, Boulder. Photo: Justin Kerr, Courtesy of American Federation of the Arts, New York. (Cat. no. 154)

Fig. 17 Bowl with bat design. New Mexico, Mimbres, 1000/1150. Ceramic. Department of Anthropology, Smithsonian Institution, Washington, D.C. (Cat. no. 166)

Fig. 18 Drawing of triangles as zone-filling elements. New Mexico, Mimbres, 1000/1150. Photo: Brody, 1977, fig. 91.

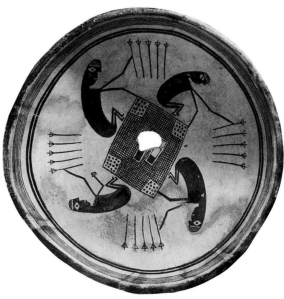

Fig. 19 Bowl depicting four figures. New Mexico, Mimbres, 1000/1150. Ceramic. Museum of Indian Arts and Culture, Santa Fe. Photo: Justin Kerr, Courtesy of American Federation of the Arts. (Cat. no. 160)

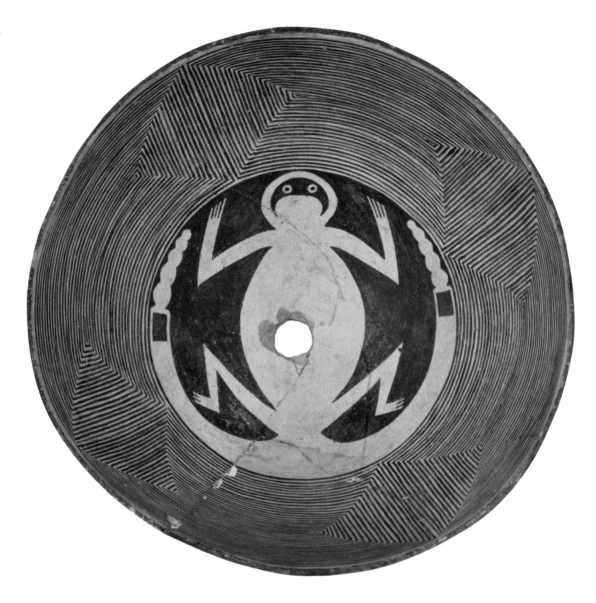

from the village communities (see figs. 2, 21, 22). It is recognizable as Mimbres, primarily because of some shared figurative pictorial content and generic stylistic features, but there is little structural or compositional similarity. The formal differences may be due, in part, to the change of medium and scale, but they may also express distinctions between art made by women on domestic artifacts and art made by men in nature.[16] Interpretations of Mimbres art may, therefore, be extended to incorporate special relationships between people and their landscape that were determined by gender-based economic and ritual roles. The art was produced in small, egalitarian communities where limited resources were shared among individuals, all of whom were known to one another. Kinship ties provided the basis for social, political, economic, and religious relationships.

How is it that art made by such people is so appealing to our urban, industrial, highly specialized world, to our diverse and complex society? In addition to its powerful visual appeal, Mimbres art gives us insights into an ancient people and their world at the same time that it provides a perspective on our world and condition. The product of a world that is the polar opposite of our own, it is about dualities and polar oppositions. It seems to be about everything that we are not. Yet, perhaps because it mediates so intensively between oppositions, it can speak directly and eloquently to us.

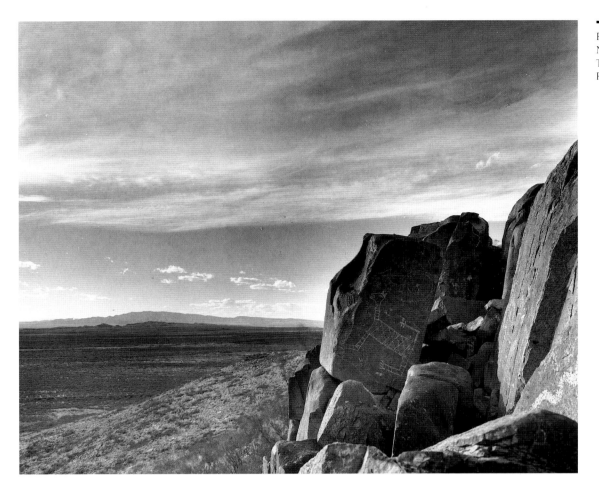

Fig. 21 Petroglyphs.
New Mexico, Mimbres,
Three Rivers, 1000/1150.
Photo: Kent Bowser.

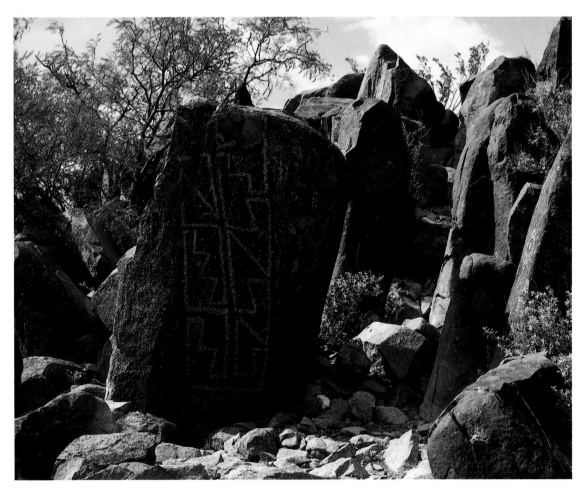

Fig. 22 Petroglyphs.
New Mexico, Mimbres,
Three Rivers, 1000/1150.
Photo: Richard Townsend.

THE ARCHITECTURE OF THE ANCIENT SOUTHWEST

After the United States Army took the region of New Mexico from the Republic of Mexico in the War of 1847, the citizens of New York, Boston, and Washington, D.C. read in the illustrated weeklies of the remarkable ruins at Mesa Verde and Chaco Canyon (see figs. 1, 2). The public imagination peopled these exotic buildings with conveniently vanished civilizations: the lost tribes of Israel, Phoenicians, and — a little more realistically — the "Chichimec" peoples who left their homes in the north and marched south to found the Aztec Empire.

It is hard, even in retrospect, to fault those fanciful interpretations. Chaco Canyon, in northwestern New Mexico, contains ruins of astonishing visual impact. Tourists of today, jaded by the modern metropolis, still stand in awe before Pueblo Bonito, Chetro Ketl, and the other structures at Chaco (see figs. 3, 4). The jumbled walls of Pueblo Bonito covered over four acres (1.6 hectares), rising in places up to five stories tall. When we walk through the ruin, it seems like a vast maze of massive sandstone walls, rooms, plazas, and circular subterranean chambers called "kivas," after ceremonial structures still in use at Indian Pueblos in New Mexico and Arizona. Only from atop the cliffs behind the building does its vast form become clear: a huge "D," with massed rooms and kivas surrounding dual plazas. Other Chaco sites show equally formalized plans. Peñasco Blanco is an enormous, perfect "O" (see fig. 5); Chetro Ketl is an inverted "D," the opposite of Pueblo Bonito; others are "E"-shaped, "L"-shaped, or massive, perfect rectangles.

Anglo-America was not prepared for such a structure as Pueblo Bonito and such an architectural complex as Chaco Canyon. The huge mounds of Cahokia and Moundville in the eastern United States were only tree-capped, eroded memories by the time the Anglo settlers reached them. In the south and across the plains, immigrants from northern Europe and the eastern states displaced Indians from villages of thatched huts, wigwams, and tepees — the ephemeral habitations of peoples pushed aside or removed from the path of Manifest Destiny. Faced with the massive solidity of Chacoan masonry and the monumental scale of Chacoan buildings, the first reaction of many was to stretch their imaginations, and to deny Indian ownership of these monumental structures.

It took more than half a century for Anglo-American civilization to recognize what Indians knew all along: The magnificent ruins of the Southwest are the ancestral homes of the living Pueblo peoples. The Hopi, the Zuni, the Acoma, and the many Pueblo peoples of the Rio Grande — the farming peoples of the northern Southwest — all began as

Fig. 1 View of Chaco Canyon. New Mexico. The "D"-shaped building in the lower center is Pueblo Bonito. Photo: Paul Logsdon.

Fig. 2 Long House ruin. Colorado, Anasazi, Mesa Verde, 1200/1300. Photo: Paul Logsdon. Sheltered within the great natural cave of an overhanging cliff, this is one of many such towns in the steep canyons of Mesa Verde National Park. The dense structure of apartments, circular kivas, and terraces facing open plazas reflects the distinctive vocabulary of ancient Southwestern architecture.

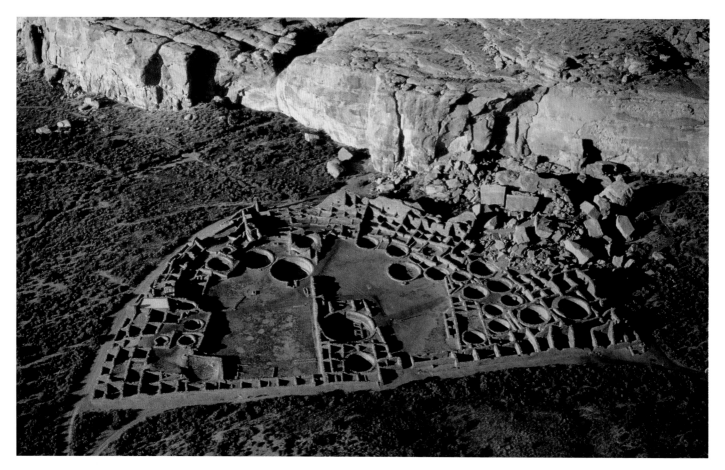

Fig. 3 Pueblo Bonito. New Mexico, Chaco/Anasazi, Chaco Canyon, 850–1150. Photo: Paul Logsdon. Pueblo Bonito originally stood five stories tall, with over five hundred rooms. The jumble of boulders to the right is the rubble of Threatening Rock, a detached segment of the canyon wall that fell in 1941.

the builders of Cliff Palace, at Mesa Verde, and Pueblo Bonito, at Chaco.

Archaeological knowledge of the ancient Southwest has continued to grow, not without error or misdirection, ever since. This essay addresses the ritual landscape of Chaco Canyon from an archaeological perspective. More accurately, it addresses changing scholarly perceptions of the idea of a ritual landscape. For reasons made clear here, I do not attempt to infuse that landscape with cosmology borrowed directly from the modern Pueblos: Uncritical use of Pueblo Indian knowledge has caused many an archaeologist to come to grief and, until very recently, actually delayed comprehension of the ancient ritual landscape at Chaco Canyon. This is not to say the modern Pueblo peoples have nothing to offer for the interpretation of the archaeological remains at Chaco. They certainly do, but archaeologists are only beginning to learn how to receive and use that information.

The Southwest, which includes both Pueblo and non-Pueblo Indian peoples, extends from the southern end of the Rocky Mountains in the Four Corners area (the common boundary point of the states of Utah, Colorado, Arizona, and New Mexico) south to the Mexican border (see map on p. 84). The southwestern region is big, covering over 300,000 square miles (800,000 square kilometers). Most of that area is desert.

The region has palpable boundaries: the Rocky Mountains on the north, the Colorado River on the west, the Great Plains on the east. But to the south, it ends at a pencil line drawn by bickering diplomats in 1853. Because Mesa Verde and Chaco are on the United States side of that line, North Americans perceive the ancient ruins as separate and distinct from those in Mexico; they have become *our* ruins, elements of *our* national heritage, and owe nothing to the civilizations that arose to the south. But, of course, the international boundary represents nothing deeper than mid-nineteenth century political realities of the moment: the line was not there in 1150 or 1200, when Chaco and Mesa Verde were flourishing centers.

Culturally, the ancient Southwest was, in fact, a northern extension of the Mesoamerican world. Ideology, art, and all the numberless elements that identify the high civilizations of central Mexico ran north as far as corn, their economic base, could sustain them. Mesoamerican ideas and ideologies split into two great prongs, separated by the Great Plains: in the east, to the great Mississippian centers of Cahokia and Moundville, which do not concern us here; and, in the west, up the flanks of the Sierra Madres

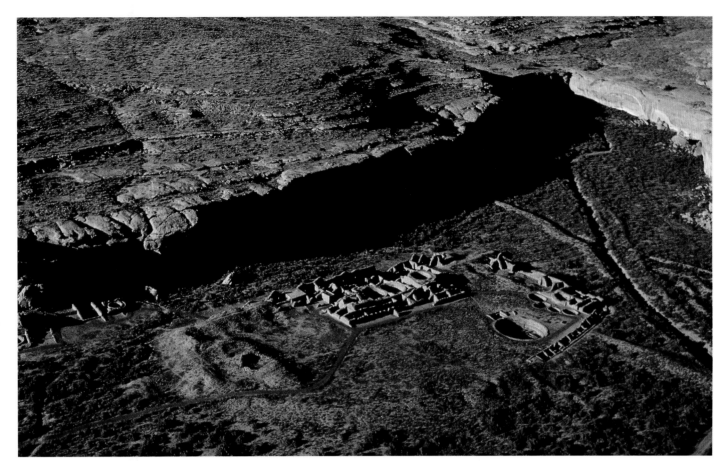

to what we call the Southwest. At the base of the Rocky Mountains, Mesoamerican corn economies and the civilizations they entailed reached their ecological limit, and there they stopped.

Chaco and Mesa Verde are at the extreme northern end of the Mesoamerican sphere of cultural influence, 3,500 miles (5,600 kilometers) from Teotihuacan and Tula. They were on the frontier and, as is the case with most frontier settlements, they had a vibrant, self-defined culture that owed as much to their own environments as to the Mesoamerican center. Chaco is not a diminished Tula: The civilization that flourished there was its own creation, unique in the world.

The precarious environment of the region—recall that it had ecological boundaries, beyond which that way of life was impossible—made the relationship of people and landscape more immediate and less mannered than the rich, cosmopolitan *mesa central*. On the one hand, the marginal southwestern environment kept human adaptations—even at their most complex—fluid, mobile, and flexible; on the other, the limits of the land denied the food surplus needed to support and maintain vast programs of construction such as had long been underway far to the south. Bricks cannot be made without straw, nor pyramids without labor. The great

Mexican centers, such as Teotihuacan or Monte Albán, almost become landscapes themselves, embracing agricultural, ritual, and urban constructions on a colossal scale. But Southwestern societies reflected their land on a more intimate scale, building within it, as part of it: "They *are* nature, pure and simple, but their resemblance to the shapes of the earth is not accidental entirely either. It is...at once an act of reverence and a natural congruence between two natural things."[1]

This tradition of building is exemplified by the Cliff Dwellings of Mesa Verde, which are literally enveloped by the landscape. They were the first of the Southwestern ruins to achieve international fame. The Wetherill brothers, cowboys turned archaeologists, took photographs and pottery to world's fairs and engaged the interest of scholars such as Gustaf Nordenskiold, who journeyed from Sweden to dig at Mesa Verde in 1891:

> Strange and indescribable is the impression on the traveller, when, after a long and tiring ride through the boundless, monotonous piñon forest, he suddenly halts on the brink of the precipice, and in the opposite cliff beholds the ruins of the Cliff Palace, framed in the massive vault of rock

Fig. 4 Chetro Ketl. New Mexico, Chaco/Anasazi, Chaco Canyon, 900–1175. Photo: Paul Logsdon. The second-largest building at Chaco Canyon, Chetro Ketl inverts the "D"-shape of Pueblo Bonito, constructed 150 years earlier.

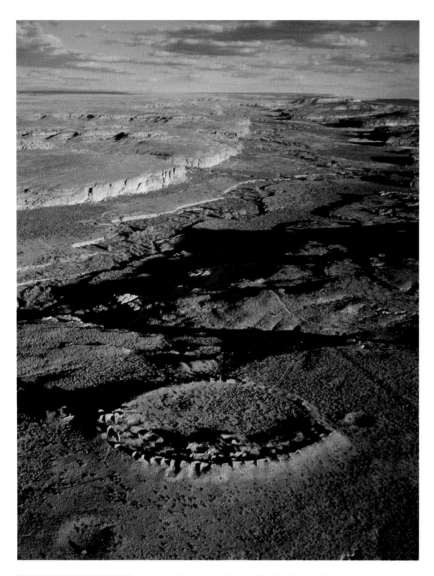

Fig. 5 Unexcavated ruin of Peñasco Blanco. New Mexico, Chaco/Anasazi, Chaco Canyon, 900–1175. Photo: Paul Logsdon. Unlike Pueblo Bonito and Chetro Ketl, which were sited below the canyon walls, Peñasco Blanco was built high above the canyon. Circular in plan and a contemporary of Pueblo Bonito, Peñasco Blanco had at least three "great kivas," seen today as huge basin-shaped depressions.

for "ancient enemies"), and the living Pueblos. Understandably, the Pueblos became an encompassing model by which to understand prehistory. The Anasazi ruins could be understood, simply and easily, as ancient Pueblos, presaging, in point-for-point detail, Pueblo life of today. This was a wonderfully comfortable situation for the field archaeologist: dig a site, select the elements of modern Pueblo life that fit the physical facts, and write the monograph. Southwestern archaeology was unrivaled in the New World for uncritical reliance on living native peoples for intellectual content, or, rather, an idealized version of those living peoples: In the early part of this century, it was our pleasure to see the Pueblos as homespun city-states, paragons of egalitarianism and—by some leap of logic—democracy. Trying to turn Zuni into Periclean Athens does no service to either, but that was chapter and verse for early Southwestern archaeology.

Neil Judd was an outstanding example of the period. Working for Smithsonian Institution and funded by the National Geographic Society, he excavated Pueblo Bonito, the largest ruin in Chaco Canyon, in the 1920s:

> Even in ruin Pueblo Bonito stands as a tribute to its unknown builders. It is one of the most remarkable achievements of all the varied Indian peoples who dwelt within the present United States in prehistoric times. Pueblo Bonito is a massive communal dwelling—a village within itself—that sheltered, in its heyday, no less than 1,200 individuals. It is a broken pile of once-terraced homes that rose four stories in height and covered ten times more ground than the White House, in Washington. It is the dead echo of a aboriginal adventure in democracy that reverberated throughout our desert regions at least 500 years before Columbus set forth on his memorable journey to the New World.[3]

During the 1920s and '30s, the Pueblos were seen as "aboriginal democracies": their society unspoiled, egalitarian, perfect; their peoples the noblest of savages. The tactic of explaining the past through the Pueblo present was well established from much earlier archaeological work. Since Pueblo Bonito looked like a modern Pueblo, Judd felt justified in painting it as he and other anthropologists chose to see the Pueblo Indians of that time. As a result, Pueblo Bonito became Athens-in-miniature, a democratic city-state.

above and in a bed of sunlit cedar and piñon trees below. This ruin well deserves its name, for with its round towers and high walls rising out of the heaps of stones deep in the mysterious twilight of the cavern, and defying in their sheltered site the ravages of time, it resembles at a distance an enchanted castle.[2]

Those were the early, romantic days of Southwestern archaeology, when the goals of the field, such as it was, were to procure pottery for museums "back East" and illustrations for the weeklies, and to have an adventure. Speculation was the basic method: Where some saw an enchanted castle, others saw the remnants of Atlantis.

Propelled by public fascination about Southwestern ruins, archaeology soon matured to a form of prehistory, writing "history" for the Pueblo peoples who had no writing. The scientific connection was finally made between the ancient ruins, which archaeologists called "Anasazi" (a Navajo word

An explosion of archaeology in the 1930s and '40s turned up surprises, too. Beneath the huge Pueblo-style sites such as Pueblo Bonito were older structures called "pit houses." Pit houses were single-celled, sunken-floored, earth-roofed domes, as unlike a modern Pueblo as a tholos differs from the Parthenon. Here was a shock: The Southwestern past was not a seamless cloth of continuity; it had experienced change.

With the recognition of change, the past suddenly became much more complicated. The Southwest had not always been the Pueblos we knew (or thought we knew) of today. Simple pit-house beginnings, in the 500s (all dates are AD), had led, by the 800s and 900s, to tiny, five-room masonry units, scattered over the landscape in no apparent order. About 1000, that dispersed pattern of settlement gave way to big, compactly massed buildings such as Pueblo Bonito, which established the architectural tradition leading to modern Pueblos, such as Taos. The sequence from rude pit house to small, dispersed masonry structures and to large and aggregated Pueblo-style buildings sat well with progressive themes in North American social thinking. Before the Great Depression of the 1930s, evolutionary progress was an article of faith in the United States, which seemed to be at the pinnacle of an ineluctible process of growth, sitting on top of the world. Things should get bigger, because bigger was deemed to be better. Archaeologists called the aggregation of the Great Pueblo Period the "gathering of the clans"—a Celtic-sounding expression that, in its curious Southwestern usage, meant the combination of little five-room structures into larger and larger communal dwellings, culminating in Pueblo Bonito.

Archaeologists thus recognized change, but only up to a point. With the construction of Pueblo Bonito (and the other Chaco sites), ancient architecture finally looked like Pueblos, and we returned to familiar territory. The old logic could again be applied: If it looked like a Pueblo, then it must be one. Pueblo Bonito and the other large buildings in Chaco Canyon were seen as independent entities, self-sufficient agrarian villages—again, a too-simple view of modern Pueblos that had only distant applicability in the ancient past.

Unfortunately, using the Pueblos as models for Chaco (or for many other episodes in the Southwestern past) makes about as much sense as reading the social fabric of the Aztec capital, Tenochtitlan, whose ruins lie beneath Mexico City, through the dynamics of the

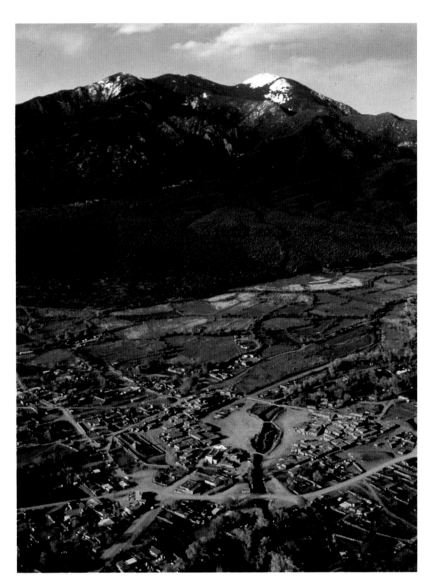

Fig. 6 Pueblo of Taos. New Mexico, Sangre de Christo Mountains, c. 1400–present. Photo: Paul Logsdon. The traditional village is split by a stream which runs through the cleared plaza. A surrounding wall defines the traditional area of the Pueblo.

modern metropolis. Such comparisons become flawed when one relies on too-simple analogies between modern and historically known societies and pre-historic groups. The Southwest is a good example of this problem; yet, as will be discussed later in this essay, it would also be wrong to reject out of hand the continuity of fundamental ideas concerning religious bonds of community and land, linking the modern Pueblos and ancient cultures such as that of Chaco Canyon.

The Pueblos of today have adapted to centuries of oppression by dominant cultures, first Spanish, then Anglo-American. Their adaptation was an astonishing success: While so many other Indian cultures are now gone, the Pueblos are still alive and well. Nonetheless, the dominant cultures completely transformed the economic and political ground rules of Pueblo life.

In the year 1100, however, the great center of Chaco Canyon was the pre-eminent culture of the Anasazi world, and its ruins provide a wonderful illustration of why we must

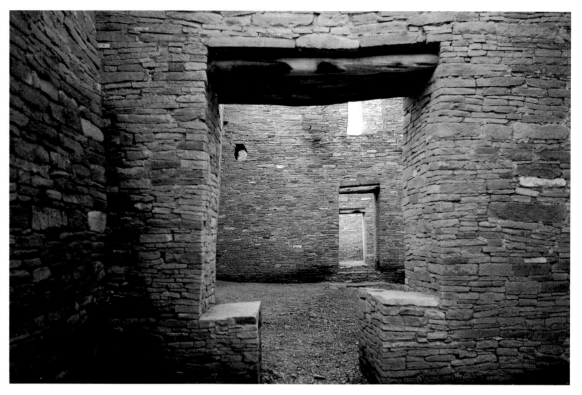

let the past speak for itself. While Judd saw Pueblo Bonito as an "aboriginal experiment in democracy"—of the people, by the people, and for the people—today, Pueblo building is usually viewed by architectural historians as architecture without architects, home-made housing that avoids the pitfalls of formal design and consequently mirrors, almost exactly, the social and ideological order of its inhabitants.

There is something in this view, at least for the modern Pueblos. Villages such as Taos are not formal constructions (see fig. 6). Rather, they may be viewed as organic things. In this sense, they are not buildings but the living body of the community itself. Taos men repairing roofs wear soft moccasins and traditional kilts; heavy-soled work shoes and dungarees would not be proper for working on the living village. Rooms are added as families grow; rooms are abandoned as families decline. The Pueblo grows, decays, and grows again, with the people living in its changing outer skin.

But that was not how Pueblo Bonito was built. Pueblo Bonito was constructed over the course of three centuries (950–1150), perhaps a dozen generations. It was not built room-by-room, with accretional additions reflecting family growth cycles. Pueblo Bonito was built in a series of massive construction events, each as large as a modern Pueblo and many times larger than the typical Anasazi five-room dwelling of that time. Precise alignment of cross-walls, rigidly patterned

placement of doorways (see fig. 7), modularity in building proportions, and a hundred other details of construction show a controlling hand and eye behind the design of the largest Chacoan structures (see figs. 8, 9, 11). Construction involved complex coordination of labor and materials, including tens of thousands of large pine beams brought from forests over sixty miles (one hundred kilometers) away. Although the construction of Pueblo Bonito hardly equaled that of the pyramids of Egypt or Teotihuacan, neither was it a simple village enterprise. There was nothing organic about the scale of labor at Pueblo Bonito or its design. For over three hundred years, design ideas evolved on scales far greater than the family or village. The master plan of Pueblo Bonito was conceived and its construction directed by a small group of people or, more likely, one person. Over the decades, that person changed, but the role remained: One individual (or at most a few people) made architectural decisions for a much larger group—the laborers and the occupants. Given the scale and formality of Pueblo Bonito, that person was—by any criteria—an architect, and Pueblo Bonito and Chacoan building in general are undoubtedly monumental architecture.[4]

The geometric order of building details hints at even larger concerns with spatial patterning embracing a larger cultural landscape at Chaco. At the large structures in the canyon and at a number of outlying sites, careful measurements of principal walls show

alignments to the cardinal directions and the lunar minor and major standstills. The basic "grid," or framework, for the Chacoan-built environment appears to have been shaped by astronomical and, by extension, cosmological concerns. On this level, a useful parallel may be drawn between cultures of the past and present:

> In the cosmologies of the historic Pueblo societies, which are the cultural descendants of the Chacoan civilization, the sun and moon are of primary importance, their cycles are related to the cycles of birth, life, and death. The sun and moon are seen in duality and their joining is often sought in Pueblo mythology and ceremonies that are timed and ordered to the solar and lunar motions.[5]

Spatial integration extended beyond the design of individual buildings. Today, the visitor sees the ruins at Chaco Canyon as a series of separate structures within the archaeological zone, a sequence of road-side attractions, each with a fanciful name, a specific trail guide, and its own parking lot. We are shown a Chaco of independent villages, but in the year 1100, it was an integrated, complex, nearly urban built environment (see fig. 15). The scale of architecture at Chaco exceeds that of the single building, even one as large as Pueblo Bonito. "Downtown" Chaco Canyon, the four-square-mile (eight-square-kilometer) area around Pueblo Bonito, was a built environment of great density and complexity, an urban/agricultural zone containing hundreds of buildings. Most edifices were less than thirty rooms (big for the contemporary Anasazi world, small for Chaco), but a half dozen sites — Chetro Ketl, Pueblo del Arroyo, Pueblo Alto, Kin Kletso, Talus Unit, and Hillside Ruin — were on the same massive scale as Pueblo Bonito. Long compound walls, elaborately constructed roads, rock-cut stairways, platform mounds, earthen berms, monumental public structures called "great kivas," canals, and carefully leveled gardens completed a built environment of startling density, quite unlike the deceptively barren landscape we see today (see figs. 9, 10, 11). John Fritz examined the symmetrical relationships between the most visible elements of this built environment — an east-west axis linking Pueblo Bonito and Chetro Ketl, intersected by a north-south axis between Pueblo Alto, Casa Rinconada, and Tsin Kletzin — and concluded:

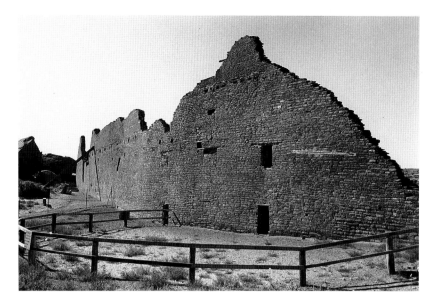

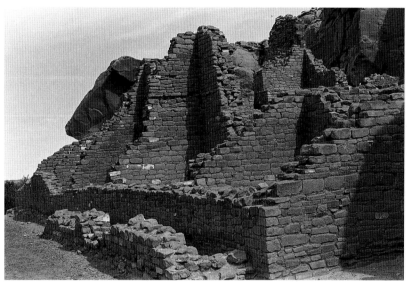

> ...certain simple principles of design organize the relationship of architectural elements lying in the east or west and in the north and south. The axes that define these relations crosscut one another and create a dynamic balance not only among the elements related but also among the relationships themselves.... [These] were components in an ideational system that expressed in material form elements and relations of a world view. Architectural design was a metaphor of the elements and relations of nature, society, and the sacred.[6]

The major constituents of Chacoan town planning — the "great houses" such as Pueblo Bonito, "great kivas" such as Rinconada (see fig. 12), the platform mounds, and the roads — were fixed within a complex geometry that linked the built elements and the physical

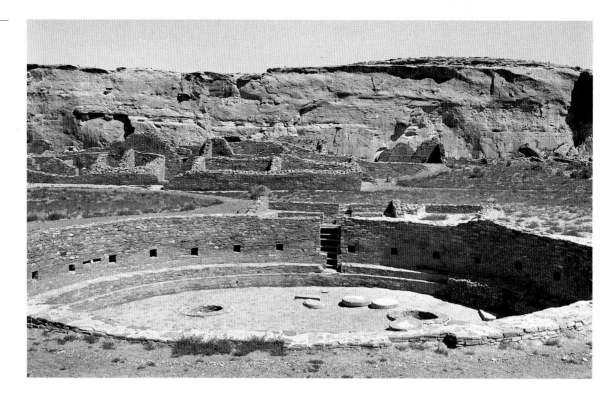

Fig. 10 "Great kiva." New Mexico, Chaco/Anasazi, Chaco Canyon, plaza of Chetro Ketl, 900–1175. Photo: Stephen H. Lekson. Kiva niches sometimes contained sealed offerings of stone and shell-bead necklaces. Their number and placement may have had calendrical significance.

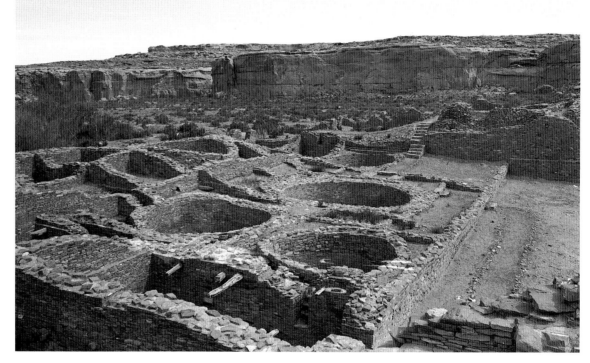

Fig. 11 Kivas. New Mexico, Chaco/Anasazi, Chaco Canyon, Pueblo del Arroyo, 900–1175. Photo: Stephen H. Lekson. Circular kivas were a focus of both domestic and ritual life.

cosmos: the sun, the moon, the stars, the cardinal points, and the land itself. Some basic aspects of this geometry derived from patterns observed in the sky, and from the idea of the four quarters and center. But town planning and extensive urban-agricultural environments also display many intricate and esoteric features and a large-scale geometric conception that suggest other specialized needs and functions. The complexity and scale of design at Chaco are of a much grander order of magnitude than has been suggested by the model of simple, self-sufficient farming villages such as those of the Pueblos today. In fact, Chaco Canyon is the premier center of a vast region, covering almost all of the ancestral Pueblo area. Its centrality is dramatically demonstrated by the physical evidence of ancient roads connecting smaller sites in the hinterland, called "outliers," to the remarkable architectural monuments at Chaco Canyon (see fig. 14). We now know that hundreds of "outliers," covering over 100,000 square miles (260,000

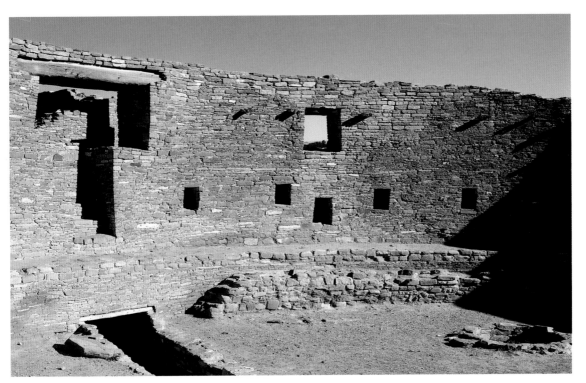

Fig. 12 Rinconada Kiva. New Mexico, Chaco/ Anasazi, Chaco Canyon, 900–1175. Photo: Richard Townsend. This largest of kivas features a stairway entrance, as well as a hidden "stage entrance," which lead into a tunnel that opened onto the center of the circular floor. This second entrance was presumably used for ritual performers to emerge from the earth.

square kilometers), were incorporated into the regional system.[7] The sheer size of the Chacoan domain seems to preclude a purely adaptive or economic basis for its integration. Without bulk transport, without a market economy, without craft specialization or strong evidence for an institutionalized elite, it would seem that the underlying structure binding "outliers" to Chaco was primarily of an ideological, religious nature. Economic forces were surely present, but Chaco was a ceremonial center, a development whose complexity is unique in the history of the American Southwest.[8]

Because archaeologists had held to a view of the prehistoric Southwest that mirrored in detail the modern Pueblos, Chacoan complexity took us by surprise. There was much more to the ancient cultural landscape than we had ever thought. The large ruins at Chaco Canyon itself are almost too complex to grasp; their architectural imagery is in some ways better illustrated at the more simplified "outlier" sites, beyond the canyon proper. Most of these are not nearly as large as Pueblo Bonito; the majority are twenty- or thirty-room structures; yet, they are built with all the massive construction details and formal geometry of the larger Chaco Canyon edifices. And they demonstrate, quite dramatically, what John Stein has recognized as the Chacoan "ritual landscape." "Our definition of ritual landscape differentiates between the man-made and the natural; the landscapes we describe are created by human hands but are inextricably tied, physically

and cognitively, to a broader sacred geography which embraces the natural landscape."[9] The natural landscape both shaped and accommodated the regional architecture: peaks, mesas, and mountains were simultaneously sacred places and signaling stations, mid-points of road segments. Chacoan structures, both in the canyon and at "outliers," were sited atop eminences that dominated their surrounding communities. Even the roads had dual functions, traversing the land and, at the same time, commemorating the cosmological principles of the larger design system. Based on parallels with modern Keres, Tewa, and Jemez Pueblo cosmology and origin-myths, Michael Marshall concluded that the roads had more than transportation functions:

> The North and South roads which converge on the ceremonial center at Chaco Canyon describe the great Axis Mundi of the Chacoan world.... The Chacoan North Road was constructed to provide a formal link or corridor between the mythic *Shipap* entrance to the underworld in the north and the sacred middle space, known in Keresan myth as "White House" in Chaco Canyon.... As an avenue of the dead the North Road no doubt saw considerable use as a pilgrimage avenue and was probably used for ceremonial events which reactualized the myth of emergence and the search for the middle place.[10]

Fig. 13 Pueblo Alto. New Mexico, Chaco/Anasazi, Chaco Canyon, 900–1175. Photo: Paul Logsdon. Three major prehistoric roads enter Chaco Canyon at Pueblo Alto, converging just to the right of the building. They pass through a "gate" in the long wall running from the right corner of the structure.

Fig. 14 Unexcavated Chacoan "outlier." Arizona, Chaco/Anasazi, Navajo Springs, 900–1175. Photo: Andrew Fowler. The building and a great kiva are enclosed in a Nazha, a circular ring of earthen mounds. A prehistoric road parallels the modern dirt track, entering the Nazha from the right and running between the building and the kiva.

Fig. 15 Map of central Chaco Canyon. Drawing: Adapted by Richard Townsend, from "The Chaco Canyon Community" by Stephen H. Lekson, Thomas C. Windes, John R. Stein, and W. James Judge, ©1988 by Scientific American, Inc. All rights reserved. By 1150 the architecture in this four-square-mile area showed greater variety and attention to problems of urban density. Only a few roads, precinct walls, and earthworks are shown; it is likely that many more were originally used to define the settlement's place within the landscape of Chaco Canyon and the larger Anasazi world.

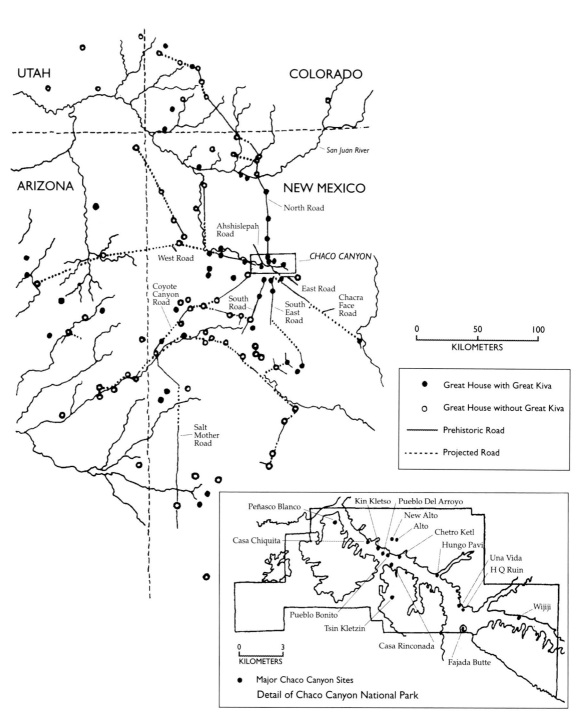

This interpretive approach extends to basic themes of the Chacoan world view, concerning the correspondence between man-made symbolic constructions and abstract notions of cosmic geometry; and widespread myths concerning the emergence of people from the earth in the time of genesis, and their subsequent migration to a place of settlement. The architectural and ritual repetition of these themes established immutable points of reference and order in the pattern of ancient life.

Chacoan architecture enveloped the land on every scale, creating a ritual landscape over the entire ancestral Pueblo area. The ritual landscape of the Chacoan region was repeated, in microcosm, at individual "outliers." Even though their diminished scale makes them much easier to see, they may still be too large in conception to be viewed from ground level. Most archaeologists work on their own two feet, pedestrian, in a non-pejorative sense. From this level, an outlying Chacoan "great house" may appear simply as an unusually large Anasazi mini-pueblo. Other features are recorded as "trash mounds," "middens," and "spall piles." However, when seen from three hundred feet (one hundred meters) in the air, these may be viewed in terms of symbolic, ritual geometries. John Stein described the site of Kin Ho 'choi, near Gallup, New Mexico, but the pattern fits any of a dozen sites (see fig. 5):

> The Great House is completely encircled by a sunken avenue 15 meters in width. The perimeter of this avenue is defined by a berm which is a composite of several earthen masses. Although the berm resembles a rampart, the feature is not obviously defensive. It does, however, provide a tangible barrier between the great house and the great beyond, and arguably functions as a conceptual boundary delineating sacred space. Because of this inferred function, we refer to this feature as the "Nazha," a Navajo term which means "to spiritually surround." On the horizontal plane, the earthen component establishes the symmetry of the composition and it bounds space. In the vertical plane, the balance between the above-grade and below-grade forms [the terms "above-grade" and "below-grade

> forms" refer to the contrast between the "great house" structure projecting upward, and the moatlike circular depression between the earth berms of the Nazha] is an obvious opposition The proximity of the above-grade and below-grade forms exaggerates the apparent vertical relationships between architectural elements, a sophisticated illusory technique. This is most apparent as the roads pass through the mass of the Nazha; symbolism relating to the transposition of opposites is commonly expressed at the threshold of religious architecture.[11]

Outside the Nazha lie dozens of typical Anasazi five-room domestic structures. Together, the clustered domestic buildings and the circular ritual configuration form a microcosm of the Chacoan world, with the Chaco "great house" at the center, surrounded by a community of settlements. The pattern replicates the huge geographic extent of the Chacoan world; at its center was Chaco Canyon, and surrounding it, like the domestic structures of a community, were the "outliers."

Archaeologists, trained to think of each separate ruin as an independent Pueblo, have not been prepared to recognize a prehistory played on so large a stage. We are now re-thinking the appropriate scales for studying the Southwestern past. No consensus has yet been reached, but it is clear that those scales must become larger and larger. Only by seeing the Southwest in the very largest proportion can we begin to understand the relationship of its people and their land. On this larger scale, that relationship is not simply adaptive or ecological. It remains fundamentally spiritual: even the largest landscape is a ritual landscape. When the Zuni people pray today, they preface their prayers with a litany of oceans and mountains that represent Earth: The prayer is for everywhere. The dances at Zuni, and at all the Pueblos, are not for the Pueblo alone; they maintain the balance of the world. Ideological perceptions can survive the most tyrannous oppression. In the Pueblos, persistence of belief meant survival of Pueblo peoples and their ideologies. Chaco might have been a very different place than Taos of today, but the Chacoan world was surely as encompassing as the whole earth of today's Pueblo peoples.

NOTES

Mimbres Art: Form and Imagery
J. J. Brody

1. See LeBlanc, 1983, for the most comprehensive overview of Mimbres culture.
2. The Mimbres Archives at the Maxwell Museum of Anthropology in Albuquerque, originally compiled by the Mimbres Foundation, has photographs of about 6,500 Mimbres pottery paintings.
3. See Brody, 1977; and Brody, LeBlanc, and Scott, 1983, for discussions of Mimbres art.
4. See Brody, in Fewkes, 1989.
5. Fewkes, 1989.
6. Especially important is the work of the Mimbres Foundation, under the direction of Steven A. LeBlanc, at the Mattox and Galaz sites, among others; Texas A & M University, under the direction of Harry J. Shafer, at the NAN site; and the University of New Mexico, under the direction of Margaret C. Nelson, at the Ladder Ranch site.
7. LeBlanc, 1983, pp. 149–57.
8. Anyon and LeBlanc, 1984, pp. 187–268.
9. Minnis, 1981.
10. Fewkes, 1989, pp. 23–49.
11. See Carr, 1979, and Kabotie, 1949, for insightful interpretations of Mimbres art from the perspective of modern Pueblo mythology.
12. See, for example, Brody, 1977, pp. 200–10; 1978.
13. Brody, LeBlanc, and Scott 1983, pp. 115–19, made note of four equally plausible and well-informed interpretations of the painting in fig. 15 in this book.
14. Ortiz, 1969, pp. 13–28.
15. Bunzel, 1929, p. 70.
16. Brody, 1991, pp. 171–77.

The Architecture of the Ancient Southwest
Stephen H. Lekson

1. Scully, 1975, pp. 9–10.
2. Nordenskiold, 1893, p. 59.
3. Judd, 1925, p. 227.
4. Lekson, 1986.
5. Sofaer, Sinclair, and Donahue, 1990, pp. 8, 10–11.
6. Fritz, 1978, p. 48.
7. Lekson, 1991.
8. Lekson et al., 1988.
9. Stein and Lekson, 1991, p. 10.
10. Marshall, 1991, p. 131.
11. Stein and Lekson, 1991, pp. 17–19.

MESOAMERICA

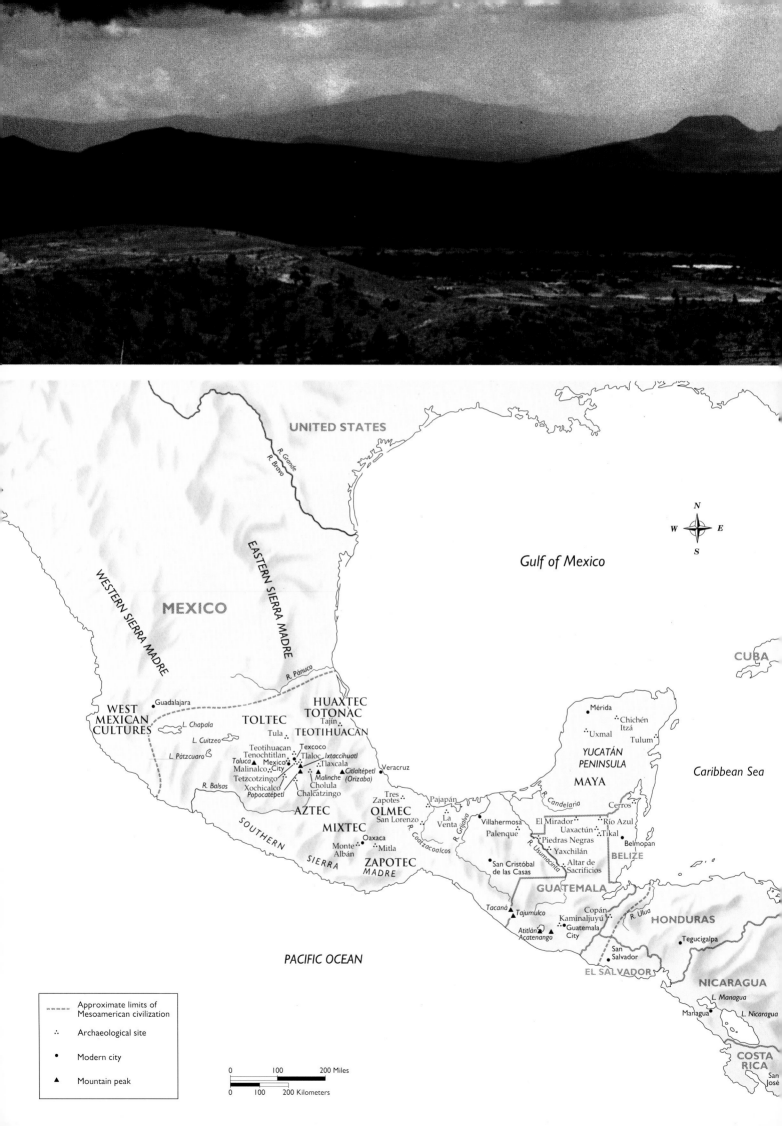

UNITED STATES

Gulf of Mexico

R. Grande

R. Bravo

WESTERN SIERRA MADRE

EASTERN SIERRA MADRE

MEXICO

R. Pánuco

CUBA

Caribbean Sea

Guadalajara

WEST
MEXICAN
CULTURES

L. Chapala

L. Cuitzeo

L. Pátzcuaro

HUAXTEC
TOTONAC

TOLTEC

Tula

Tajín

TEOTIHUACAN

Teotihuacan
Tenochtitlan
Toluca ▲
Malinalco
Mexico City
Tetzcotzingo
Xochicalco
Popocatépetl

Texcoco
Tlaloc *Ixtaccihuatl*

Tlaxcala

▲ *Malinche*

Cholula
Chalcatzingo

Citlaltépetl
(Orizaba)

Veracruz

R. Balsas

SOUTHERN

SIERRA

MADRE

AZTEC

MIXTEC

Oaxaca

Monte
Albán

Mitla

ZAPOTEC

OLMEC

San Lorenzo

Tres
Zapotes

La
Venta

Pajapán

R. Grijalva

R. Coatzacoalcos

Candelaria

YUCATÁN
PENINSULA

MAYA

Mérida

Chichén
Itzá

Uxmal

Tulum

Cerros

Villahermosa
Palenque

El Mirador
Uaxactún
Tikal

Río Azul

Belmopan

BELIZE

R. Usumacinta

Piedras Negras
Yaxchilán

Altar de
Sacrificios

San Cristóbal
de las Casas

GUATEMALA

Copán

Kaminaljuyú

R. Ulua

HONDURAS

Tacaná ▲
Tajumulco ▲
Atitlán ▲
Acatenango ▲

Guatemala
City

Tegucigalpa

San
Salvador

EL SALVADOR

NICARAGUA

L. Managua

PACIFIC OCEAN

Managua

L. Nicaragua

COSTA
RICA

San
José

N

W E

S

- - - - Approximate limits of
 Mesoamerican civilization

∴ Archaeological site

● Modern city

▲ Mountain peak

0 100 200 Miles

0 100 200 Kilometers

"Mesoamerica" is a term used by archaeologists to name an area comprising the southern half of Mexico, Guatemala, Belize, and parts of eastern Central America. This is a complex geographic region encompassing the central plateau of Mexico, a lush tropical coastal plain on the Gulf, the flat limestone expanse of the Yucatán peninsula, and the mountains and lowland forests of Guatemala and Belize. The uplands are shaken periodically by violent earthquakes, and snowcapped volcanoes rise as reminders of the unstable, fiery forces below. Yet, paradoxically, these same heights—Popocatepetl, Ixtaccíhuatl, Citlaltepetl, and others—were considered sources of life, since thunderclouds form on them after the long dry season, forecasting rain and the renewal of nature. The diverse peoples of Mesoamerica shared high achievements and cultural traits, such as ceremonial centers with pyramids and temples built around plazas, monumental sculpture, a fifty-two-year religious calendar, divinatory books, pictorial manuscripts, a ceremonial ball game, and an annual cycle of seasonal rites. The populations of cities had highly specialized religious, military, and trade organizations, and were supported by various forms of agriculture, as well as by tribute from conquered peoples. Maize, amaranth, beans, and squash were primary staples; but many other vegetables and fruits were widely cultivated, such as cacao (chocolate), tomatoes, avocados, and peanuts. In this, as in other regions of the Amerindian world, the varieties of domesticated plants far exceeded those available in medieval Europe.

Like all Amerindians, the peoples of Mesoamerica neither worked iron or used the wheel—activities that Europeans have long held to be the unmistakable traits of civilization. On the other hand, the Olmecs, Teotihuacan, the Maya, and the populations of Oaxaca and Veracruz transported, carved, and erected stone monuments weighing many tons; they built enormous pyramids and handsome cities; priestly astronomers tracked celestial phenomena, and invented sophisticated mathematical and writing systems.

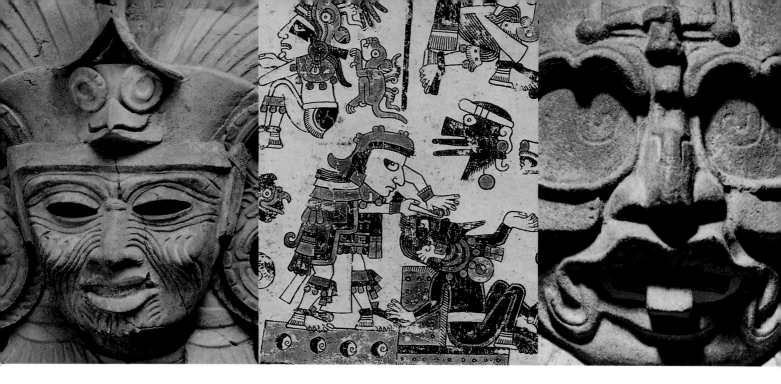

When the commander Hernán Cortés met the Aztec emperor Moctezuma in his capital, Tenochtitlan (now Mexico City), the astounded Spaniards encountered a splendid city whose empire was barely one hundred years old. The Aztecs of the early sixteenth century were heirs to a dynamic cultural tradition, transmitted and adapted in variant forms by a succession of peoples. The regions they subjugated in the brief time before the Spanish conquest held testimony of the accomplishments of many who had risen before them. The art, architecture, and recurring festivals of Mesoamerican civilization reveal many styles and systems of symbols.

Throughout the millenia, monuments built upon sacred places affirmed a basic religious charter for maintaining continuity between people and the cycles of life in the world around them. Ritual centers and activities provided visual expression of the order and coherence of society within the structures and rhythms of nature, and proclaimed the history and occupancy of a people in their habitat. In this way of thought, "religion," "history," and "economy" were not regarded as separate categories but were complementary and mutually reinforcing modes of seeing and using the land.

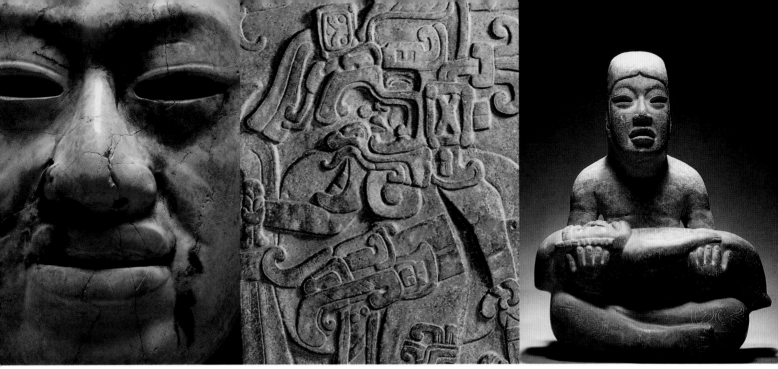

2500 B.C.	2000 B.C.	1500 B.C.	1000 B.C.	500 B.C.	B.C.	A.D.	500	1000	1550

PRECLASSIC OR FORMATIVE			CLASSIC		POSTCLASSIC	
EARLY 1500 B.C. – 900 B.C.	MIDDLE 900 B.C. – 250 B.C.	LATE 250 B.C.– A.D. 250	EARLY 250– 600	LATE 600– 900	EARLY 900– 1200	LATE 1200– 1521

WEST MEXICAN CULTURES 1500 B.C. – A.D. 1530

OLMEC 1200 B.C. – 600 B.C.

Tres Zapotes 900 B.C. – 600 B.C.

San Lorenzo 900 B.C. – 600 B.C.

La Venta 900 B.C. – 600 B.C.

Chalcatzingo 600 B.C. – 400 B.C.

Tlatilco 1000 B.C. – 500 B.C.

TEOTIHUACAN 150 B.C. – A.D. 750

ZAPOTEC 400 – 800

Monte Albán 400 – 800

TOTONAC 500 – 1521

Tajín 500 – 900

TOLTEC 900 – 1200

Tula 900 – 1200

MIXTEC 1200 – 1525

AZTEC 1350 – 1521

Tenochtitlan 1350 – 1521

Texcoco 1350 – 1521

MAYA 250 B.C. – A.D. 1000

Uxmal 700 – 1000

Palenque 600 – 800

Yaxchilán 300 – 800

Piedras Negras 300 – 800

Tikal 200 B.C. – A.D. 800

Copán 600 – 800

El Mirador 250 B.C. – A.D. 200

Uaxactún 250 B.C. – A.D. 200

Kaminaljuyú 250 B.C. – A.D. 200

Cerros 250 B.C. – A.D. 200

TOLTEC – MAYA 1000 – 1200

Chichén Itzá 1000 – 1200

ORDER AND NATURE IN OLMEC ART

Artistic Style Reveals a Culture

The concept of "the Olmec" emerged with the discovery and comparison of monumental and small-scale sculptures whose forms showed similarities, and even identical characteristics, that were different from those of sculptures from other ancient Mexican cultures known at the time. This surprising and novel artistic style was an indication of the first, firm imprints of high civilization in the Mesoamerican region.

The history of the Olmec investigations began in 1862, when José Melgar found, and later published, the Colossal Head of Hueyapan,[1] now designated Monument A of Tres Zapotes. The name by which we know these great creators of art dates to 1929, when Marshall H. Saville defined as Olmec a series of traits common to various basalt and jadeite sculptures.[2] The dominant traits, according to Saville, are: a human body with a head of feline aspect, a jaguarlike mask, a grooved or notched forehead, prominent canines, a pronounced upper lip, and a small, feline nose. This list of traits, expanded, refined, and interpreted, has been the base of scholarly inquiry into, and interpretation of, the style and the iconographic characteristics that define Olmec sculpture in both its monumental and small-scale forms.[3] Olmec art is essentially sculptural and was made both in the round and in relief. Figures carved in basalt, jade, jadeite, serpentine, and other stones exhibit smooth, curving planes and crisply delineated anatomical details and elements of costume (see fig. 6). The techniques of Olmec sculptors remained unsurpassed in Mesoamerica, and the unique style they evolved is among the most powerfully expressive. A dominant element identified in many iconographic studies of Olmec art is the image of a kind of jaguar figure, or "were-jaguar," which may appear monstrous but, on other occasions, seems humanized (see fig. 8); sometimes, it looks like an adult, but it also appears with an infantile aspect. Based on variations of this feline image and on another called the Olmec "dragon," some investigators have affirmed the existence of diverse deities related to sun, earth, fire, water, and animal forms, which are also thought to be connected to symbols that identify the Olmec governing elite.[4] Other scholars claim that Olmec images have primordial serpent and toad characteristics.[5] In recent years, some scholars have interpreted the symbolic attributes as signs corresponding to the ritual offering of blood-sacrifices and the legitimization of power of the Olmec rulers.[6]

In my opinion, Olmec sculpture is essentially centered on the human form. This becomes evident upon consideration of approximately 250 known monumental sculptures.[7] The majority represent human figures (see figs. 2, 4, 5); the minority are hybrids, which almost always have a human body with animal and imaginary attributes. On the other hand, the majority of the small jadeite or serpentine carvings represent hybrid figures (see fig. 8). Human figures are in the minority in the domain of small-scale sculptures (see fig. 6), but, in small ceramics, the dominant theme is again the human figure.

A sense of the supernatural is revealed in both human images and in those of composite appearance through the integration and interplay of animal imagery or abstract or symbolic elements with the human form. As I will outline on the following pages, these attributes refer to the creation of the world,

Fig. 1 Cave mask. Mexico, Olmec, Chalcatzingo, 500/400 BC. Basalt. Munson-Williams-Proctor Institute, Museum of Art, Utica, New York. Photo: Justin Kerr. Found in association with a burial platform at the great rock of Chalcatzingo, this was the entrance to the place of ancestors and the source of the earth's fertility. (Cat. no. 211)

the origin of humankind, and the beneficent or harmful forces of nature. Such forms speak of an ancient way of perceiving divinity in the earth, the water, the sun, and the volcanic "mountains of fire," as well as in humans, who, in communion with natural and supernatural forces and phenomena, generated creative activity. From people's imaginations sprang those monumental human figures and composite forms that aspired to permanence in large ritual centers, as well as the small, jewel-like images carved in more valued materials, which probably belonged to more intimate cults.

The Olmec

Written documents illuminating the history, beliefs, and customs of the Olmec do not exist. The most spectacular remains of their presence are found in the monumental basalt sculptures, in ceramics and smaller sculpture, and in the buildings of religious and administrative seats such as San Lorenzo, La Venta, Tres Zapotes, and Laguna de los Cerros. There are many other archaeological sites, both small and large, that have yet to be explored. At these centers, the Olmec built large earthwork platforms, pyramids, and plazas, covered with colored clays, which were drained by extensive systems of stone-lined conduits. Blocks of green serpentine stone were laid out in symbolic designs and buried by the ton beneath the plazas, and colossal basalt monuments were placed in commanding locations. From the extant archaeological materials and monuments, we can conclude that the Olmec reached a very high cultural and social level. Through these achievements, we can seek to understand, after almost three thousand years, the Olmec aesthetic and intellectual achievement.

In southern Veracruz and eastern Tabasco, both states in the Republic of Mexico, in a region of tropical-lowland forest, marshy plains and abundant rivers, and areas of hilly or mountainous ground, the Olmec developed a complex society and established their powerful centers. From earlier cultures still archaeologically uncharted, and from interactions with neighboring peoples, the Olmec created the first major manifestation of Mesoamerican civilization. The volcanic Tuxtla Mountains rise from the wide plain to the east, close by the Gulf of Mexico, and the Sierra Madre del Sur delimits the plain to the west. These are the natural frontiers of the Olmec heartland. The area is traversed by major rivers such as the Coatzacoalcos, the

Grijalva, and the Usumacinta, and their tributaries. These great waterways rise and fall according to the cycle of the rainy and dry seasons in the mountains of the interior to the west and south. Like the Nile in Egypt, the rivers carry rich silt, which was deposited along the river banks where farming areas were created in ancient times. The region is known archaeologically as the Olmec "heartland area," or "nuclear area," because most of the monumental sculptures and the remains of the principal capitals and densely populated districts have been found there. The enormous masses of basalt for sculpture and the pillar-shaped stones for tombs and the walls of ritual enclosures were transported, perhaps by rafts, from the nearby mountain ranges. Fine gemstones were imported from distant places: jadeite from Oaxaca and Guatemala, and blue-green jade, the most prized stone, from the Motagua region of Guatemala. Archaeological explorations have shown that the Olmec culture was also present on the central plateau of Mexico at such sites as Chalcatzingo in Morelos, Las Bocas in Puebla, Tlatilco and Tlapacoya in the state of Mexico, and Xochipala and Teopantecuanitlan in Guerrero; other sites have been located far to the south on the Pacific slopes, at Izapa in Chiapas, Mexico, and Abaj Takalik in Guatemala.[8] The Olmec area greatly exceeds the area imagined for it forty years ago by the great Mexican scholar Miguel Covarrubias,[9] who was among the first to recognize the importance of the Olmec in the early history of Mesoamerica, where the civilization occupied a position analogous to that of the Chavín in Andean South America.

Themes Represented in the Sculpture

The Olmec represent a way of life, thought, and aesthetic expression comparable to other early agrarian civilizations. They had to face, as all peoples do, the primordial experiences of life and death, and feelings of insignificance and finiteness in the presence of the forces of nature and the magnitude of the world around them. They were confronted with the intellectual and spiritual need to respond to questions posed by these universal circumstances. The Olmec cannot be separated from a syntax of thought and feeling that forms a common denominator of all cultures. Symbols and myths are expressions of the human desire to find order, meaning, and a sense of permanence. To understand Olmec ideas, beliefs, and the structures of their specific world view, we must rely on what their

sculptures, architecture, and natural environment show us. Understanding is possible on two levels: the first is direct, objective, and achievable by visual recognition; the second involves interpreting what we see in the world of Olmec symbols. The Olmec vocabulary of symbolic forms may be approached through analogies with the art of more well-known Mesoamerican cultures, through the placement of monuments in archaeological sites and landscapes, and through an understanding of certain universal tendencies of the human mind.

Olmec sculpture displays three major thematic groupings: mythic images, effigies of supernatural beings, and human figures, which will be outlined and discussed below.

Mythic Images

As does science, myths have as their objective the explanation of the universe and humanity's material and spiritual reassurance. Myths are realities in the inherited cultural consciousness of a community or a people. They narrate events that occurred at the beginning of time, and they tell how reality came to

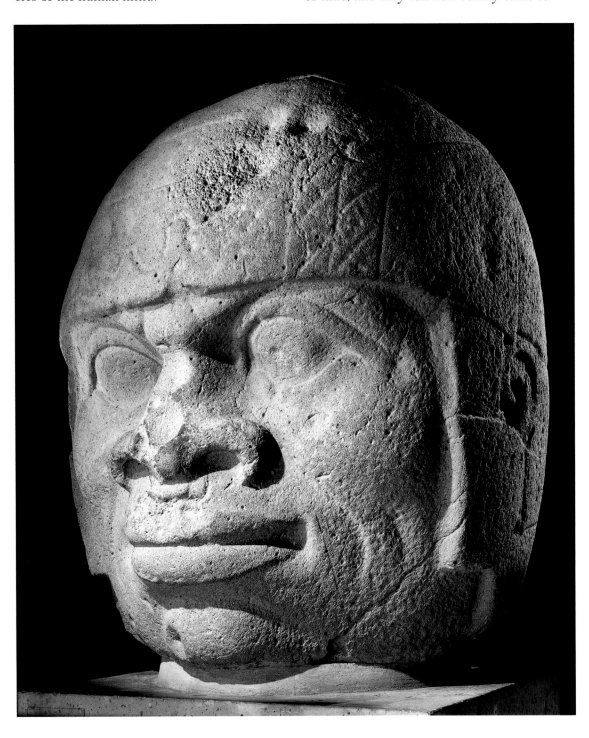

Fig. 2 Colossal portrait of ruler (Monument 9). Mexico, Olmec, Veracruz, San Lorenzo, 900/800 BC. Stone. INAH–CNCA–MEX, Museo de Antropología, Xalapa, Veracruz. Photo: Gabriel Figueroa Flores. Highly individualized features are represented on different colossal heads that commemorate a series of powerful dynastic rulers. (Cat. no. 213)

exist through acts of supernatural beings. Myths explain the act of creation as a sacred process of transformation, whereby the concrete world and humankind were brought into being. Attempting to define threads common to the universal mythology in existing Olmec sculptures, I find that the basic imagery of the sculpture is not fundamentally narrative but, rather, a condensed and fixed expression of archetypal mythic concepts.

Three groups of mythic images can be identified. The first is composed of only

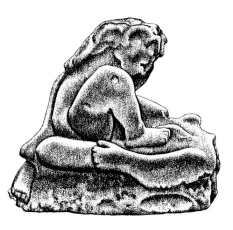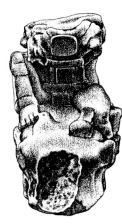

three, very deteriorated monuments—San Lorenzo Monument 1 (fig. 3), Laguna de los Cerros Monument 20, and Potrero Nuevo Monument 3—which have been said to represent the sexual union of a jaguar and a woman, a union that produced the "were-jaguar," part fantastic animal, part human. Careful analysis, however, reveals that the protagonists in the supposed act actually are different in each of the sculptures; moreover,

there is no attempt to represent an actual sexual union. Instead, the sculptures were intended to manifest the idea of a profoundly significant event: a creation myth describing the sacred marriage of the primordial male and female principles, the possession and fertilization of the earth, the union of male sky and female earth. This was the supernatural, cosmological union that was a paradigm for all unions, including the sacred origin of humankind.

A second group of mythic images is composed of sculptures with a powerful figure, larger than life size, emerging from an interior space that resembles a cave. These impressive monuments are carved from huge blocks of stone that have been called "altars," although this may not have been their function; rather, they were probably thrones or consecrated seats of Olmec rulers. Examples are La Venta "Altar" 4 (fig. 4), "Altar" 5 of Laguna de los Cerros, and "Altar" 14 of San Lorenzo. I believe that these images refer to a second episode or stage of a widespread Mesoamerican origin myth: the emergence of humankind from the cave of the earth, the great ancestral matrix, marking the beginning of life. This theme of mythic emergence was later repeated by other cultures, such as the Maya, the people of Teotihuacan, and the Aztec.

The third type of origin-myth sculpture is a more complex type; it portrays a powerful human figure holding a baby with a highly stylized, masklike head. In La Venta "Altars" 2 and 5 and San Lorenzo "Altar" 20, the man who emerges from the cave carries in his arms the inanimate body of a child with this

Fig. 3 Monument 1. Mexico, Olmec, Veracruz, San Lorenzo, 900/800 BC. Basalt. Drawing: Felipe Dávalos, in Coe and Diehl, 1980, fig. 499, p. 371. This mythical scene depicts the primordial male and female union.

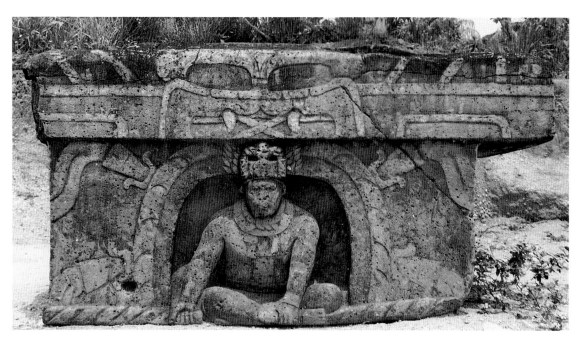

Fig. 4 "Altar" 4. Mexico, Olmec, Tabasco, La Venta, c. 800 BC. Basalt. Parque Arqueológico La Venta, Villahermosa, Tabasco, Mexico. Photo: Beatriz de la Fuente. Probably serving as a throne, the monument alludes to the emergence of an ancestral hero from the primordial earth-cave. By analogy, new rulers would "re-create" society upon assuming office.

fantastic mask. A subgroup of these depictions is found in independent sculptures such as the celebrated Las Limas figure (fig. 5) and San Lorenzo Monument 12. Although the figures are not shown emerging from caves, I presume that each was originally placed outside a natural cave or an architectural construction representing a cave, thereby repeating the sacred and mythic contexts depicted on the "altars." The inert posture of the child in the Las Limas figure, and the others, suggests that it may have been sacrificed as a precious offering. The theme of child sacrifice appears again in later cultures, both in Mesoamerica and in the Andean area (see McEwan and Van de Guchte essay in this book). It is important to note that the word sacrifice means "to make sacred," and the idea of presenting offerings to various forms of gods is as ancient and universal as human culture. In early Mesoamerica, this notion was defined in a distinctive way. Man, born from the earth-womb cave, was seen to have gained earthly life; but this was only a transition, one aspect of the totality of being. By sacrificing something most valuable to the earth in return for the original gift of life, man acted to assure the continuance of a

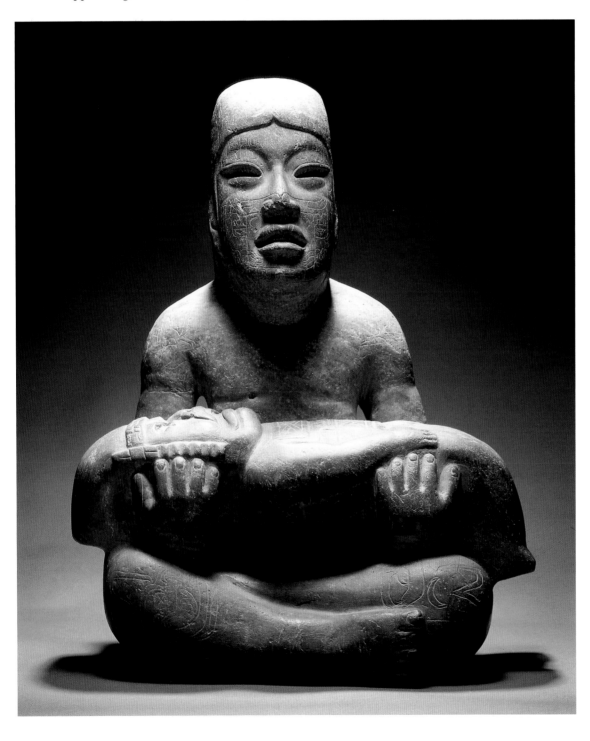

Fig. 5 Monument 1. Mexico, Olmec, Veracruz, Las Limas, c. 800 BC. Greenstone. INAH–CNCA–MEX, Museo de Antropología, Xalapa, Veracruz, Mexico. Photo: Michael Zabé.

cyclic, immutable order. The sacred offering was intended to make humankind an active participant in the eternal flow of life. With the sacrificial "return," the cycle came to a close and began again, repeating the eternal model established in the time of the first creation. This concept of sacrifice was, in essence, the expression of a fertility myth. Renewal is portrayed as a never-ending process of birth from the underworld source of life—the cave—to life on earth—humankind—culminating on a level of supernatural return—the immolated child—as an offering to ensure the regeneration of the earth and the beginning of the cosmic cycle.

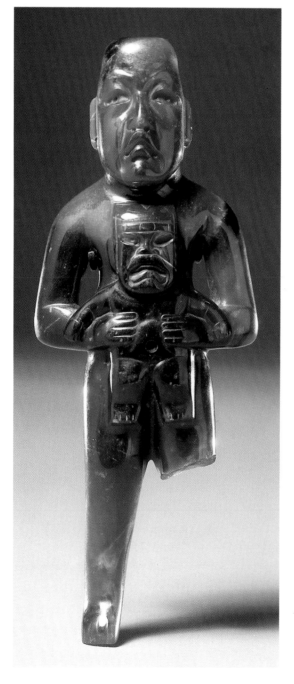

Fig. 6 Votive figurine presenting masked baby. Mexico, Olmec, 800/500 BC. Jade. Collection of Robin B. Martin, on loan to The Brooklyn Museum. (Cat. no. 206)

Human figures who hold or present inert masked children in their arms exist also in small jade or jadeite sculptures, such as the superbly carved and polished figure from the Brooklyn Museum (fig. 6). The jewel-like quality of this piece further attests to the importance of the theme.

Other images and symbols may allude, although only partially, to aspects of sacrifice: these are the so-called "scepters," "torches," and "knuckle-dusters," held, for example, in the hands of the figure that is San Lorenzo Monument 10. There are also numerous jadeite awls and spoons that have been interpreted as ritual implements used by Olmec rulers to draw blood from themselves in acts of autosacrifice to the deified forces of nature and to legitimize themselves in their office. This was also a practice that was to last throughout Mesoamerican history from the Classic Maya to the Aztecs.

Supernatural Beings

Another type of sculpture, composed of single images, incorporates in an essentially human aspect one or more animal characteristics as well as imaginary or fantastic traits. Like the monumental sculptures and figurines just mentioned, these, too, refer to the mythic archetypes and ideas central to the world view of the Olmec. They were also icons for the imagination to approach the deepest values held by the community. In the words of Mircea Eliade:

> The imagination *imitates* the exemplary models—the Images—reproduces, re-actualizes, and repeats them without end. To have imagination is to be able to see the world in its totality, for the power and the mission of the Images is to *show* all that remains refractory to the concept.... [10]

These composite, abstract figures are visual metaphors whose human and animal characteristics speak of a supernatural world beyond visible material reality. The figures of this group range between those of almost entirely animal appearance to those that are more nearly human. Again, the animal and imaginary characteristics are concentrated in the head and face. In a few cases, claws supplant hands and feet. The most animal-like figures belong to a symbolic group with two subtypes. One subtype, which comprises the "Kunz" axe (fig. 8), San Lorenzo Monument 10, and La Venta Monuments 6, 9, 11, and 64, is distinguished by a face with a thick

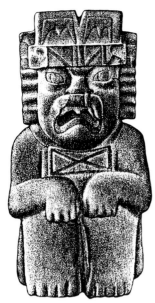

upper lip curled back to reveal large canines bifurcated at the tips; a broad, flattened nose; and, at times, parallel lines in squares instead of eyes. The other group, well represented among the smaller figures, is typified by almond-shaped eyes, with the eyelid creases turned down and inward; a thick upper lip turned up and, occasionally, bracketed; and a toothless gum, either in the shape of an inverted E or with incipient teeth. Because of their infantile aspect, these figures are generally known as "jaguar-babies." They can be seen as such in San Lorenzo Monument 52 (see fig. 7), La Venta Monument 75, and many minor sculptures, such as an axe in the British Museum, London, and the Necaxa jaguar in the American Museum of Natural History. San Lorenzo Monument 52, which demonstrates well the symbolism of the group, was found in connection with a drainage system and has a channel cut into its back. It seems legitimate to suppose, because of its direct relationship with water, that the image is an aquatic deity. The Olmec habitat contained countless rivers, streams, lagoons, and marshes. Water and its control must have been fundamental concerns in daily life, in the elaboration of myths that relate to water, and in associated rites.

Animals also belong to the group of supernatural beings: for example, San Lorenzo Monuments 7, 21, and 37 and Los Soldados Monument 1. These depictions, which are far from naturalistic, speak of a dimension of Olmec thought and perception that transcends a visible physical reality. With the exception of the very deteriorated sculpture found by Matthew Stirling at San Lorenzo,[11] the serpent motif is usually a part of more

complex sculptural images, such as La Venta Monument 19 (fig. 11). In this composition, a mythic serpent looms protectively, enclosing a seated human figure holding a bag of incense. The image may allude to seasonal rites, for serpents in Mesoamerica were variously associated with the earth and groundwater because they sheltered beneath the surface and hunted by rivers and ponds. Serpents were also associated with the sky by virtue of their fluid, gliding movement, which was likened to the wind, or their quick-striking action, which was compared to lightning. Metaphor and analogy were thus employed in the system of Olmec symbols.

Fig. 7 Drawing of Monument 52. Mexico, Olmec, Veracruz. San Lorenzo, 900/800 BC. Basalt. Drawing: Felipe Dávalos, in Coe and Diehl, 1980, fig. 493, p. 362.

Fig. 8 Votive axe with ritual mask ("Kunz" axe). Mexico, Olmec, southern Veracruz or Tabasco, 800/500 BC. Jade. American Museum of Natural History, New York. (Cat. no. 204)

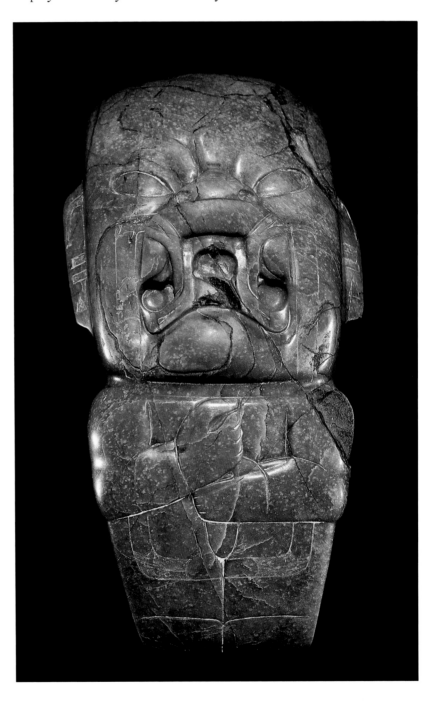

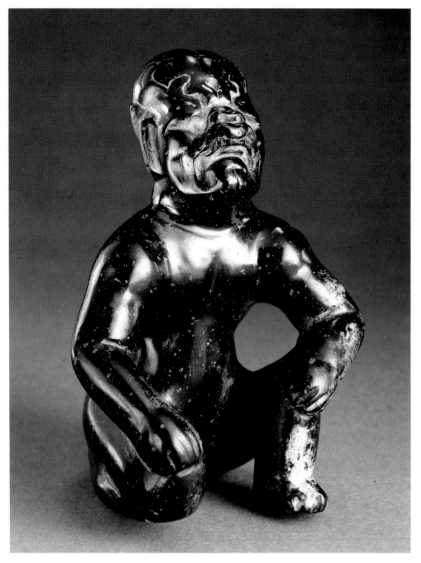

Fig. 9 Kneeling figure
depicting were-jaguar.
Mexico, Olmec, Tabasco,
800/500 BC. Dark green
serpentine with traces of
red pigment. Los Angeles
County Museum of Art.
(Cat. no. 209)

Fig. 10 Feline diadem.
Mexico, Olmec, southern
Veracruz, 800/500 BC.
Porphyry. Dumbarton Oaks
Research Library and
Collections, Washington,
D.C. (Cat. no. 207)

Fig. 11 Monument 19.
Mexico, Olmec, Tabasco,
La Venta, c. 800 BC. Basalt.
Photo: Beatriz de la Fuente.

signed in a stylized quatrefoil pattern, and plant motifs spring from the four interstices. The mouth was undoubtedly a place to make offerings to the earth and the ancestral dead within the mound. A famous petroglyph carved high on the cliff above this site also features a stylized feline mask, shown in profile (see fig. 14). A royal figure is depicted seated within this "cave," from which cloud-scrolls issue; above, rain clouds are shown with falling drops and circular "precious" pieces of jade. Nowhere else in Olmec art is the cycle of fertility represented with such graphic simplicity.

Human Figures

Naturalistic representations of human figures contrast with the preceding sculptures. They do not, however, deal with humanity in its strictly historical dimension but with humanity, anchored in myth, as the link between the supernatural and physical worlds. The human form was perceived to be imbued with divine power. I find three groups within this type of sculpture. The first

comprises images that I have called men under supernatural protection; these figures are part of a scene and are shown protected by supernatural beings placed above them. A splendid example is San Martín Pajapán Monument 1 (fig. 15), showing a massive, crouching masked human figure wearing an elaborate "were-jaguar" headdress. The same concept, in a more complex presentation, can be seen in La Venta "Altar" 4, where the figure of a larger than life-size ancestor or ruler emerges from a "cave" surmounted by a stylized feline mask (see fig. 4).

The second figural type consists of unique personages whom I call mediators. These seated human figures have individualized expressions, yet they also conform to an idealized, vigorous Olmec racial type. There is

The supernatural jaguar motif is ubiquitous in more varied contexts. For example, it is seen in several small sculptural figures, such as one in the Los Angeles County Museum of Art (fig. 9) and others in the collection of Dumbarton Oaks. The jaguar, lord of the forest, was primarily a symbol of the earth and royal power. Correspondingly, jaguar emblems were worn by Olmec lords as signs of rulership (see fig. 10). Far from the Olmec heartland, the archaeological site of Chalcatzingo in central highland Mexico offers a particularly strong illustration of this earth/jaguar/rulership imagery. The site was a provincial capital with local chieftains, probably tied by trade and marriage alliances to the centers of Tabasco or southern Veracruz. Chalcatzingo is dominated by a huge rock formation rising from the plain (see fig. 12). At the base of this great rock, a large burial mound was built and equipped with a structure (now destroyed) that contained a two-meter-high stone mask with abstract feline motifs (see fig. 1). The open mouth is de-

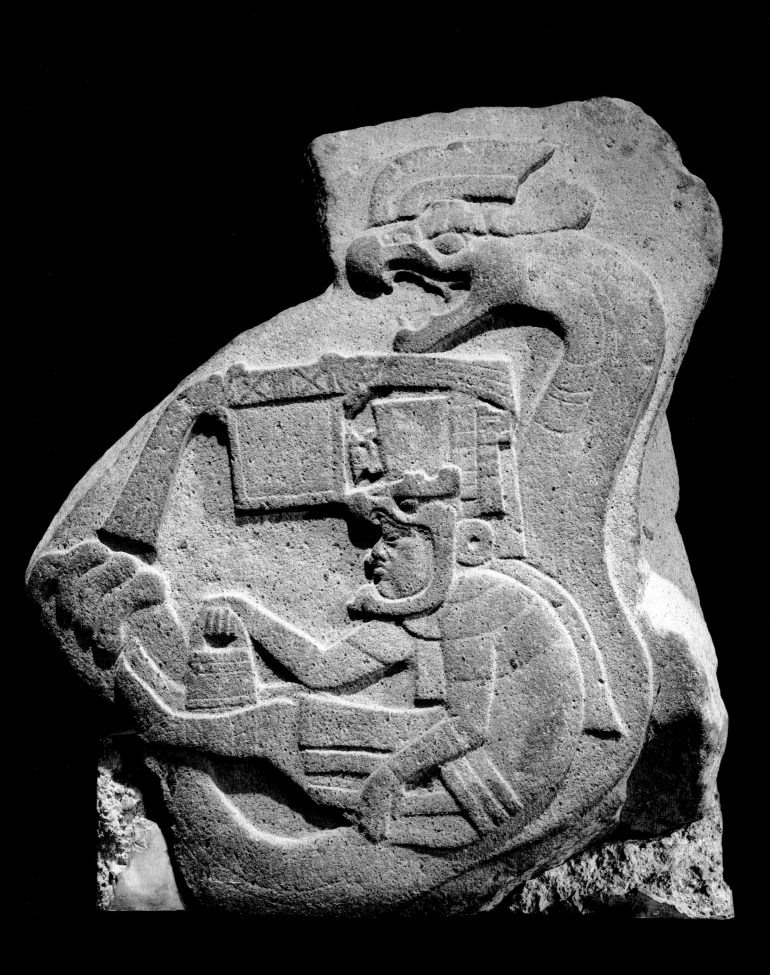

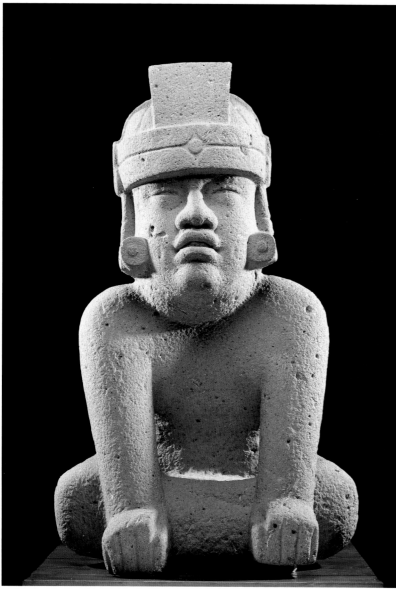

always something of the feline in their seated postures, and an aura of supernatural authority surrounds them. Many of the monumental sculptures have been decapitated. The intact pieces include some that deserve to be mentioned among the masterworks of Olmec art, most notably, the "Prince" of Cruz del Milagro (fig. 13). This imposing figure of almost colossal dimensions displays a greatly simplified torso and limbs in a modified "seated feline" pose; yet, the face, while idealized, is that of an individual. The sculptural masterpiece reveals the Olmec taste for large-scale figures suggestive of exceptional powers and linked to the memory of historical personages. Similar effects are achieved in smaller objects such as figurines and masks made of jadeite and other fine stone. Mediators are, perhaps, images of initiates or of those selected to invoke or manifest forces beyond the range of ordinary people. They project a sense of control and contained strength, and their serenity serves to indicate that they are superior to ordinary, mundane human ways. When Olmec rulers commissioned commemorative stone portrait-masks, the artists faithfully recorded their features, giving them the feeling of a vital and forceful personality (see fig. 16). In some instances, the faces convey a sense of spiritual illumination.

The third group of human representations, comprising the celebrated colossal heads, is unique in world art history. There are sixteen known examples: nine from San Lorenzo (see figs. 2, 17), four from La Venta, and three from Tres Zapotes and its environs.

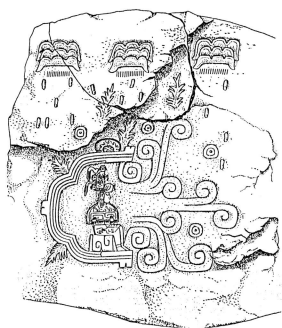

Although they represent an idealized racial type, each has a different expression and subtly distinct features; the designs and symbols that decorate their headdresses and pendants also vary. These differences signal individuality and demonstrate that the colossal heads are portraits. Opinions abound as to the identities of the subjects.[12] I agree with those scholars who contend that these are depictions of Olmec dynastic rulers. Without doubt, the portraits speak of an Olmec ideal of rulership and of those rulers who appear to have attained or fulfilled that ideal. The importance of dynastic commemorative sculptures conveying the qualities that justified the aristocracy is evident in the later Mesoamerican world, and it is reasonable to suppose that the Olmec colossal heads lie at the root of this long-lasting tradition. Aside from the political, social, and religious implications of these portraits, I believe that their expressions reveal something more profound. All have expressions of concentration and even a fiercely controlled energy; it is also not accidental that all the portraits have crossed eyes, a characteristic evident in various portraits from later Mesoamerican cultures. These traits may well indicate a form of meditation and deep inward equilibrium, through which people could obtain an intuitive comprehension of the larger order of the world around them. The presence of colossal heads in the Olmec ceremonial centers induces me to think of them both as symbols of specific socioeconomic and historical concerns and also as having significance that is both intrinsic and

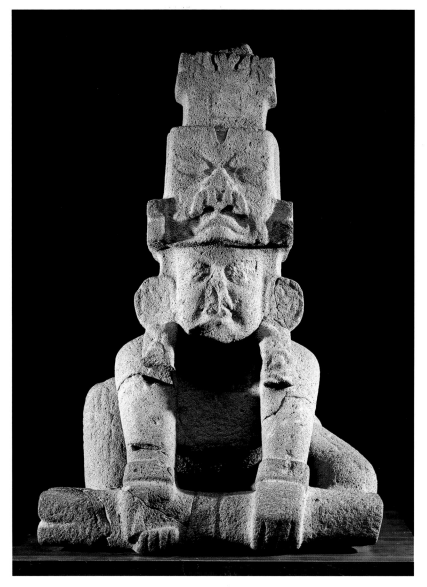

universal. The head is the receptacle that holds the superior abilities of humanity, its creative powers; the head is the center of thought and spiritual life, of humanity's capacity to commune with those forces considered more powerful, remote, and supernatural. In the civilizations of the ancient Americas, those most powerful forces resided in the forms and forces of nature.

There are few equivalents to these portraits in the minor sculpture. Notable exceptions are a serpentine piece in the Museo de Antropología de Veracruz in Xalapa,[13] a translucent bluish jade in the collection of Dumbarton Oaks, Washington, D.C., and the commemorative mask in the Museum of Fine Arts, Boston (fig. 16). The colossal heads, located in the most important Olmec ritual centers, were intended to manifest a concept of humanity's relation to nature and the supernatural. The Olmec thereby assumed a central place in their vision of the world's structure.

Fig. 16 Commemorative mask of ruler. Mexico, Olmec, Veracruz, Pesquero, 1200/600 BC. Gray jadeite with black incrustations. Museum of Fine Arts, Boston. (Cat. no. 212)

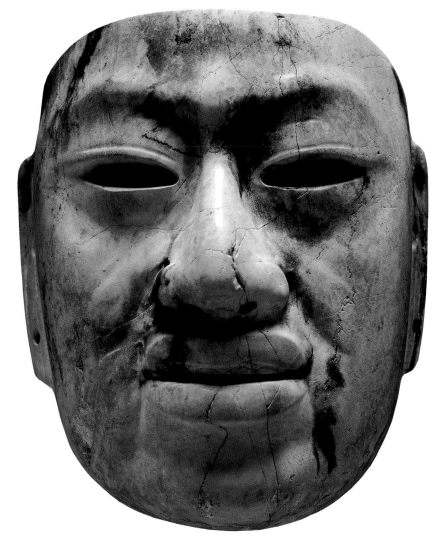

Artistic Structure in Harmonic Proportions

The monumental sculptures of the heartland area belong to an epoch of notable cultural integration, which lasted for some six centuries (1200–600 BC). The human effort displayed in these monuments—some stones weigh many tons and had to be transported from distant locations—could have been applied only to exceptional ends: to make something lasting, to preserve images of fundamental meaning. The same can be said of many small jade or jadeite sculptures. The formal organization of these pieces and the monumental works illustrates a level of symbolism that expresses a concept of harmony with nature. This is the Olmec system of harmonic proportion shown by all of the colossal sculptures, as well as many of the small, essentially human figures.

After having studied the great Olmec sculptures for a long time, one senses that, despite the variety of formal solutions they display, there is an underlying unifying element that makes them, to a certain degree, similar. This is not a similarity of style or individual expression and representation, but rather a basic formal unity deriving from the harmony of their proportions according to a mathematical pattern.

The search for balance, unity, and proportion of the human figure and the structuring of forms according to geometric patterns have been shown in different ways in different civilizations.[14] The artistic expression of great civilizations in their most developed and significant epochs is revealed in a specific and irrefutable way through this search for an ideal. The Parthenon, East Indian temples, and European cathedrals were built according to different but precise systems of measurements, which constituted a code and which proclaimed a coherent underlying unity. Similarly, by relating Olmec sculpture to a governing and determining canon, it becomes apparent that theirs was no primitive artistic manifestation; on the contrary, it was an art fully disciplined and realized as a means of expression. We have seen that its forms were designed to reflect a mythic view of the natural world and to express the place of man within that cosmic organization. What I now wish to show is that the principal forms of Olmec art were also designed according to a cohesive system of proportions.

The great cultures of Mediterranean antiquity based their artistic manifestations

on a system of proportion anchored in the natural world and in basic cultural foundations. In this respect, the art of the Olmec shows an affinity to that of classical Greece and the Renaissance, which employed a similar proportion system. This system, which explains the balance or harmony of parts in relation to the whole, has been designated variously as "golden section," "golden mean," and "divine proportion." The golden section is the division of a length, so the smaller part is to the greater part as the greater part is to the whole. As a "key" or "proportion," the golden section was used not only in ancient times; it continues to be in use at present. The Parthenon is the most famous building of antiquity to follow such a norm of proportion. In the Renaissance, it was employed by the artist Leonardo da Vinci and the architect Leon Battista Alberti. In the twentieth century, the architect Le Corbusier developed the "modular," a scale based on the human body, whose height was divided in golden section at the navel. The golden section is frequently ·used as a system of proportion in industrial design. It also occurs in nature, in animals and plants. The claim has often been made that the golden section is aesthetically superior to all other proportions, that it is the most visually pleasing and harmonious. Schematic diagrams of several Olmec colossal heads and other major sculptural figures reveal a canon based on the golden section. For example, fig. 18 shows that, if the entire head were inscribed within a rectangle, it could be subdivided further, according to the ideal ratio of the golden section. The Olmec use of the golden section can also be demonstrated in a series of monumental sculptures and in certain jade, jadeite, and serpentine figurines.

Some of the Olmec monumental sculptures carved according to the golden mean are San Lorenzo Colossal Head 4 (fig. 17), La Venta Monuments 9 and 10, San Lorenzo Monuments 10 and 52 (see fig. 7), as well as La Venta Monument 77, the "Prince" of Cruz del Milagro (fig. 13), Cuauhtotolapan Monument 1, and the Las Limas figure (fig. 5). Other sculptures reveal certain modifications to the golden section, but they are still within the canon: San Lorenzo Colossal Heads 9 (fig. 2), 1, 3, 5, 7, and 8, and La Venta Colossal Head 2. Major differences from the golden mean are found in late-period colossal heads, identified as La Venta 1, Tres Zapotes 2, and Nestepe 1. The principle of compositional order is also lost in Tres Zapotes

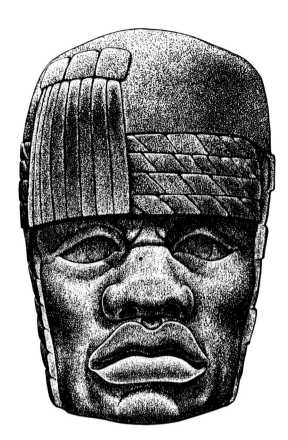

Fig. 17 Drawing of colossal head (Monument 4). Mexico, Olmec, Veracruz, San Lorenzo, 900/800 BC. Drawing: Felipe Dávalos, in Coe and Diehl, 1980, fig. 427, p. 307.

Fig. 18 Drawing of golden section of Monument 4. Drawing: de la Fuente, 1977, fig. 3.

Colossal Heads 1 and 2. It can be said that, when sculptural works lose the structure of the harmonic canon, they cease to be truly Olmec. The loss of rigorous organization reveals that the significance of the canon was waning. This phenomenon did not occur simultaneously in all the sites where sculpture was made. Nevertheless, I believe that the canon ceased to be the ruling force in works executed between about 600 and 400 BC.

Harmonic proportion exists in all organisms, including animals, plants, and human beings, and also in microscopic life. Figures carved with this proportion thus raise echoes of identity, a feeling of balance, and a sense of correspondence with living things seen and experienced in the natural environment. In the plastic arts, harmonic proportions automatically suggest an underlying order of nature. The Olmec method of using this system of proportion in the stone colossi and figures of jade reveals an intention to symbolize an ordered vision of the natural world and, perhaps, their sense of the supernatural. On this level of visual organization, Olmec sculptors gave concrete expression to an abstract principle of absolute order, while investing their forms with great expressive vitality and symbolic power. In this achievement, the human figure may be seen to have mirrored their universe.

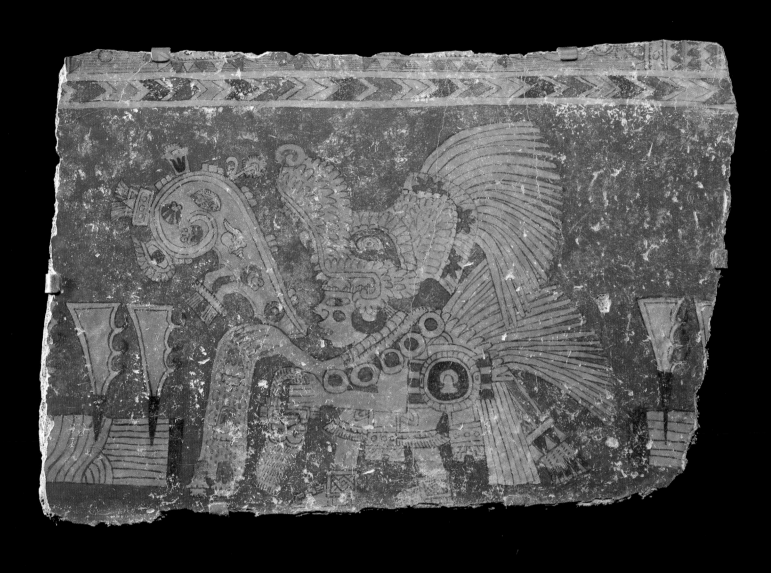

THE NATURAL WORLD AS CIVIC METAPHOR AT TEOTIHUACAN

Teotihuacan is called simply Las Pirámides ("The Pyramids"), in Mexico, because the colossal Pyramids of the Sun and Moon, located only an hour away from the capital, are, to many, synonymous with pre-Columbian civilization (see fig. 2). The neutral term "pyramids," however, indicates how little we know about the archaeological site. Teotihuacan, the Aztec name for the city, means "Place of the Gods," because the Aztec could not imagine that human hands could have built the pyramids. In myth, they associated the site with the gods and the creation of the world. We do not know what its ancient name was, what language its people spoke, or what ethnic group they thought they were. The people of Teotihuacan are more mysterious than the Aztec, Maya, or Mixtec peoples, who can be associated with many of the major ancient cultures and ruined cities in Mesoamerica.

We have to reconstruct Teotihuacan almost entirely on the basis of its archaeology. We know that the city lasted from about 150 BC to AD 750.[1] The great pyramids were built early in the first century AD (see fig. 6). From about 200 to 750, the population lived in masonry apartment compounds that were often decorated with mural paintings. Population estimates at the height of the city's development range from one to two hundred thousand. Agricultural support for the city came from nearby fields irrigated from many local springs and the small San Juan River, and perhaps from some outside tribute in foodstuffs. Obsidian, lapidary, and pottery workshops provide abundant archaeological evidence for manufacturing activities. Very likely, a significant percentage of the Teotihuacan population worked at crafts, such as featherworking, that did not survive archaeologically.

Teotihuacan has been considered an important trading culture for several reasons. Obsidian distributed by Teotihuacan has been found in many parts of Mesoamerica.[2] Some widespread trade goods, such as Thin Orange pottery, were not actually made at Teotihuacan but in Puebla, and yet were a common ware at Teotihuacan. Thin Orange appears to have been traded throughout Mesoamerica by Teotihuacan merchants.[3] Matacapan in Veracruz and Kaminaljuyú in Guatemala are believed to have been some sort of Teotihuacan merchant bases or "colonies." Several burials in Kaminaljuyú with both Teotihuacan and Maya objects suggest a Teotihuacan elite far from home.[4] A Teotihuacan settlement was likely at Matacapan, since even Teotihuacan-type figurines, which were modest household objects, were made there in some quantity.[5]

Other Mesoamerican cultures evidently saw Teotihuacan as a great military power. Maya monuments at Tikal, Uaxactún, Yaxhá, and elsewhere show persons in Teotihuacan military costume.[6] On Monte Albán monuments, Teotihuacan individuals are represented in what may be diplomatic contexts.[7] These foreign depictions suggest that Teotihuacan was a great power in Mesoamerica from 300 to 600, a time span considerably longer than that of the Aztec empire, which lasted from 1428 to 1521.

Teotihuacan was not just the largest and perhaps the most influential state in Mesoamerica in the Classic period; it was also, in many ways, unique, unlike other Mesoamerican states—the Olmec, Maya, or Aztec, for examples. Teotihuacan was the first metropolis in Mesoamerica to be built on a grid plan (see fig. 5), a design later imitated by the Aztec. There is nothing in Mesoamerica comparable to the dense habitation formed

Fig. 1 Mural fragment depicting rain priest. Mexico, Teotihuacan, 600/750. Fresco. The Art Institute of Chicago. Casting flowers and praying for water, the priest stands before a tied bundle of rods representing the completion of a cycle of time and the beginning of a new period. Repeated around the walls of a chamber, this complex figure formed part of a litany asking for water and fertility. (Cat. no. 249)

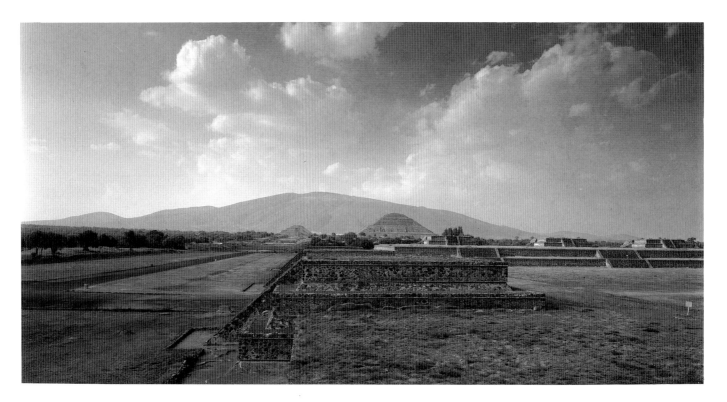

Fig. 2 The Ritual Way of Teotihuacan (also known as Avenue of the Dead or North-South Avenue), leading from the "Citadel," or central Plaza (right), past the Pyramid of the Sun, to arrive before the Pyramid of the Moon on axis with the sacred mountain Cerro Cordo. Mexico, Teotihuacan, c. 1–750. Photo: Gabriel Figueroa Flores.

by the approximately two thousand apartment compounds in which almost all the population of Teotihuacan lived (see fig. 3). These are of such high architectural quality that, when first found, they were considered to be "palaces."[8] By contrast, an actual palace of the rulers of Teotihuacan has been hard to locate—unlike the situation in Maya sites, where palaces stand out in scale and form. It has been suggested that two large habitation complexes, one next to the Temple of the Feathered Serpent and one in an area along the two-kilometer-long, forty-meter-wide North-South Avenue, called the Calle de los Muertos Complex, were the palaces of the rulers at different times.[9] It is noteworthy that, in each of these areas, palatial and religious structures were combined in one complex.

We know little about the rulers of Teotihuacan, because, unlike Aztec, Maya, Zapotec, and Mixtec rulers, they were not usually shown in art, nor were they identified by hieroglyphs and inscriptions. The art of Teotihuacan is concerned with themes of nature, fertility, sacrifice, and war, all of which are seen as parts of a collective enterprise in which humans, animals, and even gods are depicted in repetitious, anonymous rows. Repetition, as in chants or litanies, pervades the art and architecture, from mural figures to temple platforms. In view of these impersonal and collective representations, I have suggested that Teotihuacan must have had a communal ideology very different

from the dynastic, status-oriented emphasis characteristic of other Mesoamerican cultures.[10]

How did this remarkable and powerful state evolve, and what ideology inspired it? In the various theories of the political development of the state in history, two major positions have emerged. Many scholars argue that people do not willingly relinquish power to an elite unless they have to, and that states are generally created and maintained by military force. This has been called the "conflict" theory.[11] According to this view, religious and historical sanctions are seen as invented by the elite to keep the lower classes in line. It implies that conflict exists continuously, even after the initial formation of the state, and that ritual and practical measures are constantly necessary to keep it from falling apart. The proponents of an "integration" theory of the state believe in a more benign social contract, in which the lower classes willingly give up their freedom in exchange for the managerial and protective functions assigned to the elite.[12] According to this belief, states may be created initially by "conflict" or conquest, but, once formed, they comprise a citizenry willing to be part of a greater community and to accept wholeheartedly the various myths that justify it. The twentieth-century experience with democratic, fascistic, and communist states may be applicable to earlier forms of the state: "evil empires" based exclusively on force do not survive for long periods of time

(such as centuries). Polities that do survive are able to create some of both the reality and the illusion of social integration. In the end, civic myths may be as important as organized power in the creation and maintenance of states.

In their art and ideology, states may emphasize either conflict or integration as a theme around which to generate participation. The many representations of conquest in Maya and Aztec art and the "personality cult" of the ruler among the Olmec and Maya are strongly concerned with the overt expression of conflict between cities and of social hierarchy within cities. Aggressive images perhaps reinforce social distance through implied threats. In contrast, Teotihuacan images suggest a neutral, impersonal world inhabited by largely benevolent deities and by an anonymous elite preoccupied with the proper performance of ritual. The images evoke a terrestrial paradise through the depiction of waters teeming with marine life, a land of fruit- and flower-bearing plants, and mythical birds, canines, and felines. Paradoxically, in the creation of the first great urban metropolis in Mesoamerica, Teotihuacan came up with the natural world for its civic metaphor.

Although we cannot know the extent to which armed conflict may have been instrumental in the initial creation of Teotihuacan, we know from settlement-pattern surveys that, between 100 BC and AD 100, most settlements in the Basin of Mexico were abandoned and the city of Teotihuacan swelled to nearly half of its later size.[13] It has been suggested that the impetus for the growth of the city may have been the building of the Pyramids of the Sun and Moon.[14] Teotihuacan's strategy was largely "integrationist": apparently, its leaders validated the new state by suggesting that the new living arrangements were more harmoniously adapted to the ways of the cosmos. This is not an uncommon strategy in early states, but, while many came up with the transparent device of making the ruler a divine intermediary between gods and people, Teotihuacan, by denying politics altogether, suggested a civic order directly bound to the order of nature.

Without written records, little can be known of the specific details of this social and religious system. The nature of the city and its art suggests that the system included the following features: the cosmic geography of the city itself; images of benevolent deities; human self-sacrifice within a terrestrial paradise; the equivalence of man and nature,

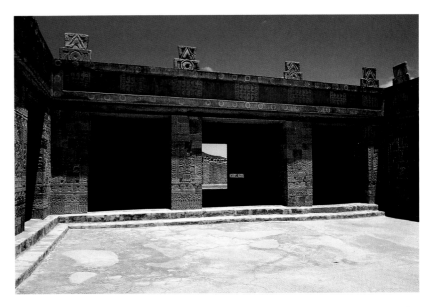

with both men and gods having animal and/ or plant counterparts; and a neutral, distant style of representation that suggested that the universe works through impersonal laws rather than through individual action or passion.

At no other period in the fifteen hundred years of pre-Columbian history was most of the population of the Basin of Mexico concentrated in one huge city. At most other times, villages and towns were distributed throughout the area, depending on the ecological potential of agriculture and the practical necessities of craft and trade. For the Teotihuacan farmers, living in the city and far from their fields, this arrangement could not have been the most practical. Such an "unnatural" settlement pattern may have been created by force and/or by a powerful ideology. Bringing the population together in a huge city was probably justified on the grounds that Teotihuacan was built according to a sacred plan and that residing within Teotihuacan was a religiously sanctioned privilege. We can deduce some of this from the natural terrain and the city plan.

Looking north from the Ciudadela quadrangle toward the Pyramid of the Moon, along the impressive North-South Avenue,

Fig. 3 View of the reconstructed Quetzalpapalotl Palace. Mexico, Teotihuacan, c. 600. Photo: Richard Townsend.

Fig. 4 Mural fragment depicting temple facades against backdrop of clouds and rain. Mexico, Teotihuacan, 600/750. Fresco. INAH–CNCA–MEX, Museo Arqueológico de Teotihuacan. Photo: Gabriel Figueroa Flores. (Cat. no. 256)

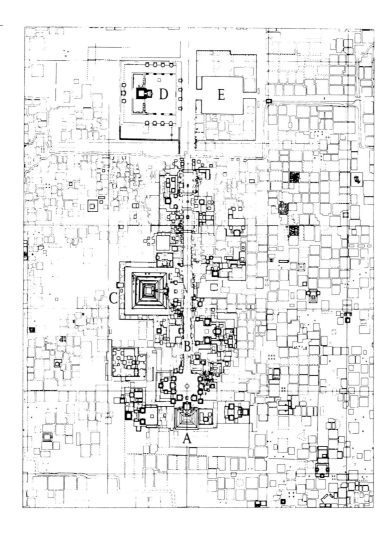

Fig. 5 Plan of Teotihuacan. Mexico, c. 1–750. Drawing: René Millon.

Legend
A. Pyramid of the Moon
B. Ritual way
C. Pyramid of the Sun
D. Ciudadela – "citadel"
E. Market place

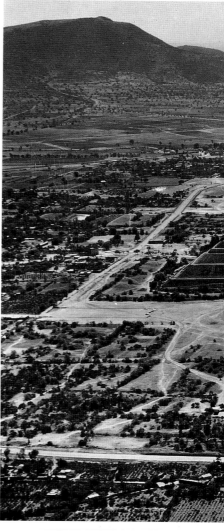

Teotihuacan is so harmoniously situated in the landscape that it appears "inevitable" (see figs. 2, 6). Cerro Gordo frames the Pyramid of the Moon, creating a dramatic vertical endpoint for the processional avenue. The entire site appears to be ringed with mountains from almost any vantage point, making the city an almost radially-centered place, sheltered and protected. Mountains, where the clouds collect in the rainy season, tend to symbolize water and fertility in Mesoamerican thought. Teotihuacan is thus nestled in the very center of fertility-bringing mountains. Cerro Gordo stands out, however, as perhaps the ultimate sacred mountain for Teotihuacan, not just because of its location at the end of the directional avenue but because the terrain slopes upward from south to north through much of the site, so that one has the continuous feeling of ascent as one approaches it. The planners of Teotihuacan thus situated the city in the landscape in such a way as to evoke powerful emotions connected with a sacred cosmos.

The city was built on a sloping but relatively level ground. The San Juan River bisects the city into a northern and a southern section. The area is rich in springs and natural caves. Judging by Teotihuacan art themes, adequate water for agriculture must have been a major preoccupation. The river and springs were necessary for agriculture, and some, if not all, were most likely sacred. The importance of caves has been recognized only recently. In 1971, a long cave was found under the Pyramid of the Sun, which may explain why the pyramid, and perhaps the entire city, was built where it is.[15] Recent explorations by Linda Manzanilla have shown that nearly all early three-temple pyramid complexes at Teotihuacan were associated with caves.[16] While we do not know the precise meaning of caves at Teotihuacan, caves in Mesoamerica are often seen as entrances to the underworld and are associated with both hidden treasure and hidden sources of water.[17] Some authors have suggested that, in Teotihuacan mythology, the people, or the gods, might have been thought to have emerged from caves.[18] Whatever their exact meaning, the caves and springs suggest that the city was built in a sacred place, and

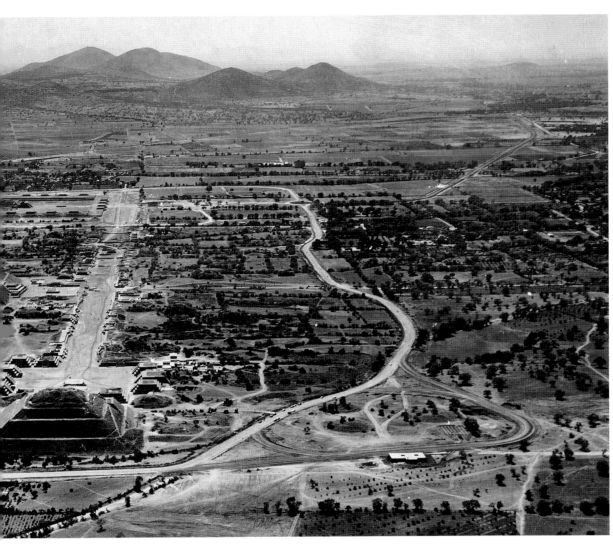

Fig. 6 Aerial view of central
Teotihuacan from the
Pyramid of the Moon down
the Ritual Way, toward
the agricultural fields
and springs to the south.
Mexico, Teotihuacan, c.
1–750. Photo: René Millon.

that, in effect, all of Teotihuacan was, to its
inhabitants, the equivalent of a cathedral.[19]

Teotihuacan was considered sacred not
only in relation to the mountains, the water,
and the earth but also to the sky. Anthony
Aveni (see Aveni essay in this book) and his
associates have found about twenty pecked
cross-circles carved into rocks in the hills
surrounding Teotihuacan and in the floors of
streets and plazas in the city itself.[20] These
pecked cross-circles have two interrelated
features: they refer to the world directions,
sky phenomena, and the alignment of the
site, and they are associated with the ritual
calendar. Aveni discovered that cross-circles
on the hills to the west line up with those on
the floors of several structures near the ave-
nue. Their significance is even more complex,
since one set of cross-circles refers to astro-
nomic north and south, while others refer to
the Teotihuacan orientation, which deviates
from fifteen to twenty-five degrees east
of true north. The latter alignment may
have had to do with the setting point of the
Pleiades, which would have been prominent
overhead in Teotihuacan times. (Some Olmec

sites were oriented eight degrees west of true
north.) Teotihuacan must have had a radical
new astronomical and mythological reason
to have come up with a new orientation.
Their interest in directions and alignment is
indicated by the many cross-circles surround-
ing Teotihuacan and even found far away
from it. One cross-circle located in the Maya
city of Uaxactún is related to a set of build-
ings there that dramatize solstices and equi-
noxes. More remarkable are two cross-circles
on the hills near Alta Vista, a site near the
Tropic of Cancer. Teotihuacan had trading
contacts with Alta Vista, but the cross-circles
indicate that the people of Teotihuacan may
have found the Tropic of Cancer — where
the sun appears to turn around on its annual
north-south trajectory — of great astro-
nomical interest.

Astronomical observation was apparently
related to divination, because the cross-cir-
cles frequently consist of 260 dots; the basic
cycle in the ritual calendar used throughout
Mesoamerica consisted of 260 days (see
Aveni and Boone essays in this book). The
fact that the markers approximate a spatial

layout of the ritual calendar suggests that astronomic alignment is associated with the will of the gods, as seen in the permutations of sign and number in the ritual calendar.

Building on an alignment based on the will of the gods as revealed by divination and the observation of celestial phenomena would have made the city of Teotihuacan a privileged space. Most likely, some feature of this alignment was focused on a celestial event visible every year, possibly the first annual appearance of the Pleiades on the same day that the sun passed overhead, as Aveni has suggested. Such events may have been dramatic for those expecting them. The view of the pyramids, at other times of the year, at different times of the day, and in different weather, varies enormously. At times, the architecture is obscured by shifting clouds; at other times, buildings are dramatically spotlighted by the sun or the moon. The annual event of an expected particular effect of sunlight or a stellar phenomenon would have been an awe-inspiring celestial affirmation of the correct placement of the city in the cosmos.

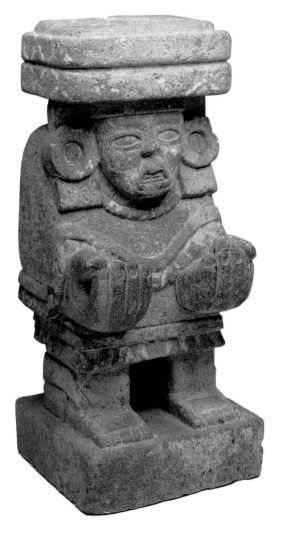

Fig. 7 Cult figure of goddess. Mexico, Teotihuacan, 250/650. Volcanic stone. Philadelphia Museum of Art. (Cat. no. 259)

Teotihuacan is not unique in Mesoamerica in being aligned with sacred geography and astronomy. What is unusual is that the alignment was carried down to the level of the residential buildings. The great North-South Avenue, which runs through the center of the city, is the material and ceremonial expression of this alignment. (The East-West Avenue, which crosses it near the Ciudadela, is of much less visual importance.) We tend to think of grid plans as practical approaches to city building. Teotihuacan, with its mandate to crowd a large population into a small space, might have found such a plan practical. It is just as likely, however, that the division of the city into more-or-less standard apartment compounds was due to a desire to mold the entire built environment into those cosmic coordinates. In other words, not only were the people of Teotihuacan living in a sacred place, but their individual habitations within it were as precisely planned as any of the temples. What is usually seen as the artificiality of the Teotihuacan plan may actually have been a desire to implement a plan of cosmic significance in every building of the city. Most apartment compounds have a temple on the east side or a shrine centered in the patio. Their dwellers thus partook of supernatural patronage not only at the main temples but in their own compounds. In a similar fashion, they participated in the cosmic alignment directly in their homes, not just through the avenue or the temples. An interesting question is whether the citizens of Teotihuacan living in apartment compounds in the very center of the sacred city felt that they were the chosen few and more blessed by the gods than other Mesoamerican commoners living in thatched huts.

Teotihuacan was a planned city in the sense that the same basic urban concepts were followed for over seven hundred years; individual enterprise, terrain, or other factors were not allowed to create more haphazard living aggregates. The grid plan also expressed the Teotihuacan view of the sacred as highly organized and systematized. One of the tenets of Teotihuacan ideology must have been that the superior practical and religious knowledge of the leaders of Teotihuacan would create a more harmonious and less unpredictable life. This systematic quality as a city and social organism differentiates Teotihuacan from all other Mesoamerican cultures of its time.

Enrique Florescano has suggested that, in the mythology of Mesoamerica, the two most basic themes are the "marvelous city" and

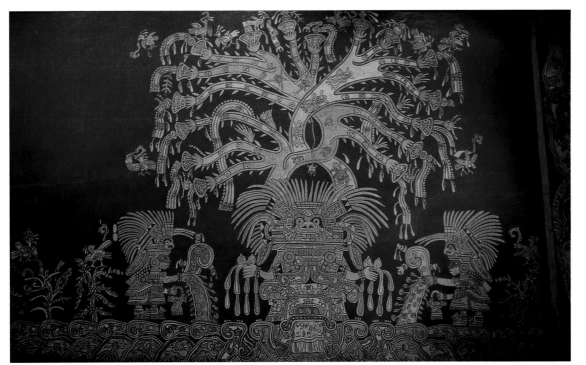

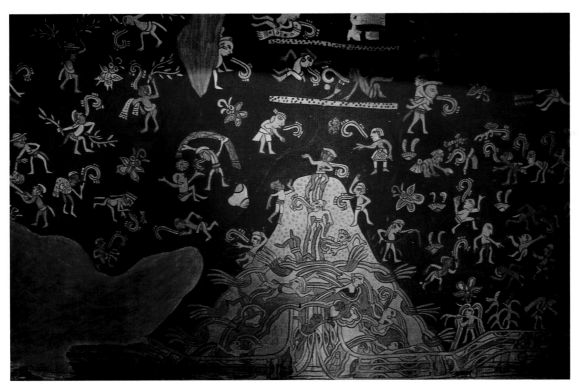

Fig. 8a,b Reconstruction of the Tlalocan mural. Mexico, Teotihuacan, 1964. Fresco. Museo de Antropologia, Mexico City. Photo: Richard Townsend. A tree of life rises from a plumed assemblage with gesturing hands and flowing water. Below, two rivers issue from a mountain cave into an agricultural paradise.

the "Eden of fertility."[21] The "marvelous city" is present in its ruined state, still embedded in its natural environment. Judging by its murals and decorated pottery, Teotihuacan was also an "Eden of fertility." In the mural images, a Storm God and a Great Goddess preside over an earthly paradise (see fig. 8a,b). They are often surrounded by water, trees and plants in bloom, animals, and, occasionally, small people. The themes of riches and water are intertwined and indicated by many repeated details, such as raindrops,

rows of jade beads, starfish, and shell creatures. The drops and flowers suggest a perpetual, fertile rainy season. Alfonso Caso was the first to recognize this, but he thought, on the basis of Aztec myth, that this paradisical vision came only to some, after death.[22] The relationship of this terrestrial paradise in relation to the people of Teotihuacan is not clear. The images could have been invocations to the deities that they should thus make nature flourish; or the images might have been thanks to the gods for already hav-

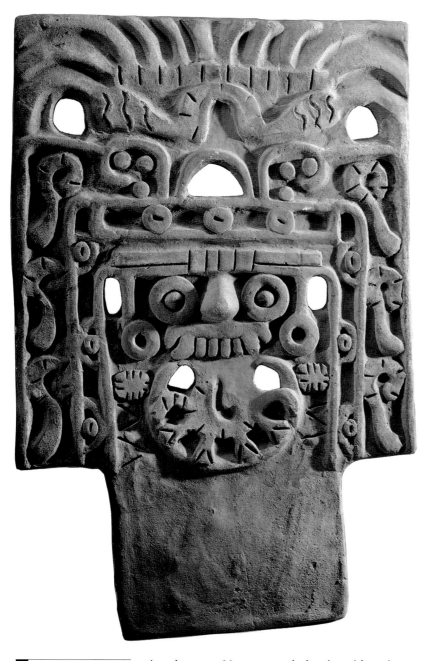

Fig. 9 Roof ornament depicting storm-god mask and headdress. Mexico, Teotihuacan, 600/750. Ceramic. INAH–CNCA–MEX, Museo Arqueológico de Teotihuacan. Photo: Gabriel Figueroa Flores. (Cat. no. 257)

aspects of gods, nature, and elites, and thus, presumably, encourage an easy adherence to the norms and traditions of society. Who would not want to live in an earthly paradise?

More, however, was asked of the Teotihuacan citizen than basking in the bounty of nature. A theme in art less clearly supervised by defined deities is that of warfare and sacrifice. Both the Storm God and the Great Goddess appear to have military or destructive aspects, and other deities, including one wearing an owl pendant, may be related to war. When not pouring gifts or libations, Teotihuacan elite figures are shown carrying spears and spearthrowers or human hearts impaled on sacrificial knives (see fig. 10). Since the representations do not indicate the conquest of other towns and their leaders, we cannot tell who is being sacrificed. Recently, I suggested that some of the victims of heart sacrifice may have been from Teotihuacan itself.[23] The recent discovery of nearly one hundred sacrificial victims, very likely from Teotihuacan and dressed in military attire, in the interior of the pyramid of the Temple of the Feathered Serpent, indicates that such sacrifice may have been part of Teotihuacan life.[24]

Besides depicting ritual sacrifice, the military/sacrifice imagery at Teotihuacan may have been an exhortation and a demand for self-sacrifice in a more general sense for the sake of the community. The community evidently put the value of the group above that of the individual. Even sacrificial victims, who paid the ultimate tribute by giving up life, are commemorated only by an anonymous heart. Perhaps both actual and symbolic sacrifice were believed to bring about the terrestrial paradise during rites that marked the change of time cycles or seasonal transformation. The fertility and sacrificial themes are interconnected, but there is no single illustration that would explain more precisely how sacrifice was justified.

Teotihuacan created what looks to us like a rigid and overorganized city, but one that the leaders must have claimed was in line with the order of nature. In some mural paintings, the benevolent realm of the Great Goddess is symbolized by water and waterlily representations beneath her headdress. The symbolic equivalence of man and nature is expressed often in Teotihuacan art. Jaguars, coyotes, and birds are variously represented (see fig. 12). Sometimes, as in the case of a famous ritual vessel from the British Museum, the animals are shown in an abstract yet recognizable form. In other instances,

ing done so. No temporal clue is evident in the murals—they exist in eternal, cosmic timelessness. It would appear from the choices made by Teotihuacan patrons and artists that they wanted to surround themselves with images of the bounty of nature. When the Teotihuacan elite are represented, they are often shown, like deities, casting wealth and plenty from their hands, while song or oratory issues from their mouths (see fig. 1). A primary Teotihuacan symbol is the divine hand from which water, seeds, jades, or other gifts flow. This theme is also evident in sculptural figures that emphasize upturned hands (see fig. 7) and in various abstract and complex metaphoric symbols painted in repeating series on polychrome mural panels (see fig. 11). Such images are positive reinforcements: they emphasize the beneficial

human figures wear animal costumes (see fig. 13); in still others, animals act as though they were human—jaguars blow conch shells dripping with water, while little bivalve shells grow on their backs. Such images may show animal aspects of gods or allegorical representations of humans performing rituals. One enigmatic depiction in storage at the Teotihuacan archaeological site shows a jaguar with a netted body, standing on a border of starfish in wavy lines signifying water; the jaguar, surrounded by birds and butterflies, holds a three-stemmed maguey flower from which flows water punctuated by eye signs. The mural is bordered by four-petaled flowers to which a variety of shells are attached. The zigzag band of the feline's headdress is like that of the Great Goddess, which could mean either that the net-jaguar is one of her aspects or that it is somehow associated with her or shares her insignia. Though we cannot interpret this mural precisely, its evocation of a terrestrial paradise could not be clearer. The plumed serpent is another ubiquitous image in Teotihuacan, appearing

in murals and on the frescoed surfaces of ritual vessels. In an example in the exhibition (fig. 15), the motif is repeated around the tripod vessel circumference, alternating with panels depicting jade roundels with eye motifs. In Aztec times, the "plumed serpent" was a metaphor for wind and storms, and a similar meaning may well be intended in the group of ideographs on the Teotihuacan vessel. Coyotes often represent the military and sacrificial aspects of life. A unique mural in the De Young Museum, San Francisco, which depicts two coyotes killing a deer, is a slice

Fig. 10 Drawing of a priestly warrior carrying darts in one hand and a heart on a sacrificial knife in the other, from a mural in the Atetelco compound. Mexico, Teotihuacan, c. 500. Drawing: Kubler, 1967, fig. 13.

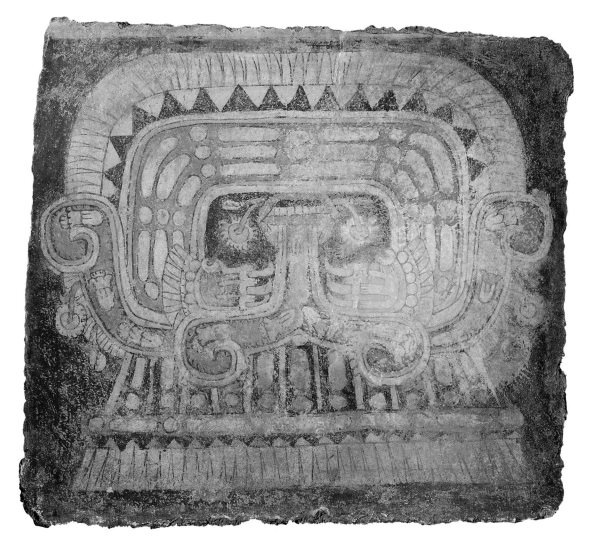

Fig. 11 Mural fragment depicting glyphic emblem of the water cult. Mexico, Teotihuacan, c. 500. Fresco. James W. and Marilynn Alsdorf Collection, Winnetka, Illinois. (Cat. no. 248)

of natural history that is also a metaphor for sacrifice. By showing it as taking place in the natural world, the social practice of sacrifice is given cosmic justification.

The people of Teotihuacan, living in the largest and densest metropolis of Mesoamerica at that time, evoked images of nature for nearly all of their activities that were manifested in art. This suggests that the elite were successful in creating a mythic vision in which Teotihuacan, rather than going against nature (and, perhaps, earlier tradition), was, in fact, more in harmony with the cosmos than in earlier times. This greater harmony was available to them because of new sources of scientific and divinatory knowledge. This

is not unlike the processes involved in religious heresies such as Protestantism, in which the reformers argued that their innovations were closer to an original truth. The Protestants claimed a more precise reading of the Biblical text than that offered by Catholicism. Teotihuacan seems to have gone to great lengths to demonstrate that it was closer to the "text" of nature than any other culture. While the Maya and, later, the Aztec invoked "history" as their model of the universe, Teotihuacan invoked "nature."

Besides suppressing political imagery, Teotihuacan developed an abstract and ornamental style. This style appears cool and distant in contrast to Olmec, Maya, and Aztec

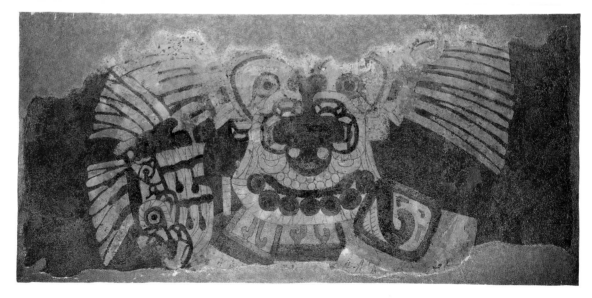

art, which draws us in by its realism or horrific detail. The effect of this neutrality is to suggest a cosmos of impersonal laws, outside the control and feelings of men. At Teotihuacan, a faceless, depersonalized elite (see fig. 14) ruled by appearing to carry out the various laws of the cosmos, rather than acting through its own capricious luck, individual will, or abilities.

I am not suggesting that Teotihuacan had a cynical elite, deceiving the ordinary man by the appearance of selflessness. Most likely, there was once an elaborate Teotihuacan mythology, enacted in ritual and represented in art, that was believed perhaps as much on the top as on the bottom of the social scale. The fact that Teotihuacan as a city and a society lasted for over seven hundred years is eloquent testimony that this model of integration was highly successful.

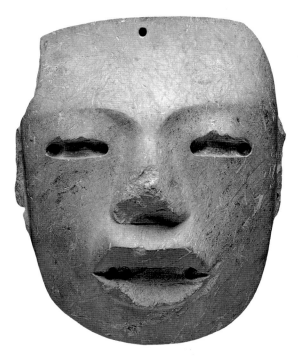

Fig. 14 Ritual mask. Mexico, Teotihuacan, 450/750. Stone. Dallas Museum of Art. Generalized features and planar surfaces are characteristic of Teotihuacan masks, which have been found in funerary contexts and are often depicted in murals as part of ritual assemblages. (Cat. no. 252)

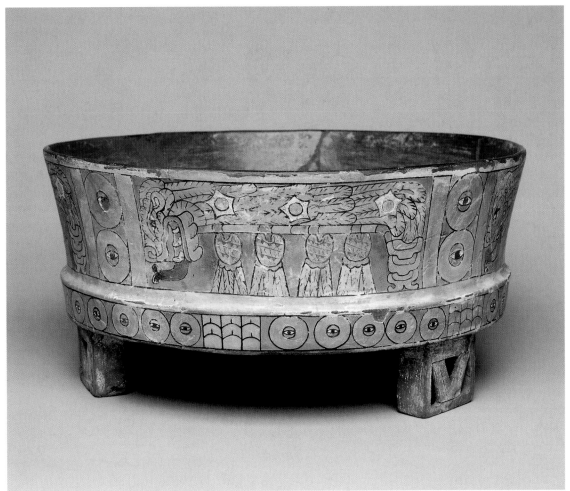

Fig. 15 Tripod vessel depicting plumed serpent. Mexico, Teotihuacan, 600/750. Ceramic. The Cleveland Museum of Art. A metaphor for wind-borne rain, the plumed serpent is one of the most ancient and persistent images of Mesoamerican civilization. (Cat. no. 251)

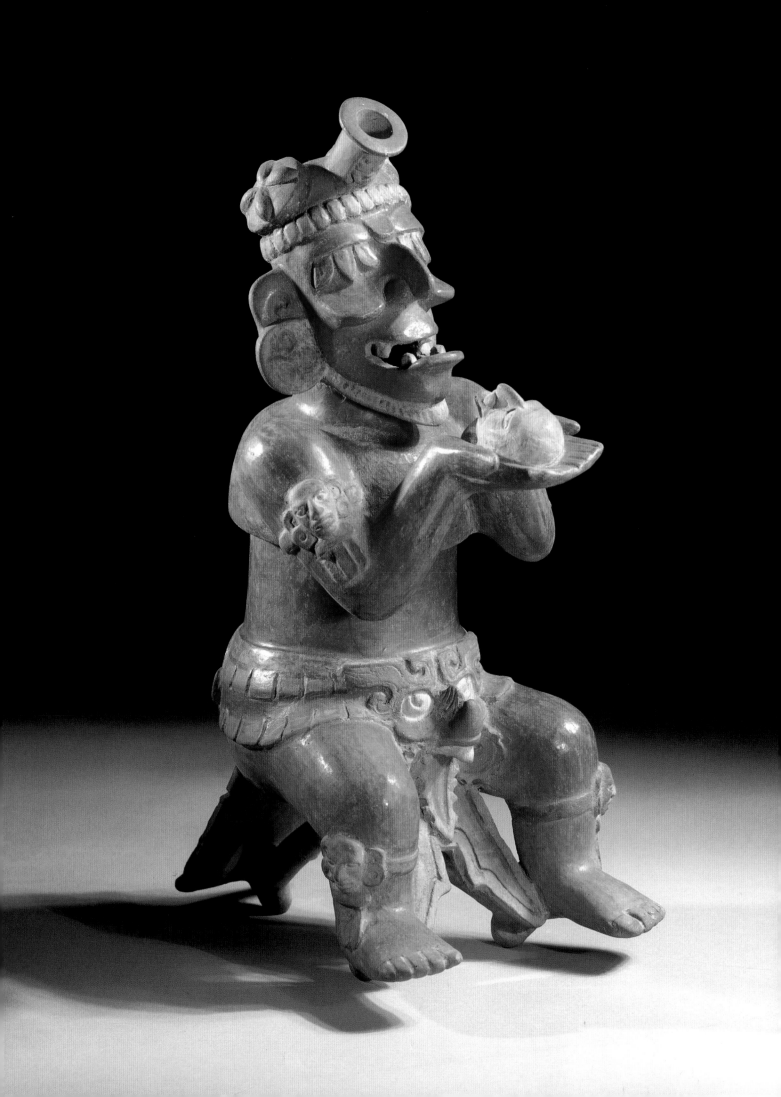

THE BEGINNINGS OF PRECLASSIC MAYA ART AND ARCHITECTURE

For generations, archaeologists have tried to determine just when ancient Maya civilization emerged and what that period of emergence meant to the later, fully developed Classic period (250–900). Early in this century, archaeologists did not expect to find buildings that predated the presence of Maya hieroglyphic inscriptions on stone, and, perhaps as a result of their intellectual expectations, they found few clues to the rise of civilization and the formation of an ethnic and cultural identity. But, especially in the last twenty years, with both deeper archaeological excavations and a re-examination of general notions about the Maya, a new and earlier level of Maya civilization has appeared, particularly at El Mirador, Tikal, Uaxactún, Cerros, Lamanai, Kaminaljuyú, El Baúl, and Izapa.

What we now see is that all across the Maya region, from the Guatemalan highlands to the lowlands of Guatemala and adjacent Mexico, Belize, and Honduras, during the period archaeologists call the Late Preclassic (250 BC to AD 250), nascent Maya civilization took form. Archaeologists have found that an intensified agriculture in both highlands and lowlands was linked to other technological advances, the growth of an economy, and a religion that encouraged a complex political and social order. Populations grew exponentially, and, during the Late Preclassic, the sociopolitical organization that ruled in later times began to take hold. From highlands to lowlands, strong culturally interactive and unifying contacts stimulated ideological changes in the entire area.

None of these phenomena is simple, nor are there simple explanations for profound local and regional differences. In the highlands, free-standing stelae appeared. (They had also been used by the earlier Olmec civilization; see de la Fuente essay in this book.) The stelae carried different sorts of information at various sites. In the lowlands, massive pyramids with elaborate stucco masks provided the primary format for recognition of new ideas and symbolic forms being used to create a social order of increasing specialization and stratification. What we may be seeing is that diverse elements, often not present at the same place or time during the Late Preclassic, came together by Classic times to form a unified idiom. Our goal here is to explore the meaning, function, and emergence of that template.

Preclassic Maya Architecture

By Classic times, a distinct and defined architectural style characterized the Maya region, but, during the Late Preclassic, innovative elements were often used, establishing the limits and canons of form and volume. During this period, Maya architecture began both to take its familiar physical shape, in massive platforms, free-standing pyramids, and galleried structures, and to carry cosmological themes that later determined many key features of Classic-period monuments.

In general, the first Maya settlements in both highlands and lowlands were established on higher elevations, frequently with attention to natural topography. This is true even from the first evidence of small-scale stone buildings in the Middle Preclassic (900–250 BC) at certain central lowland sites, such as Uaxactún and Tikal. By Late Classic times, such a concept reached exaggerated proportions at Tikal, where white-stuccoed causeways called *sacbes* linked islands of clustered, towering constructions on higher ground. Seen from a distance, these

Fig. 1 Fire-god effigy censer. Guatemala, Maya, Petén, Tikal, 350/450. Ceramic. Museo Nacional de Arqueología y Etnología, Guatemala City. Photo: Justin Kerr. The Old Fire God is counted among the oldest Mesoamerican deities, with imagery rooted in Preclassic times. This censer of early Classic date was excavated in a royal tomb in the North Acropolis at Tikal. As a lord of the underworld land of the ancestors, he sits on a stool with femur-shaped legs, and a skull is carved on the smoke spout protruding from his head. The deity also has symbols associated with the sun on its nightly sojourn below the earth's surface: sun emblems on his head, a solar beard, trident eyelids over blind eyes, and night-jaguar spot on his ear flares. He offers a human head as a sign of his link with the dead. (Cat. no. 139)

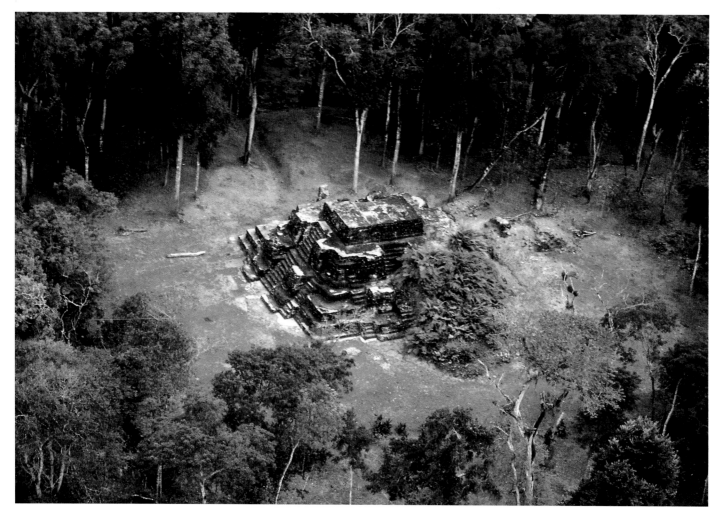

Fig. 2 Aerial view of
Pyramid E-VII-Sub.
Guatemala, Maya,
Uaxactún, c. 200 BC.
Photo: Nicholas Helmuth.

Late Classic pyramids function as symbolic mountains, beacons to be read from far and wide (see fig. 5).

Like Mesoamerican builders everywhere, the Maya superimposed a new building over an older, abandoned one. This process naturally yielded higher and larger buildings over long periods of time, although new and dramatic buildings, which did not envelop earlier efforts, were also erected occasionally. Inevitably, archaeologists recover older, almost intact buildings from within visible structures that have fallen to ruin. In the 1920s and '30s, the archaeologists who studied Uaxactún Structure E-VII likened it to an onion, as they peeled away layer after layer, revealing at its core the building known today as E-VII-Sub, a structure we can now include as a striking example of Preclassic architecture (see figs. 2, 3). In this way, buildings were like the layered strata of the earth itself—a phenomenon the Maya must have seen in cuts eaten away by rivers in the rainy season.

Just as natural topography helped form the layout of Maya sites, so materials shaped the appearance of finished buildings. Geology played a role, for the highlands are composed

primarily of basaltic stone, whereas the lowlands are of limestone. Hard, dense basalt cannot be easily quarried or transported, while vast quantities of light limestone can be more easily moved. As a result, few Preclassic structures in the highlands rose over ten meters, while some lowland buildings reached spectacular heights, at El Mirador the fifty-five-meter Tigre Pyramid and the forty-meter Monos Pyramid (see fig. 4), and at Tikal the thirty-meter Great Pyramid in the Mundo Perdido quadrangle. Lowland limestone was found to be useful not only for the construction of buildings but also for the raw material for making lime, the main ingredient of mortar and stucco. The Maya plastered their buildings inside and out and modeled large stucco figures and masks on the facades of primary religious structures.

The placement and order of buildings seen throughout ancient Maya civilization also have roots in the Preclassic period. Central civic and religious structures were united around, first, a courtyard, and later, a plaza, frequently with orientation to specific cardinal points, mainly east and west. Such initial groupings eventually gave way to the sort of arrangement seen in Late Classic

Tikal, where Temples I and II, lying along an east-west axis, bracket ancestral Early Classic tombs in the North Acropolis, which has the same axis (figs. 5, 6).

The sites of Tikal and Uaxactún have revealed two groupings of Preclassic buildings that clearly had specialized functions: Astronomical Commemoration complexes and Acropolis groups.[1] Astronomical Commemoration complexes have been reported in many sites, including Yaxha, Xultún, Naachtún, Balakbal, Yaxhuná, and Ixkun, but only those at Tikal and Uaxactún have been investigated in depth. These complexes comprise a radial-plan pyramid on the west side, with steps on all four exposures, as at Uaxactún E-VII-Sub (fig. 2), while the east side is formed by a long platform supporting three small structures or temples that face west, where the pyramid stands. The Uaxactún Astronomical Commemoration complex bears an orientation to true north, and, from the pyramid steps, accurate observation of the solstices and equinoxes can be made. Although all such complexes used to be called

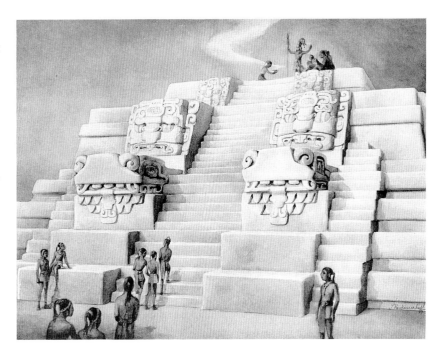

"observatories," that term has been discarded, because the other complexes have varying orientations. Some of the other complexes may celebrate the completion of a solar cycle or ceremonies of New Fire that began the cycle of fifty-two years (see Aveni essay in this book).[2]

While these astronomical buildings refer to time and space, the Acropolis groups have different forms and functions. On top of an enormous artificial platform, Acropolis structures frame a central courtyard to form an enclosed plaza (see fig. 5). Examples have been discovered in various places in the Maya region, but especially notable are the North Acropolis of Tikal and Group H at Uaxactún, with constructions dated to the Late Preclassic period.

Fig. 3 Reconstructed view of Pyramid E-VII-Sub at Uaxactún, showing stucco masks characteristic of Preclassic temple architecture. Guatemala, Maya, c. 200 BC. Drawing: Proskouriakoff, 1946, p. 5.

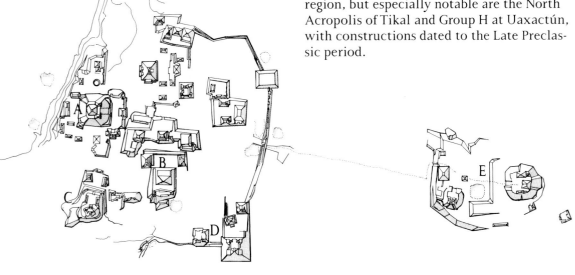

Fig. 4 Plan of Preclassic El Mirador. Guatemala, Maya, c. 200 BC. Drawing: Carlos Fuentes Sánchez. The site is dominated by the huge El Tigre pyramid, rising eighteen levels from the surface of the Central Plaza.

Legend
A. Tigre Complex
B. Central Acropolis
C. Monos Complex
D. Tres Micos Complex
E. East Group

0 300 ft
0 1000 m

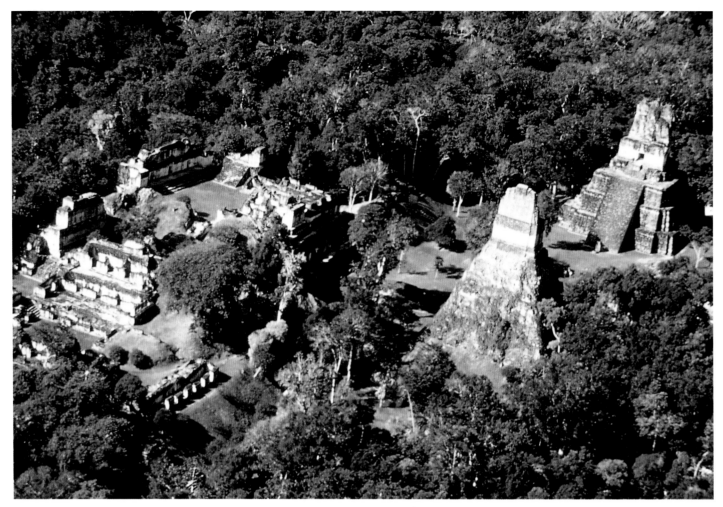

Fig. 5 Tikal, showing
Temples I and II. Guatemala,
Maya, c. 700. Photo:
Nicholas Helmuth. The
Central Plaza and the
Central Acropolis contain
major pyramids with the
tombs of Late Classic
dynastic rulers.

The Acropolis buildings are either stepped pyramids or ranging galleries, the latter usually considered "palace-type" structures. Sites with active, growing Preclassic populations, such as Cerros in Belize or El Mirador, Guatemala, feature palaces with stone walls that supported roofs of straw or palm thatch.[3] Excavations at the North Acropolis of Tikal, on the other hand, revealed small palaces in which it was still possible to see the remains of limestone corbel vaulting dating from the first half of the first century BC.[4] An especially clear example of the architecture of this period was found in the South Plaza of Group H at Uaxactún during the excavations of 1985, where, among the completely intact buildings, were various "palaces," a roofless precinct or enclosure, and a three-tiered pyramid occupying the dominant position as the highest building of the group. This pyramid lies east of the group, and its principal facade faces the west, the point of sunset, which was for the Maya the entrance to the underworld. The modeled stucco grotesques on the front of this building (H-Sub-3) depict deities related to the underworld and the heavens, demonstrating the importance of this building, not only for its makers but for the formation of Maya ideology.[5]

Contrary to what Mayanists long thought—that corbel vaulting and Initial Series hieroglyphic inscriptions began together around AD 250—the findings at Uaxactún and Tikal confirm that the Maya knew how to build the stone corbel vault from at least the first century BC. The construction of corbel-vaulted palaces brought about a new architectural design, that of rooms connected by small doors, frequently with openings to admit air and sunlight. Thick coats of stucco plaster smoothed the surfaces of roughly hewn stones. Vestiges remain of important sculptures and mural paintings, both of which occupied prominent spaces in public view and related directly to the religious and hierarchical aspects of the administrative center.

Each of these developments led to a more codified, widespread, and systematic use of architecture during the Classic period. Preclassic architects experimented with technological advances, achieving buildings and spaces that Classic architects would exploit

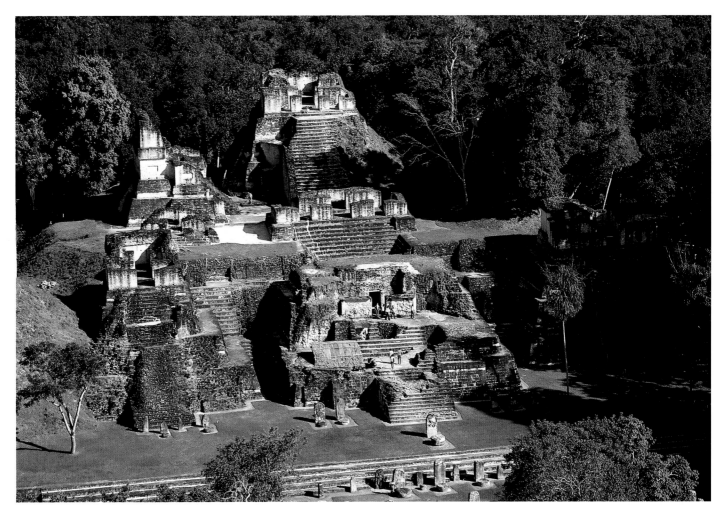

more systematically. As time went on, the social hierarchy and its ritual activities commanded more specialized forms and groupings of buildings. Eventually, experimentation gave way to standardized use.

Preclassic Maya Sculpture

During the Late Preclassic period, Maya culture attained a new height in artistic expression, especially in ceramic objects and stone and stucco sculpture that reflect cosmological and mythical themes (see figs. 1, 8). Perhaps even more obviously than Preclassic architecture, Preclassic sculpture bears most of the elements of Classic sculpture, but rarely all in a single piece or even at a single site.

The geographic expansion of the Preclassic inhabitants into varying ecosystems inspired a development of technical knowledge in agriculture and the increased exploitation of natural resources, leading first to regional trade and, later, to long-distance trade. All of this must have been accompanied by changes in the internal social scheme, yielding at last to the royal institution of kingship

so obvious in Classic art and writing. Along with population growth, these changes were surely determining factors in the appearance of imposing ceremonial centers that indicate a more complex social and religious organization than in previous times. Construction of the new building forms gave impetus to changing religious ideas, leading to increasingly more complex cults, and inspiring, in turn, the erection of stone monuments and large-scale, grotesque stucco facade figures.

Given the archaeological findings, it is probable that the rulers of the lowlands and highlands developed new ideological forms simultaneously. Although both regions employed iconographically complex symbolic systems, their methods of using art as elitist or ideological propaganda were completely different. The highland people may have been earlier in initiating stone sculpture and may have drawn on both formal and religious concepts expressed in much older Olmec art (1200–600 BC), as can be seen in some of the monuments of Abaj Takalik and Izapa on the Pacific slopes. Echoes of the three-dimensionality of that earlier art can be found on

Fig. 6 Tikal Acropolis. Guatemala, Maya, 200 BC –AD 800 . Photo: Nicholas Helmuth. The superimposition of temples reflects some nine hundred years of ceremonial activity. Commemorative stelae of successive rulers stand in the plaza below; others are buried within the structure.

certain monuments of coastal sites and at Kaminaljuyú in the highlands. But, by the beginning of the Classic period, the highland population ceased to produce much public art; at the same time, that of the lowlands adopted the practice of erecting historical stelae with written inscriptions, a practice more common in Preclassic times in the highlands. By the time the lowland people adopted the stela, the sort of information it carried had been standardized.

Through most of the Preclassic period, the art of the Pacific coast and the highland plain of Guatemala emphasized the erection of stelae and monuments carved from basalt to show major historical events and royal lineages through pictorial narratives and rituals.[6] Kaminaljuyú Altar 10 (fig. 9) shows an important personage with royal Maya dress and ornaments, including ear flares, headdress, elaborate belt, collar, and feather cape. He raises his arm in a triumphant gesture, his hand bearing a decorated, hafted axe. A second person, of lesser rank, appears in the lower part of the scene, while at the top left is the head of an important deity. A carved

Fig. 7 Drawing of Stela 11. Drawing: Carlos Fuentes Sánchez.

Fig. 8 Priestly ruler (Stela 11). Guatemala, Maya, Kaminaljuyú, 250 BC/AD 100. Stone. Museo Nacional de Arqueología y Etnología, Guatemala City. Photo: Stuart Rome, courtesy of the Albuquerque Museum. Standing between incense burners on a place-glyph, a lord is attired as a bird-deity with a baton and hafted axe. The stela is related to accession monuments of the following Classic period. (Cat. no. 133)

Fig. 9 Drawing of Altar 10. Guatemala, Maya, Kaminaljuyú, 250 BC/AD 200. Museo Nacional de Arqueología y Etnología, Guatemala City. Drawing: Carlos Fuentes Sánchez.

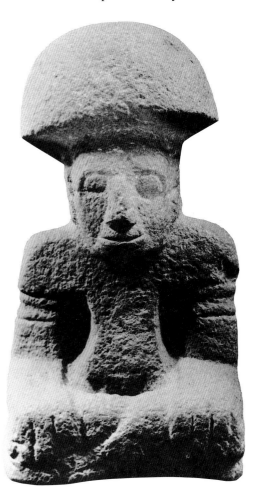

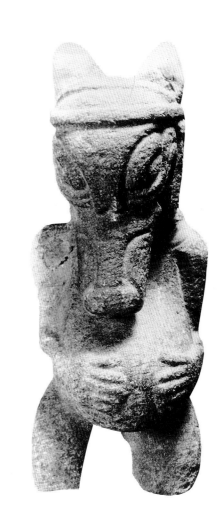

Fig. 10 Anthropomorphic mushroom figure. Guatemala, Maya, Highland region, c. 200 BC. Museo Nacional de Arqueología y Etnología, Guatemala City. Photo: Juan Antonio Valdés.

Fig. 11 Pregnant coatimundi figure. Guatemala, Maya, Kaminaljuyú. c. 200 BC. Museo Nacional de Arqueología y Etnología, Guatemala City. Photo: Juan Antonio Valdés.

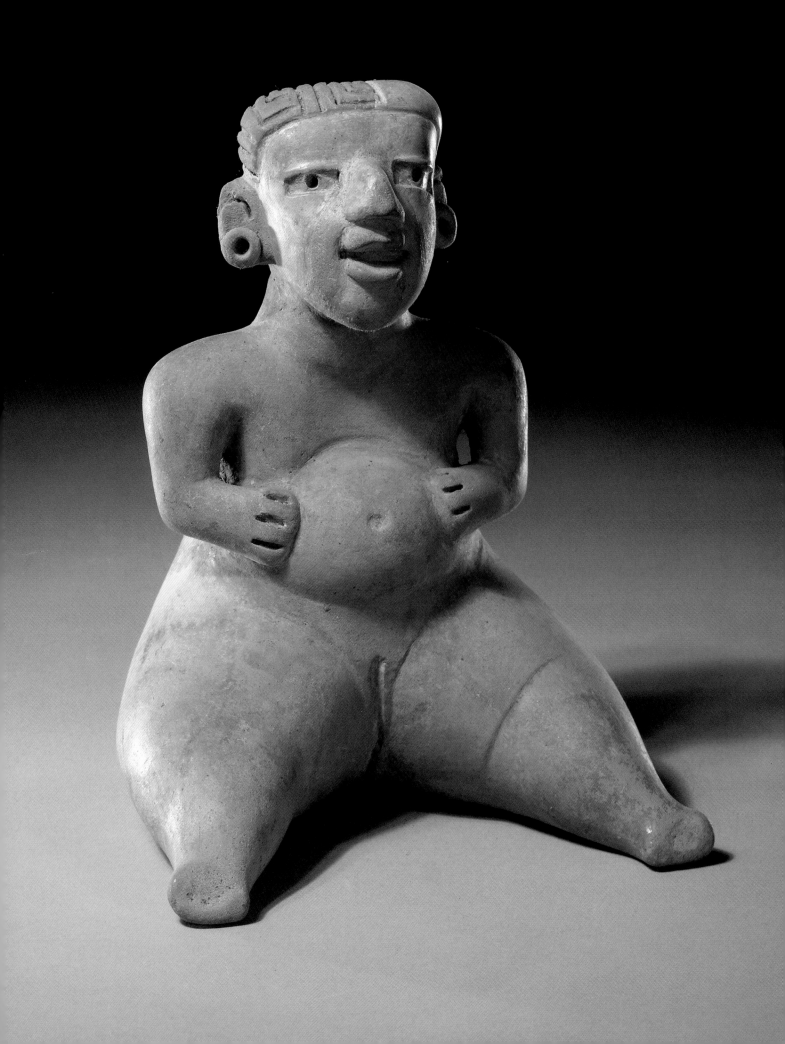

design of woven matting frames the scene, symbolizing nobility; it is probably an early reference to what later became an epithet of the ruler, "he of the mat" (that is, he who sat in a special place). On Kaminaljuyú Stela 11 (figs. 7, 8), a noble lord holds the same sort of axe. Completely masked by the great bird-deity suit he wears, the noble stands on what is probably the glyph for an early place name, likely a reference to a sacred mountain at or near Kaminaljuyú. The stelae of Abaj Taka-lik, El Baúl, and Kaminaljuyú show that, during the Late Preclassic period, a range of purely local elements accompanied the main protagonists, deities, and supernatural elements depicted in the scenes. Many of these monuments bear hieroglyphic inscriptions, but only calendrical information has been deciphered so far; it may be that these texts represent local languages.

In fact, the hieroglyphic writing may be the clue to the eventual unity seen at the beginning of the Classic period, for the topography of the Maya region did not lend itself to easy interregional exchange. Once a standard script was established, ideological concepts might have been more easily shared in correspondence than in person. This standardized script seems to have had its greatest impact on the lowlands, where it was widely used to convey information on public monuments.

Two distinct sculptural forms developed in the highlands but rarely appear in the lowlands: small, female, clay figurines (see fig. 12) and the so-called "mushroom" stones. The pronounced bellies of the nude female figures identify them with a fertility cult. The Maya linked human maternity and fertility with procreativity in general, especially with regard to the earth, the mother of nature and progenitor of plants. Animals, too, shared the meaning of abundance and fertility, as can be seen in the figurine of a coatimundi that holds its large belly in its hands (fig. 11). The "mushroom" stones may have an association with fertility as well, because of their phallic appearance, but their purpose or meaning is not known. They occur in great number and diversity, from the simplest natural mushroom shape to compound sculptural forms that include the human figure (see fig. 10).

As long as Preclassic Maya architecture remained buried inside later buildings, Maya sculpture of the same period also was lost and hidden, leading some archaeologists to believe that the lowlands had a less refined and advanced artistic and cultural tradition than

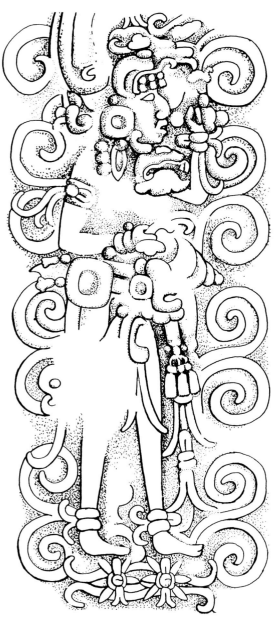

Fig. 12 Pregnant female ("Kidder Figure"). Guatemala, Kaminaljuyú, Maya, 250 BC/AD 100. Museo Nacional de Arqueología y Etnología, Guatemala City. Photo: Justin Kerr. (Cat. no. 134)

Fig. 13 Drawing of stucco panel from Structure H-Sub-10 at Uaxactún, depicting a ruler. Guatemala, Maya, c. 200 BC. Drawing: Richard Townsend. The volutes probably represent incense smoke. Items of costume are early expressions of a long tradition of royal attire.

the highlands. Recent excavations, however, have yielded evidence for a parallel cultural progression, showing the presence of sophisticated artistic expressions from the first century BC in many centers of the Petén and in Belize.[7] We now know, for example, that the lords of El Mirador, Nakbe, and other sites erected stelae in the Preclassic period. The human figures of Nakbe Stela 1 are similar to the stucco figures on Structure H-Sub-10 at Uaxactún and to painted figures on Structure 5D-Sub-10–1st of the North Acropolis of Tikal. The last two examples have been dated archaeologically to the first half of the first century BC; in all three cases, profile figures appear in the rich garb of Maya nobility.

Even the rituals of Classic kingship seem to have been in place in earlier times. The rulers who held political and administrative power during the Late Preclassic were enthroned in the above-mentioned Structure

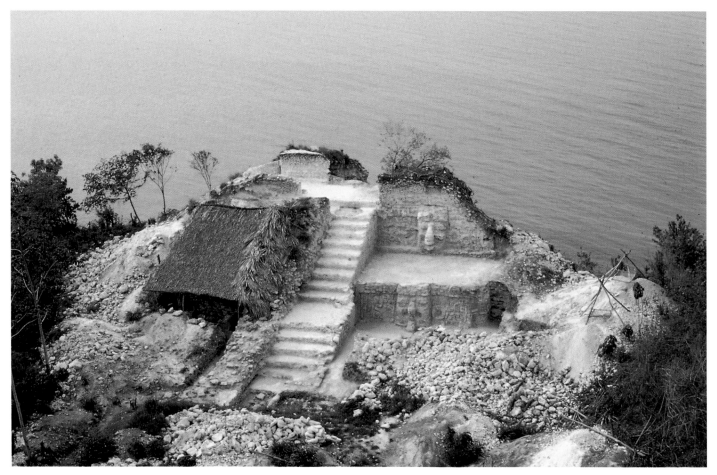

Figs. 14, 15 The terraced pyramid at Cerros. Belize, Maya, 250 BC/AD 200. Stucco masks personified the deified forces of the earth and sky, alluding to mythical origins of the world and royal lineages. Photo: David Freidel.

H-Sub-10 at Uaxactún, a small enclosure built within an Acropolis ensemble. Portrayed here are various personages wearing emblems of the ruling class (fig. 13) and marked by modeled stucco spirals of smoke or blood. Red, black, and yellow were used to color the human figures, and, as with other representations of Maya Preclassic rulers, each displays a raised arm bearing an object. The fifth-century King Stormy Sky of Tikal may have been recalling this gesture on his own monument, where he raises his headdress.

The ritual paraphernalia borne by these early kings proclaim their legitimacy, and later generations adopted many of the same elements. On the stucco figure from H-Sub-10 at Uaxactún, the emblems include ear ornaments and a headdress with a long-nosed, zoomorphic head. An important emblem was a belt assemblage with a large head at front, usually representing either an *ahau* (the glyph for "lord"), the Sun God, or the Jaguar God of the Underworld (the sun at night). From this head hangs an apron panel with three connected stone axes, to which are attached long, bifurcated plumes, reaching almost to the feet. The belt assemblage, including the three plaques, is one of the most important royal vestments of Mesoamerica; it can also be seen in the sculptures of Oaxaca, the Pacific coast, and highland Guatemala. Although sometimes retained as heirlooms within royal lineages, these belt assemblages have been discovered archaeologically from time to time, most notably in the tomb of King Pacal of Palenque, who died in 683.

In many sites of the lowland were constructed Preclassic buildings of major size and majesty that included for the first time facade sculpture on pyramids and stucco friezes with figures of deities on the upper portions of palace walls. At Uaxactún, El Mirador, and Cerros, among other sites, archaeologists have discovered great grotesque masks flanking staircases (see figs. 14, 15). Constructed over an armature of stone, these ritual symbols were then stuccoed and

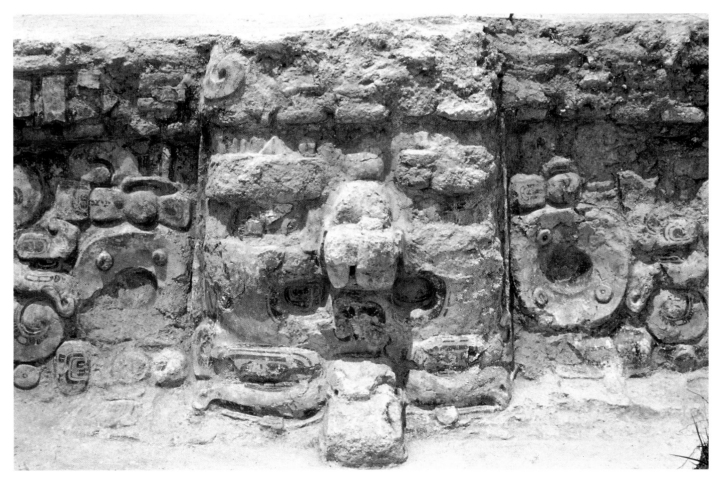

painted with bright colors to lend them prominence and importance. These masks generally depict the principal protecting deities of the Maya, among which the Sun God and the Jaguar God of the Underworld received preferential placement. One Uaxactún facade also displays giant *wits* monsters, personifications of the earth, from which all beneficence emerges. In these facades, the fundamental powers of the Maya world received their due, proclaimed in a public format. The grotesques wear the same royal vestments as human rulers, which have iconographic motifs that indicate the highest levels of power, among them the Jester God and the Vision Serpent, icons of royal ritual in Preclassic and later iconography.[8]

These friezes and grotesques came to constitute a form of propaganda employed by local rulers in the lowlands to proclaim the ancient origin and divine provenance of their lineages. In this way, the community was shown these gods and cosmological figures through a new form of artistic expression that depicted the mythic origins of the deities as well as those of the rulers who enjoyed their protection. By Classic times, the rulers began to wear these deity heads, as if to demonstrate the great power vested in the secular rulers and to confirm the identification between the rulers and their gods.

Conclusion

The evolution of architecture and sculpture as public art took place during the Preclassic period throughout the entire Maya area. The Late Preclassic period was a time of experimentation with and exploration of various forms of Maya concepts, leading, at its end, to their unification and expansion at the beginnings of the Classic period. During this era, the Maya imbued their symbolic system with the connections of their rulers to supernatural powers of the sky, earth, and underworld. This period saw the establishment of a culture that would continue to develop knowledge and power during the next centuries of the Classic Maya world.

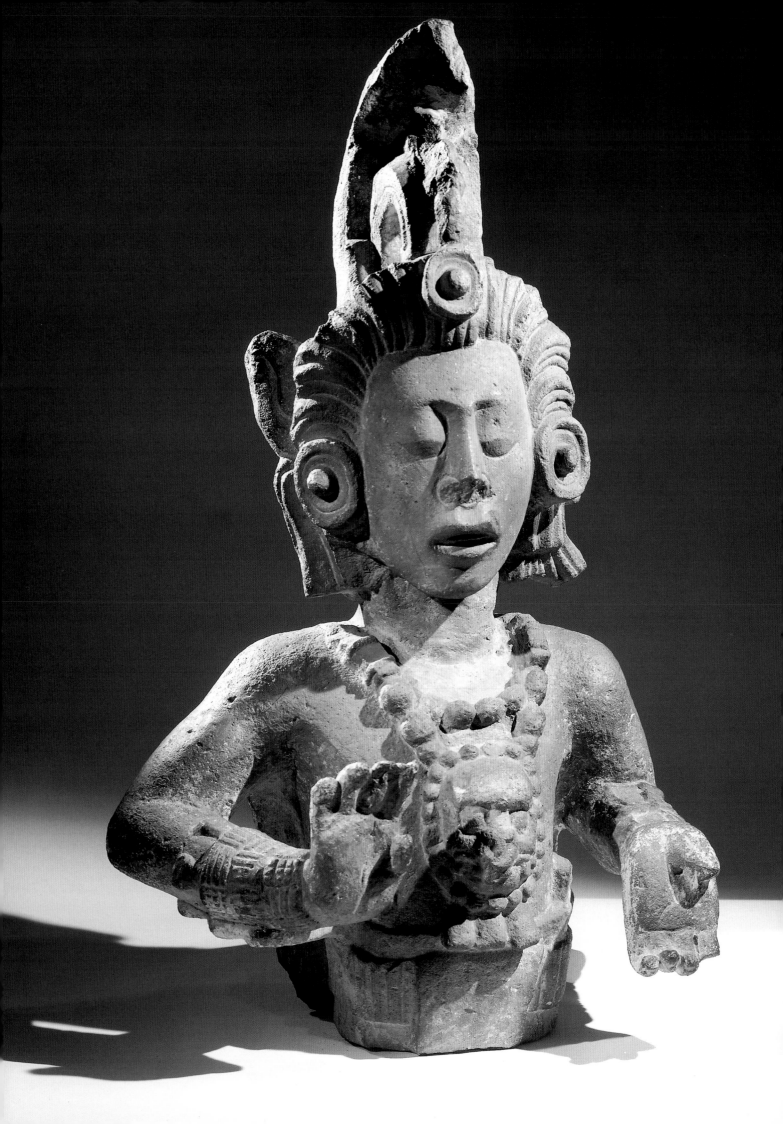

THE IMAGE OF PEOPLE AND NATURE IN CLASSIC MAYA ART AND ARCHITECTURE

In the long darkness before creation, the Maya gods pondered the dawning of a new age and the making of a people who would honor them. The gods sought yellow corn and white corn; for, as the Maya later wrote in a sixteenth-century narrative, the *Popol Vuh*, "These were the ingredients for the flesh of the human work, the human design."[1] The maize was ground with water to yield flesh and blood. The gods had tried to create humankind before, but their first attempt at creation, the animals of the earth, could not praise their makers. When the gods formed humans of earth, they collapsed as mud; when the gods carved humans out of wood, the forms looked like people, but they could not worship the gods, and so the gods destroyed them. The gods succeeded in populating the earth only when humanity was shaped from maize, the staff of human life.

We know that this was a Maya belief at the time of the Spanish conquest of the New World, but the Maya had held this to be true for generations, perhaps for more than two thousand years before the conquest, from the beginning of the rise of high civilization, when we first find the Maya confirming such beliefs through works of art that gave permanent form to their beliefs. From the start of Maya recorded time, in the first millennium BC, the cycle of maize, the cycle of seasons, and the cycle of life guided the understanding of the world shared by king and peasant, man and woman, victorious warrior and humiliated captive, hunter and hunted.

Accordingly, humankind held maize to be sacred. During Classic times (250–900), the Maize God figured prominently in Maya art (see fig. 2).[2] Recognized as young and beautiful, the image of the Maize God was emulated by Maya lords, many of whom donned his attire. Handsome young faces—multiple maize gods—formed ears of maize, their luxuriant tresses creating the corn silk, a strand for every kernel. In nature, maize plants sway to and fro, their crisp, green leaves moving like limbs of the human body; the Maize God, too, is in motion, often seeming to dance and sway (see figs. 1, 3, 4, 5). The Maize God wears an enormous rack on his back on which small creatures are wedged into a mat-and-feather frame; he often dances in the company of a tiny dwarf or hunchback. Usually attired in a netted hip-cloth or skirt, perhaps strung with green jade beads, the Maize God also characteristically wears a carved *Spondylus princeps*, or spiny

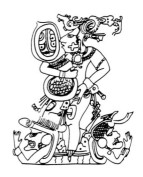

Fig. 1 Young Maize God. Honduras, Maya, Copán, Temple 22, c. 775. Stone. The Trustees of the British Museum, London. Photo: Justin Kerr. Idealized portraiture, ritualized gestures, and a sense of contemplation lend the figure personifying maize a profound emotional appeal. (Cat. no. 132)

Fig. 2 Detail of vessel depicting emergence of the Maize God. Maya, c. 500. Drawing: Taube, 1985, fig. 6a.

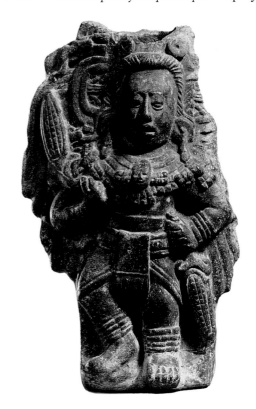

Fig. 3 Figurine of ruler dancing with maize. Guatemala, Maya, Alta Verapaz, 600/900. Ceramic. Museo Nacional de Arqueología y Etnología, Guatemala City. Photo: Justin Kerr. The Maize God dances as "mother-father"— a primary source of human life. (Cat. no. 145)

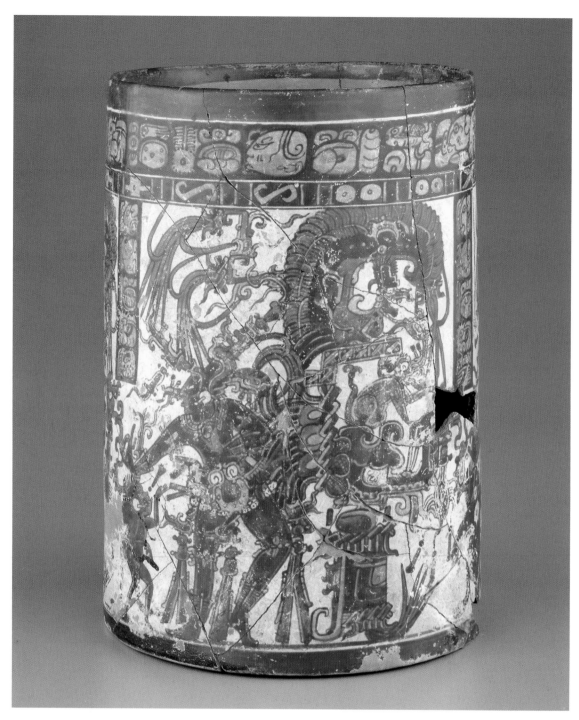

oyster, shell, concave face outward, at the groin. These bright-red shells give the wearer a symbolic vagina. In this attire, the Maize God is both male and female, progenitor and progenitrix, what the modern Maya might call a "mother-father."[3]

Like maize itself, the Maize God moves through the cycle of life: in one season, he is a handsome young man, alive and in motion; in another, he is decapitated, his harvested head put on a plate as an offering. The first fruits of succulent green corn and the mature, dried maize were presented at agricultural festivals in special vessels that celebrated the cycle of maize. Such containers

were often decorated with hieroglyphic texts alluding to maize; the "Seven Kan Vessel" (*kan* is a Maya word for maize) displayed in this exhibition is an example (fig. 11). Ground into *masa* (corn) and formed into tamales (corn cakes) and tortillas (corn pancakes), maize nourishes and sustains humankind, but humans return some seeds to the ground to start the cycle anew. The barren earth yields to the forces of regeneration: the young Maize God emerges once again, ready to dance to the tune of life.

Humankind supported and acknowledged this cycle of renewal and regeneration. Many Maya rituals imitated the actions of the

natural world. When the king or queen of a Maya city donned the attire of the Maize God, he or she became the Maize God, the source of fertility, the very flesh of all humanity—and many Maya rulers chose to be commemorated as the Maize God. On Dos Pilas Stela 17, for example, King Flint Sky appears as God K, and also wears the richly detailed back-rack assemblage of the Maize God as well as attributes of other deities (see fig. 5). Maya lords became one with the gods in whose costumes they dressed: as the Maize God, the king was giver of life and renewal; he himself ensured future fertility.

Although much of the realm inhabited by the Classic Maya lies far from mountains, and the most dramatic topography visible from the great cities is no more than hills, the Maya shared the Pan-American notion of the sacred mountain. To them, such a mountain was the source of sustenance, the source of maize. In Maya writing, sacred mountains took the form of the *wits* (also *vits*) glyph (fig. 6; see also Vogt essay in this book).[4] The Maya formed mountains with their temples and palaces (see Valdés essay in this book, fig. 5). These fabricated sacred mountains encompass tombs of noble ancestors, who became deified and continued to function in the afterlife as intermediaries between Maya society and the regenerative forces of nature. Jade was a featured material in these royal tombs, for it was the color of water, of maize, and of the tail plumes of the regal quetzal bird. Jade also embodied a sense of permanence in this world and in the hereafter. The jade mosaic urn in this exhibition is almost certainly a portrait of "Ruler A," the Maya king who was buried beneath Temple I at Tikal (fig. 13).

The Classic Maya oriented their buildings to any powerful topographic feature, thus channeling the power of nature into human architecture. In Classic-period inscriptions, the Maya described their structures—buildings that we may call shrines, temples, or palaces—as special kinds of "houses," or *na*, of one sort or another. In architecture, however, they created interiors and exteriors that formed symbolic caves. Many such sacred chambers were dedicated to the earth and conceived of as the stone hearts of mountains, places of regeneration for maize.

At Copán, Structure 22 formed a great manufactured sacred mountain (fig. 8).[5] The essence of stone and earth, any live rock formation or anything made of stone, even a sacred mountain, could take form as the Cauac Monster, the personification of the

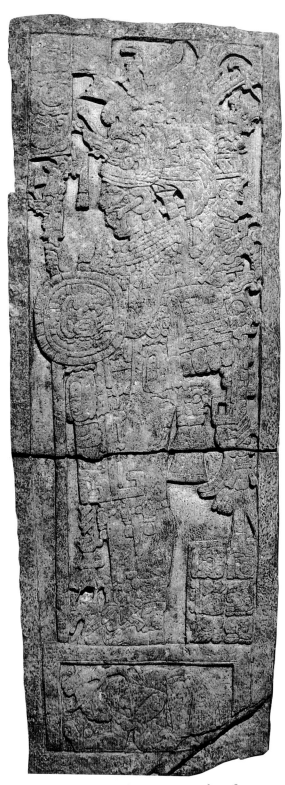

Fig. 5 Fragment (Stela 17). Guatemala, Maya, Petén, Dos Pilas, c. 810. Stone. Museo Nacional de Arqueología y Etnología, Guatemala City. Photo: Ian Graham. The bottom panel, originally photographed in the field, has since disappeared and may have been destroyed. (Cat. no. 140)

Fig. 6 Drawing of *wits* glyph. Honduras, Maya, Copán. Drawing: David Stuart. This glyph is a logograph for "hill" or "mountain."

wits glyph. Seen in its most complete form, the Cauac Monster is a frontal, craggy, and usually cleft zoomorphic head, from which maize foliage and fruit may emerge. Stacks of Cauac Monsters formed the corners of Structure 22, and rows of them ran along the cornice; richly three-dimensional young maize gods sprout from the cleft heads, silhouetted against the sky and seemingly swaying to and fro (see fig. 1). The approaching supplicant could have seen it all from a distance.

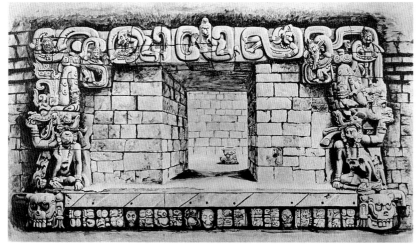

Fig. 7 Reconstruction of interior doorway of Structure 22. Honduras, Copán, c. 750. Drawing: Maudslay, 1889–1902, I, pl. 12.

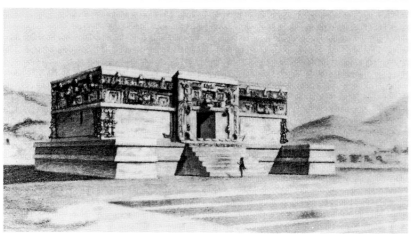

Fig. 8 Reconstruction of Structure 22. Honduras, Copán, c. 750. Drawing: Tatiana Proskouriakoff, in Trik, 1939, frontis.

Fig. 9 Drawing of Stela 11. Drawing: Linda Schele, in Schele and Miller, 1986, p. 112.

Fig. 10 Stela 11. Guatemala, Maya, Piedras Negras, 731. Stone. Photo: Maler, 1901, pl. 20. Ruler 4 of Piedras Negras is shown seated on a curtained scaffold, framed by a hieroglyphic sky-band. Above, a celestial bird sits upon a celestial monster, whose body is another sky-band. At the foot of the ladder to the throne, a sacrificial victim has been offered.

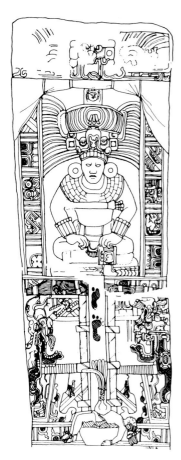

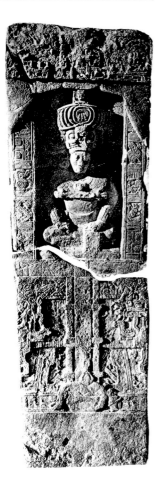

A great monster maw once formed the entrance to Structure 22. Anyone entering the structure would have stepped right into the gaping mouth, the heart of the sacred mountain (fig. 7). Teeth of the lower jaw protrude, and, in one's mind, they seem to close behind as one steps into the chamber. Once within the chamber, the supplicant faces yet another doorway, this time the entrance to a smaller, elevated space that may have functioned as a throne room. This second doorway is framed by *bacabs*, the pillars at the corners of the earth, which support a richly carved Celestial Monster, the very arc of the heavens, the diurnal path of the sun, as it is borne by Morning Star to its zenith and then delivered back to the underworld. The text that runs under the threshold tells us that King Eighteen Rabbit of Copán dedicated this building early in the eighth century. When he sat in this doorway, he was at the heart of the mountain, framed by cosmic movement.

What happened in a building like Structure 22? To become a king or to renew his kingship, a young man entered such a chamber and made sacrifices of human blood, but all Maya nobility offered blood—both that of captives and that from their own bodies—to nourish the earth and link themselves with their ancestors. A series of lintels from Yaxchilán shows Lady Xoc, wife of the powerful King Shield Jaguar, during and following bloodletting from the tongue. First, she ran a rope of thorns through her tongue and collected the precious flow on strips of paper in a bowl. Then, once she had set the paper afire, she saw a vision of an ancestor in the swirls of smoke in front of her (see fig. 12). Through bloodletting, Maya lords communicated with beings of the past and future, channeling their power into rulership. At Copán Structure 22, S-shaped blood scrolls form the body of the Celestial Monster, giving permanent architectural form to the scrolls conjured up by visions.[6]

Each king at Piedras Negras commissioned a monument to celebrate his installation as king, and these accession stelae reiterate the image of the sacred mountain (see figs. 9, 10). Each depicts the new king in a niche, sitting atop scaffolding draped with cloth, mats, and pelts, and framed by the body of a Celestial

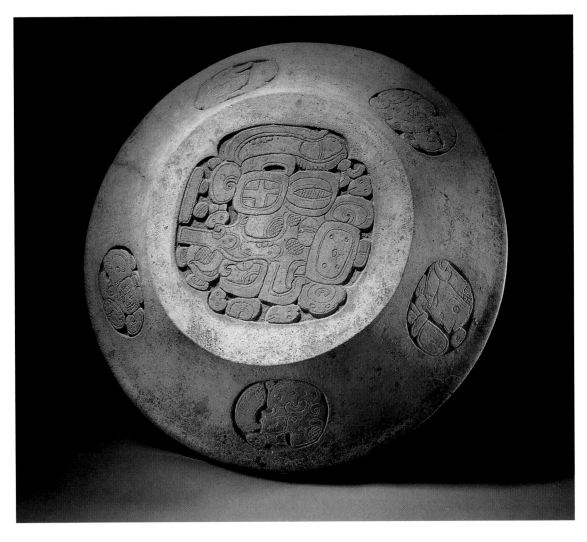

Fig. 11 Carved cache-bowl lid ("Seven Kan Vessel"). Guatemala, Maya, Petén, Tikal, Burial 132, c. 550. Ceramic. Museo Nacional de Arqueología y Etnología, Guatemala City. Photo: Justin Kerr. (Cat. no. 138)

Monster, whose two heads hang upside down, underneath the king. Some of the niche monuments include sacrificial victims; such victims may have been paraded about in the scaffolding and then slaughtered, before the king ascended to the niche. Seated in the elevated niche and framed by the Celestial Monster on the Piedras Negras stelae, the new king appeared in the same kind of frame created by the interior doorway of Copán Structure 22. Simply attired, these Piedras Negras kings may have sought identity with the young Maize God. On Stela 6 (see Aveni essay in this book, fig. 11), maize is stacked behind the webs of scaffolding—as if the scaffolding were also a granary—and issues forth from the very top of the king's headdress, demonstrating that the young king is the very matrix in which the plant can flourish. The slain captive at the base—on Stela 11 (figs. 9, 10), for example—fertilizes this growth. At the moment of inauguration, the king is the conduit for regeneration and the guarantor of plenty.

In the design of Copán Structure 22, we can see the workings of the symbolic sacred mountain, which was entered through the exterior monster jaws. Inside the rear chamber, framed by the Celestial Monster, members of the royal family drew blood, either their own or that of captives, to fertilize regeneration. Through a window at the back of this rear chamber, nobles gazed at rugged hills to the north, seeing both one summit and the sharp cleft to which so many of Copán's sacred buildings were oriented. When a noble emerged from Structure 22, he was like a kernel of maize brought from these sacred mountains. On the exterior of Structure 22, the Cauac Monsters tell us that the building was a manufactured mountain, a transformation of the mountains to the north, the fertile medium in which the Maize Gods at the cornice could thrive. At Tikal, the message was expressed in portable form: as a ceramic *incensario* (incense burner), the youthful ruler sprouts maize from his headdress as he sits upon a Cauac Monster throne (see fig. 17). Maya kingship was a conduit between earth and sustenance: maize sprouts from the heads of rulers in their portraits and from the cornices of temples, confirming in stucco and stone the fertility sustained by kingship, land, and mountain.

In Maya belief, the powers of regeneration and renewal held by the earth were sometimes opposed to the movements of Venus, Jupiter, the moon, or the sun. The sun may have been recognized as the most powerful natural force, given form both as the cross-eyed sun of the day (see fig. 14) and as the Jaguar God of the Underworld, the sun at night (see fig. 15). The sun formed rulers' thrones and shields to protect and guide them during war. Early kings adopted as the guise of rulership the awe-and-terror-inspiring image of the Principal Bird Deity, the false sun of the era just previous to the one in which we live (see Valdés essay in this book, figs. 7, 8); later kings perceived that the bird sat atop the World Tree, the *axis mundi*, or rested above the Celestial Monster (see fig. 19). The stars that we perceive as the belt of Orion or the feet of Gemini were also keenly observed and commemorated in works of art

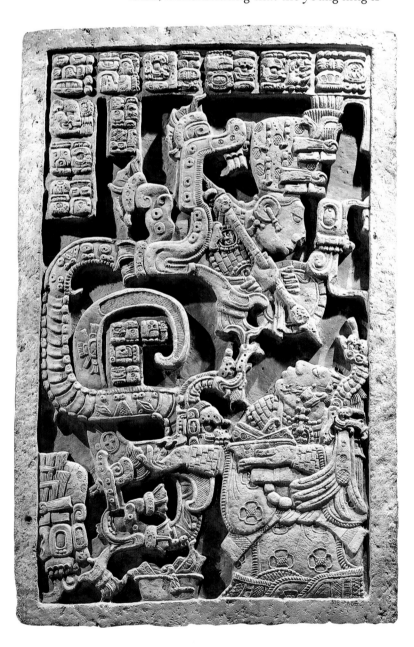

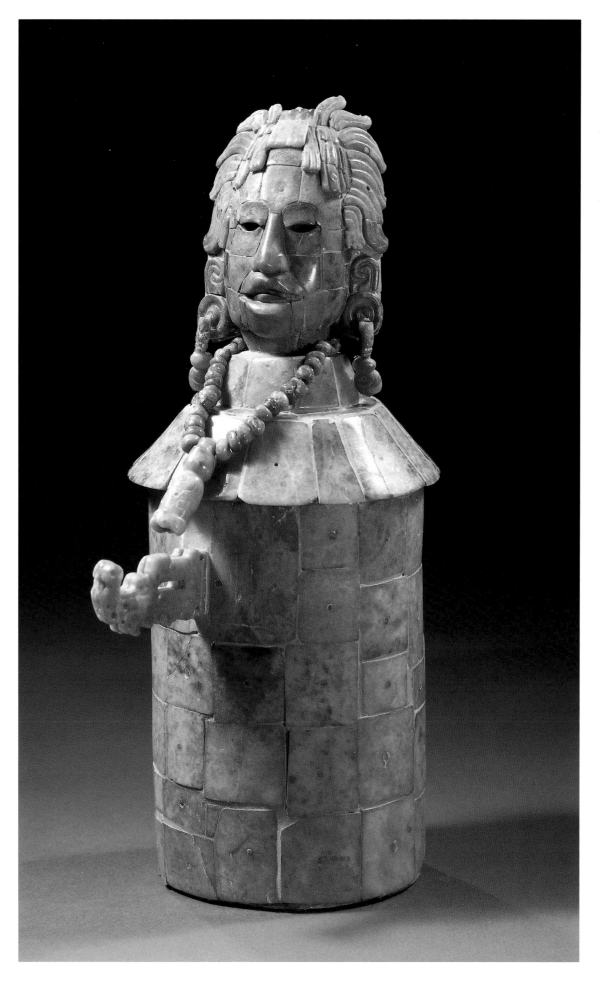

Fig. 13 Funerary vessel with portrait head. Guatemala, Maya, Petén, Tikal, Temple I, c. 700. Ceramic and jade. Museo Nacional de Arqueología y Etnología, Guatemala City. Photo: Justin Kerr. Recovered from the royal tomb beneath Temple I at Tikal, this vessel embodies the idea of the ruler as an eternally youthful provider. (Cat. no. 142)

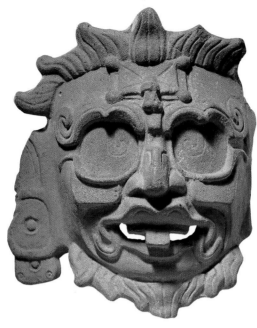

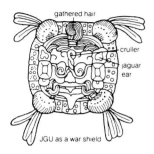

gathered hair

cruller

jaguar ear

JGU as a war shield

Taube has recently argued.[7] On one Maya painted vessel, hunters stalk an anthropomorphic deer who wears a cape covered with crossed bones; on another, warriors torture and sacrifice a man who has taken on the role of the deer. With his hair bound into two "ears," the victim adopts the deer posture atop a scaffold. While musicians play, other attendants set the captive on fire. A ritual of springtime, the hunting, baiting, and burning of deer and deer-men brought on the rains and the return of agriculture after the fallow dry season of winter.

Other types of sacrifice also generated renewal and abundance. Although heart excision was known and practiced by the Maya, most sacrificial victims were decapitated.[8] The sacrifice of a decapitated head was analogous to the harvest of maize; each fruit was lopped off the stalk in succession and eventually planted to generate new life. But, perhaps as acts of humiliation and domination—and even to prevent regeneration— Maya lords retained some heads as trophies.

Certainly, sacrifice played a role in the Maya ball game (see fig. 21). But, like all Mesoamerican peoples, the Maya seem to have recognized in the ball game a metaphor for the movements of the heavenly bodies, particularly the sun, the moon, and Venus, and the renewal and cyclical nature of life and humankind. In the *Popol Vuh*, the Maya story of creation and history, two pairs of

that survive today. Carefully charted by priests, the movements of Venus and Jupiter provoked and aided Maya raids and battles; with the particular guidance of Venus, the most bellicose planet, one Maya king could target another as his prey.

In their daily lives, the Maya must have stalked and hunted wild animals, particularly the brocket and white-tailed deer that inhabit the rain forest. From time to time, the Maya identified the hunting of deer with the hunting of men and brought the two acts together in a single ritual of renewal, as Karl

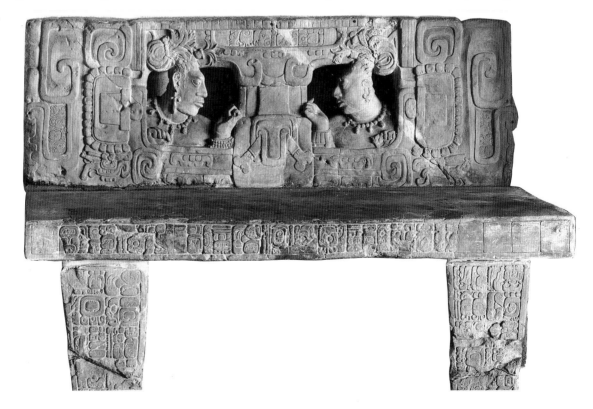

brothers enter the underworld and play the ball game against the underworld gods. As a character in the *Popol Vuh*, the Maize God, or Hun Hunahpu, is one of the first pair of brothers who enters the underworld to play the ball game against its evil denizens. The First Fathers, as this pair is known, are defeated and sacrificed by the gods, but the offspring of the Maize God, the Hero Twins, overcome the underworld gods and outwit them at every turn. Even when the underworld gods believe they have bested the Twins at the ball game, the Twins return to defeat and sacrifice the underworld gods. The Twins resurrect their father, the Maize God, and then they ascend into the heavens. Ball courts were often thought to have been entryways to the underworld, liminal places where man and god met.

Many aquatic creatures dwelt in the still, swampy water on the surface of the underworld, the place and the medium for human transitions between the world of death and the world of life.[9] Objects representing this threshold move between two and three dimensions, as if to emphasize their mutability (see fig. 20). At death, lords traveled through the still water to begin a new journey; we see them in canoes, as they embark for Xibalba, the underworld. Two deities that modern scholars have nicknamed the Paddlers guide the canoe, even as water rises over its gunwales. Like the Hero Twins, the lords face the

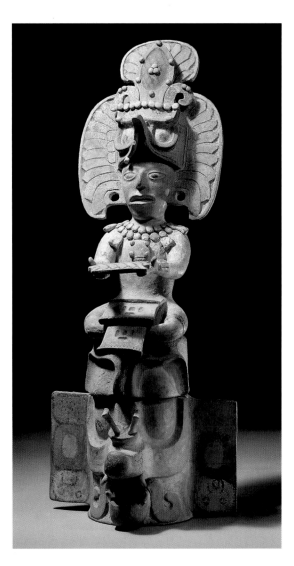

Fig. 17 Incense burner depicting ruler on Cauac Monster throne. Guatemala, Maya, Petén, Tikal, 650/700. Ceramic. Museo Nacional de Arqueología y Etnología, Guatemala City. Photo: Justin Kerr. Seated upon the Cauac mask, which represents the throne of earth, rocks, and mountains, a ruler wears a maize headdress. (Cat. no. 141)

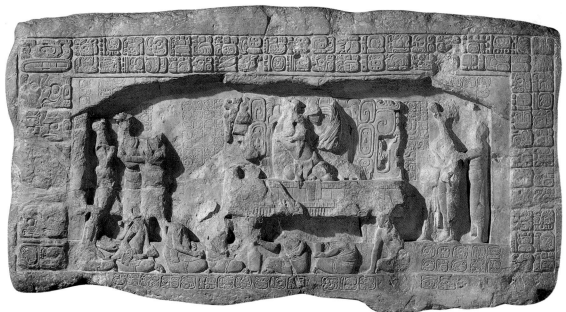

Fig. 18 Courtly scene (Lintel 3). Guatemala, Maya, Petén, Piedras Negras, 700/50. Stone. Museo Nacional de Arqueología y Etnología, Guatemala City. Photo: Justin Kerr. Seated on a Cauac Monster throne, a ruler holds court in the palace of Piedras Negras. (Cat. no. 144)

Fig. 19 Drawing of sarcophagus lid. Guatemala, Palenque, Temple of the Inscriptions, 684. Drawing: Merle Greene Robertson, in Schele and Miller, 1986, p. 282. The deceased ruler Pacal enters the realm of the ancestors. Below, the skeletal jaws of the earth yawn open, while a "tree of life" springs from King Pacal's body toward the celestial regions. A hieroglyphic sky-band enframes one scene.

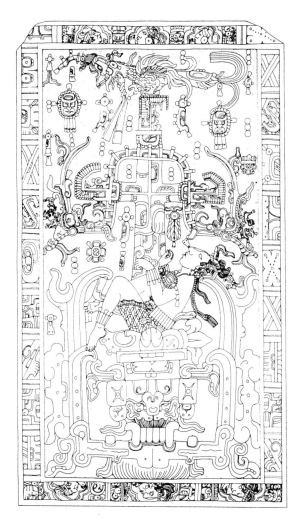

underworld gods—the putrefying lords of death—in Xibalba. The Hero Twins provided a model for overcoming death; they did not overpower the evil gods, but they outsmarted them. Deep in the underworld, many layers below the swampy water that obscured the entrance to Xibalba, and dressed as ragamuffin tricksters, the Twins fooled the lords of death into begging for their own sacrifice. The Hero Twins then took new form in the heavens, whence they reign as the brilliant heavenly bodies of night.[10]

For the Maya, this imagery of death and rebirth can be seen also in light of the life cycle of maize. On the Tikal bones in the Museo Morley at Tikal, a dead king may be depicted, at the moment of death, as the young Maize God. The same imagery is created on the lid of the Palenque Sarcophagus (fig. 19). There, the dead king Pacal (he died in 683 at the advanced age of eighty) is rendered with characteristics of both the young Maize God—whose costume he has donned—and God K, whose axe or smoking tube punctures his forehead.[11] Half-reclining, in a posture not only of rapture and repose but also of sacrifice, as if his death is a self-sacrifice, he sits on a cache vessel or miniature canoe borne by the rear head of the Celestial Monster. Simultaneously, the World Tree, surmounted by the Principal Bird, shoots

Fig. 20 Ceremonial vessel in the form of aquatic turtle with cover in the form of mythical bird. Guatemala, Maya, Petén, Tikal, 350/400. Ceramic. Museo Nacional de Arqueología y Etnología, Guatemala City. Photo: Justin Kerr. The turtle was associated with the transitional zone between the living and the dead; the bird represents the celestial realm. (Cat. no. 136)

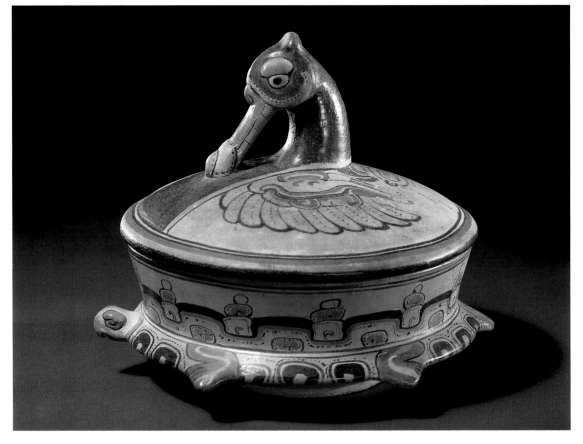

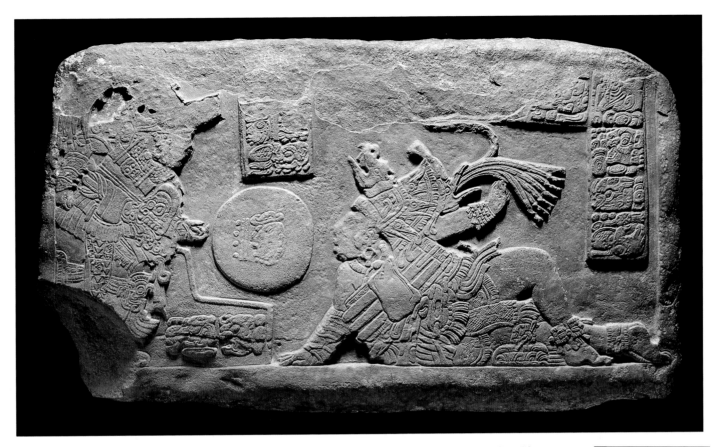

up fully developed from the dead king's body, as if regenerated through his death.

Before he died, King Pacal of Palenque had planned and commissioned the Temple of Inscriptions, the building that would be his permanent memorial. Set directly into the hill behind, it is given prominence by the surrounding topography. Ancient engineers excavated into the bedrock so that the sepulchral chamber falls below ground level, in that mutable place between life and death. The sarcophagus takes the shape of an enormous, lidded cache vessel, but the opening within has the form of a human uterus. Thus, when Pacal died, he entered the womb of the earth, and as a kernel of regeneration, he spawned the World Tree. Within the sarcophagus, Pacal wore a green mosaic mask that transformed the face of an old man into the face of youthful maize for all time.

The Maya understood the cycle of human life and death as only one of many allied cycles: the passing of the year and seasons, the movements of heavenly bodies. But the most fundamental cycle was the cycle of maize, since it is not only the metaphor for human life, death, and renewal, but the stuff of which man was formed. The Maya believed that the blood flowing in human veins was the corn (*masa*) from which the gods had shaped them. Maize sprouted from sacred mountains, and humans propitiated maize and mountain through the offering of human blood. And, finally, when a great noble died, he was buried at the base of a pyramid, a great symbolic mountain. Resting in the womb of the earth below, that lord, like the maize he emulated in life, became the seed of renewal and regeneration.

Fig. 21 Panel depicting ball game. Guatemala, Maya, 600/900. Stone. The Art Institute of Chicago. Ball games were played by the lords for various purposes, among which the fortune of a reign or an important endeavor might be forecast or signaled. (Cat. no. 125)

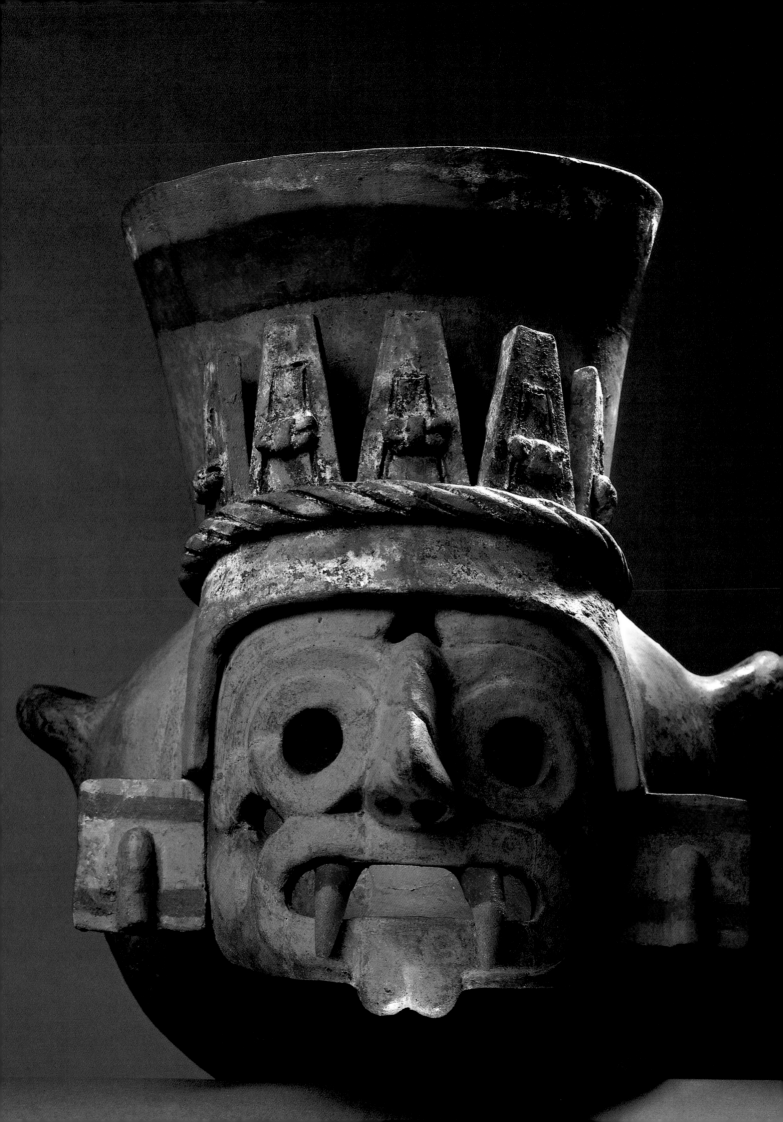

THE RENEWAL OF NATURE
AT THE TEMPLE OF TLALOC

Among the thousands of objects discovered during the excavation of the ruins of the Aztec Main Pyramid in downtown Mexico City was a pair of spectacular ritual water jars, modeled with the mask of the deity Tlaloc and painted brilliant blue (see fig. 1). The goggled eyes, fanged mouth, and heron feathers repeat the features on carved wooden and turquoise-inlaid masks worn by religious performers who appeared as Tlaloc in festivals held in the Aztec capitals (see figs. 2, 3). The cult of Tlaloc was devoted to rain and agricultural fertility, and the rites were performed on the pyramids of Tenochtitlan, Tetzcoco (Texcoco), and other cities, as well as in the adjacent fields and on certain mountaintops surrounding the Basin of Mexico. The masked ritual performers are depicted in sixteenth-century pictorial manuscripts made by Aztec artists who worked for the Spanish friars after the conquest of Tenochtitlan by Hernán Cortés in 1521. The *Codex Ixtlilxochitl* shows a ritual performer attired in Tlaloc regalia, wearing a variant of the mask and a blue mantle, and holding a serpentine lightning-bolt wand in his outstretched left hand (see fig. 2). Another figure, from the *Codex Magliabechiano*, carrying a different type of wand and a cornstalk, is depicted on a stylized agricultural *chinampa* plot (fig. 3). These raised *chinampa* fields were reclaimed from rich, shallow marshes and lakes, and their enormous production was a principal source of food for the populous urban districts. Tlaloc images and equipment portray a realm of visual metaphors and mythical themes concerning the way the Aztec perceived and used the land, the sky, and the waters around them. In this

tradition of art and culture, the figures of masked deities and their paraphernalia and associated sculptural forms were connected with temple architecture in a vital and ongoing ritual dialogue with the forms and forces of the natural environment.

Aztec art and culture occupy an especially significant place in the history of Amerindian civilizations. Nowhere else in the western hemisphere is it possible to connect archaeological remains to so many careful descriptions from texts and pictorial manuscripts, written by sixteenth-century Spanish friars and descendants of the Aztec intelligentsia. This literature forms the largest single source describing an indigenous civilization at the time of the first encounter with Europeans. Yet it also happens that many aspects of Aztec religious thought, ritual, and mythic imagery were not always understood or recorded by the friars, or were deliberately withheld by native informants from the written records. Today, archaeologists, art historians, and scholars in related disciplines are discovering that what is recorded in the texts is often only part of the story. A new area of inquiry has opened as scholars learn to trace and interpret the relationships between ritual drama, art and architecture, and the specific features of natural environments. A deeper and broader picture is being formed of the domain of thought, symbolism, and aesthetics in the evolution of early civilization in the Americas.

In this essay, we shall inquire into a central theme of Aztec religious imagery, concerning the role played by their kings in a remote mountaintop temple of Tlaloc, where

Fig. 1 Ritual vessel depicting mask of Tlaloc. Mexico, Aztec, Tenochtitlan, 1400/1521. Ceramic. INAH–CNCA–MEX, Museo del Templo Mayor, Mexico City. Photo: Gabriel Figueroa Flores. Found in the excavation of the Aztec Main Pyramid in Mexico City, the vessel formed part of a ritual connection between one urban monument and the rain-producing mountains around the Valley of Mexico. (Cat. no. 18)

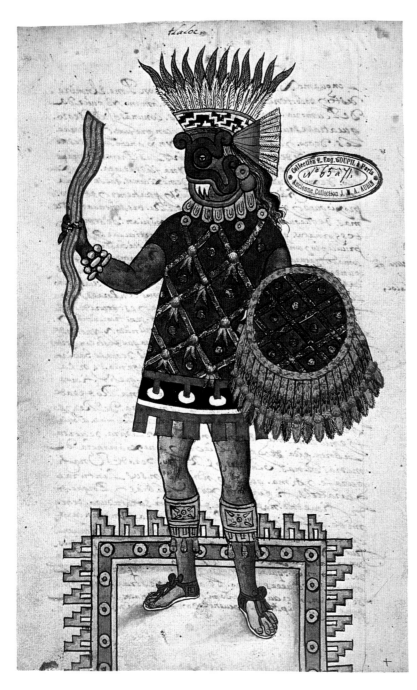

Fig. 2 Ritual impersonator of Tlaloc. From *Codex Ixtlilxochitl*, Mexico, Aztec, 1580/1620. Paper. Bibliothèque nationale, Paris. Photo: *Codex Ixtlilxochitl*, 1976, p. 110v.

cities, it is beset with intractable environmental problems. It is also a place of extraordinary cultural history, where the question of the Aztec integration of society and nature assumes particular poignancy.

The Aztec were only the latest of many peoples who had arrived in successive migrations to settle by the shallow lakes and tall snowcapped volcanoes that made the central Basin of Mexico rich in natural resources (see fig. 4). Over centuries, each group had evolved a pattern of cultural adjustments, implanting themselves upon the land and the social order developed by earlier inhabitants. These collective adaptive experiences brought many changes of culture, as immigrant tribes sought to affirm their own history and social identity in relation to their neighbors and the way of life established by pre-existing peoples. Yet, as each new community learned about the land and the ways of agricultural urban life, they bound themselves to a traditional system of religious connections with the forces and phenomena of nature. In this realm of beliefs, practices, and symbolic manifestations, the cult of Tlaloc assumed a special importance, for it stemmed from an old matrix of religious observances, transmitted from early levels of Mesoamerican culture to the fifteenth century. This cult, which was very old and widely acknowledged, had become part of Aztec religion well before the Aztec began their course of imperial expansion. A conscious part of their policy during the fifteenth and early sixteenth centuries was to incorporate the cults of conquered peoples. These cults and their many deities were assimilated and recast in the Aztec cities with new religious and political aims in the creation of an ever-more-specialized, stratified, and heterogeneous society. Art and architecture were enrolled in this program to build a consensus of ideas and endeavors in the imperial Aztec states. The unceasing round of festivals and rites was at the core of Aztec social cohesion, reaching all segments of society and providing a compelling integrating mechanism for the diversified population. The great public religious spectacles had a powerful emotional and imaginative appeal, bringing different groups together through common experiences and beliefs and a shared grammar of visual symbols. The Main Pyramid of Tenochtitlan grew as a state-sponsored architectural icon, marking the middle of the city at the center of the Aztec world. It is also important to note that this temple—and others—were linked by routes of pilgrimage

a mythic drama was enacted to ensure the annual renewal of nature. Within the imagery of the unfolding events that took place in this archetypal setting lies one of the principle roots of Aztec kingship and the recurrence of an ancient practice that had been incorporated by the Aztec from cultures that flourished long before them.

Unlike the Maya archaeological sites, with their forested settings and romantic appeal, or the ruins of Teotihuacan, still surrounded by open landscapes, the monuments of the Aztec are largely contained within or close by the colossal spread of Mexico City, today the home of some twenty million people. It is probably the largest urban concentration on the planet, and, like all major

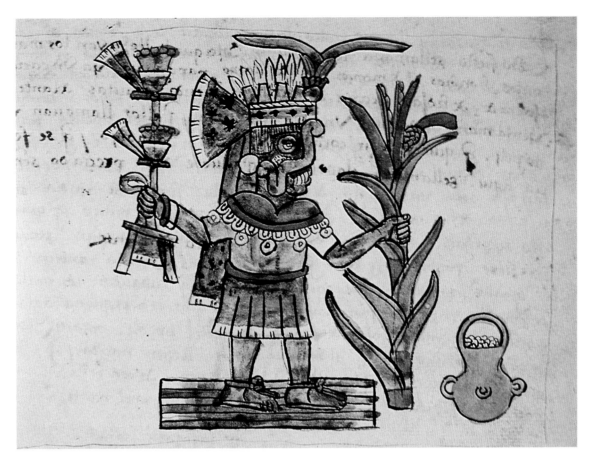

Fig. 3 Ritual impersonator of Tlaloc. *Codex Magliabechiano*, Mexico, Aztec, c. 1540. Paper. Biblioteca Nazionale Centrale, Florence. Photo: *Codex Magliabechiano*, 1970, p. 34.

and lines of sight to a system of shrines and sacred features in the surrounding natural setting. This network of connections made up what may be called a sacred geography, establishing points of engagement that were invested with history and myth. Chief among these outlying sites was the primary temple of Tlaloc.

Every year in late April or early May, at the height of the dry season, a splendid procession, led by four kings, left the inner Basin of Mexico. From the cities of Tenochtitlan, Tlacopan, and Xochimilco, the royal parties went by canoe across the lake, where they were joined by the king of Tetzcoco. The lake was drained in the late nineteenth century, and the vast residential and industrial suburbs and traffic arteries of modern Mexico City have now spread to incorporate all of these towns, except Tetzcoco. The destination of the allied kings was a temple on the summit of a distant mountain known as Mount Tlaloc, whose height reaches four thousand meters. The mountain is part of the forested sierra that includes the snowcapped peaks of Popocatepetl and Ixtaccihuatl on the eastern side of the basin.

After assembling at Tetzcoco, the kings departed at dawn on the trail through dry maize fields bordered by rows of spiny maguey. The route continued through pine and oak forests into the foothills of the sierra. Normally, at this time of year, it had not rained substantially since October; as the sun rose in the midday sky, whirlwinds moved across the land in tall, wavering columns of dust. The path to the temple probably followed the line of a fifteenth-century aqueduct that supplied drinking water to the eastern valley from springs high on Mount Tlaloc. The desolate summit and its temple, rising well above the line of the forest, are best approached by a long fault-ravine that traverses the mountain. The air is cool at this altitude, and, in winter months, the winds are freezing and snow is often recorded. The snowcapped volcanic peaks are seen on the south horizon: Ixtaccihuatl ("White Woman") and Popocatepetl ("Smoke Mountain") are often veiled in a thin, white vapor, even in the long dry season (see fig. 4).

The temple of Tlaloc was built at the meeting ground of earth and sky, removed from the sounds and activities of daily life. In the Nahuatl tongue of the Aztec, there is a word, *teotl*, that expresses the special quality surrounding this high place. Difficult to translate, it was recorded by the Spaniards as "god," "saint," or sometimes "demon." In sixteenth-century ritual texts, the word appears in several contexts: accompanying the names of the Aztec deities, associated with masks

or related items of religious use, and in connection with sculptural figures of the deities or heroes. It appears also in the framework of temples, shrines, and certain natural forces and phenomena. The word *teotl* may qualify anything beyond the reach of usual experience, such as the vastness of the sea, an awe-inspiring mountain, an eerie rock, or a phenomenon of terrible power, such as the sun or a bolt of lightning. "Numinous," "mana," or "sacred" are terms that suggest its significance. As used by the Aztec, *teotl* communicates the notion of life-force inherent in greater or lesser measure in minerals, plants, animals, and human beings, as well as in ritual objects and buildings. In this vision of the world, all things were intensely and naturally alive. The isolation, the sky, and the snow-capped mountains, the fearsome memory of sacrifices and the phantom presence of the royal ritualists invest the temple on Mount Tlaloc with the presence of *teotl*.

The royal procession to Mount Tlaloc took place when the long dry season—the time of death—must change to the time of rain and the rebirth of life. The rulers were traditionally obliged to fulfill a religious obligation, which had been theirs for generations, to assure the renewal of the earth, the abundance of crops, and the order and continuity of society. The path to the temple led up to a sheltered place on the fault escarpment, where camp was made for the night. At dawn, preparations were begun for the ritual performance. Prayers were rehearsed, the order of appearance was recounted, and all the paraphernalia and accouterments were made ready. Everything had to unfold flawlessly and with utmost elegance, including the sacrificial offering. The dramatic events that followed were described by Fray Diego Durán. Born in Seville in about 1537, he emigrated with his parents, living first in Tetzcoco and later in Mexico City. Durán became a Dominican friar and gathered information for his extraordinary books from old members of the Aztec nobility and the native scholars known as *tlamantinime*, who clearly remembered the rites of Tlaloc as performed in the reign of Moctezuma II.

> On the summit of the mountain stood a great square courtyard surrounded by a finely built wall about eight feet high, crowned with a series of merlons and plastered with stucco. It could be seen from a distance of many

leagues. On one side of this courtyard was a wooden chamber neither large nor small, with a flat roof. It was stuccoed both within and without and possessed a beautifully worked and handsome [castellated] crown. In the middle of this room, upon a small platform, stood the stone idol Tlaloc, in the same manner in which Huitzilopochtli was kept in the temple [of Mexico]. Around [Tlaloc] were a number of small idols, but he stood in the center as their supreme lord. These little idols represented the other hills and cliffs which surrounded this great mountain. Each

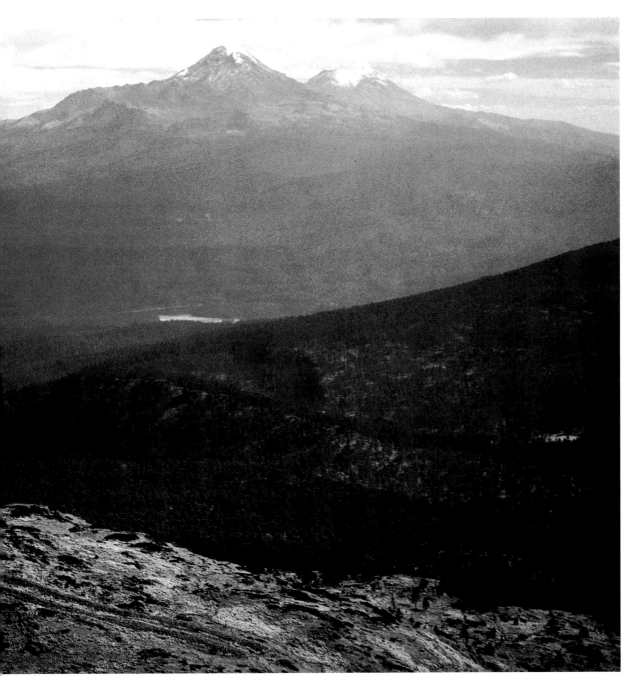

Fig. 4 Aerial view of the rain-cult temple on Mount Tlaloc between the basins of Mexico and Puebla. Mexico, Aztec, 1450/1500. Photo: Richard Townsend. A long processional way leads to the sacred enclosure. At the meeting place between land and sky, the temple represented the womb of the earth as the source of life's annual renewal. Ixtaccihuatl and Popocatepetl, seen in the distance, are also major rain-producing heights that were worshiped in antiquity.

one of them was named according to the hill he stood for. These names still exist, for there is no hill lacking its proper designation.[1]

Durán's account gives a picture of the temple precinct, the ritualists, and the costumes and choreography. However, although the description is detailed, it does not provide a complete interpretation of what the actions signified. The ruins of the temple, the features of the land itself, and the turning-point in the seasons, together with other evidence, all provide a larger dimension for understanding the rites that Durán did not fully comprehend. These diverse components were drawn together to speak of a mythical theme and a theory of kingship, rooted in a living connection between mountain, water, and people.

Aerial views of the temple ruins reveal features in addition to those mentioned by Durán. The first is a long, narrow, east-west corridor, leading into the rectangular precinct. Much destroyed today, the corridor walls and those of the enclosure were made of dry-stone masonry and would originally have risen to a height of approximately three meters. Nothing remains of the chamber and its idols, but a fragment of a stone Tlaloc sculpture was photographed in the precinct in the 1920s. The photograph is in the archives of the Musée de l'homme in Paris.

Durán's account goes on to describe the royal procession:

Just after dawn these kings and lords with their followers left [their shelters]. They took a child of six or seven years and placed him within an enclosed litter so that he would not be seen. This was placed on the shoulders of the leaders. All in order, they went in the form of a procession to the courtyard, which was called Tetzacualco. When they arrived before the image of the god Tlaloc, the men slew the child within the litter, hidden [from those present]. He was slain by this god's own priests, to the sound of many trumpets, conch shells, and flutes. King Moteczoma [Moctezuma], together with all his great men and chieftains, approached [the idol] and presented finery and a rich garment

for the god. They entered the place where the image stood, and [Moctezuma] with his own hands placed a headdress of fine feathers on its head. He then covered it with the most costly, splendid mantle to be had, exquisitely worked in feathers and done in designs of snakes. [The idol] was also girded with a great and ample breechcloth, as splendid as the mantle. They threw about its neck valuable stones and golden jewels. Rich earrings of gold and stones were placed upon him, and on his ankles also. [The king] adorned all the smaller idols who stood next [to Tlaloc] in a similar fashion. After [Moctezuma] had dressed the idol and had offered it many splendid things, Nezahualpilli, king of Tetzcoco, entered. He was also surrounded and accompanied by great men and lords, and he carried a similar garment [for the idol]; and if it was superior [to that offered by Moctezuma], so much the better. He dressed it and the smaller images with much splendor, except that he did not place the headdress upon the head but hung it from the neck and down its back. Then he departed. The king of Tlacopán then came in with another garment and offering. Finally the [sovereign of] Xochimilco, accompanied by all the rest, entered with more fine adornments: textiles, bracelets, necklaces, wristbands, and earplugs, just as the others had done. The headdress was placed at the feet [of the idol].[2]

It is important to note that Moctezuma II, the first king to enter the long narrow corridor, was the ruler of Tenochtitlan, the most powerful and populous of the Aztec cities. Those who followed him—the rulers of Tetzcoco, Tlacopan, and Xochimilco—proceeded in strict order of rank. Durán's description continues:

The idol and the smaller images had now been dressed in the manner described. Then was brought forth the sumptuous food which had been prepared for each king [to offer the god]: turkeys and their hens and game with a number of different kinds of bread. [Moctezuma] himself, acting as steward, entered the chamber where the idol stood, and his great men aided him in the serving of the food. The

Fig. 6 Five figures of Tlaloc. From *Codex Borgia*, Mexico, Mixteca-Puebla region, 1300/1400. Animal hide. The Vatican Library, Vatican City. Photo: *Codex Borgia*, 1976, p. 28, Gr. B, Abschnitt 12. Standing at the four quarters and rising from the earth to the sky at center, the figures personify the idea of the rainy season.

rest of the chamber was filled to bursting with stews of fowl and game, many small baskets of various breads, and gourds of chocolate. Everything was beautifully prepared and cooked, and there was such abundance in the room that some of it had to be left outside. At that time the king of Tetzcoco entered with his viands, which were no less rich and superb. And he fed the god in the same way as [Moctezuma], he himself as steward. Then came [the ruler] of Tlacopán, who did likewise. And after him that of Xochimilco. They offered so much food that those who tell this story (they are men who actually saw these things) affirm that the food was so plentiful—stews, breads, and chocolate in the native style—that most of the courtyard was crowded, and it was a sight to see. It was especially notable that all the pottery was new, and so were the baskets and the vessels—never

used before. When the food had been put in its place, the priests who had slit the throat of the child came in with his blood in a small basin. The high priest wet the hyssop which he held in his hand in that innocent blood and sprinkled the idol [and] all the offerings and food. And if any blood was left, he went to the idol Tlaloc and bathed its face and body with it, together with all the companion idols, and the floor. And it is said that if the blood of that child was not sufficient one or two other children were killed to complete the ceremony and compensate for what had been lacking.[3]

The custom of human sacrifice, which so appalled the Spaniards and which has since come to be especially identified with the Aztec in the popular imagination, must here be discussed in the context of the entire ritual procedure. In the Nahuatl language, the

word for sacrifice is *uemmana*, composed of the terms *uentli* ("offering") and *mana* ("to spread out," in the sense of spreading a feast). The root stem *mana* is used also in reference to patting out a thin, round maize tortilla. So important and critical was the Mount Tlaloc offering that only something of supreme value would suit the occasion: the blood of a child. Blood, in Nahuatl, is referred to in several ways: *tocelica* ("our freshness"), *totzmoluica* ("our growth"), and *nemoani* ("that which gives life"). *Mochichicaoa*, sometimes used in connection with blood, means "one is greatly strengthened." Other terms used in connection with blood-offerings to the earth or to water include *nextlaoalioia* ("payment of debt") and *nextlanlli* ("the debt paid"). The Aztec kings offered drops of their own blood as an offering to the earth to confirm

their coronation (see fig. 5). Sacrificial offerings of human beings were traditionally made in times of dire trouble or in the most critical months of the year. Blood was believed to be a primary ritual nourishing agent, assuring the arrival of water at the change of the dry to the rainy season and the regeneration of the earth for the annual planting. In this context, the sacrifice expressed a profound theme concerning the transformation of death into life. Blood formed part of a religious recycling of life energies between the social and natural orders. In this frame of reference, the forces of nature were not seen in opposition but in a process of continual change. Ritual activity focused on the need to affirm and nourish that cyclic process at the critical time of seasonal transition.

Other details of the Mount Tlaloc precinct suggest the full significance of the rites. Not mentioned by Durán, but clearly visible today, are clusters of natural boulders left in place when the enclosure was constructed. Allowing for a certain irregularity, these large rocks can be seen to correspond to the four corners of the precinct. Other clusters are located at the center and at the eastern side. These boulders were surely an integral part of the sacred ensemble, repeating the functions of the assemblage of idols within the temple chamber. The central group of boulders is today enclosed by a rude stone wall of recent construction. A page from the *Codex Borgia* (fig. 6) shows a similar symmetry in a cosmic diagram devoted to Tlaloc. The central Tlaloc stands, holding a mask, on the vertical axis, while four other Tlalocs are placed at the intercardinal points. All these figures are borne by females who crouch upon circular symbols, as manifestations of mother earth. In the enclosure on Mount Tlaloc, there was also an earth-navel measuring about 2½ by 1 meter, carved deeply into the bedrock on the eastern side of the precinct and aligned with the path of the processional way. Such orifices leading into the "heart of the mountain" are found in other Aztec temple sites.[4] They were places of offering and communication, and the orifice at Mount Tlaloc may have served also as a symbolic "place of emergence" for masked performers and deities. Such features recall the *sipapus* of Pueblo kivas in the Southwest of the United States. The conformation of the Tlaloc temple also corresponds in essential respects to the cosmological diagram on the famous page from the *Codex Fejérváry-Mayer* (see Boone essay in this book, fig. 1). Another important key to the meaning of the

Fig. 7 The birth of the Aztec tribes from the womb of Mount Chicomoztoc ("Seven Caves"). From the *Historia Tolteca-Chichimeca*, Mexico, Valley of Puebla, 1550/70. Paper. Bibliothèque nationale, Paris. Photo: *Historia Tolteca-Chichimeca*, 1976, f.16r, ms. 51–53, p. 28.

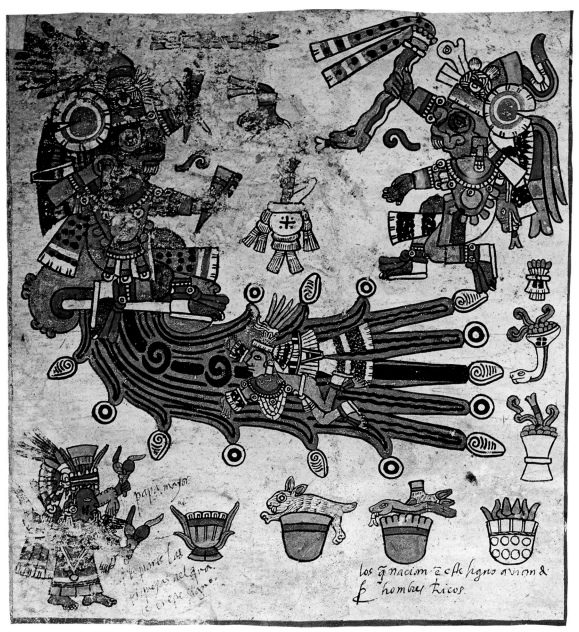

Fig. 8 Tlaloc seated on a mountain. From *Codex Borbonicus*, Mexico, Aztec, c. 1525. *Amate* paper. Bibliothèque de l'Assemblée nationale française, Paris. Photo: *Codex Borbonicus*, 1974, p. 7. The name Tlaloc ("of the earth" or "from the earth") alludes to mist or vapor rising from the earth to form clouds around mountaintops.

Tlaloc temple appears when one considers the original three-meter-height of the walls. Once inside the corridor of the processional way and the precinct, the visitor would have seen nothing but the enclosed symbolic landscape and the void of sky. Only upon emerging from the long, narrow corridor was the outside world visible again to the ritual parties. This emphatic separation of exterior and interior space was clearly intentional. What was the purpose of the processional way? Why were the kings required to parade down this corridor into the precinct and the shrine chamber?

Considering the form of the temple enclosure, its place on the mountain, the movement of ritual processions, and the act of making offerings, the form of the Tlaloc temple may be understood as a graphic "womb of the mountain." A well-known page from the

Fig. 9 Chalchihuitlicue, the "sister" of Tlaloc, Goddess of Water (springs, caves, rivers, and sea). From *Codex Borbonicus*, Mexico, Aztec, c. 1525. *Amate* paper. Bibliothèque de l'Assemblée nationale française, Paris. Photo: *Codex Borbonicus*, 1974, p. 5. The name Chalchihuitlicue ("Jade Skirt") describes the appearance of a blue-green body of water.

Historia Tolteca-Chichimeca, an illuminated manuscript from the early Spanish colonial period, recounts the twelfth-century movement of tribes from the north into central Mexico before the Aztec migration; it also sheds light on the use of the corridor at the Temple of Tlaloc (fig. 7). The page features the mountain Culhuacan, located some 320 kilometers north of Mexico City. In ancient times, it was a sacred place, where migrating peoples would gather before continuing toward the central basin. The interior of the mountain is depicted with seven caves, containing seven tribes. The caves, known as Chicomoztoc ("Seven Caves"), are shown as lobes of a womblike chamber, conveying the notion of the mountain as a manifestation of the female earth and as a procreative entity. Priestly figures, one of whom holds a staff, stand outside the entrance to the cave. The text describes a ceremony in which this personage strikes his staff into the cave-womb opening to bring forth the tribes. Striking with a staff was a ritual gesture, a metaphorical sexual act and a symbolic act of creation. The priestly figure was known by the title Uitec ("One Who Strikes"), recalling an episode of a creation myth recorded by the sixteenth-century friar Gerónimo de Mendieta, in which a stone knife comes down from the sky, or an arrow descends from the sun, to strike Chicomoztoc, the earth-womb, from which the first man and woman were born.[5] The Chicomoztoc page of the *Historia Tolteca-Chichimeca* signifies a priest enacting a creation myth as a communal rite of passage to bring the nomadic tribes from their desert habitat and send them forth on the long migration to their new place in the region of agriculture and urbanism.[6]

Fig. 10 Earth goddess Tlazolteotl. From *Codex Borbonicus*, Mexico, Aztec. c. 1525. *Amate* paper. Bibliothèque de l'Assemblée nationale française, Paris. Photo: *Codex Borbonicus*, 1974, p. 13. The name Tlazolteotl ("eater of filth") refers to the earth as receiver of confessions in Aztec religious life.

Yet another pictorial manuscript, the *Codex Borbonicus*, depicts a related mythic episode (see Matos Moctezuma essay in this book, fig. 3). The scene shows the original creator-couple, Ometecuhtli ("Two Lord") and Omecihuatl ("Two Lady"), seated within a rectangular precinct at the very beginning of time. That place was called Omeyocan, often translated as "Place of Duality," but which should more properly be named "Place of the Two." The name alludes to the notion of the union of male-female creative forces, rather than contrasting or opposing entities. The precinct in which the figures are seated has an entrance from which water flows outward, suggesting a womblike chamber. Ometecuhtli and Omecihuatl were the parents of four sons, each of whom became identified with one of the four world quadrants. Such expressions conveyed the idea of procreation and order stemming from a central place.

Turning to the natural setting, we find that mountains were widely regarded as containers of water, *atoyatl*:

> The name comes from *atl* (water) and *totoca* (it runs); as if to say "running water." The people here in New Spain, the people of old, said: "These rivers come—they flow—there from Tlalo-cán; they are the property of, they issue from the sacred one, Chalchi-huitlicue."[7]

Chalchihuitlicue ("Jade Skirt"), the female deity whose domain was the ground water, was regarded as the "sister" of Tlaloc, the male deity of rain.

> And they said that the mountains were only magic places, with earth, with rock on the surface; that they were only like ollas (water jars) or houses; that they were filled with water which was there. If sometime it were necessary, the mountains would dissolve; the whole world would flood. And hence the people called their settlements *atl tepetl* (water mountain). They said, "This mountain of water, this river, springs from there, the womb of the mountain. For from there, Chalchihuitlicue sends it—offers it."[8]

Two pages from the *Codex Borbonicus* illustrate this passage: one depicts Tlaloc seated on a mountaintop, from which a river of water issues below (fig. 8); the other depicts

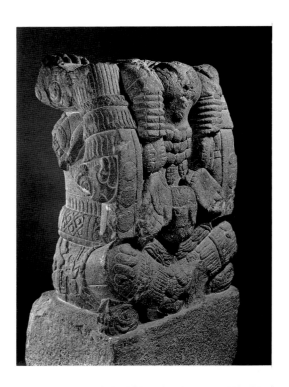

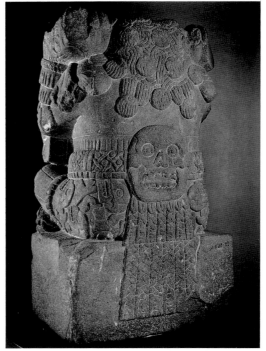

Fig. 11a, b Earth deity Tlatecuhtli. Mexico, Aztec, Tenochtitlan, 1450/1500. Stone. INAH–CNCA–MEX, Museo Nacional de Antropología, Mexico. Photo: Gabriel Figueroa Flores. The name "Serpent Skirt" metaphorically describes the earth in terms of creatures that live upon or beneath its surface. This variant figure bears a skirt of bones, alluding to the earth as eventual recipient of all that walks and grows. (Cat. no. 10)

Fig. 12 The Hill of
Tetzcotzingo, site of
Netzahualcoyotl's ritual
center near the city of
Tetzcoco. Mexico, Aztec.
Photo: Richard Townsend.

Chalchihuitlicue seated on a low stool from which another river flows (fig. 9).

Such images from the pictorial manuscripts, together with written material and the natural features of Mount Tlaloc, provide evidence for interpreting the temple enclosure as a symbolic womb of the earth-mother. The imagery of mother earth was immensely varied in Aztec pictorial and sculptural art, reflecting the ambiguity and widespread character of this cult in Mesoamerica (see figs. 10, 11a, b). A chain of metaphoric references joins a number of things: Tlaloc's water jar, a mountain, a ritual precinct, the idols and stones as objects of worship, and the womb of the earth-mother. All these forms were perceived and used in terms of life-giving sources of water. Indeed, the design of Tenochtitlan itself repeated in an urban context the motif of a long processional way leading from west to east to join the central precinct that housed the Aztec Main Pyramid, which was considered a sacred mountain.

Within about a month after the rites at the temple of Tlaloc, the first clouds would begin to form around the peaks of the sierra. It looked as if the mountains themselves were generating rain. Soon thunderclouds would billow up and black storms would blow down and across the basin in curtain-like processions, announced by strong winds and powerful peals of thunder (see fig. 12). In the metaphoric language of Aztec poetry, *quetzalcoatl* ("quetzal/feathered serpent") was a term that described the great wind-storms that brought rain, and this term was literally represented in sculptural imagery (see fig. 13). Within days, the dry land changed in color from ocher and tan to light green, crops sprang up, cultivation began, and the fruits of the earth were given.

At the temple on Mount Tlaloc, the Aztec rulers were not abject supplicants fearing a punitive deity but agents performing an essential act to ensure the change of seasons. The long pilgrimage brought the kings across the lake and up from the basin, following an arduous path to the zone of ritual danger. On this mountain at the periphery of the basin, above the boundary of forest life, they entered the sacred enclosure. Offerings were made within this womb, and the kings returned home as providers of life-giving water. This process has the structure of a mythic event: in a distant time, a hero emerges at

the center of a dry and unproductive land in a world still incomplete. He undertakes a perilous journey to a distant and dangerous place in quest of a life-giving boon. The source is found, an offering is made (perhaps drops of the hero's own blood), and the hero returns to his place of departure, bringing the gift of life. Such a myth was not recorded by the Spanish friars, yet the "text" is evident in the topography, the temple, the ritual events, and the ensuing seasonal transformation. The rites of Tlaloc upon the mountain were rites of seasonal passage, maintaining the change from the time of death to the renewal of life. This theme lay at the heart of all order and meaning and was central to the office and function of Aztec kings.

The temple on Mount Tlaloc was one of the two most important places of Aztec

know is that, beneath these fierce practices and the tragic drama of the Aztec rise and fall, there was the creative development of a complex state organization and a coherent cosmovision. The religious thought of the Aztec and their calendar of great public festivals expressed the relationships and interdependence of planting, farming, and harvesting, as well as war and trade, within the structure they perceived in the world and the cycle of annual change.

The distinctive art and culture of the Aztec were the products of historical conditions in the Basin of Mexico between the thirteenth and early sixteenth centuries, but the tradition of Tlaloclike masks and containers goes back well over a thousand years before the Aztec arrived in the region. At Teotihuacan, the cult of the water deity

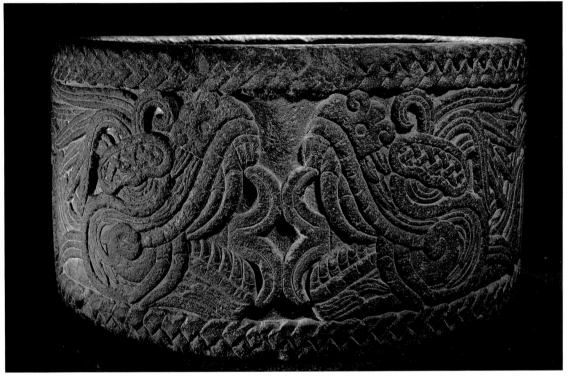

Fig. 13 Vessel of the Plumed Serpent, Quetzalcoatl ("Cuauhxicalli"). Mexico, Aztec, Tenochtitlan, 1450/ 1521. Stone. INAH–CNCA– MEX, Museo Nacional de Antropología, Mexico City. Photo: Gabriel Figueroa Flores. (Cat. no. 8)

sacred geography, along with the Main Pyramid of Tenochtitlan. These sites formed part of a larger network of connections that joined the city and the country in a unified ritual continuum. The rites of Tlaloc reveal the workings of the Aztec cosmological system. The structure of this seasonal event was undoubtedly appropriated and adapted from their predecessors in central Mexico. The Aztec are still widely perceived as the people who conducted human sacrifice, but, in this respect, they were hardly different from other early high civilizations in the New World and the Old. What is important to

is omnipresent in mural art. In one example, an elaborately costumed priestly figure is depicted in profile (fig. 15). His goggled mask is drawn with precision, as is the flowered and feathered speech-scroll, denoting a prayer, that issues from his mouth. In his right hand, he holds a masked waterpot equipped with a headdress and bannerlike streamers, while, in his extended left hand, he clasps a serpentlike lightning-bolt wand, to which symbols of clouds and plants are attached. Although the Nahuatl name Tlaloc may not have been used at Teotihuacan, the mask and attributes of this figure

Fig. 14 The volcano
Popocatepetl, seen from the
site of the Olmec petroglyph
at Chalcatzingo (see also
de la Fuente essay in this
book, figs. 12, 14). Photo:
Colin McEwan.

Fig. 15 Mural fragment
depicting a priest as Storm
God of Teotihuacan.
Mexico, Teotihuacan, c. 500.
Fresco. Photo: A. Miller,
1973, p. 168. A predecessor
of the Aztec Tlaloc, this god
wears a goggled and fanged
mask, carries a masked
waterpot (note cloud and
flowing-water motifs), and
brandishes a cloud-covered,
serpentine lightning bolt.

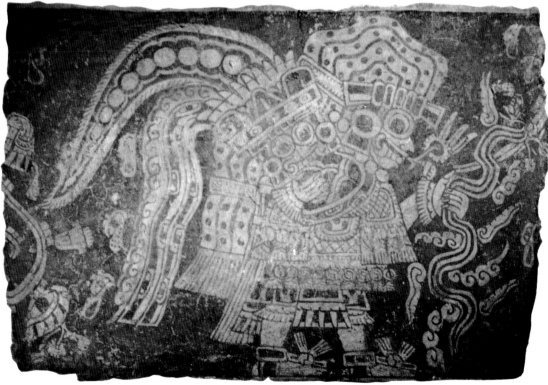

indicate the antiquity of the rain cult. Far to the south, among the Maya, a similar cult is also in evidence, as shown in a famous ritual scene on a lintel from Yaxchilán (see Miller essay in this book, fig. 12). A noblewoman is depicted burning blood-spattered papers; the rising smoke becomes a dragon bearing a goggled mask on its tail, while its jaws open to reveal the spirit of an ancestor. According to the Maya, the ancestors resided in the watery domain beneath the lakes and springs, where they dwelt in communion with chthonic forces. Still farther back in time, at Olmec Chalcatzingo, the famous reliefs on rock faces depict a related theme (see de la Fuente essay in this book, fig. 14). A regal figure — perhaps an ancestor — is enthroned within the jaguar-mask cave from which cloud-scrolls issue; above, the rain clouds float, disgorging their life-giving water. It is clearly intentional that this Chalcatzingo petroglyph was carved on the rock face looking toward Popocatepetl, a primary source of rain-clouds and water for this entire upland region (see fig. 14).

The deepest and most enduring themes that gave order and meaning to Aztec life were inherited from much older patterns that stemmed from past civilizations. Yet, each culture defined these themes in terms of its own history, symbolism, and socioeconomic condition. The mountains and waters of the highland landscape and the dry and rainy seasons provided an eternal frame of reference for a series of peoples who approached the natural environment with a sense of participation. The importance of the Aztec kings cannot be explained entirely in terms of their accomplishments in administration or fierce triumphs in war, for they were also charged with the traditional duty to assure the coming of the rains and the regeneration of nature. This obligation was vital to their authority and power. The transformation of death into life was a central theme in this dynamic world view, and the paradigm of the creation myth that was enacted every year was also the model for effecting change and creating a new social and territorial order.

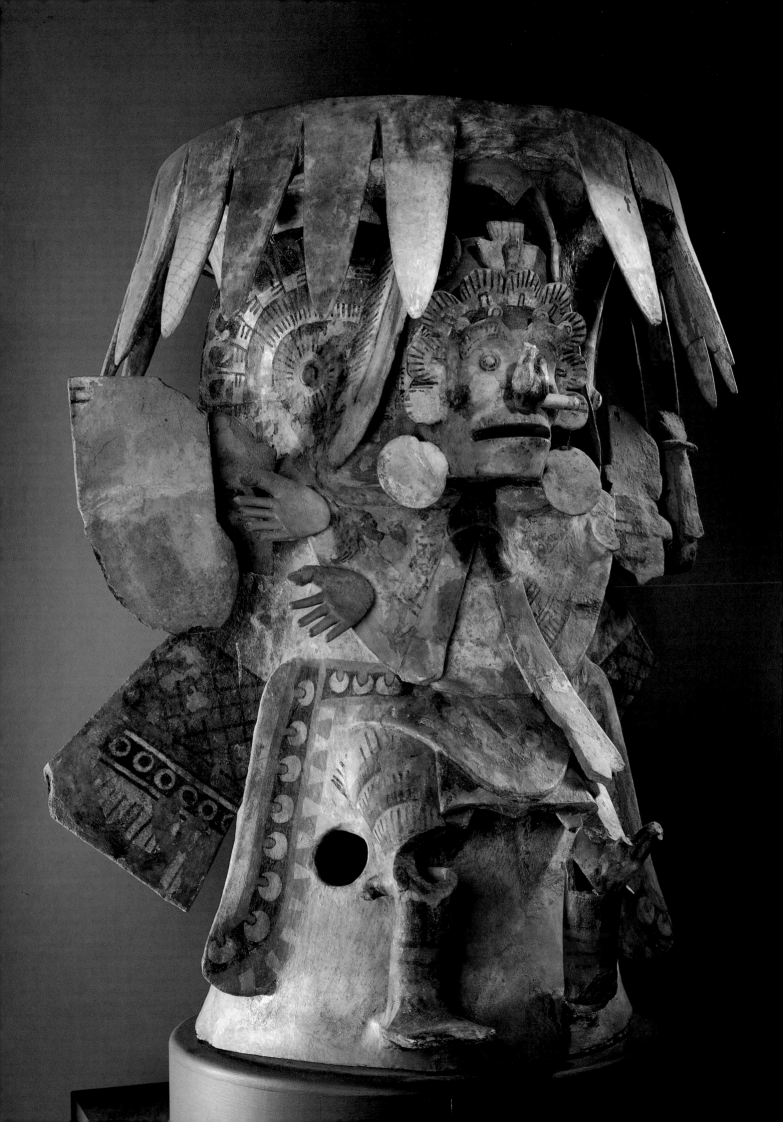

THE AZTEC MAIN PYRAMID:
RITUAL ARCHITECTURE
AT TENOCHTITLAN

Many agrarian and militaristic states have responded in similar ways to the fundamental economic and ideological necessities that confront them. Their responses stem from the particular ways in which they comprehend the universe around them. People depend on nature, and, in their endeavors as productive beings, they actively transform the natural world. At the same time, they also construct a pantheon of gods to whom they ascribe the creative power of all that exists. It is these gods who create the heavens, earth, and underworld, sun and moon (and, by inference, day and night), and fire and water—all of the elements that are indispensable in sustaining life and in the creation of man. This belief system is explained through myths that embrace notions of space and time that seem far different from the ordinary, material world and daily human activity. It is a time of gods, of that which occurred *in illo tempore*, a time that speaks of a cyclical cosmic drama of creation, destruction, and renewed creation.

In this essay, we shall explore the cosmovision of a particular people: the Aztec, or Mexica, of central Mexico. We begin with an Aztec creation myth, which will allow us to see how the Aztec cosmovision is realized in the architecture of the sacred ceremonial precinct of Tenochtitlan, the imperial capital. The ruins of this city lie beneath the Spanish colonial buildings in downtown Mexico City (see fig. 7). Thousands of artifacts, ritual objects, and sculptural monuments were recovered from the excavations at the great Aztec temple and from other nearby locations, between 1978 and 1985 (see figs. 1, 11). Tenochtitlan was originally built on an island in Lake Tetzcoco, a large, shallow body of water in the center of the Basin

of Mexico. The basin is surrounded by high mountain ranges to the east, south, and west (see fig. 2). The highest peaks of these ranges, especially those to the east and south, are the sources of great summer rainstorms and of springs that provide water to the region. When the soldiers of Hernán Cortés first saw the Aztec capital in 1519, it boasted a population of some three hundred thousand people. The city was reached by causeways leading from the north, west, and south; the east was approached by canoes, which docked at a landing on the expanse of Lake Tetzcoco. At the center of the city lay the great temple enclosure, surrounded by royal palaces and public spaces (see fig. 4). As the seat of a tribute-paying empire that reached as far south as Guatemala and to the Gulf of Mexico and the Pacific Ocean, Tenochtitlan was the most powerful and wealthy city of Mesoamerica. When the Spaniards and their Tlaxcalan Indian allies conquered the city in 1521, Tenochtitlan's great buildings were razed to make way for viceregal Mexico City.

The Creation of the Nahua Universe

A number of surviving sixteenth-century Spanish chronicles contain accounts of cosmogonic myths that detail the creation of the earth, the stars, and human beings.[1] These accounts enable us to approach an indigenous view of humankind's place in the world and to begin to reconstruct pre-Columbian concepts of the universe. One such myth is in the manuscript known as the *Historia de los mexicanos por sus pinturas*. It relates how the creator gods, sons of the primordial pair, Tonacatecuhtli and Tonacacihuatl, first created fire, then the sun, and, subsequently, the first human couple. This pair is also depicted in the *Codex Borbonicus* (fig. 3); they are

Fig. 1 Incense burner depicting deity. Mexico, Aztec, 1450/1500. Ceramic. INAH–CNCA–MEX, Museo del Templo Mayor, Mexico City. Brilliant color and flat shapes reflect the influence of manuscript painting. Ritual attire spelled out the attributes of the deities and ancestral heroes in Aztec sculptural and pictorial art. (Cat. no. 17)

Fig. 2 The Basin of Mexico, looking east, near the date of the winter solstice. Major peaks, from left to right, are Mount Tlaloc, Ixtacihuatl ("White Woman"), and Popocateptl ("Smoking Mountain"). Photo: Gabriel Figueroa Flores.

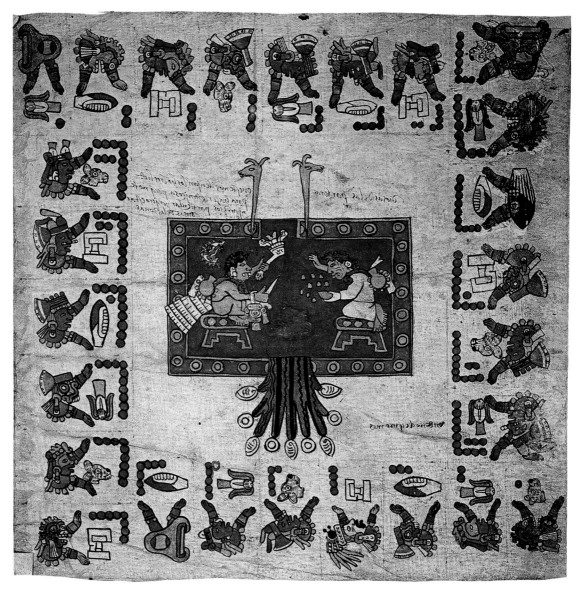

Fig. 3 The primordial male and female creative force, personified as Ometecuhtli-Omecihuatl, within a sacred enclosure at the beginning of time. From *Codex Borbonicus*, Mexico, Aztec, c. 1525. *Amate* paper. Bibliothèque de l'Assemblée nationale française, Paris. Photo: *Codex Borbonicus*, 1974, p. 21.

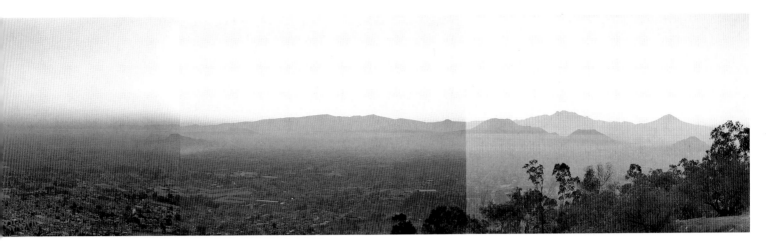

known as Ometecuhtli ("Two Lord") and Omecihuatl ("Two Lady"). The gods then set the calendar in motion, by differentiating night from day. The myth also tells how the levels of the universe were created:

> They then created Mictlantecuhtli and Mictlancihuatl, husband and wife, and these were gods of the underworld, and they placed them there; and then they created the heavens, farther than the thirteenth [level], and they created water, and in it they raised a great fish called Cipactli, who is like a caiman, and from this fish they created the earth....[2]

This myth expresses the division of the three major levels that form the cosmovision of the Aztec: the underworld, or realm of the dead, where the pair of gods presides; the thirteen heavens that form the celestial level; and, between these, the earth, the place occupied by humans. This vertical hierarchy is balanced by a horizontal view that encompasses the four cardinal directions of the universe, each of which was ruled by a different god, and associated with a different color, symbol, and tree. The south was ruled by the blue Tezcatlipoca, better known as Huitzilopochtli, the Mexica-Aztec ancestral hero and warrior god. One of his symbols was the rabbit; another was the hummingbird. He was also

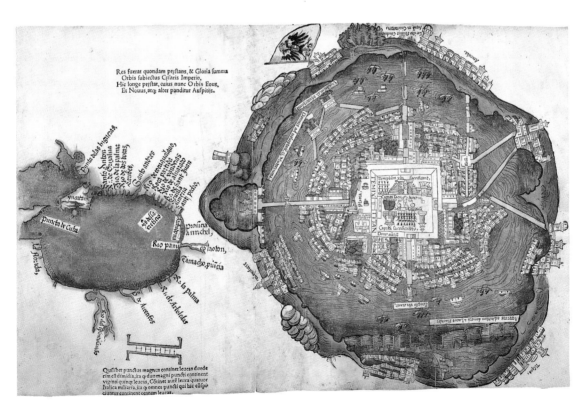

Fig. 4 Hernán Cortés (Spanish 1485–1547). Map of Tenochtitlan and Gulf of Mexico. Nuremburg, 1524. Woodcut on paper. Newberry Library, Chicago.

Fig. 5 The mythical red and blue origin springs. From *Historia Tolteca-Chichimeca*, Mexico, Aztec, Valley of Puebla, 1550/70. Paper. Bibliothèque nationale, Paris. Photo: *Historia Tolteca-Chichimeca*, 1976, f.16v, ms. 51–53, p. 29.

Fig. 6 The founding of Mexico-Tenochtitlan. From *Codex Mendoza*, Mexico, Aztec, c. 1525. *Amate* paper. Bodleian Library, Oxford University. Photo: *Codex Mendoza*, 1938, p. 2.

associated with the spines used to draw blood in ritual acts of autosacrifice. In the east presided the red Tezcatlipoca, known also as Xipe-Totec, the flayed one. The symbol of the east, the quarter of the rising sun, was a reed cane. The north corresponded to the black Tezcatlipoca, and, as it was a cold place, it was associated with the region of the dead (*mictlampa*). The symbol of the north was a flint knife. Finally, there is the west, which corresponded to the god Quetzalcoatl and was identified with the color white and the symbol for house (*calli*). The myths describe a sequence of four imperfect creations and subsequent destructions, each episode of which was a distinct era, or "sun." These eras were named Jaguar-Sun, Wind-Sun, Rain-Sun, and Water-Sun, because they had ended with a plague of jaguars, a hurricane, a rain of fire, and a flood, respectively. The fifth sun represented the present era, the time of Aztec rule; it was destined to end in earthquakes. An Aztec sculpture, "The Stone of the Five Suns" (see Aveni essay in this book, fig. 13a-c), illustrates this sequence of ages.

Universal equilibrium was maintained by the principle of duality: Ometeotl, which, in the Nahuatl tongue, means "double god," or Lord of Duality, who is also associated in mythic texts with the idea of an old god. An ancient poem speaks about the principle of duality represented by the Old God (Huehueteotl):

> Mother of the gods, father of the gods, the old god
> spread out on the navel of the earth, within the circle of turquoise.
> He who dwells in the waters the color of the bluebird, he who dwells in the clouds.
> The old god, he who inhabits the shadows of the land of the dead, the Lord of fire and of time.[3]

We can see clearly how this principle of duality is understood as the mother and father of the gods. Subsequently, Ometeotl is located in the aforementioned three levels, always at their center. This is what the poem refers to in the line: he who is "spread out on the navel of the earth," meaning the fundamental center, surrounded by water. The god is located in the celestial level, where he "dwells in the clouds," but he/she also occupies the underworld, the place of "shadows of the land of the dead." The description we have been analyzing is clear, but how was this vision of the universe given material symbolic

form? This cosmovision was established in the city of Tenochtitlan, in its ceremonial precinct and in the Templo Mayor, the Aztec Main Pyramid.

The Center of the Aztec Universe

According to their legendary accounts, the Mexica-Aztec tribe, after a long period of wandering, finally settled in the center of Lake Texcoco in the Valley of Mexico. The lands they occupied were under the authority of the Lords of Azcalpotzalco, who permitted the Aztec to settle there, provided that they paid tribute, thereby remaining under the Lords' economic and political dominion. The Aztec account of the settlement of their city is a mythical one. They tell us that, upon their arrival, they saw a series of symbols indicating that this was the place chosen by their ancestral god, the warrior Huitzilo-pochtli. The symbols were divided into two groups: the first were those appropriated from the Toltec, the culture preceding and closely related to the Aztec. When the Aztec had been in Aztlan, their place of origin, they were a tribute polity of the Toltec. The Aztec attempted to substantiate their claim that they were "descendants" of the Toltec, their principal paradigm of greatness, by emphasizing their relationship with the Toltec. Upon arriving at the center of the lake, the first symbols the Aztec are said to have seen were red and blue springs of water, as well as fish, frogs, and white plants, all of which were sacred signs traditionally associated with a "Toltec" people when they arrived at their sacred city of Cholula in an earlier time (see fig. 5). In order to legitimize their city and lineage, the Aztec sanctified the place with the well-known Toltec symbols. The following day, they continued to search for sacred signs and found those prophesied by their god of war, Huitzilopochtli: the eagle perched on a cactus. Thus, they achieved two things: the legitimization of their city and lineage in terms of the prestigious ancestral culture of the Toltec and in terms of their own ancestral tribal deity.

As the chronicles continue to relate, still within the domain of myth, the first thing the Aztec did in their new city was to establish its *center*, in order to distinguish sacred from profane space.[4] It was important for them to affirm the center of Aztec social space and the cosmological center of the earth. A historian of religions, Mircea Eliade, has described the following characteristics concerning the symbolism of the center,

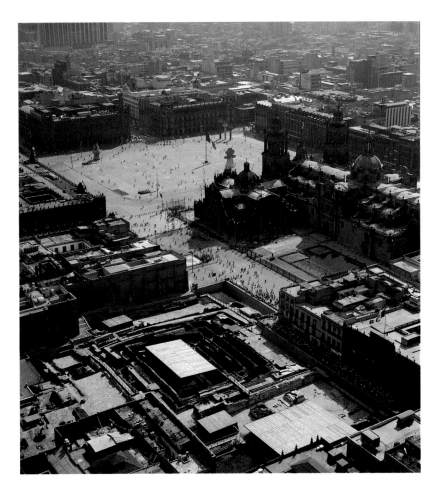

based on comparative studies of many places of worship and their symbolism in various religious traditions:

1. The Sacred Mountain—where heaven and earth meet—is at the center of the world.
2. Every temple or palace—and, by extension, every sacred city or royal residence—is a Sacred Mountain, thus becoming a Center.
3. As an *axis mundi*, the sacred city or temple is regarded as the meeting point of heaven, earth, and hell.[5]

These characteristics, as we shall see, are reflected in the Main Pyramid and its surrounding precinct. In the founding of their city, Tenochtitlan, the Aztec established the center as the place in which they saw a sign given to them by Huitzilopochtli, the symbolic eagle on the cactus. Here they constructed the Main Pyramid, which, in turn, became the center of the Aztec universe. This fundamental center, the earth's navel, as stated in the story above, was also the place where the three levels of their cosmological structure unite: the heavens, the earth, and the underworld. Eliade tells us that this concept is found in societies similar to the Aztec:

Fig. 7 Aerial view of Main Pyramid excavation. Mexico, Aztec, c. 1350–1521. Photo: INAH–CNCA–MEX, Michael Calderwood, Fundación Universo Veintiuno, Mexico City. The foundations of the pyramid lie northeast of the cathedral and the Plaza Mayor of Mexico City.

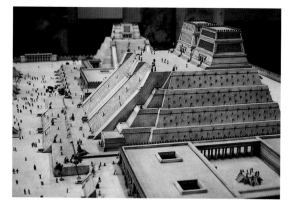

Fig. 8 Model of the Main Pyramid. INAH–CNCA–MEX, Museo Nacional de Antropología, Mexico City. Photo: Richard Townsend.

Fig. 9 Huitzilopochtli with his emblematic humming-bird headdress, fire-serpent wand, and warrior's shield with darts. From *Codex Borbonicus*, Mexico, Aztec, c. 1525. *Amate* paper. Bibliothèque de l'Assemblée nationale française, Paris. Photo: *Codex Borbonicus*, 1974, p. 34

Fig. 10 Sculptural relief of Coyolxauhqui, Huitzilopochtli's mythical adversary. Mexico, Aztec, 1450/1500. Museo del Templo Mayor, Mexico City. The relief was placed at the base of the Huitzilopochtli side of the Main Pyramid.

Hell, the center of the earth and the "gate" of the sky are, then, situated on the same axis, and it is along this axis that passage from one cosmic region to another was effected.... Because of its situation at the center of the cosmos, the temple or sacred city is always the meeting point of the three cosmic regions: heaven, earth, and hell.[6]

Having established the fundamental center in the place where they found the sacred signs prophesied by their god, the Aztec leaders immediately ordered the first construction of the temple and the layout of a four-part plan, which was to govern their future city. According to Fray Diego Durán:

The night after the Aztec had finished their god's temple, when an extensive part of the lake had been filled in and the foundations for their houses made, Huitzilopochtli spoke to his priests.

"Tell the Aztec people that the principal men, each with his relatives and friends and allies, should divide the city into four main wards. The center of the city will be the house you have constructed for my resting place."[7]

In this way, sacred space, the place for temples, was created in the ceremonial precinct of the holy city of Tenochtitlan, along with the ordinary, profane space that served as the place of urban habitation. This event is represented by a painting on a page from the *Codex Mendoza*, depicting the eagle and cactus and the Aztec chieftains within a cosmological composition stressing the inter-cardinal directions (fig. 6). This was a variant

way of indicating the integration of social and cosmological space. The *Codex Fejér-váry-Mayer* contains a page depicting the most widespread type of Mesoamerican cosmological diagram (see Aveni and Boone essays in this book and Boone essay, fig. 1). This image enables us to visualize how the Aztec drew upon ordering ideas and symbols in laying out their city.

We have explained how the Main Pyramid represented the fundamental center of the Aztec world. This was expressed in its architectural elevation: the great platform upon which the temple rests represented the terrestrial plane. A large number of offerings, as well as the great braziers that surrounded the building on its four sides, have been archaeologically excavated from this platform; (see fig. 1; see also Townsend essay in this book, fig. 1.) Four-tiered, stepped-back platforms were superimposed on the base level; these represented the heavenly levels. On the highest platform, we find an expression of cosmic dualism: the two small temples dedicated to the Aztec ancestral god of war, Huitzilopochtli, and the ancient Mesoamerican deity of water, Tlaloc (see fig. 8). Two great staircases led up the eastern facade of the pyramid

to those dual temples. The two sides of the building dedicated to the deities mentioned above represented sacred mountains. The Huitzilopochtli side was the Coatepetl, "Serpent Mountain," the site of the god's mythical battle against his enemies. The legend of this battle is briefly summarized here.

According to the story, an aged priestess, Coatlicue, kept a shrine to the earth-mother at the top of the mountain named Coatepetl.[8] One day, while she was sweeping, a ball of feathers fell from the sky and she became magically impregnated with the future warrior Huitzilopochtli. But the priestess had many other offspring, who became enraged when they learned of this situation. Coatlicue's daughter Coyolxauhqui led a force of armed warriors up the slopes of the mountain to kill her mother, but a traitor ran ahead and whispered the news of the impending attack to the unborn Huitzilopochtli. As the enemy force reached the shrine, Huitzilopochtli was suddenly born; armed with a fire-serpent, he assaulted Coyolxauhqui and routed her siblings. Coyolxauhqui rolled down the side of the mountain to lie on the plain below. Huitzilopochtli thus stood triumphant on top of the sacred mountain (see fig. 9).

The side of the temple dedicated to Tlaloc, the god of water, corresponded to Tonacatepetl, "The Mountain of Sustenance," a symbolic conception of the great rain-producing mountains of central Mexico. (A myth associated with Tlaloc's mountain is described in the Townsend essay in this book.) The Main Pyramid, therefore, was simultaneously two sacred mountains, each of which symbolized its own specific myth.[9] In keeping with this symbolic program, the sculptures and offerings discovered in the pyramid foundation reflected the militaristic, sacrificial themes associated with Huitzilopochtli: flint knives, skull masks, and large ceramic effigies of warriors and, above all, the fearsome effigy of Coyolxauhqui, the mythic personage who was defeated and dismembered by Huitzilopochtli in the mythical battle at Coatepetl (see fig. 10). Huitzilopochtli's magical spear, the fire serpent, was also sculpturally represented (see fig. 13). The mountain of Tlaloc was equipped with offerings of ritual Tlaloc jars, symbolic lightning bolts, and objects associated with many other deities of agriculture, earth, and vegetation. Significantly, many animal skeletons were recovered, including those of crocodilians, fish, corals, and seashells.

The Ceremonial Precinct

Although the Main Pyramid was the pre-eminent central point of reference in the orientation of the Aztec world, the whole ceremonial precinct was also considered a "center." This ceremonial precinct, or sacred space, was another archetypal expression of the Aztec conception of the universe, with four gates allowing access to the interior, each one directed, in turn, toward a cardinal point or quadrant of the cosmos. A major avenue led from each gate: to the north was the avenue to the causeway of Tepeyac; to the south, the avenue to the causeway of Iztapalapa; and, to the west, the avenue to the causeway of Tacuba. To the east, apparently,

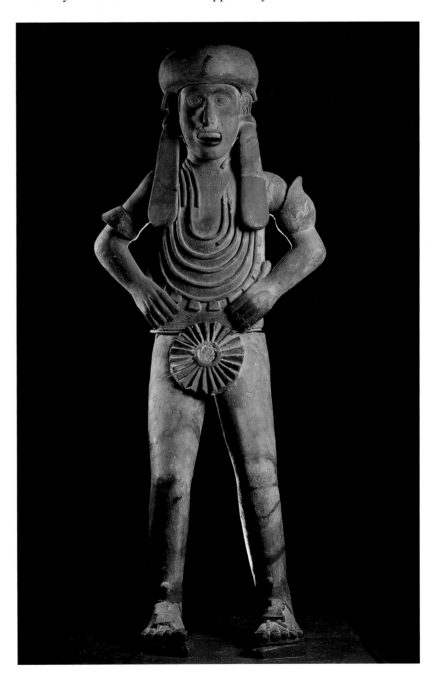

Fig. 11 Male figure, possibly an attendant of an earth goddess. Aztec, Mexico, c. 1450. Ceramic. INAH–CNCA–MEX, Museo Nacional de Antropología, Mexico City. Photo: Gabriel Figueroa Flores. (Cat. no. 11)

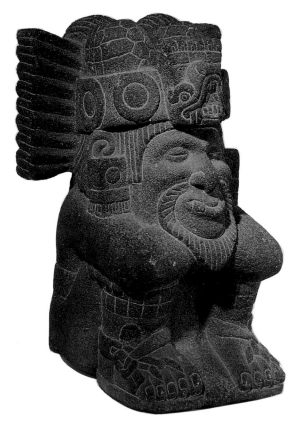

Fig. 12 Old earth god
Tepeyollotl ("Heart of the
Mountain"). Mexico, Aztec,
Tenochtitlan, 1450/1521.
Stone. Museum für
Völkerkunde, Basel.
(Cat. no. 6)

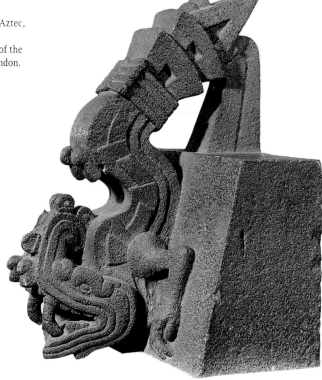

Fig. 13 Fire serpent
Xiuhcoatl. Mexico, Aztec,
Tetzcoco, 1450/1521.
Stone. The Trustees of the
British Museum, London.
(Cat. no. 5)

there was a much smaller avenue, leading to a landing place upon the expanse of Lake Tetzcoco. Within the great enclosure, there were some seventy-eight buildings placed according to a spatial order determined by cosmological geometry. The circular temple dedicated to Ehecatl-Quetzalcoatl, the deity of wind, was located in front. This god also presided over the west, so his temple was located on that side of the east-west axis of the Main Pyramid. Temples dedicated to Tezcatlipoca in the north and south were situated within the ceremonial precinct. The remains of the latter have been found under the Spanish colonial building known as the Archbishop's Palace, on the Calle de la Moneda in downtown Mexico City. These and the other temples, shrines, and related buildings reflected the cults of many deities that were celebrated throughout the cycle of annual agricultural festivals. The Aztec organized the economic life of their community through these festivals of the dry and rainy seasons. The season of cultivation and harvest alternated with the season of war and conquests to gain tributes.

This principle of archetypal structuring in the design of sacred cities meant that the founding of the new city emulated the creation of the world. After a place had been validated through rituals, a fence or wall was built in the shape of a circle or square with four doors corresponding to the four cardinal points. The cities, divided in fours, mirrored the universe.[10]

In his study *State and Cosmos in the Art of Tenochtitlan*, Richard Townsend wrote about this theme in relation to Tenochtitlan:

> The main ceremonial precinct of Tenochtitlan...had...a series of small shrines set around the edge of the principal ritual concourse. These shrines belonged to the four main wards of the city.... This ensemble was at once the most crucial space in the empire, as well as the most sanctified: it was, in effect, a microcosm of the city and a microcosm of the universe.[11]

Tenochtitlan, the fifteenth-century imperial capital, was a sacred city, with its ceremonial precinct laid out according to the Aztec conception of the order of the universe. The buildings, in their elements of construction as well as in their disposition within the precinct, obeyed an order determined by symbols and myths. They responded to, and

incorporated, traditional concepts of design, which had been transmitted to the Aztec from their predecessors in central Mexico. Nothing was left to chance in this distribution, orientation, and placement. To the contrary, everything was subject to an order perceived to organize the surrounding universe. In this way, the Aztec used a widespread, universally recognized frame of reference and employed it in order to legitimize their social order and their claim to imperial power. Because they were the people chosen by their gods, the Aztec constituted the center of their cosmos.

In effect, Tenochtitlan and its ceremonial precinct were two great centers, one contained inside the other in the city that embraced residential zones, palaces, and a host of temples and related buildings that were part of the administrative, economic, and ritual organization of the imperial state. These, in turn, enveloped the innermost, fundamental center of centers: the Main Pyramid, a building that embodied the idea of a mountain of sustenance and a mountain of the deified Aztec warrior hero. It was the symbolic land of the imperium. That the Aztec regarded this building as a place of creative power is confirmed by a type of figure frequently found in the offerings. This is an effigy of a deity with the appearance of an old man, representing the Old God of the dual life-force, which reigns at the center of the universe (see fig. 12). It could not be otherwise. Those who have attempted to see other deities in this figure ignore the symbolism of the Main Pyramid as the fundamental center of the universe, the seat of the ancient god of duality.

These ideas of cosmic symbolism were always tied to the reality of a complex political, economic, and social order. Many Aztec historical monuments illustrate this point. For example, the above-mentioned "Stone of the Five Suns," with its mythic history of the ages, also shows the date hieroglyphs corresponding to July 15, 1503, the coronation date of Moctezuma II. The emperor was thus legitimized as the heir to the earth in the present time of creation. Another related work is a cylindrical greenstone cosmological altar (fig. 14). The upper surface is finely carved with the sign of the present era, surrounded by the disc of the sun. The side of the sculpture is carved in relief, with a band of dots representing stars and a band with flint knives and skull-like forms associated with the earth and sacrifice. Such a monument is described in the Aztec coronation rites as an altar where blood offerings were made to the sky and the earth, when the kings were confirmed in office. These and other famous monuments, when considered in the context of the central precinct and pyramid, served to remind the Aztec lords of the integration of their imperial state with the structures and powers of the world around them.

Fig. 14 Sacrificial cosmological altar. Mexico, Aztec, Tenochtitlan, 1450/1521. Greenstone. Philadelphia Museum of Art. (Cat. no. 19)

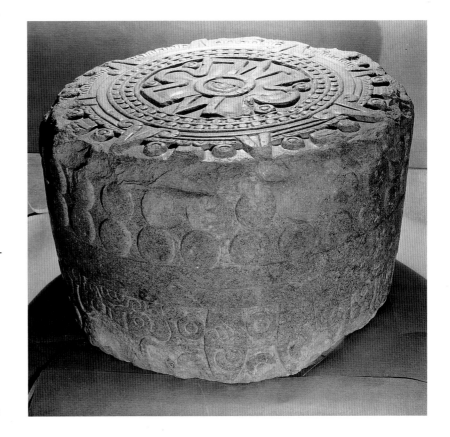

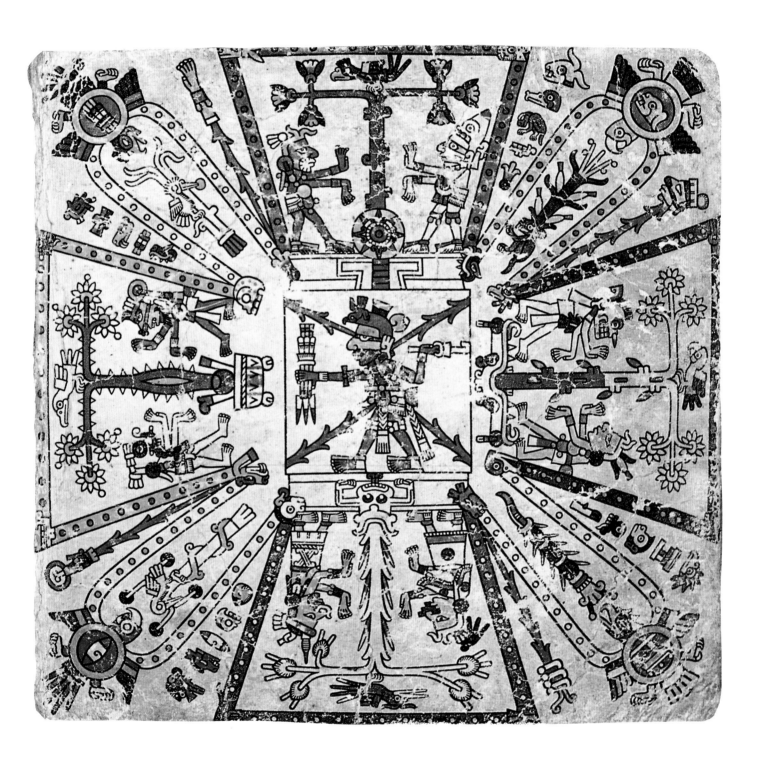

PICTORIAL CODICES
OF ANCIENT MEXICO

Introduction

The human need to record and thereby preserve information for later use manifests itself pictorially and hieroglyphically in Mesoamerica to an extent not seen elsewhere in the ancient Americas. Mesoamerican peoples developed several pictographic writing systems to preserve their knowledge; they painted and carved images on walls, containers, and sculptures, but, more fundamentally, they painted in books. The painter-authors and keepers of the books were guardians of community knowledge and thus were supremely influential members of society; their ranks included priests, high governmental officials, and rulers.

The painted books, or "codices," as they have come to be called, shaped practically every aspect of individual and community behavior. They guided the rulers in their decisions, told one when to plant and harvest and how to live, related how and when religious rituals should be observed, and gave instructions on how the gods were to be worshiped and what roles they played in human life and destiny. The codices also described the mythic and secular past and showed how all things were related within the cosmic structure. There was little in Mesoamerica that remained outside the purview of the painted books. Practically, the manuscripts took such forms as cosmologies, mythic and secular histories, manuals for divination and the performance of rituals, genealogies, accounts of tax and tribute, and maps.

The painted codices, like the pictorial and hieroglyphic systems they were developed to serve, are closely linked to the Mesoamerican desire to set humankind and its world firmly in time. Graphic systems of record keeping seem to have been developed in the New World not to keep track of commodities, as they were in the Old World, but to keep track of the calendar. Calendrical glyphs are among the first glyphic symbols to appear in Mesoamerica, deep in the past of the Formative Period.

It was supremely important for Mesoamericans to record the march of the days, as well as the cycles of the solar year, the ritual divinatory year, the great cycle of fifty-two years, and the even larger cosmic cycles of creation, destruction, and re-creation of the world, for time, and one's place in time, largely determined one's life. Especially in the Mixteca region of central highland Mexico, individuals used the day of their birth as their "day-name," or official name, and, throughout other areas of Mesoamerica, the birth day was believed to determine a person's occupation, personal characteristics and qualities, habits, and destiny. The deities, too, had their day-names. Events and activities, including such cosmic occurrences as the creation of the earth, were also governed by the good or unfavorable associations surrounding the day of their occurrence. It was important to do things at the right time. Even the histories fasten all events securely and specifically to the calendar. Once a deity, a human, or an event was dated, it would be fit within the universal order of the calendar so that it would be comprehended and accounted for. Because of this preoccupation with time, the calendar was at the heart of the manuscript-painting tradition. Probably, the first painted codices were calendrical documents.

The tradition of Mesoamerican manuscript painting may have begun as early as

Fig. 1 Cosmological diagram. From *Codex Fejérváry-Mayer*, Mexico, Aztec/Mixtec, 1400/1521. Animal hide. Free Public Museums, Liverpool. Photo: *Codex Fejérváry-Mayer*, 1971, p. 1. The screenfold codex was designed to be read from right to left when extended. The full sequence of the *Codex Fejérváry-Mayer* begins with this diagram, as seen on the bottom of p. 1, and continues on the preceding pages. The reverse side of the extended screenfold is shown at the top of these pages.

Fig. 2 *Codex Fejérváry-Mayer* (See caption, fig. 1).

about 800 BC, with the advent of pictorial writing on the stone commemorative monuments of the Olmec civilization, but firm evidence of painted books dates only to about AD 600. Fragments of codices, in the form of concentrated flakes of gesso and pigment from the disintegrated pages, have been found in Early Classic tombs in the Maya area.[1] Other than these illegible remains, however, only fifteen pre-Conquest manuscripts have come down to us, having survived in Mexican and European libraries. The corpus is amplified by over five hundred early Colonial codices, showing varying degrees of acculturation, that recall the native tradition.[2]

Manuscripts in a screenfold format seem to have been preferred in Mesoamerica. Screenfolds were made by gluing together sections of deer hide or bark paper (*amate*, from the fig tree) to create a long strip and then folding the strip back and forth like an accordion or screen. After the individual screenfold panels or pages were sized with a white compound of calcium carbonate, the pictorial content was painted on the smooth surface of both sides with a brush. Wooden boards, often covered with animal skin, were then attached to the end pages to protect the book.[3]

Within Mesoamerica, cultural preferences dictated the size and composition of the screenfolds. The Maya always used *amate*

paper, folding it to create pages that are about twice as tall as they are wide and measuring about ten by twenty centimeters (see fig. 3).[4] The Mexicans living in the region northwest of the Isthmus of Tehuantepec (including central Mexico, the Gulf Coast, and Oaxaca) preferred squarish pages ranging in size from about fifteen square centimeters (see fig. 4) to about forty square centimeters.[5] All the Aztec screenfolds are of *amate*, while the Mixtec and Borgia Group manuscripts are all of animal hide. Complementing the screenfolds were *tiras* (long strips of hide or paper that were rolled instead of folded), large panels of hide, and broad sheets of cloth, the size of flags, termed *lienzos*, which bore specialized painted images (see fig. 5).[6]

Mesoamerican pictographic writing systems varied greatly in graphic content. Some relied principally on representational images that were juxtaposed spatially to form meaningful units of information, while others used phonetically based hieroglyphs to record something close to spoken language. The type of record-keeping system affected the pictorial nature of the codices.

The fully developed hieroglyphic system of the Maya, with its structured grammar of ideographic and phonetic glyphs and glyphic components, meant that the texts of the Maya codices were the equivalent of spoken sentences and phrases (see fig. 3). The

existence of such texts brought a precision of meaning to these codices, and it also set up a distinction between glyphic passages and pictorial images. Generally, the texts and paintings were separated on the page, assigned to delineated areas. The texts carried the greater burden of record keeping, but both graphic forms complemented each other. The paintings functioned to amplify and qualify the textual record, at the same time that individual glyphs were often incorporated into the paintings to enhance the pictorial message.

West of the Maya region, the largely pictographic systems of the Aztec, Mixtec, and neighboring Central Mexican peoples led to codices that were more loosely structured and more pictorial (see fig. 8). The combination of representational forms with symbols, ideograms, and some phonetic elements created graphic systems that were less textual than iconographic. Occasionally, images were directly tied to language through their phonetic readings, but, more commonly, the pictorial elements stood for things, actions, or concepts that had to be interpreted within the larger pictorial context, where spatial arrangement and directional flow provided meaning as well as structure. The paintings in Aztec and Mixtec books carried the full burden of record keeping. Thus, the painted manuscripts lie at the intersection of record keeping and art, and their composition is

governed as much by the need to convey meaning unambiguously as by aesthetics.

Divinatory Books

The books most fundamental to Mesoamerican societies were the religious/divinatory codices, which functioned actively as the guides for human behavior (see figs. 1, 3, 4). Their contents sometimes included prescriptions for rituals and ceremonies, narrations

Fig. 3 Three almanac pages. From *Codex Dresden*, Mexico, Maya, Late Postclassic, c. 1400/1521. *Amate* paper. Sachsische Landesbibliothek, Dresden. Photo: Villacorta and Villacorta, 1930, pp. 17–19. These pages with figures and related hieroglyphs describe illnesses. Bar-and-dot numbers and calendrical hieroglyphs portray associated sequences of dangerous days.

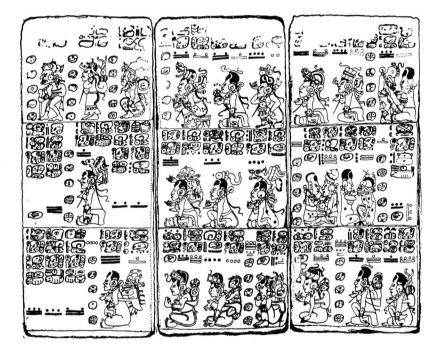

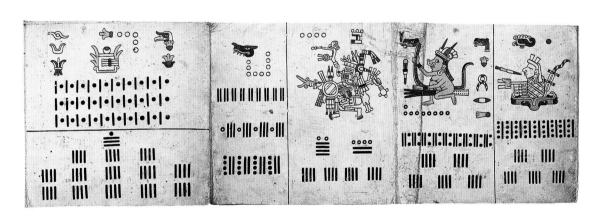

of, or references to, myth and cosmology, and astronomical events (among the Maya), but mostly these codices consisted of divinatory almanacs. Since time was the controlling factor in Mesoamerican life, these almanacs explained the divinatory associations of different units of time. They related fate to time specifically, because the Mesoamerican 260-day divinatory cycle or ritual calendar was thought to contain within it all the elements that governed actions, events, and beings. Each part of the calendar was associated with, and influenced by, specific deities, animals, plants, colors, cardinal directions, locations, actions, and qualities, all of which carried specific divinatory messages and associations. Together, these elements would function in conjunction with one another to qualify and shape a period of time. The images, as associations and portents of the different days and units of time, were painted and recorded in *tonalamatls* (Nahuatl for "books of days").

The priest, diviner, or "daykeeper" would then consult the *tonalamatls* to discover the prognostication for a particular day or group of days or to identify the most favorable day for a certain activity. The diviner would first find the glyph(s) for a day or group of days in his manuscript. Then he would identify and interpret the deities, symbols, and elements painted with the day glyphs, in order to understand the prognostication.

For example, when a child was born, he or she was taken to the diviner, who would note the child's birthday, consult the almanac to

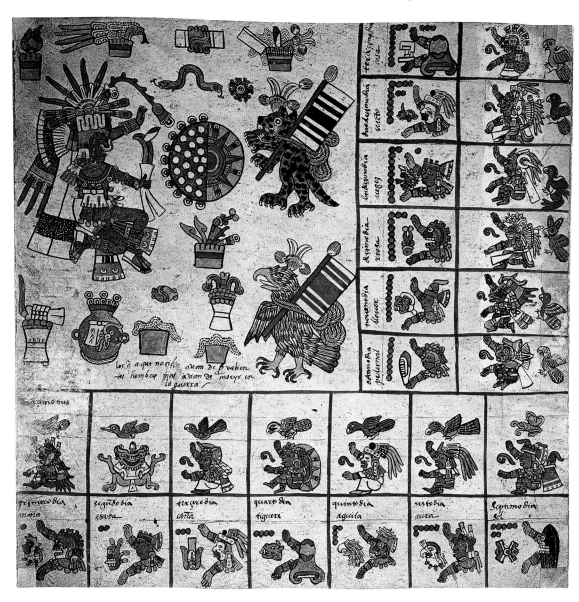

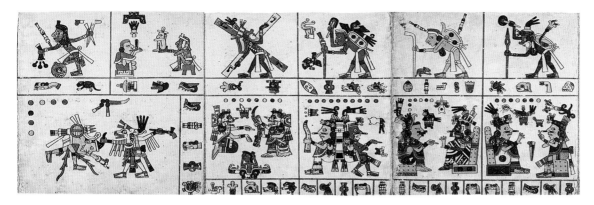

locate that day (e.g., an almanac such as the *Codex Borbonicus*, see fig. 4), and explain the child's fate by interpreting the visual images associated with that day. What the diviner found in the almanacs were paintings of the various deities, elements, and activities that governed the child's birth day and had a fundamental determining effect on the child's life. The diviner also found visual images that could tell him what ceremonies or ritual actions might be performed to help overcome harmful influences.

Farmers consulted diviners when they needed to know which periods of time were best for planting and harvesting. Merchants sought the guidance of the diviners when they embarked on and returned from journeys, for they knew that there were only certain days favorable for travel. Rulers, warriors, beekeepers, and hunters—all the range of Mesoamerican society—consulted with the readers of the divinatory codices to understand the natural and supernatural forces that governed the days of their proposed activities and to plan accordingly.

The Maya and Central Mexican almanacs functioned differently from one another: Maya almanacs focus on the specific activity being performed, while the Mexican ones focus on periods of time. Maya divinatory manuscripts contain groups of almanacs that are related to specific activities and events and that give the prognostications for these events on individual days; they are subject-specific. In the *Codex Dresden* (see fig. 3), for example, a cluster of almanacs pertaining to disease identifies the days most likely to be associated with certain illnesses; the pictures and texts describe the diseases, while the calendrical glyphs and bar-and-dot numerals provide the sequence of the perilous days. Maya divinatory codices concern themselves with a wide range of subjects, including rain, eclipses, the activities of planets, beekeeping, maize planting, hunting, warfare, commerce, disease, and marriage and other social relationships. The *Codex Dresden*, for example, has almanacs that pertain to Venus and eclipses, worked out with great precision and sophistication. The *Codex Madrid*, on the other hand, is composed almost entirely of almanacs relating to the subsistence base of a relatively small agricultural community.

In contrast, almost all of the Central Mexican almanacs are purposefully general in their treatment of subject and, therefore, are adaptable to a wide variety of circumstances (see figs. 1, 4). They do not usually concern themselves with prognostication for specific activities; rather, they focus on time. For a unit of time, each almanac pictures one or more of the sacred and secular elements that may characterize or govern that period. Since a single almanac will generally provide only part of the evidence for a full prognostication, the daykeeper had to consult widely

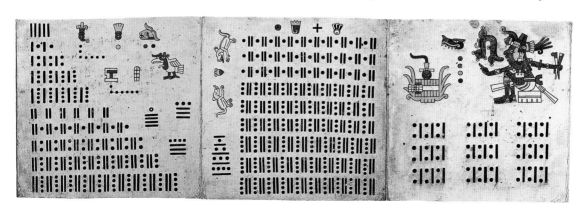

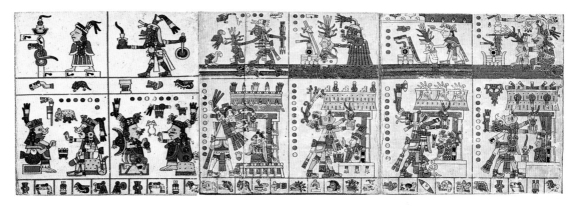

among the different almanacs in a codex to assemble all the raw materials necessary to calculate a specific destiny, comparing the elements, and weighing one against another in order to tailor the prognostication to an individual situation. When seeking a successful day for planting a maize crop, for example, the Central Mexican diviner would consult several general almanacs to understand what gods and forces were influencing the days in the near future. By understanding these associations, he could identify for the farmers the most auspicious day for planting, and he could tell them what rituals were necessary to alleviate negative forces and ensure success.

The best-known religious/divinatory manuscripts from central Mexico are the Aztec *Codex Borbonicus* (see fig. 4) and *Tonalamatl Aubin*, plus the five principal manuscripts of the "Borgia Group" (so named because of their affinities with the *Codex Borgia*): the *Codex Borgia* itself and the *Codices Cospi, Fejérváry-Mayer* (see figs. 1, 2), *Laud*, and *Vaticanus B*. Although the Borgia Group codices come from different parts of Mexico, including the Mixteca and Cuicateca regions of Oaxaca, and probably also Veracruz, they are clustered because they contain many of the same almanacs and have much of the same iconography.[7] The Aztec divinatory manuscripts are limited in their mantic content to only one version of the 260-day count, laid

out elaborately. The Borgia Group codices contain much simpler presentations of this version, stripped of the embellishments, but they contain, in addition, several dozen other arrangements of the 260-day count.

The *Codex Fejérváry-Mayer* contains fifteen separate almanacs, all of which organize groups of days in different configurations. On page one, the codex painter has fashioned a diagram of Mesoamerican time and space in a single presentation that is simple even in its complexity. The painter has not only organized the world spatially in the four cardinal directions and the fifth direction of center, he has also wrapped the 260-day divinatory count around the world and has overlaid three separate almanacs, each functioning distinctly to characterize the days and 13-day periods. Anthony Aveni discusses the cosmology of this page in his essay in this book, and I will complement his discussion with a description of the function of the Fejérváry-Mayer almanacs.

The fundamental almanac on the first page of *Codex Fejérváry-Mayer*, upon which the following two almanacs are built, is the full record of the 260-day count (see fig. 1). Here, the thirteen days in each of the twenty *trecenas* (thirteen-day periods) are indicated in a continuous counterclockwise sequence, visually creating the Maltese cross that fills the page. This count begins with the day-sign Crocodile (identified by a crocodile head),

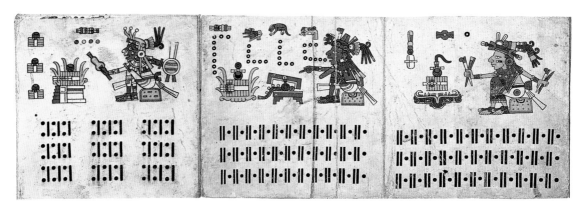

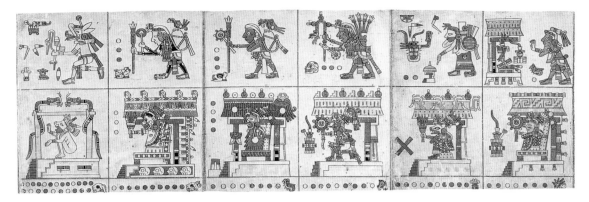

the first day of the first *trecena*, at the lower right edge of the upper arm of the cross (at the right side of the platform on which the two upper deities stand). The next twelve days of this *trecena* are not named pictorially but are represented by twelve discs or spacers that follow up the arm of the cross until the fourteenth day, Jaguar, is reached. This day introduces the second *trecena*, which also has twelve spacers to mark the days remaining until the first day of the third *trecena*, Deer, is reached. In this manner, the initial days of each of the twenty *trecenas* are pictured, followed by discs for the remaining twelve days. As always, the day-signs face in the direction the count is to be read. This presentation organizes the calendar days sequentially to the different cardinal directions, with their related deities, trees, birds, and colors; the days in the first three *trecenas* are associated with east, those in the fourth and fifth *trecenas* with the intercardinal area northeast, and so forth.

Four of the days that initiate the *trecenas* also function as the days for which years are named. These are the day-signs painted at the tops of the intercardinal loops on the backs of birds and encircled in cartouches. Together, they form a separate almanac for the year-signs, associating them with animals, plants, birds, and world directions.

The five day-signs painted in a column between each of the intercardinal loops and the arms of the Maltese cross (twenty day-signs in all) form a third almanac. Although this almanac covers the 260-day calendar, it pictures only the first day-sign of each of the twenty *trecenas*, using the first day of each *trecena* to represent the whole. The count begins with Crocodile as the bottommost sign in the column at the upper left corner. It then does not move linearly to the next sign in that column but jumps to the bottommost sign in the column at the lower left corner, Jaguar (represented by a jaguar ear), the first day of the second *trecena*. The count then jumps to the bottommost sign in the column in the lower right, Deer (represented by a deer foot), the first day of the third *trecena*, and so on, in a gradually widening spiral. The great efficiency of this almanac is that the 260-day count can be covered by using only the first day of each *trecena*. This presentation also allows the *trecenas* to be grouped differently and, therefore, to be associated with different directions, birds, trees, and deities.

The diviner consulting this page could read the multiple associations belonging to a particular day, *trecena*, or year, according to each of the three almanacs; in one page, he was given a host of determining elements on which to base his prediction. Since the Central Mexican divinatory almanacs picture mantic associations that are generally applicable to a wide variety of events and actions,

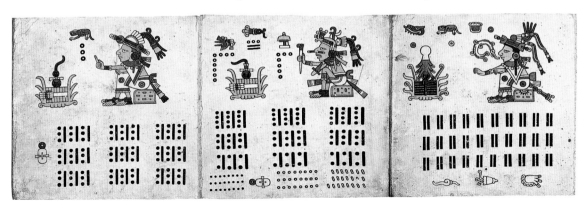

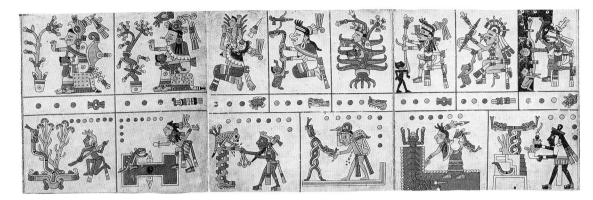

the diviner had to sort the elements and determine which were the most important for any given situation. He also consulted more than one almanac in a divinatory book to get a good overlay of associations. Ultimately, a diviner had to make the prognostication himself. The divinatory books provide all the elements required for a prognostication, but ultimately it was the diviner who had to synthesize and evaluate the data and make the final reading.

Painted Histories

In addition to relying on religious/divinatory manuscripts to relate themselves to time and space, Central Mexicans developed another manuscript type—the painted secular history—to link themselves with past events and to tell their own story. These secular histories focused on the human rather than the divine realm, presenting the history of families, polities, or ethnic groups, although they also embraced the supernatural and cosmic events of mythic history. The histories often record such events as the birth, succession to office, and death of rulers and their families, the rulers' conquests and important travels or deeds, programs of construction and dedication of important buildings or monuments, and such natural or climatic phenomena as solar eclipses, earthquakes, floods, and famines. The Mixtec histories of individual dynasties have a natural genealogical emphasis, while the histories of Aztec migrations and imperial endeavors ignore lineage to focus on Aztec deeds. The way the historical documents structure and present history divides them into three basic types.[8]

First, there are cartographic histories, which are pictorially founded as a stylized map or geographic panorama. Persons, events, and locations are then arranged spatially across the conceptualized landscape. Space, directional lines, and footprints signal the progression of time, but specific time can be stated by actual dates. The Tetzcocan histories (*Mapa Quinatzin*, *Mapa Tlotzin*, and *Codex Xolotl*; see fig. 6), the Aztec *Mapa Siguenza*, and many of the *lienzos* and *mapas* belong to this category. They were created specifically to present the actions of individuals or groups as occurring within a particular space, and generally this space is the territory or area the group claims as its own part of the cosmos.

The Mixtec historical screenfolds make up a second kind of history. They represent *res gestae* ("deeds done"), narratives in which the sequence of deeds of specific individuals or groups carries the story. The history moves efficiently from event to event; when needed, place-signs are added to indicate location, and day-signs and year-signs are given to provide the date. Thus, the narratives in the

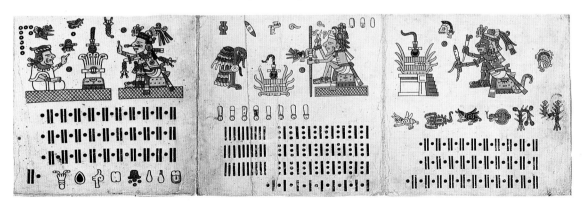

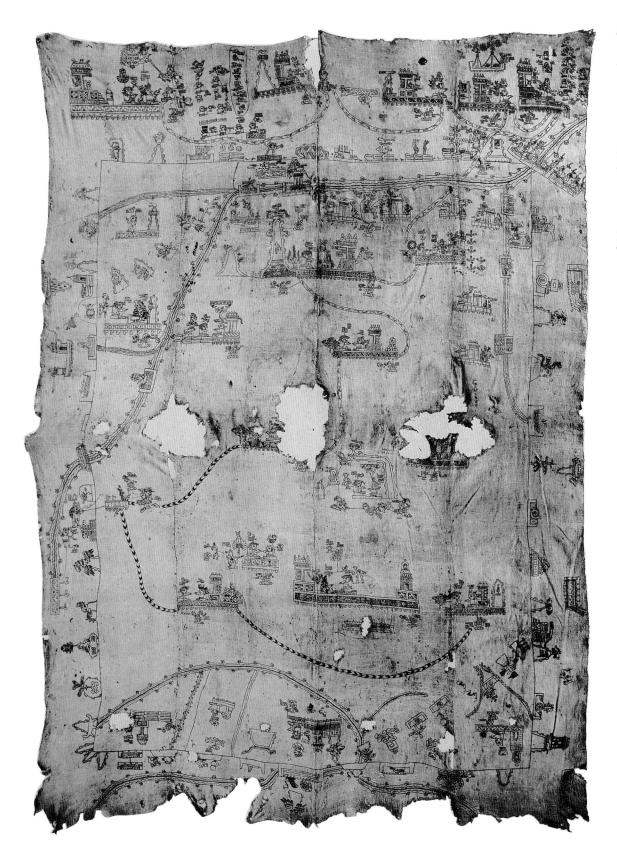

Fig. 5 Map. From *Lienzo de Zacatepec*, no. 1. Mexico, Mixtec, Santa María Zacatepec, 1550/1600. Cloth. Biblioteca del Museo Nacional de Antropología, Mexico City. Photo: Peñafiel, 1900. This map from the early Spanish colonial period continues an ancient Mixtec tradition. Rivers, mountains, roadways, and towns are represented along with named dynastic personages and depositions of historical events.

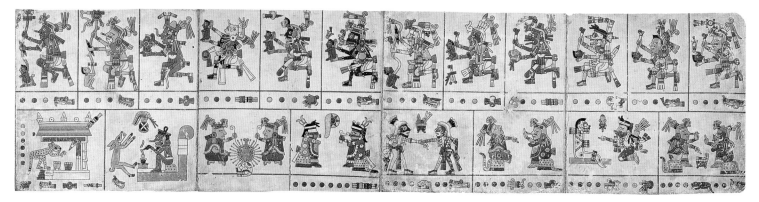

Mixtec *Codices Becker, Bodley, Colombino, Zouche-Nuttall* (see fig. 8), *Selden*, and *Vienna* follow the important deeds and events in the lives of major Mixtec rulers, winding pictorially in a boustrophedon path through the screenfold, reading alternately from right to left and left to right, with place and time depicted by pictorial conventions, where appropriate.

A third kind of history is the continuous year-count annal of the Aztec world, where sequential time is the focus. The pictorial base of the annal is the continuous sequence of the year-signs. In little-acculturated manuscripts like the *Codex Mexicanus* (see fig. 7), *Codex Moctezuma*, and *Tira de Tepechpan*, the years are painted in an unbroken line reading in a single direction, so that the years graphically form a spine for the story of earthquakes, conquests, temple building, and the reigns of the rulers. Time is thus the armature for the narrative, with events and persons organized and painted around the years and often attached to the years by lines. These continuous year-count annals were a particular Aztec invention, created to present the Aztec empire as part of an unbroken stream of events in an unbroken sequence of time.

Maps and genealogies distinct from those incorporated into the histories were also part of the Mesoamerican manuscript tradition (see fig. 5). Generally, they were painted on larger sheets of hide, cloth, or paper. The maps, like those included in the cartographic histories, showed conceptual rather than naturalistic views of territory, and the Spanish conquerors remarked on their accuracy.

These books collectively preserved an essential part of Mesoamerican memory, knowledge, and understanding. The divinatory guides and the histories, as well as the maps and genealogies, functioned to situate humans securely within the space and time of their world. At the same time, the books were a vital means of making coherent the world in which these people lived; they related mundane human activities and religious beliefs to the environment, and they made a unity of the whole. The books were more than merely record-keeping devices; they integrated life and made sense of it.

Adaptation in the Colonial World

The collapse of native cultures after the Spanish invasion of Mexico destroyed most of the religious and historical manuscripts. Many were burned by the Spaniards, who sought to eliminate indigenous religious beliefs and practices. Others were thrown out by Indians under Inquisitional threat, or they fell into disuse and disintegrated.

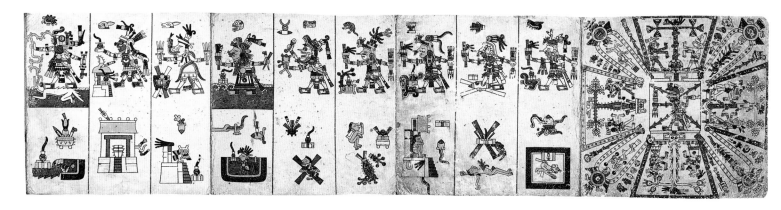

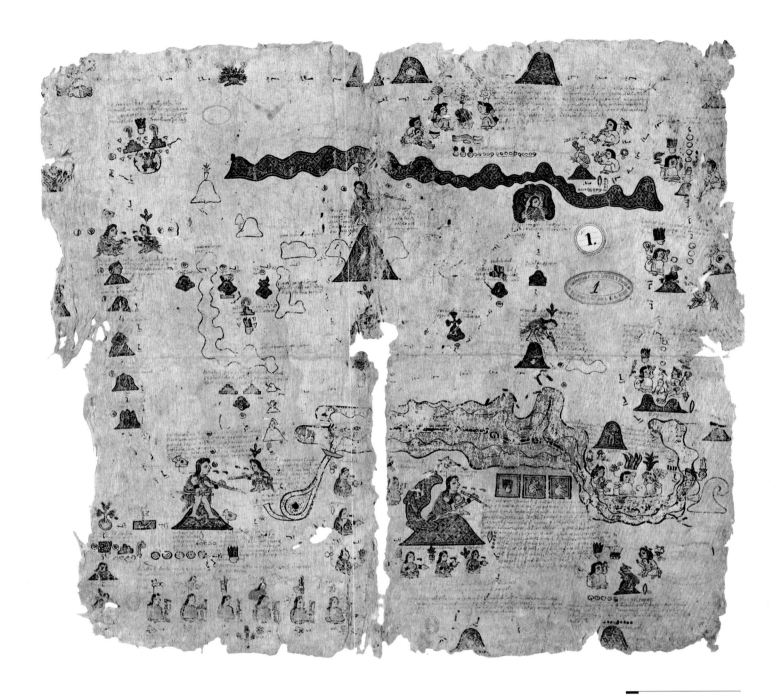

Fig. 6 The migrating
Chichimec settle in the
Valley of Mexico during
the thirteenth century.
From *Codex Xolotl*, map 1,
Mexico, Aztec, Tetzcoco
region, 1525/35. *Amate*
paper. Bibliothèque
nationale, Paris. Photo:
Codex Xolotl, 1951, p. 1.
The mountain range to the
east of the valley appears
above; the lake system is
schematically depicted
below.

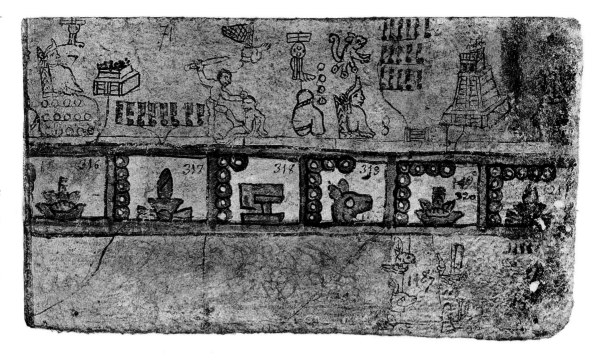

Fig. 7 Manuscript page showing chronological events at Tenochtitlan. From *Codex Mexicanus*, Mexico, Aztec, Valley of Mexico, 1570/80. *Amate* paper. Bibliothèque nationale, Paris. Photo: *Codex Mexicanus*, 1952, p. 71. Aztec historical manuscripts portray the sequence of events in time. On this page, the ruler Tizoc is enthroned in the year Four Reed, 1482 (left); three years later, in Seven Rabbit, his funerary bundle is shown next to his brother Ahnizotl, who succeeded to the throne. The following year records the rededication of the Main Pyramid in the Aztec capital, Tenochtitlan.

Fig. 8 The ruler Eight-Deer has his nose septum perforated in a dynastic kingship rite (lower left). From *Codex Zouche-Nuttall*, Mexico, Mixtec, c. 1450/1520. Animal hide. British Museum, London (Add. Mss 39671). Photo: *Codex Zouche-Nuttall*, 1987, p. 52.

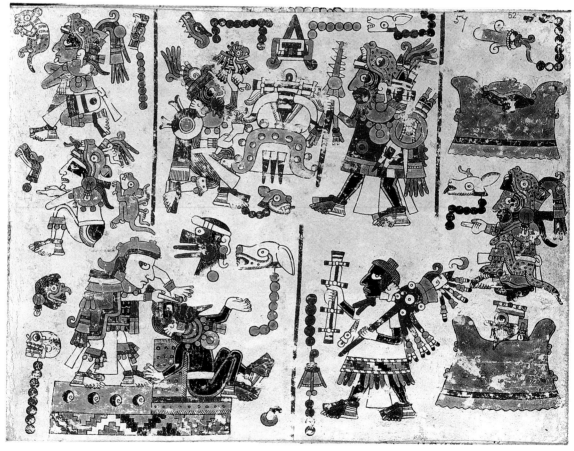

At the same time, manuscript painting survived the first sixty years of Spanish rule, as did no other art form. The native tradition of manuscript painting flourished in Mexico at least until the 1580s, and it did so because it was highly adaptable to the new historical situation. Aztec and Spaniard alike found manuscripts useful in communicating with, and adjusting to, each other. Spanish governmental authorities found that they needed administrative records for both the Aztec empire and the new viceregal order; therefore, they sponsored the painting of maps, tribute and tax assessments, and registers of properties and salaries. The Aztec, used to relying on painted codices, had their own maps and property plans painted to protect their land holdings and possessions; their genealogies and histories were recorded to support their claims. These pictorial documents were acceptable as evidence in Spanish courts. Spaniards, too, sponsored the painting of histories that included the Spanish conquest and the introduction of the new Christian and viceregal order.

Even religious manuscripts came to be seen in a new light in the mid-sixteenth century, when the mendicant friars proselytizing in the New World found that their lack of understanding of the old religious customs hindered their missionary efforts. Seeking original pictorials to copy, they created their own documents on the indigenous religion so that they might combat more effectively its continued practice. Some of the old pictorials were copied in native materials or on European paper, and new types of manuscripts were created to meet the new situations. Pictorial catechisms of the Catholic faith were drawn for the Indian proselytes, and encyclopedic compendia of native culture — which gathered information especially on indigenous religion, history, and the calendar — were created for a Spanish ecclesiastical readership.[9]

The new audience for colonial pictorials caused them to be annotated in Spanish, Nahuatl, or other indigenous languages to make them more intelligible to Spaniards and mestizos. Gradually, as the sixteenth century wore on, the texts assumed more and more of a documentary function, and the paintings became more European in style. By the early seventeenth century, the pictorial codices of Mesoamerica had become books of European form. Painted histories became written chronicles, and divinatory and religious codices gave way to Catholic catechisms, prayer books, and treatises. Written regulations, laws, histories, and prayers came to take the place of the ancient painted books as guides for living and statements of identity.

NOTES

Order and Nature in Olmec Art
Beatriz de la Fuente

1. Melgar, 1869.
2. Saville, 1929.
3. See Stirling, 1940; Caso, 1942, pp. 44–45; Covarrubias, 1942; Drucker and Heizer, 1956; Heizer, 1959; Grove, 1968, pp. 489–90; Piña Chan and Covarrubias, 1964, pp. 48–54; M. Coe, 1965; Bernal, 1968.
4. M. Coe, 1972; Furst, 1968; Joralemon, 1971, 1976.
5. Bonifaz Nuño, 1988, 1989; Gay, 1971; Luckert, 1976; Reilly, 1989.
6. Andrews, 1987; Grove, 1987.
7. De la Fuente, 1973.
8. González Lauck , 1989.
9. Covarrubias, 1942.
10. Eliade, 1969, p. 20.
11. Stirling, 1955, p. 20, pl. 26b.
12. Medellín Zenil (1960) said that they are negroid individuals; Kubler (1962, p. 72) qualified them as idealized portraits; Piña Chan and Covarrubias (1964, p. 48) thought that they represented the decapitated heads of ball players; M. Coe (1965) thought at first that they were warriors; Bernal (1968, p. 75) said they were portraits of rulers; Wicke (1971) noted that they might have had political significance; M. Coe (1972, pp. 5, 10) gave them a second reading when he identified them as portraits of kings of the Jaguar dynasty.
13. See de la Fuente, 1977.
14. Panofsky, 1955.

The Natural World as Civic Metaphor at Teotihuacan
Esther Pasztory

1. Millon, 1981.
2. Spence, 1981.
3. Rattray, 1981, 1990.
4. Sanders and Michaels, 1977, pp. 147–68, 441–67.
5. Santley, 1989.
6. A. Stone, 1989.
7. See Marcus, 1983.
8. Séjourné, 1959.
9. Cowgill, 1983.
10. Pasztory, 1988.
11. Haas, 1982, pp. 34–56.
12. Wheatley, 1971, pp. 477–82.
13. Sanders, Parsons, and Santley, 1979, pp. 98–102.
14. Millon, 1981, pp. 231–35.
15. Heyden, 1976, p. 22.
16. Manzanilla, 1990.
17. Pasztory, 1976, pp. 165–69.
18. Millon, 1981, p. 233; Taube, 1986.
19. Vidarte de Linares, 1968, p. 138, compared the North-South Avenue to the nave of a Gothic cathedral.
20. Aveni, Hartung, and Buckingham, 1978; Aveni and Hartung, 1982; Aveni, 1988.
21. Florescano, 1989.
22. Caso, 1942.
23. Pasztory, 1990.
24. Cabrera Castro, Cowgill, and Sugiyama, 1990.
25. A. Miller, 1973, figs. 116, 119 (detail).

The Beginnings of Preclassic Maya Art and Architecture
Juan Antonio Valdés

1. Fialko, 1988; Matheny, 1986; Ruppert, 1944.
2. See Valdés, 1986, pp. 125–28; see also Aveni essay in this book.
3. Freidel, 1981; Matheny, 1986.
4. W. Coe, 1965.
5. Valdés, 1987.
6. L. Parsons, 1986.
7. Schele and Miller, 1986, p. 109.
8. Ibid., pp. 26–27, 42–43, 68, 105–106.

The Image of People and Nature in Classic Maya Art and Architecture
Mary Ellen Miller

1. D. Tedlock, 1985, p. 163.
2. The significance of this deity was recently rediscovered after decades of neglect, and his importance was amplified by Taube, 1985, who was the first to identify the Maize God with Hun Hunahpu, a character in the *Popol Vuh*.
3. See D. Tedlock, 1985, p. 350.
4. Stuart, 1987.
5. Structure 22 collapsed in an ancient earthquake, so we see it today in an artist's reconstruction. Only the lower teeth of the great monster maw remain *in situ*. The interior doorway, in the form of the Celestial Monster, has been reconstructed.
6. Stuart, 1988.
7. Taube, 1988b.
8. Schele, 1984.
9. Hellmuth, 1987.
10. D. Tedlock, 1985, pp. 159–60.
11. Taube, 1992.

The Renewal of Nature at the Temple of Tlaloc
Richard F. Townsend

1. Duran, 1971, p. 156.
2. Ibid., pp. 157–58.
3. Ibid., pp. 158–59.
4. Other examples of these orifices are found at Malinalco (see Townsend introduction, fig. 14), Tetzcotzingo, and the Yopico Temple in the main ritual center at Tenochtitlan.
5. Mendieta, 1945, pp. 83–84, 158.
6. Kirchhoff et al., 1976, pp. 163–64.
7. Sahagún, 1963, p. 247.
8. Ibid.

The Aztec Main Pyramid: Ritual Architecture at Tenochtitlan
Eduardo Matos Moctezuma

1. Nahua is a generic term referring to those people who spoke the Nahuatl language, as in the case of the Aztec.
2. Garibay, 1979, p. 23.
3. León-Portilla, 1979.
4. Durán, 1964, p. 32, and Alvarado Tezozomoc, 1943, made special note of this.
5. Eliade, 1965, p. 12.
6. Ibid., pp. 13–15.
7. Durán, 1964, p. 32.
8. Sahagún, 1951–82, bk. 3.
9. Broda, 1986; Townsend, 1982.
10. Eliade, 1965; see also Wheatley, 1971.
11. Townsend, 1979, p. 47.

Pictorial Codices of Ancient Mexico
Elizabeth Hill Boone

1. For these tombs, see Angulo, 1970, p. 5; Kidder, 1935, p. 112; Smith, 1937, p. 216; Thompson, 1960, p. 23.
2. The fifteen pre-Conquest manuscripts include four Maya codices (the *Codices Dresden, Grolier, Madrid*, and *Paris*), six Borgia Group documents (see manuscripts below), and five historical-genealogical manuscripts from the Mixteca (the *Codices Becker I, Bodley, Colombino, Zouche-Nuttall*, and *Vienna*). See Glass, 1975, pp. 3–80 and 81–225, respectively, for an overview of the native tradition of manuscript painting and for the bibliography prior to about 1971.
3. Schwede, 1912; the *Codices Vienna* and *Vaticanus B* still have their wooden covers.
4. Thompson, 1972, pp. 4–5.
5. The Aztec *Codex Borbonicus* (Paris, Bibliothèque de l'Assemblée legislatif) is the largest, with pages measuring 39 x 39.5 centimeters and a total length of about 14 meters; the *Codex Vaticanus B* (Rome, Bibliotheca Apostolica Vaticana) has pages measuring only 13 x 15 centimeters, making it the smallest.
6. Thompson, 1972, pp. 5, 9; Cortés, 1986, pp. 94, 340.
7. For the provenance of the Borgia Group manuscripts, see Nicholson, 1966; Thompson, 1966; Sisson, 1983.
8. Boone, 1992.
9. Robertson, 1959; Glass, 1975; Boone, 1983.

CENTRAL AMERICA AND THE NORTHERN ANDES

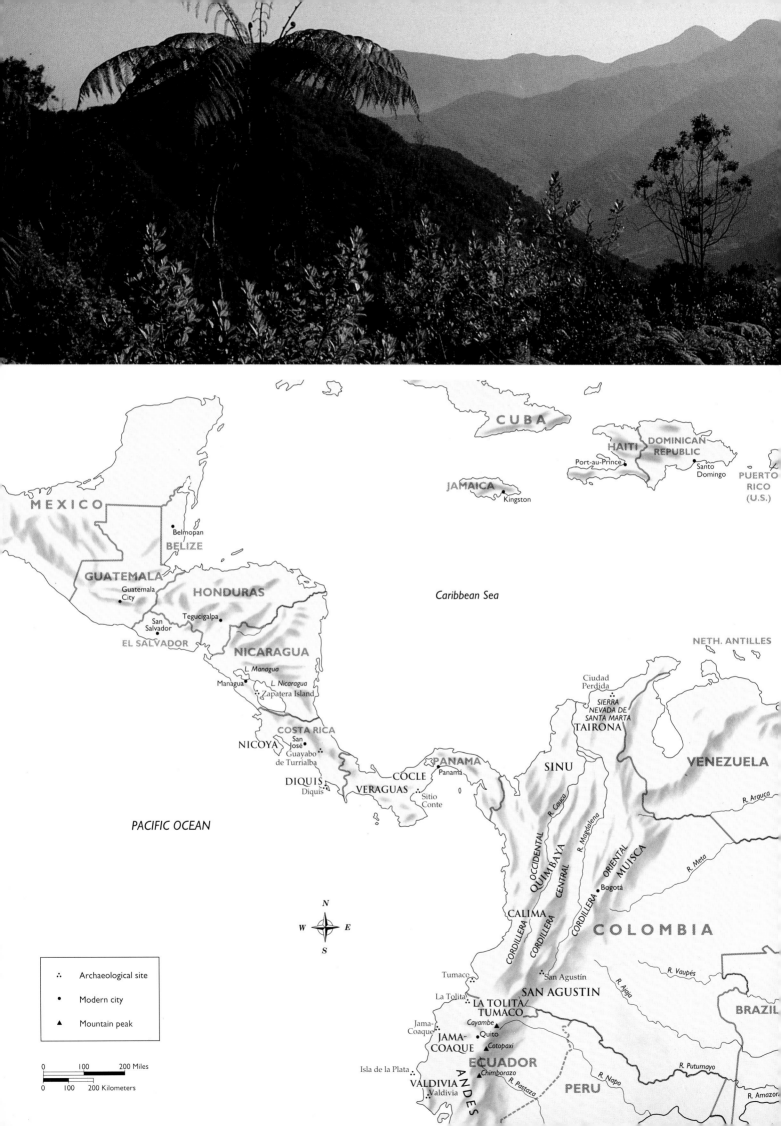

CUBA

HAITI DOMINICAN
 REPUBLIC

Port-au-Prince •Santo
 Domingo PUERTO
JAMAICA RICO
 •Kingston (U.S.)

MEXICO

•Belmopan

BELIZE

GUATEMALA

Guatemala
•City HONDURAS

San •Tegucigalpa
Salvador

EL SALVADOR

NICARAGUA

 Caribbean Sea

 L. Managua

Managua• L. Nicaragua
 ∴Zapatera Island

 NETH. ANTILLES

 Ciudad
 Perdida
 SIERRA
 NEVADA DE
 SANTA MARTA
 TAIRONA

 COSTA RICA
NICOYA San SINU
 José• VENEZUELA
 ∴Guayabo
 de Turrialba R. Cauca

 PANAMA OCCIDENTAL
DIQUIS COCLE Panamá• QUIMBAYA R. Magdalena
 Diquis• VERAGUAS CENTRAL R. Arauca
 ∴Sitio CALIMA ORIENTAL
 Conte MUISCA
 •Bogotá R. Meta

PACIFIC OCEAN CORDILLERA
 CORDILLERA
 CORDILLERA COLOMBIA

 N
 W ⊕ E R. Vaupés
 S Tumaco• ∴San Agustín
 ∴
 La Tolita• R. Apia

 ∴ Archaeological site LA TOLITA/ SAN AGUSTIN
 TUMACO
 • Modern city Jama-
 Coaque ▲Cayambe
 ▲ Mountain peak •Quito
 JAMA- ▲Cotopaxi
 COAQUE R. Vaupés BRAZIL

 R. Napo
 0 100 200 Miles
 Isla de la Plata∴ ▲Chimborazo R. Putumayo
 0 100 200 Kilometers VALDIVIA ECUADOR
 •Valdivia ANDES PERU R. Amazon
 R. Pastaza

A green canopy of tropical forest extends down from Central America across the narrow Panamanian isthmus to the tropical coastal plain of northwestern South America. The Cauca and Magdalena rivers flow the length of Colombia between three cordilleras, reaching the warm lowlands and the waters of the Caribbean. The mountains coalesce toward the south in the high Andean escarpment marked by snowcapped volcanoes—Cotopaxi, Chimborazo, Cayambe, and others—that rise from fertile upland valleys along the spine of Ecuador. The peoples who lived in this verdant region never developed the dense urban concentrations that evolved in Mesoamerica or the Andean countries of Peru and Bolivia. Yet, the archaeological sites of agricultural societies on coastal Ecuador and the northern Colombian lowlands have yielded some of the earliest remains of pottery in the Americas, dating from 4000 to 3000 BC; these sites also hold evidence of the first domestication of tropical root-crop staples, such as manioc, sweet potatoes, and *achira*. The foundations of large oval houses, arranged around oval or square plazas, follow plans that recall those of peoples in the Amazon basin.

Well-defined regional chiefdoms developed between 500 BC and AD 500. Cultures known as Jama-Coaque, La Tolita, and Tumaco achieved prominence on the coast, and developed distinctive ceramic traditions. A remarkable range of richly ornamented, modeled figures was crafted, displaying a meticulous interest in body adornments such as headdresses, jewelry, and badges signaling rank and religious significance. These figures portray a spectrum of activities from warfare to planting and harvest rites, as well as many animals and mythical creatures. Sea-going rafts from these communities along the northwestern coast specialized in the trading of exotic commodities such as *Spondylus princeps*, a marine bivalve whose spiny red shell was avidly sought for ceremonial purposes as far north as Mexico and south to

Peru. Trade networks flourished throughout Colombia, Ecuador, and Peru up to the time of the Spanish invasions in the early sixteenth century.

Ancient Colombia is most famous for its spectacular art of goldworking. Technological accomplishments included the alloying of gold and copper to form the malleable *tumbaga* (alloy), gilding and plating, lost-wax casting, soldering, as well as *mise-en-couleur*, which was achieved using plant-derived acids to remove base metals from the surface of an alloy, allowing the gold to be featured, and repoussé techniques. The golden attire worn by chieftains gave rise to legends of "*El Dorado*," the "*golden one*," for whom the Spanish were to search in many lands of the Americas. But the golden objects made in Panama, Colombia, and Ecuador, which the European invaders coveted for the value of the metal, were originally made for the primary purpose of maintaining religious connections between the people and the deified creatures and forces of nature. In Colombia, Calima is among the outstanding styles of the early first millennium AD. Concentrating on the manufacture of regal adornments, Calima artisans worked flat gold sheets into elaborate headdresses, nose ornaments, earspools, and pectorals, embossed with masklike faces, stylized animals, and geometric motifs. Quimbaya artists cast gold bottles, containers, and statuettes using the lost-wax process, achieving figures that have long been counted among the finest in the ancient Americas. The Tairona style evolved in the Sierra Nevada to the north, where the Kogi Indians continue to live and maintain their ancestral culture. Their Tairona forebears inhabited towns of up to one thousand houses and had a society that approached the complexity of statelike organizations. This people created items of facial jewelry and pendants, with small-scale figures of masked chieftains, raptorial birds, felines, and reptiles cast into gold. Like the art of Coclé in Panama, to which it is related, this imagery speaks of analogies and metaphors drawn between the hierarchy of the human community within the hierarchy of life perceived in the landscape.

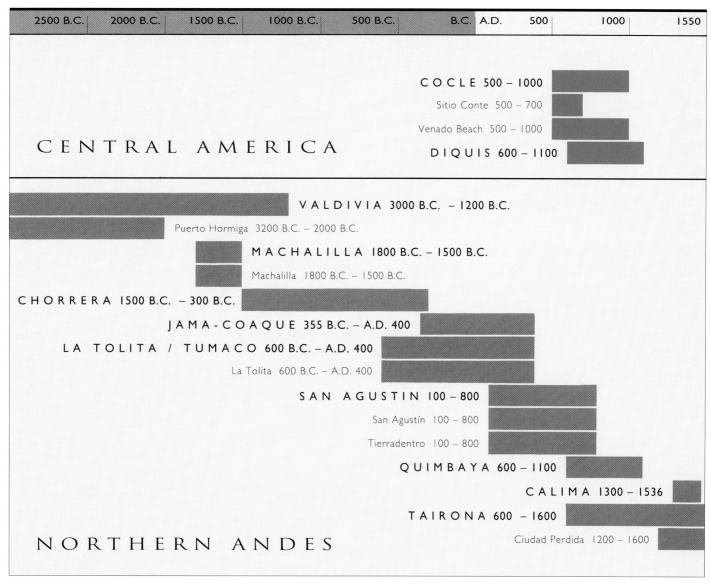

2500 B.C.	2000 B.C.	1500 B.C.	1000 B.C.	500 B.C.	B.C.	A.D.	500	1000	1550

CENTRAL AMERICA

COCLE 500 – 1000

Sitio Conte 500 – 700

Venado Beach 500 – 1000

DIQUIS 600 – 1100

VALDIVIA 3000 B.C. – 1200 B.C.

Puerto Hormiga 3200 B.C. – 2000 B.C.

MACHALILLA 1800 B.C. – 1500 B.C.

Machalilla 1800 B.C. – 1500 B.C.

CHORRERA 1500 B.C. – 300 B.C.

JAMA-COAQUE 355 B.C. – A.D. 400

LA TOLITA / TUMACO 600 B.C. – A.D. 400

La Tolita 600 B.C. – A.D. 400

SAN AGUSTIN 100 – 800

San Agustín 100 – 800

Tierradentro 100 – 800

QUIMBAYA 600 – 1100

CALIMA 1300 – 1536

TAIRONA 600 – 1600

Ciudad Perdida 1200 – 1600

NORTHERN ANDES

2 1 5

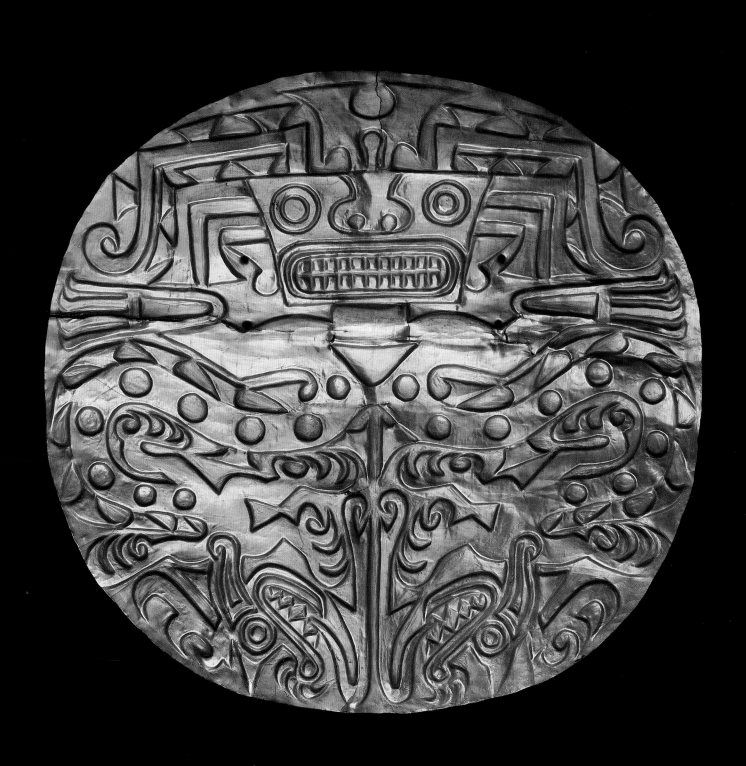

COSMOVISION OF THE CHIEFDOMS OF THE ISTHMUS OF PANAMA

The Importance of Art

It is a tremendous intellectual challenge for people of the western industrial age to comprehend the attitudes and beliefs of those whose lives were shaped by far different cultures, and whose cultural records are very limited—all the more so when the societies in question ceased to exist in their traditional form almost five hundred years ago. The peoples living in the Isthmus of Panama at the time of European contact are known to us most directly by ethnohistorical accounts written by the earliest Europeans to "discover" Panama, by archaeological investigations in recent times, and by exotic and aesthetically delightful works of art. Elegant examples of this artisanship are displayed in the exhibition that occasioned this book, among them pieces associated with the archaeological site of Sitio Conte, located in Coclé Province (see figs. 3, 14). This site, which flourished about 500–700, is known for its opulent burials of important chiefs. Materials from the adjacent region of Veraguas were also found at this site. There is every reason to believe that the goldwork and painted ceramics from Sitio Conte and elsewhere in Panama codify some of the central principles and beliefs that shaped the cosmovision of ancient Panamanian culture. The formal study and interpretation of this material has barely begun, and firm conclusions are not possible; nonetheless, it is feasible to suggest some general themes and perspectives that may assist in interpreting the meaning and significance of this ancient Panamanian art.

The cosmovision of the ancient Panamanians, like that of all other indigenous cultures of the Americas, surely rested on the belief that a dynamic life force exists throughout the universe and is found in virtually all forms and expressions of existence.[1] All things, regardless of their physical form, and whether, in fact, they are tangibly visible, are believed to contain a vital essence that indicates that "life" is present. Streams manifest life not only in their refreshing waters but in the pleasant sounds made by the flow of current; birds manifest it

by singing energetically and soaring in flight, insects by incessant humming. Less obvious but just as real is the internal energy that causes rocks, trees, and plants to be "alive" and the celestial objects—the stars, the moon, and, particularly, the sun—to shine. The same life force animates the creatures

Fig. 1 Plaque with figural relief. Panama, Coclé, Sitio Conte, c. 700. Gold. Peabody Museum of Archaeology and Ethnology, Harvard University, Cambridge, Massachusetts. Photo: Hillel Burger. Dense surface patterning and bilateral symmetry characterize the Coclé style, which features composite human and animal creatures. (Cat. no. 66)

Fig. 2 Bowl depicting dancer. Panama, Coclé, 600/800. Ceramic. Private collection. Photo: Douglas M. Parker Studio. (Cat. no. 60)

that inhabit the forests, the rivers, and the sea. This all-encompassing force was also believed to be responsible for human existence and for the special skills, talents, and capabilities with which each individual is endowed. Certain categories of human beings—for example, adults and religious specialists—were thought to be imbued with more fundamental cosmic energy than others—children or ordinary, secular persons.

The chiefs and other members of the elite aristocracies that undoubtedly existed in Panama (where there is archaeological evidence for a hierarchically organized society) were believed to be particularly highly endowed with this energy and power, primarily because, as political and religious leaders, they stood closer to the ancestors, who, in turn, had joined the invisible ranks of original culture-heroes and the primordial creative powers of the life-giving rain, sun, and earth. In other words, chiefs and aristocratic elites, along with other religious specialists, were in closer communication with that portion of the universe that existed "outside" or beyond living society. An embossed gold helmet in the exhibition was reserved for the aristocratic elite and depicts a crocodilian-masked figure, which was associated with the nonhuman universe (fig. 3).

In ancient Panama, chiefs and other elite officials were doubtlessly responsible, too, for instructing less endowed members of society in the fundamental principles of cosmology and for overseeing the proper maintenance of the dynamic universal system, as it was locally perceived. Forces of life and energy could take many guises, some good, others evil. Sun and rain had to appear in a beneficial combination, permitting crops to mature and harvests to be bountiful. Alternatively, hurricanes could flatten the landscape, or droughts could reduce it to lifeless heat and dust. If fish and game were plentiful, children could thrive; if fish and game were scarce, children would sicken and die. In such a vision of the world, the key to maintaining and restraining the powers of the universe, so that beneficial, rather than harmful, processes may prevail, lies primarily in human behavior. When people behaved in morally proper fashion and followed the appropriate religious ceremonies, by which communication was made with the forces of nature, their lives could be expected to proceed normally with positive outcomes for their enterprises. But, if these precepts of proper behavior were ignored, then problems would surely arise.

Being fallible, people had constantly to be instructed and reminded of their responsibilities to the general, positive functioning of society within their cosmic system. There are many ways in which this task was, and still is, fulfilled in traditional, nonliterate societies. The recounting of moralistic myths, chiefly orations, and the singing of special chants during political and religious ceremonies and occasions constantly reiterate the guiding principles. Tangible symbols are necessary for this educational purpose, too; thus, the plastic arts come into their own. In Panama, the most remarkable objects were fashioned by using skilled metallurgy and by painting complex figures on fine ceramics. Many techniques were involved, most notably, for goldwork, casting, embossing, and surface enhancement by depletion gilding, and, for ceramics, use of multiple colors in decoration. The production and acquisition of fine goldwork and polychrome ceramics, as well as the symbolic and especially the aesthetic qualities accorded these objects, gave visible expression to basic cosmological beliefs, ritual events, and the status of the rulers and the religious elite responsible for maneuvering and negotiating with cosmic forces and phenomena.

In ancient Panama, as in many other traditional societies, skilled craftsmanship and high aesthetic quality were associated with the expression of sacred beliefs and ceremonies, because such skills and aesthetics were recognized as representing something that was good and desirable. Skilled artistry rises above ordinary, utilitarian manufacture because of its beauty. Similarly, the person who had special ability to transform ores into molten metals and then into exquisite objects, to convert pliant clay into elegantly shaped vessels, or to paint such vessels with elaborate symbolic designs was believed to manifest the presence of special powers and energy that were also beautiful. (The presence of this supernatural force gave artists their talent and control over raw materials that were themselves thought to be imbued with power.) Beauty or aesthetics expressed by skilled design and craftsmanship was a critical element in this sacred art because it represented a concept of what is good and proper; in other words, that which is beautiful may also be equated with that which is morally right. In a society of good, moral people, it would be expected that artistic production would constitute a "national" expression of moral harmony and order, and that numerous art forms would be employed

to emphasize the value placed on aesthetic quality and on the activities of manufacture. In ancient Panama, aesthetics were expressed in a number of ways other than ceramics and metallurgy. Language became an art form when transformed into songs, chants, and oratory. Body movements became art through dance. The human body was also adorned with finely woven and patterned textiles, sometimes bearing painted designs. Household containers could be elevated from the merely utilitarian to minor masterpieces by virtue of their pleasing proportions and applied decorations. Even trays of food, especially those reserved for feasts and ceremonies, were arranged in visually pleasing ways. On ceremonial occasions, when special attention to all that is good and right was required, and the importance of correct communication with the powers of the universe was intensified, aesthetic considerations governed ritual paraphernalia and procedures. The political and religious elite, whose job it was to specialize in controlling universal powers and regulating the behavior of members of society, was especially associated with the arts. Its members were allocated larger and more elaborately decorated homes and were further distinguished by the high quality of their household utensils, by their exceptional costumes, by elaborate ornaments, and by highly formalized language and behavior.[2]

Land, Life, and Cosmography

While many of the aesthetic expressions of
ancient Panamanian society are irretrievably
lost, surviving examples of polychrome ce-
ramics and goldwork provide an idea of the
artistic accomplishments and the forms of
symbolic expression that once flourished on
the Panamanian Isthmus. Polychrome ceram-
ics and metalwork depict animal, human, and
composite forms that refer specifically to the
organization and content of the ancient Pan-
amanian world view. While it is not yet possi-
ble to identify these themes with absolute
precision, we may hazard some reasonable
interpretations about the nature of Panama-
nian cosmography—the sacred landscape
that these people perceived and that their
works of art reflect.

The isthmus is a long, narrow strip of land
with ocean on either side and several ranges
of interior mountains rising nine hundred to
fifteen hundred meters above sea level and
running the length of the isthmus. Archaeo-
logical excavations have shown that, after a
lengthy period of settled village farming life,
more complex societies began to evolve from
around 300 BC to AD 500. From approxi-
mately 500 until the Spanish conquest in
the sixteenth century, Panama was divided
into several dozen small chiefdoms. Judging
from early Spanish accounts, each chiefdom
formed an independent polity composed
of scattered households of commoners, a
smaller group of the elite, with a high chief
as paramount leader, and slaves captured in
battle. There was considerable political com-
petition among the different polities, fre-
quently involving warfare. Typical chiefdoms
extended territorially from the mountains to
the sea. Each had access to a portion of the
heights, which embraced forested uplands
good for hunting, as well as to cultivated sa-
vannahs and lower mountain slopes where a
range of crops was grown, and, in addition, to
the beach and ocean resources of the littoral.
Numerous fish-filled streams coursing from
mountains to sea also provided important
resources; some streams may have formed
the boundaries between competing or allied
chiefdoms. The central communities of these
polities, where the chiefly compounds were
built, often stood about one day's travel apart
and were connected, as were major rivers and
mountain passes, by foot trails and wider roads.

Archaeological surveys and sixteenth-
century written accounts suggest that,
within a typical chiefdom, the common pop-
ulation, particularly women and the domes-

tic household, focused much of its activity on
agricultural pursuits in the savannah areas.
(War captives may have provided additional
agricultural labor.) Men, including those of
the elite, exploited territory outside the agri-
cultural heartland by hunting in mountain-
ous forests or fishing and netting in the rivers
and the sea. This pattern focused the agricul-
tural activity of the ordinary family within a
local setting, creating a central "heartland"
of domestic life. In contrast, the hunting of
wild game and fowl, and fishing, male activi-
ties primarily associated with the elite and
probably involving resources particularly
identified with power and prestige, were con-
ducted in more distant "frontier" or periph-
eral domains beyond the areas assigned to
settled society.

This pattern emphasized a general rela-
tionship between the elite and distant
"outside" phenomena. As specialists in intel-
lectual and ideological affairs, the elite also
probed a supernatural "beyond" in the same
way that they encountered the wild animals,

birds, and fish of their geographical frontiers. Indeed, it is likely that these geographically distant zones were considered to be parts of a supernatural or cosmological "beyond," for it is commonly believed in traditional societies that one encounters sacred or spiritually powerful and "untamed" forces and phenomena, not only in prayer or religious trance but also when one enters the forest to hunt or when nets are cast into the sea or harvests are made from the beaches. All such remote or borderline places were quite possibly the rightful domain of high-ranking, extra-ordinary persons in ancient Panama. It is significant that polychrome ceramics and gold objects that were primarily associated with the rulers and with ceremonies do not appear to contain motifs obviously associated with agricultural pursuits. Instead, they portray a wide range of creatures, including birds, reptiles, mammals, fish, insects, and amphibians, that lived in the uncultivated "beyond," or they depict people wearing ritual attire with the motifs of these creatures (see figs. 4, 5, 6, 7, 10).[3]

In addition to this center/periphery distinction, the ancient Panamanians, in common with their neighbors in South America and Mesoamerica, undoubtedly conceptualized their universe as an orderly, categorized place composed of air (sky), earth (mountains and plains), and water (sea and rivers). Like their neighbors, they would have classified the flora and fauna, sounds, smells, and colors encountered in these cosmological realms according to their rightful places within these categories. There are, however, certain forms of life that do not exist in only one cosmological category, but, either because of behavior or particular physical characteristics, cross the boundaries between categories. These "anomalous" creatures, which seem to confound the basic order of the cosmos, were widely considered to be exceptional or "unnatural" and were often regarded with awe and fear.

It is not known with certainty which animals were so regarded by ancient Panamanians, but the serpent was probably one of them. Serpents, as a general category of animal, can be found in water, on land, and in trees; they move freely back and forth between these basic natural and cosmological realms, in contrast, for example, to an animal like the peccary (a relative of the pig), which stays on the forest floor. Lizards and iguanas may have been another general type of anomalous creature, for, here again, different

varieties of lizards and iguanas can burrow underground, swim across rivers, live on land, and climb trees (see fig. 9). Various creatures of the river bank or the beach that live on or frequent the border between land and water would also be considered anomalous—frogs, crabs, and nesting sea turtles, for examples— as would such animals as the deer that frequent the edges of fields or villages, traversing the boundary between open lands of cultivation and the undomesticated wilds of

Fig. 6a, b Pedestal bowl with crouching-frog designs. Panama, Coclé, 600/800. Ceramic. Private collection. Photo: Douglas M. Parker Studio. The conventions of Coclé goldwork design also inform ceramic painting, as can be seen in this calligraphic masterpiece. (Cat. no. 58)

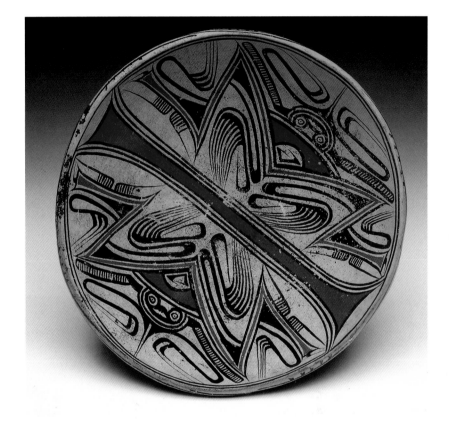

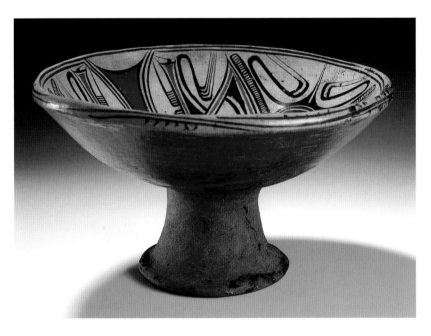

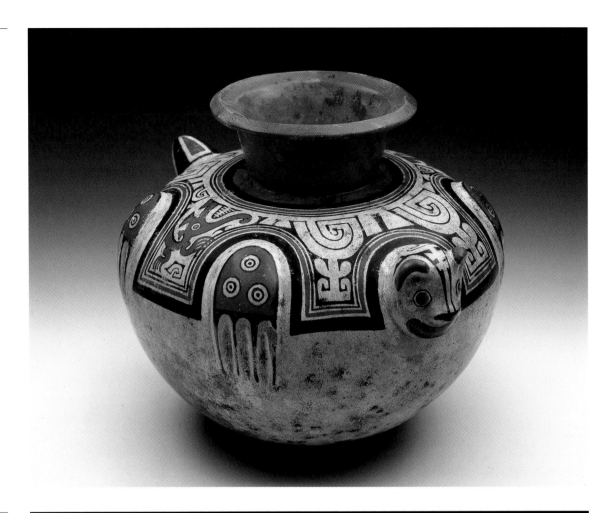

Fig. 7 Jar with modeled animal features. Panama, Coclé, 600/800. Ceramic. Private collection. Photo: Douglas M. Parker Studio. (Cat. no. 54)

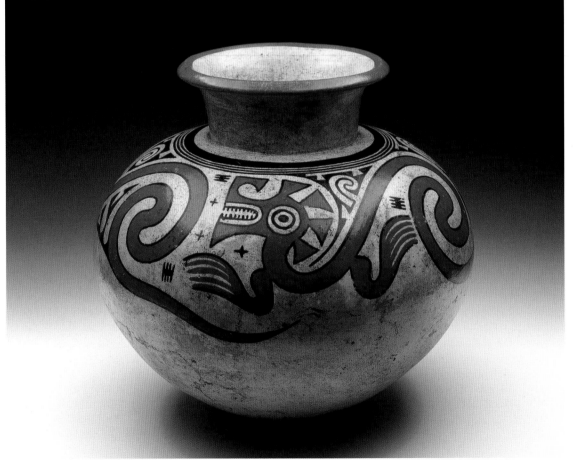

Fig. 8 Jar with dragonlike design. Panama, Coclé, 600/800. Ceramic. Private collection. Photo: Douglas M. Parker Studio. (Cat. no. 55)

bush and forest (see fig. 11). Given their special meaning and the exceptional powers and supernatural associations attributed to them, it is not surprising that many of the identifiable creatures portrayed on Panamanian ceramics or in gold objects represent animals of this sort. By reason of their ability to move between categories of the universe, these creatures may also have been seen to connect the separate realms into a single whole, or to act as powerful agents and symbols of transformation. By association, the ruling persons identified with such objects would be recognized in terms of these attributes, too, on both a political and a religious level.

The religious ceremonies in which painted ceramics would have been used, including acts of burial where ceramics were interred as grave goods, offered points of contact and expressed transformation between the realm of human life in the here-and-now and the wider realm of ancestors, deities, and cosmic forces. Perhaps it was thought that the ritual and the "distance" to be traversed under such conditions could be more easily managed or, at least, tangibly expressed and understood, if depictions of transformational animals—and, in a sense, the animal forces themselves—were available to assist. In addition, such ceremonies involved members of the ruling order, themselves an exceptional form of human being expected to mediate between ordinary human existence and the powerful, supernatural, nonhuman world (see fig. 12). It would be appropriate for such people to be associated with the imagery of anomalous beings charged with comparable intermediary tasks connecting the basic categories of the universe. An embossed gold disk in the exhibition (fig. 13) suggests human-animal transformation. Notable are the overlapping animal (jaguar?) incisors combined with level, humanlike dentition.

As tangible evidence of their identity and their responsibilities, it would also be appropriate for rulers and priestly officials to wear golden ornaments embossed or shaped to depict those anomalous creatures charged with transformational qualities (see figs. 1, 4, 14). For example, the details shown in depictions of strange beings embossed on gold chest plaques suggest that high-ranking people were associated with the "spirit owners" or "guardians" of various outside resources. Such spirit owners, sometimes called "masters of the animals," were, in effect, thought to be official representatives to the human world from categories of animals useful to

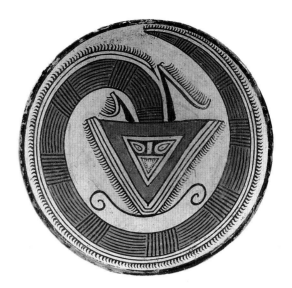

Fig. 9 Plate depicting millipede figure. Panama, Coclé, 600/800. Ceramic. Private collection. Photo: Douglas M. Parker Studio. (Cat. no. 62)

Fig. 10 Bowl with hammerhead-shark designs. Panama, Coclé, 600/800. Ceramic. Private collection. Photo: Douglas M. Parker Studio. (Cat. no. 59)

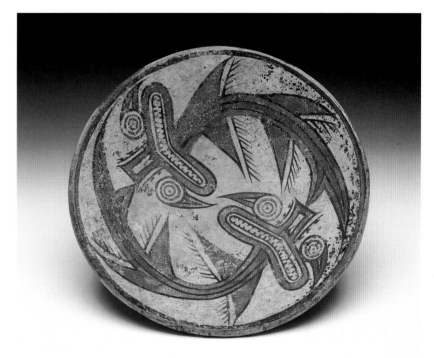

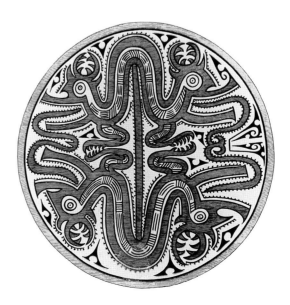

Fig. 11 Drawing of detail of plate with abstract zoomorphic designs. Panama, Coclé, Sitio Conte, c. 700. Ceramic. Peabody Museum of Archaeology and Ethnology, Harvard University, Cambridge, Massachusetts. Photo: Lothrop, 1976, p. 12. Although deer horns can be identified in this design, the curvilinear elements acquire a life of their own as animal forms become transformed into a bold abstract pattern.

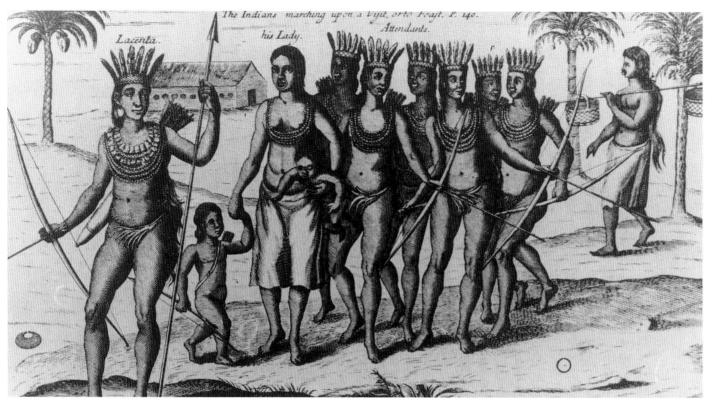

The Indians marching upon a Visit, or to Feast. P. 140.

Lacenta.　　his Lady.　　Attendants.

Fig. 12 Chief Lacenta with family and attendants en route to a festival, Panama, 1681. Seventeenth-century engraving. Photo: Wafer, 1934, p. 140.

man (e.g., deer and peccary). Their primary duty was to "negotiate" with specialized human agents regarding the availability of the game animals they represented, for game would be available to human hunters only if the spirit owner agreed to "release" animals in physical form into the forest so that hunters could find them.[4]

The ancient art of Panama conveys the social significance of skilled craftsmanship and aesthetic value; it portrays cosmologically powerful creatures, representative of the cosmic order and its forces; and it identifies the importance and responsibility of rulers. This art also conveys insights into an ancient world view by means of the particular materials used and the specific methods employed to produce it. For example, the shining brightness of gold undoubtedly linked the Panamanian rulers, providers of food and other benefits and caretakers of human society, with the sun, the source of light and warmth and caretaker of the universe. The golden surfaces of Panamanian ornaments, however, were often composed of an alloy of gold and copper (called *tumbaga* or *guanín*). The golden surface was achieved by special techniques, such as *mise-en-couleur*, involving the application of herbal baths that dissolved the surface copper and brought out the golden color. Although various theories based on details of metallurgical technology have been advanced as to why the ancient goldsmiths proceeded in this fashion,

the techniques probably reflect symbolic and aesthetic as much as technical intentions. It may well be that the indigenous Panamanians believed that the true essence of something or someone lay inside the thing or person and could be discovered only by uncovering or exposing the innermost aspect of that being. The removal of surface "impurities" on *tumbaga* objects seemingly allowed the "true," golden, inner nature of the ornament to shine through.[5] Furthermore, by covering their own skin with a wealth of shining ornaments that "exposed" the gold of which they were composed, ancient Panamanian chiefs and their associates were also stating that they, too, were inherently composed of a shining, sun-associated quality.[6]

Polychrome ceramics may have expressed something of the same information in a different manner. In addition to the message conveyed by the shape of the ceramic piece (for shape was not a matter of function alone), whether it be an effigy bowl or urn in animal form, or a plate, tray, or bowl that may have referred to the earth or the sky,[7] the manner in which the design elements are portrayed is distinctive. Frequently, the method of painting allows the background color of the ceramic surface to show through the graphic figural design in a way that creates a certain visual ambiguity of subject with background (see fig. 15, in which the elaborate depiction of a crested figure shows the interplay of subject and background). In

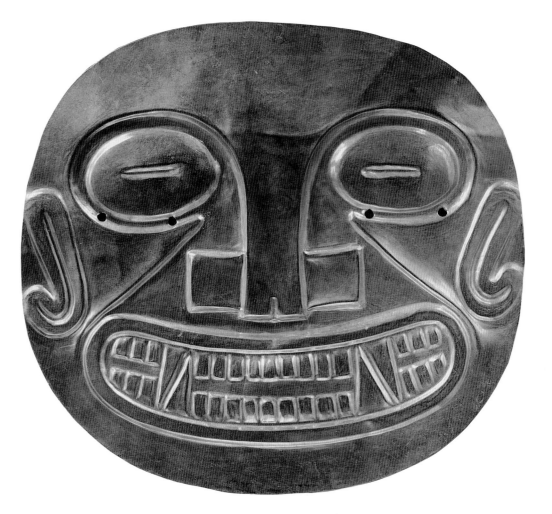

Fig. 13 Plaque depicting human and animal features. Panama, Coclé, Sitio Conte, c. 700. Gold. Peabody Museum of Archaeology and Ethnology, Harvard University, Cambridge, Massachusetts. Photo: Hillel Burger. (Cat. no. 65)

this visual interplay of field and motif, linear designs often seem to merge with the background, while, at the next moment, the background seems to come forward as an active part of the figure. The symbolic quality of ceramic objects often seems closely linked to these ambiguities of figure and ground, as the internal quality of the ceramic itself is revealed through the message-laden design on the surface.

Ceramic design and techniques of goldwork may also express the refinement of knowledge and control of the supernatural, as well as a concern with abundance and wealth. These concerns may be seen in the proliferation of design detail and construction.[8] Panamanian goldwork is famous for its intricate fine detail achieved with lost-wax casting; similarly, in polychrome ceramics, space is frequently filled with intricate curvilinear and geometric motifs, surrounding as border or springing energetically from the boldly graphic figural forms (see fig. 16). In both goldwork and ceramic design, there is richness and a sense of dynamics in the disciplined forms that may signify the beauty and abundance of the life that results when a well-ordered, morally cohesive society, under

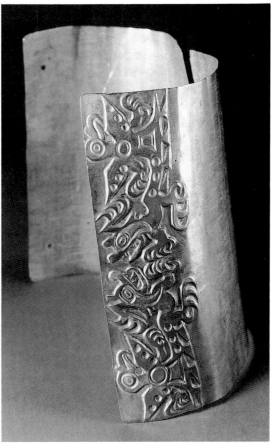

Fig. 14 Armband depicting confronted felines and raptorial birds. Panama, Coclé, Sitio Conte, c. 700. Gold. Peabody Museum of Archaeology and Ethnology, Harvard University, Cambridge, Massachusetts. Photo: Hillel Burger. (Cat. no. 63)

the leadership of intellectually and spiritually refined rulers, successfully fulfills the religious and economic roles required to obtain and control the energies and materials of nature.[9]

For the ancient Panamanian peoples, human beings were distinguished from other living things, and rulers and their associates were similarly distinguished from commoners by virtue of the various "civilizing" attributes they adopted. Foremost among these were those material, symbolic expressions of the organization and functioning of the universe in which they lived and for which they felt responsible. Using natural

ores, clays, multicolored feathers, pigments, woods, stones, and crystals as tangible manifestations of their energy-filled domain, they skillfully fashioned highly sophisticated, symbolically complex, and aesthetically pleasing works of art that succinctly voiced their complex vision. Hundreds of years later, and in spite of the limitations of our imperfect knowledge of their world, the surviving samples of this art continue to elicit awe and appreciation. The ancient Panamanians kept no written records to present their view of life, but the quality and beauty of their skilled craftsmanship continues to speak volumes.

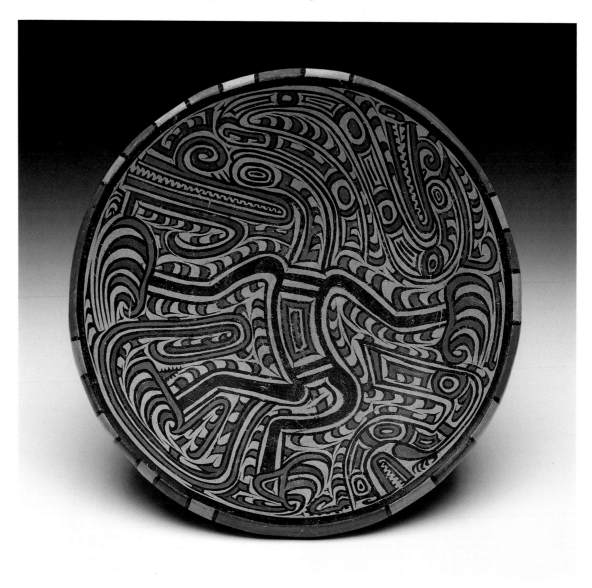

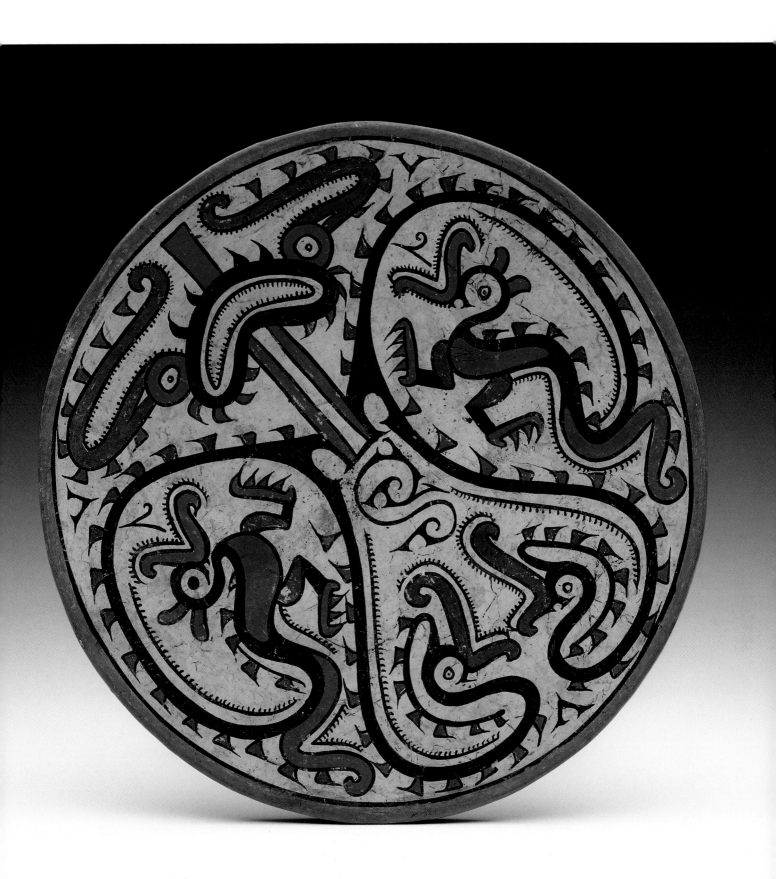

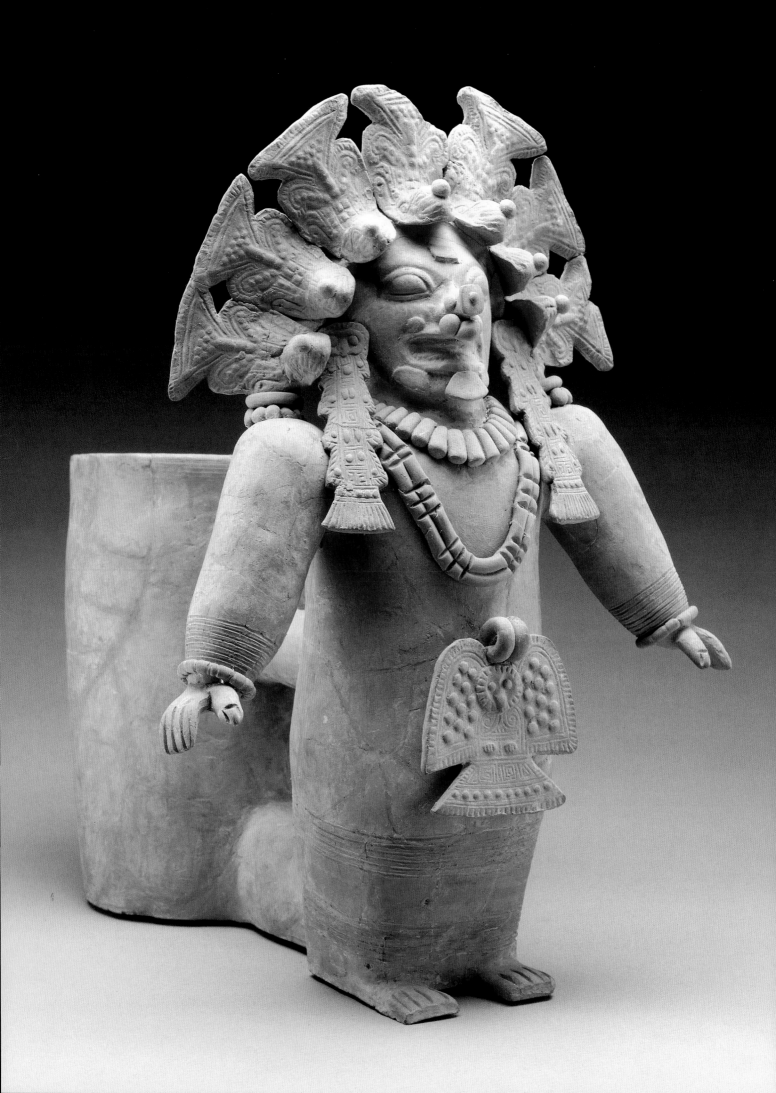

SYMBOLS, IDEOLOGY, AND THE EXPRESSION OF POWER IN LA TOLITA, ECUADOR

Introduction

One of the principal objectives of modern archaeology is to comprehend the cultural significance of the material vestiges of ancient societies. Interpretation of the art and architecture of past civilizations in South America, where written texts were not developed, depends on the identification of patterns of signs and symbols. These provide clues to coherent visual codes that may lead to the discovery and understanding of other ways of ordering the world. The archaeologist can recover only the external manifestations of symbolic forms that were meaningful to individuals who were well versed in their particular cultural tradition. The materials that have survived offer a window through which we can glimpse ideas, beliefs, and perceptions that were very different from those of industrial civilizations. It is a particular challenge to our attempts at interpretation when the archaeological remains of societies whose language and cultural identity have long since disappeared display both naturalistic and abstract symbolic images (see figs. 1, 2). Such is the case of the objects belonging to the culture called La Tolita/Tumaco and its neighbor, the Jama-Coaque, which flourished two thousand years ago in the Pacific coast lowlands close to the border of present-day Ecuador and Colombia.

The technical and aesthetic mastery expressed in the arts of these cultures offers clear examples of the sophistication achieved by the tropical-forest peoples of pre-Columbian America. The confident manipulation of forms, fine detail, and technical competence evident in metallurgy, ceramics, and stonework reflect the specialization and painstaking attention of accomplished artisans (see fig. 1 and frontispiece, p. 2). The compelling symbolic arrangements, detailed naturalistic representations, and dynamic expressive qualities of La Tolita figures (as well as those from Jama-Coaque) give them an especially memorable place in ancient Amerindian art. In this essay, I will discuss in particular the connections between the imagery of ceramic figures, the organization of architectural space, and the archaeological and natural settings at the site of La Tolita. First, I will summarize the chronological development of this culture, as seen from the evidence of excavations in its principal ceremonial center. Then I will discuss the spatial organization of this center as a setting for ritual activity. Finally, I shall deal with the structure of ideas that informed La Tolita artistic production. I will also refer to ceramic figures from the contemporary neighboring Jama-Coaque tradition, which express many related themes.

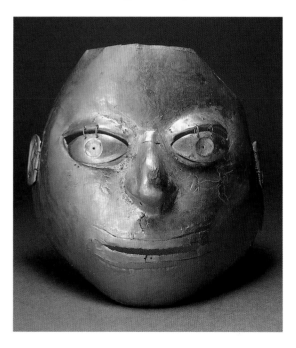

Fig. 1 Festival celebrant adorned with birds. Ecuador, Jama-Coaque, 200/400. Ceramic. Museo Antropológico del Banco Central, Guayaquil. Photo: Dirk Bakker. Funerary sculptures portray a rich ceremonial life at this and neighboring sites of coastal Ecuador and nearby Colombia. (Cat. no. 110)

Fig. 2 Funerary mask. Ecuador, La Tolita, 200/400. Gold. Museo Antropológico del Banco Central, Guayaquil. Photo: Marcos Vinueza. (Cat. no. 118)

Fig. 3 In the tropical riverine setting on the coast of Ecuador, canoes and balsa rafts remain an indispensable means of transportation. Photo: Colin McEwan.

The Growth of La Tolita as a Ceremonial Center of Regional Importance

The results of the most recent archaeological investigations at La Tolita, in the state of Esmeraldas, point to four phases of development in the growth of the ceremonial center.[1] The sequence of occupation began around 600 BC (Early Tolita period), when the first signs of human settlement appear at the mouth of the Río Santiago. This was the locus of a progressive adaptation to exuberant freshwater and marine ecosystems, comprising both mangrove-enclosed, small islands and tropical forests in a broad area of coastal flood plain (see fig. 3). From the beginning, settlement was concentrated along the river-edge marshes, the primary focus of subsistence activities. The mangroves fringing the coastline harbored innumerable species of mollusks and crustaceans. These riparian resources were complemented by the cultivation of maize, beans, squash, and the starchy root crop yuca on inland agricultural plots arranged around the settlements. The archaeological remains reveal a wealth of ceramic art. The techniques used in the manufacture and decoration of vessels, utensils, and figurines are distinctive, yet they have clear affinities with the Machalilla (1800–1500 BC) and the Chorrera (1500–300 BC) traditions of the central coast of Ecuador.[2]

Significant organizational changes in the settlement pattern appeared around 400 BC (Transition period). At La Tolita itself, there is a marked increase in the density and distribution of cultural remains, indicating a growing population. The inhabitants began to reclaim the marshland to create dry land on which to settle. There are places where land clearing and filling raised the ground level almost one meter above that of the original site, revealing a well-organized effort to create an ordered living space within this forested, watery domain.

The settlement system also expanded into the hinterland. Cult objects—anthropomorphic and zoomorphic figurines, masks, and figures carved in shell, bone, wood, and stone—that exhibit formal and decorative innovations are material indications of a strong sense of the importance of ritual in community life. There is also an increase in the production of body ornaments in various materials, which include, for the first time, the use of metals (gold, copper, and platinum). All of these innovations gradually spread out from the principal La Tolita center to surrounding hamlets and villages.

Around 200 BC, the character of La Tolita as a regional ceremonial center on the northwest part of one of the islands in the mangroves was well established. The period of the greatest cultural achievement (Classic Tolita period) lasted until around AD 400. The nucleus of the site grew to occupy an area of approximately one square kilometer, with a resident population of one to two thousand individuals. Ceramic models of La Tolita architecture show a variety of huts, houses, and related specialized structures. Featured in this exhibition are a pitched-roof enclosure (fig. 4) and a circular structure with a diamond-shaped door (fig. 5). The proportions of these structures in relation to the human figures and the associated poses and objects suggest that such architectural forms were dedicated to the performance of specific rituals and ceremonies in the cycle of community life.

The production of ceremonial and sumptuary objects gathered momentum. The crafts of ceramics, metallurgy, woodcarving, weaving, leather working, and basketry were practiced with great technical virtuosity and artistic accomplishment. The remains that have been recovered archaeologically indicate that production lay in the hands of specialized artisans. Many of the sumptuary objects appear to be directly linked to ritual activities that took place in the center: cult implements, personal adornments, offerings, and mortuary paraphernalia.

During the Classic period, La Tolita became the pre-eminent ceremonial center on

the north coast of what is now Ecuador. Its position at the juncture of land and sea favored maritime contacts, which extended as far as Central America and even western Mexico. From far afield, people gathered on the riverine island to celebrate seasonal ceremonies, to trade goods, and to exchange ideas. Both ideas and objects were spread to distant areas; in turn, the center imported the exotic materials necessary for the manufacture of its crafts, ritual paraphernalia, and related objects.

Agricultural activity was concentrated on the outer edges of the island. Here the natural ridge-and-swale topography was replicated by the creation of systems of artificially constructed raised fields. This intensive agriculture technique took advantage of the marshy ground by combining drainage canals with raised beds. The field systems were expanded incrementally, in the course of many generations, by cleaning out mud and silt and heaping it onto the intervening areas to form the raised beds. The seasonal inundation of the wetlands was thus turned to advantage by creating an immensely productive microecology that permitted multiple cropping of a great variety of food plants. Similar intensive agricultural systems, on a grander scale, have now been located as far north as the Valley of Mexico and the Maya area, as far east as Marajó Island at the mouth of the Amazon, and, to the south, along the shores of Lake Titicaca on the Bolivian altiplano.

During the final phase of development (Late Tolita Classic period, 90–400), the inhabited area of La Tolita grew to approximately two square kilometers. Its population of probably some five thousand inhabitants was clearly stratified, with theocratic rulers, artisans, and farmers. The demographic increase at La Tolita is reflected in a dense settlement pattern and an intensified use of the land. Borderland marshes were filled to provide additional living space; the central area was further elaborated by the construction of new *tolas*, or mounds, and zones reserved for cemeteries were enlarged. But, as standardized techniques of mass manufacture of ritual objects became established, artistic quality declined. The use of molds in ceramics generated coarse stereotypes for figurines, and receptacles and utensils exhibit a poverty of detail and decoration. The quality and distinctive precision of Classic-period works was supplanted by a crude style that has been called "Provincial Tolita."

In spite of its importance, the center lost its pre-eminence as the region's sole major

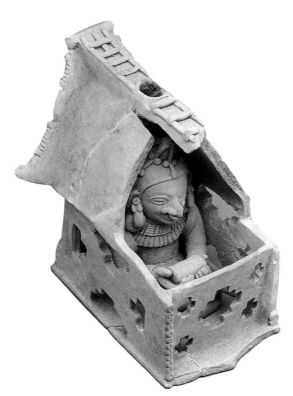

Fig. 4 Model of hut with figure in ritual seclusion. Ecuador, Jama-Coaque, 200/400. Ceramic. Museo Antropológico del Banco Central, Guayaquil. (Cat. no. 109)

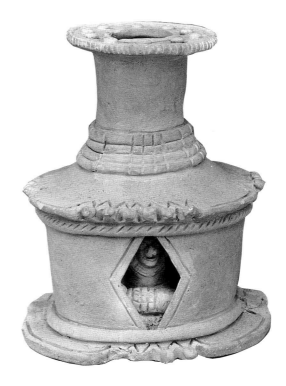

Fig. 5 Model of hut with shamanistic scene. Ecuador, Jama-Coaque, 200/400. Ceramic. Museo Antropológico del Banco Central, Guayaquil. Photo: Dirk Bakker. (Cat. no. 108)

ceremonial center. Minor centers in adjoining areas began to compete. Around the year 400, the inhabitants of La Tolita abandoned the ancient ceremonial site entirely. Thereafter, it continued to serve as a place of pilgrimage, and the memory of its former splendor was preserved in the traditions of towns to the north of Esmeraldas until the arrival of the Spaniards in the sixteenth century.[3]

The Organization of Ritual Space

During the Classic period, the ceremonial core of the site was laid out in the heart of the residential area, according to a well-conceived formal plan. The spatial order governing the public architecture was first recognized by Max Uhle in 1925, when the site had not yet experienced unscrupulous looters.[4] Our more recent survey confirms Uhle's original plan. The site was designed with a rectangular plaza approximately 190 meters wide, surrounded on three sides by the most important mounds. The mounds were aligned from west to east, forming a rectangle that was open at one end toward the northeast. Within this clearly defined space, smaller mounds, houses, and open areas indicate a thriving economic and religious life, with specialized activities ordered and supervised by the ruling elite.

In its conception, this site conforms to a general plan found in Formative-period ceremonial centers elsewhere in South America. Carlos Williams has drawn attention to the regularities evident in the U-shaped plans of Formative-period ceremonial centers throughout the Andean region—most especially on the coast of Peru.[5] (See also Burger essay in this book.) Coastal centers such as Moxeke and Las Haldas have been dated to the second millennium BC. The typical plan consistently comprises a plaza enclosed on three sides, with one end open along the principal axis of orientation. William Isbell postulated that the formal architectural configuration of such ceremonial centers reflects a social and religious template of great antiquity, in which two opposing but complementary divisions are mediated.[6] By analogy to Andean indigenous societies whose ancient systems of organization have persisted down to the present, we may infer that basic cultural information regulating social conduct was expressed and the exchange of goods from different regions was organized in these ceremonial centers. Although the mounds at La Tolita are mostly destroyed, their spatial disposition appears to echo this ancient pattern of defining a carefully regulated "sacred" space. A more detailed analysis of the spatial relationships at La Tolita is constrained by the severe depredations suffered during the Spanish colonial and modern periods. Nevertheless, the spatial order still visible today indicates a clear intent to define the relationships between mounds and plaza for symbolic as well as pragmatic ends.

Another characteristic of the center is the great quantity of funerary remains. This argues not only that the population was dense but that the settlement perhaps also functioned as a regional burial ground. The extraordinary number of graves excavated by archaeologists or despoiled by looters suggests that not all persons buried actually inhabited the island. The great differences in burial arrangements and the wealth of grave goods interred with the deceased indicate that personages of high rank were brought from surrounding communities to be buried at this sacred center.

Environment, Culture, and Iconography

We have already touched on the relation of man to nature, as this was expressed in the organization of sacred space within the natural environment. In common with other Amerindian cultural traditions, the corpus of La Tolita/Tumaco art articulates a cultural structuring of the world in a logical way. Ceramic sculptures, gold masks, and other items depict a realm of visible natural phenomena, which was itself influenced and animated by one of invisible entities and supernatural forces. Produced for ritual use, these objects are attempts to relate the world of supernatural powers to the activities and material concerns of daily life.

For Amerindian peoples, the great procreative and destructive powers underlying the visible forces and phenomena of nature may act to the benefit or detriment of humanity. Thus, abundant crops and success in hunting or in fishing are seen as manifestations of orderly and harmonious relationships between supernatural forces, humans, and the land animals and aquatic creatures that are sources of subsistence. Offerings made as a reciprocal gesture to the supernatural entities maintain an orderly balance in human and cosmic relationships. Economic, social, and religious ideas that structure society are ordered by ritual activity to ensure continuity and coherence in this vision of the world.

The iconography of Tolita art allows us to glimpse some of these ideas. Aesthetic production was not simply a matter of craftsmanship or technical expertise, nor was it intended merely as a faithful copy of the visible, physical world. The frame of reference and the content of artistic representations were essentially sacred and mysterious. Art was intended to communicate and manifest the truths hidden in the forces and phenomena of nature, and to focus and direct supernatural power. This was accomplished by endowing the figures with a sense of vital-

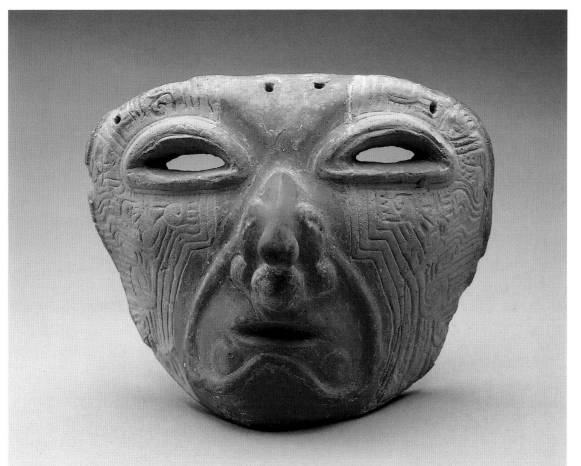

Fig. 6 Mask with scarification pattern. Ecuador, La Tolita, 200/400. Ceramic. Museo Antropológico del Banco Central, Guayaquil. Photo: Dirk Bakker. (Cat. no. 119)

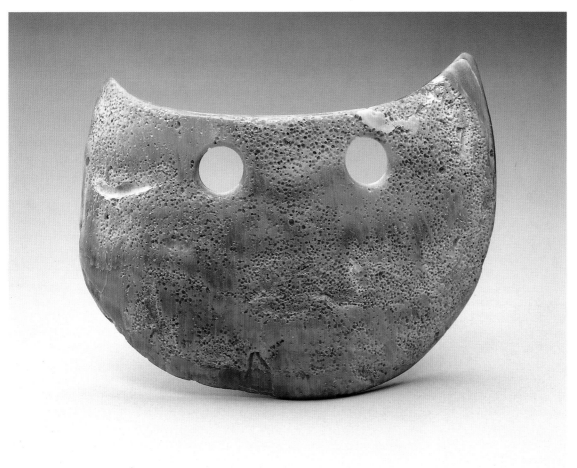

Fig. 7 Pendant or mask. Ecuador, Valdivia, c. 1800 BC. *Spondylus* shell. Museo Antropológico del Banco Central, Guayaquil. Photo: Dirk Bakker. (Cat. no. 283)

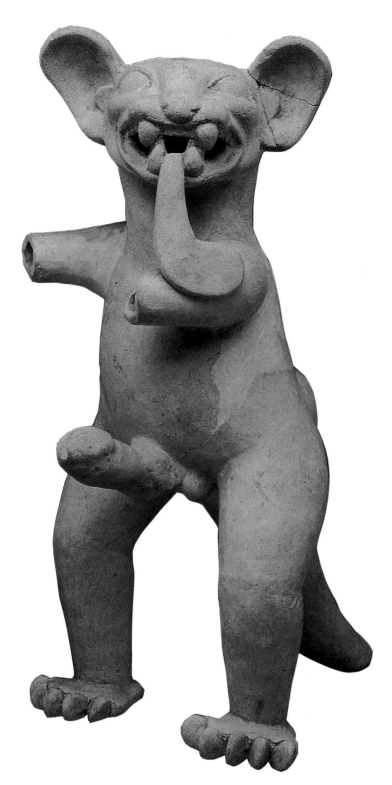

Fig. 8 Phallic feline. Ecuador, La Tolita, 200/400. Ceramic. Museo Antropológico del Banco Central, Guayaquil. Photo: Dirk Bakker. (Cat. no. 115)

the cosmic forces than human beings; hence, they were seen as especially powerful, and they attained a deitylike status. The human intermediaries charged with the manipulation and control of these animal agents were priests or shamans, who directed the power of the animal world to benefit the whole community. While the shaman might transform himself into a particular spirit, the priests, on the other hand, elaborated formal public rites and ceremonies designed to mediate between social, animal, and cosmological worlds.[7]

Such ceremonies formed the core of community ritual life, in which priests and shamans, adorned with masks and other paraphernalia that had signifying attributes, acted as interlocutors and were obliged to enter into contact in various distinctive ways with the supernatural forces. At the same time, they had to make offerings to these forces and deities to reciprocate for favors bestowed.

The compelling figurative art of La Tolita suggests that ritual festivals involved dramatic enactments and manifestations of the animal deities in order to elicit a powerful emotional response from, and establish a spiritual bond with, the participants. Upon completion of the collective rites, the participants were inextricably linked to the power of their deities. The sculptural forms of La Tolita played a role in this bonding, for they were carried as icons or kept to guard the home, and were buried to accompany the deceased into life after death.

The imagery of Tolita art can be divided into nine principal categories: deities or fantastic beings (anthropomorphized animals; see fig. 8); personages in formal, stereotypical poses, usually without specific attributes indicating rank, who perhaps represented an ideal type; priests or their assistants engaged in ritual acts with the artifacts that express their role and status (see fig. 12); ordinary men and women engaged in daily activities; trophy heads and masks (see figs. 6, 11); secondary sacred animals; common animals of the region, without apparent ritual significance; and houses or temples (see figs. 4, 5). In addition, there are metaphoric figures that combine animal and human forms with items such as headdresses and masks; these are attached to seats or vessels (see fig. 10). These are all symbols and signifiers in an intricate communication system, designed to express ideas, sentiments, and basic information about humanity, the deities, and the powers of nature.[8]

ity and by creating complex abstract symbols as metaphors of powers and attributes beyond the normal realm of experience.

The sacred character of Tolita art is shown by the importance it gives to themes derived from an animal hierarchy well known among tropical peoples. The most powerful predators in the domains of earth, water, and sky were creatures such as caymans, serpents, felines, eagles, and bats. These animals were perceived as occupying positions closer to

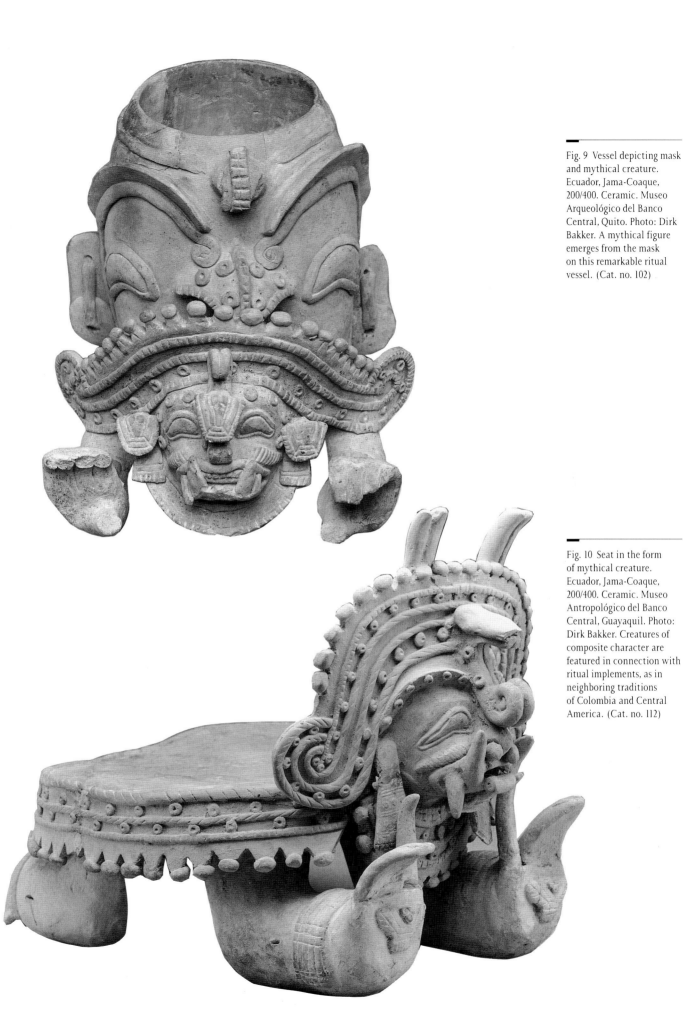

Fig. 9 Vessel depicting mask and mythical creature. Ecuador, Jama-Coaque, 200/400. Ceramic. Museo Arqueológico del Banco Central, Quito. Photo: Dirk Bakker. A mythical figure emerges from the mask on this remarkable ritual vessel. (Cat. no. 102)

Fig. 10 Seat in the form of mythical creature. Ecuador, Jama-Coaque, 200/400. Ceramic. Museo Antropológico del Banco Central, Guayaquil. Photo: Dirk Bakker. Creatures of composite character are featured in connection with ritual implements, as in neighboring traditions of Colombia and Central America. (Cat. no. 112)

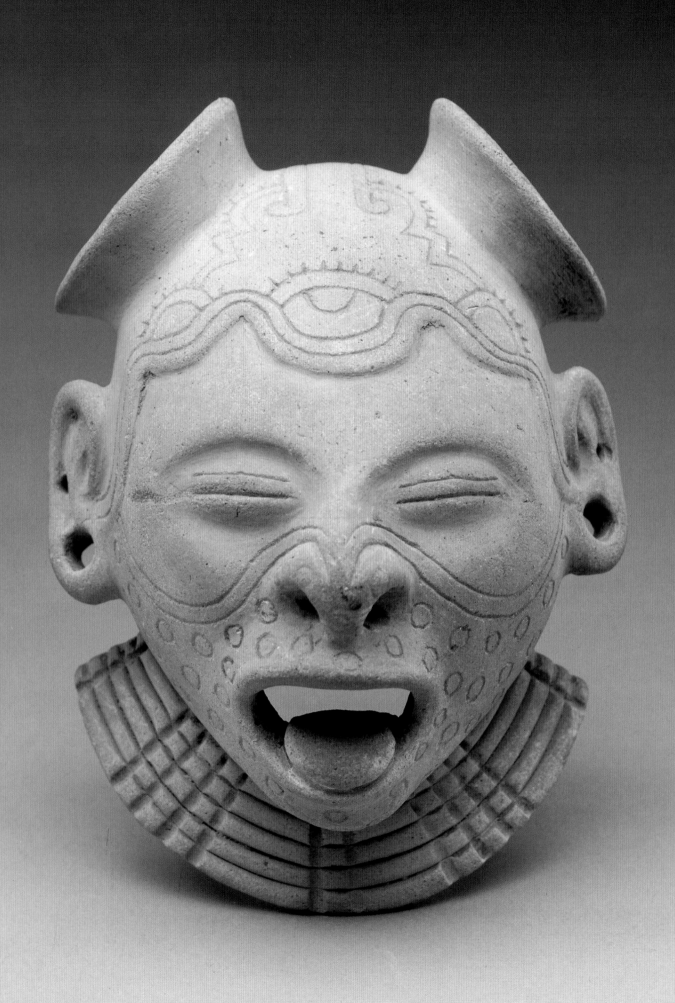

The three realms of this world with their associated dominant animal powers were: the sky/air (bat and birds, particularly the eagle and owl), the earth/forest (feline and serpent), and the water (cayman and shark). These associations have much in common with the symbolic art of other early Andean traditions, most especially that of Chavín, and are ultimately rooted in the Formative cultures of lowland tropical South America.[9] Different symbols became particularly significant at certain times in La Tolita. During the period before AD 200, a triad of marine shells—*Strombus* (bivalve mollusk), *Malea* (mollusk), and *Spondylus* (conch) (see fig. 7)—appears to have been very meaningful in ritual life. Examples of the first two species have been found exclusively in areas dating to the beginning of the occupation of the site, a period in which ceramic vessels with shell-like forms are also found. Perhaps the most important find to date emphasizing the symbolic importance of sea shells is a deposit in the subfloor of the principal plaza. During the Transition period (400–200 BC), this space, a sacred area, received offerings of many species of marine shells, together with other objects in ceramic, bone, and gold. Such is the quantity of shell accumulated here that people still refer to the space as "The Shell Place." During the entire Tolita occupation, shells were continually deposited in the plaza area, but the great accumulations of *Strombus*, of *Malea*, and, more sporadically, of *Spondylus* were made in the earliest periods. During the Classic period, these marine symbols were supplanted by the jaguar, the serpent, and the eagle.

An important characteristic of Tolita iconography is the inventive combination in a single representation of attributes from different human and animal sources. These are complex metaphoric syntheses of beings from different physical and/or symbolic domains. A feline, for instance, may display the powerful curved beak of an eagle, or a human torso is combined with the fangs of a cayman or the body of an eagle.

Many of the most spectacular ceramic figures from La Tolita and Jama-Coaque combine diverse forms from the natural world to represent human activities and social hierarchies. In one example (fig. 12), the agricultural realm is clearly described by a figure, which stands with a planting stick and seed bag and wears a garment adorned with seed-like motifs. The birds on his headdress seem to lie in wait for this annual planting ritual. The second example represents a sturdy

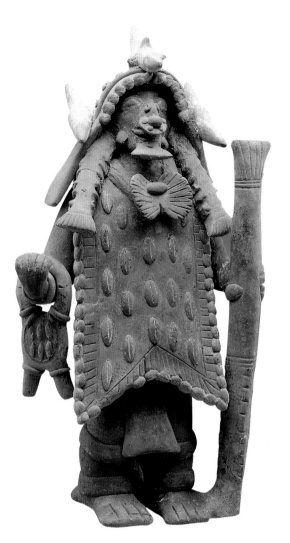

Fig. 11 Model of trophy head. Ecuador, La Tolita, 200/400. Ceramic. Museo Arqueológico del Banco Central, Quito. Photo: Dirk Bakker. (Cat. no. 113)

Fig. 12 Ritual sower with seed bag and staff. Ecuador, Jama-Coaque, 200/400. Ceramic. Museo Antropológico del Banco Central, Guayaquil. Photo: Dirk Bakker. The attire and accessories worn by this figure suggest first rites performed in the fields to begin the agricultural season. (Cat. no. 111)

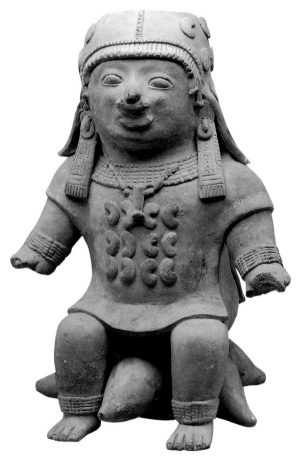

Fig. 13 Figure seated on harvest of manioc roots. Ecuador, Jama-Coaque, 200/400. Ceramic. Museo Arqueológico del Banco Central, Quito, Photo: Dirk Bakker. (Cat. no. 106)

woman, also clad in ceremonial attire with seedlike decorations (fig. 13). She sits on a heap of large manioc roots; in lowland tropical America, this root crop was—and still is—a major staple. Her attire and pose suggest that she is a participant in rites of the harvest season.

Other aspects of ritual life are portrayed in this expressive ceramic tradition. The crouching figure of a warrior raises his spear thrower; his mask signals that this must be a ritual display, perhaps connected with hunting rites or territorial defense (fig. 14). Another figure, a seated woman, is in courtly regalia with beaded necklaces, bracelets, and spectacular ear ornaments (fig. 15). Her nose ornament is similar to one that rests upon a box in her lap. Could she be the guardian

of the precious regalia reserved for a chiefly lineage?

Other questions are posed by an elaborate figure bearing an upended, three-legged stool upon his head (fig. 17). A feline diadem stands as a sign of the power embodied in this seat of authority. Another type of effigy is a seat, resting upon the back of a mythical, supine figure whose masklike face bears the nose of a bat and fearsome fangs (fig. 10). This startling creature opens its claws in an aggressive gesture to display enigmatic symbols in the palm of each hand. Could this seat allude to the possession and transformation experienced by shamans in the course of a ritual trance? Another ritual vessel features a fanged monster emerging from the mouth of a larger face modeled on the wall of the

Fig. 14 Vessel in the form of masked warrior. Ecuador, Jama-Coaque, 200/400. Ceramic. Museo Arqueológico del Banco Central, Quito. Photo: Dirk Bakker. (Cat. no. 103)

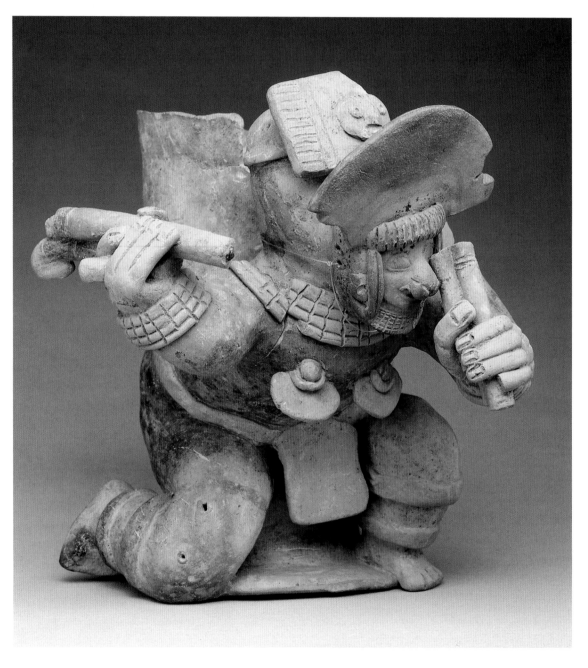

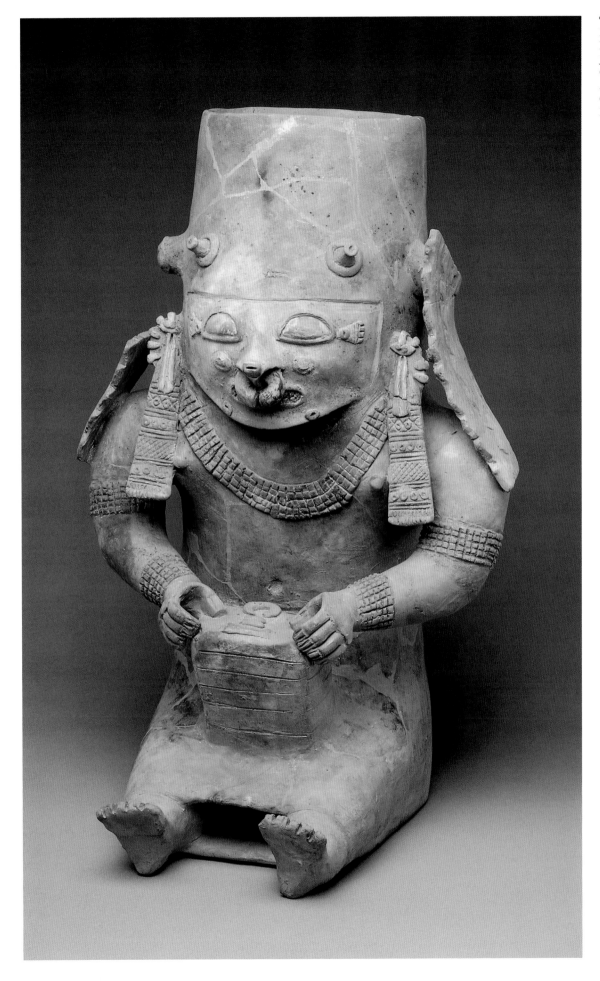

Fig. 15 Female keeper of lineage insignia. Ecuador, Jama-Coaque, 200/400. Ceramic. Museo Arqueológico del Banco Central, Quito. Photo: Dirk Bakker. (Cat. no. 105)

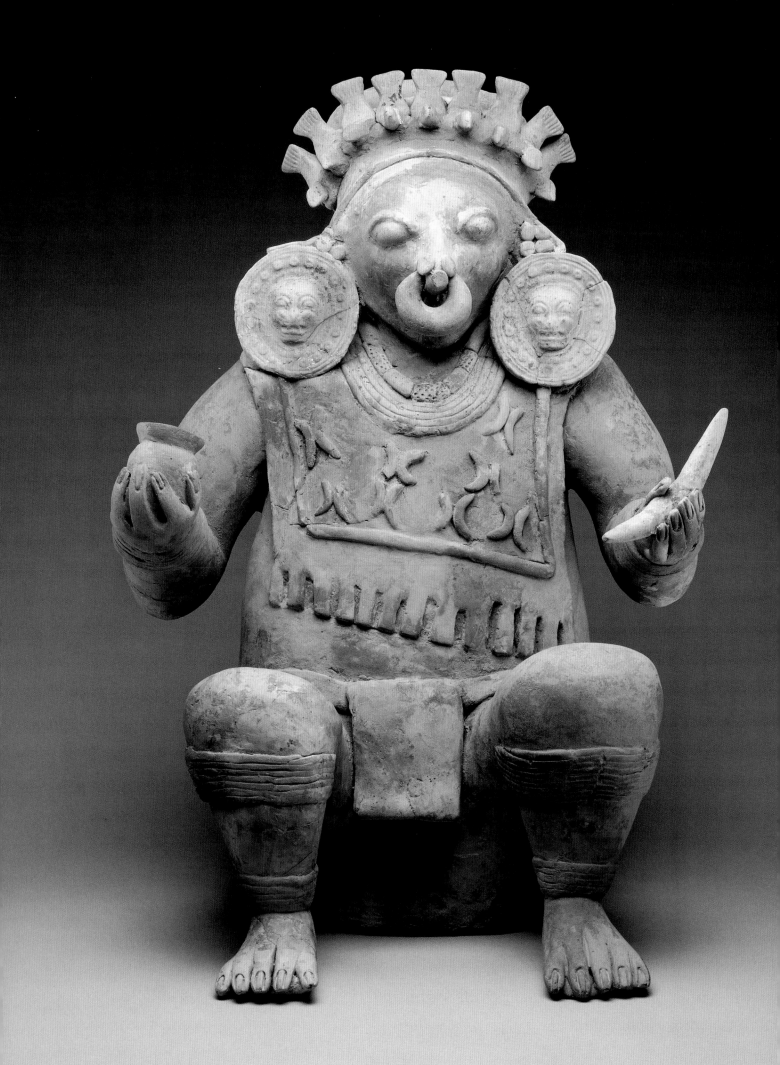

container (fig. 9). One may speculate that the contents of this container would have induced a powerful vision or manifestation of a supernatural being.

Some ceramic figures certainly allude to the chiefs of the La Tolita forest domain, for they bear resplendent regalia announcing their rank and status. A seated man wears massive ear spools, a headdress of birds, and a layered collar of necklaces (fig. 16). He bears a lime flask in one hand and, in the other, a spatula: these were the implements of coca-chewing, a prerogative of Andean rulers in rites performed at specified times in the cycle of the seasonal calendar. Another figure is seated cross-legged, with his hands resting upon his knees (fig. 18). The twin tusks on his chest were traditional emblems of authority and may represent male and female lines of descent of a ruling family. The bulge in each cheek indicates that he is chewing two quids of coca leaves. Among all the vital and lively figures of Jama-Coaque art, this seated man conveys an exceptional sense of quiet detachment. The gestures indicate the transmission of ritual conventions in a repertory of standardized poses.

Solar representations are rare in the art of La Tolita. Thus, the "Sun God" is a notable and exquisite example of Tolita repoussé and elaborately cut sheet goldwork (see frontispiece, p. 2). Once worn on the forehead of a powerful individual, it was probably also a funerary mask. Rich in symbolism and full of energy, it features a masklike human face surrounded by radiating serpents, each of which holds a small human face in its mouth. Through the use of shimmering gold, reflecting brilliant sunlight, and through the synthesis and interplay of metaphoric forms, this magnificent diadem powerfully conveys the vital energy of the cosmic forces.

The themes expressed by these works of art follow a symbolic codification of concepts concerning the ordering of a world perceived as sacred. Art became a means of discourse through various primary materials and forms, inspired by the visionary role of shamans and the formalized rites of priests. Naturalistic images and abstract combinations were invented to codify structures of thought and perception that represented a world of powers and spirits, and their many connections with human activities.

Conclusion

Throughout the history of La Tolita, the presence of the rivers and forest, with their extraordinary variety of fauna and flora, exerted a basic and lasting influence on economic and religious practices. The community first appeared on small islands within the mangroves, which form part of a larger flood-plain ecosystem. This environment offered a rich array of economic resources and also provided a frame of reference for a powerful symbolic system. The tropical forest was the locus of life-giving forces, as well as mysteries and dangers, all of which shaped the sacred character of the settlement and were expressed in art, architecture, and the cycle of seasonal ritual. The mangroves are the home of the cayman and the serpent, amphibious beasts of prey that ruled aquatic and terrestrial domains. Beneath the trees of the

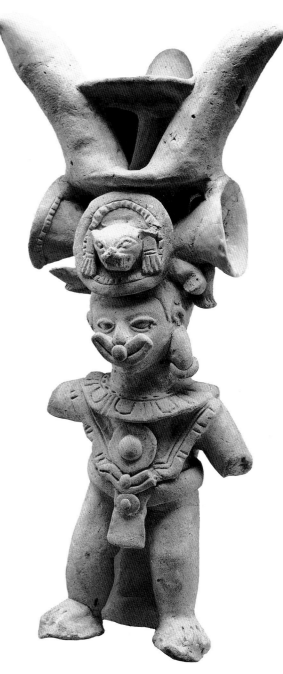

Fig. 16 Chieftain chewing coca. Ecuador, Jama-Coaque, 200/400. Ceramic. Museo Antropológico del Banco Central, Guayaquil. Photo: Dirk Bakker. The lime flask and spatula held by this figure were part of the equipment for coca chewing, a ritual performed by rulers at critical periods during the agricultural cycle. (Cat. no. 107)

Fig. 17 Figure bearing tripod throne. Ecuador, La Tolita, 200/400. Ceramic. Museo Antropológico del Banco Central, Guayaquil. Photo: Dirk Bakker. Seats of authority were especially important in the accession of rulers. (Cat no. 114)

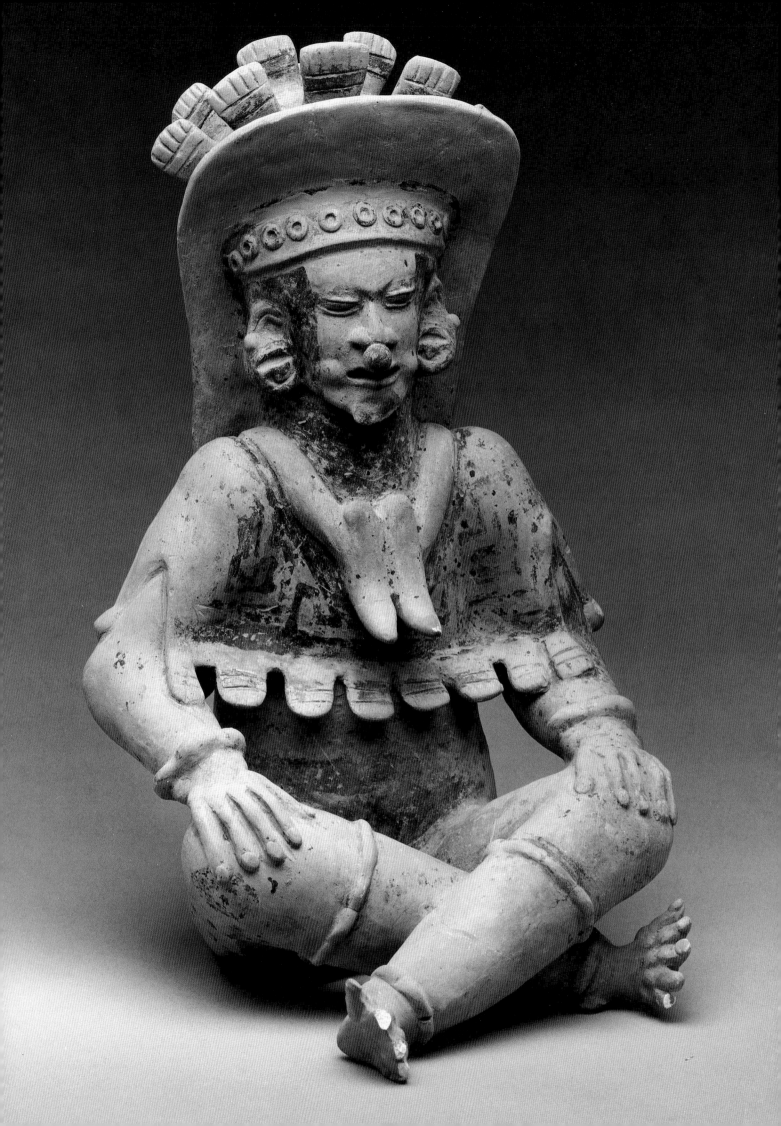

nearby forest, the jaguar was seen as the lord of the lesser mammal kingdom, which included deer, peccaries, coatis, spotted cavies, and many other species. The swamp and the forest are habitats of pelagic and land birds, which form yet another hierarchy of hunters and hunted. The eagles, falcons, owls, and bats that inhabit this aerial universe by day and by night were also perceived as forest rulers. These creatures live in a zone between the human habitat and the remote, all-powerful natural forces.

The forms of the great beasts of prey were translated into a hierarchy of signs and symbols, which were incorporated into the ritual attire of La Tolita chieftains, shamans, and priests. In the same manner, many other animals and birds lent their showy pelts and brilliant plumage to the imagery and color of La Tolita ceremonial life.

It must be remembered that the forest was also the source of food and shelter in the form of fruits, edible roots, mushrooms, vines, palms, and rattan. Certain plants also had psychotropic qualities that were used to communicate with the spirits of nature. Above this teeming landscape moved the radiant sun. To inhabit this ecologically varied and spiritually magical place, the people of La Tolita were required to form bonds with all its forces and elements. Even as the ceremonial center grew, as the forest was cut back, and the swamp was filled in to make room for the expanding population, the animals and plants continued to exercise an essential presence in La Tolita imagery and sacred landscape.

When the site was finally abandoned, the forest returned to claim the ruins with a protective green mantle. For fifteen hundred years, it lay untouched, until discovered by people moved by different spirits. La Tolita, along with other sites of this coastal region, has begun to be explored archaeologically only in recent years. Interpretation of this ancient culture and its links with other peoples and regions has only just begun. In many instances, the activities of looters and treasure-hunters have preceded officially sponsored excavations. The unique record left by the art and architecture of La Tolita provides a fragile record of one of man's successful adaptations to the rich forest and riverine environments of northwestern South America. Not the least part of this attunement was the development of a richly varied and highly expressive tradition of ritual imagery. The attire displayed by figurines, the glittering shapes of golden masks, the sculptured vessels, and the architectural plan of the ritual center all speak of an ancient dialogue between economic life and mythic perception, in which the community wove its existence as an integral part of the larger design of forests, skies, and rivers.

Fig. 18 Seated chieftain with emblems of rank. Ecuador, Jama-Coaque, 200/400. Ceramic. Museo Arqueológico del Banco Central, Quito, Photo: Dirk Bakker. (Cat. no. 104)

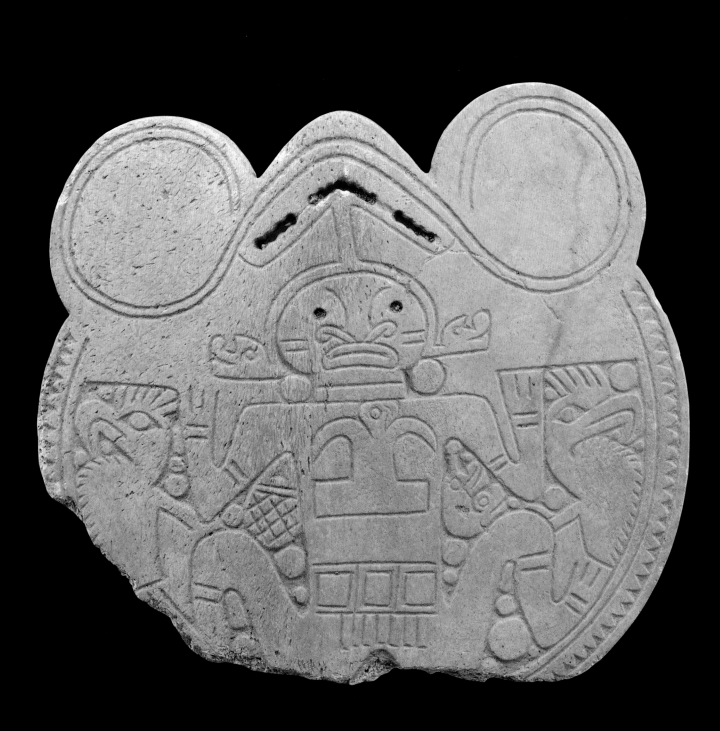

THE TAIRONA OF
ANCIENT COLOMBIA

The Tairona and
Their Kogi Descendants

The conquest of a great part of Mesoamerica and South America was accomplished by the Spaniards in a relatively brief time. In 1519, Hernán Cortés landed on the coast of Mexico and, within two years, had conquered the Aztec empire. In 1527, word reached Francisco Pizarro of the fabulous wealth of kingdoms further south. Cutting short his sojourn in Panama, he led several exploratory forays along the Pacific coast of South America, then sailed to the north coast of Peru, where he struck inland toward the heart of the Andes. By 1534, he had conquered the enormous Inca empire, which stretched some five thousand kilometers from what is now northern Ecuador into Argentina and Chile.

These two conquests have always amazed the Europeans, because Cortés and Pizarro, with the tiny armies they had at their command, overpowered militaristic states that controlled extensive armies seasoned by centuries of imperial success. The Conquest was both political and ideological. The native kings were quickly dethroned and their bureaucracies dismantled. The Catholic church, carrying out vigorous missionary campaigns, abolished all exterior forms of indigenous religion and ritual.

Among Spanish intellectuals, however, the unexpected splendor of the New World civilizations awoke a genuine curiosity concerning the origins of the people now under Spanish dominance. Not far from Tenochtitlan, the Aztec capital, they saw the impressive ruins of Teotihuacan, "the city of the gods," and accepted Aztec opinion that it had been the capital of a former empire. After entering Cuzco, the capital of the Inca, the Spaniards continued to Lake Titicaca and discovered the ruins of Tiwanaku, the place whence Viracocha, the creator god, was said to have brought forth not only the sun and the moon and all of humanity, but, more specifically, the ancestors of the Inca kings. Missionaries described in detail the Aztec and Inca languages. Chroniclers inquired about royal dynasties and their histories to describe the novel culture, organization, and religion of these states. From the sixteenth century onward, Europeans became convinced that Mesoamerica and the central Andean region were centers of civilization in the New World, just as Egypt and Mesopotamia had been in the Old World.

Nonetheless, exploration of the New World was not limited to the lands contained within the boundaries of these two great empires. The Spaniards had established a foothold on the Atlantic coast of Colombia before Pizarro sailed south. Upon hearing of his exploits, other conquerors raised rival armies and traveled overland toward Ecuador and Peru; but the Colombian chiefdoms, perhaps because they lacked the state pageantry and urban grandeur found in Mexico and Peru, never quite caught the Spaniards' imagination. Although an exception was the legend of El Dorado, "the Golden Man," derived from Muisca traditions close to present-day Bogotá, it was left to nineteenth-century antiquarian interests and the even later work of archaeologists in the twentieth century to arouse an interest in the pre-Columbian cultures of the northern Andes. Gradually, it has become apparent that these peoples also had highly sophisticated cultures and arts before European contact, and that Colombia, strategically positioned between North and South

Fig. 1 Pectoral depicting seated chieftain with raptorial birds. Colombia, Tairona, 1200/1600. Bone. Museo del Oro del Banco de la República, Bogotá. Photo: Dirk Bakker. (Cat. no. 243)

Fig. 2 In the rugged Sierra Nevada de Santa Marta in Colombia, certain peaks are considered sacred by the Kogi Indians, who are descended from the Tairona. Photo: Juan Mayr.

America, made seminal contributions to the earliest inventions of American man—pottery, for example—which led to the rise of both Mesoamerican and Andean civilization. Modern ethnohistorical research enables us to partially reconstruct the early Colonial survivals of some cultures in the regions between Mexico and Peru, although, in general, we lack elaborate descriptions of political ideology, cosmology, and pre-Hispanic rituals that would have made possible an interpretation of their arts.

One culture, that of the Tairona, is an exception to this condition. In the final centuries before contact with the Spaniards, the Tairona had one of the most advanced societies in Colombia. Their descendants, the Kogi, located on the northern and western slopes of the Sierra Nevada near the city of Santa Marta, and their relatives, the Ika, on the southern slopes of the Sierra Nevada, have preserved much of their culture. This is especially true in the areas of religion and social and ritual organization.

The Sierra Nevada massif (fig. 2), a formation next to and independent of the Andean mountain chain, rises precipitously from the Atlantic Ocean and claims some of the highest mountains in Colombia (5,670 meters). Crowned by snow-capped peaks and high, tundralike plains, the deeply dissected mountain slopes are cloaked with dense forests cut by rivers that plunge either toward the sea or onto the tropical plains to the south and east.

The name Tairo or Tairona originally applied to just one of the groups on the western and northern slopes, but it now encompasses all of them. Until the end of the sixteenth century, the various valleys bore intensive occupation, comprising towns of up to three thousand inhabitants surrounded by dispersed settlements of varying sizes, mostly built on ridges up to an altitude of about one thousand meters. All towns and villages maintained extensive terraced and irrigated fields, cultivating maize, cotton, and other products. A vast network of stone-paved paths and roads connected towns and fields, and long stairways led from the rivers up to settlements, some of which had stone house foundations (see figs. 3, 4). The Tairona region was probably more densely populated

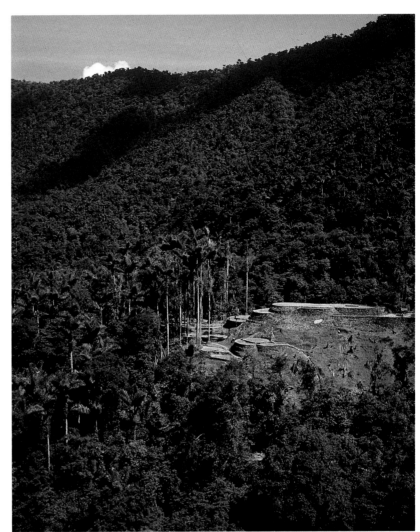

than any other in all of Colombia and Central America. It was also a region of intense artistic activity, especially goldworking (see figs. 12, 15).

Colonial-period contact between the Spaniards and the Tairona was an exercise in frustration for the former. The Spaniards founded the coastal city of Santa Marta in 1526, but their attempts to practice agriculture and husbandry near the town met with little success. Punitive expeditions against the militant Tairona did not lead to enduring conquest. Missionary activities brought meager results; most Tairona revolts were inspired by their refusal to accept Christianity. Only after the last great and general rebellion of 1559–60 was their resistance finally broken, and not to the advantage of the Spaniards. Upon seeing their chiefs executed, the people abandoned their villages and fled to higher, less accessible valleys. Consequently, the Spaniards spurned the region where the Tairona culture had once flourished for hundreds of years, and the valleys north and west of the Sierra Nevada became uninhabited.

The modern Kogi, who live at altitudes of one to two thousand meters, consider the Tairona their ancestors. The tradition of

Fig. 3 Ciudad Perdida. Colombia, Tairona, 1200/ 1600. Photo: Juan Mayr. Circular house platforms follow the ridge line at this archaeological site. Tairona structures were similar to those of the Kogi today.

Fig. 4 Plan of central axis of Ciudad Perdida. Colombia, Tairona, 1200/1600. Drawing: Carlos Fuentes Sánchez.

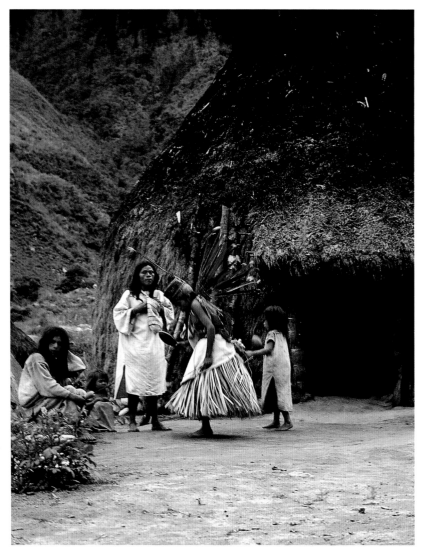

within this larger context, it becomes possible to interpret many of the aspects of the art that heretofore have seemed mysterious.

Continuities of an Ancient World View

The Tairona political situation can best be compared to that of independent city-states. Towns had their own chiefs, but in some of the largest towns—one of these was divided into four neighborhoods—chiefs could be subject to supreme chiefs, who were called *naoma* (in Spanish, *cacique mayor*). Chiefs could take on other functions, such as leadership in war or commercial expeditions, and they could also assume priestly duties. There was, in addition, a distinct class of highly influential priests who bore no formal political responsibilities. Notwithstanding the political autonomy of individual towns, one chronicler spoke of the existence of a "New Rome," a pilgrimage place where all the major towns maintained their own large ceremonial house or temple with a priest; one priest was recognized as the supreme priest.

ideological and political resistance established by their Colonial forebears continued into later centuries, and missionary activities proved futile. While the Kogi have accepted various European elements, such as domesticated animals, they still recognize these as alien. The Tairona had been great warriors; the pacific Kogi now defend their identity by clinging to traditional beliefs and ritual practices (see fig. 5).

Since the beginning of this century, ethnographers have described Kogi culture in great detail.[1] Their works are of inestimable value for an understanding of the world view of Kogi and Tairona alike. They enable us to approach Tairona art from a broad cultural perspective, hardly matched by any other people living in Central America or the Andes.

Some of the continuities between Tairona and Kogi cultures suggest how an understanding of the Kogi world view can help us to approach that of the Tairona. Tairona art and architecture can be viewed also against the background of Mesoamerican and Andean civilizations. By looking at Tairona art

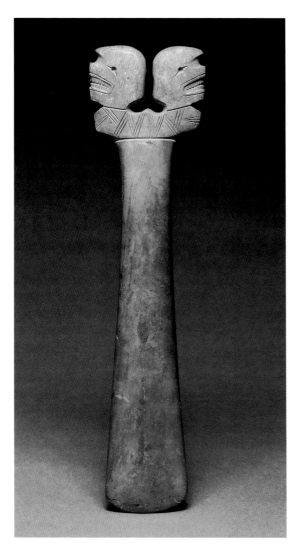

The hierarchical specificity of Tairona society is now almost completely lost. Today, the Kogi use the name *naoma* only for the respected elders in the villages, who assist the priests, the *mama*, who now hold most of the authority. The *mama*, with their knowledge of the past, are the guardians of tradition: myths, rituals, and the calendar. They wield a great moral authority in the village, largely replacing the *naoma*.

The very peculiar Kogi lineage organization may well derive from that of the Tairona. Men are organized in male lineages, the *tuxe*, descending from father to son, and women in female ones, the *dake*, going from mother to daughter. After marriage, husband and wife maintain their own houses opposite each other, with meals served in the space between. This is perhaps an extreme expression of a trait of social organization widely recognized in the Andes. According to a Kogi origin myth, there were at first four *tuxe* and four *dake*, descending from animals that were considered as male and female, respectively. The large Tairona town that the Spaniards described as being divided into four neighborhoods may well have represented such a fourfold pattern.

The recently excavated town of Ciudad Perdida, "Lost City," gives an excellent idea of Tairona urbanism.[2] Perched on the crests of mountain ridges, in groups of one to three, the houses stood on stone-walled terraces. The circular foundations remind us of contemporary, round Kogi houses with high, conical roofs. Some Tairona houses at Ciudad Perdida were much larger than the rest and might have had two entrances instead of one. These were probably ceremonial houses, corresponding to larger ritual structures located in modern Kogi villages and in nearby ceremonial centers.

Today, Kogi men gather on feast days with the *mama* in the ceremonial house; here no women are allowed. The chewing of coca leaves is an essential accompaniment to discussions concerning tradition and moral subjects underpinning community life. Weaving is a male occupation, and men can be punished by the *mama* for a transgression by having to weave in the ceremonial house. The punitive function of the ceremonial house was observed by one chronicler in the early seventeenth century.

The Kogi still use ceremonial objects either inherited from Tairona times or made

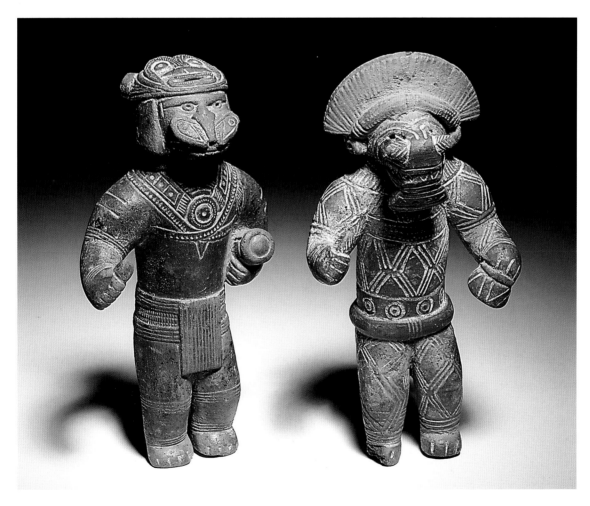

Fig. 7 Masked performers. Colombia, Tairona, 1200/ 1600. Ceramic. The Art Institute of Chicago. (Cat. no. 225)

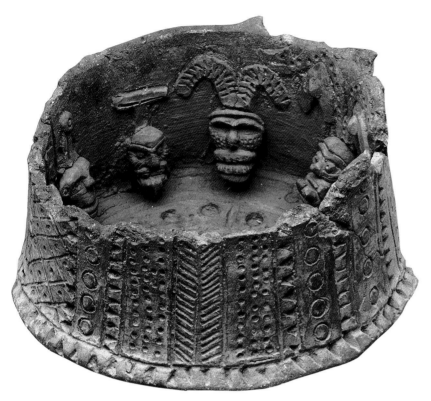

Fig. 8 Model of ritual enclosure with hanging masks. Colombia, Tairona, 1200/1600. Ceramic. Museo del Oro del Banco de la República, Bogotá. Photo: Dirk Bakker. (Cat. no. 241)

Fig. 9 Bat pendant with sharks. Costa Rica, Guanacaste-Nicoya zone, 1/500. Jade. Instituto Nacional de Seguros, San José. Photo: Dirk Bakker.

according to the old canons.³ The Tairona fashioned monolithic axes by imitating the complete wood-and-stone form entirely in stone. Today, the Kogi use these in rituals and dances that presage the changing seasons. Two wet and two dry seasons alternate successively in the course of the year. Axes of green stone are used to mark the rainy seasons that coincide with the equinoctial feasts and axes of red stone for the dry seasons at the time of the solstices.⁴ Pendants of red or greenish stone bear mostly abstract (but occasionally realistic) forms representing bats. Worn in pairs dangling from the elbows of dancers, these produce a tinkling sound akin to that of wind chimes. The beautifully shaped, stone ceremonial batons or clubs (see fig. 6) once sculpted by the Tairona are still in use today, but are now made of wood. The Kogi wear expressive wooden masks for their dances that may well be heirlooms from early Colonial times.⁵ Not only are they very similar to masks collected in the seventeenth century, but the forms of the nonrealistic ones resemble figurines, found archaeologically, that represent mythical beings or ritual performers impersonating such beings (see figs. 7, 15).⁶ The ceramic model of a Tairona circular house shows masks ranged around the interior wall (fig. 8).⁷

The calendar and calendrical rituals provide the best evidence for continuity of pre-Hispanic material and symbolic culture. There are thirteen lunar months in the Kogi year, going from new moon to new moon. These months are defined in sequence in terms of the risings of certain stars; thus, the year begins with the solstice of June 21, when the Pleiades rise in the morning. The stars or constellations used for calendrical purposes are called the concubines of the Sun, and the Sun may stay longer with one than with another. The *mama*, as the calendrical specialists, also mention a sequence of nine constellations in each half-year from solstice to solstice, relating these to a division of the year into eighteen months of twenty days. The most important feasts are those of the solstices and equinoxes, when villages specialize in celebrating one or the other.

The Tairona and the Outside World

This sketch of Tairona art and culture, seen, as it were, from the perspective of their descendants, the Kogi, invites us to explore cultural connections further afield. First, we can consider those within the context of what can be called the intermediate area of northern Colombia, Panama, and Costa Rica. This area participated in the "International" style, known for its goldwork.⁸ Tairona goldsmiths produced some of the most exuberant and technically advanced pieces in this style, culminating in the final centuries before contact with the Spaniards. Stylistic similarities can be found on a larger scale at villages such as Guayabo de Turrialba in Costa Rica, which were occupied in the last centuries before European contact.⁹ Here, the physical organization of the village is strikingly similar to that of Tairona villages and towns, with their roads and stairways. Monolithic axes and bat pendants are also found in Costa Rica, though in a somewhat different style. The pendants are of jade and depict, more realistically than is common in Tairona art, a frontal bat flanked by two sharks or whales in lateral position (see fig. 9).

Andean connections among neighboring peoples of Colombia can also be explored. Tairona culture probably was most similar to that of the contemporaneous Muisca; both peoples spoke related languages of the Chibcha family. Many cultural traits, such as the use of coca leaves or the descent system described above, are characteristically Andean. To this list might be added the intensive and variegated agricultural exploitation of contrasting ecological niches in the "vertical"

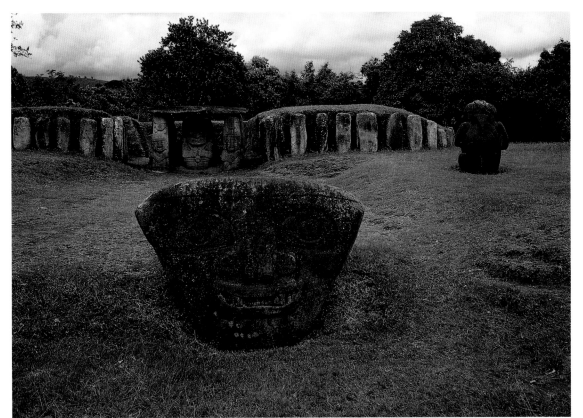

Fig. 10 Excavated burial mound. Colombia, San Agustín, 400/800. Photo: Colin McEwan. Stone masks and stelae are ranged by a burial enclosure, one of dozens marking the sacred geography of the San Agustín culture in the Upper Magdalena river valley.

landscape of the Sierra Nevada. This aspect complemented the remarkable feeling that the Tairona had for integrating urban planning into the landscape. The aesthetic and symbolic unification of landscape with architecture is an ancient, widespread Andean tradition, as is seen at sites such as San Agustín in Colombia (see figs. 10, 11),[10] Chavín de Huántar and Machu Picchu in highland Peru (see Burger and Niles essays in this book), and Tiwanaku in Bolivia (see Kolata and Ponce Sanginés essay in this book).

While these associations are rather general, connections with Mesoamerica are more specific. The Kogi calendar of eighteen months of twenty days each and their vigesimal system of counting, known also to the Tairona and the Muisca, could have been derived only from Mesoamerica, although applied to a non-Mesoamerican world. The Mesoamerican model may have reached more cultures in northern Colombia than we realize at present. The number nine plays a fundamental role in many aspects of Kogi religion—for instance, their universe is divided into nine layers: four heavens, the earth, and four underworlds. Nine as a cosmic-model number appears also in Mesoamerica.

Notwithstanding the specific calendrical connections of the Kogi to the Tairona and, ultimately, to Mesoamerica, it remains problematical to use them for an understanding

Fig. 11 Stela. Colombia, San Agustín, 400/800. Volcanic stone. The Denver Art Museum. The tradition of masked figures in frontal poses, presenting ritual implements, is very old in Colombia. (Cat. no. 223)

of Tairona cosmology, as reflected in their arts. The Tairona left no codices or elaborately decorated stone monuments like those of the Maya, which refer to the calendar with its integration of personal or yearly religious observances. Nonetheless, two kinds of art objects allow us to gain some insights into the world view of the Tairona and to study the range of the actors that played a role in their myths and rituals. The first consists of decorated gold or bone plaques or pendants and the second of sculpted miniature vessels and ocarinas in pottery, stone, and bone.

Displayed Figures

All of the gold pectorals or pendants depict a frontal solar deity, either standing or sitting with drawn-up legs and arms held close to the body in such a way that the elbows and knees touch, or nearly touch, each other (see fig. 12). The latter pose, often referred to as displayed, is found in many archaic art styles worldwide and, in most cases, is assumed by a female.[11] Carl Schuster, a scholar in comparative symbol systems, summarized certain additional features that frequently characterize the displayed figure: the occurrence of frontal or lateral faces on elbows and knees, or a face or a circle between the elbow and knee on either side.[12]

The formal traits of the displayed figure enable us to view the Tairona examples in a wider context. A well-known example of this type of figure can be found in sixteenth-century Aztec representations of the female earth deity (see Townsend essay in this book, fig. 11).[13] The squatting position here is clearly associated with giving birth. Chavín art, from the last millennium BC in Peru, shows a similar, complex representation of a

Fig. 12 Circular pectoral depicting sun god. Colombia, Tairona, 1200/ 1600. Gold. Museo del Oro del Banco de la República, Bogotá. Photo: Dirk Bakker. (Cat. no. 233)

Fig. 13 Ocarina with enthroned chieftain. Colombia, Tairona, 1200/ 1600. Ceramic. The National Museum of the American Indian, Smithsonian Institution, New York. (Cat. no. 246)

Fig. 14 Pectoral or pendant depicting sun god. Colombia, Tairona, 1200/ 1600. Gold. Museo del Oro del Banco de la República, Bogotá, Colombia. Photo: Jorge Mario Múnera.

deity with the mouth of a spider.[14] The sex of
this being is both accentuated and hidden by
a conch-shell appendage, so that it is difficult
to decide whether the figure is male or fe-
male. However, a displayed figure frequently
found in the art of Nazca, with added mon-
key faces, is decidedly male.[15] He plays both
a panpipe, which hangs from his mouth, and
a drum. Musicians who play the two instru-
ments together, especially at planting time,
are still found in Peru, and the Nazca per-
formance may have been intended to induce
the fertility of the earth. Other cultures from
nuclear America and Amazonia feature the
displayed figure in their art, each embellish-
ing the core motif with its own idiosyncratic
details.

Some of the Tairona displayed figures are
unequivocally marked as male. Figure 12 is a
gold pectoral showing a displayed solar deity,
with a triangular face; he balances a baton or
ceremonial bar on his shoulders. In other rep-
resentations (see figs. 13, 14), a male wearing
a large feather crown, which symbolizes the
sun among many Amazonian cultures,[16] sits
upon an undulating band that terminates
at both ends in a serpent head. The double-
headed serpent calls to mind a kind of seat
represented in miniature ceramic examples.[17]
The actual seats, made of stone, are rectangu-
lar in shape, have four legs, and bear serpent
heads that extend laterally on either side.
Other figurines show deities sitting on a seat,
and, although Kogi priests use such seats for
similar purposes within the ceremonial
house, miniature examples are used also for
presenting offerings. Until recently, similar
seats in wood were found in various parts of
South America. Günther Hartmann noted
that, in the Northwest Amazonian region,
they were used by shamans when smoking
long cigars held with forked staffs.[18] Since
some of the Tairona stone batons have two
long prongs, it is possible that seats and
batons for cigar-smoking were used as
equipment for shamans in trances while
conducting healing séances. Other Tairona
seats are of a decidedly different form. Some
models in bone suggest that we are probably
dealing with the three-legged, reclining
seats found in northern South America and
the Caribbean (see fig. 16). These, in turn,
remind us of the highly decorated, three-
legged, stone *metates* of Costa Rica. These
grinding stones may also have functioned
as thrones.[19]

Where the displayed figures do not reveal
the sex, we may infer that it is female. In

one case, a bat in an upside-down position is represented beneath the seat and under the figure.[20] Anne Legast, who has studied the importance of this animal in Tairona art, makes use of Kogi symbolic conventions.[21] Central among these is the euphemistic reference to menstruating women as having been bitten by a bat. This has led to a connection between the primordial mother-deity and the bat. When, therefore, the Kogi interpret the gold plaques as representing the "Mother," they may be thinking primarily of examples such as this.

The idea that women are bitten by bats might suggest that the bat represents a male figure. Legast pointed out the likeness between the mask of Heisei—the male Kogi god of death, rain, and fertility, whose mask is characterized by square jaws (the lower much longer than the upper)—and a Tairona deity represented in ceramic ocarinas and elaborate gold pendants (see fig. 15). The

additional motif of a bat or bats is found also on another gold plaque of a displayed woman, in the Museo del Oro del Banco de la República collections, Bogotá, Colombia (not in exhibition). Both this and the previous example allow us to study the figures of bats in the wider context of Tairona cosmology.

A distinctive feature of these plaques and of other examples is that the feet of the central figure are not on the ground but are drawn up on the seat. A ceramic example of a modeled female figure sitting on a rectangular seat with two serpent heads comes from the Nicoya Peninsula of Costa Rica, and dates about 500/1000.[22] This Intermediate Area convention can also be found on the coast of Ecuador: on a stone stela with decoration in low relief, exhibiting the Manteño style from the time of Spanish contact, a displayed female figure occupies a seat typical of this culture.[23]

Fig. 15 Pendant depicting masked priestly figure. Colombia, Tairona, 1200/1600. Gold. Museo del Oro del Banco de la República, Bogotá. Photo: Dirk Bakker. The bird headdress, mask, and ceremonial bar seen on this figure were worn on festival occasions and served as emblems of the religious office of Tairona chieftains.

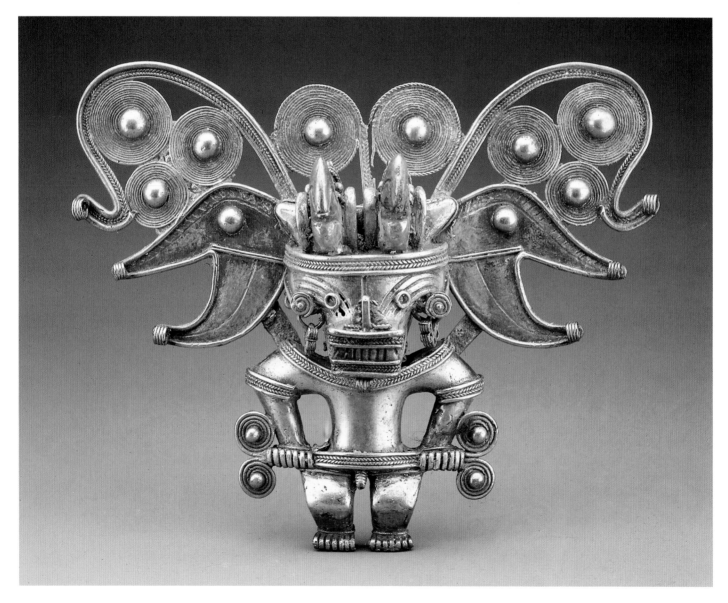

The Displayed Figures as Emblems of Chiefs

The displayed figures in Tairona art clearly do not depict only a single deity or mythological figure but seem to be a fusion of at least two—the male Sun and the female Earth—and probably more, as indicated by the frequent use of attendant figures that flank the central one. These composite images portray ideas concerning primordial creative forces. The attendant iconographic components enable us to develop a more integrated picture of the subject matter of Tairona art. Two examples of displayed Tairona figures do not appear to represent a deity or mythic figure as such, but rather a chiefly personage. The first (fig. 1) is a pendant made of bone, engraved with a displayed figure—probably male, although the sex cannot be determined because of damage in the lower part of the pendant. The central figure is flanked by birds with the crest and curved beak of a frigate bird (similar to fig. 17).[24] An image of a bird is also engraved on the chest of the main figure, with wings outspread and head turned sideways. The design alludes to Tairona gold pendants defined as the Bird-man (similar to figs. 18, 19).[25] On such pendants, the bird's body, wings, and tail are rendered in flat, two-dimensional form, except for a decorative bar or waistband, which usually ends in two small bird heads under the outstretched wings. The head, on the other hand, is modeled fully in the round and points forward. The aggressive, predatory character of the frigate bird is expressed well in a second carved bone object, from the Museo del Oro, where it is shown accompanying a bat-masked figure in a scene of human sacrifice.

Variations of such pendants replace the head with two complete modeled birds, and the most elaborate examples even have four or six of these (see fig. 20). Sitting upon the head of each bird is a man in a squatting position, his arms folded upon his knees. These pendants no longer represent a single Bird-man but, rather, an organization of men dominating birds. The pendants probably functioned as emblematic status-markers for important personages, as did the bone plaque.

A comparison of the bone pendant (fig. 1) with the cast-gold pendants (figs. 18, 19) points to a stylistic convention in Tairona art. As noted earlier, despite a tendency toward two-dimensionality, the gold pendants have three-dimensional features—generally, the head of a bird. However, when such pen-

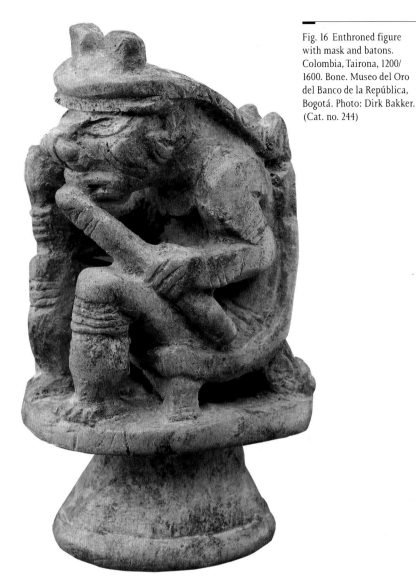

Fig. 16 Enthroned figure with mask and batons. Colombia, Tairona, 1200/1600. Bone. Museo del Oro del Banco de la República, Bogotá. Photo: Dirk Bakker. (Cat. no. 244)

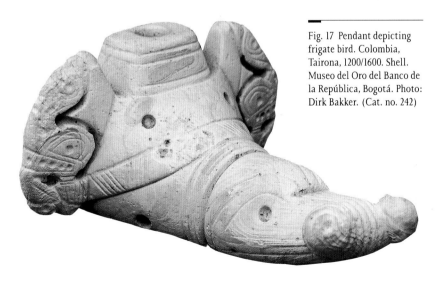

Fig. 17 Pendant depicting frigate bird. Colombia, Tairona, 1200/1600. Shell. Museo del Oro del Banco de la República, Bogotá. Photo: Dirk Bakker. (Cat. no. 242)

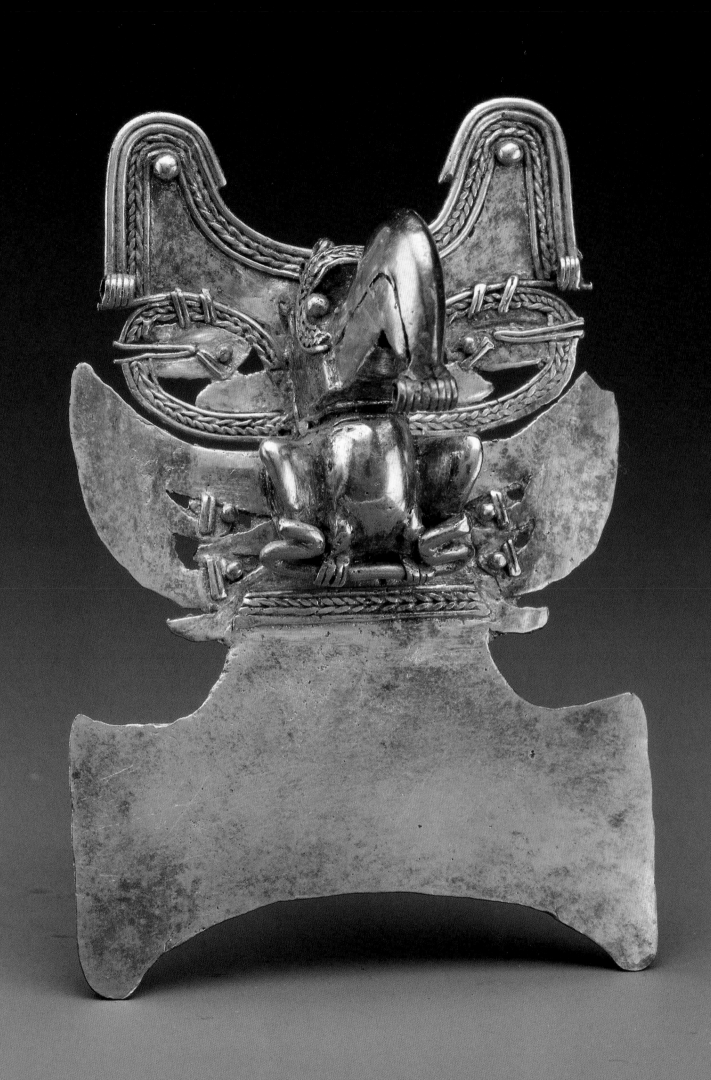

dants are represented graphically in the context of a larger scene, as on the chest of the main figure engraved on the bone, the bird head is, by necessity, reduced to two-dimensional form and shown in profile. A similar three- to two-dimensional shift can be seen in the main figure, which corresponds to the squatting human forms on the gold pendants.

The displayed figure on a gold pectoral (fig. 21) wears a pendant, which is a variation on the Bird-man type.[26] Examples of this more abstract variation omit the modeled head or, in a few cases, include a head at chest level below the wings.[27] On the pectoral, a horizontal bar, extending over the abdomen of the figure and ending in two serpent heads, is carried by two human figures running in the same direction. Although similar bars are represented on other pectorals of displayed figures, only in this case is it possible to suggest a function: the main figure seems to be carried in a litter, a conveyance reserved for important people or supernatural entities (see McEwan and Van de Guchte essay in this book, figs. 13, 14).

Conclusion

The above discussion of displayed figures focused on a male figure who probably represents the Sun, and on a female who is probably the Earth, with her attendants of the night or underworld, the bats. Poised on a seat, both figures are in a position of rest. The Kogi, like many other peoples, observe that the Sun at the solstices does not move but "sits on its seat," since, at those times, it will appear to rise and set for several days at the same places on the east and west horizons. The Sun then proceeds to travel from one solstice to the other, visiting various concubines. The Sun can be seen as the model of a ruler. While the bone pendant (fig. 1) and the gold pendants (figs. 18, 19) discussed might include a reference to the Sun, they appear to serve primarily as emblems of rulership, bringing men and groups of men together.

In this excursion into Tairona art, I have proposed tentative suggestions that point to the feasibility of arriving at a dynamic and integrated picture of relationships and correspondences between the order of the universe and the organization of society by examining a series of pectorals and pendants. Tairona and Kogi cultures together offer an indispensable link in any comparative study of the rise of civilization in pre-Hispanic Mesoamerica and the Central Andes.

Fig. 18 Winged pendant depicting frigate bird. Colombia, Tairona, 1200/1600. Gold. Museo del Oro del Banco de la República, Bogotá. Photo: Dirk Bakker.

Fig. 19 Pectoral depicting frigate bird with avian attendants. Colombia, Tairona, 1200/1600. Gold. Museo del Oro del Banco de la República, Bogotá. Photo: Jorge Mario Múnera. (Cat. no. 229)

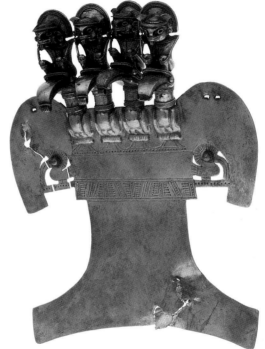

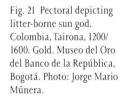

Fig. 20 Winged pendant depicting birds carrying squatting male figures. Colombia, Tairona, 1200/1600. Gold. Museo del Oro del Banco de la República, Bogotá. Photo: Jorge Mario Múnera.

Fig. 21 Pectoral depicting litter-borne sun god. Colombia, Tairona, 1200/1600. Gold. Museo del Oro del Banco de la República, Bogotá. Photo: Jorge Mario Múnera.

NOTES

Cosmovision of the Chiefdoms of the Isthmus of Panama
Mary W. Helms

1. Western industrial societies, in contrast, may be said to believe in the ubiquity of matter in which all things share and are united by, a basic physical or material base of atoms and molecules.
2. Helms, 1979.
3. It is also likely that the "beyond" of chiefly influence extended well beyond a single chiefly territory to include sacred locales in distant Colombia, the source of some of the gold worn by Panamanian elites and the site of places of pilgrimage.
4. Ingold, 1987, pp. 249–51.
5. A comparable technique was used in chiefly oratory. Chiefly orations were conducted in a "special language" believed to be incomprehensible to ordinary persons until an official chiefly translator "revealed" the content, the hidden or inner message, in ordinary speech. This practice continues today among the San Blas Cuna Indians, who also express the same sense of "exposing" the true interior by using the technique of reverse appliqué in the production of the decorative panels, called *molas*, used in women's blouses.
6. Helms, 1981.
7. D. Tedlock, 1985, p. 58.
8. Jonaitis, 1986, p. 99.
9. Helms, 1981, pp. 226–28.

Symbols, Ideology, and the Expression of Power in La Tolita, Ecuador
Francisco Valdez

1. Valdez, 1987, 1990.
2. See Chicago, 1975; Lathrap, Marcos, and Zeidler, 1977; Crespo and Holm, 1977, pp. 72–95.
3. See Cabello de Balboa, 1945, p. 15.
4. Uhle, 1927a, 1927b.
5. Williams, 1985.
6. W. Isbell, 1978.
7. Paradis, 1988, p. 91.
8. Pasztory, 1984, p. 20.
9. Chicago, 1975, pp. 56–59.

The Tairona of Ancient Colombia
Tom Zuidema

1. Bolinder, 1925; Oyuela Caycedo, 1986; Preuss, 1926–27; Reichel-Dolmatoff, 1975, 1976, 1977a, 1977b, 1977c, 1978, 1984, 1985, 1986, 1987a, 1987b, 1988, 1990.
2. Cadavid Camargo and Groot de Mahecha, 1987; see also Groot de Mahecha, 1985; Lleras, 1987.
3. Reichel-Dolmatoff reported some remarkable examples in his various publications, e.g., 1950, pp. 65, 67, 81–82, 87, 125, 140, 144–45; 1985, pp. 140–43.
4. Preuss, 1926–27; Reichel-Dolmatoff, 1975, pp. 206–207, 230–31; 1977b, p. 102.
5. Reichel-Dolmatoff, 1986, pp. 140–43; Cardoso, 1987, p. 117.
6. Reichel-Dolmatoff, 1975; 1977b, pp. 103–104.
7. Reichel-Dolmatoff, 1990, pl. 43.
8. See Bray, 1978; Plazas and Falchetti, 1979, pp. 38–41; Falchetti, 1987; and Reichel-Dolmatoff, 1988, for a discussion of the "International" style in goldwork for the Intermediate Area.
9. Fonseca Zamora, 1981, p. 104.
10. Reichel-Dolmatoff, 1986.
11. Fraser, 1966; Cordy-Collins, 1982.
12. Schuster, 1951, p. 5.
13. Klein, 1976.
14. Burger and Salazar Burger, 1982.
15. Lavalle, 1986, p. 132.
16. Reichel-Dolmatoff, 1988, p. 149.
17. Reichel-Dolmatoff, 1986, fig. 162.
18. Hartmann, 1975.
19. Graham, 1981, p. 127; Detroit, 1981, pp. 180, 190–91.
20. Reichel-Dolmatoff, 1988, fig. 245.
21. Legast, 1987.
22. Detroit, 1981, p. 191, fig. 79.
23. Saville, 1907, p. 147, fig. 17.
24. Reichel-Dolmatoff, 1988, p. 82.
25. Ibid., pp. 83–93, figs. 93–115.
26. Ibid., p. 152, fig. 241.
27. Ibid., pp. 110–16, figs. 170–86.

ANDEAN CIVILIZATION

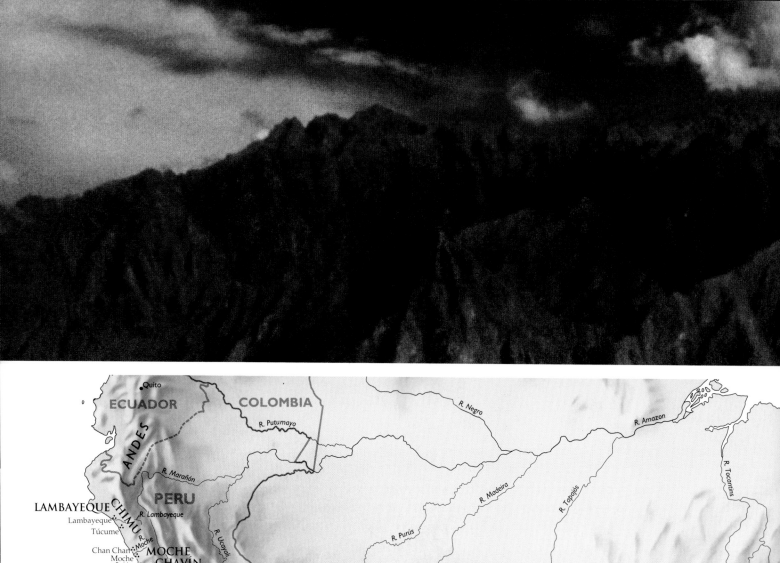

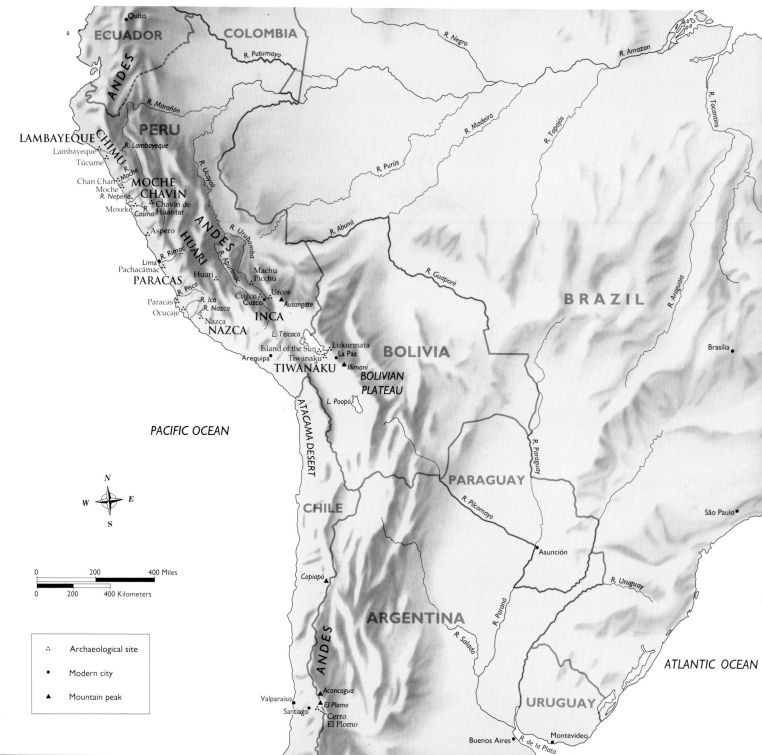

Quito

ECUADOR COLOMBIA

ANDES

R. Putumayo

R. Marañón

PERU

LAMBAYEQUE R. Negro

CHIMU R. Amazon

Lambayeque R. Lambayeque

Túcume

R. Moche

Chan Chan MOCHE

Moche CHAVÍN

R. Nepeña Chavín de

Moxeke R. Casma Huántar

R. Ucayali

R. Madeira

R. Tapajós

R. Purús

Aspero

R. Urubamba R. Abuná

ANDES R. Tocantins

HUARI

Lima R. Rímac R. Apurímac

Pachacámac Machu

Huari Picchu R. Guaporé BRAZIL

PARACAS Urcos

Cuzco R. Araguaia

Paracas R. Pisco Cuzco ▲ Ausangate

R. Ica INCA

Ocucaje R. Nazca

Nazca L. Titicaca

NAZCA Island of the Sun Lukurmata Brasília

Tiwanaku ▪ La Paz BOLIVIA

Arequipa TIWANAKU ▲ Illimani

BOLIVIAN

PLATEAU

L. Poopó

PACIFIC OCEAN R. Paraguay

ATACAMA DESERT

PARAGUAY São Paulo

CHILE R. Pilcomayo

Asunción

N

W E R. Uruguay

S

Copiapó ▲ R. Paraná

ARGENTINA

R. Salado

ANDES

| 0 | | 200 | | 400 Miles |
| 0 | 200 | | 400 Kilometers |

ATLANTIC OCEAN

Valparaíso ▲ Aconcagua

Santiago ● ∴ El Plomo

Cerro URUGUAY

El Plomo

Buenos Aires ● Montevideo

R. de la Plata

∴ Archaeological site

● Modern city

▲ Mountain peak

A forbidding coastal desert traversed by narrow rivers, snowcapped peaks and ranges above the highland basins, and the lush edges of the Amazon forest: these are the contrasting landscapes of the Andes of Peru and adjacent parts of Bolivia. The abundance of the sea and the harvest of domesticated crops from the tropical Amazonian lowlands provided the base for early complex societies in valleys to the east and west of the Andes. During the second millennium BC at Aspero, Moxeke, and other sites on the Pacific coast, ceremonial centers were being built with impressive stone and adobe platforms. Their U-shaped formations were often oriented to mountains and sources of water. The earliest forms of art recovered are carved gourds and textile fragments. The designs of this woven cloth include abstract figures of condors, crabs, men, and double-headed serpents. These were among the first examples of what was to become one of the world's most extraordinary textile traditions. Textiles became a principal vehicle for aesthetic and symbolic expression, and garments and accessories were especially prized as indicators of the wearer's social group, geographic location, and rank and office. Sacred stones were covered in precious textiles, and the deceased were similarly enveloped for their return to the womb of the earth. The ceramic arts and gold and copper metallurgy began to appear in developed form during the first millennium BC; both mediums soon became important vehicles for visual communication. At the temple of Chavín de Huántar, on the eastern slopes of the Andes, the first great sculptural style was synthesized, incorporating earlier motifs and themes from coastal and Amazonian cultures. From the beginning, these arts display metaphoric, conventionalized figures that affirm a vital connection between the poetic language of ritual and the functions of visual imagery.

The cultures that followed on the coast and in the highlands evolved highly ordered societies with dense populations, a high level of specialization, and marked social stratification. They were supported by agricultural

systems carefully adjusted to local conditions. Potatoes, manioc, and other root crops; maize, *quinoa*, and a variety of beans; and the herding of llamas and alpacas: all reflect the exploitation of contrasting ecological zones. Evidence of well-organized economies is seen in great irrigation works on the coast, the terracing of mountain slopes, and the construction of raised fields for intensive cultivation on the upland plateau and along the borders of the Amazon basin. Long-distance trade, the conquest of empires, and the establishment of colonies promoted the diffusion of ideas and art styles. Nevertheless, each culture invented its own distinctive formal language. The remarkably naturalistic sculptural ceramics of Moche, richly embroidered Paracas mantles, the Nazcas' polychrome vessels and the ritual lines they drew on the desert, the severe geometric abstraction of Huari and Tiwanaku textiles, the plan of Tiwanaku as a mythic island equipped with monumental sculptures, and the immense adobe compounds of Chan Chan: all were made centuries before the creation of the fifteenth-century Inca state. The Inca builders of Cuzco and Machu Picchu drew upon this economic, intellectual, and artistic heritage. Yet, throughout the millennia of cultural changes, the visual arts fulfilled a mission, to direct and maintain the human community in accord with the eternal sources of life perceived in the land, the sky, and the waters of this austerely beautiful region.

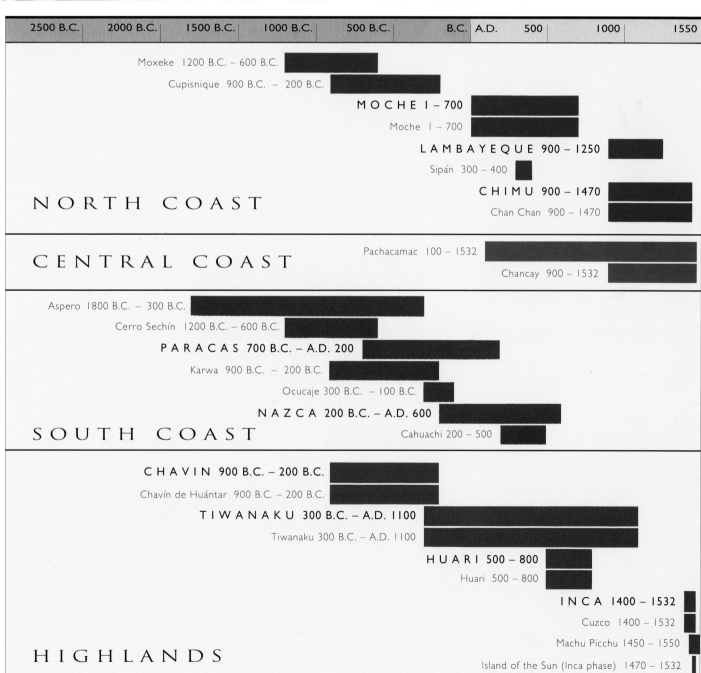

	2500 B.C.	2000 B.C.	1500 B.C.	1000 B.C.	500 B.C.	B.C.	A.D.	500	1000	1550

NORTH COAST

Moxeke 1200 B.C. – 600 B.C.

Cupisnique 900 B.C. – 200 B.C.

MOCHE 1 – 700

Moche 1 – 700

LAMBAYEQUE 900 – 1250

Sipán 300 – 400

CHIMU 900 – 1470

Chan Chan 900 – 1470

CENTRAL COAST

Pachacamac 100 – 1532

Chancay 900 – 1532

SOUTH COAST

Aspero 1800 B.C. – 300 B.C.

Cerro Sechín 1200 B.C. – 600 B.C.

PARACAS 700 B.C. – A.D. 200

Karwa 900 B.C. – 200 B.C.

Ocucaje 300 B.C. – 100 B.C.

NAZCA 200 B.C. – A.D. 600

Cahuachi 200 – 500

HIGHLANDS

CHAVIN 900 B.C. – 200 B.C.

Chavín de Huántar 900 B.C. – 200 B.C.

TIWANAKU 300 B.C. – A.D. 1100

Tiwanaku 300 B.C. – A.D. 1100

HUARI 500 – 800

Huari 500 – 800

INCA 1400 – 1532

Cuzco 1400 – 1532

Machu Picchu 1450 – 1550

Island of the Sun (Inca phase) 1470 – 1532

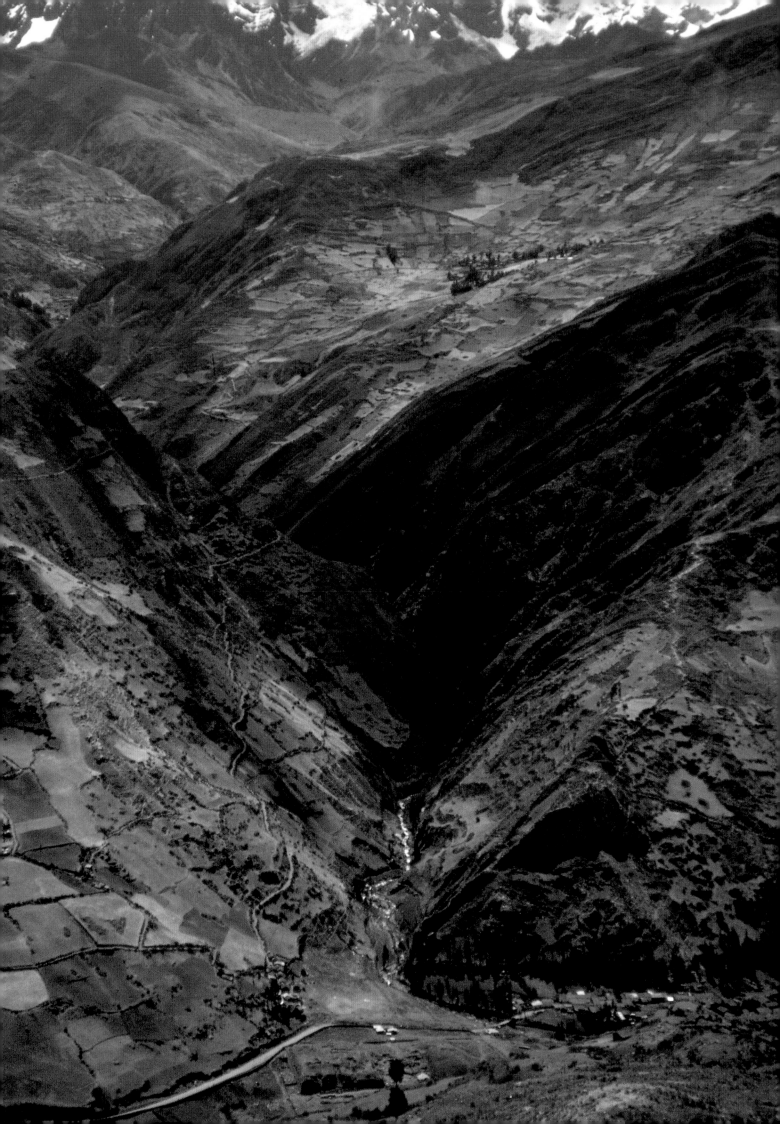

THE SACRED CENTER
OF CHAVÍN DE HUÁNTAR

Introduction

Over two thousand years before the Inca conquests that led to the empire of Tahuantinsuyu, highland peoples created a sacred center at Chavín de Huántar that rivaled Inca Cuzco in grandeur and beauty. According to Julio C. Tello, one of the founding fathers of Peruvian archaeology and the first to excavate Chavín de Huántar, in 1919, this center and the ancient culture that it expressed were responsible for the matrix of civilization from which the Inca and all other pre-Hispanic Andean civilizations grew.[1] Located over three thousand meters above sea level in what today is an impoverished and isolated portion of the northern Peruvian highlands, the ceremonial complex of Chavín de Huántar has been a focus of curiosity and interpretation since the time of the Spanish conquest in the sixteenth century.

The ruins at Chavín de Huántar (fig. 1) had already achieved legendary status by the time Spanish travelers arrived in the region. In 1553, Pedro de Cieza de León reported that, according to local residents, the center had been built, long before the reign of the Incas, by a race of giants whose portraits could still be seen in large stone sculptures. When the Archbishop of Lima, Santo Torribio Alfonso de Mongrovejo, visited Chavín in 1593, he described the ruins as the remnants of a fortress with underground passageways.[2] A very different interpretation of its function was offered in 1616 by Antonio Vázquez de Espinosa. He wrote:

> It was a huaca or sanctuary, one of the most famous of the gentiles, like Rome or Jerusalem among us; a place where the Indians came to make offerings and sacrifices, because the demon in this place declared many oracles to them, and so they attended from throughout the kingdom.[3]

This description is corroborated by other evidence that the early temple architecture of Chavín de Huántar continued to be utilized in Colonial times and that its religious authority was acknowledged over a large area. According to a 1619 account by a Jesuit mission to Cajatambo, a town one hundred kilometers to the south of Chavín, the principal Chavín construction was:

> ...a building that is very feared and greatly venerated and they call it the house of the huacas...and they [the *huacas*] spoke and answered the men [who were] their children, and [they spoke] to the heads of lineages that exist today among the Indians of this land.[4]

In the sixteenth century, the Quechua term *huaca* referred to an object or place in which sacred power was immanent. The *huacas* in this passage probably were *ídolos* (cult objects) that served as the focus for oracular predictions. Prehistoric mounds are still widely referred to as *huacas*, although the term has lost its religious connotations for most Peruvians.

In 1657, more than a century after the Spanish conquest of Peru, a representative from the Catholic church arrived in Chavín de Huántar to investigate persistent rumors of idolatry. He entered the temple and described its "very vast passageways and labyrinths made of very large and highly worked stones."[5] According to him, the site was a large temple dedicated to the god Huari. While exploring the ruin, he surprised

Fig. 1 The temple complex of Chavín de Huántar in Peru (below, center) was built at the confluence of rivers to address the waters and mountains of the Peruvian Andes. Peru, Chavín, 900/200 BC. Photo: Johan Reinhard/ ©National Geographic Society.

an old priest burning black maize kernels and masticated coca leaves while a spider walked along the edge of the heated brazier. The smoke from the scorched maize and coca was said to be an offering to Huari so that the spider would make divinations for the priest.

After this account, the temple of Chavín de Huántar disappeared into obscurity for two centuries, until interest in it was revived, first by nineteenth-century travel writers such as Mariano Eduardo de Ustariz, Antonio Raimondi, Charles Wiener, and Ernst Middendorf, and later by archaeologists, notably Julio C. Tello and Wendell Bennett. Tello viewed Chavín as one of the most important early centers of Andean civilization and a possible source from which advanced culture "irradiated" to the coast and other parts of the highlands.

Numerous investigations have been carried out at Chavín de Huántar since Tello's 1919 expedition, and the public core of the site has been extensively excavated.[6] Archaeological research has established that the monumental architecture and religious sculpture at the site were made roughly 900/200 BC.[7] A massive, flat-topped platform mound; several low, lateral platforms; a small, sunken, circular court; and a large, rectangular, semisubterranean plaza have been documented. The site is best known for its fine stone carvings, most of which originally decorated the exterior of the public constructions.

Despite research carried on in the highlands over the last two decades, no local antecedents have been found for Chavín de Huántar's distinctive constructions and carvings. On the contrary, many of the design features of the architecture were native to the coast, and the inspiration for the composite, mythic sculptures of powerful predatory animals appears to have been drawn from the forested eastern Andean slopes and tropical lowlands. The sculptural representations, like the site's architectural elements, are generally assumed to have served as metaphors for more abstract concepts underlying the cosmology of the Chavín temple.

The Invention of Tradition at Chavín de Huántar

Chavín de Huántar was founded by highland people who drew upon their knowledge of high-altitude farming, llama herding, and deer hunting to survive. This cultural legacy, alien to the people of the coast, was a prerequisite for maintaining a large sedentary population in the Mosna Valley and for producing a surplus that could be appropriated to support the specialist artisans and work crews responsible for building the center. At its zenith, some two to three thousand people lived in a settlement on the bottomlands surrounding the public architecture, and many more resided in small hamlets and villages dispersed at elevations around three thousand five hundred meters above sea level, adjacent to the prime potato fields and pastures. The subsistence economy included llama herding on the high grasslands, rainfall farming on the valley slopes, and irrigation agriculture on the narrow valley floor.[8]

The earliest pottery assemblage recovered at Chavín de Huántar reflects the local background of the population and also shows similarities to highland centers such as Kotosh in Huánuco. However, the tradition of ceremonial construction referred to as the Kotosh Religious Tradition was not followed at Chavín. This highland tradition, originating before 2000 BC, was characterized by ritual presentations of burnt offerings in small round or subrectangular rooms, each with a central, semisubterranean fire pit and, in many cases, multilevel floors. Barely larger than a house, these roofed structures had plastered walls of rough fieldstone or cobbles, and their interiors and exteriors were rarely decorated. After a relatively short period, the buildings were ritually buried and new chambers, often virtually identical to their predecessors, were erected.[9] In the Andes, as in Mesoamerica, this process of repetitive superposition of similar ceremonial constructions was probably linked to ideologies emphasizing cyclical rebirth and renewal.

While the people of the northern highlands erected small chambers with ceremonial hearths for their rituals, the coeval societies occupying the littoral and lower valleys of the arid coast developed distinctive regional traditions of public architecture, most of which featured massive, flat-topped platform mounds and large open spaces. The U-shaped, truncated pyramid of Chavín's Old Temple was modeled on the monumental public constructions of the central coast, and the Old Temple's sunken circular court took its basic architectural design from complexes on the north-central coast (see fig. 2).[10] In both cases, these features had been popular on the coast for at least a millennium before they were emulated by the people of Chavín.

The eclectic appropriation of alien architectural elements continued throughout the history of Chavín de Huántar. Sometime after 500 BC, decorated cylindrical columns

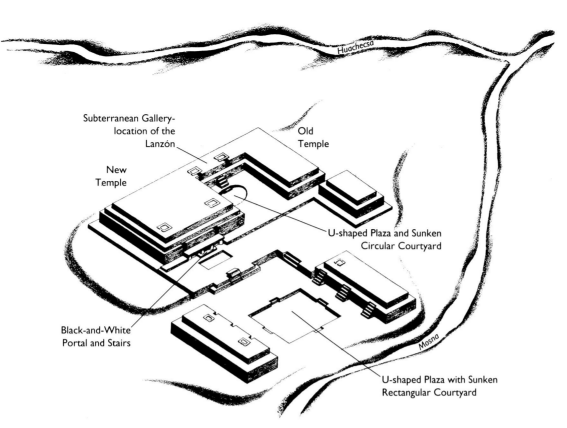

Fig. 2 Plan of the sacred center at Chavín de Huántar showing the sunken courtyards and the U-shaped system of platforms. Peru, Chavín, 900/200 BC. Drawing: Mapping Specialists Limited.

Subterranean Gallery-
location of the
Lanzón

Old
Temple

New
Temple

U-shaped Plaza and Sunken
Circular Courtyard

Black-and-White
Portal and Stairs

U-shaped Plaza with Sunken
Rectangular Courtyard

were added as a feature of Chavín's New Temple. The source of this "innovation" was most likely the building tradition of the north coast or the adjacent highland area of Pacopampa. By using basic elements of site architecture and organization from these alien sources, the builders of Chavín symbolically distanced themselves from their own history and linked themselves with the rich pasts of groups with whom their historical connections were quite limited.[11]

The pre-Chavín coastal groups adorned the exterior walls of public buildings with low relief and modeled clay sculpture, and, by 1200 BC, sites such as Cerro Sechín in the Casma drainage were embellished with stone carvings.[12] The artistic traditions that evolved over the centuries to decorate the ceremonial architecture along the coast were the primary inspiration for the stylistic conventions and features that appear in the earliest stone carving at Chavín de Huántar, as shown by sculptures like that called the Lanzón (see figs. 6, 7).

Having borrowed and synthesized from multiple sources, Chavín established an "invented tradition" that was unique and remarkably cosmopolitan. It was also maladapted to the highland environment. While flat-topped pyramids and sunken courts and plazas can last indefinitely in the climate of Peru's coastal desert, these features would begin to self-destruct when exposed to a

highland climate in which the annual rainy season lasts for seven months (October–April). Semisubterranean courts and plazas would become ponds, flat-topped platforms with solid cores would soak up water, and the clayey mortar holding this architecture together would provide little resistance to the resulting slumping. At Chavín de Huántar, it was only through the creation of technologically sophisticated and labor-expensive systems of drainage, ventilation, stone-facing, and other techniques that these coastal architectural elements could be employed.[13] Thus, Chavín's architectural design and layout are anything but a natural outgrowth of the history and environment of the site.

If ceremonial architecture was not only a stage for ritual but also a tool for focusing and directing supernatural power, as Donald Lathrap has suggested,[14] then the builders of the Chavín de Huántar complex might be thought of as having constructed a powerful ritual mechanism by drawing upon sacred knowledge acquired over millennia in many different regions. The ability to produce and maintain it, despite the environmental constraints, could only have added greater power and mystery to the enterprise.

The carved images that adorned the walls of the platform mounds and sides of the open-air courts were also foreign to the local landscape. Llamas, white-tailed deer, and guinea pigs were the main sources of meat

for the inhabitants of the Chavín de Huántar community,[15] but these creatures were never depicted in religious art. The high-altitude tubers (potatoes, *mashua*, *oca*), grains (*quinoa*, *achis*), and lupines (*tarwi*) that probably constituted the staple of the diet were also ignored, as was maize, whose cultivation was limited to the bottomlands around the temple.[16] Instead of depicting the local fauna and flora, the artists of Chavín sculpted unforgettable images of caymans, jaguars, and crested eagles, often combined into formidable hybrids.[17] These creatures are, respectively, dominant carnivores of the water, land, and sky in the tropical lowlands, and their principal habitats are found in the Amazonian rain forests far to the east.

The Tello Obelisk, a sculpted, prismatic granite shaft, served as a central cult icon rather than as an architectural adornment (see figs. 3, 4). Although it was discovered by Tello in the large, open, rectangular plaza of the most recent portion of the temple, this was probably not its original setting. It is one of the few sculptures to feature plants as well as animals. On the basic level, its subject matter appears to be a creation myth in which a pair of flying caymans are shown as the donors of a series of domesticated low-land plants, including manioc, none of which could be cultivated in the highland environment of Chavín de Huántar.[18]

Considered in isolation, the exotic focus of the religious art is puzzling, but, placed in the context of the equally alien architectural elements, it can be appreciated as part of the larger pattern of cultural construction in which the sacred knowledge of the Amazonian lowlands, as well as that of the Pacific

Fig. 3 Rollout drawing of the Tello Obelisk (see fig. 4). Drawing: Rowe, 1978, p. 99.

Fig. 4 Tello Obelisk at Chavín de Huántar. Peru, Chavín, 900/200 BC. Stone. Museo Nacional de Antropología y Arqueología, Lima. Photo: Dirk Bakker. Enveloping a prismatic stone, the design features motifs of caymans, plants, birds, seashells, and human figures.

Fig. 5 Vessel depicting *Spondylus* shell. Peru, Chavín, Cupisnique, 900/200 BC. Ceramic. Museo Nacional de Antropología y Arqueología, Lima. Photo: Dirk Bakker. (Cat. no. 44)

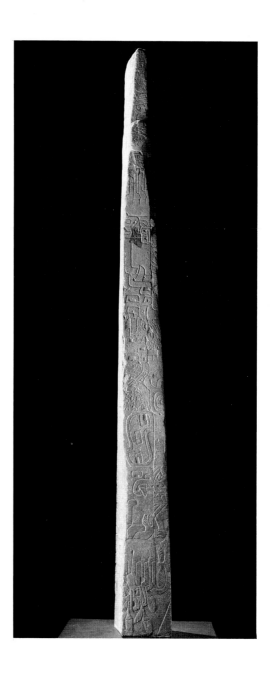

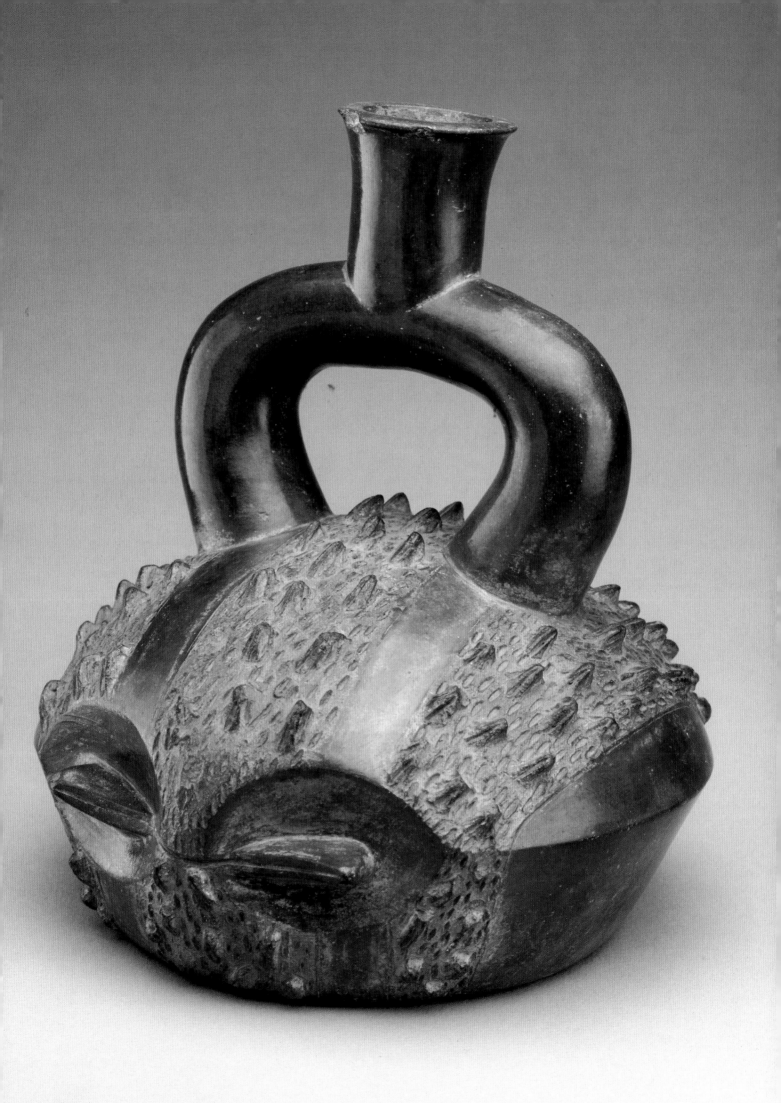

Fig. 6 Drawing of the Lanzón at Chavín de Huántar (see fig. 7). Drawing: Richard Burger and Luis Caballero. Deep within the labyrinth at the Temple at Chavín, the Lanzón rises as an *axis mundi* joining cosmological levels.

Fig. 7 The Lanzón at Chavín de Huántar. Peru, Chavín, 900/200 BC. Stone.

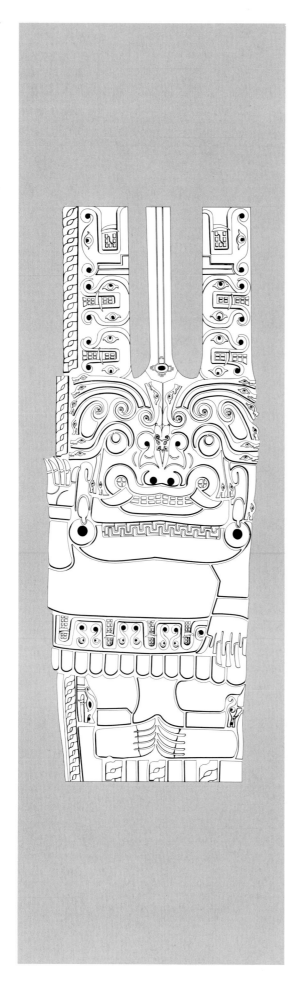

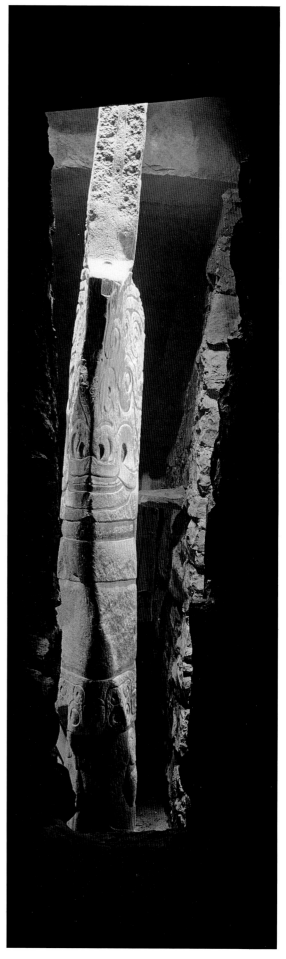

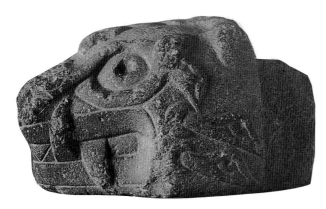

coast, was incorporated into the new tradition. As in the architecture, the religious sculpture did not draw exclusively from one region (i.e., the tropical lowlands): there are also occasional depictions of marine creatures, notably *Spondylus* (bivalve mollusks) (see fig. 5) and *Strombus* shells (conchs), whose habitats are in the warmer waters off the Ecuadorian coast.

The desire to transcend the limits of everyday reality and experience is evident also in the materials of the ceremonial complex. Much of the stone used for the sculpture and the pyramid exterior was not quarried from the local sandstone-slate bedrock, but was dragged from distant deposits of white granite and black limestone. The alien stone blocks were then transformed by cutting, pecking, abrading, and polishing until they took on a shape and luster far removed from their original appearance.

The tenon heads (see fig. 8) that punctuated the upper wall of the main pyramid also illustrate the lengths to which the builders went to create a milieu outside of mundane experience. Through the use of stone shafts set into wall sockets, it was possible to suspend massive carvings of fanged jaguar heads three stories above the ground without any visible support. These and other larger-than-life stone carvings portrayed felines and crested eagles, as well as priests or mythic personages in the process of transformation into these predatory creatures. At Chavín de Huántar, as in other seats of religious power in the ancient Americas, a central event in ritual activity was the ingestion of psychotropic substances. These hallucinogenic agents had the transformational effects sought by priests and other religious functionaries in their quest to communicate with the great unseen powers permeating the natural world.

Religious Ideology and Ritual

Underlying the art and architecture of the ceremonial center was a coherent view of humankind's relationship to the different domains of the natural world and the cosmos. We can begin to understand this by considering the Lanzón (see figs. 6, 7), a 4.53-meter-long granite shaft carved in the image of a fanged anthropomorphic deity. Its location in a subterranean chamber at the center of the temple, along with its size, workmanship, and iconography, indicate that this was the principal cult image of the original temple. The Lanzón faces east along the axis of the site. Its right arm is raised, with the open palm of the hand exposed, and its left arm is lowered, with the back of the hand visible. This pose expresses eloquently the role of the deity as a mediator of opposites, a personification of the principle of balance and order. The association of the deity with the concept of centrality, underlined by its placement in the middle of a cruciform gallery complex, is iconographically reinforced by four parallel ropes rising along the sides of the sculpture. The Lanzón, which penetrates both the roof and the floor of the chamber, can be seen as an axis or conduit connecting the heavens, earth, and underworld. A channel leads down from the top of the sculpture into a cruciform design with a central depression (see fig. 6). This symbol can be interpreted as a cosmogram, representing the world with the four cardinal directions and indicating the sacred center by the depression.[19] A version of this cosmogram appears on most major Chavín sculptures, and its configuration is mirrored by the layout of the Old Temple's circular court, which reiterates the role of the ceremonial center as the place of mediation with the heavens and the underworld.

The religious functionaries at Chavín de Huántar served as intermediaries through their presumed transformation into supernatural jaguars and crested eagles. Many sculptures, particularly the tenon heads, are

Fig. 8 Tenon head. Peru, Chavín de Huántar. 900/200 BC. Stone. Museo Arqueológico Rafael Larco Herrera, Lima. Photo: Colin McEwan. Inserted in the high temple walls, such jaguarlike heads represented themes of cults of the natural elements. (Cat. no. 39).

Fig. 9 Mortar. Peru, Chavín, 900/200 BC. Stone. The University Museum of Archaeology and Anthropology, University of Pennsylvania, Philadelphia.

regarded as representations of the process of shamanic transformation. Some Chavín sculptures clearly suggest that hallucinogens were employed to facilitate this process. The sculpted tenon heads frequently show strands of mucus hanging from their nostrils, an indication that hallucinogenic snuff had been ingested. Moreover, some of the finest pieces of portable art in the Chavín style— for example, a mortar at the University of Pennsylvania (fig. 9) —were probably used to grind psychotropic substances.[20] Too small to have been used for grinding food staples such as maize or potatoes, these mortars were carved in the form of jaguars and crested eagles. Analogous mortars were reported by Cristóbal de Albórnoz to have been used by native priests in Colonial times for preparing *vilca*, a psychotropic plant substance.[21] Elaborately decorated tubes and small spoons for the ingestion of snuff have also been discovered. The ingestion of psychoactive substances was probably only one aspect of the ceremonial activities at the temple.

The rituals at the temple also involved elaborate costumes, music played on special instruments, and public banquets. Evidence of the paraphernalia used in the rites exists in the sculptural representations and in the artifacts recovered from the temple. The carved ashlars used to decorate the walls of the Old Temple's circular court are an especially rich source of information (see fig. 11).[22] They show two matching lines of priestly figures advancing in procession toward the staircase leading to the summit.

Fig. 10 Offering vessel. Peru, Chavín, 900/200 BC. Steatite. The Brooklyn Museum. This figure, crouched in a childbirth position and with an upturned mask, almost certainly represents a concept of the earth as a female entity. (Cat. no. 31)

Fig. 11 View of the sunken circular courtyard at Chavín de Huántar, encircled by sculptural reliefs showing a procession of felines and ritually costumed priestly figures. Peru, Chavín, 900/200 BC. Photo: Julio C. Tello.

One sculpture depicts a figure blowing a *Strombus*-shell trumpet and wearing a crownlike headdress with a jaguar tail hanging from it. Fragments of *Strombus* from Ecuador have been found in the interior galleries nearby, and *Strombus* trumpets have appeared at coeval sites on the coast and in the highlands. The famous Pickman *Strombus* trumpet from Chiclayo was engraved with decoration depicting a trumpet-blowing scene in which serpents emerge from the trumpet,[23] suggesting the power of this instrument for communicating with the supernatural. In another carving from the circular court, a fanged individual grasps a ribbed staff or club, which closely resembles a stalk of San Pedro (*Trichocereus pachanoi*), a columnar cactus whose flower blooms in the night. Its stalk contains a high content of mescaline, an active alkaloid that produces hallucinations.[24] Stalks of San Pedro appear also on coeval pottery from the north coast, sometimes in association with jaguars (see fig. 12).

Although the public spaces of the temple were kept clean, evidence of ceremonial feasting comes from the hundreds of decorated ceramic vessels for serving food and drink that were discovered in the subterranean chambers (known as the Gallery of the Offerings) adjacent to the circular court. Exotic foods such as mussels and coastal fish, as well as guinea pig and llama, were found alongside the pottery. Numerous cut and burnt fragments of human bone were mixed in with the food remains; cannibalistic rites have been proposed to account for their presence.[25] Many of the roughly five hundred ceramics found in the gallery had been produced in workshops located hundreds of kilometers from Chavín de Huántar.

A basic organizing principle of indigenous Andean thought is that the cosmos comprises

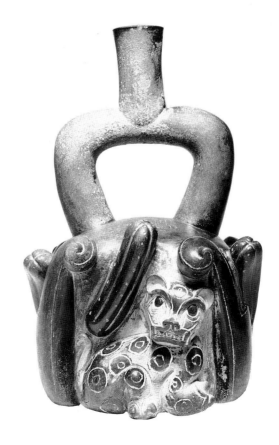

Fig. 12 Vessel depicting jaguar, possibly representing a shaman, surrounded by hallucinogenic San Pedro cactus. Peru, Chavín, Cupisnique, 900/200 BC. Ceramic. Munson-Williams-Proctor Institute, Museum of Art, Utica. (Cat. no. 42)

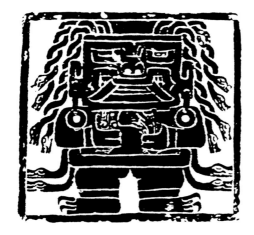

Fig. 13 Drawing of sculptural relief from the New Temple at Chavín de Huántar showing the principal deity with *Strombus* and *Spondylus* shells. Peru, Chavín, 900/200 BC. Drawing: Rowe, 1978, p. 103.

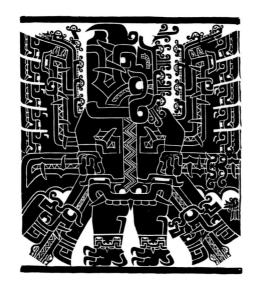

Fig. 14 Drawing of sculptural relief at Chavín de Huántar depicting performer with crested eagle mask. Peru, Chavín, 900/200 BC. Drawing: Rowe, 1978, p. 100.

Fig. 15 Relief fragment. Peru, Chavín de Huántar. 900/200 BC. Stone. Museo Nacional de Antropología y Arqueología, Lima. Photo: Colin McEwan. Comparison of this fragment with the costume of the performer in fig. 14 reveals that the fragment represents a portion of a ritual costume — the end of a sash on which a mask is sewn. (Cat. no. 37)

an infinite series of dual but complementary oppositions. The architecture and art of the Chavín de Huántar temple demonstrate the longevity of this concept. In the New Temple, for example, the monumental stairway leading from the rectangular plaza was built of two types of cut stone blocks: white granite on the southern half of the stairs, black limestone on the northern half. This use of white and black stone was repeated on the columns that flanked the monumental staircase, on the stairs directly in front of the New Temple pyramid-platform, on the massive slabs used to face the base of the New Temple, and in the large sculpture that apparently served as the lintel spanning the symbolic portal of the New Temple.

The principle of dual organization is equally evident in the iconographic program of this area. In the rectangular court at the foot of the temple, there was a small representation of the principal deity of the site (see fig. 13). Although dressed similarly to the Lanzón image, this deity holds shells from the Pacific — in the right hand, the *Strombus*, a male symbol, and, in the left hand, a *Spondylus* shell, a female symbol. Moreover, each of the paired cylindrical columns of the New Temple portal was carved with the image of a supernatural predatory bird: on one, a crested eagle with a metaphorical representation of female genitals (see fig. 14); on the other, a hawk with metaphorical male genitals.[26] If we are guided by what is known of later pre-Hispanic Andean societies, it is likely that Chavín society was split into dual divisions or moieties, and that these sculptural representations of dual cosmological principles may have served, among other things, to express this social order. Even the U-shaped layout that forms the organizational basis of the Chavín site may have its cosmological basis in this principle. William Isbell has argued that the two arms of the U represent dual opposing but complementary forces, and that the apex of the U in which the Lanzón is located represents the mediation of these forces.[27]

Cosmology and Landscape

The Chavín de Huántar temple was built at the convergence of the Mosna River and one of its tributaries, the Huachecsa. Two of the trails that cross the glaciated Cordillera Blanca also join at this location. Among modern Quechua speakers, the point at which two rivers or trails merge is referred to by the term *tinkuy*. For the Inca, such places were viewed as propitious sites for religious

activity. For example, in Cuzco, sometime after the full moon of the month of Camay (January), the Inca would bring out the bones, ashes, and charcoal that had been kept from the llama and alpaca sacrifices of the entire year, grind them up with coca leaves, flowers of many colors, chili peppers, salt, and roasted peanuts, and then throw them into the confluence of the Huatenay and Tullumayo Rivers, along with cloth, feathers, gold, and silver.[28] In its broadest sense, *tinkuy* refers to the harmonious meeting of opposing forces.[29] The location of the Chavín temple at the joining of the Mosna and Huachecsa can be interpreted as embodying the *tinkuy* concept and linking the local landscape to the underlying dualistic cosmology expressed in the art and architecture of Chavín.

Several scholars, including John H. Rowe, have suggested that the principal deity of Chavín de Huántar was a nature god, perhaps associated with thunder or other celestial phenomena.[30] In later times, deities with meteorological connotations were associated with high mountain peaks. This symbolic relationship of celestial phenomena and mountains may help to explain why the people of Chavín created, as the stage for their ceremonies, a four-story artificial mountain with fine stone buildings for summit rites. Moreover, when standing in the plazas and courts of Chavín, facing the flat-topped pyramid, worshipers on a clear day would have seen the massive mountains and snow-capped peaks of the Cordillera Blanca rising above the constructions. Johan Reinhard has suggested that some of the ceremonies may have been directed toward the powerful meteorological forces associated with these distant mountains, particularly Huantsán, whose summit ascends to about six thousand four hundred meters above sea level.[31]

Pre-Hispanic Andean conceptions of meteorology are poorly understood, but it appears that water was envisioned as circulating underground into the mountains from its source in the vast ocean upon which the earth floats. The subterranean water was then transferred from the mountains to the sky by the Milky Way (called in Quechua *mayu* [river]) to be returned to the fields as precipitation and then to begin the long journey through the visible world back to the ocean. At least some, and perhaps all, of this model existed during the Inca empire.[32] By offering ocean shells, a practice sometimes described as "feeding the gods," the supernatural forces immanent in the landscape were drawn into a reciprocal relationship with human society, and the uninterrupted flow of water was ensured. Had an earlier version of this cosmological model been developed by Chavín times?

It is impossible to answer this question at present, but the elaborate hydraulic system of Chavín de Huántar may have had a religious significance above and beyond the practical need for draining the temple area. By receiving waters from the melting mountain peaks

Fig. 16 Vessel with seed motif. Peru, Chavín, Cupisnique, 900/200 BC. Ceramic. Museo Nacional de Antropología y Arqueología, Lima. Photo: Dirk Bakker. (Cat. no. 43)

Fig. 17 Textile fragment depicting masked figures holding staffs. Peru, Chavín, Karwa, 900/200 BC. Painted cotton. Museo Amano, Lima. (Cat. no. 35)

Fig. 18 Textile fragment with splayed cayman imagery, multiple masks, and serpent motifs. Peru, Chavín, Ica Valley, Callango. 900/200 BC. Painted cotton. Dumbarton Oaks Research Library and Collections, Washington, D.C. Closely related in format and imagery to the Tello Obelisk (see figs. 3, 4), such painted cloths may well reflect the antiquity of an Andean custom of wrapping sacred rocks with precious textiles. (Cat. no. 32)

Fig. 19 Textile fragment depicting earth goddess. Peru, Chavín, Ica Valley, Callango. 900/200 BC. Painted cotton. Dumbarton Oaks Research Library and Collections, Washington, D.C. The mask may personify the earth with plant forms, serpents, and dragonlike creatures. (Cat. no. 33)

and associated rains and then channeling them into the Mosna through the stone-lined canals in the body of the religious architecture, the designers of the temple succeeded in bonding the ceremonial architecture to the meteorological system that the Chavín religious leaders sought to influence through ritual intervention. An innovative experiment by Peruvian archaeologist Luis Lumbreras suggests that, during the rainy season, the roar of the canalized water would have been heard throughout the temple area as its sounds echoed in the subterranean gallery chambers.[33] Thus, the Chavín canal system linked the temple physically and symbolically to the mountainous terrain surrounding it.

The hydraulic system also provided water to irrigate the bottomlands surrounding the temple. On these select lands, maize could be grown for *chicha*, a fermented, beerlike beverage. In later pre-Hispanic times, *chicha* was essential for religious rituals and all other public activity. It is likely that *chicha*-drinking was already a part of Chavín ceremonial life, in light of the depiction of maize ears on a ceramic bottle found in the Gallery of the Offerings.

The intimate connection between the temple complex and the surrounding landscape is implied also by the discovery of Chavín carvings in small, high-altitude village sites near Chavín de Huántar. These carvings, which depict the supernatural figures found on the temple, presumably once decorated small shrines devoted to the cult based at Chavín.[34] Just as the local Chavín economy was founded on the integration of subsistence staples produced from the valley floor upward to the puna grassland, so, too, the cycle of religious worship seems to have drawn together the isolated ridge tops, the steep valley slopes, and the narrow valley bottom into a coherent system of sacred geography.

This configuration was likely to have been further linked to the celestial realm through the orientation of the public architecture. Transit measurements taken by Gary Urton, an expert on Andean archaeoastronomy, indicate that the temple buildings have an orientation of 103°31', more than 13° clockwise of due east.[35] Urton observed that the western axis of the complex is remarkably near the setting of the Pleiades around the time of the construction of the Old Temple, if one postulates the use of a hypothetical flat horizon, or, if the actual horizon was utilized, a possible correlation exists with the setting of the nadir, or antizenith, sun.

Through the various means outlined here, the temple of Chavín de Huántar presented itself as a cosmic center in which opposites were mediated and balance was maintained through appropriate religious ceremonies and the esoteric knowledge of its religious leaders. Its setting in the landscape and its architectural organization expressed these cosmological principles and gave to them a sense of unchanging truths, all the more necessary when one considers the relatively shallow time depth of this ceremonial center. The acceptance of the temple's role, first by local groups and later by more distant highland and coastal communities, had a profound impact on Peruvian prehistory. By about 400 BC, the symbol system of the Chavín temple spread over a vast area and was used, with some local variation, to decorate pottery, religious paraphernalia, jewelry, and other items among groups that previously had shared few, if any, cultural features (see figs. 5, 16; see also introduction to chapter five). This pattern has been widely interpreted as the result of the spread of the Chavín cult, perhaps by means of local oracles authorized by the Chavín temple itself. The finely painted cotton textiles found in Karwa on the Paracas Peninsula of Peru's south coast comprise some of the most compelling evidence for the presence of the Chavín cult in distant regions (see figs. 17, 18, 19).

In conclusion, we must point out another meaning of *tinkuy*, as the friendly resolution of conflicts between two groups.[36] From the outset, the Chavín de Huántar temple served as a place where different local social units came together in peace. Its favorable crossroads location made it a natural center of long-distance exchange, and this role was augmented as the temple achieved panregional recognition. At its zenith, Chavín's

claims as a cosmic center resonated with its more mundane functions as one of the most important centers of long-distance exchange and interregional cultural contact in the Central Andes. In this respect, we must acknowledge the dynamic, culturally integrating functions of Chavín art, architecture, and ritual in the evolution of Andean civilization.

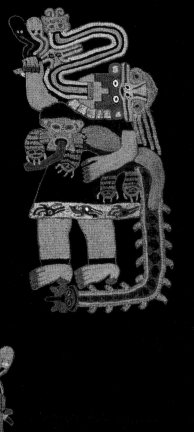
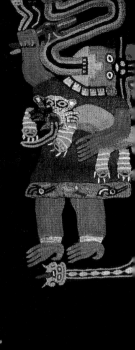
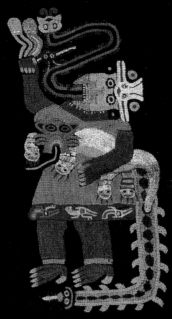
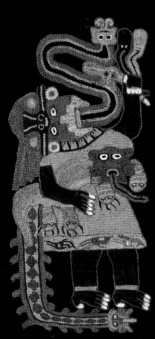
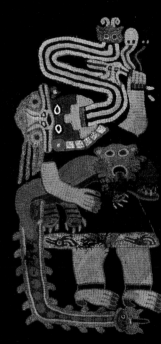
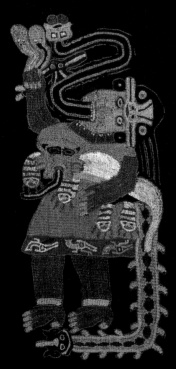
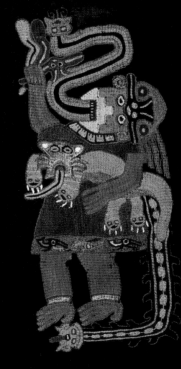

PARACAS NECROPOLIS TEXTILES: SYMBOLIC VISIONS OF COASTAL PERU

The word "Paracas" evokes images of handsome post-fire painted pottery decorated in deep, earthy tones (see fig. 2); exquisitely crafted monochrome pottery modeled into the shapes of flora and fauna; and stunning textiles employing masterfully dyed threads and yarns (see figs. 1, 4). These are the principal artistic legacies of a culture that flourished on the south coast of Peru for nine hundred years, from approximately 700 BC to AD 200.[1] This cultural tradition had a wide geographical spread: archaeological remains have been found in six valleys (Cañete, Topará, Chincha, Pisco, Ica, and the Río Grande de Nazca drainage), as well as in the coastal littorals between those valleys and the starkly beautiful desert peninsula from which the Paracas culture takes its name. The neck of this arid protrusion into the Pacific Ocean was the site, in 1925, of one of the most spectacular discoveries in the history of Peruvian archaeology.[2] There, hidden from humankind until this century, hundreds of funerary bundles containing members of Paracas society lay buried in dry, sandy graves. The ritual garments preserved in the most elaborate of these bundles are the subject of this essay.

Of the four hundred twenty-nine bundles excavated by the Peruvian archaeologist Julio C. Tello from the cemetery called the Necrópolis of Wari Kayan, on the north face of Cerro Colorado, seventy-five were medium or large in size. These held leaders of the Paracas polity, whose special status in both life and death was marked by cloth. While living, these persons dressed for ritual occasions in embroidered garments, and at death they were wrapped with quantities of cloth—layer upon layer of the garments worn in life, as well as large cotton sheets. The woven garments, with their rows of repetitive images, were a fundamental form of visual communication within the society. Although the people who made and wore them had no notion of writing, they utilized a complex visual-symbol system in which the embroidered

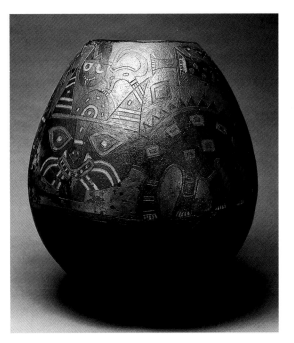

Fig. 1 Mantle. Peru, Paracas, 1/200. Camelid wool. The Art Institute of Chicago. Paracas weavers employed some 190 hues of dyed or natural fiber. Mantles display figures with identical contours, but with several distinct color sequences. The variations of color pattern and changing directions of figures have been likened to the movements of a musical composition. (Cat. no. 214)

Fig. 2 Vessel depicting feline. Peru, Paracas, Ica Valley, 300/100 BC. Ceramic. The Field Museum of Natural History, Chicago. Simple, gourdlike shapes and unbroken surfaces were covered with abstract figures strongly influenced by textile imagery. (Cat. no. 216)

images functioned as ideograms, a ritual language relaying information about the Paracas world view and the religious obligations of their leaders.

Paracas Necrópolis textiles display three styles of formal construction of images.[3] The linear style of depiction is formally, iconographically, and conceptually abstract; it may have been the vehicle for communicating abstract information. For example, supernatural images that were probably totemic signs

or symbols of mythical ancestors would have established a relationship among the persons affiliated with them.[4] Tiny, linear-style anthropomorphs and birds are present in the composite warp-patterned-weave neck border of an early Paracas tunic allegedly from Ocucaje (fig. 3).

The broad-line style is related to the linear style in that the formal and iconographic characteristics of broad-line depictions reveal a desire to represent ideographs rather than

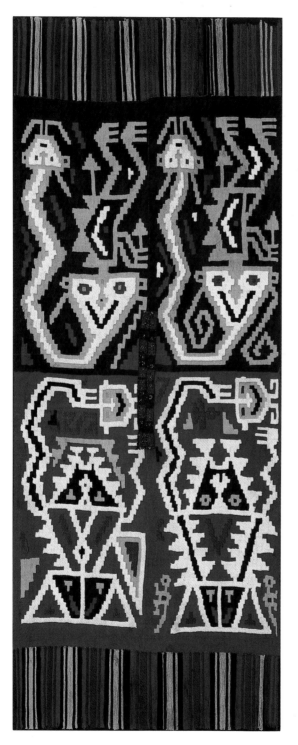

Fig. 3 Mantle fragment. Peru, Paracas, Ocucaje, 300/100 BC. Camelid wool. Linde Collection, Phoenix. (Cat. no. 215)

actual objects. The interlocked plain-weave ground cloth of the Ocucaje tunic illustrated here has broad-line anthropomorphic figures and birds woven into its structure. Like other images executed in this style, the anthropomorphs are shown without recognizable costumes, and the birds do not refer to any specific avian creature. Unlike Paracas Necrópolis broad-line images, however, the figures' faces and the thin lines that run down the center of their mouth appendages are of a different color than the background, so that figure and ground are more distinct than their stylistic counterparts among the embroidered garments. Paracas-style Ocucaje textiles, then, share some features with Paracas Necrópolis textiles, but are sufficiently different to be classed apart.

The block-color style of formal construction was used to describe parts of the physically real world—the fauna and flora of the Paracas Peninsula, the nearby river valleys, and the ocean, as well as the ritual dress of the human inhabitants. The personages illustrated in fig. 4, for example, wear some of the types of garments and adornments actually present in burial bundles, including necklaces, ear-danglers, and tunics. Embroiderers working in this style focused on the description of tangible elements, such as the diagnostic features of a specific animal, the regalia of rulers and officials, or the pose of a ritual performer like those repeated in fig. 4.[5] The block-color style was appropriate for the depiction of specific cult images and was suited to the presentation of information about the rank, roles, and occupations of an individual in Paracas society. Since the identification of some of those cult figures and officials is a principal objective of this essay, the following discussion will be concerned with block-color-style images only.

Images of Animals and Plants

There are 112 garments from scientifically excavated and opened Paracas Necrópolis bundles with block-color-style depictions of animals. Of these, sixty-one percent are birds, fourteen percent are felines, and ten percent are snakelike creatures; smaller percentages are fish, camelids, rodents, monkeys, and lizards. There are also twelve zoomorphic conflations, each of which combines feline traits with features of another animal. A review of the first four groups, and of the plants depicted, will give a partial picture of the Paracas region ecosystem.

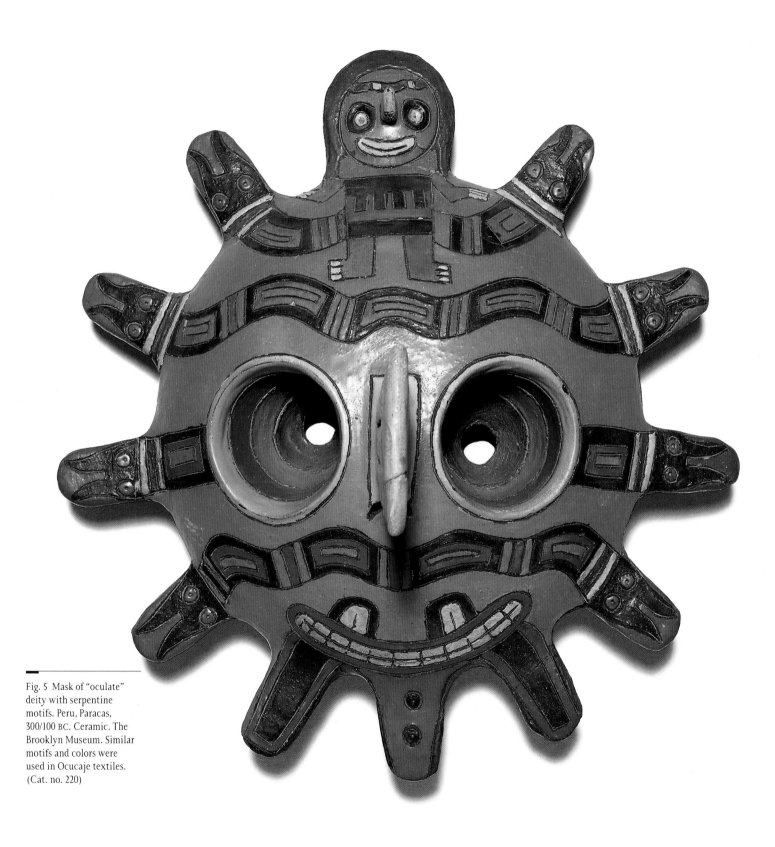

Fig. 5 Mask of "oculate"
deity with serpentine
motifs. Peru, Paracas,
300/100 BC. Ceramic. The
Brooklyn Museum. Similar
motifs and colors were
used in Ocucaje textiles.
(Cat. no. 220)

Birds

The prominence of birds in the Paracas land-scape—dozens of different species darken the skies, dive into the ocean for fish, nest on the rocky coastline and offshore islands, and run along the beaches—is reflected in Paracas textile iconography. Birds are the most frequently represented animal, and the greatest number of species shown are birds. Since the plumage patterns and coloration essential for the identification of birds are not always conveyed in the small-scale stitches of the embroidered images, the birds are sometimes not identifiable. Seventy-five percent of the avian representations can be associated with actual birds, however.

Black-crowned night herons (*Nycticorax nycticorax*) are birds of the coastal beaches that hunt fish, frogs, small mammals, and young birds at dusk or at night. The bird depicted in fig. 6a, with prominent plumes on the top of its head and an animal in its beak, may represent this heron.[6] The guanay cormorant (*Phalacrocorax bougainvillii*; see fig. 6b) is a short-legged, long-necked fisher that nests on the offshore guano islands and on mainland promontories. It is the most important producer of guano, sea-bird dung, which was mined on these islands and used for fertilizer. Inca terns (*Larosterna inca*; see fig. 6c) feed on fish captured by diving from the air into the ocean. This species has several long plumes forming a structure that curves out from the face. Shore birds (see fig. 6d) can usually be recognized by their long beaks.

The male condor (*Vultur gryphus*), with a wingspan that can reach nearly two meters, is an awesome spectacle. Although it nests in the Andes, the condor regularly visits the coastal hills and beaches of Paracas, sweeping over the peninsula to scavenge for dead animals. Salient characteristics of the bird are the fleshy caruncle and the ruff of feathers at the base of the neck (see fig. 6e). The female condor, recognizable by a curved beak, is also occasionally represented (see fig. 6f).

Like the condor, the falcon is an impressive creature, known for its remarkable ability to seize other birds in mid-flight. On the textiles, this raptor is shown with eye bands and zigzag-patterned tail feathers, and often with almond-shaped areas of feathers on either side of the chest (see fig. 6g). Different species of this bird may be combined in one depiction, as in fig. 6h, where the "spot" on top of the head suggests a kestrel (*Falco sparverius*), while the breast markings and

Figs. 6a-q Drawings of images embroidered on Paracas Necrópolis fabrics in the Museo Nacional de Antropología y Arqueología, Lima. Drawings: Anne Paul.

Fig. 6a Black-crowned night heron. Poncho, specimen 262–36, c. 50/100.

Fig. 6b Guanay cormorant. Turban, specimen 378–59b, c. 50/100.

Fig. 6c Inca tern. Unidentified garment type, specimen 310–54a, c. 50/100.

Fig. 6d Shore bird. Loincloth, specimen 89–20, c. 100.

Fig. 6e Male condor. Mantle, specimen 310–42, c. 50/100.

Fig. 6f Female condor, Poncho, specimen 89–26, c. 100.

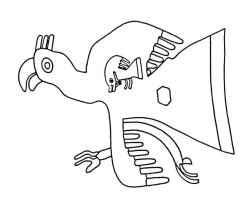

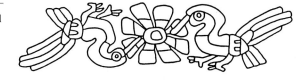

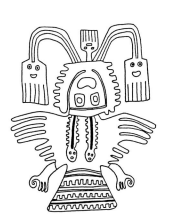

the wing- and tail-feather patterning indicate the aplomado falcon (*Falco femoralis*).

A long-necked bird with crest (see fig. 6i) may be a curassow, a bird native to the tropical forests of South America. Hummingbirds (see fig. 6j) are represented occasionally, always in association with flowers. The bird illustrated in fig. 6k may be a nighthawk, a bird that has a laterally banded tail and belly, and wide white bands on the wings.[7] Although parrots are indigenous to the tropical forests of the eastern slopes of the Andes, they may have been domesticated on the coast. They are depicted on a few Paracas Necrópolis garments; the one illustrated here (fig. 6l) has the large eye-ring typical of the mealy parrot (*Amazona farinosa*). The crest, collar, and finch bill of the bird illustrated in fig. 6m indicate that it is a passerine, a song bird.

Felines

Identifiable felines in Paracas iconography represent the pampas cat (*Felis colocolo*; see fig. 6n). The tail and limbs of the pampas cat are banded, the torso is spotted, the ears are pointed, and the hairs along the mid-dorsal line, slightly longer than the rest of the fur, produce a distinct crest. Although the whiskers are not long, the facial fur has marks that look like extensions of the whiskers and create the illusion of considerable length. The pampas cat, which inhabited the irrigated fields where crops grew, is shown in association with vegetation. It feeds on insects, rodents, and birds attracted to the seeds and growth of crops, and on snakes.

Snakelike Creatures

A number of snakelike zoomorphs are depicted; usually bicephalic, they have a variety of body markings (see fig. 6o). It is difficult to say to what extent they are based on natural models.

Fish

Although the fish images on Paracas textiles are represented in a variety of ways, they usually record the same animal, shown with a predictable set of anatomical features. Most of the depictions resemble sharks (see fig. 6p). The shark has two dorsal fins; in addition, it has a pair of pectoral fins, pelvic fins, and an anal fin. Sharks have five to seven gill openings on each side of the body. The eyes are usually above the mouth, which, in most sharks, is located back beneath a long snout. Triangular teeth are serrated on the two visi-

ble edges. It is not possible to identify conclusively the species depicted, but the Paracas sharks strongly resemble the whale shark (*Rhincodon typus*), a plankton-feeder. No subpolar region in the world is richer in plankton than the Peru Current, which runs close to the Paracas Peninsula.

Plants

Vegetation represented in Paracas textile iconography is shown in association with an animal or with a human figure. Among the selected plants depicted are *ají* peppers *(Capsicum)*, lima beans (*Phaseolus lunatus*; see fig. 6n), *lúcuma* (*Lucuma bifera*), pepinos (*Solanum muricatum*), and tubers such as *jíquima* (*Pachyrrhizus tuberosus*) and the sweet potato (*Ipomoea batatas*).

Discussion

The images of Paracas-region animals and plants stitched in the block-color style on Necrópolis textiles allude to the larger habitat in which the Paracas people lived, and it is probable that some of the images were used to describe metaphorically that ecological realm. For instance, Paracas representations of the pampas cat are commonly shown with certain cultivated plants—the lima bean, *ají* peppers, and tubers. Strongly associated in textile imagery with plants, the cat appears to have been regarded as a guardian of the fields and, by extension, the earth. The pampas cat may have been a metaphor for the life-giving properties of the earth, functioning as an ideogram of an earth cult when embroidered on garments. Snakes could also have been viewed as metaphors for the terrestrial realm. Among the sea creatures swimming off the coast of Paracas, the shark was likely thought of as the ruler of the sea and a metaphor for the ocean.

Some animals appear to have no territorial limits; these no doubt bridged ecological niches in the minds of Paracas people. Birds must have had multiple associations with natural phenomena, as inhabitants of the guano islands, of the beaches ringing the Bay of Paracas, and of the air. Fish-eating sea and shore birds (twenty percent of all birds represented) may have been associated with marine cults. Land birds, or those that feed on seeds and vegetation, may have connoted earth-related phenomena. Condors and falcons, birds of prey that are impressive in flight and dominate the sky, may have referred metaphorically to the celestial realm or to the mountains. In the Andean world,

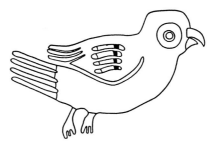

Fig. 6l Mealy parrot. Unidentified garment type, specimen 378–32, c. 50/100.

Fig. 6m Passerine. Hanging, specimen 89–56, c. 100.

Fig. 6n Pampas cat. Skirt, specimen 378–18, c. 50/100.

Fig. 6o Snake. Unidentified garment type, specimen 310–58b, c. 50/100.

Fig. 6p Shark. Mantle, specimen 94–9, c. 1/50.

Fig. 6q Bird, feline, snake conflation. Poncho, specimen 378–28, c. 50/100.

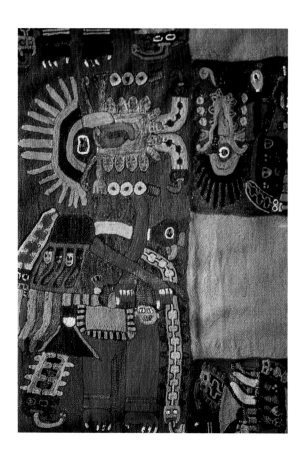

Fig. 7 Condor impersonator. Detail embroidered on mantle, specimen 318–8. Peru, Paracas, c. 100/200. Camelid wool and cotton. Museo Nacional de Antropología y Arqueología, Lima, Peru. Photo: Anne Paul.

these birds were intimately tied to mountain cults;[8] although the Paracas region has a non-mountainous landscape, the mountains to the east were the sources of the rivers that were vital to the desert coast. Some images are composites of several animals; that illustrated in fig. 6q, for example, has bird-tail feathers conjoined with the head, lower torso, and limbs of a pampas cat, and carries a snake in its mouth. Birds, cats, and snakes inhabited agricultural fields and were thus ecologically associated — this zoomorphic conflation may have been a visual metaphor for an earth-related phenomenon.

On one level, the images described here give an accurate, though fragmentary, record of the physical universe observed by the people of Paracas. On another level, the images outline a conceptual structure of that universe, by showing how the ecological order of this geographical setting was fundamental to the symbolic system of Paracas culture. The local ecosystem, then, can be used as a template when trying to reconstruct portions of Paracas world view. Although it is not possible to pin down the precise meaning of any image, many animals and plants in Paracas iconography were probably metaphors for different aspects of the three great realms of nature on the coast: earth, sea, and sky. The suggestion that some depictions were cult images is supported by the fact that many were shown as parts of ritual costumes on human impersonators.

Images of Human Impersonators

There are 258 different elaborately costumed human figures depicted in the block-color style on Paracas Necrópolis textiles. These costumes include the following iconographic types: birds (twenty-three percent of total), felines (eleven percent), fish (four percent), snakes (three percent), vegetation (four percent), figures wearing fox headdresses (three percent), shamans (twelve percent), and costumes comprising at least two different zoomorphs (thirteen percent). All other anthropomorphs account for twenty-seven percent.

Human impersonators were ritually costumed dancers who imitated cult images and spirits at religious festivals, which must have included dancing, chanting, and invocations of natural forces. One painted textile shows differently depicted figures, lined up as if in a ceremonial procession,[9] but embroiderers usually portrayed only one iconographic unit — one kind of figure — per cloth, repeated

without variation in contour, and with no interaction among discrete design units (see fig. 4). Rather than depicting the particulars of the rituals, Paracas artists stitched visual descriptions of the actors.

Among the many examples of bird impersonators, there is great variety in the images. One condor impersonator, for example, wears the wings and tail of a bird, and a cape fastened at the neck by a wide collar analogous to the condor's ruff;[10] his headdress includes a condor head with its typical caruncle. In another example (fig. 7), the condor impersonator wears a mask with beak and caruncle, and presses a condor against his chest.

Falcon impersonators typically have banded eyes and a zigzag pattern in the tail and wing feathers; sometimes, patterned areas on either side of the chest replicate the breast markings of the aplomado falcon. The falcon status of the impersonator can be conveyed also by the presence of a falcon's head projecting from the mouth (see fig. 8). Identifiable bird images in these impersonator costumes are usually those of a condor or a falcon; in many representations, the identity of the bird cannot be established.

Humans are also shown dressed as pampas cats. The image in fig. 9 has banded limbs and tail; other ritual functionaries may wear the whiskers and skin of the pampas cat. There

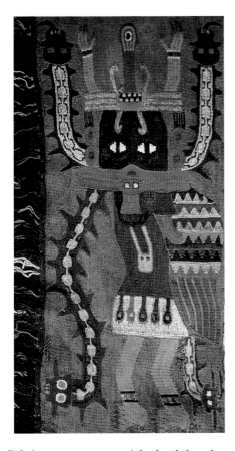

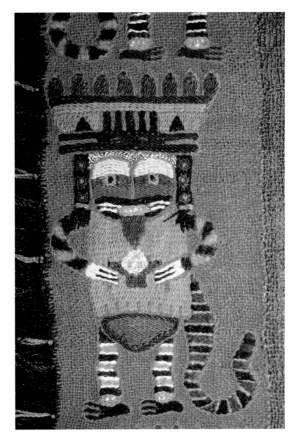

are fish impersonators with shark headdresses that, when viewed upside down, become grimacing masks; other impersonators have shark-body suits. A vegetation impersonator, who holds in one hand a staff with attached *lúcumas* and, in the other, a stick with lima beans, has part of a beanlike form attached to his upper back and sprouts appendages that terminate in legume pods and *jíquima* (fig. 11). Other humans wear headdresses that comprise undulating snakes; sometimes the torso, arms, and legs are painted in snake patterns (see fig. 5).

Some impersonators are associated with more than one zoomorph. An image with snakes on his headdress, for example, has fish within a tape or streamer issuing from his mouth, shamans in a tape that flows from the nape of his neck, and birds on the border of his tunic. The impersonator in fig. 12 wears a shark suit with what appear to be falcon-feather wings on the upper torso. A feline skin with images of beans is draped over the head and down the back of a figure who has a snake on his face and shamans in a mouth tape with a nighthawk at its other end (fig. 13). Still more visually complex is the image illustrated in fig. 10; the principal figure has five streamers (one with beans in it) that link him to a feline, a shaman, and three bird impersonators (one of which is a falcon and

one a condor). These conflated impersonators incorporate into a single design unit several types that appear separately on other textiles; in my sample of thirty-three such impersonators, nearly eighty percent are on textiles that come from the latest Paracas Necrópolis bundles (those that date to Early Intermediate Period Epoch 2).

This iconographic consolidation appears also on a fragmentary, but nevertheless stunning, interlocked plain-weave fabric that lacks exact provenance (fig. 14). Here, there were at least three principal figures linked by a maze of head, mouth, torso, and leg streamers; all of the iconographic details are

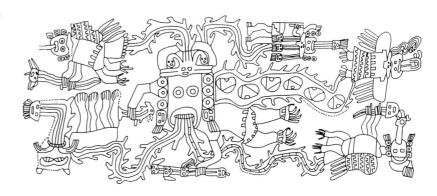

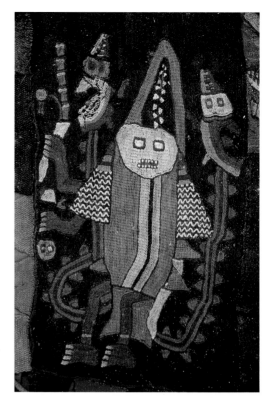

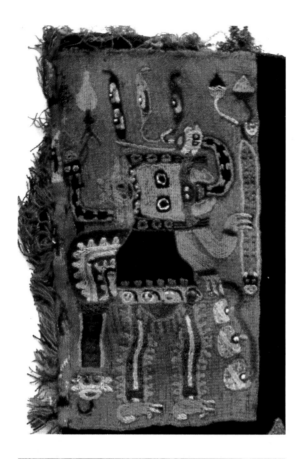

Fig. 11 Vegetation impersonator. Detail embroidered on mantle, specimen 38-4. Peru, Paracas, c. 100/200. Camelid wool and cotton. Museo Nacional de Antropología y Arqueología, Lima. Photo: Anne Paul.

Fig. 12 Shark-falcon impersonator. Detail embroidered on mantle, specimen 38-48. Peru, Paracas, c. 100/200. Camelid wool and cotton. Museo Nacional de Antropología y Arqueología, Lima. Photo: Anne Paul.

Fig. 13 Composite figure. Detail embroidered on mantle, specimen 319-48. Peru, Paracas, c. 100/200. Camelid wool and cotton. Museo Nacional de Antropología y Arqueología, Lima. Photo: Anne Paul.

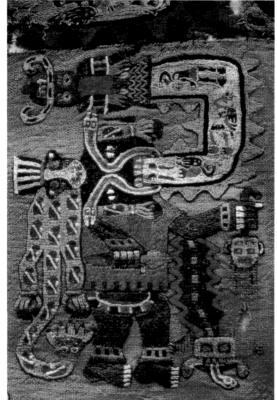

known from Paracas Necrópolis textiles. Although nothing precisely like this piece is known to have come from the scientifically excavated Necrópolis bundles, its iconography is so close to late Paracas embroidered garments that there is little doubt as to its affiliation with the Paracas Necrópolis textile style.

Discussion

The human figures ritually disguised as animals and draped with plants are related to the fauna and flora represented on other Paracas Necrópolis fabrics, and they help define some of the animals as cult images. As ritual attire worn by human impersonators, the animals and composite creatures became living, moving cult objects in the religious life of the Paracas people. When embroidered on the garments worn by the Paracas rulers, these images became ideograms of the cults of nature, indicating also the character of a Paracas functionary's ritual obligations.

Detailed study of several Necrópolis bundles has shown that ritual clothing was likely made for leaders to wear in life. Since the majority of garments in any particular bundle were made specifically for the person with whom they were later buried,[11] we may suppose that their iconography reflected something about that man—who he was and what he did as a ranking member of his society. As officials of Paracas communities, the

Fig. 14 Mantle fragment. Peru, Paracas/Nazca, 100 BC/AD 100. Camelid wool. Private collection. Cat. no. 221)

persons who wore the embroidered fabrics described here must have been responsible for ritually establishing and maintaining order in their universe. The embroidered depictions of costumed humans show community leaders in their various roles as imitators of natural phenomena. Since many of the imitated animals (such creatures as the condor, falcon, pampas cat, and shark) are lords of their own realms, a relationship may be drawn between social and cosmic orders. The embroidered ideograms—which linked the leader to the forces of nature and underscored his ritual involvement with those forces—suggest that he participated in ceremonies directed toward ensuring the fertility of animals and crops. The anthropomorphic themes in each of the large and medium Necrópolis bundles are essentially the same, indicating that, during the timespan represented by those bundles, the definition of "leader" in Paracas society remained constant.

Conclusion

Paracas textiles belong to a long Andean weaving tradition in which many of the important ideas of a society are expressed through the medium of cloth. This tradition predated Paracas culture by thousands of years and continues to the present. The woven garments and the textile iconography illustrated here encode social, religious, and environmental information, and, although many aspects of meaning are not accessible to modern viewers, it is certain that Paracas cloth functioned symbolically on multiple levels.

The people of Paracas looked to the physical world about them for their imagery, and the ecological order was fundamental to a symbolic system encoded in their textiles. It is likely that, in their structuring of reality, man and environment maintained a live relationship with each other, with the phenomena of nature conceived as though imbued with vital forces. The basic structure of this world view is common to other Indian societies in the Andes, past and present. Since ancient times, Andean peoples have been intimately tied to their lands, venerating natural phenomena and creating symbolic systems that look to local ecologies. On the coast, the great expanse of the Pacific Ocean was a dominant ecological presence, and the concern with, and reliance on, the sea was reflected in the Paracas world view, along with an intense awareness of terrestrial and celestial phenomena. In Paracas culture, where the framework of this cosmovision is portrayed by animals and plants that describe a specific ecological realm, both literally and metaphorically, we see the antecedent for what was presumably a widely shared vision of the universe among the coastal peoples of ancient Peru.

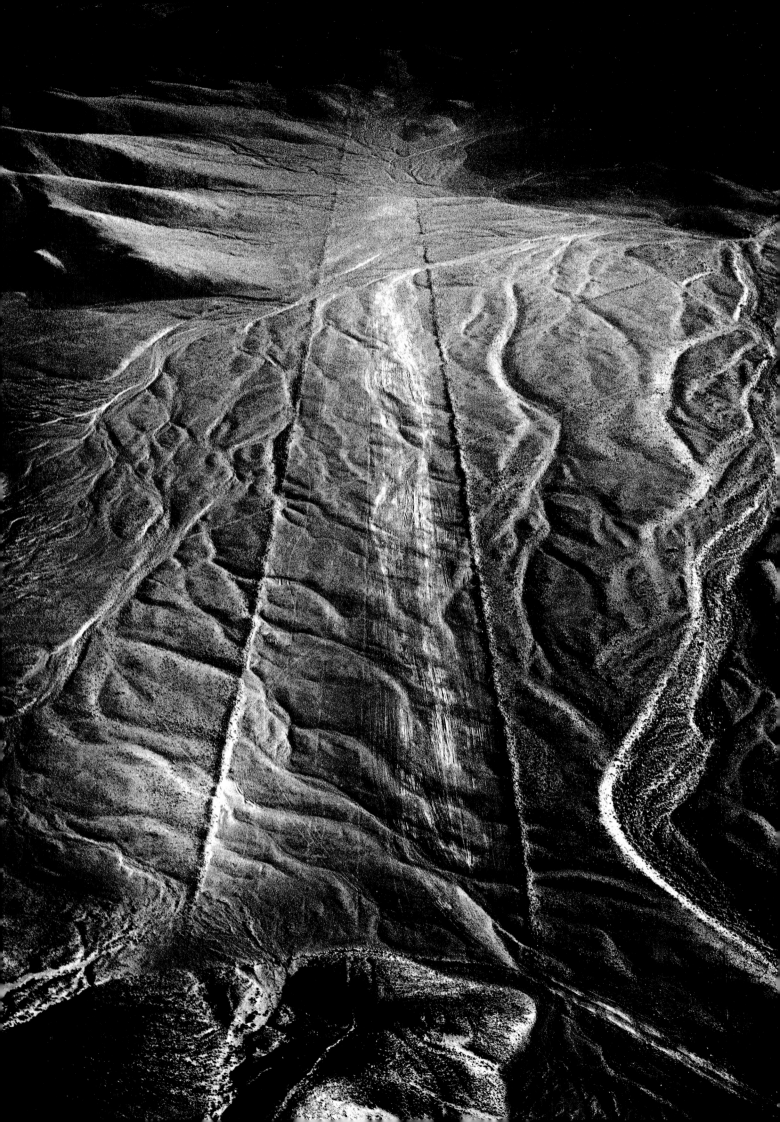

INTERPRETING THE NAZCA LINES

On the arid coastal plain of southern Peru arose a culture that was to become one of the most famous in the prehistory of that country.[1] Between roughly 200 BC and AD 600, the people inhabiting the Nazca River system made textiles and ceramics that were of the highest technical and artistic quality. Thanks to the desert climate, many of these objects were well preserved and can be seen in museums much as they appeared to the people who made them nearly two thousand years ago. Among the finest collections of Nazca

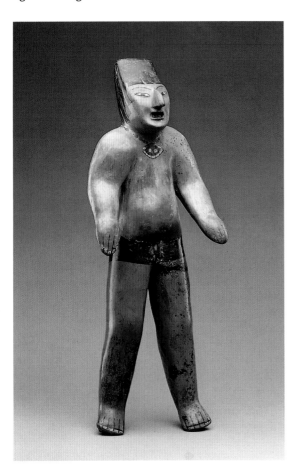

ceramics are those of the Museo Nacional de Antropología y Arqueología in Lima and in The Art Institute of Chicago (see, for example, figs. 2, 8, 12, 13, 14, 18).[2]

The Nazca people also constructed large pyramidal structures for ceremonial purposes and an intricate system of underground canals, the latter apparently unique in the Americas.[3] However, it was the discovery, over fifty years ago, of giant desert markings that brought the Nazca culture to the public eye. Large figures and lines constructed on the desert surface near the town of Nazca came to be called "one of the most baffling enigmas of archaeology"[4] (see fig. 1). The figures comprise drawings of animals, fish, birds, geometrical designs, and even anthropomorphic figures, all made on such a scale — some are over one hundred meters long — that they can be seen without distortion only from the air. The term used today to describe a drawing on the earth's surface is geoglyph, but the lines and figures at Nazca came to be called collectively the Nazca Lines. Their meaning has continued to puzzle archaeologists to the present day.

The Nazca Lines are not the only geoglyphs in South America. In Peru, important figures have been found in other coastal plains and valleys — for instance, in the Zaña, Santa, and Sechín Valleys on the north coast, in the Pampa Canto Grande to the north of Nazca, and in the Sihuas Valley to the south. Numerous geoglyphs have been found also in northern Chile.[5] Although at times impressive, none of the concentrations of these other geoglyphs can rival that found on the desert plain near Nazca in the variety and elaboration of forms.

There is little doubt who made the Nazca geoglyphs. Many of the figures on the desert

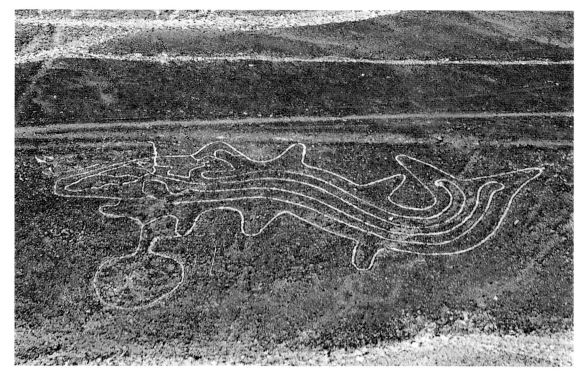

Fig. 3 Aerial view of Nazca
lines depicting mythical
fish with shark or killer-
whale motifs. Peru, Nazca,
1/700. Photo: Servicio
Aerográfico de Peru.
Giant figures drawn on the
desert repeat the forms
on painted ceramics and
may be emblems of cults
connected with the sea, the
sky, and the mountains.

Fig. 4 Vessel depicting
composite fish, feline, and
human figure. Peru, Nazca,
50/200. Ceramic. The Art
Institute of Chicago.
(Cat. no. 193)

are also portrayed in the ceramics and tex-
tiles of the Nazca culture (compare, for
example, figs. 3, 4). Moreover, much of the
pottery found at the geoglyphs was of Nazca
origin. A C-14 date of wood from a post in the
area of the geoglyphs falls within the time
frame of the Nazca culture.

The construction of the geoglyphs has
often been described as requiring advanced
technology, some authors even claiming that
the lines could not have been made without
aerial supervision.[6] However, it has been suc-
cessfully demonstrated that the huge desert
figures could have been amplified from scale
models using elementary tools and tech-
niques.[7] The geoglyphs are formed when
gravel with an oxidized surface, which covers
the land, is removed to expose the light soil
below. The almost total lack of rain in this
region has been a primary reason that the
lines have survived until the present day.

While the basic questions as to who cre-
ated the geoglyphs, as well as when and how
they were made, appear to have been an-
swered, the question as to *why* continues to
raise controversy. It is not possible to exam-
ine here the many theories that have been
presented to explain the geoglyphs.[8] Some
theories (such as the one that they were
made by extraterrestrials) have no scientific
basis and ignore much of the information
available on the geoglyphs and on Nazca cul-
ture. One of the most widely accepted the-
ories is that the geoglyphs were used as aids
in making astronomical observations.[9] Recent
studies, however, show that the alignments
are no more accurate than would be expected
to occur by chance.[10] Also, many of the lines
are shorter or longer than necessary, do not
point to areas where the most significant as-
tronomical activity takes place, and cannot

be dated accurately enough to deal with problems of changes in the positions of celestial bodies through time. Moreover, it has not yet been possible to relate scientifically the geometric and zoomorphic figures to astronomical observations. The geoglyphs are left largely unexplained by this theory.

Because they lived in a desert climate, the Nazca people would obviously have been concerned with their relationship to the natural environment. Indeed, such a concern was common throughout the Americas and has continued to be so in coastal South America to the present time. In the case of the Nazca people, we see this demonstrated by motifs on their ceramics. The immense repertory of motifs includes various bird species, reptiles (see fig. 12), mammals, and fish, as well as cultivated plants such as *achira* (see fig. 5), maize (see fig. 7), and *lúcuma* (see fig. 6). An ingenious adaptation to the desert is seen also in the elaborate system of underground filtration canals that were constructed over many centuries. Water has always been a critical problem because the Nazca River does not have water for some months of the year and may have none at all for several years. If there were insufficient rainfall in the mountains to the east, the rivers would dry up, and the underground water currents would also gradually disappear. Since the Nazca people were dependent on an intensive agriculture utilizing irrigation, their position was always precarious.[11]

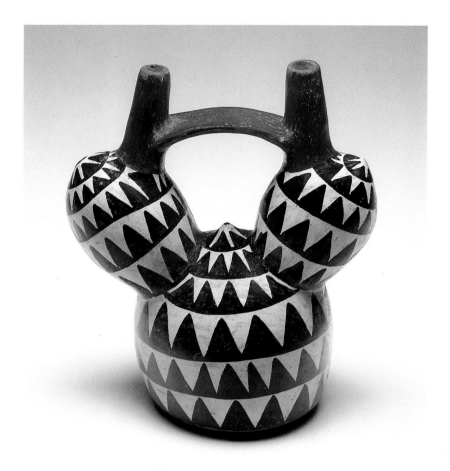

The beliefs held by the Nazca are indicated by the archaeological remains, the abundant imagery on Nazca ceramics, accounts written in Spanish colonial times as to traditional worship, current beliefs that

Fig. 5 Vessel in the form of *achira* root. Peru, Nazca, 100/400. Ceramic. The Art Institute of Chicago. (Cat. no. 196)

Fig. 6 Vessel in the form of *lúcuma* fruits. Peru, Nazca, 100/400. Ceramic. Museo Nacional de Antropología y Arqueología, Lima. Photo: Dirk Bakker. (Cat. no. 199)

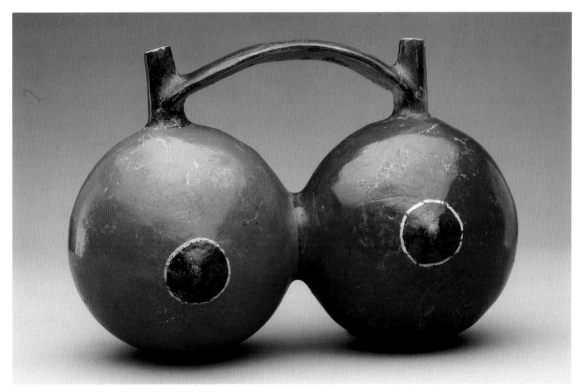

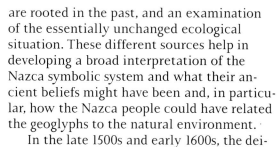

Fig. 7 Vessel depicting
ripening maize. Peru,
Nazca, 200/400. Ceramic.
Museo Nacional de
Antropología y Arqueología,
Lima. Photo: Dirk Bakker.
(Cat. no. 201)

Fig. 8 Woman chewing
coca. Peru, Nazca, 200/400.
Ceramic. Museo Nacional
de Antropología y
Arqueología, Lima. Photo:
Dirk Bakker. (Cat. no. 203)

are rooted in the past, and an examination of the essentially unchanged ecological situation. These different sources help in developing a broad interpretation of the Nazca symbolic system and what their ancient beliefs might have been and, in particular, how the Nazca people could have related the geoglyphs to the natural environment.

In the late 1500s and early 1600s, the deities that were worshiped at Nazca prior to the arrival of the Spanish were identified as mountains and springs. The principal deity was a mountain of sand.[12] This mountain, now called Cerro Blanco, dominates the town of Nazca. According to local legend, it is associated with the highest mountain on the eastern horizon, Illa-kata, with a still more distant snow peak, Carhuarazo, and with the mountain Tunga near the coast. Illa-kata is the mountain/weather deity that is thought to supply the surface water of the Nazca River, while Tunga is linked with the god of the sea. A lake believed to exist in the center of Cerro Blanco feeds the underground canal system. Pre-Hispanic ritual sites were found on the tops of Illa-Kata and Tunga, while

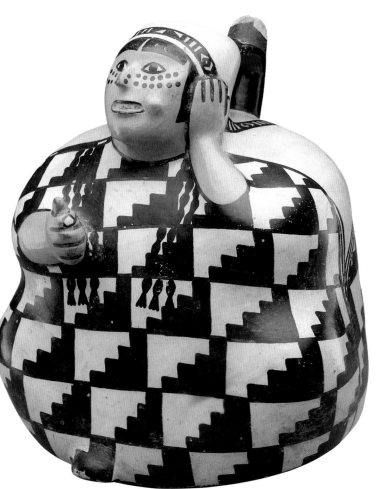

modern offerings have been seen on Cerro Blanco's sandy, and thus constantly shifting, summit. Sea shells and river stones, both common offerings for water, were found, respectively, on the summits of Tunga and Cerro Blanco.[13]

Current rituals at Nazca also occur as part of a mountain/water cult, and offerings for rain are made on mountains to the east of Nazca. Although distant from Nazca, straight lines are still being used in the Andean highlands as sacred paths to reach points from which the surrounding water sources, principally mountains, are worshiped (see fig. 9). These sacred lines may belong either to individual families or entire villages. If this was the case at Nazca, the numerous lines might have been made by different groups, constructing them through the centuries.[14]

At Nazca, sea shells and remains of ceremonial vessels for liquids were found at some of the geoglyphs, especially at mounds of

stones at the centers of converging lines ("ray centers") or at the ends of trapezoidal figures (see fig. 1).[15] Clearly, those mounds at which offerings were made had a ritual significance. During the Inca period (and still today), stone mounds were used as places for making offerings to mountains, and they were often perceived as representing the mountains themselves.[16]

According to one study, the orientations of the triangles and trapezoids are statistically correlated with the flow of water, and the ray centers are generally situated relative to the river system.[17] The evidence indicates, therefore, that the straight lines were utilized in ceremonies relating to a water cult, likely as ritual paths to places at which offerings were made. Today, the lines in the Andean highlands are said to have been kept straightened in order to gain religious merit and because this added to their power. The more open triangles and trapezoids were probably

Fig. 9 Villagers returning from ceremonies performed at the end of a straight line. Photo: Johan Reinhard. Today, as in the distant past, linear processions transverse the land on routes between communities and sacred places.

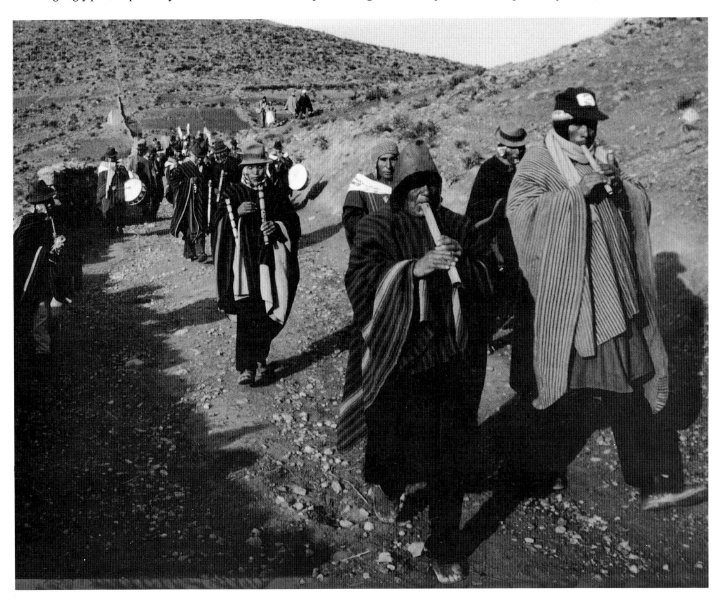

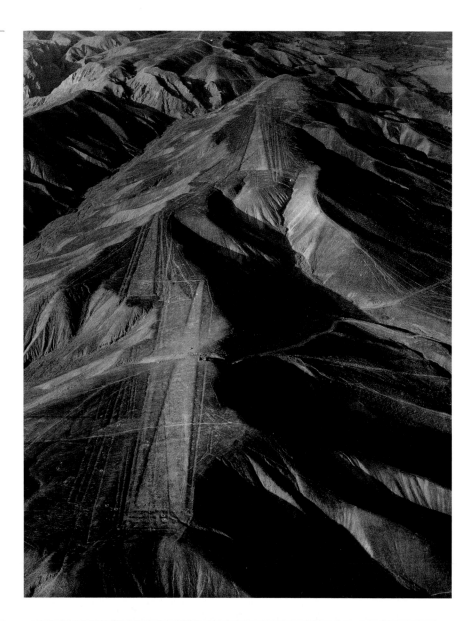

Fig. 10 A sequence of trapezoidal areas and lines served as ritual paths and concourses. Peru, Nazca, 1/700. Photo: ©Marilyn Bridges 1979.

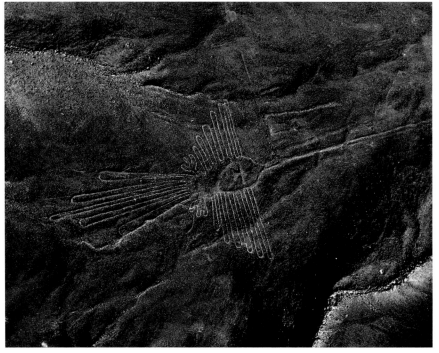

Fig. 11 Hummingbird figure drawn on the desert. Peru, Nazca, 1/700. Photo: ©Marilyn Bridges 1979.

places where larger groups gathered for such ceremonies. We know that, both during the Inca period and in recent times, offerings were made in open places, including plazas, to the surrounding water sources, among which the most important were mountains.[18]

The geometric figures can be interpreted similarly. Spirals, zigzags, and oscillating motifs were common in South America and have been widely interpreted as motifs of a water cult.[19] For example, zigzags represented lightning and rivers, while spirals symbolized sea shells and, thus, the ocean, which was perceived as the source of all water.

Animal and plant figures have particularly puzzled observers, but they, too, begin to make sense when analyzed in terms of traditional Andean beliefs. Let us first examine the bird figures. Today at Nazca, the sighting of a heron, pelican, or condor is interpreted as a sign that it will rain in the mountains. The condor is widely believed to be the mani-festation of the mountain gods. In some areas, hummingbirds are considered inter-mediaries with, or even manifestations of, mountain gods (see fig. 11). The various sea birds have an obvious association with the ocean.

Turning to the animal and insect figures, the monkey and lizard may have been seen as protectors or as symbols of water because of their association with places where water is available. When many lizards are out, this is taken as a sign that it will rain (see fig. 12). Large marine creatures need no further comment in this context; the identification of a shark or killer-whale motif could indicate that it played a role in rituals for success in fishing (see fig. 3). Foxes (see fig. 13) are perceived in some areas as the "dogs" of the mountain gods, and the Incas tied dogs out to howl until the Weather God sent rain. Spiders and millipedes also appear when it is about to rain (see figs. 13, 15).

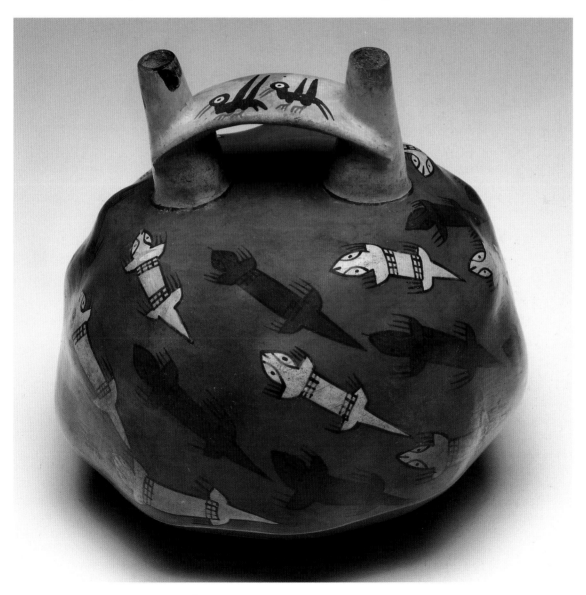

Fig. 12 Double-spouted vessel depicting lizards. Peru, Nazca, 100/200. Ceramic. The Art Institute of Chicago. Lizards sun themselves on the desert, observed by predatory birds. (Cat. no. 194)

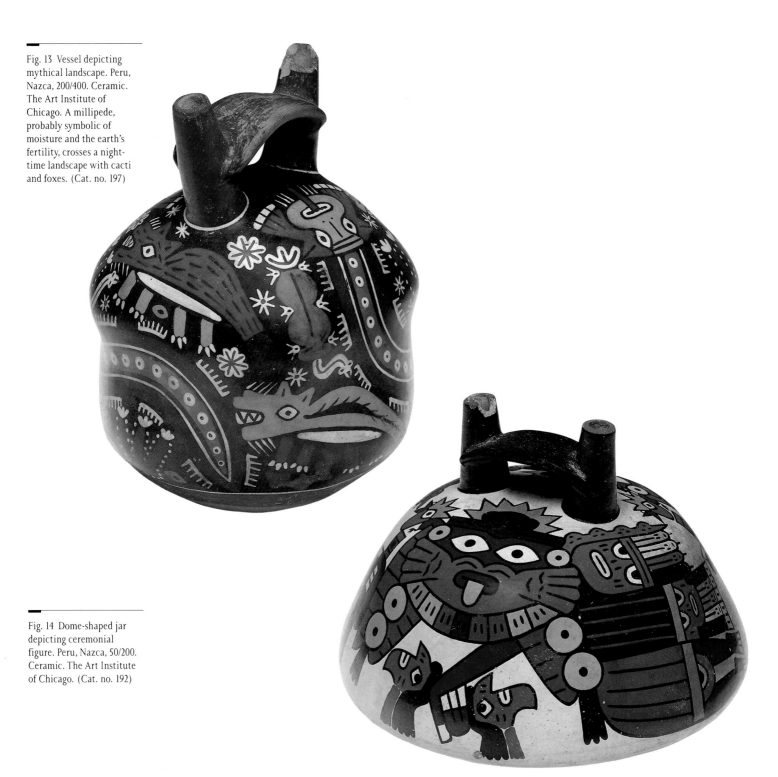

Fig. 13 Vessel depicting mythical landscape. Peru, Nazca, 200/400. Ceramic. The Art Institute of Chicago. A millipede, probably symbolic of moisture and the earth's fertility, crosses a night-time landscape with cacti and foxes. (Cat. no. 197)

Fig. 14 Dome-shaped jar depicting ceremonial figure. Peru, Nazca, 50/200. Ceramic. The Art Institute of Chicago. (Cat. no. 192)

Flowers, algae, and trees are also believed to be depicted on the desert. In an arid climate, these can all be interpreted as fertility symbols, and there are also more specific ways that they may have been perceived within this context. Flowers are used in rituals to the east of Nazca to invoke the mountain deities that bring rain, seaweed appears in a ceremony to induce rain, and wood was employed in the construction of the filtration canals.

The anthropomorphic figures on the hillsides near Nazca are generally versions of figures found in Nazca ceramic iconography (see figs. 14, 15, 16). Their contexts and accompanying details have led most researchers to the conclusion that they represent deities associated with agricultural fertility and water.

A major theme of Nazca ceramic art features complex figures with feline faces, human trophy-heads, and shark or killer-whale appendages, probably alluding to war, the taking of heads, and the use of blood offerings to earth, sky, and water. Similarly dressed figures may have appeared in rites

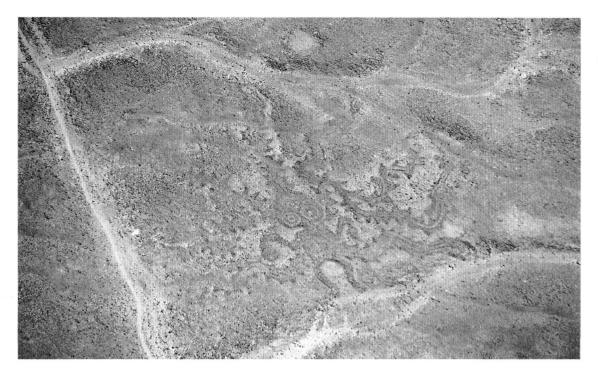

Fig. 15 Ritual figure with bannerlike appendages drawn on the desert. Peru, Nazca, 1/700. Photo: Johan Reinhard.

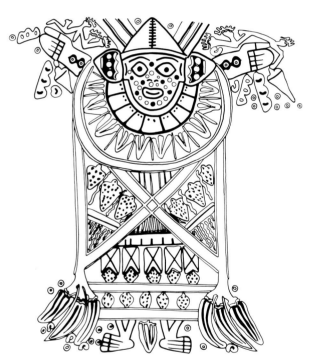

textiles, which may show symbolic animals, metaphoric figures, the sun, and many other motifs, including abstract forms (see figs. 19, 20). A few of the figures—the spider, the dog, and the monkey, for instance—sometimes appear to have extended sexual parts. This has been interpreted by some scholars as indicating that these animals had roles in a fertility cult,[20] a theory that is in accord with the general conclusion reached here.

The explanation of the lines and figures as having played roles in a water/fertility cult still leaves unanswered the question of why many were made on such a large scale and can best be seen only from the air. Weather deities, generally perceived as residing in mountains, were—and still are—widely thought to oversee their domains, either by manifesting themselves as birds or by taking the form of a mythological flying feline. Thus, the construction of the figures would have been seen as a means of attracting their attention in order to invoke an increase in crop fertility, especially through the means of a stable water supply.[21]

Fig. 16 Drawing of detail of vessel depicting costumed performer. Peru, Nazca, 50/200. The Art Institute of Chicago. Drawing: Joanne Berens.

Fig. 17 Drawing of detail of shallow flared vessel depicting harvest-festival performer. Peru, Nazca, 50/200. The Art Institute of Chicago. Drawing: Joanne Berens.

designed to "feed" the natural elements upon which human existence depended (see fig. 14). Other figures pertain to rites of the harvest season (see fig. 17). The relationship between this imagery and the Nazca terrain is further borne out by a vessel depicting a desert landscape on its surface yet intended to contain liquid within (fig. 13), and by a remarkable drum in the shape of a man, covered with a complete "text" of signs and symbols pertaining to the Nazca world view (fig. 18). Similar observations can be made about the imagery of spectacular feathered

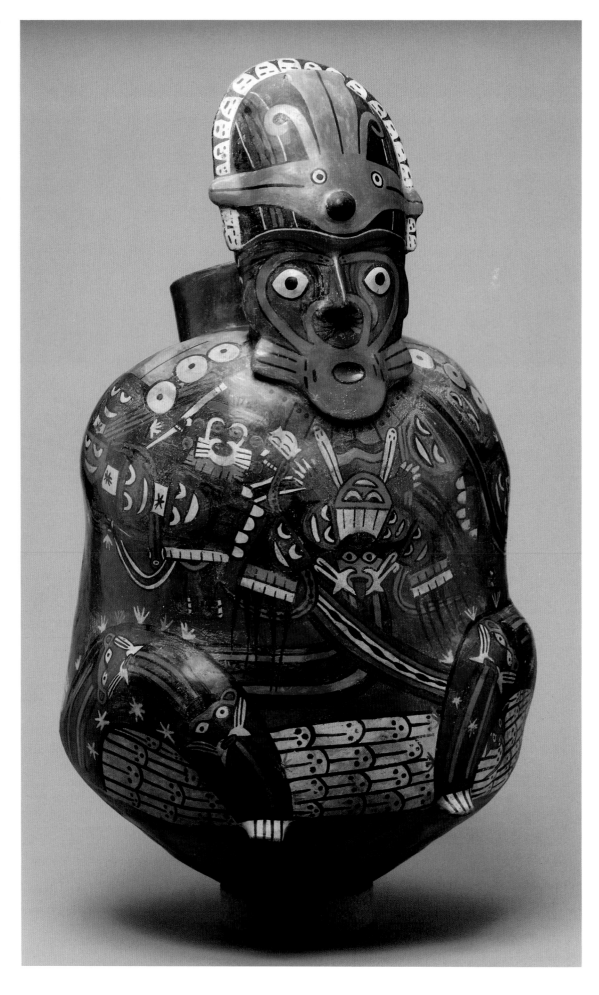

Fig. 18 Vessel depicting seated chieftain in ceremonial dress. Peru, Nazca, 200/400. Ceramic. Museo Nacional de Antropología y Arqueología, Lima. Photo: Dirk Bakker. Nazca ceramics feature rounded volumes covered with polychrome designs. The painted mantle enveloping the chieftain portrays a series of mythical figures. (Cat. no. 200)

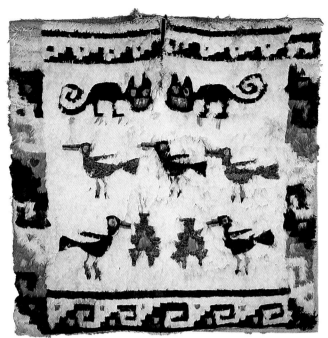

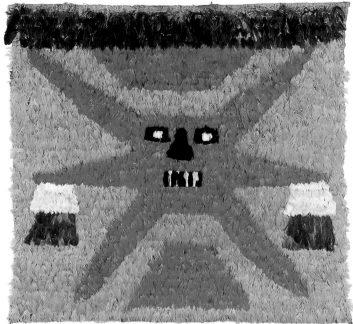

The interpretation provided above covers the vast majority of the geoglyphs at Nazca. Given the lack of historical information dating to the time the geoglyphs were made, it is clear that their precise meanings will never be known. Symbols can vary in meaning over time and, indeed, can change, depending upon their contexts, even within the same time period. We know, however, that many basic concepts have remained relatively stable over several centuries in the Andes. Some types of artistic representations have been only slightly modified over two millennia, and some concepts, shared throughout the Andes at the time of the Spanish conquest, have persisted to the present day, despite Christian proselytism.

According to one of these basic concepts, deities residing in mountains controlled metereological phenomena (rain, hail, snow, frost, clouds, lightning, etc.) and, thus, the fertility of crops, livestock, and, ultimately, humans. Such a belief has a sound ecological basis, since mountains do play a critical role in the condensation of rainland formations, and rivers lead down from them into valleys and across the plain to the sea. This helps to explain why mountain worship was of such widespread importance at the time of the Spanish conquest in many regions, including the coast of Peru, and why it continues to be so in traditional communities to the present day.[22] The cult of the mountains as life-giving icons has played a central role in the Andean people's relationship with the natural world around them.

By viewing the geoglyphs from the perspective of sacred geography, we can explain diverse data in a logically consistent manner that is in accord with traditional Andean beliefs and with the available archaeological, ethnographic, and historical material. Although we can never completely decipher the Nazca Lines, we can go beyond fanciful interpretations and come closer to understanding the practical concerns and world view of the people who were responsible for constructing what became one of the greatest mysteries of archaeology.

Fig. 19 Tunic depicting felines and birds. Peru, Nazca, 200/400. Camelid wool, cotton, and feathers. The Art Institute of Chicago. Feathers for ceremonial ponchos and mantles were obtained from birds of the coast and the Amazon basin. Technical requirements for weaving feathers produced angular, simplified shapes, but the imagery reflects standardized subjects of the Nazca visual repertory. (Cat. no. 190)

Fig. 20 Textile with sun motif. South coast Peru, Nazca, 100/500. Cotton and feathers. Alan Brown Gallery, Hartsdale, New York. (Cat. no. 198)

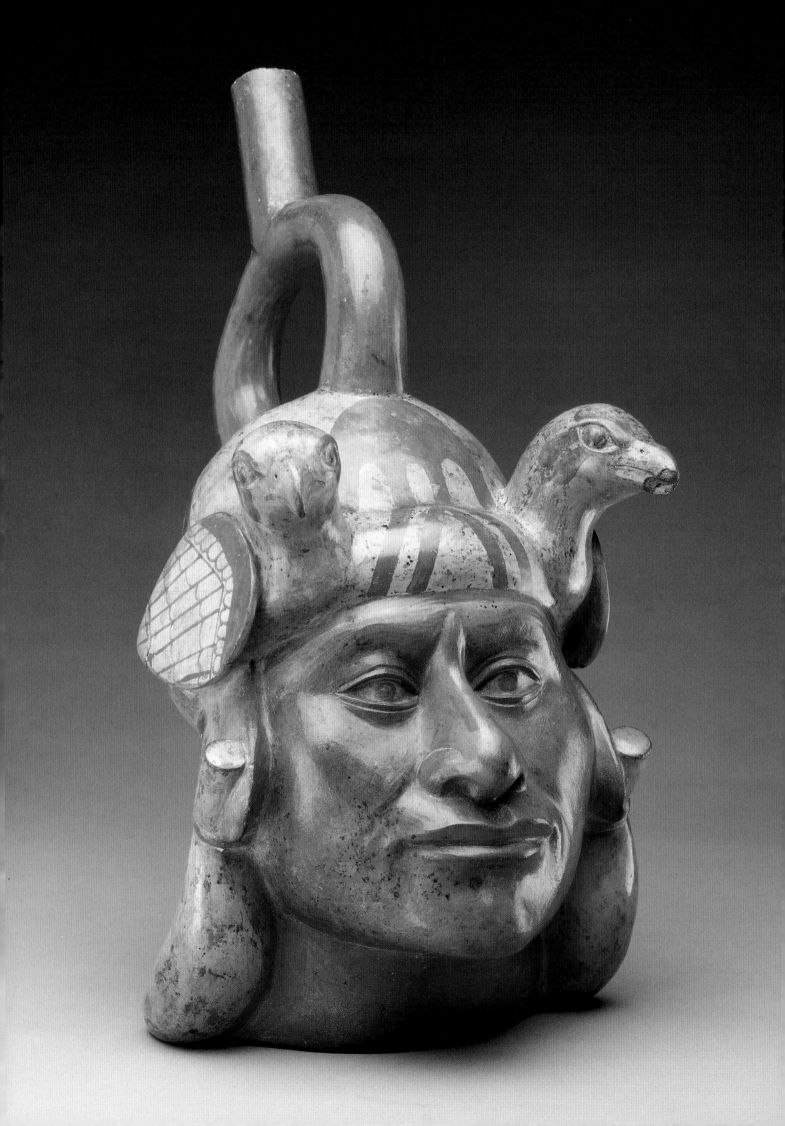

THE WORLD OF MOCHE

The World in Nature

The desert north coast of Peru is bounded by the Pacific Ocean to the west and the Andes to the east. Here, the Moche, or Mochica, people flourished from before the beginning of our era until the seventh century. The cold Peru Current, running in a deep trough offshore, is normally one of the world's richest fishing grounds. Using rafts formed of bundles of *totora* reeds, the Moche acquired from the ocean food and probably fertilizer— bird guano from offshore islands, as well as fish for this use.

The rafts are pictured on many Moche ceramics; similar rafts are still made at Huanchaco, on the coast not far from the pyramids at Moche (see fig. 4).[1] The figures in the rafts on Moche pottery are sometimes naturalistic fishermen with their gear, but even these may ride upon a supernatural boat that is a giant fish (see fig. 3). Often the fisherman has the fanged mouth that indicates a supernatural or sacred being. Some rafts are realistically depicted, but sometimes the reed bundles end in fish heads or snake heads, and the raft—paddled by a god, perhaps assisted by an anthropomorphic cormorant—is propelled below by cormorants or by human legs (see fig. 5). In these scenes, jugs and/or captives or sacrificial victims may be seen in the "hold" of the raft. When a supernatural woman, perhaps a moon goddess, rides in it, the "raft" is often a crescent.[2] This female figure sometimes has a goblet like those depicted in scenes of human sacrifice.

The sea and the shore were important themes in Moche art. The rich range of ceramic subjects includes realistic sea and shore birds, sea lions, fish, crustaceans, and littoral vegetation. A Moche ruler or noble may wear sea birds (ospreys) on his head-

dress (see fig. 1). Some vessels depict ritual sea-lion hunts on offshore guano islands (see fig. 6), where offerings have been found in archaeological remains.[3] The rock-based piles of white guano on these islands are miniature versions of the snow-capped mountains to the east, and sea-lions are marine mammals who resemble land creatures. In the mountains, men hunted edible snails, whose shells look like seashells (see fig. 2). These inversions in nature suggest multiple, related cosmic models at the roots of Moche art. In other sea scenes, a fanged-mouth god, wearing a belt with snake extensions, snake-head ear ornaments, and a jaguar headdress, may battle a fish monster with human limbs holding a knife and a decapitated human head, or the god confronts a crab demon with a fanged mouth and a pair of human legs, in addition to its natural appendages. Sometimes the snake-belt god decapitates an anthropomorphic crab. We do not know the myths, but, surely, at least one of them told of the god's battle with a giant sea monster which had attacked human beings.

There is no doubt of the mythic and/or ritual character of the sea scenes, or of their basis in reality as the source of the importance of this theme. Moche fishermen went out at night to face the dangers of the deep in their quest for food.[4] The sun disappears into the sea every night; the moon rides its reflections across the water. The western sea represented the edge of the world, the unknown, death, and the entrance to the underworld, but it was also a vital source of food and life.

The land inhabited by the Moche is a narrow strip of desert between the ocean and some of the world's highest mountains. Sea winds, blowing over a cold current from the Antarctic, condense offshore, depriving the

Fig. 1 Portrait vessel of ruler. Peru, Moche, 250/550. Ceramic. Museo Nacional de Antropología y Arqueología, Lima. Photo: Dirk Bakker. The sculptural naturalism of Moche ceramic art is exceptional in ancient Peru. (Cat. no. 184)

coast of rain; the mountains block moist air from the Amazon Basin to the east. From the mountains, however, rivers bring precious water to coastal dwellers, long dependent on irrigation agriculture, who needed to control both seasons of little water and seasons of flood for the cultivation of maize, beans, squash, peppers, peanuts, cotton (for fishing nets, as well as for cloth), potatoes, and other crops. Architecture, from the third millennium BC onward, was oriented toward water sources, mountains, and celestial phenomena.[5] Like the sea, the mountains were an integral part of coastal life. The east provided resources of sun and water, a landscape of symbolic imagery, cultural exchange with its inhabitants, and the products of various mountain elevations and the Amazon Basin beyond. Mountain passes were traversed from early times. The ancient form of the stirrup-spout vessel, inherited by the Moche people from real or adopted ancestors, was the common form for fine Moche ceramics, modeled as an effigy and/or painted with

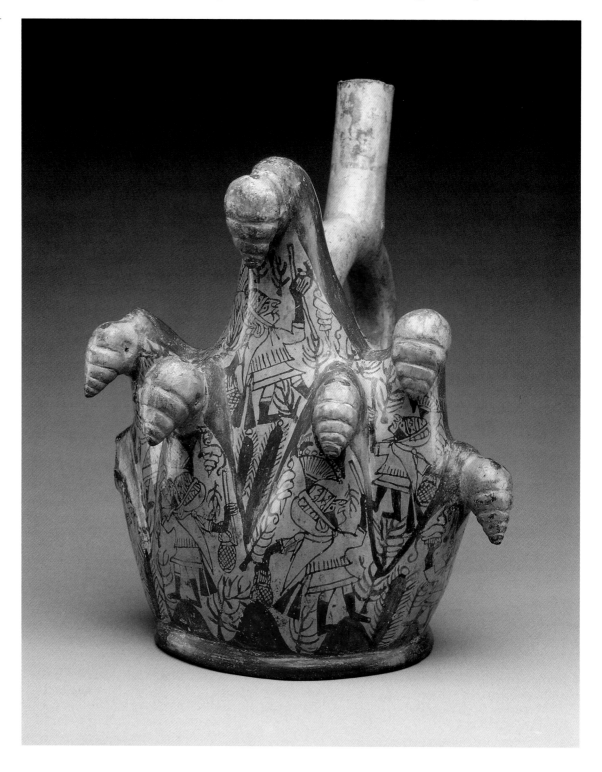

Fig. 2 Vessel depicting seven-peaked mountain. Peru, Moche, 250/550. Ceramic. Museo Nacional de Antropología y Arqueología, Lima. Photo: Dirk Bakker. Land snails, which are still eaten today, were hunted in the mountains in a ritual involving figures in priestly dress. (Cat. no. 181)

lively drawings. This form existed in pre-Moche times in the sierra and on the eastern slopes of the Andes, as well as on the coast.

In the Andes today, analogies are made between the parts of the human body and the parts of mountains, and important rocks are thought to have once been people. Some Moche vessels show five mountain peaks, like stubby fingers of a hand. Often, these finger-mountains surround a rite of human sacrifice, in which a figure with down-flowing hair sprawls supine on the top of the pot; this scene may illustrate the origin of a river. A god is seated at one side like a sculpture or a deified ancestor turned to stone. He is probably the creator god, successor to a deity of the last millennium BC at the highland site of Chavín de Huántar on the eastern slopes of the Andes, an apparent place of pilgrimage for the Moche. The active, snake-belted, fanged god in Moche art may also be an aspect or a son of the deity of the mountain scenes (see fig. 7); he is most probably the sun, which comes down to the coast every

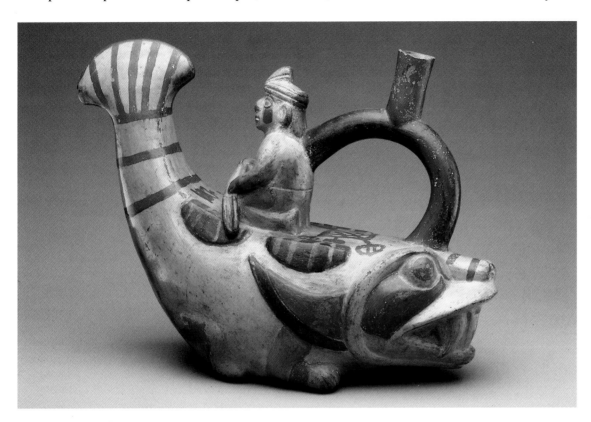

Fig. 3 Figure paddling raft in the form of supernatural fish, probably representing the sea. Peru, Moche, 250/550. Ceramic. Museo Nacional de Antropología y Arqueología, Lima. Photo: Dirk Bakker. (Cat. no. 180)

Fig. 4 Reed rafts at Huanchaco, north coast Peru. Photo: Elizabeth P. Benson.

Fig. 5 Drawing of vessel with raft motif. Peru, Moche, 250/550. The Art Institute of Chicago.

Fig. 6 Drawing of vessel depicting sea-lion hunt. Peru, Moche, 250/550. Drawing: Donna McClelland, in Donnan, 1978, p. 32.

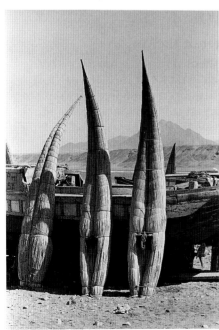

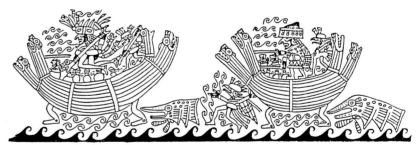

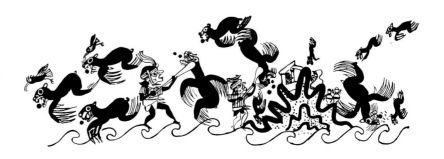

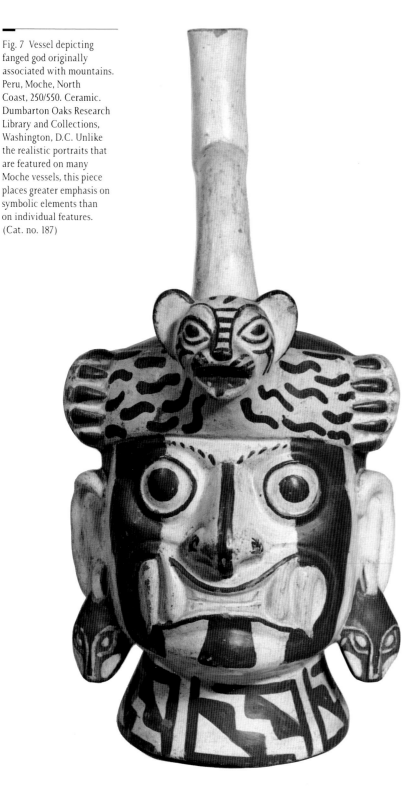

seaward end of the valley. (The even-more-powerful, later Chimú empire was even closer to the sea, on open land at the northern end of the valley.)

Moche art evinces, on many levels, the importance of the contact with the highlands and beyond. Llamas, for example, are highland animals, but they were bred on the coast and used as beasts of burden in interaltitude trade; both their physical remains and their effigies appear in coastal burials.[8] Jaguars, whose preferred territory is moist lowland forest like that on the far side of the Andes, may have been brought to the coast as cubs and kept by shamans, along with native coastal pampas cats, for ritual occasions (see figs. 8, 9). These powerful, symbolic felines are portrayed by Moche artists in confrontation or coexistence with man, as predators or protectors. Snakes are present on the coast, but Moche serpentine imagery sometimes incorporates the gigantic Amazonian anaconda. Moche rulers can be depicted with serpents painted on their headdresses, and often both men and gods wear pairs of these regeneration symbols on their collars (see fig. 13). Monkeys, native to the Amazon region and southern Ecuador, are depicted most often with the bag and the pendant-disk ear ornaments of human participants in a coca-leaf-chewing ritual. Monkeys may have been associated in myth with the origins of coca and the first Moche possession of the leaf. Coca, a sacred substance in the Andes, an aid to high-altitude labor and hunger repression, probably originated on the eastern slopes of the mountains, although there is a long archaeological record of the plant on the coast, and it is still grown in some north-coastal valleys.[9]

The Center of the World

At the southern side of the Moche valley, the so-called Pyramid of the Sun rises forty meters high and three hundred fifty meters long, the largest solid adobe structure in the Americas (see fig. 10); it was probably three times as large before Spanish explorers diverted the Moche river to destroy the mound in their search for gold.[10] Across a plain, which once contained structures and cemeteries, is a group of long, low, palace-type structures, known collectively today as the Pyramid of the Moon; these are placed at the base and on the lower slopes of a steep, sandy hill, Cerro Blanco, at the shoreward end of the foothills (see fig. 11). The entire site seems to be laid out in relation to the hill, on whose summit offerings have been found. The

day, as well as the culture hero who slayed sea monsters.

Architecture and sculpture of Chavín style remaining along the coast include examples at Caballo Muerto, located where the Moche Valley narrows as the mountains approach.[6] Cerro Orejas, across the valley neck, was probably the seat of Moche authority at the beginning of the Moche rise to power.[7] In the years of decline, the Moche returned to this region, after a florescence at the wide,

huge, fabricated hill, the Pyramid of the Sun, faces the natural sacred hill and the Pyramid of the Moon. Early in this century, the Pyramid of the Moon still had Moche paintings of myth and rite. Most of these no longer exist, although some of a later period remain.[11] The Pyramid of the Moon was likely the residence of the ruler and perhaps the religious center of the site—even of the whole Moche polity.[12] The Pyramid of the Sun, which was built over a considerable period of time, has domestic remains on and near it; it may well have been the center of community life, as well as a place of pilgrimage. The two large pyramids, placed near but not on the best fields of the valley, are close to the river, with its plant and animal resources and its fresh water for domestic use and irrigation. The structures are also close to the sea and the long-used,

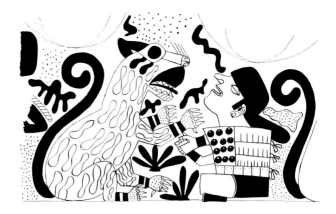

north-south route along the coast, and near an east-west coast-highland route. The site of Moche and its valley must have been considered the center of the world of its thriving inhabitants, as they increasingly controlled other coastal valleys and uplands.

Fig. 8 Drawing of detail of vessel depicting man facing jaguar. Peru, Moche, 250/550. The Art Institute of Chicago. (Cat. no. 178)

Fig. 9 Vessel depicting seated ruler with pampas cat. Peru, Moche, 250/550. Ceramic. The Art Institute of Chicago. (Cat. no. 174)

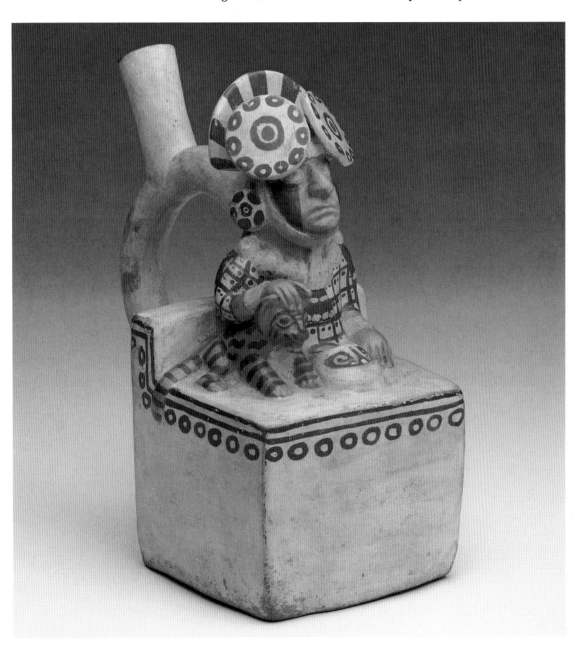

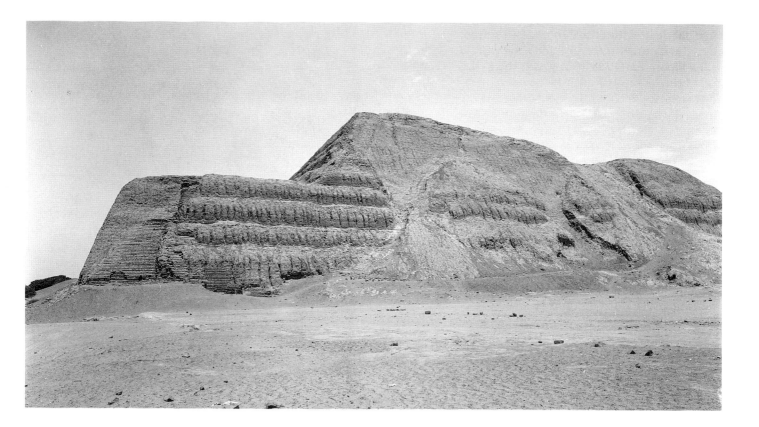

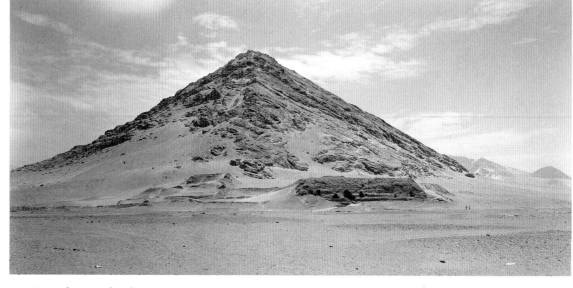

Fig. 10 Pyramid of the
Sun. Peru, Moche, 1/700.
Photo: Edward Ranney.
The Pyramid of the Sun, as
it has been called since
the nineteenth century, was
reduced to less than half
its original volume when
a river was redirected
to erode one side in a
Spanish colonial search
for gold objects within the
pyramid. Today it rises
forty meters above the river
valley. Tiered platforms
were built in unbonded
stacks of adobe bricks by
contributing communities.

Fig. 11 Pyramid of the
Moon. Peru, Moche, 1/700.
Photo: Edward Ranney.
The so-called Pyramid of
the Moon is formed by
adobe platforms extending
from the rock-bound hill.
Chambers and open courts
are part of this temple
complex.

How the Moche domain developed and
was governed is not yet fully known.[13] Before
the Moche polity, the region had been occu-
pied for more than two thousand years by
societies with large-scale, ritual architecture
and irrigation systems for agriculture.[14]
Moche culture combined the coastal inheri-
tance with more intense intercourse with the
highlands and the tropical forests beyond,
and probably with what is now Ecuador, to
the north. The Moche conquered new lands
for cultivation, control of irrigation water
and sea coast, and the acquisition of re-
sources and probably also of sacred places.
Although the pattern of conquest and move-
ment is not clear, Moche remains are found
in many northern coastal valleys. Some of
the finest Moche goldwork comes from Loma
Negra in far-northern Peru. Rich burials
recently excavated at Sipán, north of the
Moche Valley, also contained splendid Moche
gold artifacts.[15] The remains of chieftains
were richly garbed in gold jewelry — masks,
headdresses, necklaces, ear ornaments, and
other appurtenances — symbols of regen-
eration for their continued life in the other
world. Stylized human representations ap-
peared, as well as fanged-mouth faces. The
Moche expanded to the south in a valley-to-
valley progression, as their power and need

increased. All of these valleys had river water from the mountains, as well as level land for cultivation. Moche textiles have been found as far south as the Huarmey Valley; the southernmost Moche architecture occurs in the Nepeña Valley at Pañamarca, a city once richly decorated with mural paintings of ritual or myth.[16] In each conquered valley, the Moche placed one or more ceremonial/administrative centers, usually constructing them on or near a place that was already sacred.[17]

The World in Art

The Moche ritual activity depicted on pottery was surely directed toward the gods of nature for the furthering of agricultural and fishing success to feed a growing population. Vegetation is a common motif in Moche art. Effigy vessels may depict realistic vegetables, but vegetables also had specific supernatural identities with ranked status: maize could be portrayed with an emergent deity head and squash with an owl head; beans are shown as warriors, and potatoes have the faces of captives or diseased people. Gold necklace beads from a Sipán burial took the form of peanuts.[18] A pod or fruit that floats in scenes or adorns accessories is known as *ullucho*; recently identified as a relative of papaya, it is believed to have been used by the Moche as an anticoagulant when drinking blood in sacrificial rites.[19] Some writers think that the designs on beans shown on pottery were a kind of script, possibly for auguries.[20] In many Moche pottery scenes, various kinds of vegetation float in space with roots attached. Trees and plants appear in deer-hunt-ritual depictions, in which priestly figures accompany well-dressed hunters as they pursue a speared deer; sometimes the hunter is a god. Deer, which had been hunted by the sacred ancestors, had agricultural symbolism for settled farmers: the buck's antlers, which resemble tree branches, grow like vegetal matter, along with the agricultural cycle; they fall off and begin to grow again as the new crops sprout. A group of pots showing a ritual scene portrays a god and certain humans dressed in garments worn otherwise only by deer hunters. This rite was surely related to the deer hunt. In one example (fig. 13), the nose-ornamented god, standing on a platform and holding a spear-thrower, receives from the most prominent human figure a goblet, perhaps containing the blood of the deer. The man wears a jaguar headdress and holds a disk or plate like that seen in other sacrificial scenes. An armless, modeled

figure on top of the vessel is dressed in garments like those of certain figures in the painted scene. Disfigured men often served as priests in rituals,[21] for they were thought to have special powers.

Irrigation canals control and distribute water when the Moche River runs full from December to March; other northern valleys have similar systems. The cleaning and seasonal opening of the canals must have been occasion for Moche rituals, as they have been in recorded history. The Moche made roads as well as canals, and, in many ceramic scenes,

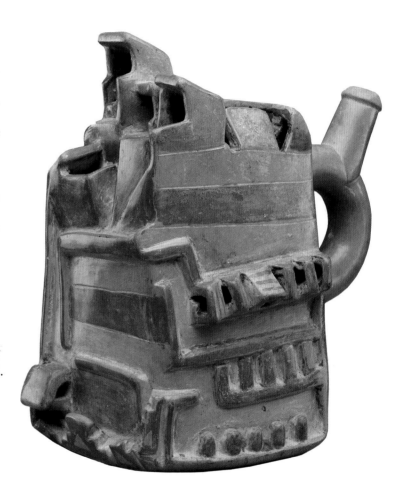

Fig. 12 Vessel depicting cultivated landscape or pyramid. Peru, Moche, 250/550. Ceramic. Museo Nacional de Antropología y Arqueología, Lima. Photo: Dirk Bakker. Upper structures overlook terraces and walled compounds with outlying buildings and granaries. (Cat. no. 183)

runners sprint through sandy landscapes (see fig. 17) that often have various kinds of vegetation. Effigy vessels and "deck" figures above painted scenes depict a runner tying on his distinctive headdress. Some of the finest Moche gold jewelry is related to this activity: the distinctive runners' headdresses and inlaid ear ornaments depicting the runners. On two vessels from the Museum für Völkerkunde in Berlin, the runners' destination is shown — a temple platform, in one case inhabited by a god. On many pots, the runners are anthropozoomorphs, beings of the "other" world.

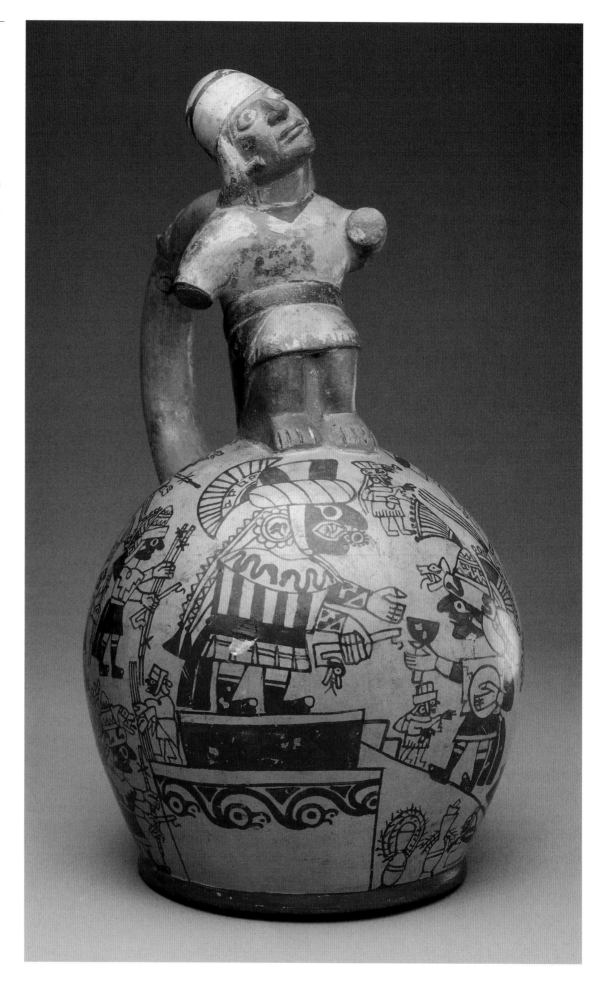

Fig. 13 Vessel depicting scene related to ritual deer hunt, with mutilated priestly figure at top. Peru, Moche, 250/550. Ceramic. Museo Nacional de Antropología y Arqueología, Lima. Photo: Dirk Bakker. Moche artists often combined sculptural figures and lively drawing to narrate selected episodes of mythical, historical, or ritual events. (Cat. no. 182)

Warriors also run through the desert. They appear as single figures or in procession; they fight in hand-to-hand combat or lead captives to be presented to officials. A captive was stripped, and his gear and garments were bundled and displayed as a symbol of his conqueror's triumph. Weapons or garments can be animated, as they are in one of the Pyramid of the Moon murals. Like the runners, some warrior figures have the heads and other attributes of animals: prominent are owls, eagles, hummingbirds, jaguars, and foxes—some are local creatures, some exotic, but all were animals with traits to be emulated by successful warriors. Human and anthropomorphic warriors are also depicted as effigy vessels (see fig. 15), often kneeling on one knee and holding a war club in a seemingly ceremonial pose.

A gigantic, anthropomorphic owl symbolized the chief Moche warrior or god of war; he is not shown in battle scenes, but he sometimes appears with a diminutive human warrior.[22] The figure is usually based on the great horned owl or the barn owl, both of which are prominent nocturnal predators on the coast.[23] Human warriors often wear the distinctive headdress and small-plate armor of this figure, and captives may also be dressed in his garb. Captives taken in warfare were surely sacrificed to the gods, and an anthropomorphic owl was the chief sacrificer, who dispatched the victim to the dark underworld. The sacrificer is depicted either holding a knife and a decapitated head or about to slit the throat of a small human figure. The only Moche portrayals in which a mask is clearly worn are those of an owl imitator who holds the head but not the knife and is not seen in the act of decapitation. A frequent question in descriptions of ancient American art is whether anthropozoomorphs are supernatural mixtures of human and animal, animal alter egos, ritually masked humans, or depictions of a person who, by donning the mask, becomes the creature. Transformation was and is an important religious concept; both human beings and gods have animal alter egos, and modern folk tales about the ease of animal-human transformation suggest that most Moche anthropozoomorphs were more than masked figures. Many animal depictions are polymorphs, assembled from significant attributes of various creatures—jaguar and scorpion, serpent and deer, etc. One creature is known as the Moon Animal; different versions of it seem to derive from different animal prototypes—jaguar, fox, etc., mixed with human or other

traits, and distinguished by spiral extensions from the head and often from the tail. An example of a related creature (fig. 16) seems to be bat-derived.

It is not clear whether pottery battle scenes show actual historical battles, re-enactments of ancient history or myth, ceremonial warfare to take captives for sacrifice,

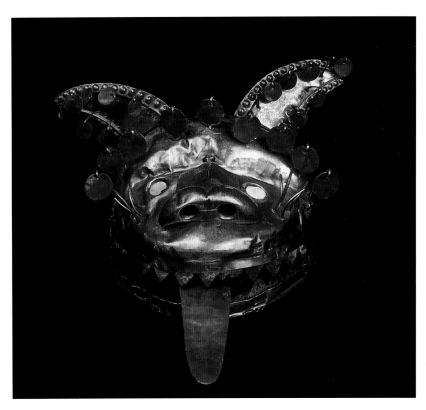

initiation rites, or a combination of these. In different clusters of scenes, warriors wear diverse garb and are surrounded by distinct symbolic imagery. One group of battle scenes is related to the coca-leaf ritual, which involved human sacrifice, probably of captives. Some of the warriors in this complex wear headgear featuring upraised jaguar paws (see fig. 15).

Death and a probable afterlife are the subject of many Moche ceramics on which partially skeletal figures dance and play musical instruments—panpipes, flutes, drums, and trumpets that sometimes take serpentine or feline form. According to an early Spanish missionary in Peru, the Indians believed "that the dead feel, eat and drink."[24] Death is a part of the cyclical process of life: the sun drowns in the sea and is reborn in the east; vegetation dies and is regenerated. Moche depictions of petting and skeletal human figures with sex organs may imply continuity and fertility.

Although data on Moche astronomy is lacking, portrayals of radiant figures, rayed

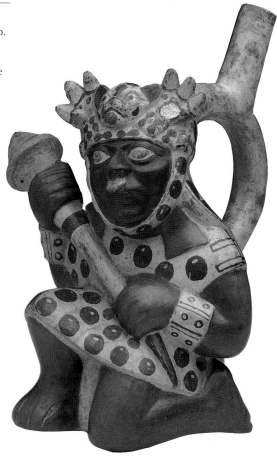

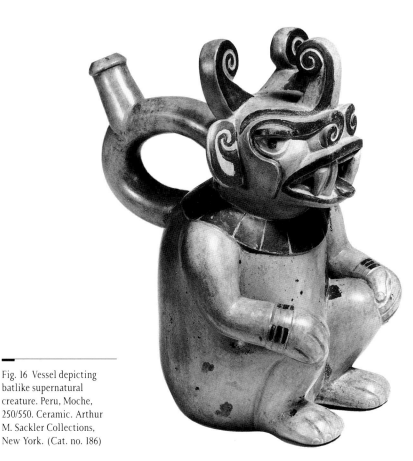

litters, and double-headed-serpent skybands surely had astronomical/astrological import. The snake-belt deity—whose belt can be read as a skyband—was probably the sun, among other aspects. During the latter part of the Moche period, a warrior with radiances emanating from his body was introduced as a prominent figure, probably a different manifestation of the sun. Later, Inca rulers saw themselves as earthly incarnations of the solar being; it seems likely that similar political manipulation of the most important celestial body occurred in Moche history. Other sky phenomena must have been represented as well. Today, the heliacal rise and set of the Pleiades mark fishing and agricultural cycles on the north coast.[25] Both the Southern Cross and Venus are significant in recent South American lore and probably match up with Moche deity figures, although it is difficult to fix identifications.

All media of Moche art expressed beliefs about their world. Cloth, which had great value and significance in the Andes, displayed cosmological beliefs (see Paul and Stone-Miller essays in this book), but few Moche textiles have been preserved, and these are often in poor condition. One textile (fig. 19) presents an alignment of four regal figures with plumed headdresses and bird-staffs, between lines of birds and a fringe of felines and serpents. On another textile (fig. 18), a frontal figure is repeated, flanked by two figures who seem to be holding a skyband over the central figure's head. Architecture made cosmological statements in orientation and decoration that are no longer obvious. Mural painting, confined to certain contexts, was more limited in subject matter than pottery, although some of the same mythic and ritual themes occur in recorded examples. Stone was uncommon in the natural environment, and large sculpture is lacking. Most Moche goldwork was destroyed by the Spaniards, but what metallurgy remains displays great technical skill and inventiveness in its representations of themes that signify cosmology and rulership. In contrast to Old World uses of bronze and iron for weapons, carriages, and implements, New World metallurgy was largely used for ritual objects and adornments that declared the religious and political status of the wearer and the symbolic value of the offering.[26] Moche metallurgy clearly reflects this attitude.

Pottery is Moche's most abundant art. It was considered a sacred substance. Clay came from the earth, which was home to the

Fig. 17 Vessel depicting ritual runners. Peru, Moche, 250/550. Ceramic. The Art Institute of Chicago. (Cat. no. 173)

ancestors and to the living roots of plants; it was mixed with water and fired. The most basic and sacred elements went into the manufacture of pottery, which held nourishment for people and gods. The finest creative energy was engaged to make elaborate ceramics depicting important religious concepts. Jugs often have a tie painted around the neck, or a face is added at the top; the body of a vessel becomes that of a person, an animal, or a bird. Pottery itself appears in many scenes as a symbolic element (see fig. 13). Complex painted scenes present an ordered world in which important figures are enlarged and centered, and all elements have a proper place.

The Nature of the World

Moche art is often described as portraying "everyday life." Superb portraits of rulers reveal what they looked like (see fig. 1); clothing, accessories, and gesture specified not only status but the role and the ritual occasion in which the subject was participating. Animals were portrayed naturalistically;

they were also metaphors. Frogs and toads, associated with water and agricultural fertility, can be rendered with realism; but some sprout vegetation or have serpent or jaguar traits. Two types of houses are depicted on Moche vessels; their construction techniques are still used today. Because there is rarely rain in this climate, some eight degrees from the Equator, a simple house is made of matting supported by wooden poles. Adobe houses are also erected—clay is common in the Moche Valley—and Moche ceramic vessels sometimes show adobe structures of considerable complexity (see fig. 12). Some of these may have had significance as models of temples or of the cosmic house. The structures can have roof ornaments of war clubs, snakes, felines, or a step motif—a symbol of status or sacredness, perhaps deriving from the shapes of mountains. These simple houses, often inhabited by priestly figures, seem to denote ritual.

We have little documented proof of Moche beliefs, but, from what is known of Moche art, of other cultures in the Americas,

Fig. 18 Royal mantle. Peru, Moche, Lambayeque, 250/550. Textile. Bentley-Dillard Collection, Las Vegas. Virtually identical figures hold an arched panel and are enframed by attendants repeated with minor variations. In its abstract approach to the figure and use of overall patterning, this textile departs from the naturalistic style of Moche ceramic sculptures. (Cat. no. 188)

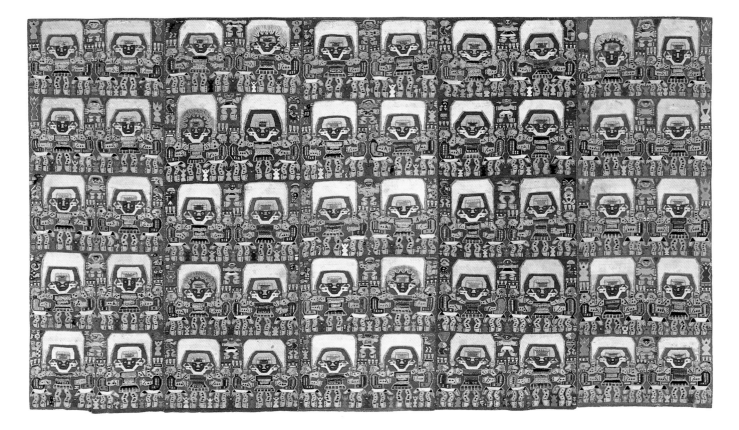

and of civilizations at a similar stage in other parts of the world, assumptions can be made about Moche social structure and cosmology. There were sacred, mythological ancestors for the group and/or its ruler (the snake-belt god copulated with a Moche woman); rulers had supernatural ties, reinforced through rituals in which they took part; noblemen, warriors, administrators, priest-shamans, and specialized artisans functioned under the ruler; traders traveled distances for the goods of different environments, or foreigners brought goods in; at the base of the social structure, large labor resources dug canals, maintained roads, made and hauled adobe bricks, raised monuments, and produced food. A complex ritual life reflected a complex mythology, inherited from the past,

adapted to the present, and coordinated with agricultural and ritual calendars and with political expediency. Warfare—a major motif in the art—was ritual as well as political. In the Moche world, all objects had life; everything had animation, power, depths of meaning, and serious reason for being represented. A cosmological aspect was probably always embedded in even the most naturalistic representations. The "other" world was rooted in nature, in plants and animals, the sea and the mountains, the desert and the water. Moche art demonstrates that everyday reality and the "other" were intertwined parts of a whole; the multi-faceted world of their extended physical environment was the cause of, and companion to, their complex cosmology.

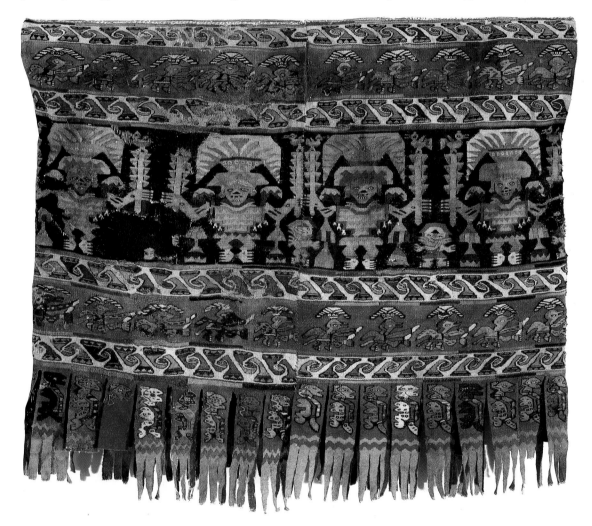

Fig. 19 Royal tunic. Peru, Moche, 250/550. Camelid wool and cotton. Private collection. Like the mantle in fig. 18, this tunic may have been produced late in the Moche period. Repeated images of animal-masked creatures on Moche textiles anticipate the highly repetitious, patterned art of Chimú on the north coast of Peru. (Cat. no. 179)

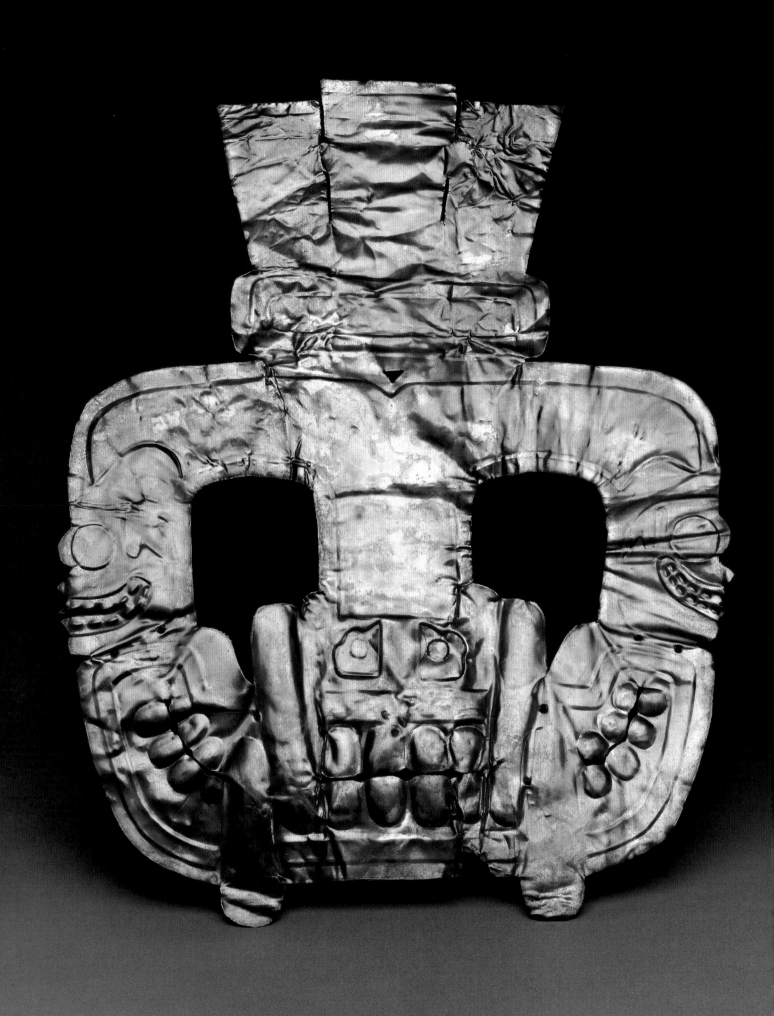

TIWANAKU: THE CITY
AT THE CENTER

Introduction

The mystique of the city of Tiwanaku in late pre-Hispanic Andean society was intimately associated with its role as a place of origin in cosmogonic myths. According to the sixteenth-century accounts of Betanzos, Sarmiento, and Molina, it was in Tiwanaku that the creator god Viracocha ordained a new social order, and it was from Tiwanaku that the primeval couple was sent out along symmetrically opposed migratory paths to call forth the nations of the Andean world from springs and rivers, rocks and trees.

Tiwanaku was founded on the Andean altiplano, or high plateau, near the southern shores of Lake Titicaca, an inland sea ringed by glaciated mountain peaks. In the ancient Andean world, Lake Titicaca was the sacred locus for many indigenous myths of creation. Early Spanish chronicles relate that native Aymara Indians referred to the fertile axis formed by the lake as *taypi*, the essential conceptual and physical zone of convergence between the principles of *urco* (associated with west, highlands, dryness, pastoralism, celestialness, and masculinity) and *uma* (associated with east, lowlands, wetness, agriculture, underworld, and femininity). These qualities were constantly re-experienced in reality, embedded in salient physical and symbolic characteristics of the environment.

The altiplano dweller can gaze westward from atop the Chila mountain range above the valley of Tiwanaku toward the immense, high, arid plains of the *urcosuyo* countryside. From a high pass on Mount Illampu, across the lake, east of Tiwanaku, one can look down toward the *yungas*, the cloud-shrouded valleys on the eastern slopes of the Andean chain, the lands of the *umasuyo*. From either vantage point, the glistening, cobalt-blue sur-

face of the lake marks the axis of ecological transition from one zone to another. The continuity and orderliness of the cosmos demanded that these complementary, opposing principles of *uma* and *urco*—an interwoven skein of natural and cultural qualities—be brought into creative conjunction, that the structural fault line between them be seamed in some fashion. This was the conceptual role of *taypi*, and Tiwanaku was its central representation. According to the chronicler Bernabé Cobo, the true name of Tiwanaku was Taypikhala, in Aymara, "the stone in the center."[1] Such a name had a geocentric and ethnocentric meaning signifying that the city was conceived not only as the political capital of the state but also as the central point of the universe.

At its apogee, Tiwanaku was not simply an altiplano village writ large. The city's conceptual and social roots resided in the fundamental organizational forms of *ayllu*

Fig. 1 Fanged skull mask. Bolivia, Tiwanaku, 400/800. Silver. Museo de Metales Preciosos Precolombinos, La Paz. Photo: Dirk Bakker. This fearsome mask combines human skull and feline motifs into a powerful, abstract composition. In Tiwanaku art, as in the larger Andean tradition, emphasis was placed on images as visual metaphors of ideas, rather than as naturalistic representations. (Cat. no. 270)

Fig. 2 View of the Island of the Sun in Lake Titicaca, Bolivia. Photo: Johan Reinhard.

(lineage) and moiety relationships that undergirded native Andean civilization. Gaining religious prestige as the paradigmatic ceremonial center of the high plateau, Tiwanaku was transformed qualitatively: it became, in Lewis Mumford's words, "a new symbolic world, representing not only a people, but a whole cosmos and its gods."[2] Structuring the city according to cosmic principles extended to its physical form, and, more importantly, to those who created it.

Tiwanaku, especially its civic/ceremonial core, was a regal city, redolent with the symbolism of power, both sacred and secular. It was the principal seat of its ruling lineages, the locus of the royal court, and the holiest shrine of the imperial religion. Simultaneously, the city was an icon of Tiwanaku rule and a cosmogram that displayed symbolically, in the spatial arrangement of public architecture and sculpture, the structure that framed the natural and social orders. Conceived as the *axis mundi*, it was the ultimate nexus of wealth and power, social identity and prestige, cult and command.

The architectural form of Tiwanaku, together with its public ensemble of monumental stone sculptures, intensified the mythic aura of the city (see figs. 3, 4, 5, 6). The ceremonial core of Tiwanaku was surrounded by an immense artificial moat that restricted easy access to its centrally located public buildings (see fig. 8), recalling the encircling fortress walls protecting an enceinte in medieval Europe. The intent behind this shaping of the high-status, urban landscape by a physical barrier of water was not, however, to provide the Tiwanaku elite with a defensive structure against marauding barbarians or the potentially hostile lower classes of the city, as Arthur Posnansky believed.[3] Rather, the concept evoked the image of the city core as an island—but not a common, generic island. At the cost of a huge investment in human labor, an image was created of the sacred islands of Lake Titicaca, the mythic *situs* of world creation and human emergence. The moat was a dramatic visual cue that emphasized the ritually charged nature of the social actions played out in the center. Going from the landlocked outer ring of Tiwanaku's vernacular architecture across the moat into its interior island circle of temples and elite residences, the visitor to the city moved from the space and time of ordinary life to the space and time of the sacred. The interior core was a human re-creation, or, perhaps more aptly, re-representation, of the space and time of human origins.

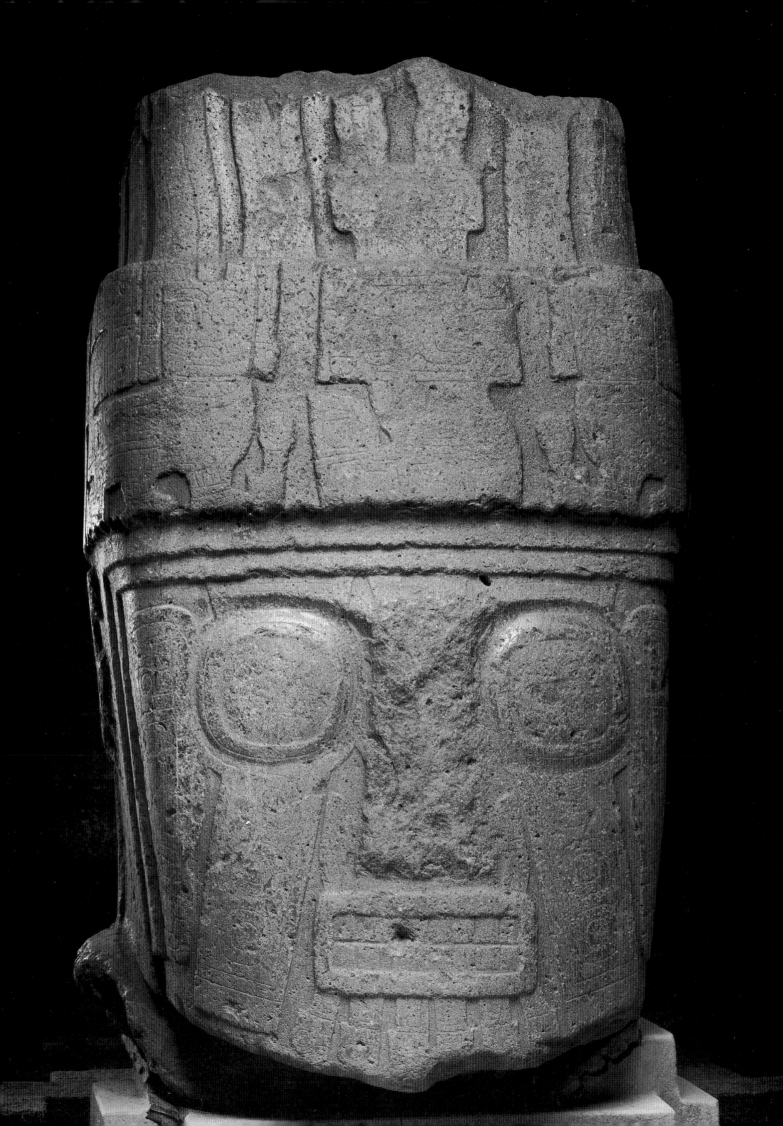

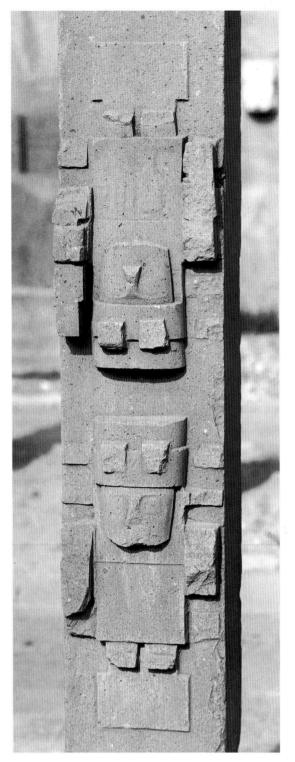

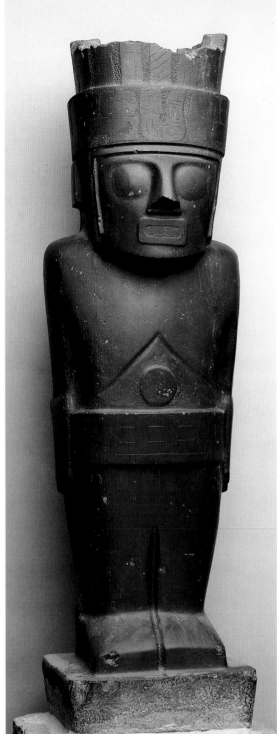

In the Andean world, as in many other cosmologies, the time of origins was not a vague, distant historical event to be commemorated in yearly ceremony. Rather, cosmological time was cyclical, regenerative, and re-created by human agency; the time of origins was past, present, and anticipated to recur in the future. Humans existed in this sacred time, as well as in the profane time of daily life. The ceremonial core of Tiwanaku was the theatrical setting for the recurrent social construction of cosmological order.

The parallel message in this architectonic text was the appropriation of sacred time, space, and activity by the Tiwanaku elite. Within the ceremonial core were constructed not only the principal temples of the city but also the palatial residences of the ruling class. By living within this sacred inner precinct, the elite were claiming for themselves the right (and assuming the obligation) to intercede on behalf of society with the supernatural in order to maintain harmony in the natural and social orders. The elite lineages

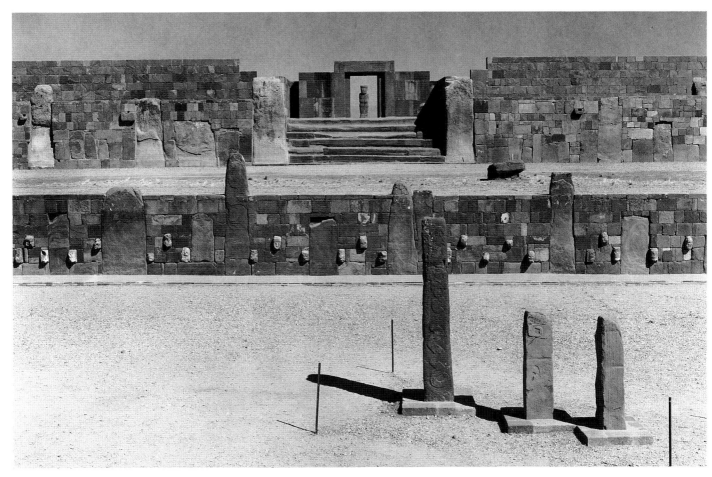

conjoined historical time (the linear experience of time lived here and now) with cosmogonic time (the cyclical, regenerative time of myth). As Robert Ellwood has suggested, the figure of the king—and the symbolic process of kingly accession—played the pivotal role in merging the powers of myth and history on behalf of society in the archaic world:

> [Kingly accession] brought the cyclical eternal-return time of nature and its seasons together with time as history, the time of society which could only approximate repeating itself in the line of kings. Fundamentally, then, the rite of accession is an act of civilization. However primitive the society, it catches up the temporal paradox which underwrites civilization. The rites seek to impose upon human society a continuity with nature.[4]

Lacking indigenous texts, we have no access to the names of Tiwanaku's kings, their lineages, or their individual deeds, but the architectural and sculptural arrangements within the core of their capital city permit us to reconstruct a plausible theory regarding the meaning of the built environment of which

they were the principal authors and patrons. This, in turn, gives us insight into the nature of rulership at Tiwanaku.

Sacred Geography and Urban Design

To the tourist, Tiwanaku appears as a city without an obvious plan. A few monumental stone structures loom isolated above the surface (see fig. 7), as dramatic landmarks in an otherwise seemingly featureless plain covered by *ichu*, the tough bunch grass of the high plateau. Drawn to these salient monuments, the tourist's invariant path toward them cuts across the ancient circulation, now interred beneath the surface. Yet the ground undulates; ancient public plazas and private courtyards persist in vague tracery. Weathered stone pillars project from the earth, marking the corners of ruined buildings now deeply buried under the fine-grained sediment of erosion from ancient adobe structures and from the surrounding mountainous landscape, deposited over centuries. Although much of what was once the internal urban order of Tiwanaku is obscure, sight lines remain along walls and between structures. Enormous segments of polished sandstone, granite, and andesite drains, sophisticated technological artifacts from Tiwanaku's system of fresh water supply,

Fig. 7 Sunken plaza and ceremonial gate in the Kalasasaya building complex, at Tiwanaku, Bolivia, 400/800. Photo: Richard Townsend. The gate is aligned to frame the rising and setting sun on equinoctial days.

lie scattered, with no immediately understandable relationship to one another. Ironically, only the intact, deeply buried network of subterranean sewer lines offers clues to the original plan of the city's hydraulic infrastructure.

Despite the physical impediments to deciphering the morphology of the ancient city, the underlying concepts of social order that brought form to Tiwanaku are emerging from the cumulative evidence of systematic archaeological research that began in 1957 under the aegis of Bolivia's Centro de Investigaciones Arqueológicas en Tiwanaku (CIAT), subsequently incorporated into the Instituto Nacional de Arqueología de Bolivia (INAR), which was founded and directed for many years by Carlos Ponce Sanginés. We can now extract some of the organizing principles that structured the capital, and we can trace those that carried over to the design of Tiwanaku's satellite cities.

The Concentric Cline of the Sacred

We have alluded to the civic/ceremonial core of the city as the image of the sacred island of universal origins and human emergence. Tiwanaku's moat demarcated the concentrated, sacred essence of the city, acting as a psychological and physical barrier, setting up by its shape, dimensions, and symbolic representation a concentric hierarchy of space and time (passage across the moat represented change, a movement into the place and time of ethnic origins). An inherent contradiction must have been clear to the people of Tiwanaku: the central island of cosmogonic myth was believed to be the point of origins for *all* humans, but only *some* humans, the elite of Tiwanaku society, appropriated the special right of residence in this sacred core. Social inequality and hierarchy were encoded in Tiwanaku's urban form.

This principle of urban order at Tiwanaku might be described as a concentric cline, or gradation, of sacredness that diminished in intensity from the city core to its peripheries. Within this framework of urban order, keyed to conceptions of the sacred, the inhabitants of Tiwanaku occupied physical space in accordance with their relative social and ritual status. At the highest level, ritual status was identified and partially merged with political authority. Not surprisingly, the upper echelons of the Tiwanaku elite monopolized the innermost (and most sacred) core of their artificial island enceinte for their residences. The notion that there was some image of concentricity in the mind of the people of Tiwanaku that shaped conceptions of "proper order" within their capital is reinforced by the presence of two additional, although partial, moats situated to the east of the primary moat. It is possible that these moats drained

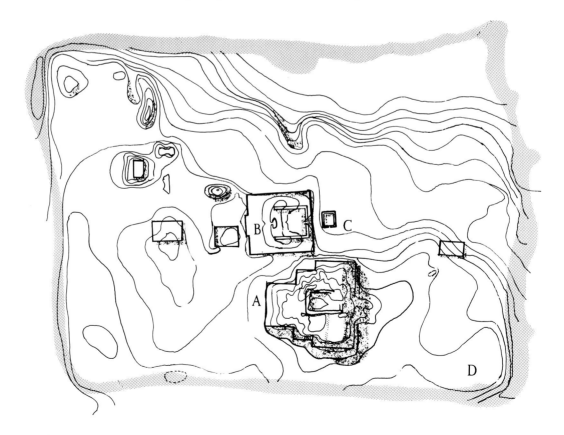

Fig. 8 Plan of ceremonial core of Tiwanaku, Bolivia, 400/800. Drawing: Carlos Fuentes Sánchez. The moat encircling the sacred precinct designated the center as a symbolic island. Myths recorded in the sixteenth century describe Tiwanaku as a place of origin—the site of the birth of the sun.

Legend
A. Akapana
B. Kalasasaya
C. Sunken courtyard
D. Moat surrounding the inner precincts

excess groundwater and seasonal rainfall from inhabited portions of the urban landscape. However, given our interpretation of Tiwanaku's principal moat, we suggest that the essential purpose of the peripheral moats was to symbolically mark social boundaries, to differentiate further the ritual status of the urban residents by their relative positions along the concentric cline of the sacred. Movement from the east of Tiwanaku toward the civic/ceremonial core of the city, then, entailed passage across a nested, hierarchical series of socially and ritually demarcated spaces.

Cities and urban design played a distinct role in the agrarian world of archaic states. These were fundamentally nonurban, or even antiurban, societies. The bulk of the population resided in the countryside, dispersed in small villages. The dominant social reality was one that turned on the cyclical, seasonal rhythms of rural life, radically removed from the cosmopolitan world of the elite. Cities were few and, consequently, exceptionally special. Most were centers of pilgrimage for the inhabitants of the countryside, a necessary nexus of religious tourism and venal commercialism. At the same time, they were the focal points of publically expressed concepts of universal order. To exert moral authority over the rural hinterlands, the cities needed an immediately understandable design that directly stated a sense of humanity's (and, more specifically, the ethnic group's) place in the world. Ironically, this sense of place evoked a rural sensibility. The life of the farms and the fields provided the model for the relationship between people and nature that profoundly influenced the internal design and social order of the city. The symbolic text written into the design of these cities attempted to identify or to harmonize the productive (yet potentially destructive) forces of nature with the culturally created order of society.

The Solar Path:
From Mountains to the Lake

A second principle of urban organization at Tiwanaku crosscuts the concentric cline of the sacred. This principle derived from cardinality and, more fundamentally, from the path of the sun across the urban landscape. The major structures within the civic/ceremonial core of Tiwanaku are aligned generally to the cardinal directions. The division of the city by an east-west solar axis was not so much a physical, planetary concept as it was a cultural one. The intersection

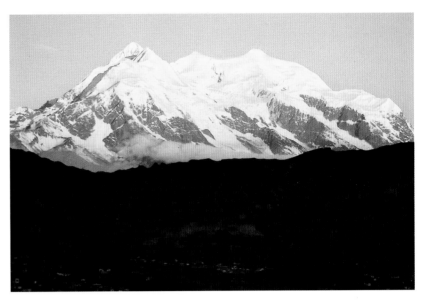

Fig. 9 Illimani, one of Bolivia's sacred mountains overlooking La Paz, is revered today by the Quechua and Aymara Indian populations. Photo: Richard Townsend.

of the solar path with the central point of the city was perceived as the place of union between the earth and the celestial and subterranean worlds. This place was represented physically by the image of the sacred mountain rising from earth to sky; this image was powerfully evoked by the stepped pyramid of the Akapana, Tiwanaku's tallest terraced platform mound.

The solar path that bisected the city emerges from and dissolves back into two salient geographic features to which indigenous peoples in the Valley of Tiwanaku still orient themselves: the glacier-shrouded peaks of the Cordillera Real, particularly the three peaks of Mount Illimani (fig. 9) to the east (the emergent sun) and Lake Titicaca (fig. 2) to the west (the waning, setting sun). The mountains and the lake are visible from the flanks of the mountains that enclose the valley, but both can be glimpsed simultaneously from Tiwanaku only from the summit structures of the Akapana. These must have been embued with symbolic power derived, in part, from this unique visual frame of reference. Only from here could one track the path of the sun from its twin anchors in the mountains and the lake.

That the elite of Tiwanaku were conscious of—and manipulated—this solar element of sacred geography to invest their capital with social and spatio-temporal symbolic meaning seems certain from key aspects of the architectural design of the Akapana and its companion terraced mound to the southwest, the Puma Punku. As Cieza de León recounted, in clear reference to the Akapana and Puma Punku, the doorways of these two towers of the native lords of Tiwanaku face the rising sun.[5] Recent excavations show that each of these structures also had a second staircase,

directly opposite those mentioned by Cieza de León. Axial, twin staircases are constructed centrally in both east and west facades. East-west axial entryways were design features also of the Kalasasaya, Chunchukala, and Putuni complexes in Tiwanaku's civic/ceremonial core. The axial staircases differ dramatically in terms of architectural elaboration. Both sets of western staircases are significantly smaller than their eastern counterparts. Furthermore, the western staircases of the Puma Punku and Putuni complexes lack the elaborate, monumental, carved-stone jambs and lintels that grace the eastern entries. It is likely, although not yet demonstrated archaeologically, that this pattern

applies to the Akapana as well. This architectural treatment implies that these buildings and, more specifically, their points of entry and egress, encode a symbolic or status hierarchy. We suggest that, in Tiwanaku's system of sacred geography, east was of higher status than west and that this hierarchy derived from the symbolism of the solar path: the ascending sun of the east is more energetic and powerful than the waning sun of the west. As with the concentric principle of urban organization, the principle of axiality differentiated social space in Tiwanaku. The solar path divided the city conceptually into two hierarchically ranked segments with distinct symbolic associations: east (upper/celestial/more prestigious) and west (lower/chthonic/less prestigious).

The Twin Ceremonial Centers

Crosscutting the east-west axis of the solar path at Tiwanaku, there was, apparently, a further bipartition of social and symbolic space into northern and southern segments to form a division of Tiwanaku into four quadrants. We can assume that these replicated the four quarters of the known Tiwanaku world. Such a division is common to archaic cities throughout the world, particularly cities of empire.[6] The Inca capital, Cuzco, was organized in this fashion, having been partitioned into two hierarchically ranked sectors, *hanan* Cuzco and *hurin* Cuzco, and further divided into quadrants defined by the four principal roads leading to the provinces.[7] The Cuzco quadripartition rendered the capital a microcosm of the empire, as well as a metaphor for the Inca universe.

Tiwanaku's north-south division may be inferred from the distribution of its two principal terrace-mounds, Akapana (north) and Puma Punku (south) (see fig. 8). They do not stand isolated. Each terraced mound forms the central piece of an orchestrated tableau of sacred architecture and monumental sculpture. The building complex flanking the northeast side of the Akapana is the most complete example of this concentrated ceremonial architecture. The individual elements (Kantatayita, Semisubterranean Temple, Kalasasaya, Chunchukala, and Laka Kollu) were, most likely, constructed at different times, but they were always oriented to, or composed around, the imposing presence of the Akapana platform. These flanking structures, along with the Akapana, were the dramatic theatrical backdrops for some of Tiwanaku's most iconographically rich

and visually arresting sculptures (see figs. 3, 4, 10). It was within the Kalasasaya precinct that six identical gold diadems were unearthed (see fig. 12). These brilliant items of ceremonial dress, and similar diadems and masks recovered elsewhere (see figs. 1, 13), show that the splendor of ritual dramas equalled the achievements of Tiwanaku architects and sculptors.

Although less massive than the Akapana complex, the Puma Punku platform was the visual and, one can infer, symbolic lynchpin of a second, southern, ceremonial complex in the city. The Puma Punku, now virtually in total ruins, is still one of the most beautiful and complex structures ever created in the ancient Andean world. Its principal, eastern entry court was graced by massive, but delicately carved, door jambs and lintels, and by a series of monumental figural sculptures. This court was probably the original location of the justifiably famous monolithic sculpture referred to as the Gateway of the Sun (fig. 11).

If we accept that Tiwanaku was spatially and symbolically partitioned into northern and southern segments, and, if we take as a potential model the dual division of Cuzco into *hanan* and *hurin* segments, this partition reflects patterns of social, economic, political, and religious organization. In Cuzco, each of these two divisions was associated with specific lineages, or *ayllus*, that were ranked according to the degree of their kin relationship with the king and the royal lineage. As Tom Zuidema has noted, these *ayllus*

possessed territorial rights and access to sources of water within the district of Cuzco, and they had certain obligations, such as "funding" the celebration of the agricultural rituals or maintaining a particular *huaca*, or sacred place, according to a complex ceremonial calendar.[8]

John Murra's extensive ethnohistorical research established that a similar principle of dual division of the political landscape operated among the Lupaqa, an Aymara-speaking kingdom of the fifteenth and sixteenth centuries, centered in Tiwanaku's old core territory in the Lake Titicaca basin.[9] Two principal Aymara lords, Qari and Qusi, were the pre-eminent political leaders of the Lupaqa during the mid-sixteenth century. As might be anticipated under a thoroughgoing system of dual division, Qari and Qusi's "kingdom" as a whole, as well as each province, was divided into upper and lower moieties, and two lower-ranking lords ruled at each of these territorial levels.

A Colonial document from 1547 describes the political situation in the village of Tiwanaku as similar to that of the contemporary Lupaqa kingdom.[10] The village and its near hinterland were led by a principal lord named Tikuna, assisted by a second *curaca* named Jichuta, who was of somewhat lower prestige and rank ("la segunda persona"). This is a clear allusion to a moiety system with political and social bipartition. In his 1612 dictionary, the Italian Jesuit Ludovico Bertonio, who lived in Juli, one of the seven *cabeceras* of the Lupaqa, remarked that the

Fig. 11 Gateway of the Sun. Bolivia, Tiwanaku, Kalasasaya complex, 400/800. Photo: Richard Townsend. The gateway displays the sun deity, whose pose may be traced to Chavín. Such quotations from the past suggest a cultural renascence.

Fig. 12 Diadem mask with radiating tassels. Bolivia, Tiwanaku, Kalasasaya complex, 400/800. Gold and turquoise. Museo de Metales Preciosos Precolombinos, La Paz. Photo: Dirk Bakker. (Cat. no. 265)

Aymara names of the complementary moieties were "Alasaa" and "Maassa," and that "all of the pueblos [villages] of the altiplano" possessed this division.[11] This duality persisted in a remarkably integrated and systematic fashion in the village of Tiwanaku into the nineteenth century, as recorded by Adolph Bandelier, who, in 1894, questioned the locals regarding their form of political and social organization:

> The reply came that there were only two [divisions], Arasaya and Masaya. These two groups are geographically divided at the village. Masaya occupies the buildings south, Arasaya those north, of the central square, the dividing line going, ideally, through the center of the plaza from east to west. This geographical division is (at Tiahuanaco) even indicated at church. We saw, when at mass, the principals of the two clusters, each with his staff of office, enter in procession: Masaya walking on the right or south, Arasaya on the left, or north, and take their places in the same order on each side of the altar. After the ceremony they jointly escorted the priest to this home. But we were told also, that there were other allyus (and as many as ten) within the parish. This caused me to inquire for the church books... and I soon found out what I already had suspected, that the two main clusters just named were not kins or clans, but groups of such, perhaps phratries. This is a very ancient arrangement and existed, among other places, at aboriginal Cuzco....[12]

Bandelier proceeded to recount that the church records of local marriages in Tiwanaku, reaching back to 1694, refer to the same Masaya and Arasaya territorial dichotomy.

But the question remains: given their remoteness from each other in time, and to a lesser extent, geography, are we on secure ground in applying principles and practices of spatial and social partitioning from Cuzco and the early Colonial-period Aymara to Tiwanaku? Are these principles historically contingent, or are they the product of fundamental structures of great antiquity and broad geographical distribution in the Andean region? It would seem that the preponderance of the ethnographic and ethnohistorical evidence confirms the latter

proposition, although, as in any circumstance in which we lack primary textual evidence, we can never claim absolute certainty.[13] But, along with other Andeanists who have considered the problem, we would argue that a Lupaqalike social, political, and religious structure of dual division did govern Tiwanaku society and resulted in the urban design of twin ceremonial centers that we can perceive in the capital.

Concepts of sacred geography and the symbolic integration of natural landscapes were clearly strong forces shaping the urban design of Tiwanaku. In a general sense, then, we can conceptualize the plan of Tiwanaku as a circle (the concentric cline of the sacred) within a square (quadripartition). The innermost island enceinte demarcated by Tiwanaku's principal moat was the heart of elite residence and the setting for one of the most important shrines, the Akapana. The island enceinte represented the concentrated essence of the sacred. At the same time, this core was the ceremonial center for Tiwanaku's northern moiety, linking the concentric principle with that of dual division and cardinality. Puma Punku, to the southwest, formed the complementary ceremonial center for the southern moiety.

Tiwanaku's Civic/Ceremonial Core

If there is a single emblem of Tiwanaku elite architectural design, it is the terraced platform mound constructed around an interior sunken court. This form dominates the civic/ceremonial core of Tiwanaku and those of its satellite cities, such as Lukurmata, Pajchiri, Khonko, Wankane, and Oje. At Tiwanaku, the Akapana and Puma Punku, although different in scale and architectural detailing, share this concept, as do, on a less grand scale, the major building complexes of the Kalasasaya, Putuni, Chunchukala, and Kheri Kala. Each complex also shares elaborate carved stone monuments (see fig. 3) and an apparent nonresidential character. For the people of Tiwanaku, the terraced mound and the sunken court were the standard framework for ceremonial display and public religious expression.

Akapana: The Sacred Mountain

Perhaps because of the massive scale of the Akapana, archaeologists early in this century assumed that it was a natural hill, superficially modified by the people of Tiwanaku,[14] but, as recent excavations have demonstrated unequivocally, Cieza de León had it right nearly five hundred years ago, when he described it as "a man-made hill, built on great stone foundations."[15] The Akapana is an entirely artificial construction of transported earth, clay, gravel, and cut stone, stepping up in seven terraces. The design, techniques, and materials of construction are fascinating in themselves, but even more so for the insight they provide into the function and meaning of the structure.

The Akapana conforms to a plan that has been described as one half of an Andean cross, one of the most common, if least understood, elements in Tiwanaku iconography

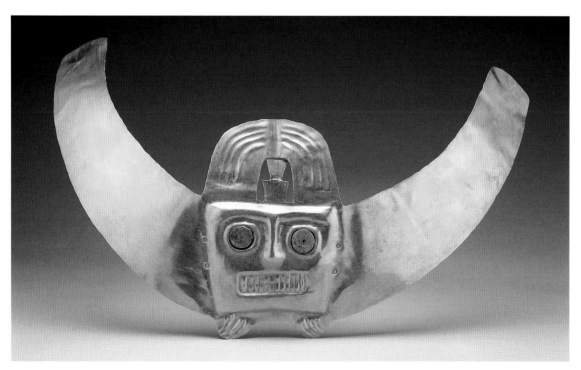

Fig. 13 Winged diadem depicting mask. Bolivia, Tiwanaku, San Sebastian, Cochabamba, 400/800. Gold and turquoise. Museo de Metales Preciosos Precolombinos, La Paz. Photo: Dirk Bakker. (Cat. no. 266)

Fig. 14 Architectural fragment with "gateway" motif. Bolivia, Tiwanaku, 400/800. Stone. Museo Arqueológico Regional de Tiwanaku. Photo: Dirk Bakker. The original placement of this curious sculpture remains a mystery. Sometimes referred to as a "gateway" or "window," its concentric design echoes the plan of the Akapana pyramid. (Cat. no. 277)

(see figs. 8, 14). The Andean cross may be a symbol for the four quarters of the inhabited world. The Akapana is approximately two hundred meters on a side at its maximum extent and rises to nearly seventeen meters in height. The basal terrace is a monumental and strikingly beautiful revetment of cut stone with rounded, beveled edges at the joins between blocks. This massive stone foundation replicates a construction technique employed at the adjacent Kalasasaya complex: vertical pillars were erected at the corners of the structure and every few meters along the facade of the terrace. In the Akapana, these pillars occur at intervals of approximately three-and-one-half meters. Between the pillars, the architects of the Akapana set cut stone blocks in ashlar masonry, precision-joined, without mortar. This gigantic revetment wall was then capped with large, rectangular blocks that projected slightly beyond its vertical face, much like modern coping tiles.

The upper six terraces of the Akapana differ substantially in architectural detail. They lack, for instance, the distinctive beveled edges of the stones employed in the basal terrace and make less frequent use of pillars to mark facade intervals. Instead, these terraces incorporate large, highly visible stone panels into their facades. Based on

similar architectural elements in the Kheri Kala, Kalasasaya, and Kantatayita complexes, we can assume that these panels were covered with iconographically rich metal plaques and textiles, or they may have been carved and painted. The upper terraces, in short, constituted a public, symbolic text, the specific content of which is now irrevocably lost. Given the ritual meaning that we ascribe to the Akapana, these "public texts" most likely referred to the role of this structure in Tiwanaku's cosmogonic myths. Excavations along the upper terraces also recovered tenon-head sculptures of pumas and humans that were, at one time, inserted into the facades, punctuating the flat, vertical surfaces of the terrace walls with gargoylelike projections.

We suggest that the Akapana was conceived by the people of Tiwanaku as their principal emblem of the sacred mountain, a simulacrum of the highly visible, natural mountain *huacas* in the Quimsachata range. The Akapana mimics a mountain, ascending in terraces to dominate visually the urban landscape. Throughout the archaic world, there are countless instances of this kind of mimesis between pyramidal structures and mountain peaks.[16] Moreover, certain structural features of the Akapana intensify the mountain association and, even more specifically, the link between mountains and sources of water.

Recent excavations at the Akapana revealed an unexpected, sophisticated, and monumental system of interlinked surface and subterranean drains. The system begins on the summit with sets of small, subterranean, stone-lined channels that originally drained the Akapana's central sunken court. The sunken court on the summit was not roofed, and huge amounts of water collected there during the altiplano's furious rainy season, between December and March. These stone channels conducted water from the sunken court to a major trunk line that was buried deeper beneath the summit surface. This line probably extended around the four sides of the summit, but we have direct evidence for it only on the north (the drain fragments uncovered by Créqui-Montfort, which Posnansky referred to as the "cloaca maxima"[17]) and west sides. On the west side, we excavated an extensive segment of this subterranean trunk line, running in a north-south direction. The drain is rectangular in cross-section and finely crafted of large (120 x 70 centimeters), precisely fitted sandstone

blocks with an interior dimension of forty-five centimeters, which would have accommodated an enormous flow. The drain, as a whole, dips northward on a sharp downward slope of twelve degrees. To stabilize the construction, this slope is set on a foundation of flagstones, and individual blocks are joined with copper clamps that were originally poured, while molten, into depressions carved in adjacent stone blocks in the form of a double T. This elaborate trunk line collected water flowing from the channels draining the sunken court on the summit and conducted it inside the structure to the next lower terrace.

Here, the water emerges onto an exterior stone channel tenoned into the vertical terrace face. The water poured over the edge of the tenoned drain to a stone channel on the terrace, flowed for a few meters on the surface, and then dropped back into the interior of the structure to the next lower terrace through a vertical drain. This process of alternating subterranean and surface flow on the stepped terraces was repeated until the water debouched from the basal terrace of the Akapana through beautifully constructed tunnels. Eventually, this water, flowing from the Akapana's summit, merged into a major subterranean sewer system installed three to four meters under the civic/ceremonial core of Tiwanaku. This system drains into the Tiwanaku River and, ultimately, into Lake Titicaca.

It is apparent that the complex system of draining the Akapana was not a structural imperative. A much simpler and smaller set of canals could have drained accumulated rainwater from the summit. In fact, the system installed by the architects of Akapana, although superbly functional, is overengineered, a piece of technical stone-cutting and joinery that is pure virtuosity. There is clearly a dimension to this elaborate drainage network that goes beyond simple utility; we can approach this dimension by posing a single question: why is the water alternately threaded inside of, and on, the surface of the structure?

The connection between the Akapana and the mountains of the Quimsachata range is more profound than the general morphological similarity of stepped-terrace mounds and mountain peaks. During the rainy season, almost every day, banks of black clouds, swollen with rain, well up in the deep ravines and intermontane basins of the Quimsachata range. Sudden, ominous thunderstorms sweep the slopes with torrential rains, driving hail,

and claps of thunder and lightning. Water rapidly pools in the saddles and peaks along the summits of Quimsachata and then begins to flow down to the valley floor. But the flow is not direct. Surface water drains into subterranean streams that periodically re-emerge downslope, gushing and pooling in natural terraces, only to tumble down inside the mountain again. The peculiarities of mountain geology and the erosive power of water combine to create this natural alternation between subterranean and surface streams. Runoff finally emerges from the foot of the mountains in rivers, streams, springs, and marshy seeps. This water recharges the aquifer of the Tiwanaku Valley and is the source for virtually all of the valley's irrigation and drinking water. Vast tracts of raised agricultural fields developed by the people of Tiwanaku were dependent on this seasonal recharge of surface streams and ground water. The altiplano rainy season is the principal growing season for major food crops, and the success of agriculture is tied to this critical period of rainfall. Mountains were sacred because they were the source of fresh water that nourished people and their fields.

The Akapana partook of the spiritual essence of the Quimsachata range and evoked its image by its shape and by its mimicry of the natural circulation of mountain waters in the rainy season. The flow on the Akapana replicated that of nature, pooling, dropping out of sight, gushing onto terraces, emerging at the foot of the mound. In a storm, the subterranean drains inside the structure may even have generated an acoustic effect, a vibrating roar of rushing water that shook the mountain-pyramid as the thunderstorms rumbled across the peaks of Quimsachata.

The Akapana was Tiwanaku's principal earth shrine, an icon of fertility and agricultural abundance. Its location in the core of the city suggests yet another kind of symbolic representation. It was the mountain at the center of the island-world and may even have evoked the specific image of sacred mountains on Lake Titicaca's Island of the Sun (see fig. 2). In this context, the Akapana was the principal *huaca* of cosmogonic myth, the mountain of human origins and emergence, which took on specific mytho-historic significance. The elite who lived within the moated precinct appropriated images from the natural order and merged them with their concept of social order, asserting, through a mimetic program of architectonic and sculptural display, their intimate affiliation with the life-giving forces of nature.

The arrangement of a central stepped-terrace mound in the center of an artificial island-city, evoking cosmogonic origins, is found also in important regional Tiwanaku centers such as Lukurmata, Pajchiri, and Khonko Wankane. In each of these cities, canals or moats carved the urban landscape into a ceremonial core of temples and elite residences, arrayed within an island enceinte, counterposed against extensive sectors of vernacular architecture. At Lukurmata (fig. 16), the central ceremonial complex, organized around a terraced mound, had a drainage network similar to that of the Akapana.[18] Rainwater collecting on the summit of the complex was threaded through carved stone drains to the base of the artificially modified rock outcrop on which the complex was constructed. Water from the summit flowed into the principal canal demarcating the island-core of the site and, ultimately, into Lake Titicaca. This canal also drained an adjacent sector of raised fields, associating the summit complex with agricultural productivity.

We know, then, that the Akapana served as a key shrine in Tiwanaku religion and elite ideology, but there remain other elements of the structure revealed in recent excavations that add fascinating textures to our understanding of its function and meaning. Although the Akapana was a center of cult and ritual behavior, part of its summit was used for living quarters as well. Most of the Akapana summit was taken up by the centrally

located sunken court, which measured approximately fifty meters on a side. Access to the court was gained by the twin, axial staircases. We can assume that, within the sunken court, as at its counterparts, the Semisubterranean Temple and the Kalasasaya, were placed towering stone sculptures with complex, religiously charged iconography. Flanking the central court, however—at least on the northern side, where we completed major excavations—were distinctly secular structures.

Here, arrayed around a central patio, was a well-constructed suite of rooms that appear to have served as residences. Although no hearths or food-preparation areas were encountered, these rooms, as well as the central patio, yielded large quantities of broken, utilitarian pottery, and botanical remains from the rooms indicate that the inhabitants ate potato, maize, and possibly fruits from the semitropical *yunga* zones. Beneath the central patio, a series of burials was uncovered. A file of seated adults, originally wrapped tightly in textile mummy bundles, faced a seated male holding a feline-shaped incense burner (see fig. 15). The burials under the patio suggest that the inhabitants of the structure were of an elite stratum in Tiwanaku society. Drawing on analogy from the Inca state, the excavator of this complex interpreted the rooms as the residences of priests who presumably served as the principal ritual practitioners for ceremonies that took place on the Akapana summit.[19]

In the southwest corner of the complex, we discovered a major offering that was associated with the sealing and abandonment of one of the rooms. The offering consisted of fourteen disarticulated llamas; copper pins, plaques, and a miniature figurine of a sitting fox; hammered silver sheets; a polished bone lip plug; mica; obsidian; quartz; fragments of complex, polychrome ceramics, including a miniature *kero* (ritual drinking cup), a puma-shaped incense-burner, and a vase with an image of a resplendent crowned figure like that on the Gateway of the Sun. The skulls and upper jaws of the llamas were found in the north and west sides of the room; the lower jaws were placed in the southeast corner; and the metal objects were concentrated in the northeast portions of the room. The polychrome ceramics, lip plug, mica, and fragments of obsidian and quartz tools were found immediately outside the entrance to the room.

Fig. 15 Incense burner in the form of feline. Bolivia, Tiwanaku, 400/800. Ceramic. Instituto Nacional de Arqueología de Bolivia, La Paz. Photo: Dirk Bakker. (Cat. no. 273)

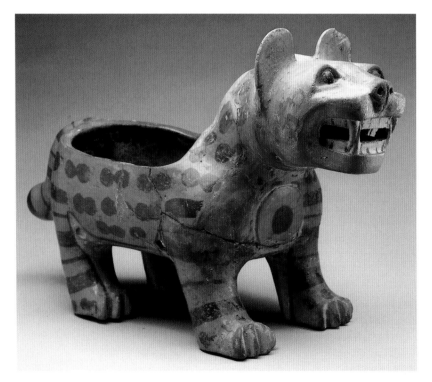

Fig. 16 The ancient agricultural fields near Lukurmata, Bolivia, dating from sometime between 400 and 800, were part of the vast, highly organized agricultural system managed by Tiwanaku and its outlying towns. Photo: Hugo Boero Rojo.

As noted by the excavator, the distribution of these objects evokes a powerful sense that these are the remnants of an important ritual.[20] A sample of wood charcoal taken from these materials yielded a radiocarbon date of 1130 ± 210, which fixes the date of this ritual event between 1000 and 1300. Given that the offering rendered the room inaccessible and that the event occurred at a time of general abandonment of the city, the ritual may have been one of closure, during which the great Akapana earth shrine and the practitioners of its cults were symbolically interred. In any event, the treatment accorded the sealing off of this room suggests that these habitations on Akapana's summit were not ordinary dwellings.

Terraces farther down the mound also show evidence of surface buildings with andesite-block foundations and adobe superstructures. A series of small, but finely wrought, buildings was uncovered on the first terrace of the Akapana in excavations by Bolivian archaeologists in the mid-1970s.[21] A number of these appear to be late constructions, perhaps even erected by the Incas after the abandonment of Tiwanaku. The Incas incorporated Tiwanaku as an important shrine in the organization of their imperial space and reputedly built structures there. Other terrace structures, however, clearly belong to the florescence of Tiwanaku.

Excavations on the northwest corner of the Akapana revealed a fascinating and, to date, not entirely understood set of ritual offerings associated with the foundations of the structure and with buildings on the first terrace. Here, we uncovered a series of twenty-one human burials, commingled with llama bones and associated with ceramics that date to the Classic Tiwanaku period (c. 400–800). Most of the burials are incomplete, but the bones that were present are articulated in correct anatomical position.

At first glance, we assumed that these individuals (many of whom were adult males from seventeen to thirty-nine years old) were dismembered prior to, or shortly after, death. However, none of the bones showed evidence of cut marks, and there is little evidence of intentional physical violence. In lieu of a preternatural capacity to butcher a human body without leaving a mark on adjacent bones, the skulls and other body parts must have been removed post-mortem, some time after the corpse and its tough connective tissue had begun to decay. It is possible that these individuals died or were sacrificed and that their bones were later interred at the Akapana in the form of mummy bundles. Although some body parts, such as the skull and lower limbs, were removed in the process of assembling the mummy bundle, the remaining portions of the skeleton remained in correct position.

Why were individual bones, and particularly skulls, removed? One clue comes from an offering of deliberately broken polychrome ceramics associated with five of the partial skeletons. This ceramic cache and its associated burials were uncovered in the destroyed room of a structure on the first terrace of the Akapana. The ceramics are iconographically associated with the Classic Tiwanaku period, and three radiocarbon dates fix the episode between 530 and 690.

These dates, along with the burial pattern of partial skeletons, indicate that the offering was contemporaneous with those excavated along the foundation wall, perhaps even part of a single sacrificial event. The ceramic offering consisted of hundreds of fine polychrome bowls and *keros*, which we found shattered into small fragments. The bowl fragments have a consistent, standardized motif: painted bands of stylized human trophy heads. Some *keros* display painted images of humans, elaborately costumed as pumas and condors. Trophy heads hang from the belts of these figures or are worked into the elements of masks worn by the dancing celebrants portrayed on the vessels. Human trophy heads often appear as the finials of staffs carried by the condor or puma-masked dancers. The trophy heads, although stylized skeletal images, clearly represent actual human trophy heads. Cut and polished skulls have been found in excavations at Tiwanaku, leaving little doubt that the practice of taking heads in battle was a central symbolic element of warfare and ritual sacrifice.

The testimony of state art indicates that the elite of Tiwanaku were obsessed with decapitation and the ritual display of severed heads. Many animal-masked humans (ritual warriors?) resplendent in costumes studded with pendant trophy heads, carry sacrificial knives and battle axes. A class of stone sculptures called *chachapumas* portrays powerful, puma-masked warriors holding a severed head in one hand and an axe in the other. In September 1989, we discovered one remarkable example of a *chachapuma* at the base of the Akapana's ruined western staircase in the same stratigraphic context as the human offerings placed at the structure's foundations. This ferocious-looking sculpture, carved of dense black basalt, seems poised in a crouch, ominously displaying in its lap a human trophy head with long braided hair (see fig. 10). In addition to evoking the image of a gigantic earth shrine, the sculptures and offerings arrayed on and around the Akapana constituted a ritual text glorifying the warrior-priests who formed the apex of Tiwanaku's ruling hierarchy.

Tiwanaku as an Urban Phenomenon

The impressive visual quality of Tiwanaku's civic/ceremonial core led some scholars of past generations astray in their interpretations of the city's social significance. They argued that Tiwanaku consisted only of a few major temples, with some dispersed minor structures, and that, therefore, the site played a strictly ceremonial role as a "vacant ceremonial center" of religious pilgrimage, without substantial resident population. These scholars assumed that the stone architecture visible on the surface reflected all human activity at the site and also at such regional Tiwanaku sites as Lukurmata and Pajchiri, which were described as exclusively centers of cult activity. These scholars never realized that most of the architecture at Tiwanaku and its satellite settlements was constructed of adobe on stone foundations. Without systematic excavation, such architecture is

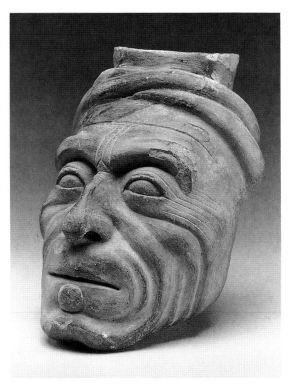

difficult to identify: over the centuries, the construction material melted back into the landscape.

Intensive research, initiated by CIAT and continued in recent excavations sponsored by INAR and the University of Chicago,[22] demonstrates unequivocally that the minimal area of the civic/ceremonial core, together with surrounding sectors of dense habitations, extends over four square kilometers, and that the entire urban environment sprawls over an area of six square kilometers. It is clear that a substantial population was permanently resident at Tiwanaku; an estimate of thirty to sixty thousand is not unreasonable.

Even more fascinating than the dimensions and population size of the urban landscape is its careful planning. Ongoing excavations in an area of vernacular architecture to the east of the Akapana demonstrate that, at least for the period

c. 400–1100, residential barrios in the city were oriented to the same cardinal directions as the civic/ceremonial core. This implies that the concept of proper urban order played out in the core held, in some sense, for Tiwanaku's ordinary citizens, as well.

The current excavations and intensive surface collections at Tiwanaku also reveal direct evidence for specialized craft workshops that produced both utilitarian and ceremonial pottery; polished bone and stone objects, such as snuff tablets for the consumption of hallucinogenic drugs; status emblems of gold, silver, and copper; and lapidary work of lapis lazuli, sodalite, turquoise, and jasper. Individual households produced textiles and basic tool kits of obsidian, basalt, and chert for their own use, as well as for potential consumption by the city elite.

This recent archaeological work strengthens Ponce Sanginés's basic concept of Tiwanaku society as stratified minimally into three classes: a governing group of lineages composed of warrior-elites who held political and religious offices; a middle class of artisans, who worked as retainers of the ruling lineages; and a commoner class of farmers, herders, and fishers, the sustaining force for Tiwanaku's economic system.[23] The agriculturalists and herders, the bulk of whom lived and worked in the rural hinterlands surrounding Tiwanaku's urban centers, provided the surplus product that underwrote the complex system of public works that came to characterize Tiwanaku civilization. These public works included audacious projects for reclaiming vast tracts of rural land that were incorporated into the Tiwanaku economic system as dedicated agricultural estates under the direct control of Tiwanaku's ruling lineages.[24]

From these remarkably productive estates, wealth, in the form of agricultural surplus, flowed back into Tiwanaku's urban society, providing the economic bedrock for unparalleled achievements in the realm of religious and political art. The urban and rural milieux were intimately interconnected in the process of creating Tiwanaku civilization. Perhaps the greatest enduring testament to the ingenuity and power of that civilization was the manner in which it reshaped entire natural landscapes for the benefit of its populations. Tiwanaku's harnessing of the natural environment found intense symbolic expression and recapitulation in the artificial environment of its cities and in its monumental architecture and art.

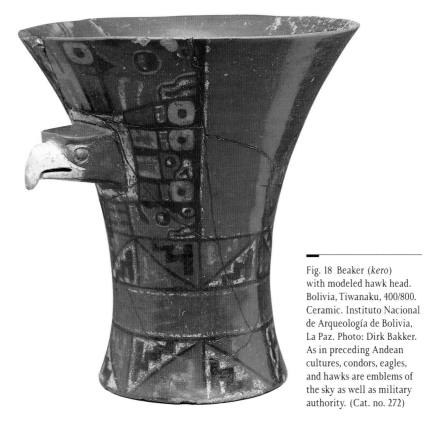

Fig. 18 Beaker (*kero*) with modeled hawk head. Bolivia, Tiwanaku, 400/800. Ceramic. Instituto Nacional de Arqueología de Bolivia, La Paz. Photo: Dirk Bakker. As in preceding Andean cultures, condors, eagles, and hawks are emblems of the sky as well as military authority. (Cat. no. 272)

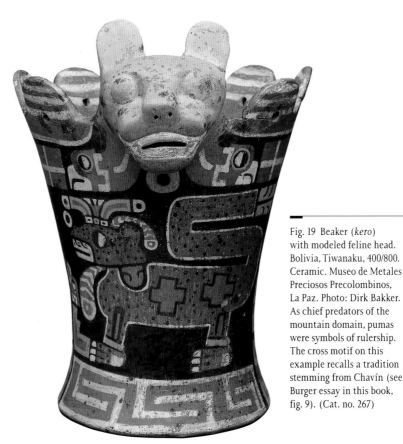

Fig. 19 Beaker (*kero*) with modeled feline head. Bolivia, Tiwanaku, 400/800. Ceramic. Museo de Metales Preciosos Precolombinos, La Paz. Photo: Dirk Bakker. As chief predators of the mountain domain, pumas were symbols of rulership. The cross motif on this example recalls a tradition stemming from Chavín (see Burger essay in this book, fig. 9). (Cat. no. 267)

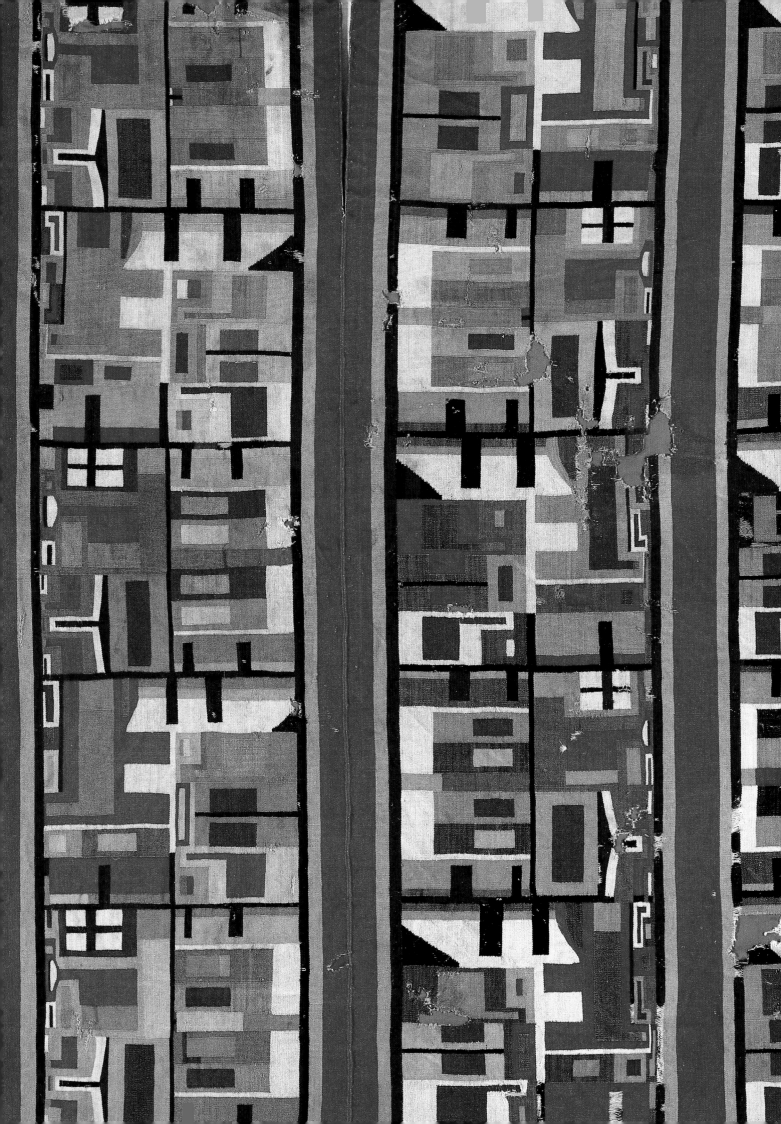

CAMELIDS AND CHAOS IN HUARI AND TIWANAKU TEXTILES

Introduction

Although ancient Andean textiles remain virtually unknown to the North American public, there is no doubt that the fiber arts played a pre-eminent role in the indigenous cultures that flowered in western South America before the sixteenth-century European invasions. Thousands of well-preserved examples survive to make up the longest, most complete textile record in the world. In the Andean area, the widespread use of textiles preceded that of fired ceramics by at least a thousand years, and the fiber arts continued to be a major focus of creative expression throughout the pre-Hispanic, Colonial, and modern eras. The major reasons for the "textile primacy" lie in the human response to remarkably inhospitable environmental conditions.

The high mountain ranges of the Andes, the world's longest and second-highest mountain chain, and the arid coast, the world's driest coastal desert, both present extraordinary challenges to human survival. It is fascinating that both areas independently developed a series of fiber solutions to their climatic problems. The early coastal textile complex, based first on wild, then on domesticated, cotton, consisted of fishing nets, baskets, bags, and protective clothing. In turn, the highland assemblage, based first on hunted, then herded, camelids, included carrying-cloths and bags, in addition to protective wear and unique forms such as the quipu (knotted cords for keeping records). Domesticated llamas and alpacas, together with their wild cousins, the vicuña and guanaco, are members of the family *Camelidae* and are often referred to collectively as camelids (see fig. 2).

Whatever the great practical benefits of fiber objects (their portability and flexibility, for example), simple nets and bags gave way to highly complex, sophisticated fiber arts from the earliest times onward. Twined cotton scraps from the midden site of Huaca Prieta, dated by radiocarbon at approximately 2300 BC, reveal extremely elaborate composite animal imagery.[1] Early fishing-net techniques inspired later gauze weaves; flat textiles became three-dimensional sculptures; patterns developed from simple stripes to compositions involving over one million color changes.[2] Yet, even as necessity yielded to inspiration, the profound connection of the fiber arts with the natural realm remained vital.

This essay seeks to illuminate two ways in which the human interaction with the environment was made manifest in woven form. Serving as examples of this interaction are

Fig. 1 Tunic (*unku*). Peru, Huari, 500/800. Camelid wool and cotton. Museo Nacional de Antropología y Arqueología, Lima. Photo: Dirk Bakker. Here figural forms have been disassembled into rectilinear geometric motifs and arranged in new abstract patterns within a series of regular compartments. (Cat. no. 75)

Fig. 2 Alpacas crossing high pass in the Andes. Photo: Sigmund Csicsery.

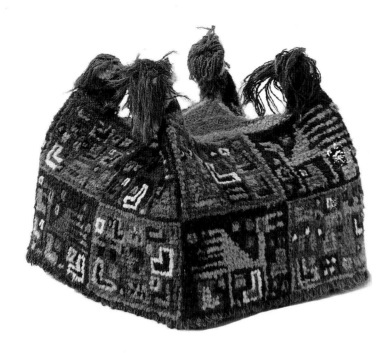

the related styles known as Huari (Wari) and
Tiwanaku (Tiahuanaco) — the names of the
major cities identified with each style —
which began in the southern highlands of
Peru and adjacent Bolivia and spread through
the Andes during the Middle Horizon (c.
500–800). Focus will be placed on the Huari-
style tapestries, which are more numerous
and better-known. First, the fundamental
adaptive association with the camelid repre-
sents the most concrete aspect of this human/
nature relationship. Selections of raw mate-
rials, as well as certain iconographic choices
for textiles and other media, demonstrate the
great importance that these animals held for
the Andean peoples. Second, on a more ab-
stract and hypothetical level, the design
structure of official tunics may reveal that
the Huari state presented itself as a human
order mediating the chaos of nature. In fact,
both camelid herding and statecraft in the
Andes are based on the diversification of
pursuits in order to mitigate the effects of
adverse environmental conditions. Thus, the
textile medium offers a vision of human sur-
vival in the Andes from practical, conceptual,
and political perspectives. A brief overview
of Huari and Tiwanaku textiles and related
arts will serve to introduce the topic of
camelids and chaos, and how they figured in
one of the most extraordinary visual achieve-
ments of the ancient Americas.

Huari and Tiwanaku Textiles

Because of the primacy of fiber and the num-
ber of roles it played, the Middle Horizon
textile record is fairly diverse in terms of

function, technique, and style. It encom-
passes a number of object types, including,
but not limited to: tunics (see figs. 1, 8),
mantles (see fig. 5), hats (see fig. 3), quipus
(see fig. 4), and what appear to be hangings
(see fig. 12), as well as headbands, bags, and
belts. Techniques include tapestry, knotted
pile, so-called "patchwork," weft wrapping,[3]
and Tiwanaku-style embroidery and warp-
patterning.[4] Two principal stylistic poles of
Huari and Tiwanaku have recently been dis-
tinguished on technical and stylistic grounds;
however, this simple dichotomy by no means
illuminates the entire Middle Horizon textile
corpus.[5] The two major substyles overlap in
their relation to the iconography of Tiwanaku
sculpture, particularly to the secondary fig-
ures on the Gateway of the Sun (see Kolata
and Ponce Sanginés essay in this book,
fig. 11); but the Huari style demonstrates a
marked progression away from the legible
communication of the religious figures (see
figs. 1, 13).[6] In Huari-style compositions.
formal inventiveness (i.e., the exploration of
color and shape possibilities) subverts ico-
nography (i.e., understandable subject mat-
ter), and pattern itself becomes the subject.[7]

Tapestry tunics, apparently worn by high-
land-Huari state representatives on the coast,
are the most widely preserved, with well over
two hundred examples extant. In life, the
tunics were worn as ceremonial garb, and, in
death, they were dressed over the wearer's
mummy bale. Tapestry, a form of plain weave
(the basic alternation of weft over and under
warp), involves discontinuous wefts packed
down so as to obscure continuous warp
threads. Camelid fiber is perfectly suited to
the role of colorful, flexible weft, and coastal
cotton to the role of warp. After the hegem-
ony of the state had been extended from
highlands to coast, both materials were avail-
able to the Huari. Tapestry allows for very
intricate color patterning, making it suitable
for complex imagery, such as that favored by
the Tiwanaku religion. In addition, tapestry

necessitates—and, therefore, displays—huge amounts of thread: the average Huari tunic includes between six and seven miles of thread. Such an expenditure, organization, and presentation of resources, skill, and labor made "official" textile art symbolic of power in the human and natural realms.

According to illustrations of textiles and their wearers in ceramic effigy vessels and shell-mosaic sculptures (see fig. 7), the tunic or mantle formed part of an elaborate ensemble with geometrically patterned headgear and textile-related facial painting (see figs. 3, 6). The hats or headbands depicted were knotted, using a single ground thread paralleled by brightly colored threads, which were left as loops toward the outside and subsequently cut to form pile. Effigy vessels also show the wearing of the tunic or the plangi (tie-dyed) "patchwork" mantle (see fig. 5), a plain-weave fabric constructed not by simple piecing of patches but by a complex process featuring the use of scaffold threads.[8] In ceramic and mosaic versions, complex textile patterns are inevitably simplified, but the original effect of the wearer is suggested. The varied but related patterns obscure the wearer, creating a dematerialized image of authority. The entire, full-body ensemble imposes the geometry of rectilinear pattern over the contours of the human form, just as the Tiwanaku and Huari peoples imposed their severely rectilinear architecture over the irregular Andes.[9] The containment of chaotic irregularities—whether physical or topographic—within a formal grid seems basic to Huari and Tiwanaku aesthetic expressions of all kinds (see fig. 1).

The very rare Huari wrapped quipus (see fig. 4) deserve particular mention, because they are the earliest-known Andean fiber-recording device and because they relate closely to the tunic form. Dyed camelid fiber threads wrapped around cotton pendant cords codified oral information through color pattern. Technically, this type of quipu is allied to the tapestry tunic, whose warp threads are "wrapped" by dyed wefts. The direct employment of color pattern to create meaning in the quipu also supports the hypothesis that the formal aspects of the tunics themselves convey information. The quipu also represents a particularly Andean adaptation to nature: a highly portable, lightweight, unbreakable device is perfectly suited to carrying information on treks through rugged mountains. Transportation difficulties especially made textiles the preferred medium of the Andes.

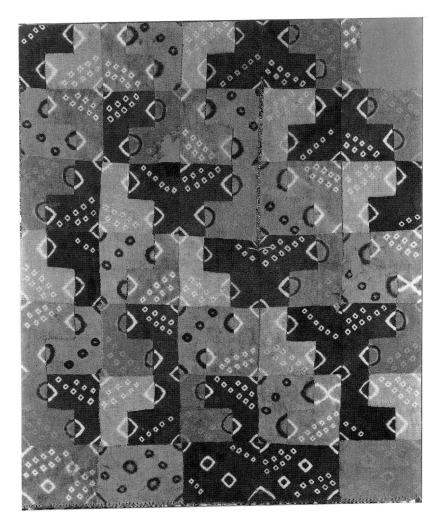

Camelids

"Textile primacy," as well as transportation, was predicated on the camelid in Andean civilization. In fact, without the herding of the llama and alpaca and, to a lesser extent, the hunting of the guanaco and vicuña, neither pre-Columbian nor modern settlement in the inhospitable Andes would have been possible. As David Browman asserted:

> Camelid pastoralism represents a cultural adjustment to a semiarid grassland ecosystem that can support grazing animals but is poorly suited to cultivated crops. In the central and southern highlands of Peru, herding of llama and alpaca is the most effective form of land use and resource exploitation.[10]

Above a certain altitude, herding is the only mechanism for survival. The camelids are perfectly adapted to the harsh environmental conditions: they eat the dry *ichu* grass, withstand the biological stresses of high altitude, and are sure-footed in mountainous terrain (through which male llamas can carry up to about fifty kilograms). New World camelids

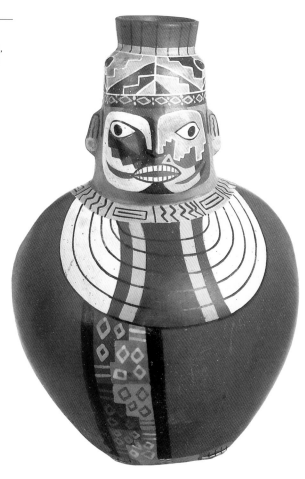

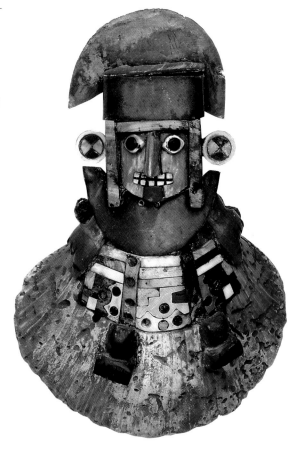

on long treks through dry, rugged landscapes reportedly can go three days without liquid and five days without food.[11] In addition, their thick coats of silky fur keep their body temperatures regulated, despite climatic extremes.

Andeans capitalized on all these traits, using camelids to carry food and objects on long migrations, shearing camelid fur to make protective clothing for themselves, using dried dung for fuel, as well as slaughtering selected animals periodically for many other necessary products (e.g., meat and organs for consumption and sacrifices, tallow for medicine, skins for clothing and rope, and bones for weaving tools and flutes). In short, humans were highly dependent on these versatile animals. Yet, while camelids are well adapted to their environment, the interference of humans in their natural state has had adverse effects. Herds require intensive and extensive care and protection, lest they fall prey to disease. Fertility is very low and mortality of the young very high. Camelid pastoralism itself constitutes an unstable equilibrium, subject to disruption by many human causes and such natural factors as pasture failure due to freeze, snow, or drought, resulting in mass animal starvation.[12]

In addition, the yield of fur during life and of meat upon death is relatively low for each individual animal, relative to the effort involved in extraction. At the time of the Spanish conquest, shearing took place most profitably only every four to five years.[13] The greatest producer, the male alpaca, yields only three to six kilograms of fur each shearing. Within a life span of under ten years, a prime producer may yield only ten kilograms of total fiber. Preparation of camelid fiber was time-consuming and painstaking; it tended to involve many individuals and specialized skills, considering that the fiber must be shorn, washed, dried, carded, spun, dyed, dried, and then woven into a design within the accepted canon. The dyeing process itself included many steps, as well. Huari and Tiwanaku textiles, in particular, exhibit a range of saturated, evenly dyed colors possible only through concerted group efforts to locate dye sources in various regions and to support dye specialists. For example, the use of indigo for blues shows great dedication and skill, for indigo preparation and dyeing represent the most obscure, unpredictable, and complex processes of all the natural dyeing methods.[14] Such a great premium was placed on camelid fiber as a material that most of the society

was involved in its production.[15] Then, at death, an animal contributed only thirty percent of his/her body weight in meat. In sum, the necessary reliance on these animals was fraught with difficulty, labor, and, ultimately, uncertainty.

There were several cultural responses to this situation. The Andean pattern was—and is—to diversify. First, herding was initially combined with wet-season horticulture, then, beginning around the time of the Huari, with agriculture. Second, the benefits of the camelids in life or death allowed for needed flexibility and served as a hedge against environmental chaos. Browman explained:

> Herds of llama and alpaca served as a reserve against droughts, freezes and other calamities; in such crises the herds could either be utilized directly [i.e., killed] or exchanged with neighboring groups for necessary foodstuffs. Moreover, a reasonable amount of wealth could be accumulated, as the

animals not only themselves constitute wealth but also serve as pack animals to transport additional goods.[16]

This third diversification mechanism, trade, was also made possible with the camelid: caravans of hundreds, even thousands, of pack animals traversed the Tiwanaku sphere in particular, linking the highlanders with the entire range of foodstuffs from lower, richer climes.

In the aesthetic realm, the importance of, and a concomitant anxiety about, camelids can be seen in textiles and other art forms. These animals figure prominently in the selection of materials and iconographic choices.

On the material level, the silky hair of the alpaca (as well as, possibly, that of the llama or vicuña) was chosen universally for the pattern-bearing element in Middle Horizon textiles. Tiwanaku-style pieces also use it for the load-bearing warp strings, while Huari-style pieces often mix camelid-fiber threads with the predominantly cotton warps. Camelid fiber is scaly; hence, it is highly flexible

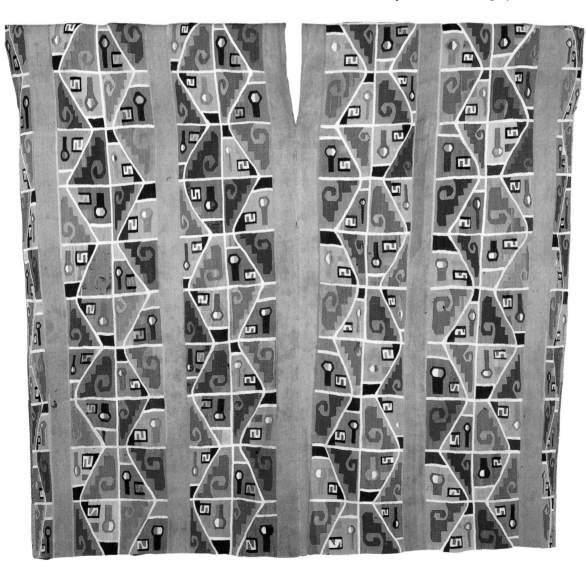

Fig. 8 Tunic. Peru, Huari, 500/800. Camelid wool. The Art Institute of Chicago. Abstract heads alternate with step-fret seashell motifs in densely patterned, repetitive squares, traversed by linear rhomboidal compartments. (Cat. no. 68)

and, because of its protein composition, particularly permeable to dyes. Huari and Tiwanaku textiles, with their densely packed threads of the brightest shades arrayed in detailed patterns, exploit these advantages to the fullest.

It is not surprising to find that the camelid also plays an important role in artistic subject matter. A Huari cup illustrates a herder leading a llama, and full-figure camelid-effigy vessels, often referred to as *sahumerios* (incense burners), were produced in what must have been state-sponsored workshops (see fig. 9).[17] The abstraction displayed by the finest of these forms echoes the sophistication of Huari and Tiwanaku textiles and monumental sculptural art. Gold plaques with llama imagery from the Island of Koáta, near Tiwanaku,[18] prove that camelids were depicted in many media. The Middle Horizon certainly is not unique in this,

for earlier Moche and later Inca sculptures demonstrate that the camelid held importance throughout antiquity.[19]

The inclusion of camelid imagery on a textile was obviously self-referential, since the textile itself was created of dyed camelid fiber. Because so much of Huari and Tiwanaku textile imagery was concerned with conventional religious figures, the few depictions of llamas in tapestry hangings are all the more noteworthy. A charming "mama llama"-and-herder tapestry (fig. 12) communicates the understandable preoccupation with camelid fertility. The pregnant llama is shown with the fetal llama inside her as she stands in the birth position. Another extraordinary composition features births actually taking place (fig. 11).[20] These quite literal images are exceptional in Huari and Tiwanaku art, for capturing a moment is not a typical concern of Middle Horizon or Andean art in

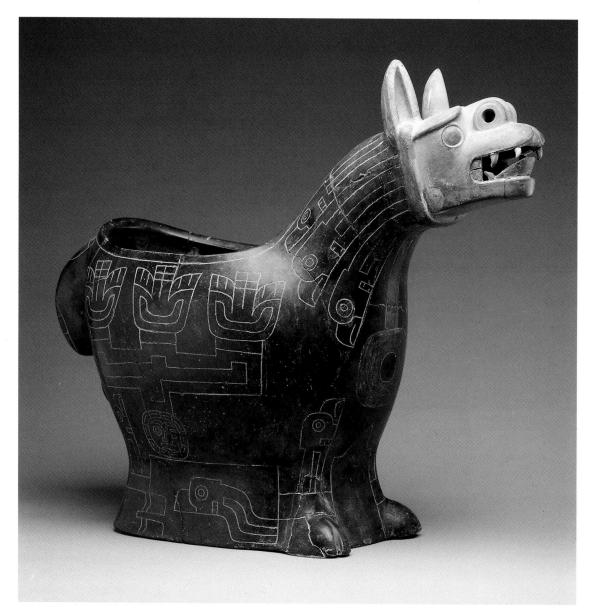

Fig. 9 Incense burner in the form of llama. Bolivia, Tiwanaku, 400/800. Ceramic. Museo de Metales Preciosos Precolombinos, La Paz. Photo: Dirk Bakker. (Cat. no. 268)

Fig. 10 Tunic fragment. Peru, Huari, 500/800. Camelid wool and cotton. Private collection. Twelve masked figures presenting staffs are arranged symmetrically across the middle of the garment, recalling the sculptured reliefs on the Gateway of the Sun at Tiwanaku. (Cat. no. 69)

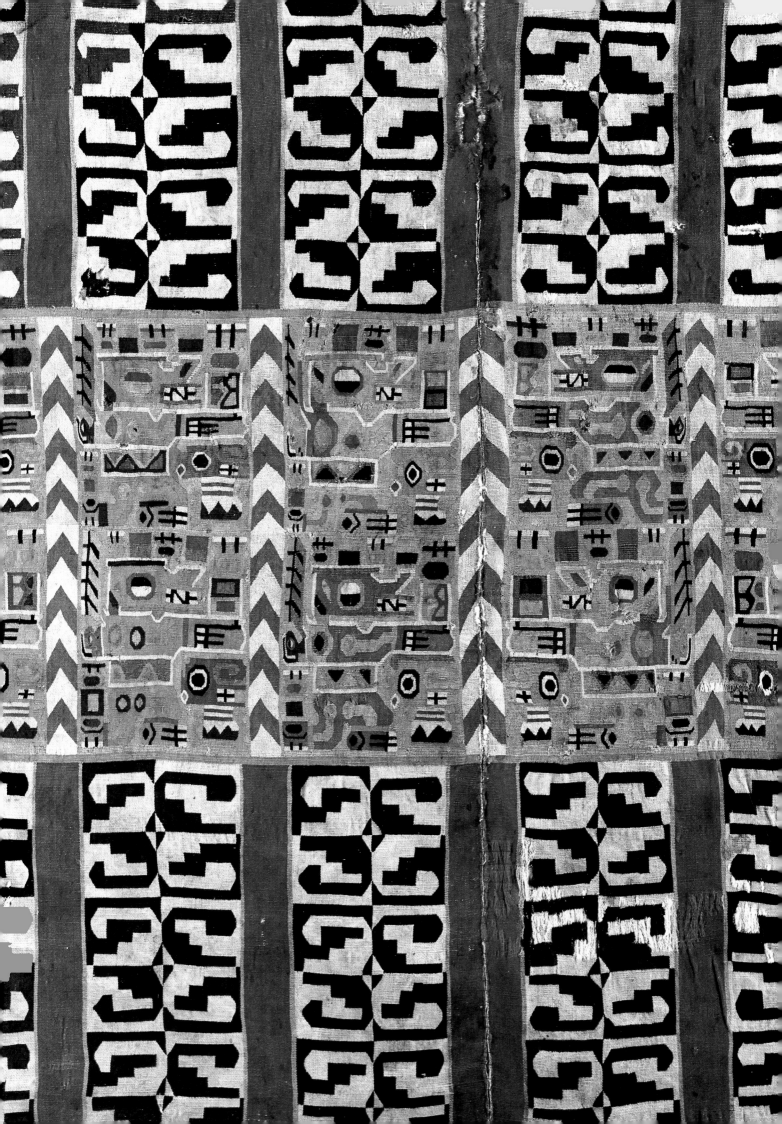

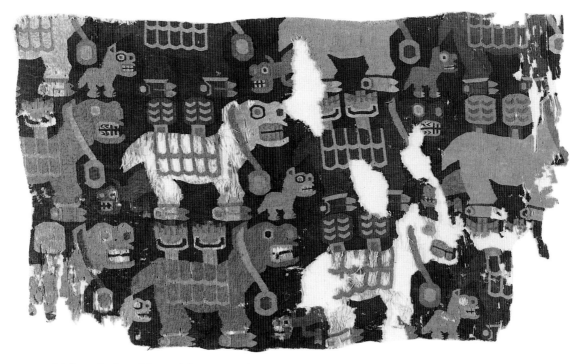

Fig. 11 Tapestry depicting birthing llamas. Peru, Huari, 500/800. Camelid wool and cotton. The Brooklyn Museum.

general. Thus, in breaking with convention in their treatment of the subject, these two pieces demonstrate the intensity with which people viewed the perpetuation and growth of their camelid herds.

Chaos

While material and iconographic choices in Middle Horizon textiles feature the camelid as a primary mediator between nature and culture, the formal patterns of a large sample of Huari tapestry tunics indicate another level of mediation by the state. Formal patterns consist of the arrangement of colors and shapes, as opposed to the materials, techniques, or overt subject matter of the piece. Among complete Huari tunic compositions there exists a very consistent set of design rules with implications for a state rhetoric — an imposed expression of unifying conformity — that the Huari may have imbedded in tapestry.

The typical tunic contains repeated versions of one to three motifs arrayed in vertical columns and assigned sequences of colors for their principal component shapes.

Fig. 12 Tapestry fragment depicting "mama llama" and herder. Peru, Tiwanaku, 400/800. Camelid wool. Virginia Museum of Fine Arts, Richmond. (Cat. no. 281)

Fig. 13 Tunic depicting enclosure of felines and assembly of figures. Peru, Huari, 500/800. Camelid wool and cotton. Dumbarton Oaks Research Library and Collections, Washington, D.C. (Cat. no. 70)

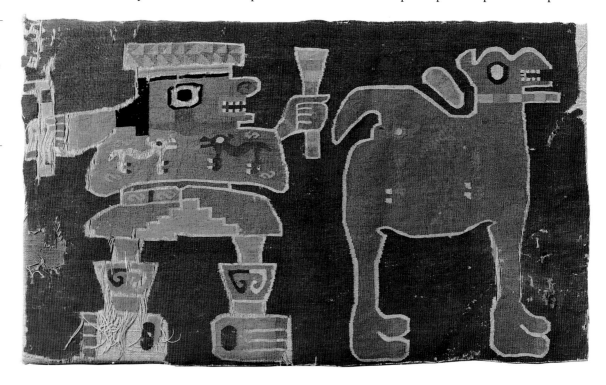

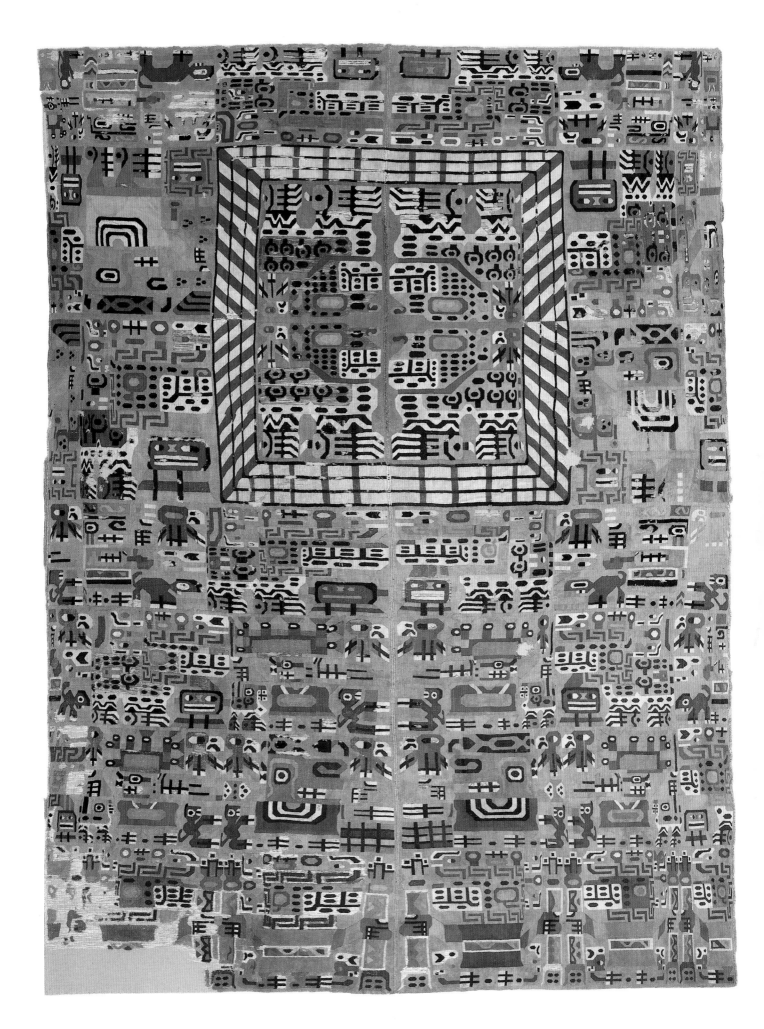

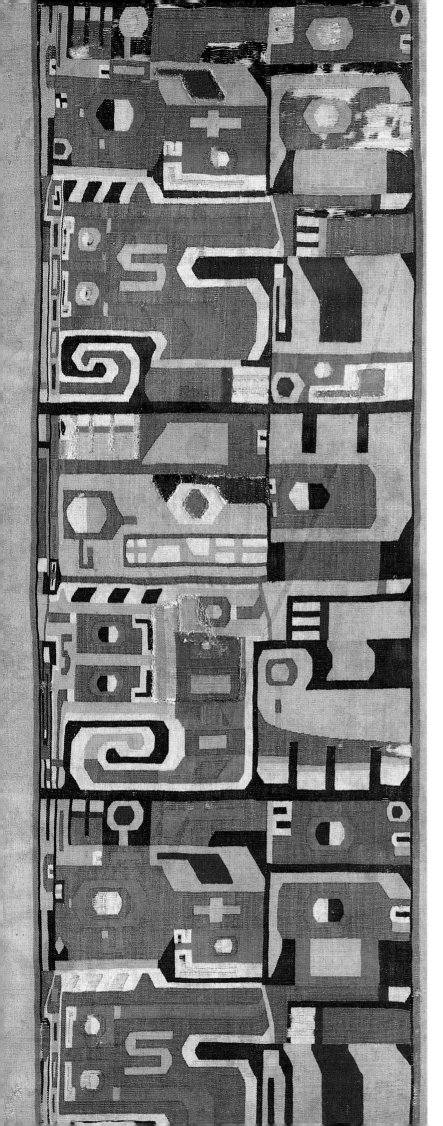

Recurrent motifs include the staff-bearing figure (see figs. 10, 13), profile face, stepped fret, and interlocking, double-headed animal. However, there are many possible combinations of these and other motifs within tunics. From four to eight, but most commonly six, columns of motifs are found (including the very narrow side columns). Colors assigned to these motifs tend to create diagonal patterns; however, every composition is unique in its exact color assignments and in the resulting diagonals.[21]

What makes the Huari aesthetic system so fascinating and culturally reflective is that most tunic compositions intentionally break this rigid formal repetition through deviations in color and shape. Fig. 13 has five instances of intrusive turquoise-blue striping, and fig. 1 has fourteen blue color anomalies, plus three four-part eye-shaped anomalies.[22] The deliberate nature of tapestry, in which hundreds of carefully planned weft passes create every tiny shape, precludes these being mistakes.[23] These examples show a characteristic, if not diagnostic, feature of the Huari aesthetic: one of the design rules was to break the rules. They also point up the fact that the most difficult dye color to achieve played a special role as the anomaly; two-thirds of all color anomalies lie within the range of indigo-produced blues and greens.

There are important implications for such unique aesthetic choices in an official art form such as the tunic. All involve levels of chaos. First, the variety, unpredictability, and idiosyncracy of anomalies underline the strong contribution of the textile artist to the design system. The anomaly can be seen as an expression of the individual creating visual interest within the confines of a set state iconography. The many manifestations of anomalies indicate that weavers interpreted "the rule to break the rules" in their own ways. Thus, there was a measure of contained chaos in individual expressiveness. Second, the designer-weaver's preoccupation with color makes the patterning itself part of the subject matter. Complex color patterning and the abstraction of shapes both tend to break down readable figures into shifting repeated forms (see figs. 13, 14).[24] Rather than being the result of garbling or misunderstanding, this process represents the purposeful breakdown of that which is recognizable into an abstract formal essence. In this process, color assumes prominence over figure. At its most extreme (see fig. 1), this visual chaos disorients the perception of even skilled viewers.

Third, the juxtaposition of regular and intentionally irregular color assignments betrays an interest in the principles of order and chaos. At this level of discourse, wider implications for the "cosmic" self-image of the Huari state can be inferred.

As is noted above in the discussion of the camelid, the Huari and Tiwanaku peoples strove to assert their existence in a harsh, even marginal, environment. Droughts, frosts, and particularly earthquakes characterize the Andes, while storms caused by the El Niño current in the Pacific periodically devastate the coastal regions. The Middle Horizon states of Huari and Tiwanaku, like the later Inca empire, sought to be the privileged mediators between an unpredictable nature and the population. By intervening economically to allay famine in one area with surpluses from another, as well as providing ritual interpretation of natural/supernatural actions, the disastrous effects of droughts, frosts, or earthquakes were mitigated. A wide social network organized the necessary, reciprocal food redistribution and collaborative labor projects. In this self-proclaimed role, the state represented an adaptive, ordering principle and sought to contain the threat of natural chaos by its structural, hierarchical organization.[25] In a sense, the state served as a larger version of the ancestral, diversified camelid-herding strategy.

It is interesting, therefore, that the Huari state chose a structurally analogous textile-design system with which to represent itself: one in which strictly regular visual order was deliberately, repeatedly, and randomly tried by the chaos of formal anomalies. Robert Layton asserted:

> Art is perhaps concerned with ordering experience and expressing that order not in general statements but in a most succinct and concrete way that nevertheless [refers] to the many diverse orders of experience that man encounters: the natural, the animal, the social, the physiological; and this may be done representationally, through symbolism, *or it may be done abstractly, through the portrayal of order in balanced or rhythmically repeated forms* [author's italics].[26]

The Huari tunic compositional scheme constitutes just such an abstract representation of the order of natural/social experience through its repeated forms, yet adds an element challenging balance and rhythmic repe-

tition in the form of the anomaly. Rather than the protests of rebellious artists against a rigid state directive, anomalies are a constant feature of a long-lasting style based on creative abstraction and visual variety. By definition, anomalies deviate from, yet are contained by, regularity. Therefore, they may symbolize the state's claim to be the mechanism for control of the unexpected, the orderer of chaos.

Given the primacy of the textile medium in the ancient Andes, elaborate fiber arts are understandably chosen for this cosmological, communicative, even propagandistic role. The fiber arts express concretely the profound interconnectedness of humans with a generally hostile nature, concretely via the camelid and conceptually via a compositional system that mitigates chaos with social order. The great beauty and inventiveness with which these aims are accomplished in Huari and Tiwanaku textiles only adds to our appreciation of these sophisticated and telling works of art.

Fig. 14 Tunic fragment. Peru, Huari, 500/800. Camelid wool and cotton. The Metropolitan Museum of Art, New York. (Cat. no. 72)

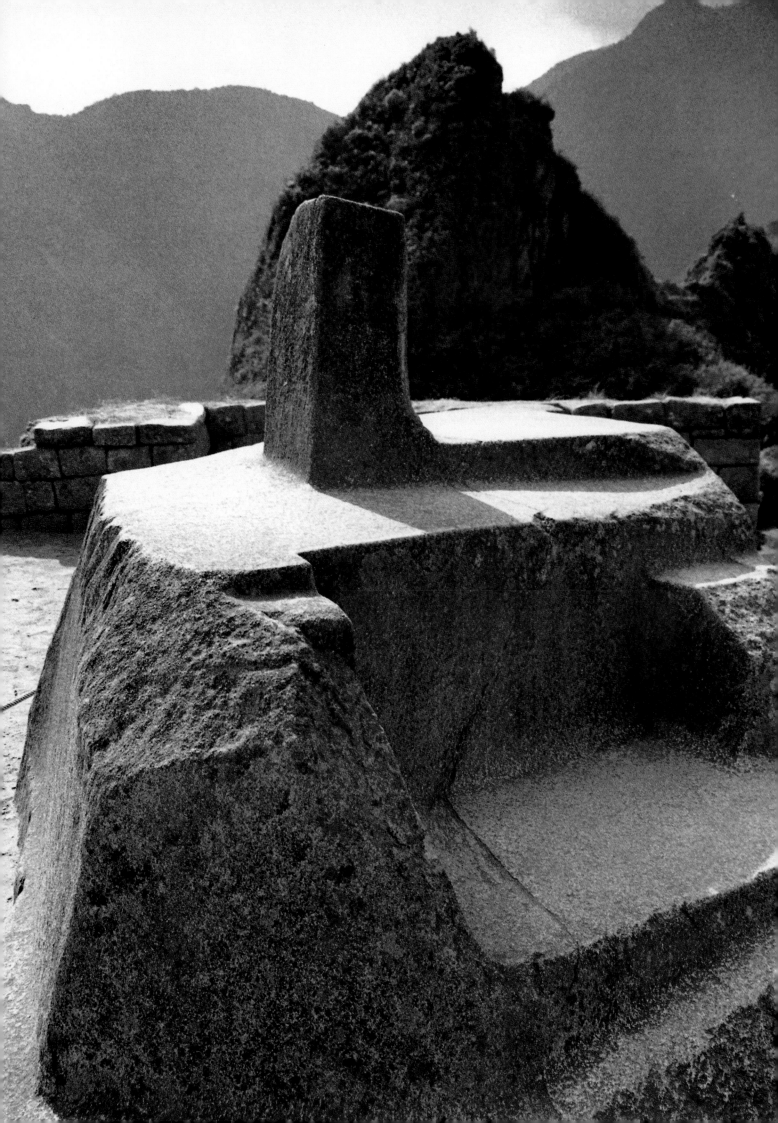

INCA ARCHITECTURE AND THE SACRED LANDSCAPE

The Incas, the last of the independent pre-Hispanic civilizations of the Andes, had an empire that included the lands within the modern political boundaries of Peru, Bolivia, and Ecuador, and parts of Colombia, Chile, and Argentina. The mythic beginnings of the Incas, their arts, and their religion are described in their origin stories. From the outset, the Incas defined themselves in terms of their sacred landscape and the people in it. One origin myth, reported by Bernabé Cobo, a Spanish priest, describes the emergence of the Incas' ancestors from the earth:

> ...there came forth from a cave... called Pacarictampu...four brothers called Manco Capac, Ayar Cache, Ayar Uchu, and Ayamanco; and with them four sisters of theirs who were called Mama Huaco, Mama Ocillo, Mama Ragua and Mama Cura.... With the seeds of maize and other foods that the Creator gave them, they set off on the road to the Valley of Cuzco, the one guiding the rest. And they had agreed that wherever they stopped, they would make their settlement and home. They came to a high hill called Huanacauri (which afterward was a famous place of worship among the Indians because this fable took place there), and from there the eldest brother marked the land, and, hurling four slingstones toward the four corners of the earth, he took possession of it. At this point the Indians disagree....Some say that one of the brothers returned to Pacarictampu, entered the cave which he had left, and remained there without ever appearing again; of the three that remained, two of them turned themselves into stones; one of them became the hill of Huanacauri itself, and the other remained not far from there; thus only Manco Capac arrived with his four sisters at the site where the city of Cuzco is located now. There Manco Capac made friends little by little with the natives of the region, who were few in number and lived spread out over that valley like savages without order or harmony. With the industry and help of his sisters, who called him the son of the Sun and spoke to him with a great respect and reverence, especially because he was a peaceful, very prudent and humane man, he came to be respected and obeyed by all.[1]

In the beginning, Inca mythic geography was essentially local, comprising nearby places of origin, graves of ancestors, and sites that defined the immediate peripheries of the Incas' political world. As they adopted a foreign policy based on military conquest, the Incas encountered new peoples, new religions, and new topographic features. The expansion of social and political horizons led to a cosmovision that encompassed places far from the capital at Cuzco, and took into account the beliefs of people from other ethnic groups and societies. Their changing outlook included redefinitions of the Incas' position with respect to foreign polities, the restatement of their real and mythical histories, and a continual process of incorporation and revision of new features of their sacred landscape.

Fig. 1 The Inti Huatana stone at Machu Picchu. Peru, Inca, c. 1500. Photo: Susan A. Niles. At the heart of Machu Picchu, the Inti Huatana embodied forces residing in the earth. Other stones in the Inca homeland marked mythological events or were regarded as petrified ancestors of humankind.

Reflections of the Social Order

Running through their history is the notion that the Incas ruled by divine right. Political and religious authority was delegated from a king who was thought to be the son of the Sun and was himself divine. The empire was built and rule was enforced by an army led by officers from royal families. It was governed through a hierarchy of appointed administrators who oversaw the labor of conscripts. Some of the more draconian policies of imperial control involved forcible movements of peoples.[2] Colonies of workers from newly conquered areas were moved to planned towns devoted to agricultural production in the imperial heartland, where the inhabitants grew up indoctrinated in the ways of the Inca state. Similarly, people from pacified areas were relocated as privileged colonists into newly conquered zones, to set up communities that were models of economic efficiency and adherence to Inca standards. Such social policies were designed both to build upon the underlying common elements of Andean culture and to impose greater uniformity, as the Inca language (Quechua) and Inca values were spread.

Tribute was rendered in the form of labor, with each commoner owing a certain number of days of work per year. Most worked as farmers, but some paid in goods that were a specialty of the province. Ceramics were made to Inca specifications by some; cloth and clothing woven to Inca pattern were contributed by others. Objects made by tribute labor were taken to storage facilities for later redistribution to conscript workers, colonists, or armies.

The Incas enforced sumptuary laws marking social divisions in the kind of objects that were owned or used. The ruling Inca was the most important living being. His legitimate heirs, progeny of his union with a full sister, formed a descent group that retained its prominence in accord with the reputation established by its founder. The kin of each Inca who had ruled formed a class of royalty that called itself "Inca," in contrast to other ethnic groups and to lower nobility that had achieved status by promotion.[3] Each class was granted access to particular kinds of goods. The ruling Inca sat on a royal seat (see fig. 2) carved in the form of felines, and ate food from dishes of gold or silver.[4] Silver could be owned by royalty and high nobles. Similarly, different qualities of clothing were worn by people of different rank.[5] Reserved for the Inca was especially fine cloth woven by cloistered women who devoted themselves to the royal service and the state religion. Feather cloth was worn by nobles in military triumphs. The lavish expenditure of specialized work in the production of royal garments is expressed in the report that Atahuallpa, during his captivity by the Spaniards, wore a shirt woven of fiber spun from bat fur.[6] High-quality cloth or other objects were given by the Inca to reward military prowess or special services.[7]

Much of Inca architecture was designed to advance the needs of the state: barracks to house armies, administrative buildings to serve bureaucratic ends, and facilities for storing tribute goods. State-designed engineering projects developed a network of roads and bridges over which people and goods could be moved. Terracing and irrigation works made marginal land productive. The symbolic import of this "architecture of power"[8] would have been enormous: the Incas could command the work of laborers to build monuments to Inca ability to control resources and govern lands.

The Inca capital at Cuzco (see fig. 3), begun by the ruler Pachacuti after an important military victory around 1438, exemplifies the Inca vision of an appropriate social order. The association of the city with royal Inca activity is shown by its plan.[9] It has been said that Cuzco was laid out in the form of a puma, the animal that symbolized the Inca dynasty. The feline motif was also featured on thrones, and miniature felines were used in making ritual offerings, perhaps signaling

Fig. 2 Royal seat. Peru, Inca, Cuzco, c. 1540. Painted and lacquered wood. The Field Museum of Natural History, Chicago. Photo: Kathleen Culbert Aguilar. Made in the early Spanish colonial period, this seat reflects the Inca tradition of reducing figures to essential geometric shapes, often in association with utilitarian forms. (Cat. no. 100)

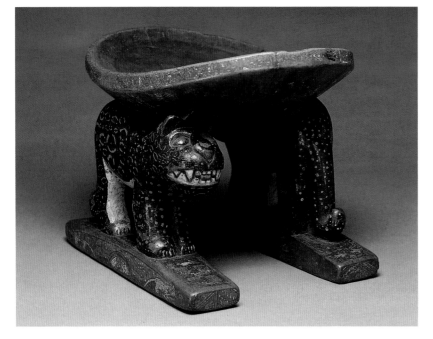

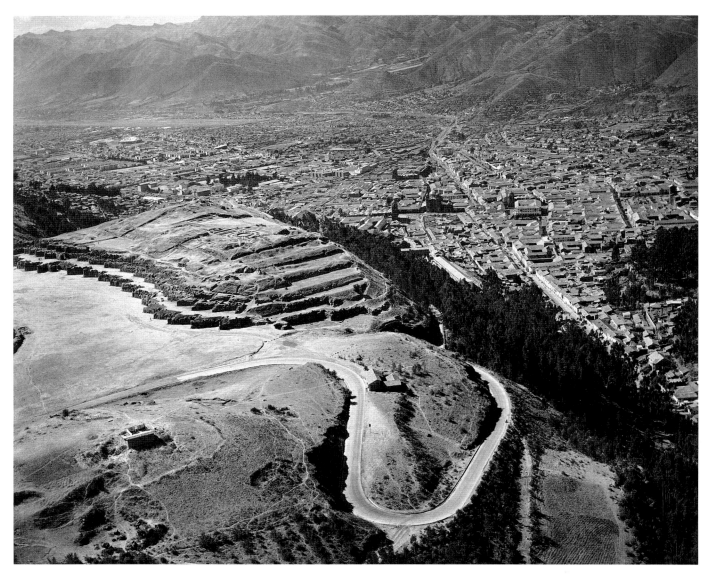

Fig. 3 Cuzco, site of
the Inca capital, lay in
the triangle between
the confluence of the
Huatanay (right) and
Choque Chacca rivers
(left). Peru, Inca, 1400/1532.
The ruined fortress-temple
Sacsahuaman (below, left)
dominates the city. Photo:
©Marilyn Bridges 1989.

the special bond between rulers and land. If taken literally, in the plan of Cuzco, the body of the puma was bounded by streets, walls, and canals; its belly would have been the main plaza; its head was the fortress overlooking the city. Within the constraints imposed by this form and by topographic irregularities, the design was a regular grid plan, with blocks and streets defined by the high, severe stone surrounding walls of its constituent buildings. In addition to the palace compounds built by successive rulers, the city comprised structures dedicated to religious and political functions. Little purely secular architecture was to be found. Commoners did not live in this sacred capital at the center of the Inca world, nor did they have any business being there. Strict laws governed access to the urban zone and the comportment of visitors to it, for Cuzco was not, in a European sense, really a city at all: it was instead a sacred artifact, an enclosure of power, the center of the Inca cosmos. The

political and religious centrality of Cuzco in the Inca polity was marked physically at the great plaza, Haucaypata, where there rose a monolithic dais, the *capec usno*, which only *the* Inca himself might ascend to preside on state occasions. This awesome rock was, in fact, the central point from which the four main roads led to the four quarters of Tahuantinsuyu, as the empire was called.

The most important structures in Cuzco, such as palace-compounds and temples, were made of carefully fitted masonry that required the labor of many workers. In Cuzco today, there are long, narrow streets still lined with walls of polygonal stones or coursed rectangular blocks. Most buildings were plastered with carefully selected but non-pigmented clay, while the finest structures were painted.[10] The Temple of the Sun in Cuzco, known as the Coricancha, was the most sacred building in the land. The structure was incorporated into and overbuilt by the Church of Santo Domingo, but still

clearly visible are several original walls and foundations of perfectly cut and fitted basalt blocks (fig. 4). According to the Spanish chronicles, much of this stonework was originally covered by plaques of beaten gold, which were stripped to pay Atahuallpa's ransom when he was held by Pizarro.[11] The terraced temple grounds enclosed a model garden that included effigies of people, animals, and crops rendered in gold—a landscape motif that we shall see expressed in other forms. Such places made Cuzco the sacred seat of Tahuantinsuyu, the vast imperium that stretched along the west coast of South America. Its governance required special architecture and shrines in the land to serve administrative ends and to ritually establish the Inca presence. The imposition

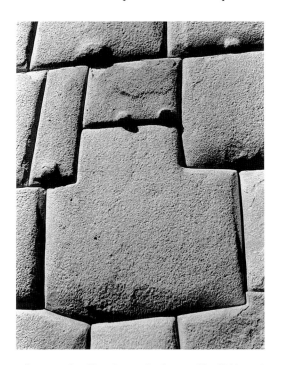

Fig. 4 Stone masonry from foundation wall in Cuzco. Peru, Inca, 1450/1532. Photo: Susan A. Niles. The stone foundations of royal Inca compounds are still visible along many streets in Cuzco. Precise polygonal stonework was used for retaining walls.

of a standardized vocabulary of buildings in widely removed parts of the empire indicates some of the symbolic intentions of Inca architecture. A distinctive Inca language of forms was also an important aspect of portable art. Stone sculptures of llamas and alpacas and imposing ritual vessels display simple, abstract geometric forms of great monumentality (see fig. 14). The Inca practiced an artistic imperialism, spreading their style by force, as they required the production of highly standardized ceramic and textile objects from subject populations.[12] Thus, in the Nazca region of the desert coast far to the south, the Inca occupation is clearly distinguished by ceramics made in the Cuzco style.

The Reconstruction of History

Another aspect of the way the Inca regarded their land can be inferred from how actual and mythical history determined the placement of major monuments. The Incas remembered history as deeds commissioned or carried out by their kings. Although the Incas did not use dates, it is possible to compare histories recorded by the Spanish in order to account for the pre-Conquest dynastic succession and to estimate some dates for the later rulers.[13]

Rule	Approximate Reign
Manco Capac	mythical
Sinchi Roca	mythical
Lloqui Yupanqui	mythical
Mayta Capac	mythical
Capac Yupanqui	unknown
Inca Roca	unknown
Yahuar Huacac	unknown
Viracocha	until 1438
Pachacuti	1438–71
Topa Inca	1471–93
Huayna Capac	1493–1525
Huascar	1525–32
Atahuallpa	1532–33

The royal histories mention military campaigns, weddings, the births of sons, palace coups initiated by ambitious regents, encounters with gods, and the creation of architectural monuments. The first act of any Inca assuming office was to erect his own personal royal compound in Cuzco and villas in the surrounding countryside, to house the king and his court and to serve the symbolic function of marking his place in dynastic history. It is highly likely that this action was prescribed by ancient traditions, for a similar city of royal compounds was built at Chan-Chan by the Chimú on the desert north coast of Peru. The city was conquered by the Inca in the late fifteenth century.

According to Inca oral history, the act of creating architecture was used as a metaphor for affirming control. The first Inca king to embark on serious campaigns of conquest took the name Pachacuti, "shaper of the earth," when he assumed office. Partisan histories stress his role in shaping the moral and administrative order of the Inca state, crediting him with the creation of Inca policies of tribute and government and rules for marriage and descent. The legends also credit him with erecting buildings and establishing the canons of Inca architectural style.[14]

Building a fortress or a military monument reminds subject people of their political

position; conscripting laborers from newly conquered areas solved the problem of quashing resistance and further consolidated political authority. Even allowing for royal exaggeration, the magnitude of the movements of peoples involved in such conscription was enormous. For example, the construction of the Sacsahuaman, the fortress and shrine-site overlooking Cuzco, required twenty thousand workers for each building season.[15] Huayna Capac's renovation of the Yucay Valley involved the work of one hundred fifty thousand workers, who were brought to Cuzco within six months of his request.[16]

Architecture also memorialized events of historical and religious significance. The construction of Cuzco itself was a commemorative act, which marked an important victory over the Incas' enemies, the Chancas, about 1438, and took place at the same time as the construction of victory monuments on the battlefield itself. The battlefield shrines no longer stand, but accounts provided by early chroniclers describe a building in which the flayed bodies of the Chanca dead, filled with ashes and straw and arrayed in gruesome positions, reminded visitors of the Inca triumph.[17] According to the traditional stories, the sanctified battlefield included a spring that had refreshed the victorious warriors.[18]

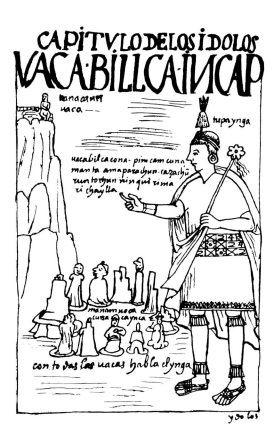

Fig. 5 Drawing of Topa Inca addressing assemblage of idols at a rock shrine similar to the one in fig. 6. Peru, Inca, seventeenth century. Drawing: Guaman Poma, 1986.

Ethnohistorical and archaeological evidence shows that this concern with history was extended to include certain sites and monuments considered sacred by earlier peoples. A most notable instance was the relationship between the Incas and the Middle

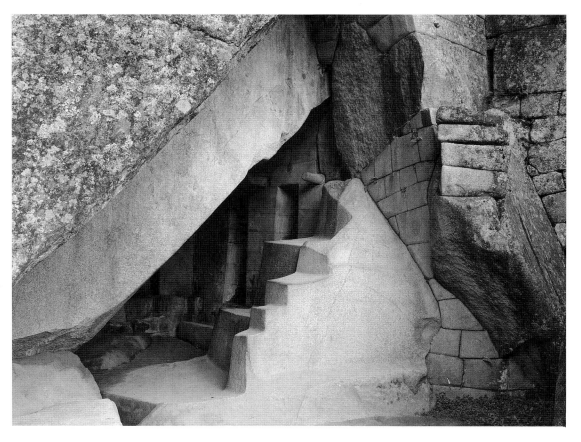

Fig. 6 Perfectly fitted masonry in shrine at Machu Picchu. Peru, Inca, c. 1500. Photo: Edward Ranney.

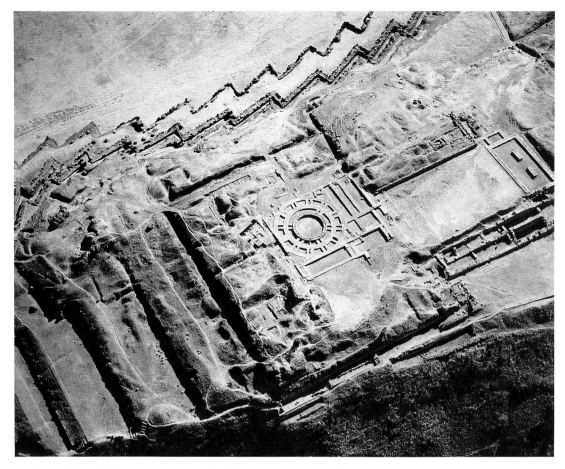

Horizon site of Tiwanaku, near Lake Titicaca. (See essay by Kolata and Ponce Sanginés in this book.) For the Colla peoples, during the Late Intermediate Period (1000–1476), the site was sacred; it was the center of the world and their place of origin.[19] Although it was probably largely in ruins by Inca times, Tiwanaku was to become one of the chief shrines of the Inca empire and a pilgrimage site for Inca kings. It was visited by both Pachacuti and Topa Inca during their military campaigns in Collasuyu (the Titicaca region), and one of Huayna Capac's sons was born there.[20] The Incas rededicated the temple of Puma Punku there and constructed buildings nearby, establishing an Inca presence at the site. According to Fray Bernabé Cobo, Inca Pachacuti was so impressed by the finely made stone masonry of the ancient buildings that he sought to emulate it in the style he devised for the rebuilding of Cuzco.[21] Such conscious archaism linked the Incas to the political power of their great rivals of Collasuyu, served to draw from the spiritual power of the ancients who had built Tiwanaku, and perhaps helped to redirect the loyalties of the conquered people of that province. Like the Aztecs, who sought to emulate their prestigious "Toltec" predecessors in what may be called a cultural renascence, so too the Inca

were directly quoting and incorporating themes from the art of the ancients.

An Inca temple on the Island of the Sun in Lake Titicaca likewise shows the pragmatic use of architecture to acknowledge the cultural heritage of the past, to redirect political and religious loyalties, and to commemorate sacred space (see fig. 8). The island was holy to the Colla peoples long before the Inca conquest of that region, and, after the Inca victory, a minister of the Colla temple journeyed to Cuzco to ask that Topa Inca install a shrine on the site so that worship could continue there.[22] Topa Inca obliged and created a temple dedicated to the Sun, which was paired with one on the nearby Island of Koáta, dedicated to the Moon. The sacred precinct surrounded a large rock outcrop, named Titikala or Titicaca in Aymara, signifying "wild cat rock," that was believed to be the original home of the Sun and the place where the world began. Topa Inca enlarged the existing temple and built a cloister for the women charged with making corn beer and cloth for the cult of the Sun, as well as facilities for housing visitors and officials of the temple.[23] He also placed storehouses on the mainland to provision the temple, and populated both island and mainland with colonists to serve it.[24] The importance of the

site is confirmed by elaborate offerings of gold and silver, stonework, ceramics, and textiles, tangible evidence of which was encountered by Adolph Bandelier in his excavations and in local collections that he acquired in the late nineteenth century.[25] Pre-Inca objects found at the site testify to the island's prominence in earlier times.[26]

Although the architecture was important to the Incas, descriptions of the sanctuary make clear that its focus was the live rock, Titicaca, which was approached by a formal path leading through a gateway (see fig. 9); three additional doorways delineated the route and set off sacred space as petitioners neared the rock.[27] The landscape was enhanced by a grove of trees planted by Topa Inca.[28] The Incas, taking over the sacred space of the Collas, laid claim to its history and modified the space in a way that expressed their own presence and conception of sacred landscape. Some versions of the Inca origin myth show how they incorporated into their mythic geography the sacred spaces they encountered as the empire advanced. One passage refers specifically to the major shrine sites at the Island of the Sun, in a narrative that takes place before human creation:

> When the Creator of the world... made all things in Tiaguanaco...he ordered the Sun, Moon, and Stars to go to the Island of Titicaca...and that from there they should go up to the sky. When the Sun was ready to leave in the form of a brightly shining man, he called the Incas, and the Sun himself spoke like an older brother to Manco Capac in the following way: "You and your descendants will subjugate many lands and peoples, and you will be great rulers...." And then the Sun went up to the sky with the Moon and Stars, where each one assumed its habitual place. And at once, by order of the Creator, the Inca brothers made their way beneath the earth and emerged at the cave of Pacarictampu.[29]

The descendants of Manco Capac fulfilled the Sun's prophecy, taking dominion over others as their divine right and giving mythical legitimacy to their empire by expanding their sacred geography to match their political boundaries. Inca concepts of spatial order were thus not only shaped by the cosmological geometry of Tahuantinsuyu, but by inherited notions of sacred history perceived in the Andean landscape.

The Shape of the Sacred Landscape

We have seen that Inca administration, warfare, and social organization cannot be considered without reference to religion. Omens

Fig. 10 View of Machu
Picchu. Peru, Inca, c. 1500.
Photo: Johan Reinhard.

dictated choice of marriage partners, the rights of succession, and the timing of battle; military campaigns were undertaken with idols in hand; key victories were attributed to divine intervention; and temples displayed the heads of vanquished generals. Accounts of the lives of rulers mythologized their reigns, synthesizing history and myth in the accounts told to Spanish chroniclers. And just as the Inca sought to incorporate the sacred sites of foreign peoples, so too their expansionist civilization was inspired — at least in part — by the desire to bring all the Andes to the worship of Inca deities.

The complex Inca religion operated on several levels. The formal pantheon of deities, headed by the Sun, included the Moon, Thunder, and Venus. A creator god, Viracocha, prominent in most accounts of Inca religion, doubtlessly appealed to the moral sensibilities of the Spanish chroniclers, who saw in him a parallel to their own Christian notion of God. Temples to Inca deities were erected in the capital city, in other important sites surrounding the capital, and in provincial regions. Devotion was displayed in public festivals carried out in open precincts.

The contractual relation of humans to the spirit world necessitated the provision of goods to be offered to the deities. As new provinces were brought under Inca control, specially designated parcels of land were set aside for the state religion; local people were obligated to work these lands to support the cults promulgated from Cuzco.[30] These lands provided the basic materials for offerings. Corn beer and coca leaves were used in ceremonies, and herds of llamas and alpacas dedicated to the Sun provided sacrificial victims and the wool for cloth used in ritual presentations. The provinces also provided children to be sacrificed in the most solemn of rituals.[31] The movement of goods and people to Cuzco, or to subsidiary temples dedicated to Inca gods, served to reinforce the central place of Inca religion and political control even in the most remote provinces of the empire.

Much of daily religious life in the capital was focused on localized shrines propitiated by the royal families of Cuzco. The nearly four hundred sacred places were arrayed on forty imaginary lines, called *ceques*, that were believed to radiate outward from the Coricancha, the Temple of the Sun. The shrines included springs, rocks, and mountain peaks, which made up the sacred landscape of Cuzco. Some shrines testified to the intervention of supernatural forces in the human

world. Origin myths tell of founding ancestors emerging from the earth, being converted to stone, and remaining for all time as tangible proof of the story. Some stones, called *pururuacas*, were seemingly ordinary rocks that, according to one source, were changed into human form to fight in battle; after the victory, they reverted to stone and were venerated.[32] Near Cuzco, a rock fell from the quarry in human form, and the work site became a shrine.[33] Some places were considered sacred because of their associations with royalty: the houses of Pachacuti and his queen were shrines. Yet other sites were associated with the great rituals of state, such as a seat on the route to the festival of Raymi or places associated with the induction of young noblemen to manhood. Other shrines linked places visually: a pass where travelers lost the view of one valley and gained a view of the next, or a place from which Cuzco was first seen by travelers.

The royal families were responsible for feeding the shrines, which were treated as though they had human needs (see fig. 5). Offerings included corn beer and coca leaves, while some, especially springs and fountains, demanded ground or broken shells. One shrine was given only the chewed quids of coca of travelers who crossed its mountain pass, another, only sacrificed herd animals. Some received especially fine clothing, and one was given the leftover dust from offerings to other shrines. Some shrines were fed with miniature objects, such as tiny clothes or figurines of herd animals rendered in stone, shell, or silver. Elsewhere, especially on distant mountaintops, small gold or silver images of children could stand in for, or accompany, the sacrifice of real children (see McEwan and Van de Guchte essay in this book). The rock at the Island of Titicaca was dressed in fine cloth and covered with gold plaques; in front of it, a pierced, round stone was given corn beer so that the Sun could drink.[34]

Some documents suggest that other centers had shrine systems similar in principle to that of Cuzco, although none is described in such detail.[35] The shrines were points of communication between humans and the spiritual powers, places where the Incas expressed their contractual relationship with the holy. In most cases, details of the petitions made to shrines are given, but shrines were propitiated for specific ends; for example, to ensure that hail would not destroy crops, to give health, to grant sleep, or to guard against the death of children.

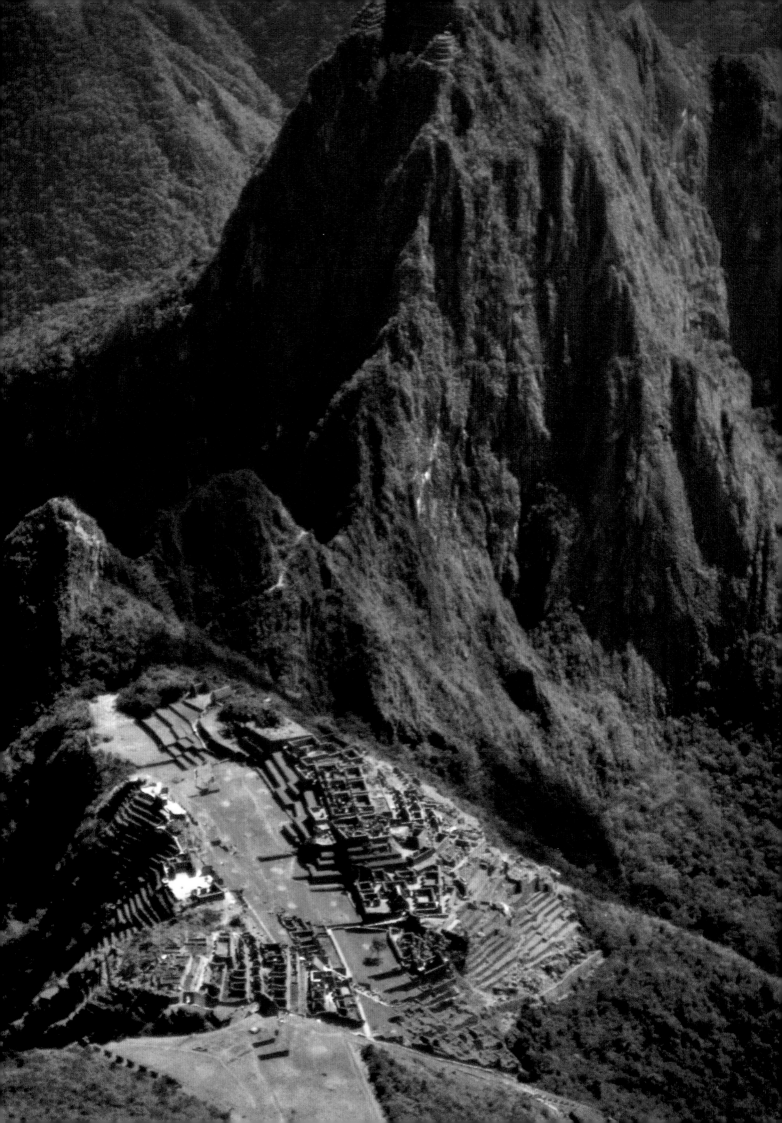

Fig. 11 A bedrock outcrop carved as a royal dais at Sacsahuaman, Cuzco. Peru, Inca, c. 1480. Photo: Susan A. Niles.

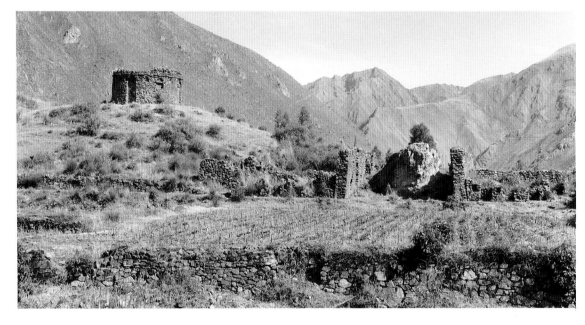

Fig. 12 The enclosed sacred boulder faced a plaza near Urco. Peru, Inca, c. 1500. Photo: Edward Ranney.

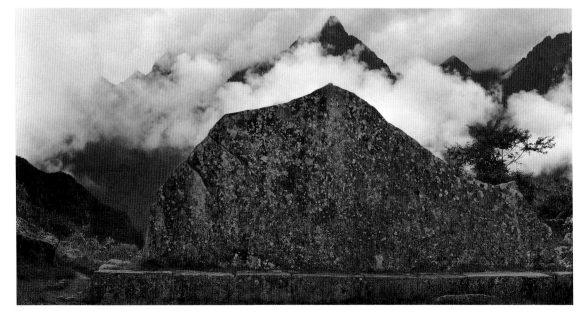

Fig. 13 A sacred rock at Machu Picchu echoes the shape of the distant mountain. Peru, Inca, c. 1500. Photo: Edward Ranney.

Although only a few shrines have been reliably identified, and fewer still have standing architectural remains, the importance of a sacred landscape, designed to enhance the experience of the natural and supernatural world, is still easily seen in and around Cuzco. The Inca repertory of forms includes viewing platforms, thrones, and fenestrated walls oriented to frame prominent features of the landscape. Sculpture or masonry frequently enhanced elements of the landscape.[36] The Incas used artistic intervention to reveal the nature of an important, but not visually imposing, natural feature. At Urco, in the Vilcanota Valley, an outcrop was provided with a channel and eyes to suggest the form of a serpent coiled around the rock. The slope of the channel is such that liquid poured on the rock would flow out through the serpent's face. The rock is given a home in a structure that frames the head of the serpent (see fig. 12). Similar serpents are carved into bedrock boulders at the shrine of Kenko, near Cuzco; at Ingapirca, near Quito, Ecuador; and on the monolithic throne at Saihuite, near Abancay, north of Cuzco. The association of serpents with liquid offerings and the earth is demonstrated also in a splendidly carved stone ritual vessel of probable Cuzco manufacture (fig. 14); the symbolic affinities between this object and the carved boulders suggest closely related functions. (Cobo reported that the sanctuary on the Island of the Sun at Lake Titicaca was guarded by an enormous serpent that surrounded the island.[37]) The Incas also highlighted distant elements of the landscape by echoing their forms with sculptured rocks placed close at hand. At Machu Picchu (fig. 10), an outcrop is polished so that the unworked portion of the rock repeats the craggy shape of the mountains that form its backdrop. At the same site, the Inti Huatana emulates the shape of one of the Huayna Picchu formations (see fig. 1). Perhaps such creations were offerings in miniature, analogous to the tiny garments or statues given to shrines, or perhaps the visual dialogue was intended to heighten the visitor's sense of the sacred elements contained in the shapes of the landscape.

As their legends describe, the division for the Incas between the visible landscape and the social world was permeable. Inca legends describe this, and Inca architects were charged with the task of making the unseen forces of their world visible to their contemporaries; and, because the works have endured over time, this visual dialogue is still accessible to us.

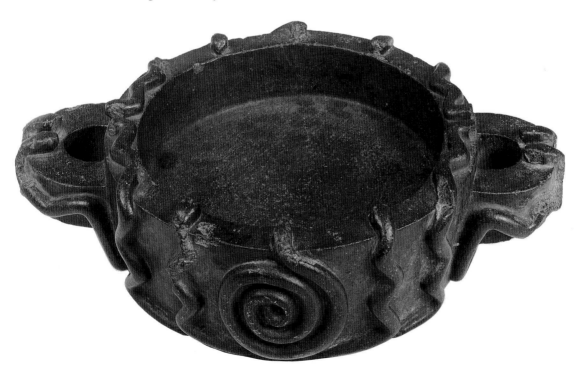

Fig. 14 Vessel depicting serpents. Peru, Inca, c. 1450. Stone. The Trustees of the British Museum, London. Inca art does not display the composite forms common to earlier Andean traditions. Figures are abstracted into essential generic shapes that are frequently subordinated to utilitarian forms, as in this monumental vessel. (Cat. no. 92)

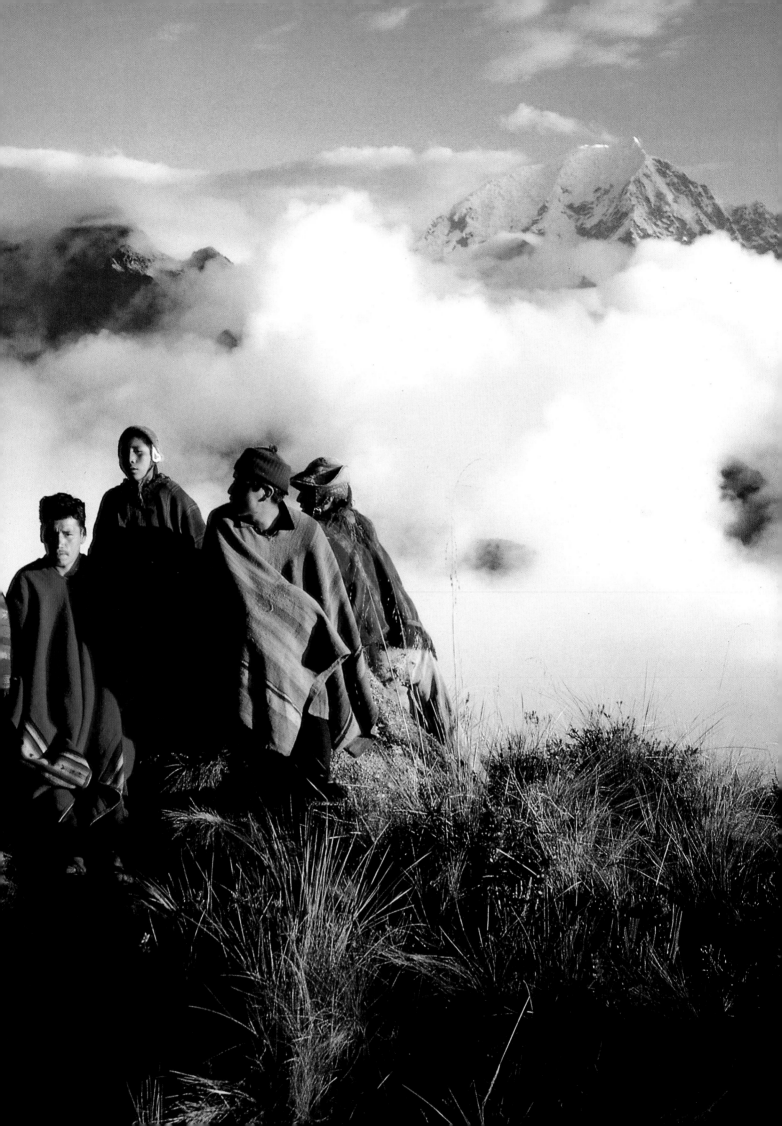

COLIN MCEWAN AND
MAARTEN VAN DE GUCHTE

ANCESTRAL TIME AND SACRED SPACE IN INCA STATE RITUAL

Introduction

Occasionally, the "otherness" of people living in remote times and distant places is evoked by an event so alien in its particulars, yet startling in its general character, that it encapsulates a whole era and a social configuration. The Inca ritual festival of *capac hucha* was such an event. This elaborate ceremony, staged periodically by the Inca priesthood, embraced mountains, islands, and religious sanctuaries scattered thousands of kilometers apart throughout Tahuantinsuyu, the Inca name for their empire (see fig. 2). The ritual culminated in the sacrifice and interment, at carefully selected sites in the Andean landscape, of a number of young children, accompanied by miniature votive figurines of precious metals. Our understanding of these events is hampered by the lack of indigenous voices from Peru prior to the Spanish invasion. We must rely on the native oral traditions that were collected, translated, and manipulated by European scriveners in the years following Francisco Pizarro's forceful entry into the Inca realm. By compiling the fragmentary accounts recorded by the Spaniards in widely dispersed chronicles and theological tracts, we can reconstruct the complexity and theatricality of the *capac hucha* ritual in broad terms.

One account describes a mid-sixteenth-century assembly of old Inca noblemen, convened in Cuzco, the Inca capital (fig. 3), to recount the myths and histories of their ancestors to a Spanish priest.[1] The Inca nobles spoke at length about their kings, their gods, and their customs, for, despite the trauma of the Conquest, many traditional Andean beliefs and practices survived. The drama and pageantry of the great seasonal festivals aroused the curiosity of the Spanish, especially the sacrificial ritual called *capac hucha*, which can be translated as "royal obligation." From the four quarters of Tahuantinsuyu, every village would send one or two young children to Cuzco. These children, aged six to ten years, were chosen for their exceptional beauty and had to be without a blemish. Upon arrival in the city, they assembled on the main square to stand before

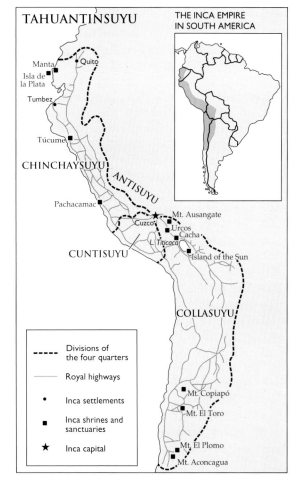

TAHUANTINSUYU

THE INCA EMPIRE IN SOUTH AMERICA

Manta
Quito
Isla de la Plata
Tumbez
Túcume
CHINCHAYSUYU
ANTISUYU
Pachacamac
Cuzco
Mt. Ausangate
Urcos
Cacha
L. Titicaca
Island of the Sun
CUNTISUYU
COLLASUYU
Mt. Copiapó
Mt. El Toro
Mt. El Plomo
Mt. Aconcagua

- - - - Divisions of the four quarters

———— Royal highways

• Inca settlements

■ Inca shrines and sanctuaries

★ Inca capital

Fig. 1 A party of Quechua Indians traversing a ridge with the sacred mountain Salcantay, near Cuzco, Peru, in the background. Photo: Sara Steck.

Fig. 2 Map of Tahuantinsuyu, the Inca "empire of the four quarters." Peru, Inca, 1450/1532. Drawing: Mapping Specialists Limited.

Fig. 3 The Plaza of Cuzco in Peru was the epicenter of the Inca world and the starting point of major Inca state rituals. Peru, Inca, 1400/1532. Photo: Richard Townsend.

the statues of the Creator God, the Sun, the Thunder, and the Moon. The Inca king and priests received the children, sacrificed selected animals, then symbolically married the boys and girls. In solemn procession, the future sacrificial victims walked twice around the square within which lay the *ushnu*,[2] the symbolic center of the Inca universe. Together, the children, priests, and their companions then began their homeward journey. After weeks of traveling, the arrival of the sacrificial child in his or her native village was acclaimed with joy. Following these celebrations, the young boy or girl would be intoxicated with *chicha*, a maize beer, and buried in a specially constructed tomb, surrounded by rich offerings. Priests ritually fed the deceased child liquids through a tube for five days.[3]

Human sacrifice was comparatively rare in Inca society.[4] Sacrifice was primarily restricted to animals, such as llamas and guinea pigs. Astoundingly large numbers of llamas were sacrificed in particular months, and criteria such as the animal's age and color and the patterning on its coat were considered vital in determining the selection made for offering on special occasions. The llamas destined for sacrifices in the month of August had to be without a blemish, like the *capac hucha* children.[5] The Incas' selective use of human sacrifice poses many questions.

Why were human lives offered? Why were children selected for this purpose? Why were they "married" to each other prior to their deaths? Fortunately, some of the objects and offerings used in the *capac hucha* ceremony have survived in graves and tombs. The locations of these archaeological finds on remote mountain tops, islands, and other revered features in the landscape reveal the final destinations of the sacrificial victims, which are not described in the written sources. Bringing both literary and archaeological data to bear on the interpretation of this act enables us to explore the relationship between Inca cosmology and territoriality.[6]

Literary Accounts of the Great State Ritual of *capac hucha*

Several Spanish chroniclers traveling or living in Peru in the years immediately following the Conquest describe the elaborate ritual surrounding the *capac hucha* ceremonies.[7] According to the Spanish chronicler Cristóbal de Molina, the ritual of *capac hucha* was invented by the legendary king Pachacuti Inca Yupanqui. The fullest account appeared in 1551, published by Juan de Betanzos in the earliest narrative treatment of Inca society. Betanzos wrote:

> The lords of Cuzco made many important sacrifices to all the idols and *huacas* [sacred places],... situated

Fig. 4 Mount Ausangate in Peru, one of many peaks featured in Inca sacred geography and the site of *capac hucha* (Inca state ritual) sacrifices. Photo: Sigmund Csicsery.

around the city and particularly in the Temple of the Sun.... They sacrificed many boys and girls, whom they interred alive and sumptuously dressed. The [children] were buried in pairs of male and female, and with each pair they buried silver and gold household utensils.... These children were the sons and daughters of caciques [lords] and chiefs.[8]

The pairing of the young children in sacrificial couples is emphasized in another statement by the same author. He wrote that, during the ritual, the male and female victims were paired off and, thus "married," were given all the goods that married people would have in their home.[9] This coupling of male and female elements in the sacrifice was replicated in the material offerings accompanying the young victims, as archaeological finds have shown. Once the ceremonies in Cuzco were completed, the king instructed the priestly representatives from the four quarters to take the offerings and sacrifices to their most important *huacas*.[10]

The religiously charged nature of the whole event was underlined by the carefully orchestrated processional movement of the *capac hucha* parties both to and from Cuzco. On their journey to Cuzco, the children, accompanied by a retinue of priests and village elders, followed the royal Inca roads that were constructed throughout Peru (see fig. 2).[11] The return journey to their homelands assumed quite a different character. Forbidden to take the royal Inca road, the various groups were required to travel in prescribed straight lines over the rugged Andean terrain, traversing valleys and streams, climbing mountains and hills, until they reached their final destinations hundreds, if not thousands, of kilometers distant. When they came to a village, the local people were obliged to stay inside their houses and avert their eyes. Molina wrote that the people in a *capac hucha* group walked one after the other, at regular intervals. One official was instructed to intone a solemn chant, directed to the deity whom the Spaniards called the Creator God. This cantor set the cadence, while the others followed in unison. Thus the *capac hucha* parties sang during their walk, praising their gods and king. Statues and offerings borne by the Inca officials preceded the children, who walked on foot, or, in some cases, were carried by their mothers.

The offerings that accompanied the sacrificial victims are described in some detail. For instance, Betanzos mentioned that the children:

> ...were buried wearing all their finery and each one bearing the objects that they would use. The girls carried precious offerings and small vessels

full of chicha, a bag of coca leaves, and toasted and cooked maize in the pots and jars, all made of gold and silver, and the boys carried [similar offerings] according to the rank they held in their houses.[12]

One of the principal reasons for performing the *capac hucha* ritual was to implore the *huacas* to ensure the health of the reigning king, so that he would live in peace and reach old age. Not a single *huaca*, small though it might be, was neglected. A complementary goal was the strengthening of ties between the center of the empire and its periphery. The participating villages and their chiefs in the provinces understood this and manipulated these state-designed objectives for their own benefit. A case in point is the experience of Caque Poma, lord of the village of Ocros in central Peru.[13] He had a daughter, ten years old, beautiful beyond exaggeration, we are told, whom her father dedicated as a sacrifice to the Sun. After being given permission by the Inca king to send his daughter to Cuzco, Caque Poma was given a wooden stool (see Niles essay in this book, fig. 2), the material expression of the lordship he would be awarded after his daughter's sacrifice. The girl was sent to Cuzco, and, when she came

Fig. 5 Mummy from Cerro el Plomo. Chile, Inca, c. 1500. Photo: Loren McIntyre. Found at an altitude of twenty thousand feet, this child sacrifice was accompanied by numerous figurines (see fig. 6) and a bag of coca leaves.

back from the celebrations there, she was feted in her native village. The author of the seventeenth-century document containing this account noted that the "old people" related that, according to tradition, the girl said: "You can finish with me now because I could not be honored more than I have been already by the feasts that they celebrated for me in Cuzco." They brought her to a high mountain, lowered her into a tomb already prepared for her, and walled her in alive.

In this universe of sacred offerings, a hierarchy of burials can be distinguished. The most significant *capac hucha* sacrifices were performed upon the death of an Inca king or the accession of a new king to the throne. These events were supervised by the imperial bureaucracy and invested with all the pomp of a major state occasion. It appears that children were sacrificed also to mark the beginning and the end of the agricultural year.[14] Many local *capac hucha* rituals, however, were performed by the elders of small villages and were intended to bind the village into an intimate network of genealogical and symbolic relationships both with the landscape and with neighboring settlements. Thus, the ancestral ties linking a place of origin with its satellites would be reaffirmed or the dependency between a seat of power and its subjects emphasized. The differences in the range and quality of material offerings accompanying the sacrificial victims probably reflect the status of the ritual, according to whether it was enacted on the state or village level.

The Archaeological Evidence

The stories of child sacrifice might have been interpreted simply as unverifiable tales, were it not for the fact that, in the course of this century, a small number of spectacular Inca burials of children have been discovered, with grave goods that closely match the written descriptions of the objects used in the *capac hucha* ritual. The presence of a child's body accompanied by suites of miniature offerings in precious metals, sea shell, and textiles is convincing proof that the final act of sacrifice was carried out at carefully selected locations as far apart as Isla de la Plata, off the Ecuadorean coast; Túcume on the Peruvian north coast; Mount Ausangate, some 150 kilometers east of Cuzco (see fig. 4); and Cerro el Plomo in Chile (see figs. 5, 6). Among the most remarkable finds are the high mountain sacrifices found on or close to the summits of Andean peaks that tower

at altitudes of up to six thousand meters. In 1985, a party of Argentinian mountaineers stumbled upon the frozen mummy of a young boy on the southwestern flank of Aconcagua, the loftiest mountain in the western hemisphere.[15] As in the case of the El Plomo sacrifice, the seated child had his forehead resting on his knees. The body was almost perfectly preserved, due to its exposure to the extremely cold, dry atmosphere. As suggested above, before being left to their fate, the children were induced to drink *chicha* beer until intoxicated, thus passing unconsciously from a deep stupor to death. The boy wore an Andean tunic and sandals. He was wrapped in several blankets made of wool and cotton, embroidered with stylized bird designs. The outermost textile was layered with yellow feathers, probably those of an Amazonia parrot. Inca-style figurines were left as offerings:

> Three were male human figures: one of gold (formed by hammering and soldering sheet metal), one of solid silver-copper alloy, and one of *Spondylus* [conch] shell.... Averaging about two inches high, all the human figures were clothed, had plumed crests, and carried little bags containing fragments of coca leaves.... The other three statuettes, one of gold and two of *Spondylus* shell, were stylized llamas, colored red on one side and white on the other.[16]

Similar offerings have been found on the volcano Copiapó (see figs. 7, 8), in the southern Andes.[17] Clusters of tomb burials reported from the Inca sanctuary of the Island of the Sun in Lake Titicaca,[18] and the figurines found at the great coastal temple and oracle of Pachacamac[19] suggest that multiple *capac hucha* events took place at these important sites. One of the most surprising and significant *capac hucha* burials was discovered by the American archaeologist George Dorsey at the northern margin of the Inca empire on Isla de la Plata, off the coast of modern Ecuador (fig. 9).[20] Excavating in a deep gully close to the best anchorage and landing point on the northern side of the island, he reported finding "two skeletons in such fragile condition that they could not be preserved." While all textiles and other perishable materials had long since disappeared by the time Dorsey unearthed the burial, the composition of the original set of offerings in metal, pottery, and shell can be inferred by piecing together the information from his published account and comparing it to material now in the Field Museum of Natural History, Chicago.[21] This cache comprises one of the most complete sets of figurines and vessels known to date. It originally included three gold figurines of different sizes, two of which have survived (fig. 10), together with three other female figurines in matching sizes but made of silver, copper, and shell. All were most likely richly dressed in miniature textiles when interred. Along with these were found five pairs of small ceramic vessels: two *urpus* (vessels used for storing and carrying liquids), two pedestal vessels, two dishes, two saucers with modeled handles, and two miniature plates, the whole making up a set of domestic serving ware (fig. 11). Although the two skeletons reported from the La Plata burial were not accurately recorded in their original context, their association with the carefully arranged, paired sets of figurines and vessels supports the written accounts that describe the offerings accompanying the pairs of young children.

The figurines found in these burials consistently follow the established canons of Inca visual art. Within a recognizable overall style, distinct subgroups can be distinguished, and figurines that are virtually identical have occasionally turned up in burials separated by great distances. This suggests that suites of figurines may have been produced for specific

Fig. 6 Votive female figurine. Chile, Inca, Cerro el Plomo, c. 1500. Silver, feathers, and textiles. Museo Nacional de Historia Natural, Santiago. The figurine is dressed in an exquisitely woven miniature textile fastened by a silver *tupu* (pin). (Cat. no. 79)

Marriage and the Miniature World

Archaeology and ethnohistory seldom combine as harmoniously as in the case of the *capac hucha* ritual. The descriptions of *capac hucha* events are confirmed and complemented by data from archaeological explorations. The most salient aspects of the rite are the marriage of the children within the context of a miniature world, the dualism expressed in the offerings accompanying the young victims, the spatial movement of the sacrificial party, and the final destinations of the sacrifices.

The children selected for the sacrifice represented their villages and symbolized the perfection, innocence, and health of youth. Perhaps the offering of the life of a child at this stage of growth held special significance, not just for the health of the king but for that of the body politic as a whole. As miniature adults, their selection can be interpreted within the larger context of the Inca fascination with the notion of an ideal but invisible world, and their attempt to represent this world in miniature. In Inca art, scenes depicting Andean life were often rendered in scaled-down models or images. The best example was the "garden of gold" from Cuzco, known to us only from surviving descriptions. The soldier Pedro de Cieza de León wrote of this garden in 1553:

> There was a garden in which the earth was lumps of fine gold, and it was cunningly planted with stalks of corn that were of gold—stalk, leaves, and ears.... Aside from this, there were more than twenty sheep of gold with their lambs, and the shepherds who guarded them, with their slings and staffs, all of this metal. There were many tubs of gold and silver and emeralds, and goblets, pots, and every kind of vessel all of fine gold.[22]

The garden of gold was situated, according to Garcilaso de la Vega, within the walls of the Temple of the Sun in Cuzco.[23] The inclusion of this garden within the sacred precinct of the most important temple, and its location at the end of an irrigation canal bringing water to the Temple of the Sun, stresses its prominent place within Inca religious concepts. By placing this "double" or "twin" of the natural world within the temple limits, the Incas expressed their need to shape and control the "other" sphere upon which they depended. This golden world became fixed in time and space, a static, even archetypal

Fig. 7 Archaeologists on summit of Mount Copiapó, Chile, where another *capac hucha* burial was uncovered (see fig. 8). Photo: Johan Reinhard.

Fig. 8 Votive female figurine. Chile, Inca, Mount Copiapó, c. 1500. Silver, feathers, and textiles. Museo Regional de Atacama. Photo: Johan Reinhard. (Cat. no. 88)

events and then carried to their different destinations by parties of priests, nobles, and children. Although the figurines reveal technical mastery in their manufacture, the range of anatomical detail, hairstyles, and headdresses portrayed is limited. The male figures sport a braided headband (*llauto*) and boast the oversized earspools that identify an Inca nobleman. The females have long hair intricately arranged in twin braids that are tied at the back. Male and female figures alike display a characteristic gesture found nowhere else in Inca art: both arms are raised so that the hands, with palms turned inward, touch the chest. The rigid stance and distant, expressionless gaze, common to all the figurines, further emphasize their hieratic character.

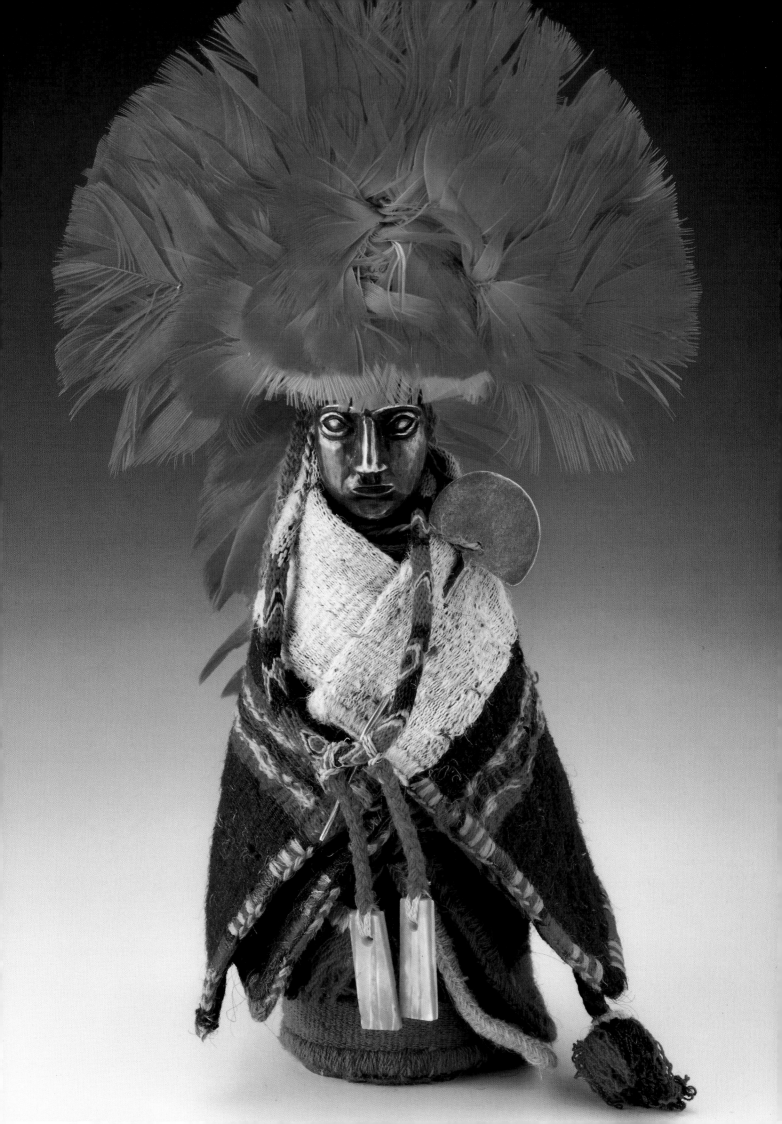

creation, as opposed to the fertile, creative
dynamism of the material world. The garden
of gold embodied man's attempts to achieve a
balance between the volatile forces of nature,
such as water, lightning, and procreation,
and the more ordered, codified forms of the
cultural world.

The ritual marriage of the *capac hucha*
children points to the fundamental impor-
tance of kin relationships in the Andean
world. The daughter of the chief of one vil-
lage "married" the son of another, thereby
establishing genealogical bonds and cement-
ing the social fabric through the instrument
of the Inca court, with the Inca king acting
as arbiter and matchmaker. The small statues
of animals and human beings and the minia-
ture sets of serving vessels that accompanied
the young couples as burial goods give us a
glimpse of a miniature world in which the
young newlyweds, through their mock mar-
riage and eventual death, mimic the social
universe of the adult world. The assemblages
of figurines accompanying the *capac hucha*
burials can be seen as replicas in miniature of
the cosmos of the Inca king, his subjects, and
his material possessions. Thus, the child sac-
rifice established a relationship between the
mortal king and his earthly realm, between
the head of the empire and the chief of a
village, and between the center of Tahuan-
tinsuyu and its periphery.

The symbolic union of male and female
domains is reflected in the accompanying
burial goods, where, within each pair of ob-
jects, there is usually a slight difference in
size or a contrasting decorative motif on each

vessel. This patterning stems from the appli-
cation of a principle of dual organization
that permeated all levels of the Inca social
world. The Inca dynasty, for example, was
based on a double monarchy,[24] but the care-
fully arranged sets of figurines in gold, silver,

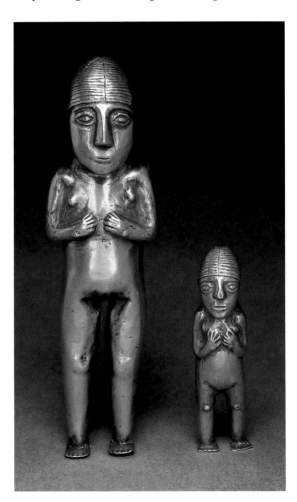

copper, and marine shell probably also reflect a threefold system of hierarchical ranking found in Inca society.[25]

Sacred Space

To appreciate why the *capac hucha* ritual was focused on Cuzco and how it unfolded throughout the empire, some insight into the principles governing Inca concepts of space is required. In the Andean world, a fundamental distinction was made between "upper" and "lower." Both the Valley of Cuzco and the Inca capital within it were divided into upper and lower halves, expressing a principle of complementary opposites.[26] A subdivision was then made, in which the Inca empire was divided into four parts (*suyus*), hence, its Quechua name, Tahuantinsuyu, "empire of the four quarters." The provinces of Chinchaysuyu and Antisuyu lay to the north and east, and Collasuyu and Cuntisuyu to the south and west, respectively (see fig. 2). The social and hierarchical status of the different ethnic groups in each *suyu* was signaled symbolically by distinct costumes, hair styles, and even cranial deformation.

This four-part pattern was further divided by forty-one straight "sight lines" (*ceques*), which radiated out, like spokes of a wheel, from the Temple of the Sun in the heart of Cuzco (see fig. 12). Each quarter (except for Cuntisuyu) was divided by nine *ceques*, which were themselves hierarchically ranked into three groups. The *ceque* system formed a logically coherent, unifying conceptual scheme, which was used to impose cultural order on the natural landscape. Along these lines of sight within the Cuzco Valley, there lay a total of 328 sacred places (*huacas*), the descriptions of which are preserved in a seventeenth-century chronicle recorded by the Jesuit Bernabé Cobo. Far from being an arbitrary number, this total of 328 derives from the precise calendrical purposes that the *ceque* system served in Inca social and ritual life. The *huacas* signified special places in the natural landscape, such as rocky outcrops, springs, or mountains, which were assigned great ritual importance in Inca sacred geography. Woven into a skein of complex rituals and mythologies, such sacred places received special attention as the backdrops for human deeds enacted to reflect cosmic events. Relating these sacred places to conceptual lines (*ceques*) radiating out from Cuzco also provided a tool for the territorial organization of the Inca empire, which was designed to focus the attention of distant places on the capital as the pre-eminent center of political and religious power. The use

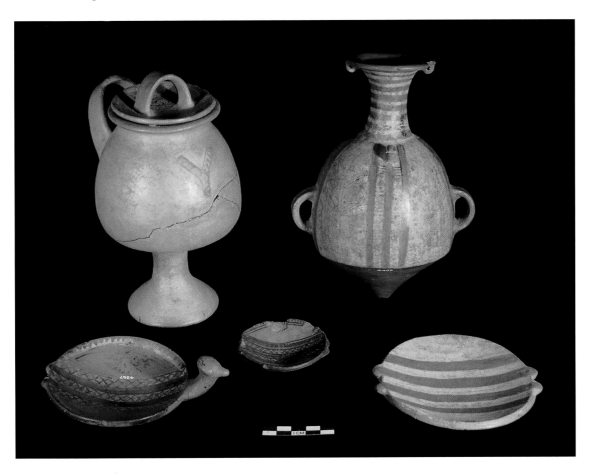

Fig. 11 Suite of miniature vessels and serving dishes found with burial on Isla de la Plata. Ecuador, Inca, c. 1500. Ceramic. The Field Museum of Natural History, Chicago. Photo: Colin McEwan.

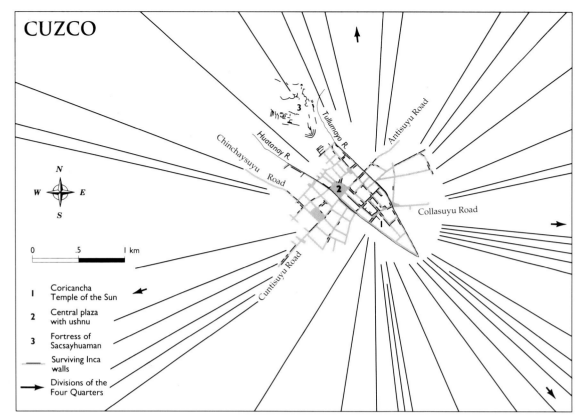

Fig. 12 Cuzco and the *ceque* (sight-line) system. Peru, Inca. Drawing: Mapping Specialists Limited.

CUZCO

N
W — E
S

0 .5 1 km

1 Coricancha
 Temple of the Sun
2 Central plaza
 with ushnu
3 Fortress of
 Sacsayhuaman
 Surviving Inca
 walls
 Divisions of the
 Four Quarters

Chinchaysuyu Road
Huatanay R.
Tullumayo R.
Antisuyu Road
Collasuyu Road
Cuntisuyu Road

of sibling terminology emphasizes the interdependence between points in this conceptual network. For instance, terms like "brothers" and "sisters" were used to designate relations between mountains, between rocks and mountains, and between mountains and human beings. The most sacred mountain in the Valley of Cuzco, Huanacauri, was said to be a brother of the first Inca king, Manco Capac. Equally important were relationships of genealogical descent. The mythological relations between different points in the landscape were expressed in a system of geographical relations that was organized along generational lines. Monumental sculpture, carved in bedrock at carefully selected locations in the Andes, functioned as commemorative features in the landscape by establishing a visual link between people, topography, and ancestral time.[27] The movement of ancestors and supernatural beings brought to life the connections between distant social groups and political and ecological zones and imbued them with symbolic and mythological significance.

The appropriation of Inca space was always ruled by both symbolic and pragmatic concerns. The *capac hucha* ritual was employed as a means of forging and maintaining effective ties with subject polities throughout the empire. This entailed marking the boundaries between the known, "civilized" Inca world and the "uncivilized" world beyond, boundaries between the known and the unknown that were as much perceptual as geographical. What lay within the Inca domain was ordered and defined; every element or being found its place within a tightly structured social hierarchy. All that lay outside Inca territory and the Inca social universe belonged to a wild, unordered, and uncontrollable world that was at once ambivalent and potentially threatening. Monumental rock sculpture and architectural monuments were often placed precisely at the critical borders between Inca territory and the "other," as at Ingapirca (Ecuador), which looked toward the unruly people in the north, and Samaypata (Bolivia), which confronted the "man-eating" people in the Amazonian rain forest. The relationships between Cuzco as center and the sacred geography of its surrounding landscape were reinforced by annual pilgrimages, which are still a vital part of living Andean culture today.

Nor were the *capac hucha* children the only Inca subjects to be buried in order to sanction specific territorial claims. The Inca kings themselves, and their "doubles" or "stone brothers," were also buried with strict geographical desiderata in mind. The "stone brothers" had houses, fields to plant, and servants, and they were accorded the full respect due living lords in the Inca hierarchy. The spatial distribution of their sacred tombs mirrored the division of Incaic Cuzco into

two halves: *hanan* (upper) Cuzco and *hurin* (lower) Cuzco. The "stone brothers" of *hanan* Cuzco were all laid to rest in their sector of the city, and those of *hurin* Cuzco in the other half.

A singular aspect of the journey made by the *capac hucha* parties was their adherence to a straight line along which to travel. Similar lineal relationships are revealed in an evocative myth narrating the travels of the "Tired Stone." According to different variants of the myth, this stone is said to have come from a distant place—according to some sources, as far away as Huánuco in central Peru or even Quito in present-day Ecuador. It was brought to the Cuzco area to be used as a building block in the construction of the temple/fortress Sacsahuaman, situated some 150 meters above the city of Cuzco. Just before reaching the building site, the stone became tired—it did not want to move anymore, and it shed tears of blood.[28] A well-defined spatial code is clearly articulated in the various routes taken by the "Tired Stone." Essentially, the movement of the stone serves to establish a relationship between two locations. This network of geographical and ideological relationships is anchored in a model of kinship or dynastic politics. Garcilaso de la Vega, for instance, said that the stone was brought to Cuzco along the Yucay river (the Urubamba).[29] Guaman Poma affirmed that, at first, "the stone was transported from Cuzco to Guanoco," but, in another folio, he said that "the stone was brought to Quito, to Tomi [bamba], and to Nobo Reyno from the city of Cuzco [and] from Yucay, many miles distant from each."[30] It is not so much the movement and direction of the stone that is important, but rather the connection that is established between two cities in a network of symbolic relationships, depending on the viewpoint of the person telling the myth.

Ancestral Time

The Incas described the creation of their world and the origins of human life on earth in a myth that features the god Viracocha. This deity's mythical journey toward Cuzco began at the ancient archaeological site of Tiwanaku, which, by Inca times, stood as an abandoned but imposing ruin, visible evidence of a distant epoch in which great deeds were performed by an ancestral race (see Kolata and Ponce Sanginés essay in this book). Moving from southeast to northwest, Viracocha's progress mirrored the sun's daily passage across the sky, as well as its annual journey from the December solstice sunrise to the June solstice sunset, and can be traced in the place names that are mentioned. Some of these are natural features in the landscape, which may be quite unassuming. Others were "marked" in a different way. To the southeast of Cuzco, Cacha (San Pedro de Racchi), a place where Viracocha rested, is still known for its large temple complex; and Urcos, another stop on the Creator God's travels, used to be similarly distinguished by a temple and a throne. These places all lie along an axis running from Lake Titicaca in the southeast to Ecuador in the northwest. From Cuzco, Viracocha proceeded in a northwestern direction toward the coast of the Pacific Ocean, where he disappeared over the waves—his name, "Foam of the Sea," alludes to this.

This mythical journey assumes special significance, for it was replicated in practice by every Inca king, in turn. Each king's journey reaffirmed the extent of his political domain and was legitimized by divine authority in the form of myth. Curiously, in the various versions of the story that have been recorded, different points of departure are mentioned for Viracocha's disappearance across the ocean to the west. Some versions name Acarí and Pachacamac on the central coast of Peru; others point to Tumbez in the far north; and, in a third version, Manta, yet farther north, in Ecuador, is mentioned.[31] It is likely that the myth was adapted to reflect changing geopolitical reality as successive kings waged military campaigns to conquer new territory. Topa Inca Yupanqui and Huayna Capac, for example, both mounted incursions northward into Ecuador. Topa Inca Yupanqui is said to have emulated Viracocha's feat by leading an expeditionary fleet of balsa rafts on an ocean voyage. A number of chroniclers detail the Incas' political program of building replicas of their capital—"new" Cuzcos—in various locations throughout Tahuantinsuyu. These civilizing acts proclaimed the successful subjugation and incorporation of new provinces into the empire. A passage from Betanzos reveals how the *capac hucha* ritual was intimately linked to these deeds: "The king Inca Yupanqui ordered that a thousand young boys and girls be brought and *buried in the places and sites where he had slept and sojourned*" (authors' italics).[32]

The *capac hucha* ceremony was used as a device for bonding sacred space and ancestral

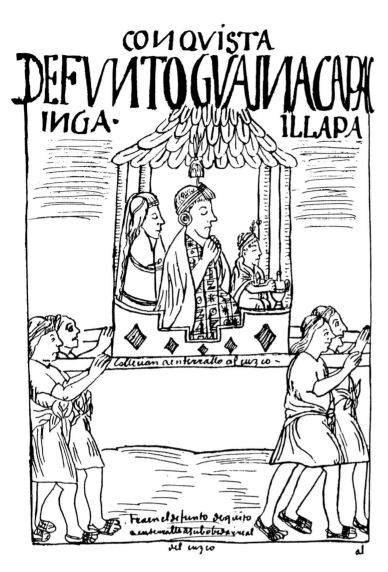

CONQVISTA
DEFVNTOGVAINACAPA
INGA. ILLAPA

Collicuan ach terratto al cusco ~

Feaen el defunto dequito acusterrallo asubobier avical del cusco

al

the Spanish soldiers and priests who witnessed this solemn rite suffuses their narrative accounts. The native participants in the drama speak only of joy and celebration, of dancing and singing, of dressing the young victim in colorful clothes. The precious gift of the young child's life affirmed and authenticated the role of the village in the Inca world at large. The relationship established with the Inca capital hinged on the concept of reciprocity, a central tenet of Inca society. A village or ethnic group offered a sacrificial victim, and, in return, the chief of the village ascended in the state hierarchy. In terms of Inca cosmology, the young child did not "die" but joined the ancestors, who were watching the village from their high mountain tops. The sacrifice must be seen in the context of a different moral order. Death was perceived by the Incas as a transitional phase, not the end of a long journey. In a world where stones are believed to have souls, and spirits to inhabit springs and rivers, the death of a child could restore balance in the universe after an occasional upheaval, such as the death of a king.

The movement of the *capac hucha* party effectively mirrored the movement of the Inca king leading his army outward from

time. It linked points of ancestral and cosmological importance throughout the empire. In this scheme, the mythological movements of the Creator God reflect the archetypal movement of the Sun, rising in the morning and setting in the evening. In the course of his life, the Inca king replicated this movement in his earthly journeys of conquest. Finally, on the occasion of his death, the movement was repeated by the child sacrifice that marked the end of a cycle of earthly rule. Thus, the cyclical nature of celestial movements found earthly expression in the Incas' belief in the cyclical nature of kingship and society at large—a cycle suddenly broken by the arrival of foreigners on their shores in 1531.

The Role of Human Sacrifice in Sanctifying the Land

The *capac hucha* victims marched to their death singing rhythmic chants and songs in praise of the Inca king. The astonishment of

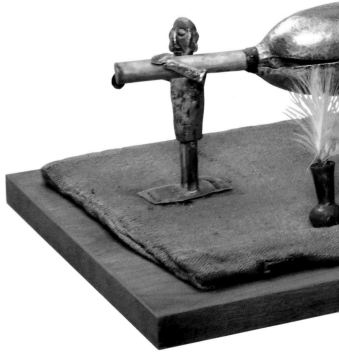

Cuzco to the margins of the empire and then returning in triumph. Should the death of a king have occurred far afield, his body would have been brought back to Cuzco on a litter (see figs. 13, 14). The chosen children also traveled from the four quarters to Cuzco before returning once more to the periphery to fulfill their sacrificial obligation. The movement of *huacas* such as the "Tired Stone" can be compared to the "pilgrimage" of the young children destined for the *capac hucha* sacrifice. The earthly journeys made by each king during his lifetime marked a new expansion of the empire and were legitimized by divine authority in the form of myth. By the same token, the death of each king demanded a redefinition of the empire's boundaries. While the Inca king made his last journey into ancestral time, his subjects commemorated his rule and achievements by having selected children repeat and sanctify his earthly journeys by virtue of their journey and sacrifice.

The points in the landscape selected for ritual sacrifice were carefully chosen, according to the precepts of Inca sacred geography. Thus, human affairs both past and present became inextricably bound to an animate landscape. The *capac hucha* rituals carried out within the Valley of Cuzco were subsequently projected to the uttermost extremities of the Inca world as state-ordained pilgrimages. The locations of the burials that have been found are ample testimony to the extraordinary lengths to which the Incas were willing to go in order to realize these concepts. The sacrifices were left precisely at the geographical limits of the Inca world, as if to impress the memory of the deed into the very landscape itself. The enactment of the ritual thus made a pragmatic political statement by unequivocally marking the territory under Inca hegemony. At the same time, its culmination in the act of human sacrifice stood as an eloquent gesture linking human culture to the unfathomable cosmos beyond.

Fig. 14 Model of funeral procession. Peru, Chimú, Chancay, 1400/1500. Silvered copper, textiles, reeds, and feathers. Krannert Art Museum and Kinkead Pavilion, University of Illinois, Champaign-Urbana. (Cat. no. 49)

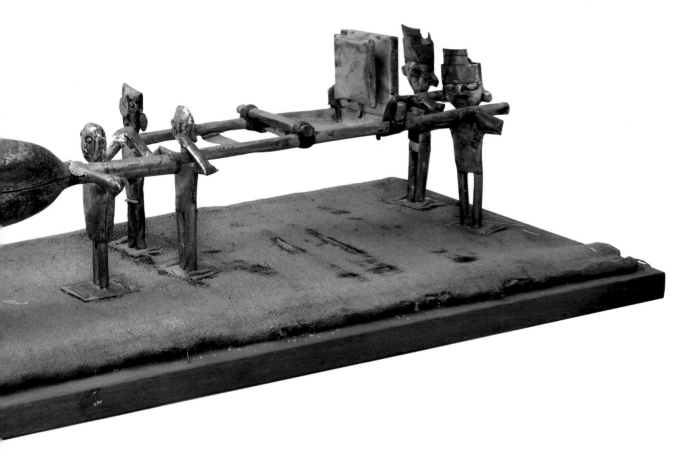

NOTES

The Sacred Center of Chavín de Huántar
Richard L. Burger

1. Tello, 1929, 1943, 1960.
2. Kauffmann Doig, 1964.
3. Vásquez de Espinosa, 1948, p. 458.
4. Duviols, 1973.
5. Ibid.
6. For summaries of modern archaeological research at Chavín de Huántar, see Burger, 1984, pp. 159–87; Lumbreras, 1989, pp. 115–34.
7. Burger, 1981.
8. Burger, 1983, 1984.
9. Burger and Salazar Burger, 1980; Grieder et al., 1988, pp. 24, 58, 202.
10. Williams, 1980, 1985.
11. Hobsbawn and Ranger, 1983.
12. Samaniego, Vergara, and Bischof, 1985.
13. Lumbreras, González, and Lietaer, 1976.
14. Lathrap, 1985.
15. G. Miller, 1984.
16. Burger and van der Merwe, 1990.
17. Rowe, 1967.
18. Lathrap, 1974, p. 148; 1977a; 1977b, pp. 741–42; 1982.
19. Lathrap, 1985.
20. Cordy-Collins, 1977, 1980.
21. Duviols, 1973.
22. Lumbreras, 1989, pp. 135–82.
23. Rowe, 1962, fig. 40.
24. Sharon and Donnan, 1977.
25. Lumbreras, 1989, pp. 183–216.
26. See Cordy-Collins, 1979; Rowe, 1962.
27. W. Isbell, 1978.
28. G. Miller, 1979, pp. 88–91, n. 3.4.
29. Mayer, 1977; B. J. Isbell, 1978, p. 113.
30. Rowe, 1967.
31. Reinhard, 1985a.
32. Bastien, 1978, pp. 155–57; Sherbondy, 1982; Urton, 1981, p. 69.
33. Lumbreras, González, and Lietaer, 1976.
34. Burger, 1983.
35. Urton, 1983, personal communication.
36. Mayer, personal communication.

Paracas Necrópolis Textiles: Symbolic Visions of Coastal Peru
Anne Paul

1. The basic chronological framework used here is one proposed by Rowe, 1962, pp. 40–45. It includes seven principal time units; the Paracas cultural tradition spans the Early Horizon and the first two epochs of the Early Intermediate Period. While not all scholars agree on the absolute or chronometric ages of the Paracas objects assigned to this system of relative chronology, it is reasonable to accept a date of 700 BC for the start of the Early Horizon. The dates used for the Paracas objects in this essay reflect the author's recent conclusions after a thorough review of the carbon-14 measurements of Paracas archaeological material. See Paul, 1991a.
2. See Tello, 1959; Tello and Mejia Xesspe, 1979; Paul, 1990a, pp. 22–28; 1991a; Daggett, 1991.
3. See Paul, 1990a, pp. 65–76; 1991b.
4. See Paul, 1986.
5. For a discussion of the shaman figure, see Paul and Turpin, 1986.
6. This identification was made by Peters, 1991.
7. This identification was suggested by Peters, 1991.
8. See Reinhard, 1987, p. 44.
9. See Kajitani, 1982, pl. 40.
10. A three-tiered cape made of condor feathers was placed around the "shoulders" of Necrópolis bundle 290 (illustrated in Tello and Mejia Xesspe, 1979, pl. 4D).
11. Paul, 1990a, pp. 95–99; 1990b; 1991b.

Interpreting the Nazca Lines
Johan Reinhard

1. It has not been possible to include original references to all the information presented in this article. Although a few works have been cited, I have primarily indicated pages from my publications on the subject which provide original sources for the interested reader. See Reinhard, 1988, for my acknowledgments to the many people and organizations that assisted in my research at Nazca.

2. Townsend, 1985.
3. Reinhard, 1988, p. 58, figs. 69–70; Silverman, 1986.
4. Waisbard, 1981.
5. Reinhard, 1988, pp. 25–29, 40–41.
6. Ibid., p. 10, n. 3.
7. Morrison, 1987, pp. 41–42.
8. Reinhard, 1988, pp. 9–11.
9. Reiche, 1968.
10. Aveni, 1986; Hawkins, 1973.
11. Reinhard, 1988, p. 11.
12. Ibid., pp. 16–18.
13. Ibid., pp. 14–20.
14. Ibid., pp. 22–25, 57–59; Silverman, 1990.
15. Hawkins, 1973, pp. 107, 117, 120, 139; Reiche, 1968, p. 50; Reinhard, 1988, pp. 29, 31–32.
16. Reinhard, 1988.
17. Aveni, 1986, p. 38.
18. Reinhard, 1988, pp. 27–29.
19. Ibid., pp. 34–51.
20. Hawkins, 1973, p. 147.
21. Reinhard, 1988, p. 56.
22. Reinhard, 1985b, p. 314.

The World of Moche
Elizabeth P. Benson

1. For general background and examples of Moche iconography, see Benson, 1972; Donnan, 1978; Hocquenghem, 1987; Kutscher, 1983.
2. Benson, 1985.
3. Kubler, 1948; Shimada, 1987, p. 135.
4. Gillin, 1947, pp. 34–36.
5. Donnan, 1985.
6. Pozorski, 1975.
7. Topic, 1977, pp. 334–35.
8. Shimada and Shimada, 1985.
9. Plowman, 1984.
10. Moseley, 1975.
11. For Moche paintings, see Bonavia, 1985, pp. 47–109.
12. Topic, 1977, pp. 352–57, 373.
13. Shimada, 1987.
14. Donnan, 1985.
15. Alva, 1988, 1990.
16. Bonavia, 1985, pp. 48–71.
17. Proulx, 1982, p. 83.
18. Alva, 1988.
19. Wassén, 1987.
20. Larco Hoyle, 1939, pp. 85–124.
21. Benson, 1975.
22. Benson, 1982, pp. 183–84.
23. Mester, 1983.
24. Arriaga, 1968, p. 64.
25. Urton, 1982.
26. Lechtman, 1984.

Tiwanaku: The City at the Center
Alan Kolata and Carlos Ponce Sanginés

1. Cobo, 1893, p. 65.
2. Mumford, 1961, p. 36.
3. Posnansky, 1945, pp. 120–21.
4. Ellwood, 1973, p. 3.
5. Cieza de León, 1959, p. 284.
6. See, for example, Wheatley, 1971.
7. Zuidema, 1990.
8. Ibid.
9. Murra, 1968, 1985.
10. Ponce Sanginés, 1971, p. 25.
11. Ibid., p. 36.
12. Bandelier, 1911, p. 235.
13. Ponce Sanginés, 1971, pp. 71–88.
14. See Bennett, 1934, p. 478; see also, Posnansky, 1945, p. 69.
15. Cieza de León, 1959, p. 283.
16. See Townsend, 1979, 1982; see also Wheatley, 1971.
17. Créqui-Montfort, 1906, p. 535; Posnansky, 1945, p. 71.
18. Kolata, 1989.
19. Manzanilla and Woodard, 1990, p. 138.
20. Manzanilla and Woodard, 1990.
21. Cordero Miranda, 1976.

22. Many of the conclusions and interpretations drawn here are based on the results of research conducted under grants from the National Science Foundation, the National Endowment for the Humanities, and the Inter-American Foundation, Alan Kolata, principal investigator. The United States government has certain rights to this material. Additional support was generously provided by Tesoro Petroleum Corporation, Occidental Oil and Gas Corporation, and the Pittsburgh Foundation. Field research at Tiwanaku and affiliated sites in Bolivia was authorized under permissions granted by the Instituto Nacional de Arqueología (INAR) and the Ministry of Education and Culture, La Paz, Bolivia. The senior author is particularly indebted to Dr. Carlos Ponce Sanginés, Director Emeritus of INAR, and to Oswaldo Rivera Sundt, current Director of INAR, for introducing him to the archaeology of Tiwanaku and for actively encouraging his participation in the life of Bolivia and the native communities surrounding Lake Titicaca. This is a debt that can never be repaid in full.
23. Ponce Sanginés, 1979; 1981, pp. 71–88.
24. Kolata, 1986, 1989, 1991.

Camelids and Chaos in Huari and Tiwanaku Textiles

Rebecca Stone-Miller

1. Skinner, 1986.
2. R. Stone, 1987, pp. 75–77.
3. Conklin, 1982, pp. 278.
4. Oakland, 1986b, pp. 167–211.
5. Recent work by myself (R. Stone, 1987) and by Oakland (1986a, 1986b) have helped define technical and stylistic parameters, especially for tunics.
6. See also Sawyer, 1963, figs. 1, 4.
7. R. Stone, 1986, pp. 142–43; 1987, pp. 110–78.
8. See Zurich, 1971, fig. 127, p. 281, for an effigy vessel of a man wearing a tie-dyed mantle or tunic. See Harcourt, 1962, p. 159, on the technique of scaffolding used to create the so-called "patchwork."
9. Stone-Miller and McEwan, 1990.
10. Browman, 1974, p. 188.
11. Ibid., p. 194.
12. Ibid., p. 189.
13. Ibid., p. 193.
14. Polakoff, 1980.
15. Gayton, 1973, pp. 277–82.
16. Browman, 1974, p. 188.
17. The cup is in the Dumbarton Oaks Research Library and Collections, Washington, D.C., acc. no. B.609. A camelid effigy vessel is shown in Grey, 1978, fig. 30.
18. Examples are in the American Museum of Natural History, New York, Bandelier-Heyde Collection, acc. nos. B/9605, B/9606, and B/6007.
19. See Benson, Niles, and McEwan and Van de Guchte essays in this chapter. See also, for example, Emmerich, 1984, pp. 50–51, figs. 61, 62, for Inca silver sculptures of an alpaca and a llama. See also Zurich, 1971, p. 299, figs. 135, 136, for stone versions of the same.
20. A piece in a Swiss private collection is either very closely related to or part of the same original composition (see Zurich, 1957, cat. no. 282). I am grateful to Diana Fane for bringing both pieces to my attention.
21. R. Stone, 1987, ch. 3
22. R. Stone, 1986, fig. 6.
23. R. Stone, 1987, pp. 167–78.
24. R. Stone, 1986; 1987, pp. 166, 171–73, 187–89.
25. R. Stone, 1987, pp. 193–96.
26. Layton, 1978, p. 29.

Inca Architecture and the Sacred Landscape

Susan A. Niles

1. Cobo, 1964, bk. 12, ch. 3, p. 62; 1979, pp. 103–104.
2. See, for example, Cobo, 1964, bk. 12, ch. 23, pp. 109–11; 1979, pp. 189–93.
3. Cobo, 1964, bk. 12, ch. 27, pp. 118–19; 1979, pp. 208–10.
4. Pizarro, 1986, p. 12.
5. Betanzos, 1987, p. 110.
6. Pizarro, 1986, p. 68.
7. Cobo, 1964, bk. 12, ch. 27, p. 120; 1979, p. 210.
8. Gasparini and Margolies, 1980, p. 195.
9. Cuzco's plan is described in ethnohistorical sources and can be traced on the ground by looking at the outline of still-visible Inca walls, as discussed by Rowe, 1967b, pp. 59–76. Alternatively, these references may be metaphors for the place of the capital in the body politic, as discussed by Zuidema, 1985.

10. Cobo, 1964, bk. 14, ch. 3, p. 242; 1990, p. 193; see also Bonavia, 1985, pp. 151–75.
11. Pizarro, 1986, pp. 59, 91–93; see also Cieza de León, 1959, pp. 146–47.
12. See, for example, Rowe, 1979; Menzel, 1976.
13. Based on Rowe, 1944, pp. 57–58. An alternative view of Inca history rejects an organization of the king lists by chronology and posits an interpretation based on genealogical distance from the reigning king. See, for example, Zuidema, 1990.
14. See, for example, accounts of his reign by Cobo, 1964, bk. 11, ch. 12, pp. 77–83; 1979, pp. 133–37; see also Betanzos, 1987, pp. 49–79.
15. Cieza de León, 1986, pp. 147–48.
16. Betanzos, 1987, p. 187.
17. Cieza de León, 1986, pt. 2, pp. 135–36.
18. Rowe, 1980, p. 29.
19. Cobo, 1964, bk. 13, ch. 19, p. 195; 1990, p. 100.
20. Cobo, 1964, bk. 12, ch. 14, p. 83, ch. 17, p. 94, bk. 13, ch. 19, p. 198; 1979, pp. 144–45, 154; 1990, p. 105.
21. Cobo, 1964, bk. 12, ch. 13, p. 82; 1979, p. 141.
22. Cobo, 1964, bk. 12, ch. 14, p. 83, bk. 13, ch. 18, pp. 190–91; 1979, p. 143; 1990, pp. 92–93.
23. Cobo, 1964, bk. 13, ch. 18, p. 193; 1990, pp. 93–94.
24. Cobo, 1964, bk. 13, ch. 18, p. 191; 1990, p. 93; Ramos Gavilán, 1976, pp. 43–44.
25. Cobo, 1964, bk. 13, ch. 18, p. 194; 1990, p. 99; Bandelier, 1910.
26. See, for example, Bandelier, 1910, pl. 21 (Tiwanaku-style drinking cups).
27. Cobo, 1964, bk. 13, ch. 18, p. 193; 1990, pp. 96–98; Ramos Gavilán, 1976, pp. 22–23, 48–49.
28. Ramos Gavilán, 1976, pp. 22–23.
29. Cobo, 1964, bk. 12, ch. 14, pp. 62–63; 1979, pp. 104–105. Similar versions of the story were presented by Cieza de León, 1986, pp. 8–12 and Betanzos, 1987, pp. 11–15.
30. Cobo, 1964, bk. 12, ch. 28, pp. 120–23; 1979, pp. 211–14.
31. Cobo, 1964, bk. 12, ch. 34, pp. 133–35; 1979, pp. 235–38.
32. Pachacuti Yamqui, 1968, p. 297.
33. Cobo, 1964, bk. 13, ch. 14, p. 177; 1990, p. 66.
34. Cobo, 1964, bk. 13, ch. 18, p. 193; 1990, p. 97.
35. Duviols, 1967.
36. See also Hyslop, 1990, pp. 102–28.
37. Cobo, 1964, bk. 13, ch. 18, p. 193; 1990, p. 98.

Ancestral Time and Sacred Space in Inca State Ritual

Colin McEwan and Maarten Van de Guchte

1. Betanzos, 1987; Sarmiento de Gamboa, 1943, pp. 177–79.
2. Zuidema, 1979.
3. Molina, 1989; Hernández Principe, in Duviols, 1986, pp. 461–75; Pizarro, 1978; Cieza de León, 1985, ch. 29, pp. 87–89.
4. These are accounts of war captives being sacrificed. Uhle, 1903, suggested that a group of women were sacrificed at the site of Pachacamac.
5. August, in Molina's Julian calendar, corresponds to September in the Gregorian calendar; see Molina, 1989.
6. See Duviols, 1976, and Zuidema, 1977–78, for earlier interpretations of this ritual.
7. Betanzos, 1987, p. 50; Molina, 1989; Guaman Poma, 1986, fol. 259 [261].
8. Betanzos, 1987, p. 84.
9. Ibid., p. 142.
10. Molina, 1989, p. 121.
11. See Hyslop, 1984, for a discussion of the Inca road system.
12. Betanzos, 1987, p. 142.
13. Hernández Principe, in Duviols, 1986, pp. 461–75; see also Zuidema, 1989, pp. 159–66.
14. Zuidema, 1991, personal communication.
15. Schobinger, 1991, pp. 63–64; Besom, 1991.
16. Schobinger, 1991, p. 64.
17. Reinhard, 1991.
18. Bandelier, 1910, p. 166.
19. Baessler, 1904.
20. Dorsey, 1901, pp. 255–60.
21. McEwan and Silva, 1989; see also Marcos and Norton, 1981.
22. Cieza de León, 1959, p. 147.
23. Garcilaso de la Vega, 1966, pp. 187–88.
24. Seler, 1914; Duviols, 1979; Zuidema, 1964.
25. Zuidema, 1964.
26. Zuidema, 1989, pp. 264–67.
27. Van de Guchte, 1990.
28. Van de Guchte, 1984.
29. Garcilaso de la Vega, 1966, p. 464, 470–71.
30. Guaman Poma, 1986, fol. 160 [162].
31. Sarmiento de Gamboa, 1943, p. 30; Guaman Poma, 1986.
32. Betanzos, 1987.

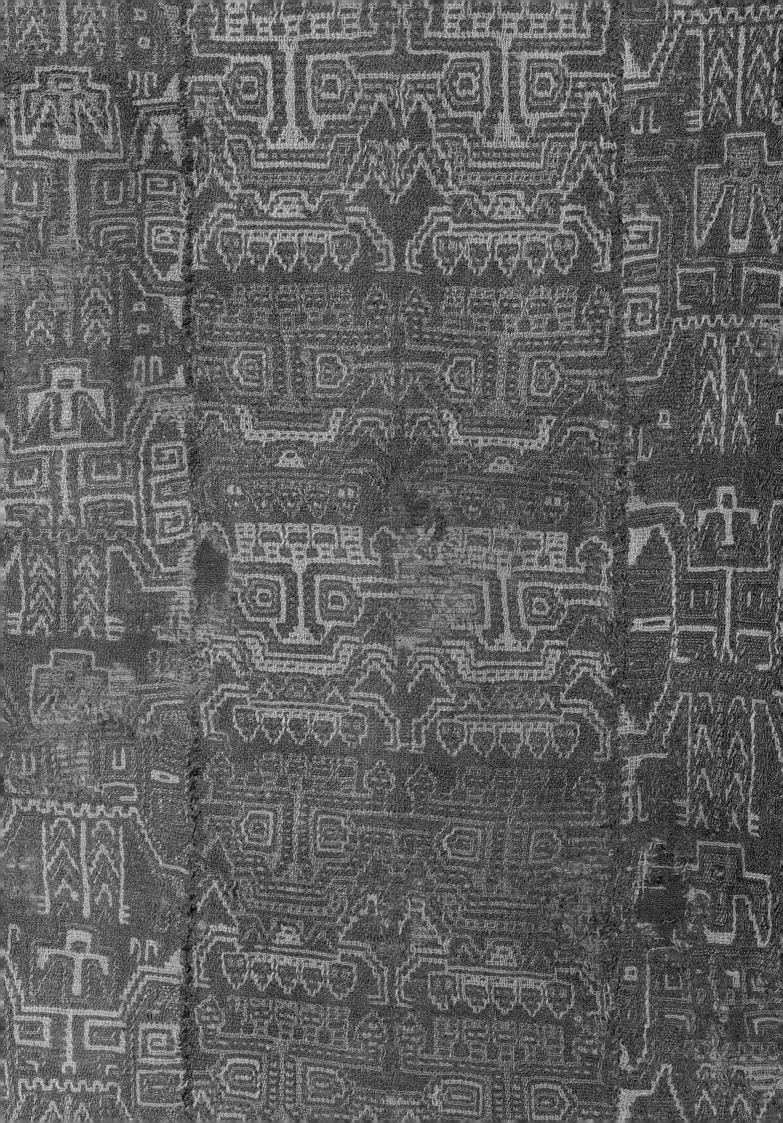

CHECKLIST OF THE EXHIBITION

This list is arranged alphabetically by culture. Unless otherwise noted, dimensions are listed by height, followed by width, followed by depth.

AZTEC

The objects listed below date 1450/1521, unless otherwise noted.

1. Dog. Mexico. Basalt; 36 x 20.3 x 19 cm. James W. and Marilynn Alsdorf Collection, Winnetka, Illinois (PC 59).

2. Monkey. Mexico. Basalt; 38 x 24 x 24 cm. James W. and Marilynn Alsdorf Collection, Winnetka, Illinois (PC 60).

3. Coronation stone of Moctezuma II ("Stone of the Five Suns"). Mexico, Tenochtitlan, c. 1503. Basalt; 55.9 x 66 x 22.9 cm. The Art Institute of Chicago, Major Acquisitions Fund (1990.21). Ill. Aveni essay, fig. 13a-c.

4. Figure of deity Xipe-Totec. Mexico. Ceramic; h. 60 cm. The Art Institute of Chicago. Gift of Florene May Schoenborn and Samuel A. Marx (1960.905).

5. Fire serpent Xiuhcoatl. Mexico, Tetzcoco. Stone; 75.5 x 60.5 x 56.5 cm. The Trustees of the British Museum, London (1825.12–1). Ill. Matos Moctezuma essay, fig. 13.

6. Old earth god Tepeyollotl ("Heart of the Mountain"). Mexico, Tenochtitlan. Stone; 34 x 21.6 x 24 cm. Museum für Völkerkunde, Basel (NR. IV b649). Ill. Matos Moctezuma essay, fig. 12. (The Art Institute of Chicago, only.)

7. Casket with name glyph of Moctezuma II. Mexico, Tetzcoco, c. 1503. Stone; 22 x 24 x 24 cm. INAH–CNCA–MEX, Museo Nacional de Antropología, Mexico City (10–223670/11–3132).

8. Vessel of the Plumed Serpent, Quetzalcoatl ("Cuauhxicalli"). Mexico, Tenochtitlan. Stone; h. 48.3 cm, diam. 94 cm. INAH–CNCA–MEX, Museo Nacional de Antropología, Mexico City (10–1159/11–1111). Ill. Townsend essay, fig. 13.

9. Priest drawing blood for ritual offering. Mexico, Tenochtitlan, c. 1480. Stone; 58.7 x 36.8 (widest) x 30 cm. INAH–CNCA–MEX, Museo Nacional de Antropología, Mexico City (10–116583/11–3787). Ill. Townsend essay, fig. 5.

10. Earth deity Tlatecuhtli. Mexico, Tenochtitlan, 1450/1500. Stone; 61 x 53.3 x 35.6 cm. INAH–CNCA–MEX, Museo Nacional de Antropología, Mexico City (10–81265/11–3473). Ill. Townsend essay, fig. 11a, b.

11. Male figure, possibly an attendant of an earth goddess. Mexico, c. 1450. Ceramic; 156 x 65 cm. INAH–CNCA–MEX, Museo Nacional de Antropología, Mexico City (10–222238/11–5131). Ill. Matos Moctezuma essay, fig. 11.

12. Female figure. Mexico, 1480/1521. Stone; 146 x 40 x 25 cm. INAH–CNCA–MEX, Museo Nacional de Antropología, Mexico City (10–81584/11–3475).

13. Cult mannequin ("Macehual"). Mexico. Basalt; 132.5 x 30.7 x 44.5 cm. INAH–CNCA–MEX, Museo Nacional de las Intervenciones, Churubusco, Mexico (CH-10102–3).

14. Sacrificial knife. Mexico, 1400/1521. Obsidian, silica, and copal; 21.6 x 7.3 x 5 cm. INAH–CNCA–MEX, Museo del Templo Mayor; Mexico City (10–253138).

15. Sacrificial knife. Mexico, 1400/1521. Obsidian, silica, and copal; 18.4 x 7 x 5.1 cm. INAH–CNCA–MEX, Museo del Templo Mayor, Mexico City (10–253139).

16. Sacrificial knife. Mexico, 1400/1521. Obsidian, silica, and copal; 15.2 x 6.7 x 4.8 cm. INAH–CNCA–MEX, Museo del Templo Mayor, Mexico City (10–253099).

17. Incense burner depicting deity. Mexico, 1450/1500. Ceramic; 91 x 76 cm. INAH–CNCA–MEX, Museo del Templo Mayor, Mexico City (133646). Ill. Matos Moctezuma essay, fig. 1.

18. Ritual vessel depicting mask of Tlaloc. Mexico, Tenochtitlan, 1400/1521. Ceramic; 35 x 31 cm. INAH–CNCA–MEX, Museo del Templo Mayor, Mexico City. Ill. Townsend essay, fig. 1, and back cover.

19. Sacrificial cosmological altar. Mexico, Tenochtitlan. Greenstone; h. 49.5, diam. 83.8 cm. Philadelphia Museum of Art, The Louise and Walter Arensberg Collection (1950–134–403). Ill. Matos Moctezuma essay, fig. 14.

20. Xiuhmolpilli, sculpture marking the completion of a fifty-two-year cycle. Mexico, c. 1508. Stone; 30.5 x 31.8 x 61 cm. INAH–CNCA–MEX, Museo Nacional de Antropología, Mexico City (11–3331/10–22091). Ill. Aveni essay, fig. 9.

21. Maskette of Tezcatlipoca. Aztec/Cholula, Mexico, Penon. Ceramic; 11 x 10.5 x 4.5 cm. The Field Museum of Natural History, Chicago (164569).

22. Maskette of Tlaloc. Aztec/Cholula, Mexico, Penon. Ceramic; 4.5 x 10 x 15 cm. The Field Museum of Natural History, Chicago (164568).

23. Serpent labret. Aztec/Mixtec, Mexico. Gold; 6.5 x 4.3 cm. Courtesy of The Detroit Institute of Arts. (The Art Institute of Chicago, only.)

CALIMA

The objects listed below date 1300/1500.

24. Ring for ear ornament. Colombia. Gold; diam. 9 cm. Museo del Oro del Banco de la República, Bogotá (22.046).

25. Ring for ear ornament. Colombia. Gold; diam. 8.9 cm. Museo del Oro del Banco de la República, Bogotá (29.520).

26. Pair of ear spools. Colombia. Gold foil on wood base; each diam. 8.8 cm. Museo del Oro del Banco de la República, Bogotá (3394, 3395).

27. Pectoral with face mask and mask pendant. Colombia. Gold; 25.2 x 30.5 cm. Museo del Oro del Banco de la República, Bogotá (5370).

28. Plumed diadem with mask and pendants. Colombia. Gold; 31 x 27 cm. Museo del Oro del Banco de la República, Bogotá (4833).

29. Ceremonial ear pendant. Colombia. Gold; diam. 15.5 cm. Museo del Oro del Banco de la República, Bogotá (56.14).

30. Ceremonial ear pendant. Colombia. Gold; diam. 16 cm. Museo del Oro del Banco de la República, Bogotá (56.13).

CHAVIN

The objects listed below date 900/200 BC

31. Offering vessel. Peru. Steatite; h. 4.8 cm, diam. 16.8 cm. The Brooklyn Museum, The Roebling Society Fund and Dick S. Ramsay Fund (71.23). Ill. Burger essay, fig. 10.

32. Textile fragment with splayed cayman imagery, multiple masks, and serpent motifs. Peru, Ica Valley, Callango. Painted cotton; 89.9 x 62.9 cm. Dumbarton Oaks Research Library and Collections, Washington, D.C. (B-544). Ill. Burger essay, fig. 18.

33. Textile fragment depicting earth goddess. Peru, Ica Valley, Callango. Painted cotton; 27.3 x 78.4 cm. Dumbarton Oaks Research Library and Collections, Washington, D.C. (B-545). Ill. Burger essay, fig. 19.

34. Vessel with incised designs. Peru. Ceramic; 28 x 15.5 x 15 cm. Fowler Museum of Cultural History, University of California, Los Angeles, gift of Mr. and Mrs. Herbert L. Lucas, Jr. (X88–853).

35. Textile fragment depicting masked figures holding staffs. Peru, Karwa. Painted cotton; 241 x 61 cm. Museo Amano, Lima (MA. 3230). Ill. Burger essay, fig. 17.

36. Processional figure displaying human trophy head. Peru. Stone; 75 x 75 x 31.7 cm. Museo Nacional de Antropología y Arqueología, Lima (L-8912).

37. Relief fragment. Peru, Chavín de Huántar. Stone; 33 x 42 x 5 cm. Museo Nacional de Antropología y Arqueología, Lima (L-8771, 1248 50 LXXXII). Ill. Burger essay, fig. 15.

38. Relief fragment with feline design. Peru. Stone; 35.5 x 20.3 x 15 cm. Museo Nacional de Antropología y Arqueología, Lima (835 1241, 27 LXXX U).

39. Tenon head. Peru, Chavín de Huantár. Stone; 31.7 x 49.5 x 38 cm. Museo Arqueológico Rafael Larco Herrera, Lima. Ill. Burger essay, fig. 8.

40. Vessel with appliquéd serpent. Peru. Ceramic; h. 19.4 cm, diam. 14 cm. Arthur M. Sackler Collections, New York (82.6.18).

41. Vessel depicting spread-winged rapacious birds. Peru. Ceramic; 24.1 x 18.3 cm. Arthur M. Sackler Collections, New York (82.6.5).

42. Vessel depicting jaguar, possibly representing a shaman surrounded by hallucinogenic San Pedro cactus. Peru, Cupisnique. Ceramic; 26.7 x 17.8 cm. Munson-Williams-Proctor Institute, Museum of Art, Utica, New York (69.4). Ill. Burger essay, fig. 12.

43. Vessel with seed motif. Peru, Cupisnique. Ceramic; 34.2 x 11.4 x 11.4 cm. Museo Nacional de Antropología y Arqueología, Lima (1/2905, C 54032). Ill. Burger essay, fig. 16.

44. Vessel depicting *Spondylus* shell. Peru, Cupisnique. Ceramic; 18.4 x 15.5 x 15.5 cm. Museo Nacional de Antropología y Arqueología, Lima (C 54029, 1/2923). Ill. Burger essay, fig. 5.

CHIMU

The objects listed below date 1200/1470, unless otherwise noted.

45. Flask depicting litter bearers. Peru. Ceramic; 19 x 20.5 cm. The Art Institute of Chicago, restricted gift of Mrs. Leigh Block (1980.178).

46. Ceremonial knife (*tumi*). Peru. Gold and turquoise; 34 x 12.7 cm. The Art Institute of Chicago, Ada Turnbull Hertle Endowment (1963.841).

47. Man's ceremonial garment set. Peru, 1300/1400. Cotton; mantle 142 x 270 cm; padded hat 35.5 x 30.5 cm, 87 x 65 cm (with ties); band with tassles 306 x 5.5 cm; loincloth 244 x 90 cm; turban center 182 x 132 cm, 99.2 x 24.5 cm (with tabs). Private collection.

48. Plaque depicting confronted figures. Peru, Lambayeque. Gold; 15 x 12 x 2 cm. Museo Arqueológico Bruning, Lambayeque (142-MB).

49. Model of funeral procession. Peru, Chancay, 1400/1500. Silvered copper, textiles, reeds, and feathers; 17.1 x 28 x 64.1 cm. Krannert Art Museum and Kinkead Pavilion, University of Illinois, Champaign-Urbana (67-29-303). Ill. McEwan and Van de Guchte essay, fig. 14.

COCLE

The objects listed below date 600/800, unless otherwise noted.

50. Figurine. Panama, Chiriqui, 700/900. Gold; 11.1 x 7.62 cm. American Museum of Natural History, New York (30.0/3334/1915–66).

51. Pendant depicting double dragon. Panama, 700/900. Cast gold with plaster restoration; w. 9.5 cm. The Art Institute of Chicago, restricted gift of the Auxiliary Board (1982.1484).

52. Pendant depicting frog. Panama, Venado Beach, 700/900. Gold; 18.26 cm. The Art Institute of Chicago, Wirt D. Walker Fund Income (1969.792).

53. Plaque depicting ritually attired performer. Panama, Macaracas, 700/900. Gold; 25.1 x 26.7 cm. The Cleveland Museum of Art, John L. Severance Fund (52.459). Ill. Helms essay, fig. 5.

54. Jar with modeled animal features. Panama. Ceramic; 27.3 x 30.4 cm. Private collection. Ill. Helms essay, fig. 7.

55. Jar with dragonlike design. Panama. Ceramic; 33 x 35.5 cm. Private collection. Ill. Helms essay, fig. 8.

56. Pedestal dish depicting figure with sacrificial sting-ray spines. Panama. Ceramic; 24.7 x 14 cm. Private collection.

57. Pedestal bowl depicting dancer wearing crocodile mask. Panama. Ceramic; 33 x 16.5 cm. Private collection. Ill. Helms essay, fig. 15.

58. Pedestal bowl with crouching-frog designs. Panama. Ceramic; 29 x 16.5 cm. Private collection. Ill. Helms essay, fig. 6a, b.

59. Bowl with hammerhead-shark designs. Panama. Ceramic; 37 x 10.1 cm. Private collection. Ill. Helms essay, fig. 10.

60. Bowl depicting dancer. Panama. Ceramic; 26.6 x 9.6 cm. Private collection. Ill. Helms essay, fig. 2.

61. Pedestal bowl with abstract design of aquatic and dragonlike creatures. Panama. Ceramic; 31.7 x 4.12 cm. Private collection. Ill. Helms essay, fig. 16.

62. Plate depicting millipede figure. Panama. Ceramic; 23.4 x 62 cm. Private collection. Ill. Helms essay, fig. 9.

63. Armband depicting confronted felines and raptorial birds. Panama, Sitio Conte, c. 700. Gold; 13 x 16 cm. Peabody Museum of Archaeology and Ethnology, Harvard University, Cambridge, Massachusetts (31–36–20/C13368). Ill. Helms essay, fig. 14.

64. Helmet depicting animal impersonator. Panama, Sitio Conte, c. 700. Gold; h. 9.5 cm, diam. 21 cm. Peabody Museum of Archaeology and Ethnology, Harvard University, Cambridge, Massachusetts (31–36–20/C13366). Ill. Helms essay, fig. 3.

65. Plaque depicting human and animal features. Panama, Sitio Conte, c. 700. Gold; 17 x 18.5 cm. Peabody Museum of Archaeology and Ethnology, Harvard University, Cambridge, Massachusetts (30–49–20/C11058). Ill. Helms essay, fig. 13.

66. Plaque with figural relief. Panama, Sitio Conte, c: 700. Gold; 25.5 x 26.5 cm. Peabody Museum of Archaeology and Ethnology, Harvard University, Cambridge, Massachusetts (33–42–20/1612). Ill. Helms essay, fig. 1.

67. Plaque depicting composite animals. Panama, Sitio Conte, c. 700. Gold; 22.5 x 24 cm. Peabody Museum of Archaeology and Ethnology, Harvard University, Cambridge, Massachusetts (33–42–20/1613). Ill. Helms essay, fig. 4.

HUARI

The objects listed below date 500/800, unless otherwise noted.

68. Tunic. Peru. Camelid wool; 109.8 x 119.9 cm. The Art Institute of Chicago, Kate S. Buckingham Endowment (1955.1784). Ill. Stone-Miller essay, fig. 8. (The Art Institute of Chicago, only.)

69. Tunic fragment. Peru. Camelid wool and cotton; 114 x 104 cm. Private collection. Ill. Stone-Miller essay, fig. 10.

70. Tunic depicting enclosure of felines and assembly of figures. Peru. Camelid wool and cotton; 151.1 x 112.1 cm. Dumbarton Oaks Research Library and Collections, Washington, D.C. (B-501.PT). Ill. Stone-Miller essay, fig. 13.

71. Mantle fragment. Bolivia. Dyed cotton; 112 x 97.5 cm. Henry Art Gallery, University of Washington, Seattle, Harriet Tidball Collection, (77.7–1105). Ill. Stone-Miller essay, fig. 5.

72. Tunic fragment. Peru. Camelid wool and cotton; 103.5 x 50.5 cm. The Metropolitan Museum of Art, New York, The Michael C. Rockefeller Memorial Collection, bequest of Nelson A. Rockefeller (1979.206.393). Ill. Stone-Miller essay, fig. 14. (The Art Institute of Chicago and The Museum of Fine Arts, Houston, only.)

73. Tunic fragment. Peru. Camelid wool and cotton; 69.9 x 53.3 cm. The Metropolitan Museum of Art, New York, gift of George D. Pratt (1930.16.4). (The Art Institute of Chicago and The Museum of Fine Arts, Houston, only.)

74. Tunic fragment. Peru. Camelid wool and cotton; 53.3. x 32.7 cm. The Metropolitan Museum of Art, New York, The Michael C. Rockefeller Memorial Collection, bequest of Nelson A. Rockefeller (1979.206.394). (The Art Institute of Chicago and The Museum of Fine Arts, Houston, only.)

75. Tunic (unku). Peru. Camelid wool and cotton; 100 x 92.3 cm. Museo Nacional de Antropología y Arqueología, Lima (T-01650). Ill. Stone-Miller essay, fig 1.

76. Effigy vessel depicting official. Bolivia. Ceramic; h. 41.2 cm, diam. 27.9 cm. Arthur M. Sackler Collections, New York (83.1.1). Ill. Stone-Miller essay, fig. 6.

77. Pendant and ear spools. Huari/Tiwanaku, Bolivia. Spondylus shell, mother of pearl, silver, and copper; pendant 14.2 x 9.5 cm, ear spools diam. 6.5 cm. The Art Institute of Chicago, Buckingham Fund (1955.2542, 1955.2543 a, b). Ill. Stone-Miller essay, fig. 7.

78. Ceremonial conch-shell trumpet. Huari/Tiwanaku, Bolivia, 600/800. Conch shell inlaid with jade, Spondylus, and other shells; h. 18.4 cm. The Dayton Art Institute, Ohio, museum purchase (70.32).

INCA

The objects listed below date 1450/1532, unless otherwise noted.

79. Votive female figurine. Chile, Cerro el Plomo, c. 1500. Silver, feathers, and textiles; 14 x 11.5 cm. Museo Nacional de Historia Natural, Santiago. Ill. McEwan and Van de Guchte essay, fig. 6.

80. Votive male figurine. Bolivia, Island of Titicaca, c. 1500. Silver; 6.35 x 2 cm. American Museum of Natural History, New York (B/1635/1896-31).

81. Votive female figurine. Bolivia, Island of Coati, c. 1500. Silver; 15.2. x 4.4 cm. American Museum of Natural History, New York (B/9608/1894-13).

82. Plate with fish and pepper design. Peru, probably vicinity of Cuzco. Ceramic; 7.6 x 23.7 cm. The Art Institute of Chicago, Buckingham Fund (1955.2223).

83. Aryballos. Peru, vicinity of Cuzco. Ceramic; 78 x 49 cm (widest). The Art Institute of Chicago, Buckingham Fund (1955.2214).

84. Miniature aryballos. Peru, Ica Valley, South Coast. Ceramic; 11.4 x 9.2 cm. The Art Institute of Chicago, Buckingham Fund (1955.2217).

85. Miniature aryballos. Peru, Ica Valley, South Coast. Ceramic; 11.4 x 9.5 cm. The Art Institute of Chicago, Buckingham Fund (1955.2218).

86. Votive female figurine. Peru, c. 1500. Silver; 6.35 x 1.5 cm. The Art Institute of Chicago, gift of Mr. and Mrs. James W. Alsdorf through the Alsdorf Foundation (1965.3).

87. Tunic (unku). Peru, 1532/50. Tapestry; 88.9. x 73.7 cm. Private collection. Ill. Léon Portilla essay, fig. 6.

88. Votive female figurine. Chile, Mount Copiapó, c. 1500. Silver, feathers, and textiles; 14 x 11.5 cm. Museo Regional de Atacama, Chile. Ill. McEwan and Van de Guchte essay, fig. 8.

89. Votive female figure. Chile, Mount Copiapó, c. 1500. Spondylus shell and textile; 10 x 6 cm. (approx.). Museo Regional de Atacama, Chile.

90. Figure of llama. Chile, Mount Copiapó, c. 1500. Spondylus shell. 3 x 1.5 cm. (approx.). Museo Regional de Atacama, Chile.

91. Vessels in the form of llamas and alpacas. Peru. a. speckled blackstone: 6 x 11 x 4.5 cm (1989.31); b. blackstone: 6 x 11 x 4 cm (1989.30); c. white alabaster: 8 x 10 x 4.5 cm (1989.27); d. blackstone: 8.5 x 13 x 5.5 cm (1989.27); e. wood: 5 x 7 x 3.5 cm (1989.32); f. beige stone with black veining: 8.5 x 12 x 4.5 cm (1989.28); g. blackstone: 7 x 10 x 3.5 cm (1989.29). The Detroit Institute of Arts, Founders Society Purchase with funds from June and William Poplack.

92. Vessel depicting serpents. Peru, c. 1450. Stone. The Trustees of the British Museum, London (1991 AM 3). Ill. Niles essay, fig. 14.

93. Vessel in the form of llama. Peru, Cuzco. Stone; 6 x 5 x 10 cm. The Field Museum of Natural History, Chicago (3444).

94. Miniature votive Spondylus shell. Peru, Cuzco. Probably turquoise; h. 1.5 cm, diam. 3 cm. The Field Museum of Natural History, Chicago (2336).

95. Miniature votive Spondylus shell. Peru, Cuzco. Probably turquoise; h. 1 cm, diam. 2 cm. The Field Museum of Natural History, Chicago (2341).

96. Miniature votive puma. Peru, Chancas, Koripakela. Lapis lazuli and gold; 1.5 x 6 x 2 cm. The Field Museum of Natural History, Chicago (2372).

97. Miniature votive puma. Peru, Chancas, Koripakela. Probably carnelian; 1.5 x 6 x 2 cm. (approx.). The Field Museum of Natural History, Chicago (2373).

98. Votive female figurine. Ecuador, Isla de la Plata, c. 1500. Gold; 15 x 4 x 4 cm. The Field Museum of Natural History, Chicago (4450). Ill. McEwan and Van de Guchte essay, fig. 10.

99. Votive female figurine. Ecuador, Isla de la Plata, c. 1500. Gold; 9 x 2 x 4 cm. The Field Museum of Natural History, Chicago (4451). Ill. McEwan and Van de Guchte essay, fig. 10.

100. Royal seat. Peru, Cuzco, c. 1540. Painted and lacquered wood; 29 x 37 x 28 cm. The Field Museum of Natural History, Chicago (2832). Ill. Niles essay, fig. 2.

JAMA-COAQUE

The objects listed below date 200/400.

101. Figure adorned for ancestral rites. Ecuador. Ceramic; 30.3 x 13 x 15 cm. Museo Antropológico del Banco Central, Quito (JC 6-111-72).

102. Vessel depicting mask and mythical creature. Ecuador. Ceramic; 20.5 x 21 x 23.5 cm. Museo Arqueológico del Banco Central, Quito (JC 4-57-80). Ill. Valdez essay, fig. 9.

103. Vessel in the form of masked warrior. Ecuador. Ceramic; 21 x 18.8 x 21.7 cm. Museo Arqueológico del Banco Central, Quito (JC 1-70-72 A). Ill. Valdez essay, fig. 14.

104. Seated chieftain with emblems of rank. Ecuador. Ceramic; 35.6 x 22.9 x 20.3 cm. Museo Arqueológico del Banco Central, Quito (3-53-77). Ill. Valdez essay, fig. 18.

105. Female keeper of lineage insignia. Ecuador. Ceramic; 42.5 x 27 x 24.3 cm. Museo Arqueológico del Banco Central, Quito (JC 1-22-75). Ill. Valdez essay, fig. 15.

106. Figure seated on harvest of manioc roots. Ecuador. Ceramic; 38 x 28.4 x 24.5 cm. Museo Arqueológico del Banco Central, Quito (JC 1.910.2.60). Ill. Valdez essay, fig. 13.

107. Chieftain chewing coca. Ecuador. Ceramic; 54.3 x 39.2 x 31.8 cm. Museo Antropológico del Banco Central, Guayaquil (GA-1-2500-83). Ill. Valdez essay, fig. 16.

108. Model of hut with shamanistic scene. Ecuador. Ceramic; h. 13.9 cm, diam. 12.4 cm. Museo Antropológico del Banco Central, Guayaquil (GA-1-883-78). Ill. Valdez essay, fig. 5.

109. Model of hut with figure in ritual seclusion. Ecuador. Ceramic; 20.1 x 18.4 x 15.8 cm. Museo Antropológico del Banco Central, Guayaquil (GA-1-429-77). Ill. Valdez essay, fig. 4.

110. Festival celebrant adorned with birds. Ecuador. Ceramic; 34 x 24.6 x 31.3 cm. Museo Antropológico del Banco Central, Guayaquil (GA-1-2469-83). Ill. Valdez essay, fig. 1.

111. Ritual sower with seed bag and staff. Ecuador. Ceramic; 30.6 x 16.2 x 8 cm. Museo Antropológico del Banco Central, Guayaquil (GA-1-2267-82). Ill. Valdez essay, fig. 12.

112. Seat in the form of mythical creature. Ecuador. Ceramic; 41.5 x 27.7 x 26.7 cm. Museo Antropológico del Banco Central, Guayaquil (GA-1-2448-83). Ill. Valdez essay, fig. 10.

LA TOLITA

The objects listed below date 200/400.

113. Model of trophy head. Ecuador. Ceramic; 7 x 8.5 x 10.5 cm. Museo Arqueológico del Banco Central, Quito (38-112-70). Ill. Valdez essay, fig. 11.

114. Figure bearing tripod throne. Ecuador. Ceramic; 43 x 21.5 cm. Museo Antropológico del Banco Central, Guayaquil (GA-6-2889-86). Ill. Valdez essay, fig. 17.

115. Phallic feline. Ecuador. Ceramic; 39.8 x 23 x 20.1 cm. Museo Antropológico del Banco Central, Guayaquil (GA-32-1924-81). Ill. Valdez essay, fig. 8.

116. Sun mask (diadem). Ecuador. Gold; 44.6 x 48.2 cm. Museo Antropológico del Banco Central, Guayaquil (GA-1-911-78). Frontispiece.

117. Mask (diadem) fragment. Ecuador. Gold; 29 x 18.9 cm. Museo Antropológico del Banco Central, Guayaquil (GA-2-911-78).

118. Funerary mask. Ecuador. Gold; 16.7 x 16.9 x 9.3 cm. Museo Antropológico del Banco Central, Guayaquil (GA-2-2928-86). Ill. Valdez essay, fig. 2.

119. Mask with scarification pattern. Ecuador. Ceramic; 10.3 x 12.6 x 7.1 cm. Museo Antropológico del Banco Central, Guayaquil (GA-7-901-78). Ill. Valdez essay, fig. 6.

120. Musician with rattles. Ecuador. Ceramic; 24.7 x 12.3 x 28 cm. Museo Antropológico del Banco Central, Guayaquil (GA-3-1012-78).

121. Musician with pan pipes and rattles. Ecuador. Ceramic; 26.3 x 15.2 x 25.6 cm. Museo Antropológico del Banco Central, Guayaquil (GA-1-1262).

LAMBAYEQUE

The objects listed below date 900/1250.

122. Mask for funerary bundle. Peru. Gold; 19.5 x 32.2 cm. Museo Arqueológico Bruning, Lambayeque (52-MB). Ill. page 1.

123. Beaker with royal figures and sea-bird design. Peru, Cementerio de La Merced, Batán Grande, Illimo, Lambayeque. Gold; h. 15.6 cm; mouth: 9 cm; base: 3.7 cm. Museo Arqueológico Bruning, Lambayeque (48-MB).

124. Spider laying eggs. Peru. Gold; 6 x 4.5 cm. Museo Arqueológico Bruning, Lambayeque (147-MB).

MAYA

125. Panel depicting ball game. Guatemala, 600/900. Stone; 23.9 x 43 cm. The Art Institute of Chicago, The Ada Turnbull Hertle Fund (1965.407). Ill. Miller essay, fig. 21.

126. "Vase of the Water Lilies." Guatemala, Petén, Naranjo, 750/800. Ceramic; h. 24 cm, diam. 16 cm. The Art Institute of Chicago, Ethel T. Scarborough Fund (1986.1080).

127. "Vase of the Dancing Lords." Guatemala, Petén, Naranjo, 750/800. Ceramic; h. 24 cm, diam. 17 cm. The Art Institute of Chicago, Ethel T. Scarborough Fund (1986.1081). Ill. Miller essay, fig. 4.

128. Vessel with cloud-and-star motif. Teotihuacan/Maya, Guatemala, 250/550. Ceramic; h. 8 cm, diam. 15.5 cm. Museo Nacional de Arqueología y Etnología, Guatemala City (11411).

129. Vase depicting nourishment of the gods. Guatemala, Northern Petén, 750/800. Ceramic; h. 15 cm, diam. 13 cm. Museum of Fine Arts, Boston, gift of Landon T. Clay (1988.1175).

130. Vase depicting hero twins in ball-court scene. Guatemala, Petén, 600/900. Ceramic; h. 21 cm. The Chrysler Museum, Norfolk, Edwin Pearlman and museum purchase (86.405).

131. Invocation of royal ancestor (Lintel 25). Guatemala, Yaxchilán, c. 725. Stone; 130 x 86.3 cm. The Trustees of the British Museum, London (1886-316). Ill. Miller essay, fig 12.

132. Young Maize God. Honduras, Copán, Temple 22, c. 775. Stone; 89.7 x 54.2 cm. The Trustees of the British Museum, London (1886-321). Ill. Miller essay, fig. 1.

133. Priestly ruler (Stela 11). Guatemala, Kaminaljuyú, 250 BC/AD 100. Stone; 198 x 68 x 18 cm. Museo Nacional de Arqueología y Etnología, Guatemala City (3093). Ill. Valdés essay, figs. 7, 8.

134. Pregnant female ("Kidder Figure"). Guatemala, Kaminaljuyú, 250 BC/AD 100. Ceramic; 25 x 19 x 17 cm. Museo Nacional de Arqueología y Etnología, Guatemala City (10603). Ill. Valdés essay, fig. 12.

135. Snuff box. Guatemala, Petén, Tikal, 300/600. Ceramic; h. 12 cm, diam. 24 cm. Museo Nacional de Arqueología y Etnología, Guatemala City (11129).

136. Ceremonial vessel in the form of aquatic turtle with cover in the form of mythical bird. Guatemala, Petén, Tikal, 350/400. Ceramic; h. 15.5 cm, diam. 19.5 cm. Museo Nacional de Arqueología y Etnología, Guatemala City (11469). Ill. Miller essay, fig. 20.

137. "Plate of the Sun." Guatemala, Petén, Tikal, 350/450. Ceramic; h. 13 cm, diam. 38.1 cm. Museo Nacional de Arqueología y Etnología, Guatemala City (11130).

138. Carved cache-bowl lid ("Seven Kan Vessel"). Guatemala, Petén, Tikal, Burial 132, c. 550. Ceramic; h. 10 cm, diam. 48 cm. Museo Nacional de Arqueología y Etnología, Guatemala City (3B-4/4). Ill. Miller essay, fig. 11.

139. Fire-god effigy censer. Guatemala, Petén, Tikal, 350/450. Ceramic; 37 x 16 x 22 cm. Museo Nacional de Arqueología y Etnología, Guatemala City (12C-508 a, b). Ill. Valdés essay, fig. 1.

140. Fragment (Stela 17). Guatemala, Petén, Dos Pilas, c. 810. Stone; h. 249 cm. Museo Nacional de Arqueología y Etnología, Guatemala City (10374). Ill. Miller essay, fig. 5.

141. Incense burner depicting ruler on Cauac Monster throne. Guatemala, Petén, Tikal, 650/700. Ceramic; 62 x 27 x 25 cm. Museo Nacional de Arqueología y Etnología, Guatemala City (12U-82/16). Ill. Miller essay, fig. 17.

142. Funerary vessel with portrait head. Guatemala, Petén, Tikal, Temple 1, c. 700. Ceramic and jade; h. 25 cm, diam. 9 cm. Museo Nacional de Arqueología y Etnología, Guatemala City (11080 a, b). Ill. Miller essay, fig. 13.

143. Altar support depicting Rain God. Guatemala, Petén, Piedras Negras, leg from Altar 4, 700/50. Stone; 72 x 54 x 45 cm. Museo Nacional de Arqueología y Etnología, Guatemala City (864 C).

144. Courtly scene (Lintel 3). Guatemala, Petén, Piedras Negras, 700/50. Stone; 62 x 120 x 15 cm. Museo Nacional de Arqueología y Etnología, Guatemala City (613). Ill. Miller essay, fig. 18.

145. Figurine of ruler dancing with maize. Guatemala, Alta Verapaz, 600/900. Ceramic; 23 x 16 x 11.5 cm. Museo Nacional de Arqueología y Etnología, Guatemala City (5897). Ill. Miller essay, fig. 3.

146. Mask of Sun God. Guatemala, Alta Verapaz, 600/900. Ceramic; 21 x 19 x 13.5 cm. Museo Nacional de Arqueología y Etnología, Guatemala City (5235). Ill. Miller, essay, fig. 14.

147. Ceremonial vessel with lid in the form of portrait head. Guatemala, 350/400. Ceramic; h. 24.5 cm, diam. 25 cm. Museo Nacional de Arqueología y Etnología, Guatemala City (11417).

148. Maize plate depicting dancer. Guatemala, Petén, Uaxactún, 600/50. Ceramic; diam. 42.1 cm. New Orleans Museum of Art, museum purchase, Ella West Freeman Foundation Matching Fund (69.2).

149. Vase depicting jaguar and mythical-bird impersonators. Guatemala, 600/900. Ceramic; h. 19.3 cm, diam. 14.3 cm. The Art Museum, Princeton University, museum purchase, gift of Mr. and Mrs. James E. Burke, with matching funds from IBM Corporation, Johnson & Johnson, and the Prudential Foundation (1988–22).

MIMBRES

The objects listed below date 1000/1150, unless otherwise noted.

150. Ritual cache figures. New Mexico, Salado region, c. 1350. Stone, wood, cotton, feathers, and pigment; basket: 15 x 21 x 97 cm; ritual figure: 64 x 18 x 8 cm; ritual figure: 36 x 17 x 5.5 cm; snake: h. 5 cm, l. 40 cm; snake: h. 65 cm, l. 44 cm; mountain lion: h. 9 cm; four sticks: each 2 x 61.5 cm. The Art Institute of Chicago, Major Acquisitions Centennial Fund Income (1979.17 a-k). Ill. Townsend introduction, fig. 16, and front cover.

151. Bowl depicting man wearing antler headdress and bat costume. New Mexico. Ceramic; h. 12.7 cm, diam. 29.2 cm. Collection of Tony Berlant, Santa Monica, California. Ill. Brody essay, fig. 1.

152. Bowl depicting decapitation scene. New Mexico. Ceramic; h. 12.3 cm, diam. 26 cm. University of Colorado Museum, Boulder (CU3198). Ill. Brody essay, fig. 12.

153. Bowl depicting horned toad. New Mexico. Ceramic; h. 10 cm, diam. 29 cm. University of Colorado Museum, Boulder (CU 3201). Ill. Brody essay, fig. 20.

154. Bowl depicting two figures and large fish. New Mexico. Ceramic; h. 8.5 cm, diam. 20.5 cm. University of Colorado Museum, Boulder (CU3267). Ill. Brody essay, fig. 16.

155. Bowl depicting crane and fish. New Mexico. Ceramic; h. 8 cm, diam. 17 cm. Logan Museum of Anthropology, Beloit College, Wisconsin (16114). Ill. Brody essay, fig. 4.

156. Bowl depicting figure, basket, and staff. New Mexico, Cienega. Ceramic; h. 10.5 cm, diam. 26.5 cm. Maxwell Museum of Anthropology, University of New Mexico, Albuquerque (40.4 277). Ill. Brody essay, fig. 15.

157. Bowl depicting bear-hunting scene. New Mexico, Galaz. Ceramic; h. 12.1 cm, diam. 21 cm. Department of Anthropology, University of Minnesota, Minneapolis (15-B156). Ill. Brody essay, fig. 14.

158. Bowl depicting ritual fertility clown. New Mexico, Galaz. Ceramic; h. 12 cm, diam. 28.9 cm. Department of Anthropology, University of Minnesota, Minneapolis (15-B339). Ill. Brody essay, fig. 5.

159. Bowl with abstract animal designs. New Mexico. Ceramic; h. 10.2 cm, diam. 24.1 cm. Laboratory of Anthropology/Museum of Indian Arts and Culture, Museum of New Mexico, Santa Fe (20396/11). Ill. Brody essay, fig. 3.

160. Bowl depicting four figures. New Mexico. Ceramic; h. 8.3 cm, diam. 22.9 cm. Laboratory of Anthropology/Museum of Indian Arts and Culture, Museum of New Mexico, Sante Fe (43438/11). Ill. Brody essay, fig. 19.

161. Bowl with four-part cosmological design. New Mexico. Ceramic; h. 12 cm, diam. 27.3 cm. Museum of Northern Arizona, Flagstaff (834 NA3288.74). Ill. Brody essay, fig. 8.

162. Bowl with insect and rabbit designs. New Mexico. Ceramic; h. 12.3 cm, diam. 27.7 cm. Museum of Northern Arizona, Flagstaff (834 NA3288.50). Ill. Brody essay, fig. 11.

163. Bowl depicting lizard. New Mexico, Swarts Ranch. Ceramic; h. 10 cm, diam. 23.5 cm. Peabody Museum of Archaeology and Ethnology, Harvard University, Cambridge, Massachusetts (25–11–10/94789).

164. Bowl depicting warrior. New Mexico, Swarts Ranch. Ceramic; h. 8 cm, diam. 19.1 cm. Peabody Museum of Archaeology and Ethnology, Harvard University, Cambridge, Massachusetts (24–15–10/94584). Ill. Brody essay, fig. 10.

165. Bowl depicting ceremonial performer holding staff with animal effigies. New Mexico. Ceramic; h. 8 cm, diam. 19.1 cm. Peabody Museum of Archaeology and Ethnology, Harvard University, Cambridge, Massachusetts (26–07–10/95798). Ill. Brody essay, fig. 13.

166. Bowl with bat design. New Mexico. Ceramic; h. 10.2 cm, diam. 25.4 cm. Department of Anthropology, Smithsonian Institution, Washington, D.C. (70367, museum cat. no. 326245). Ill. Brody essay, fig. 17.

167. Bowl depicting masked animal trickster. New Mexico. Ceramic; h. 9 cm, diam. 20.3 cm. Southwest Museum, Los Angeles (491.P.3772). Ill. Brody essay, fig. 7.

168. Bowl depicting antelope on mountain. New Mexico. Ceramic; 10.8 x 22 x 24 cm. William Endner Collection, Museum of Western Colorado, Grand Junction (G497, C.3895). Ill. Brody essay, fig. 9.

169. Bowl depicting figure carrying basket. New Mexico. Ceramic; h. 7.3 cm, diam. 19.6 cm. William Endner Collection, Museum of Western Colorado, Grand Junction (G495–3007, 3898). Ill. Brody essay, fig. 6.

MIXTEC

The objects listed below date c. 1400.

170. Tripod vessel. Mexico, Oaxaca, Monte Albán. Ceramic; h. 21.4 cm, diam. 14.9 cm. The Field Museum of Natural History, Chicago (241178).

171. Cup with handles. Mexico, Oaxaca, Monte Albán. Ceramic; h. 11.5 cm, diam. 19.9 cm. The Field Museum of Natural History, Chicago (241199).

MOCHE

The objects listed below date 250/550, unless otherwise noted.

172. Portrait vessel of one-eyed man. Peru. Ceramic; 28.9 x 21.6 cm. The Art Institute of Chicago, Buckingham Fund (1955.2339).

173. Vessel depicting ritual runners. Peru. Ceramic; 27 x 19.7 cm. The Art Institute of Chicago, Buckingham Fund (1955.2291). Ill. Benson essay, fig. 17.

174. Vessel depicting seated ruler with pampas cat. Peru. Ceramic; 19.4 x 19.1 cm. The Art Institute of Chicago, Buckingham Fund (1955.2281). Ill. Benson essay, fig. 9.

175. Vessel depicting kneeling warrior with club. Peru, Chimbote, Santa Valley. Ceramic; 23.8 x 21.6 cm. The Art Institute of Chicago, gift of Nathan Cummings (1957.409). Ill. Benson essay, fig. 15.

176. Vessel in the form of reed boat. Peru. Ceramic; 15 x 13 x 37.5 cm. The Art Institute of Chicago, gift of Nathan Cummings (1957.612).

177. Seated figure of deer impersonator. Peru, Chimbote, Santa Valley. Ceramic; 27.6 x 8 x 24 cm. The Art Institute of Chicago, gift of Nathan Cummings (1958.708).

178. Vessel depicting man facing jaguar. Peru. Ceramic; 30.5 x 16.9 cm. The Art Institute of Chicago, Buckingham Fund (1955.2264). Ill. Benson essay, fig. 8.

179. Royal tunic. Peru. Camelid wool and cotton; 48 x 57.5 cm. Private collection (PC427). Ill. Benson essay, fig. 19.

180. Figure paddling raft in the form of supernatural fish, probably representing the sea. Peru. Ceramic; 20.3 x 26 x 10.8 cm. Museo Nacional de Antropología y Arqueología, Lima (1/3966, C04495). Ill. Benson essay, fig. 3.

181. Vessel depicting seven-peaked mountain. Peru. Ceramic; 26 x 20 x 20 cm. Museo Nacional de Antropología y Arqueología, Lima (1/4107, C-54462). Ill. Benson essay, fig. 2.

182. Vessel depicting scene related to ritual deer hunt, with mutilated priestly figure at top. Peru. Ceramic; 26.3 x 14.6 x 21.5 cm. Museo Nacional de Antropología y Arqueología, Lima (1/3494, C-54608). Ill. Benson essay, fig. 13.

183. Vessel depicting cultivated landscape or pyramid. Peru. Ceramic; 19.3 x 18 x 12 cm. Museo Nacional de Antropología y Arqueología, Lima (1/2655, C-54163). Ill. Benson essay, fig. 12.

184. Portrait vessel of ruler. Peru. Ceramic; 33 x 17.8 x 22.9 cm. Museo Nacional de Antropología y Arqueología, Lima (1/3873, C-60572). Ill. Benson essay, fig. 1.

185. Dipper depicting battle. Peru. Ceramic; 30 x 17.8 x 11.4 cm. Museo Nacional de Antropología y Arqueología, Lima (1/71, C-02370).

186. Vessel depicting batlike supernatural creature. Peru, North Coast. Ceramic; 21.5 x 13.3 cm. Arthur M. Sackler Collections, New York (82.6.22). Ill. Benson essay, fig. 16.

187. Vessel depicting fanged god originally associated with mountains. Peru, North Coast. Ceramic; 28.6 x 13.3 x 15.8 cm. Dumbarton Oaks Research Library and Collections, Washington, D.C. (B-579.70.PP). Ill. Benson essay, fig. 7.

188. Royal mantle. Peru, Lambayeque. Textile; 91.4 x 167.6 cm. Bentley-Dillard Collection, Las Vegas. Ill. Benson essay, fig. 18.

189. Emblematic head of fox. Peru, Frías, 100/300. Gold and copper; 7.5 x 9 cm. Museo Arqueológico Bruning, Lambayeque (188-MB). Ill. Benson essay, fig. 14.

NAZCA

The objects listed below date 200/400, unless otherwise noted.

190. Tunic depicting felines and birds. Peru. Camelid wool, cotton, and feathers; 85.2 x 86 cm. The Art Institute of Chicago, Kate S. Buckingham Endowment (1955.1789). Ill. Reinhard essay, fig. 19. (The Art Institute of Chicago, only.)

191. Vessel depicting four *lúcuma* fruits. Peru. Ceramic; 12.7 x 17.3 cm. The Art Institute of Chicago, Buckingham Fund (1955.2150).

192. Dome-shaped jar depicting ceremonial figure. Peru, 50/200. Ceramic; 15 x 15 cm. The Art Institute of Chicago, Buckingham Fund (1955.2128). Ill. Reinhard essay, fig. 14.

193. Vessel depicting composite fish, feline, and human figure. Peru, 50/200. Ceramic; 18.6 x 17.2 cm. The Art Institute of Chicago, Buckingham Fund (1955.2100). Ill. Reinhard essay, fig. 4.

194. Double-spouted vessel depicting lizards. Peru, 100/200. Ceramic; 16.5 x 29.7 cm. The Art Institute of Chicago, Buckingham Fund (1955.2096). Ill. Reinhard essay, fig. 12.

195. Vessel in the form of warrior with trophy head and dart thrower. Peru, Palpa Valley. Ceramic; 17.8 x 10.5 cm. The Art Institute of Chicago, Buckingham Fund (1955.2162).

196. Vessel in the form of *achira* root. Peru, 100/400. Ceramic; 17.5 x 15.2 cm. The Art Institute of Chicago, Buckingham Fund (1955.2083). Ill. Reinhard essay, fig. 5.

197. Vessel depicting mythical landscape. Peru. Ceramic; 19.8 x 15.5 cm. The Art Institute of Chicago, Buckingham Fund (1955.2137). Ill. Reinhard essay, fig. 13.

198. Textile with sun motif. Peru, 100/500. Cotton and feathers; 64.8 x 73.4 cm. Alan Brown Gallery, Hartsdale, New York (0523). Ill. Reinhard essay, fig. 20.

199. Vessel in the form of *lúcuma* fruits. Peru, 100/400. Ceramic; 12 x 18.7 x 9.5 cm. Museo Nacional de Antropología y Arqueología, Lima (85258, C-62595). Ill. Reinhard essay, fig. 6.

200. Vessel depicting seated chieftain in ceremonial dress. Peru. Ceramic; 73.6 x 43 x 43 cm. Museo Nacional de Antropología y Arqueología, Lima (C 54196). Ill. Reinhard essay, fig. 18.

201. Vessel depicting ripening maize. Peru. Ceramic; 26 x 9.5 x 6 cm. Museo Nacional de Antropología y Arqueología, Lima (C-12485, 3/6509). Ill. Reinhard essay, fig. 7.

202. Male figure wearing *Spondylus*-shell necklace. Peru. Ceramic; 33 x 12.7 x 7.6 cm. Museo Nacional de Antropología y Arqueología, Lima (3/6213, C 54312). Ill. Reinhard essay, fig. 2.

203. Woman chewing coca. Peru. Ceramic; 15.2 x 12.7 x 11.4 cm. Museo Nacional de Antropología y Arqueología, Lima (103880, C-66315). Ill. Reinhard essay, fig. 8.

OLMEC

The objects listed below date 1200/600 BC, unless otherwise noted.

204. Votive axe with ritual mask ("Kunz" axe). Mexico, Southern Veracruz or Tabasco, 800/500 BC. Jade; 30 x 15.2 cm. American Museum of Natural History, New York (30/7552/1891–93–25). Ill. de la Fuente essay, fig. 8.

205. Male figure. Mexico. Hornfels with traces of cinnabar; 30.2 x 8 cm. The Art Institute of Chicago, Ada Turnbull Hertle Fund (1971.314).

206. Votive figurine presenting masked baby. Mexico, 800/500 BC. Jade; 21.9 x 8.1 x 4.1 cm. Collection of Robin B. Martin, on loan to The Brooklyn Museum (L47.6). Ill. de la Fuente essay, fig. 6. (The Art Institute of Chicago and The Museum of Fine Arts, Houston, only).

207. Feline diadem. Mexico, southern Veracruz, 800/500 BC. Porphyry; 11.1 x 13.3 x 2.8 cm. Dumbarton Oaks Research Library and Collections, Washington, D.C. (B-4). Ill. de la Fuente essay, fig. 10.

208. Miniature portrait head. Mexico, State of Puebla. Talc; 9.5 x 6.7 x 6 cm. Dumbarton Oaks Research Library and Collections, Washington, D.C. (B-6).

209. Kneeling figure depicting were-jaguar. Mexico, Tabasco, 800/500 BC. Dark green serpentine with traces of red pigment; 10.8 x 7.9 cm. Los Angeles County Museum of Art, gift of Constance McCormick Fearing (M.86.311.6). Ill. de la Fuente essay, fig. 9.

210. Ceremonial ball-game implement. Mexico, probably from Guerrero. Stone; h. 19.1 cm. The Metropolitan Museum of Art, New York, The Michael C. Rockefeller Memorial Collection, gift of Nelson A. Rockefeller (1978.412.39).

211. Cave mask. Mexico, Chalcatzingo, 500/400 BC. Basalt; 182.9 x 142 x 15.2 cm. Munson-Williams-Proctor Institute, Museum of Art, Utica, New York (70177). Ill. de la Fuente essay, fig. 1.

212. Commemorative mask of ruler. Mexico, Veracruz, Pesquero, 1200/600 BC. Gray jadeite with black incrustations; h. 21.6 cm. Museum of Fine Arts, Boston, gift of Landon T. Clay. (1991.968). Ill. de la Fuente essay, fig. 16.

213. Colossal portrait of ruler (Monument 9). Mexico, Veracruz, San Lorenzo, 900/800 BC. Stone; 165 x 136 x 117 cm. INAH–CNCA–MEX, Museo de Antropología, Xalapa, Veracruz (SLT 2). Ill. de la Fuente essay, fig. 2.

PARACAS

214. Mantle. Peru, 1/200. Camelid wool; 238.3 x 106.6 cm. The Art Institute of Chicago, Emily Crane Chadbourne Endowment (1970.293). Ill. Paul essay, fig. 1. (The Art Institute of Chicago, only).

215. Mantle. Peru, Ocucaje, 300/100 BC. Camelid wool; h. 218 cm (with fringe) x 86.3 cm. Linde Collection, Phoenix. Ill. Paul essay, fig. 3.

216. Vessel depicting feline. Peru, Ica Valley, 300/100 BC. Ceramic; h. 40.2 cm, diam. 32.4 cm. The Field Museum of Natural History, Chicago (155350). Ill. Paul essay, fig. 2.

217. Mantle. Peru, Necropolis, c. 200 BC. Camelid wool; 250 x 145 cm (without fringe). Los Angeles County Museum of Art, Costume Council Fund (67.4). (Los Angeles County Museum of Art, only).

218. Mantle. Peru, Necropolis, c. 200. Camelid wool; 256 x 150 cm (without fringe). Los Angeles County Museum of Art, Costume Council Fund (M.72.68.7). Ill. Paul essay, fig. 4. (Los Angeles County Museum of Art, only).

219. Mantle with mask motifs. Peru, c. 300 BC. Camelid wool; 183 x 75.6 cm. Private collection. Ill. page 374.

220. Mask of "oculate" deity with serpentine motifs. Peru, 300/100 BC. Ceramic; 28.4 x 27.5 x 19.5 cm. The Brooklyn Museum, Frank L. Babbott Fund and Dick S. Ramsay Fund (64.94). Ill. Paul essay, fig. 5.

221. Mantle fragment. Peru, Paracas/Nazca, 100 BC/AD100. Camelid wool; 165 x 188 cm. Private collection (PC356C). Ill. Paul essay, fig. 14.

QUIMBAYA

222. Lime flask. Colombia, 600/1100. Gold; 23 x 7 x 5.5 cm. University Museum, University of Pennsylvania, Philadelphia (SA 2751).

SAN AGUSTIN

The objects listed below date 400/800.

223. Stela. Colombia. Volcanic stone; 66 x 34 x 12 cm. The Denver Art Museum, gift of Mr. and Mrs. Edward L. Luben (1986.487). Ill. Zuidema essay, fig. 11.

224. Pendant depicting flying fish. Colombia. Gold; 3.1 x 9.7 cm. Museo del Oro del Banco de la República, Bogota (32924).

TAIRONA

The objects listed below date 1200/1600.

225. Masked performers. Colombia. Ceramic; each 12.7 x 7.62 cm. The Art Institute of Chicago, gift of Mrs. Everett McNear in memory of her husband (1986.1084 a, b). Ill. Zuidema essay, fig. 7.

226. Pectoral. Colombia, Pueblito. Greenstone; 40 x 6 x 1 cm. The Field Museum of Natural History, Chicago (152653).

227. Bat pendant. Colombia, Pueblito. Jade; 5 x 2.2 x 15 cm. The Field Museum of Natural History, Chicago (152814).

228. Ceremonial baton. Colombia, Pueblito. Greenstone; 2.2 x 8.5 x 33 cm. The Field Museum of Natural History, Chicago (152637). Ill. Zuidema essay, fig. 6.

229. Pectoral depicting frigate bird with avian attendants. Colombia. Gold; 9.5 x 11.9 cm. Museo del Oro del Banco de la República, Bogotá (16584). Ill. Zuidema essay, fig. 19.

230. Flanged nose ring with spiral motifs. Colombia. Gold; 5.7 x 8.9 cm. Museo del Oro del Banco de la República, Bogotá (11683).

231. Double-headed mythical creature. Colombia. Gold; 5.6 x 5 cm. Museo del Oro del Banco de la República, Bogotá (12563).

232. Winged pendant depicting frigate bird. Colombia. Gold; 12.3. x 9.3 cm. Museo del Oro del Banco de la República, Bogotá (23820).

233. Circular pectoral depicting sun god. Colombia. Gold; diam. 14 cm. Museo del Oro del Banco de la República, Bogotá (16146). Ill. Zuidema essay, fig. 12.

234. Pectoral depicting mask and frigate-bird headdress. Colombia. Gold; 13.6 x 11.7 cm. Museo del Oro del Banco de la República, Bogotá (16.791).

235. Necklace with abstract zoomorphic motif. Colombia. Gold; 56 pieces, each 3.3 x 1.1 cm. Museo del Oro del Banco de la República, Bogotá (20289).

236. Penis sheath in the form of sea shell. Colombia. Gold; 20.4 x 4.9 cm. Museo del Oro del Banco de la República, Bogotá (21215).

237. Nose ring with bilateral zoomorphs. Colombia. Gold; 5.7 x 8.2 cm. Museo del Oro del Banco de la República, Bogotá (22819).

238. Nose ring with spiral motifs. Colombia. Gold; 6.4 x 7.5 cm. Museo del Oro del Banco de la República, Bogotá (26128).

239. Anthropomorphic figure. Colombia. Gold; 5 x 6 cm. Museo del Oro del Banco de la República, Bogotá (11.445).

240. Nose pendant with ornaments. Colombia. Gold; 10.6 x 12.2 cm. Museo del Oro del Banco de la República, Bogotá (32506).

241. Model of ritual enclosure with hanging masks. Colombia. Ceramic; 7 x 17 cm. Museo del Oro del Banco de la República, Bogotá (CT.738). Ill. Zuidema essay, fig. 8.

242. Pendant depicting frigate bird. Colombia. Shell; 8.5 x 11.8 cm. Museo del Oro del Banco de la República, Bogotá (ConT. 388). Ill. Zuidema essay, fig. 17.

243. Pectoral depicting seated chieftain with raptorial birds. Colombia. Bone; 8 x 10 cm. Museo del Oro del Banco de la República, Bogotá. Ill. Zuidema essay, fig. 1.

244. Enthroned figure with mask and batons. Colombia. Bone; 7.9 x 6.5 cm. Museo del Oro del Banco de la República, Bogotá (PhT. 1). Ill. Zuidema essay, fig. 16.

245. Masked figure carrying sacrificial victim. Colombia. Bone; 7.2 x 5.4 cm. Museo del Oro del Banco de la República, Bogotá (HT. 123).

246. Ocarina with enthroned chieftain. Colombia. Ceramic; 11.1 x 3.1 x 10 cm. Courtesy of the National Museum of the American Indian, Smithsonian Institution, New York (24/6783). Ill. Zuidema essay, fig. 13.

247. Vessel with four feet and serpents. Colombia. Ceramic; 8 x 8.7 x 10.8 cm. Courtesy of the National Museum of the American Indian, Smithsonian Institution, New York (24/8962).

TEOTIHUACAN

248. Mural fragment depicting glyphic emblem of the water cult. Mexico, c. 500. Fresco; 67.3 x 74 cm. James W. and Marilynn Alsdorf Collection, Winnetka, Illinois (PC 84). Ill. Pasztory essay, fig. 11.

249. Mural fragment depicting rain priest. Mexico, 600/750. Fresco; 62 x 95 x 6 cm. The Art Institute of Chicago, Primitive Art Purchase (1962.702). Ill. Pasztory essay, fig. 1.

250. Mask from incense burner depicting the old deity of fire. Mexico, 450/750. Ceramic; 36.83 x 33.5 cm. The Art Institute of Chicago, gift of Joseph Antonow (1962.1073). Ill. page 5.

251. Tripod vessel depicting plumed serpent. Mexico, 600/750. Ceramic; diam. 34.9 cm. The Cleveland Museum of Art, purchase from the J.H. Wade Fund (65.20). Ill. Pasztory essay, fig. 15.

252. Ritual mask. Mexico, 450/750. Stone; 32.1 x 28.2 x 18.4 cm. Dallas Museum of Art, gift of Mr. and Mrs. Eugene McDermott, The McDermott Foundation, and Mr. and Mrs. Algur H. Meadows and the Meadows Foundation, Inc. (1973.49). Ill. Pasztory essay, fig. 14.

253. Architectonic parrot head. Mexico, 100/500. Polychromed basalt; 57 x 34 x 66 cm. The Denver Art Museum, museum purchase (1962.291).

254. Votive receptacle in the form of jaguar. Mexico, 150/250. Stone; 1.33 cm. The Trustees of the British Museum, London, England (1926–22).

255. Mural fragment depicting figure in plumed jaguar headdress. Mexico, 600/750. Fresco; 162 x 75 x 2.5 cm. INAH–CNCA–MEX, Museo Nacional de Antropología, Mexico City (9–4669/10–357205). Ill. Pasztory essay, fig. 13.

256. Mural fragment depicting temple facades against backdrop of clouds and rain. Mexico, 600/750. Fresco; 121.9 x 48 (widest) x 295 cm. Museo Arqueológico de Teotihuacan. Ill. Pasztory essay, fig. 4.

257. Roof ornament depicting storm-god mask and headdress. Mexico, 600/750. Ceramic; 57.5 x 38.7 (widest) x 3.8 cm. INAH–CNCA–MEX, Museo Arqueológico de Teotihuacan. Ill. Pasztory essay, fig. 9.

258. Mural fragment depicting two plumed coyotes with heraldic emblems. Mexico, Atetelco, 600/750. Fresco; 73.7 x 198 cm. Philadelphia Museum of Art, The Louise and Walter Arensberg Collection (1950-134-404). Ill. Pasztory essay, fig. 12.

259. Cult figure of goddess. Mexico, 250/650. Volcanic stone; 91.4 cm. Philadelphia Museum of Art, The Louise and Walter Arensberg Collection (1950-134-282). Ill. Pasztory essay, fig. 7.

260. Bowl. Mexico, Valley of Mexico, 450/750. Ceramic; diam. 22.5 cm. The Art Institute of Chicago, Primitive Art Purchase Fund (1968.790).

261. Tripod vessel depicting completion of fifty-two-year cycle. Teotihuacan/Maya, Guatemala, Kaminaljuyú, 250/550. Ceramic; 17.7 x 20 cm. The Denver Art Museum, museum purchase (1971.417).

TIWANAKU

The objects listed below date 400/800, unless otherwise noted.

262. Drinking beaker depicting masked figure and feline. Bolivia. Ceramic; h. 15.5 cm, diam. 14 cm. Museo de Metales Preciosos Precolombinos, La Paz (CFB 709).

263. Embossed pectoral. Bolivia. Gold; diam. 15.2 cm. Museo de Metales Preciosos Precolombinos, La Paz (CIAT 2751).

264. Embossed pectoral. Bolivia. Gold; diam. 16.5 cm. Museo de Metales Preciosos Precolombinos, La Paz.

265. Diadem mask with radiating tassels. Bolivia, Kalasasaya complex. Gold and turquoise; 20 x 36 cm. Museo de Metales Preciosos Precolombinos, La Paz (2748–2749). Ill. Kolata and Ponce Sanginés essay, fig. 12.

266. Winged diadem depicting mask. Bolivia, San Sebastian, Cochabamba. Gold and turquoise; 20 x 40 cm. Museo de Metales Preciosos Precolombinos, La Paz. Ill. Kolata and Ponce Sanginés essay, fig. 13.

267. Beaker (kero) with modeled feline head. Bolivia. Ceramic; 33 x 33 x 25.4 cm. Museo de Metales Preciosas Precolombinos, La Paz (MNA CFB1600). Ill. Kolata and Ponce Sanginés essay, fig. 19.

268. Incense burner in the form of llama. Bolivia. Ceramic; 36 x 29 cm. Museo de Metales Preciosos Precolombinos, La Paz (AL/5/15). Ill. Stone-Miller essay, fig. 9.

269. Stela in the form of guardian figure. Bolivia. Stone; 106 x 30 x 26 cm. Museo de Metales Preciosos Precolombinos, La Paz (1249). Ill. Kolata and Ponce Sanginés essay, fig. 6.

270. Fanged skull mask. Bolivia. Silver; 25.5 x 30.4 cm. Museo de Metales Preciosos Precolombinos, La Paz (CFBLP 01946). Ill. Kolata and Ponce Sanginés essay, fig. 1.

271. Monumental head with mask and headdress. Bolivia. Stone; 110.5 x 70 x 70 cm. Instituto Nacional de Arqueología de Bolivia, La Paz. Ill. Kolata and Ponce Sanginés essay, fig. 4.

272. Beaker (kero) with modeled hawk head. Bolivia. Ceramic; 16.8 x 16.5 x 19 cm. Instituto Nacional de Arqueología de Bolivia, La Paz (MNA, CFD 8). Ill. Kolata and Ponce Sanginés essay, fig. 18.

273. Incense burner in the form of feline. Bolivia. Ceramic; 35.5 x 23 x 15.2 cm. Instituto Nacional de Arqueología de Bolivia, La Paz (MNA 287). Ill. Kolata and Ponce Sanginés essay, fig. 15.

274. Architectural fragment depicting confronted figures. Bolivia. Andesite; 147 x 28.5 x 28.5 cm. Instituto Nacional de Arqueología de Bolivia, La Paz (MNA7). Ill. Kolata and Ponce Sanginés essay, fig. 5.

275. Guardian chachapuma figure. Bolivia. Basalt; 84 x 43 x 48 cm. Museo Arqueológico Regional de Tiwanaku (TIW19684-A). Ill. Kolata and Ponce Sanginés essay, fig. 10.

276. Portrait vessel. Bolivia, Kalasasaya complex. Ceramic; 12.7 x 12 x 16.5 cm. Museo Arqueológico Regional de Tiwanaku (MRT471 TKJ25). Ill. Kolata and Ponce Sanginés essay, fig. 17.

277. Architectural fragment with "gateway" motif. Bolivia. Stone; 73 x 50 x 26 cm. Museo Arqueológico Regional de Tiwanaku (MRT 2015). Ill. Kolata and Ponce Sanginés essay, fig. 14.

278. Model of colossal figure. Bolivia. Stone; h. 46.7 cm. The Metropolitan Museum of Art, New York, The Michael C. Rockefeller Memorial Collection, bequest of Nelson A. Rockefeller (1979.206.833).

279. Beaker (kero) with modeled feline head. Bolivia. Ceramic; h. 27.9, diam. 30.4 cm. Arthur M. Sackler Collections, New York (N-16).

280. Beaker (kero) with modeled condor head. Bolivia. Ceramic; h. 20 cm, diam. 15 cm. Arthur M. Sackler Collections, New York (N-14).

281. Tapestry fragment depicting "mama llama" and herder. Peru. Camelid wool; 35.6 x 53.3 cm. Virginia Museum of Fine Arts, Richmond, The Glasgow Fund (60.44.1). Ill. Stone-Miller essay, fig. 12.

282. Tasseled hat with avian motifs. Tiwanaku/Huari, Peru, 600/800. Camelid wool and cotton; h. 11.4 cm (irreg.), each side 12.7 cm (irreg.). Seattle Art Museum, gift of Jack Lenor Larsen (76.51).

VALDIVIA

283. Pendant or mask. Ecuador, c. 1800 BC. Spondylus shell; 10.9 x 13.9 x 3.2 cm. Museo Antropológico del Banco Central, Guayaquil (GA-8-1238-79). Ill. Valdez essay, fig. 7.

BIBLIOGRAPHY

Alegría, Ricardo E. 1986. *Las primeras representaciones gráficas del indio americano 1493–1523*. Barcelona.

Alva, Walter. 1988. "Discovering the New World's Richest Unlooted Tomb." *National Geographic* 174, pp. 510–49.

Alva, Walter. 1990. "New Tomb of Royal Splendor." *National Geographic* 177, pp. 2–15.

Alvarado Tezozomoc, Fernando. 1943. *Crónica mexicana*. Mexico City.

Andrews, E. Wyllys. "Spoons and Knuckle-Dusters in Formative Mesoamerica." Paper prepared for publication in the proceedings of the third Texas Symposium, "Olmec, Izapa, and the Development of Maya Civilization," University of Texas, Austin.

Angulo, Jorge. 1970. *Un códice de El Mirador, Chiapas*. Mexico City.

Anyon, Roger, and Steven A. LeBlanc. 1984. *The Galaz Ruin: A Prehistoric Mimbres Village in Southwest New Mexico*. Albuquerque.

Arriaga, Pablo Joseph de. 1968. *The Extirpation of Idolatry in Peru*. Lexington.

Artes de Mexico 51–52. 1964.

Aveni, Anthony F. 1986. "The Nazca Lines: Patterns on the Desert." *Archaeology* 39, pp. 32–39.

Aveni, Anthony F. 1988. "The Thom Paradigm in the Americas: The Case of the Cross-Circle Designs." *Records in Stone*. Edited by Clive L. N. Ruggles. Cambridge, England. Pp. 442–72.

Aveni, Anthony F. 1991. "Mapping the Ritual Landscape." Carrasco, 1991.

Aveni, Anthony F., and Horst Hartung. 1982. "New Observations on the Pecked Cross Petroglyphs." *Symposium [on] Time and Space in the Cosmovision of Mesoamerica*. Edited by Franz Tichy. *Latinamerika Studien* 10, pp. 25–41.

Aveni, Anthony F., Horst Hartung, and Beth Buckingham. 1978. "The Pecked Cross Symbol in Ancient America." *Science* 202, 4365, pp. 267–79.

Aveni, Anthony F., and Gary Urton, editors. 1982. *Ethnoastronomy and Archgeoastronomy in the American Tropics. Annals of the New York Academy of Sciences* 385. New York.

Baessler, Arthur. 1904. *Altperuanische Metallgerate*.

Bandelier, Adolf F. 1910. *The Islands of Titicaca and Koati*. New York.

Bandelier, Adolf F. 1911. *The Ruins of Tiahuanaco*. Worcester.

Bandelier, Adolf F. 1969. *A History of the Southwest*. 2 vols. Edited by E. J. Burrus and S. J. Rome. St. Louis.

Bastien, Joseph. 1978. *The Mountain of the Condor: Metaphor and Ritual in the Andean Ayllu*. St. Paul.

Bennett, Wendell C. 1934. *Excavations at Tiahuanaco. Anthropological Papers of the American Museum of Natural History* 34. New York.

Benson, Elizabeth P. 1972. *The Mochica: A Culture of Peru*. New York.

Benson, Elizabeth P. 1975. "Death-Associated Figures on Mochica Pottery." *Death and the Afterlife in Pre-Columbian America*. Edited by Elizabeth P. Benson. Washington, D.C. Pp. 104–44.

Benson, Elizabeth P. 1982. "The Well-Dressed Captives." *Baessler-Archiv* 30, pp. 181–222.

Benson, Elizabeth P. 1985. "The Moche Moon." *Recent Studies in Andean Prehistory and Protohistory*. Edited by Peter Kvietok and Daniel H. Sandweiss. Ithaca. Pp. 121–35.

Bernal, Ignacio. 1968, 1969. *El mundo olmeca*. Mexico City: 1968. English translation: *The Olmec World*. Berkeley: 1969.

Besom, Thomas. 1991. "Another Mummy." *Natural History* (April).

Betanzos, Juan de. 1987. *Suma y narración de los Incas*. Transcription, notes, and foreword by María del Carmen Martín Rubio. Madrid.

Binford, Louis. 1962. "Archaeology as Anthropology." *American Antiquity*.

Bolinder, Gustave. 1925. *Die Indianer der Tropische Schneebirge: Forschungen im Nordlichsten Sudamericka*. Stuttgart.

Bolle, Kees W. 1987. "Myth: An Overview." *The Encyclopedia of Religion*. 1988. Edited by Mircea Eliade. New York. Pp. 261–73.

Bonavia, Duccio. 1985. *Mural Painting in Ancient Peru*. Translated by Patricia J. Lyon. Bloomington.

Bonifaz Nuño, Rubén. 1988. "Los Olmecas no son jaguares." *Chicomoztoc; Boletín del Seminario de Estudios para la descolonización de México* 1, pp. 51–68.

Bonifaz Nuño, Rubén. 1989. *Hombres y serpientes; Iconografía olmeca*. Mexico City.

Boone, Elizabeth Hill. 1983. *The Codex Magliabechiano and the Lost Prototype of the Magliabechiano Group*. Berkeley.

Boone, Elizabeth Hill, editor. 1986. *The Aztec Templo Mayor. A Symposium at Dumbarton Oaks. October 8th and 9th, 1983*. Washington, D.C.

Boone, Elizabeth Hill. N.d. "The Aztec Pictorial History of the Codex Mendoza." *The Codex Mendoza*. Edited by Frances F. Berdan and Patricia R. Anawalt. Berkeley, in press.

Bowditch, Charles P. 1910. *Book of Chilam Balam of Kaua*. Cambridge, Massachusetts.

Boyceaux de la Barauderie, Jacques. 1638. *Traité du jardinage*. Paris.

Bray, Warwick. 1978. *The Gold of El Dorado*. London.

Bricker, Victoria R. 1989. "The Calendrical Meaning of Ritual Among the Maya." Bricker and Gossen, 1989. Pp. 231–50.

Bricker, Victoria R., and Gary H. Gossen, editors. 1989. *Ethnographic Encounters in Southern Mesoamerica: Essays in Honor of Evon Zartman Vogt, Jr.* Austin.

Broda, Johanna. 1986. "The Provenience of the Offerings: Tribute and Cosmovision." Boone, 1986. Pp. 211–56.

Broda, Johanna. 1991. "The Sacred Landscape of Aztec Calendar Festivals: Myth, Nature, and Society." Carrasco, 1991.

Broda, Johanna, David Carrasco, and Eduardo Moctezuma. 1987. *The Great Temple of Tenochtitlan: Center and Periphery in the Aztec World*. Berkeley.

Brody, J. J. 1977. *Mimbres Painted Pottery*. Albuquerque.

Brody, J. J. 1991. *Anasazi and Pueblo Painting Before 1900*. Albuquerque.

Brody, J. J., Steven A. LeBlanc, and Catherine J. Scott. 1983. *Mimbres Pottery: Ancient Art of the American Southwest*. New York.

Browman, David L. 1974. "Pastoral Nomadism in the Andes." *Current Anthropology* 15, pp. 188–96.

Brown, Joseph E. 1974. *The Sacred Pipe: The Seven Holy Rites of the Oglala Sioux*. Norman.

Bunzel, Ruth. 1929. *The Pueblo Potter*. New York.

Burger, Richard L. 1981. "The Radiocarbon Evidence for the Temporal Priority of Chavín de Huántar." *American Antiquity* 46, pp. 592–602.

Burger, Richard L. 1983. "Pójoc and Wanan Wain: Two Early Horizon Villages in the Chavín Heartland." *Nawpa Pacha* 20, pp. 3–40.

Burger, Richard, L. 1984. *The Prehistoric Occupation of Chavín de Huántar, Peru. University of California Press Publications in Anthropology* 14. Berkeley.

Burger, Richard L., and Lucy Salazar Burger. 1980. "Ritual and Religion at Huaricoto." *Archaeology* 33, pp. 26–32.

Burger, Richard L., and Lucy Salazar Burger. 1982. "La arana en la iconografía del horizonte temprano en la Costa Norte del Perú." *Beitrage zür Allgemeinen und Vergleichenden Archäologie* 4, pp. 213–53.

Burger, Richard L., and Nikolaas van der Merwe. 1990. "Maize and the Origins of Highland Chavín Civilization." *American Anthropologist* 92, pp. 86–96.

Burkhardt, Jakob. N.d. *The Civilization of the Renaissance in Italy*. Translated by S. G. C. Middlemore. New York.

Cabello de Balboa, Miguel. 1945. "Verdadera descripción y relación de la provincia de las Esmeraldas." *Obras de Miguel Cabello de Balboa*. Edited by Jacinto Jijón y Caamaño. Quito. Pp. 1–76.

Cabello Valboa, Miguel. 1951. *Miscelánea antártica*. Lima.

Cabrera Castro, Rubén. 1990. "El proyecto templo de Quetzalcoatl y la práctica a gran escala del sacrificio humano." Cardos de Méndez, 1990. Pp. 123–46.

Cabrera Castro, Rubén, George Cowgill, and Saburo Sugiyama. 1990. "Nuevos exploraciones en el Templo de Quetzalcoatl, Temporada 1988–1989." Paper presented at the Conferencia sobre el Período Clássico. Mexico City.

Cadavid Camargo, Gilberto, and Ana María Groot de Mahecha. 1987. "Buritaca 200: Arqueología y conservación de una población precolombina (Sierra Nevada de Santa Marta, Colombia)." *Boletín del Museo del Oro* 19, pp. 57–82.

Cardós de Méndez, Amalia, editor. 1990. *La época clásica: Nuevos hallazgos, nuevas ideas*. Mexico City.

Cardoso, Patricia. 1987. "Uso y significado de las cuencas tairona." *Boletín del Museo del Oro* 19, pp. 117–24.

Carr, Patricia. 1979. *Mimbres Mythology*. El Paso.

Carrasco, David, editor. 1991. *To Change Place: Aztec Ceremonial Landscapes*. Boulder.

Caso, Alfonso. 1927. *El Teocalli de la guerra sagrada*. Mexico.

Caso, Alfonso. 1942a. "Definición y extensión del complejo 'Olmeca'." *Mayas y olmecas; Segunda Reunión de Mesa Redonda de la Sociedad Mexicana de Antropología*. Mexico City. Pp. 43–46.

Caso, Alfonso. 1942b. "El paraíso terrenal en Teotihuacan." *Cuadernos americanos* 6, pp. 127–36.

Caso, Alfonso. 1958. *The Aztecs*. Norman.

Charnay, Desiré. 1888. *The Ancient Cities of the New World*. New York.

Chicago, Field Museum of Natural History. 1975. *Ancient Ecuador: Culture, Clay, and Creativity 3000–300 BC*. Exhibition catalogue by Donald Lathrap, Donald Collier, and Helen Chandra. Chicago.

Chimalpaín, Francisco de San Antón Muñon. 1965. *Relaciones originales de Chalco amaquemecan*. Edited by S. Rendón. Mexico City.

Cieza de León, Pedro de. 1864. *Travels 1532–1550*. London.

Cieza de León, Pedro de. 1959. *The Incas of Pedro de Cieza de León*. Translated by Harriet de Onís. Norman.

Cieza de León, Pedro de. 1967. *El señorío de los incas*. Lima.

Cieza de León, Pedro de. 1985, 1986. *Crónica del Peru*. Lima.

Closs, Michael, Anthony F. Aveni, and B. Crowley. 1982. "The Planet Venus and Temple 22 at Copán." *Indiana* 9, pp. 221–47.

Cobo, Bernabé. 1893. *Historia del Nuevo Mundo*. Seville.

Cobo, Bernabé. 1964. *Historia del Nuevo Mundo*. Madrid.

Cobo, Bernabé. 1979. *History of the Inca Empire*. Translated by Roland B. Hamilton. Austin.

Cobo, Bernabé. 1990. *Inca Religion and Customs*. Translated by Roland B. Hamilton. Austin.

Codex Borbonicus. 1974. Commentary by Karl Anton Nowotny and Jaqueline de Durand-Forest. Graz.

Codex Borgia. 1976. Commentary by Karl Anton Nowotny. Graz.

Codex Dresden: Der Dresdner Maya Handschrift. 1989. Edited by Helmut Decker and Ferdinand Anders. Graz.

Codex Fejérváry-Mayer. 1971. Introduction by C. A. Burland. Graz.

Codex Ixtlilxóchitl. 1976. Commentary by J. de Durand-Forest. Graz.

Codex Magliabechiano. 1970. Graz.

Codex Mendoza. 1938. 3 vols. Edited and translated by James Cooper-Clark. London.

Codex Mexicanus. 1952. Paris.

Codex Zouche-Nuttall. 1987. Introduction by Nancy P. Troike. Graz.

Codice Xolotl. 1980. Edited by Charles Dibble. Mexico City.

Coe, Michael D. 1965. "The Olmec Style and its Distribution." *Handbook of Middle American Indians* 3. *Archaeology of Southern Mesoamerica*. Edited by Robert Wauchope and Gordon R. Willey. Austin. Pp. 739–75.

Coe, Michael D. 1972. "Olmec Jaguars and Olmec Kings." *The Cult of the Feline: A Conference in Precolumbian Iconography*. Edited by Elizabeth P. Benson. Washington, D.C. Pp. 1–18.

Coe, Michael D. 1973. *The Maya Scribe and His World*. New York.

Coe, William R. 1965. "Tikal, Guatemala and Emergent Maya Civilization." *Science* 147, 3664, pp. 1401–19.

Coe, Michael D., and Richard A. Diehl. 1980. *In the Land of the Olmec*. Austin.

Conklin, William J. 1982. "The Information System of Middle Horizon Quipus." Aveni and Urton, 1982. Pp. 261–81.

Cordero Miranda, Gregorio. 1976. *Excavaciones en la pirámide de Akapana*. La Paz.

Cordy-Collins, Alana. 1977. "Chavín Art: Its Shamanic/ Hallucinogenic Origins." Cordy-Collins and Stern, 1977. Pp. 353–62.

Cordy-Collins, Alana. 1977. "Chavín Art: Its Shamanic/ Hallucinogenic Origins." Cordy-Collins and Stern, 1977. Pp. 353–62.

Cordy-Collins, Alana. 1979. "The Dual Divinity Concept in Chavín Art." *El Dorado* 3, pp. 1–31.

Cordy-Collins, Alana. 1980. "An Artistic Record of the Chavín Hallucinatory Experience." *Masterkey* 54, pp. 84–93.

Cordy-Collins, Alana. 1982. "Earth Mother/Earth Monster Symbolism in Ecuadorian Manteño Art." *Pre-Columbian Art History: Selected Readings*. Edited by Alana Cordy-Collins. Palo Alto. Pp. 205–30.

Cordy-Collins, Alana, and Jean Stern, editors. 1977. *Pre-Columbian Art History: Selected Readings*. Palo Alto.

Covarrubias, Miguel. 1942. "Origen y desarrollo del estilo artístico olmeca." *Mayas y Olmecas; Segunda Reunión de Mesa Redonda de la Sociedad Mexicana de Antropología*. Mexico City. Pp. 46–49.

Covarrubias, Miguel. 1957, 1971. *Indian Art of Mexico and Central America*. New York.

Cowgill, George L. 1983. "Rulership and the Ciudadela: Political Inferences from Teotihuacan Architecture." *Civilization in the Ancient Americas: Essays in Honor of Gordon R. Willey*. Edited by Richard M. Leventhal and Alan L. Kolata. Albuquerque. Pp. 313–43.

Créqui-Montfort, G. de. 1906. "Fouilles de la Mission Scientifique Française à Tiahuanaco: Ses Recherches archéologiques et ethnographiques en Bolivie, Chili et dans la République argentine." Fourteenth *Internazionaler Amerikanisten-Kongress* 2. Stuttgart. Pp. 531–50.

Crespo, Hernán, and Olaf Holm. 1977. *Arte precolombino del Ecuador*. Barcelona.

Crown, Patricia L., and W. James Judge, editors. 1991. *Chaco and Hohokam: Prehistoric Regional Systems in the American Southwest*. Santa Fe.

Daggett, Richard E. 1991. "Paracas: Discovery and Controversy." Paul, 1991. Pp. 35–60.

De la Fuente, Beatriz. 1973. *Escultura monumental olmeca: Catálogo*. Mexico City.

De la Fuente, Beatriz. 1977a. "Pequeña obra maestra de la escultura olmeca." *Anales del Instituto de Investigaciones Estéticas* 47, pp. 5–10.

De la Fuente, Beatriz. 1977b. *Los hombres de piedra, escultura olmeca*. Mexico City.

Detroit Institute of Arts. 1981. *Between Continents/Between Seas: Pre-Columbian Art of Costa Rica*. Exhibition catalogue. New York.

Diaz del Castillo, Bernal. 1956. *The True History of the Conquest of Mexico* . Translated by A. P. Maudslay. New York. First published London: 1908–16.

Diehl, Richard A., and Janet C. Berlo. 1989. *Mesoamerica After the Decline of Teotihuacan AD 700–900*. Washington, D.C.

Doering, Heinrich Ubbelohde. 1952. *The Art of Ancient Peru*. New York.

Donnan, Christopher B. 1978. *Moche Art of Peru*. Los Angeles.

Donnan, Christopher B., editor. 1985. *Early Ceremonial Architecture in the Andes*. Washington, D.C.

Dorsey, George A. 1901. *Archaeological Investigations on the Island of La Plata, Ecuador. Field Columbian Museum Publication 56. Archaeological Series 2, 5*. Chicago.

Drucker, Philip, and Robert F. Heizer. 1956. "Gifts for the Jaguar God." *National Geographic Magazine* 110, 3, pp. 366–75.

Dürer, Albrecht. 1925. "Tagebuch der Reise in die Niederlande, Anno 1520." *Albrecht Dürer in seine Briefen und Tagebuchern*. Edited by Ulrich Peters. Frankfurt-am-Main.

Durán, Diego. 1867. *Historia de Nueva España e Islas de Tierra Firme*. Mexico City.

Durán, Diego. 1951. *Historia de las indias de Nueva España e Islas de Tierra Firme*. Mexico City.

Durán, Diego. 1964. *The Aztecs: The History of the Indies of New Spain*. Translated with notes by Doris Heyden and Fernando Horcasitas. New York.

Durán, Diego. 1971. *Book of the Gods and Rites and the Ancient Calendar*. Translated and edited by Fernando Horcasitas and Doris Heyden. Norman.

Duviols, Pierre. 1967. "Un inedito de Cristóbal de Albórnoz: La instrucción para descubrir todas las guacas del Pirú y sus camayos y haziendas." *Journal de la Société des Américanistes* 56, pp. 7–39.

Duviols, Pierre. 1973. "Huari, Llacuaz, agricultores y pastores: un dualismo pre-hispánico de oposición y complementaridad." *Revista del Museo Nacional* 34, pp. 153–92.

Duviols, Pierre. 1976. "La Capacocha-Mecanismo y función del sacrificio humano, su proyección geometrica, su papel en la política integracionista en la economía redistributiva del Tawantinsuyu." *Allpanchis* 9, pp. 11–57.

Duviols, Pierre. 1979. "La dinastía de los Incas: Monarquía o diarquía?" *Journal de la Société des Américanistes* 66, pp. 67–83.

Duviols, Pierre. 1986. *Cultura andina y represión-procesos y visitas de idolatrías y hechicerías, Cajatambo, siglo XVII*. Cuzco.

Eliade, Mircea. 1964. *Myth and Reality*. Translated by Willard R. Trask. London.

Eliade, Mircea. 1965. *The Myth of the Eternal Return*. Translated by Willard R. Trask. New York. Spanish translation: *El mito del retorno eterno*. Madrid: 1984.

Eliade, Mircea. 1969. *Images and Symbols*. Translated by Philip Mairet. New York. Spanish translation: *Imágenes y símbolos*. 2d edition. Madrid: 1974.

Eliade, Mircea. 1978. *History of Religious Ideas* 1. Translated by Willard R. Trask. Chicago. Spanish translation: *Tratado de la historia de las religiones*. Mexico City: 1979.

Ellwood, Robert S. 1973. *The Feast of Kingship: Accession Ceremonies in Ancient Japan*. Tokyo.

Emmerich, André. 1984. *Sweat of the Sun and Tears of the Moon: Gold and Silver in Pre-Columbian Art*. Exhibition catalogue. New York.

Falchetti, Ana María. 1987. "Desarrollo de la orfebrería tairona en la provincia metalúrgica del norte colombiano." *Boletín del Museo del Oro* 19, pp. 3–24.

Fernandez, Justino. 1954. *Coatlicue: Estética del arte indígena antigua*. Mexico City.

Fewkes, J. Walter. 1989. *The Mimbres: Art and Archaeology*. Albuquerque.

Fialko, Vilma. 1988. "Mundo Perdido, Tikal: Un ejemplo de complejos de commemoración astronómica." *Mayab*, pp. 13–21.

Florentine Codex. 1978. Santa Fe.

Florescano, Enrique. 1989. "Mito e historia en la memoria mexicana." Paper presented at the Academia Mexicana de la Historia. Mexico City.

Fonseca Zamora, Oscar. 1981. "Guayabo de Turrialba and its Significance." Translated by Michael J. Snarskis. Detroit, 1981. Pp. 104–12.

Fraser, Douglas. 1966. "The Heraldic Woman: A Study in Diffusion." *The Many Faces of Primitive Art*. Edited by Douglas Fraser. Englewood Cliffs.

Freidel, David A. 1981. "Civilization as a State of Mind: The Cultural Evolution of the Lowland Maya." *The Transition to Statehood in the New World.* Edited by Grant D. Jones and Robert R. Kautz. Cambridge, England. Pp. 188–227.

Freidel, David A., and Linda Schele. 1989. "Dead Kings and Living Temples: Dedication and Termination Rituals Among the Ancient Maya." *Word and Image in Maya Culture.* Edited by William Hanks and Don Rice. Salt Lake City. Pp. 233–43.

Fritz, John. 1978. "Paleopsychology Today: Ideational Systems and Human Adaptation in Prehistory." *Social Archaeology Beyond Subsistence and Dating.* Orlando. Pp. 37–59.

Furst, Peter T. 1968. "The Olmec Were-Jaguar Motif in Light of Ethnographic Reality." *Dumbarton Oaks Conference on the Olmec.* Edited by Elizabeth P. Benson. Washington, D.C. Pp. 143–74.

Gamio, Manuel. 1922. *La población del Valle de Teotihuacan.* 3 vols. Mexico.

Garcilaso de la Vega, El Inca. 1966. *Royal Commentaries of the Incas and General History of Peru.* Translated by Harold V. Livermore. Austin.

Garibay, Angel Maria. 1979. *Teogonía e historia de los mexicanos.* Mexico City.

Gasparini, Graziano, and Luise Margolies. 1980. *Inca Architecture.* Bloomington.

Gay, Carlo T. 1971. *Chalcacingo.* Graz.

Gayton, Anna H. 1973. "The Cultural Significance of Peruvian Textiles: Production, Function, Aesthetics." *Peruvian Archaeology: Selected Readings.* Edited by John H. Rowe and Dorothy Menzel. Palo Alto. Pp. 275–92.

Gillin, John Philip. 1947. *A Peruvian Coastal Community.* Smithsonian Institution Institute of Social Anthropology Publication 3. Washington, D.C.

Glass, John B. 1975. "A Survey of Native Middle American Pictorial Manuscripts," and "A Census of Native Middle American Pictorial Manuscripts." *Handbook of Middle American Indians* 14. Edited by Robert Wauchope and Howard F. Cline. Austin. Pp. 3–80, 81–225.

González Lauck, Rebecca. 1989. "Recientes investigaciones sobre la civilizacion olmeca." *Vigesimaprimera Reunión de Mesa Redonda de la Sociedad Mexicana de Antropología,* Mexico City.

Graham, Mark M. 1981. "Traditions of Costa Rican Stone Sculpture." Detroit, 1981. Pp. 113–34.

Greene Robertson, Merle. 1985. *The Sculpture of Palenque.* Vol. 3: *The Late Buildings of the Palace.* Princeton.

Grey, Michael. 1978. *Pre-Columbian Art.* London.

Grieder, Terence, Alberto Bueno, C. Earle Smith, Jr., and Robert Malina. 1988. *La Galgada, Peru: A Preceramic Culture in Transition.* Austin.

Groot de Mahecha, Ana María. 1985. "Arqueología y conservación del la localidad precolombina de Buritaca 200 en la Sierra Nevada de Santa Marta." *Informes antropológicos* 1, pp. 55–102.

Grove, David C. 1968. "Chalcatzingo, Morelos, Mexico: A Reappraisal of the Olmec Rock Carvings." *American Antiquity* 33, pp. 486–91.

Grove, David C. 1987. "Torches and Knuckledusters and the Legitimization of Formative Period Rulership." *Mexicon* 9, pp. 60–64.

Guaman Poma de Ayala, Felipe. 1986. *El primer nueva corónica y buen gobierno (1583–1615).* Edited by John V. Murra, Rolena Adorno, and Jorge L. Urioste. Madrid.

Haas, Jonathan. 1982. *The Evolution of the Prehistoric State.* New York.

Harcourt, Raoul de. 1962. *Textiles of Ancient Peru and Their Techniques.* Seattle.

Hardoy, Jorge E. 1973. *Pre-Columbian Cities.* New York.

Hartmann, Günther. 1975. "Sitzbank und Zigarrenhalter." *Tribus* 24, pp. 137–56.

Hartung, Horst. 1971. *Die Zeremonialzentren der Maya.* Graz.

Hawkins, Gerald. 1973. *Beyond Stonehenge.* New York.

Heizer, Robert F. 1959. "Specific and Generic Characteristics of Olmec Culture." *Actas del 33ero Congreso Internacional de Americanistas* 2. San José. Pp. 178–82.

Hellmuth, Nicholas M. 1987. *Monster und Menschen in der Maya-Kunst.* Graz.

Helms, Mary W. 1979. *Ancient Panama.* Austin.

Helms, Mary W. 1981. "Precious Metals and Politics: Style and Ideology in the Intermediate Area and Peru." *Journal of Latin American Lore* 7, pp. 215–38.

Heyden, Doris. 1973. "An Interpretation of the Cave Underneath the Pyramid of the Sun in Teotihuacan, Mexico." *American Antiquity* 40.

Heyden, Doris. 1976. "Caves, Gods, and Myths: World-View and Planning in Teotihuacan." *Mesoamerican Sites and World-Views.* Edited by Elizabeth P. Benson. Washington, D.C. Pp. 1–30.

Heyden, Doris. 1986. "Los ritos de paso en las cuevas." *Boletín del Instituto Nacional de Antropología e Historia* (época 2).

Hillerman, Tony, editor. 1976. *The Spell of New Mexico.* Albuquerque.

Historia Tolteca-Chichimeca. 1976. Kirchhoff, 1976.

Hobsbawn, Eric, and Terence Ranger. 1983. *The Invention of Tradition.* Cambridge, England.

Hocquenghem, Anne Marie. 1987. *Iconografía mochica.* Lima.

Humboldt, Alexander von. 1845–62. *Kosmos, entwurf einer physischen weltbeschreibung.* Stuttgart.

Hyslop, John. 1984. *The Inka Road System.* New York and San Francisco.

Hyslop, John. 1990. *Inka Settlement Planning.* Austin.

Ingold, Tim. 1987. *The Appropriation of Nature.* Iowa City.

Isbell, Billie Jean. 1978. *To Defend Ourselves: Ecology and Ritual in an Andean Village.* Austin.

Isbell, William. 1978. "Cosmological Order Expressed in Prehistoric Ceremonial Centers." *Actes du 42ème Congrès des Américanistes* 4. Paris. Pp. 269–99.

Iwanewski, Stanislaw. 1986. "La arqueología de alta montaña en México y su estado actual." *Estudios de cultura nahuatl* 18, pp. 249–73. Mexico City.

Ixtlilxóchitl, Fernando de Alva. 1951. *Obras históricas.* Edited by A. Chavero. Mexico City. First published Mexico City: 1891–92.

Jonaitis, Aldona. 1986. *Art of the Northern Tlingit.* Seattle.

Jones, Julie. 1964. *Art of Empire: The Inca of Peru.* New York.

Joralemon, Peter D. 1971. *Study of Olmec Iconography. Studies in Pre-Columbian Art and Archaeology* 7. Washington, D.C.

Joralemon, Peter D. 1976. "The Olmec Image: A Study in Precolumbian Archaeology." *Origins of Religious Art and Iconography in Precolumbian Mesoamerica.* Edited by Henry B. Nicholson. Los Angeles. Pp. 27–72.

Judd, Neil. 1925. "Everyday Life in Pueblo Bonito." *National Geographic Magazine* 48, 3, pp. 227–62.

Judd, Neil. 1954. *The Material Culture of Pueblo Bonito.* Smithsonian Miscellaneous Collections 124. Washington, D.C.

Judd, Neil. 1964. *The Architecture of Pueblo Bonito.* Smithsonian Miscellaneous Collections 147. Washington, D.C.

Jung, Carl. 1976. "The Pueblo Indians." Hillerman, 1976. Pp. 37–43.

Kabotie, Fred. 1949. *Designs from the Ancient Mimbrenos with a Hopi Interpretation*. San Francisco.

Kajitani, Nobuko. 1982. *Andesu no Senshoku*. Kyoto.

Kauffmann Doig, Federico. 1964. "Los estudios de Chavín, 1553–1919." *Fénix* 14, pp. 147–249.

Keleman, Pál. 1959. *Medieval American Art*. 2 vols. New York. First published New York: 1943.

Kidder, Alfred V. 1935. *Notes on the Ruins of Acasaguastlan, Guatemala. Carnegie Institution of Washington, Notes on Middle American Archaeology and Ethnology* 1. Washington, D.C.

Kirchhoff, Paul. 1943. "Mesoamerica." *Acta Americana* I.

Kirchhoff, Paul, et al. 1976. *Historia Tolteca-Chichimeca*. Mexico City.

Klein, Cecelia. 1976. *The Face of the Earth: Frontality in Two-Dimensional Mesoamerican Art*. New York.

Kolata, Alan L. 1986. "The Agricultural Foundations of the Tiwanaku State: A View from the Heartlands." *American Antiquity* 51, pp. 746–62.

Kolata, Alan L., editor. 1989. *Arqueología de Lukurmata*. La Paz.

Kolata, Alan L. 1991. "The Technology and Organization of Agricultural Production in the Tiwanaku State." *Latin American Antiquity* 2, pp. 99–125.

Krickeberg, Walter. 1949. *Felsplastik und Felsbilder bei den Kulturvolken Altamerikas*. Berlin.

Kubler, George. 1948. "Towards Absolute Time: Guano Archaeology." *Memoirs of the Society for American Archaeology* 4, pp. 29–50.

Kubler, George. 1962. *The Art and Architecture of Ancient America*. Baltimore.

Kubler, George. 1991. *Esthetic Recognition of Ancient Amerindian Art*. New Haven and London.

Kugler, Franz T. 1842. *Handbuch der Kunstgeschichte*. Stuttgart.

Kutscher, Gerdt. 1983. *Nordperuanische Gefässmalereien des Moche-Stils*. Munich.

Landa, Diego de. 1941. *Landaís Relación*. Edited by A. M. Tozzer. Cambridge, Massachusetts.

Larco Hoyle, Ráfael. 1939. *Los Mochicas* 2. Lima.

Las Casas, Bartolomé de. 1966. *Brevísima relación de la destrucción de las indias*. Buenos Aires.

Las Casas, Bartolomé de. 1967. *Apologética historia de las indias*. Edited by E. O'Gorman. Mexico City.

Lathrap, Donald W. 1971. "The Tropical Forest and the Cultural Context of Chavín." *Dumbarton Oaks Conference on Chavín*. Edited by Elizabeth P. Benson. Washington, D.C.

Lathrap, Donald W. 1974. "The Moist Tropics, the Arid Lands, and the Appearance of Great Art Styles in the New World." *Art and Environment in Native America*. Edited by Mary Elizabeth King and Indris R. Traylor, Jr. Lubbock. Pp. 115–58.

Lathrap, Donald W. 1977a. "Gifts of the Cayman: Some Thoughts on the Subsistence Basis of Chavín." Cordy-Collins and Stern, 1977. Pp. 333–51.

Lathrap, Donald W. 1977b. "Our Father the Cayman, Our Mother the Gourd: Spinden Revisited, or a Unitary Model for the Emergence of Agriculture in the New World." *Origins of Agriculture*. Edited by C. A. Reed. The Hague. Pp. 713–52.

Lathrap, Donald W. 1982. "Complex Iconographic Features by Olmec and Chavin and Some Speculations on Their Possible Significance." *Primer simposio de correlaciones antropológicas andino-mesoamericano*. Edited by Jorge Marcos and Presley Norton. Guayaquil. Pp. 301–27.

Lathrap, Donald W. 1985. "Jaws: The Control of Power in the Early Nuclear American Ceremonial Center." Donnan, 1985. Pp. 241–67.

Lathrap, Donald, Jorge Marcos, and James Zeidler. 1977. "Real Alto: An Ancient Ceremonial Center." *Archaeology* 30, pp. 3–13.

Laughlin, Robert M. 1975. *The Great Tzotzil Dictionary of San Lorenzo Zinacantan*. Washington, D.C.

Lavalle, José Antonio. 1986. *Culturas precolombianas: Nazca*. Lima.

Lawrence, D. H. 1976. "New Mexico." Hillerman, 1976. Pp. 29–36.

Layton, Robert. 1978. "Art and Visual Communication." *Art and Society*. Edited by Michael Greenhalgh and Vincent Megaw. London. Pp. 21–30.

LeBlanc, Steven A. 1983. *The Mimbres People: Ancient Painters of the American Southwest*. London and New York.

Lechtman, Heather. 1984. "Andean Value Systems and the Development of Prehistoric Metallurgy." *Technology and Culture* 25, pp. 1–36.

Legast, Anne. 1987. *El animal en el mundo mítico tairona*. Bogotá.

Lekson, Stephen H. 1986. *Great Pueblo Architecture of Chaco Canyon*. Albuquerque.

Lekson, Stephen H. 1991. "Settlement Patterns and the Chaco Region." *Chaco and Hohokam: Prehistoric Regional Systems in the American Southwest*. Edited by Patricia L. Crown and W. James Judge. Santa Fe. Pp. 31–55.

Lekson, Stephen H., Thomas C. Windes, John R. Stein, and W. James Judge. 1988. "The Chaco Canyon Community." *Scientific American* 259, 1, pp. 100–109.

León y Gama, Antonio de. 1990. *Descripción histórica y cronológica de las dos piedras*. Edited by Carlos María Bustamante. Mexico City.

León-Portilla, Miguel. 1969. *Pre-Columbian Literature of Mexico*. Norman.

León-Portilla, Miguel. 1979. *La filosofía nahuatl*. Mexico City.

León-Portilla, Miguel, editor. 1983. *El reverso de la conquista: Relaciones nahuas, mayas y quechuas de la conquista*. Mexico City.

Lleras, Roberto. 1987. "La utilización de las areas libres en Ciudad Perdida." *Boletín del Museo del Oro* 19, pp. 97–116.

Lothrop, Samuel K. 1972. *Treasures of Ancient America*. Geneva.

Lothrop, Samuel K. 1976. *Pre-Columbian Designs from Panama; 591 Illustrations of Coclé Pottery*. New York.

Luckert, Karl W. 1976. *Olmec Religion*. Norman.

Lumbreras, Luis. 1989. *Chavín de Huántar en el nacimiento de la civilización andina*. Lima.

Lumbreras, Luis, C. González, and B. Lietaer. 1976. *Acerca de la función de sistema hidráulica de Chavín. Investigaciones de Campo* 2. Lima.

McEwan, Colin, and Maria Isabel Silva I. 1989. " Que fueron a hacer los Incas en la costa central del Ecuador?" *Proceedings of the 46th International Congress of Americanists. BAR International Series* 503. Oxford. Pp. 163–85.

Magaña, Edmundo. 1988. *Orion y la Mujer Pléyades: Simbolismo astronómico de los indios Kalina de Surinam*. Dordrecht.

Maler, Teobert. 1901. "Researches in the Central Portion of the Usumacintla Valley." *Memoirs of the Peabody Museum* 2, 1. Cambridge, Massachusetts.

Manzanilla, Linda. 1990. "Sector noroeste de Teotihuacan: Estudio de un conjunto residencial y rastros de túneles y cuevas." Cardós de Méndez, 1990. Pp. 81–88.

Manzanilla, Linda, and Eric Woodard. 1990. "Restos humanos asociados a la Pirámide de Akapana (Tiwanaku, Bolivia)." *Latin American Antiquity* 1, pp. 133–49.

Marcos, Jorge G., and Presley Norton. 1981. "Interpretación sobre la arqueología de la Isla de La Plata." *Miscelánea antropológica ecuatoriana* 1, pp. 136–54.

Marcus, Joyce. 1983. "Teotihuacan Visitors on Monte Alban Monuments and Murals." *The Cloud People: Divergent Evolution of the Zapotec and Mixtec Civilizations*. Edited by Kent V. Flannery and Joyce Marcus. New York. Pp. 175–80.

Marshall, Michael P. 1991. "The Chacoan Road—A Cosmological Interpretation." *The Mesa Verde Symposium on Anasazi Architecture and American Design Proceedings*. Edited by Baker H. Morrow and V. B. Price. Albuquerque. Pp. 123–37.

Martyr, Peter. 1964. *Décades del Nuevo Mundo*. Edited by E. O'Gorman. Mexico City.

Matheny, Ray T. 1986. "Early States in the Maya Lowlands during the Late Preclassic Period: Edzna and El Mirador." *City-States of the Maya: Art and Architecture*. Edited by Elizabeth P. Benson. Denver. Pp. 1–44.

Matos Moctezuma, Eduardo. 1986. "Symbolism of the Templo Mayor." Boone, 1986.

Matos Moctezuma, Eduardo. 1988. *The Great Temple of the Aztecs*. London.

Maudslay, Alfred P. 1889–1902. *Archaeology*. 4 vols. London.

Mayer, Enrique. 1977. "Beyond the Nuclear Family." *Andean Kinship and Marriage. American Anthropological Association Special Publication* 7. Edited by Ralph Bolton and Enrique Mayer. Washington, D.C. Pp. 60–80.

Medellín Zenil, Alfonso. 1960. "Unedited Olmec Monolith." *The Word and the Man* 16, pp. 75–97.

Melgar, José. 1869. "Antigüedades mexicanas, notable escultura antigua." *Boletín de la Sociedad Mexicana de Geografía y Estadística* (época 2), 1, pp. 292–97.

Mendieta, Gerónimo de. 1945. *Historia eclesiástica indiana* 1. Mexico.

Menzel, Dorothy. 1976. *Pottery Style and Society in Ancient Peru: Art as a Mirror of History in the Ica Valley, 1350–1570*. Berkeley.

Mester, Ann Marie. 1983. "The Owl in Moche Iconography." Pre-dissert. paper, Dept. of Anthropology, University of Illinois, Champaign-Urbana.

Miller, Arthur G. 1973. *The Mural Painting of Teotihuacan*. Washington, D.C.

Miller, George R. 1979. "An Introduction to the Ethnoarchaeology of the Andean Camelids." Ph.D. dissert., Stanford University, Palo Alto.

Miller, George R. 1984. "Deer Hunters, and Llama Herders: Animal Species Selection at Chavín." *The Prehistoric Occupation of Chavín de Huántar*. Edited by Richard L. Burger. Berkeley. Pp. 282–87.

Millon, René. 1981. "Teotihuacan: City, State, and Civilization." *Supplement to the Handbook of Middle American Indians* 1. Edited by Victoria R. Bricker and Jeromy R. Sabloff. Austin. Pp. 198–243.

Minnis, Paul E. 1981. *Economic and Organizational Responses to Food Stress in Non-Stratified Societies: An Example from Prehistoric New Mexico*. Ann Arbor.

Molina, Cristóbal de. 1989. "Relación de las fábulas y ritos de los Incas." *Fábulas y Mitos de los Incas*. Edited by Henrique Urbano. Madrid. Pp. 121–28.

Mollet, André. 1651. *Le Jardin du plaisir*. Stockholm.

Mollet, Claude. 1652. *Théâtre des plans et jardinages*. Paris.

Montaño, Maria Clara. 1989. "El diálogo sociedad-naturaleza." *Nuestra pasado: La Tolita*. Edited by R. Adoum and F. Valdez. Quito.

Morrison, Tony. 1987. *Pathways to the Gods: The Mystery of the Nazca Lines*. Lima.

Moseley, Michael E. 1975. "Secrets of Peru's Ancient Walls." *Natural History* 84, pp. 34–41.

Mumford, Lewis. 1961. *The City in History*. New York.

Murra, John V. 1968. "An Aymara Kingdom in 1567." *Ethnohistory* 15, pp. 115–51.

Murra, John V. 1985. "The Limits and Limitations of the 'Vertical Archipelago' in the Andes." *Andean Ecology and Civilization: An Interdisciplinary Perspective on Andean Ecological Complementarity*. Edited by Shozo Masuda, Izumi Shimada, and Craig Morris. Tokyo. Pp. 15–20.

Murúa, Martín de. 1962. *Historia general del Perú*. Madrid.

Neihardt, John. 1988. *Black Elk Speaks*. Lincoln.

Nicholson, Henry B. 1966. "The Problem of the Provenience of the Members of the 'Codex Borgia Group': A Summary." *Suma antropológica en homenaje a Roberto J. Weitlaner*. Mexico City. Pp. 145–58.

Nordenskiold, Gustaf. 1893. *The Cliff Dwellers of the Mesa Verde*. Chicago.

Nuttall, Zelia. 1904. "The Periodical Adjustments of the Ancient Mexican Calendar." *American Anthropologist* 6, pp. 486–500.

Oakland, Amy S. 1986a. "Tiwanaku Tapestry Tunics and Mantle from San Pedro de Atacama, Chile." Rowe, 1986. Pp. 101–22.

Oakland, Amy S. 1986b. "Tiwanaku Textile Style from the South Central Andes, Bolivia and North Chile." Ph.D. dissert., University of Texas, Austin.

O'Flaherty, Wendy Doniger. 1980. *Woman, Androgynes and Other Mythical Beasts*. Chicago.

O'Gorman, Edmundo. 1961. *The Invention of America: An Inquiry into the Historical Meaning of the New World and the Meaning of Its History*. Bloomington.

Orozco y Berra, Manuel. 1877. "El Cuauhxicalli de Tizoc." *Anales del Museo Nacional de Mexico* 1. Mexico City.

Ortiz, Alfonso. 1969. *The Tewa World*. Chicago.

Oyuela Caycedo, Augusto. 1986. "De los taironas a los Kogi: Una interpretación del cambio cultural." *Boletín del Museo del Oro* 17, pp. 32–43.

Pachacuti Yamqui, Juan de Santa Cruz. 1968. *Relación de antigüedades desde reyno del Perú*. Madrid.

Panofsky, Erwin. 1955. *Meaning in the Visual Arts*. New York.

Paradis, Louise. 1988. "Le Chamanisme en Meso-amerique précolombienne." *Recherches amérindiennes au Québec* 18, pp. 91–100.

Parsons, Elsie C. 1936. *Hopi Journal of Alexander M. Stephen. Columbia University Contributions to Anthropology* 23. 2 vols. New York.

Parsons, Lee Allen. 1986. *The Origin of Maya Art. Studies in Pre-Columbian Art and Archaeology* 28. Washington, D.C.

Pasztory, Esther. 1976. *The Murals of Tepantitla, Teotihuacan*. New York.

Pasztory, Esther. 1984. "The Function of Art in Mesoamerica." *Archaeology* 37, pp. 18–25.

Pasztory, Esther. 1988. "A Reinterpretation of Teotihuacan and its Mural Painting Tradition." *Feathered Serpents and Flowering Trees: Reconstructing the Murals of Teotihuacan*. Edited by Kathleen Berrin. San Francisco. Pp. 45–77.

Pasztory, Esther. 1990. "El poder militar como realidad y retórica en Teotihuacan." Cardós de Méndez, 1990. Pp. 181–204.

Paul, Anne. 1986. "Continuity in Paracas Textile Iconography and its Implications for the Meaning of Linear Style Images." Rowe, 1986. Pp. 81–99.

Paul, Anne. 1990a. *Paracas Ritual Attire: Symbols of Authority in Ancient Peru*. Norman.

Paul, Anne. 1990b. "The Use of Color in Paracas Necropolis Fabrics: What Does it Reveal about the Organization of Dyeing and Designing?" *National Geographic Research* 6, pp. 7–21.

Paul, Anne. 1991a. "Paracas: An Ancient Cultural Tradition on the South Coast of Peru." 1991b. "Paracas Necropolis Bundle 89: A Description and Discussion of its Contents." *Paracas Art and Architecture: Object and Context in South Coastal Peru.* Edited by Anne Paul. Iowa City. Pp. 1–34, 172–221.

Paul, Anne, and Solveig Turpin. 1986. "The Ecstatic Shaman Theme of Paracas Textiles." *Archaeology* 39, pp. 20–27.

Peñafiel, Antonio. 1900. *Lienzo de Zacatepec.* Mexico City.

Peters, Ann H. 1991. "Ecology and Society in Embroidered Images from the Paracas Necropolis." Paul, 1991. Pp. 240–314.

Piña Chan, Román, and Luis Covarrubias. 1964. *El pueblo del jaguar.* Mexico City.

Pizarro, Pedro. 1978, 1986. *Relación del descubrimiento y conquista de los reinos del Perú.* Lima.

Plazas de Nieto, Clemencia, and Ana María Falchetti de Sáenz, 1979. *La orfebrería prehispánica de Colombia.* Bogotá.

Plowman, Timothy. 1984. "The Origin, Evolution, and Diffusion of Coca, 'Erythroxylum' ssp. in South and Central America." *Pre-Columbian Plant Migration.* Edited by Doris Stone. Cambridge, Massachusetts. Pp. 125–63.

Polakoff, Claire. 1980. *Into Indigo: Africa Textiles and Dyeing Techniques.* Garden City.

Ponce Sanginés, Carlos. 1971. *Procedencia de las areniscas utilizadas en el templo precolombino de Pumapunku. Academia Nacional de Ciencias de Bolivia Publicacion* 22. La Paz.

Ponce Sanginés, Carlos. 1979. *La cultura nativa en Bolivia.* La Paz.

Ponce Sanginés, Carlos. 1981. *Tiwanaku: Espacio, tiempo y cultura: Ensayo de síntesis arqueológica.* La Paz and Cochabamba.

Posnansky, Arthur. 1945. *Tiahuanacu: The Cradle of American Man.* New York.

Pozorski, Thomas, G. 1975. "El complejo de Caballo Muerto." *Revista del Museo Nacional* 41, pp. 211–51.

Prescott, William H. 1843. *History of the Conquest of Mexico.* New York.

Prescott, Willam H. 1847. *History of the Conquest of Peru.* New York.

Preuss, Konrad T. 1926–27. *Forschungsreise zu den Kagaba: Beobachtungen, Textaufnahmen und sprachliche Studien bei einem Indianerstamme in Kolumbien, Sudamerika.* St. Gabriel-Moedling b. Wien.

Proskouriakoff, Tatiana. 1946. *Album of Maya Architecture.* Washington, D.C.

Proskouriakoff, Tatiana. 1960. "Historical Implication of a Pattern of Dates at Piedras Negras, Guatemala." *American Antiquity* 25, pp. 454–75.

Proskouriakoff, Tatiana. 1963, 1964. "Historical Data in the Inscriptions of Yaxchilan." *Estudios de cultura maya* 3; pp. 149–67; 4, pp. 177–202.

Proulx, Donald A. 1982. "Territoriality in the Early Intermediate Period: The Case of the Moche and Recuay." *Nawpa Pacha* 20, pp. 83–96.

Ramos Gavilán, Alonso. 1976. *Historia de Nuestra Señora de Copacabana.* La Paz.

Rattray, Evelyn C. 1981. "Anaranjado delgado: Cerámica de comercio de Teotihuacan." *Interacción cultural en México Central.* Edited by Evelyn C. Rattray, Jaime Litvak, and Clara Diaz Oyarzambal. Mexico City. Pp. 55–80.

Rattray, Evelyn C. 1990. "Nuevos hallazgos sobre los orígenes de la cerámica anaranajado delgado." Cardós de Méndez, 1990. Pp. 89–106.

Reiche, Maria. 1968. *Mystery on the Desert.* Stuttgart.

Reichel-Dolmatoff, Gerardo. 1950. *Los Kogi.* Bogotá.

Reichel-Dolmatoff, Gerardo. 1975. "Templos Kogi: Introducción al simbolismo y a la astronomía del espacio sagrado." *Revista colombiana de antropología* 19, pp. 199–246.

Reichel-Dolmatoff, Gerardo. 1976. "Training for the Priesthood among the Kogi of Colombia." *Enculturation in Latin America: An Anthology.* Edited by Johannes Wilbert. Los Angeles. Pp. 265–88.

Reichel-Dolmatoff, Gerardo. 1977a. "La conquista de los Tairona." 1977b. "Contactos y cambios culturales en la Sierra Nevada de Santa Marta." 1977c. "Notas sobre el simbolismo religioso de los indios de la Sierra Nevada de Santa Marta." *Estudios antropológicos* 29, pp. 49–74, 75–184, 229–48.

Reichel-Dolmatoff, Gerardo. 1978. "The Loom of Life: A Kogi Principle of Integration." *Journal of Latin American Lore* 4, pp. 5–27.

Reichel-Dolmatoff, Gerardo. 1984. "Some Kogi Models of the Beyond." *Journal of Latin American Lore* 10, pp. 63–85.

Reichel-Dolmatoff, Gerardo. 1985. *Los Kogi.* 2d edition. Bogotá.

Reichel-Dolmatoff, Gerardo. 1986. *Arqueología de Colombia: Un texto introductorio.* Bogotá.

Reichel-Dolmatoff, Gerardo. 1987a. "Análisis de un templo de los indios Ika, Sierra Nevada de Santa Marta, Colombia." *Antropológica* 68, pp. 3–22.

Reichel-Dolmatoff, Gerardo. 1987b. "The Great Mother and the Kogi Universe: A Concise Overview." *Journal of Latin American Lore* 13, pp. 73–113.

Reichel-Dolmatoff, Gerardo. 1988. *Orfebrería y chamanismo: Un estudio iconográfico del Museo del Oro.* Medellín.

Reichel-Dolmatoff, Gerardo. 1990. "The Sacred Mountains of Colombia's Kogi Indians." *Iconography of Religions,* section 9 (South America). Leiden and New York.

Reilly, F. Kent, III. 1989. "The Shaman in the Transformation Pose; a Study of the Theme of Rulership in Olmec Art." *Record of the Art Museum, Princeton University* 48, pp. 5–21.

Reinhard, Johan. 1985a. "Chavín and Tiahuanaco: A New Look at Two Andean Ceremonial Centers." *National Geographic Research* 1, pp. 345–422.

Reinhard, Johan. 1985b. "Sacred Mountains: An Ethno-Archaeological Study of High Andean Ruins." *Mountain Research and Development* 5, 4.

Reinhard, Johan. 1987. "Chavin y Tiahuanaco: Una nueva perspectiva de dos centros ceremoniales andinos." *Boletín de Lima* 9, 50, pp. 29–49.

Reinhard, Johan. 1988. *The Nazca Lines: A New Perspective on Their Origin and Meaning.* Lima.

Reinhard, Johan. 1991. "An Archaeological Investigation of Inca Ceremonial Platforms on the Volcano Copiapo, Central Chile." *Contributions to New World Archaeology.* Oxford.

Riley, Carroll L., and Basil C. Hedrick. 1978. *Across the Chichimec Sea.* Carbondale.

Robertson, Donald. 1959. *Mexican Manuscript Painting of the Early Colonial Period.* New Haven.

Rodenwaldt, Gerhart. 1957. *The Acropolis.* Photographs by Walter Hege. Oxford.

Rowe, Ann P., editor. *The Junius B. Bird Conference on Andean Textiles, April 7th and 8th, 1984.* Washington, D.C.

Rowe, John H. 1944. *An Introduction to the Archaeology of Cuzco. Papers of the Peabody Museum of American Archaeology and Ethnology* 27. Cambridge, Massachusetts.

Rowe, John H. 1946. "Inca Culture at the Time of the Spanish Conquest." *Handbook of South American Indians* 2. Washington, D.C.

Rowe, John H. 1962a. "Stages and Periods in Archaeological Interpretation." *Southwestern Journal of Anthropology* 18, 1, pp. 40–54.

Rowe, John H. 1962b. *Chavín Art: An Inquiry into its Form and Meaning.* New York.

Rowe, John H. 1963. "Inca Culture at the Time of the Spanish Conquest." *Handbook of South American Indians* 2. Edited by Julian Steward. New York. Pp. 183–330.

Rowe, John H. 1967. "What Kind of a Settlement Was Inca Cuzco?" *Nawpa Pacha* 5, pp. 59–76.

Rowe, John H. 1978. "Form and Meaning in Chavín Art." *Peruvian Archaeology: Selected Readings.* Edited by John H. Rowe and Dorothy Menzel. 6th ed. Pp. 72–103. First published Palo Alto: 1967.

Rowe, John H. 1979. "Standardization in Inca Tapestry Tunics." *The Junius B. Bird Pre-Columbian Textile Conference.* Edited by Ann P. Rowe, Elizabeth P. Benson, and Anne L. Schaffer. Washington, D.C. Pp. 239–64.

Rowe, John H. 1980. "An Account of the Shrines of Ancient Cuzco." *Nawpa Pacha* 17, pp. 1–80.

Ruppert, Karl. 1944. "A Special Assemblage of Maya Structures." *The Maya and Their Neighbors.* Edited by Clarence L. Hay, et al. New York and London. Pp. 222–31.

Sahagún, Bernardino de. 1951–82. *Florentine Codex: General History of the Things of New Spain.* Translated by Arthur J. O. Anderson and Charles E. Dibble. Salt Lake City.

Samaniego, Lorenzo, Enrique Vergara, and Henning Bischof. 1985. "New Evidence on Cerro Sechín, Casma Valley, Peru." Donnan, 1985. Pp. 165–90.

Sanders, William T., and Joseph W. Michaels. 1977. *Teotihuacan and Kaminaljuyu: A Study in Prehistoric Culture Contact.* University Park, Pennsylvania.

Sanders, William T., Jeffrey R. Parsons, and Robert S. Santley. 1979. *The Basin of Mexico: Ecological Processes in the Evolution of a Civilization.* New York.

Sanders, William T., and B. Price. 1968. *Mesoamerica.* New York.

Santley, Robert R. 1989. "Obsidian Working, Long-Distance Exchange, and the Teotihuacan Presence on the South Gulf Coast." Diehl and Berlo, 1989. Pp. 131–52.

Sarmiento de Gamboa, Pedro. 1943. *Historia de los incas.* Buenos Aires.

Saville, Marshall H. 1907. *The Antiquities of Manabi, Ecuador, A Preliminary Report by Marshall H. Saville.* New York.

Saville, Marshall H. 1929. "Votive Axes from Ancient Mexico," *Indian Notes* 6, part 1: pp. 266–99, part 2: 335–42.

Sawyer, Alan. 1963. "Tiahuanaco Tapesty Design." *Museum of Primitive Art Studies* 3.

Schele, Linda. 1984. "Human Sacrifice Among the Classic Maya." *Ritual Human Sacrifice in Mesoamerica.* Edited by Elizabeth H. Boone. Washington, D.C. Pp. 6–48.

Schele, Linda, and Mary Ellen Miller. 1986. *The Blood of Kings: Ritual and Dynasty in Maya Art.* Exhibition catalogue. Kimball Art Museum, Fort Worth.

Schobinger, Juan. 1991. "Sacrifices of the High Andes." *Natural History* 100, 4, pp. 62–68.

Schuster, Carl. 1951. *Joint-Marks: A Possible Index of Cultural Contact Between America, Oceania and the Far East.* Afdeling Culturele en Physische Anthropologie 39. Amsterdam.

Schwede, Rudolf. 1912. *Ueber das Papier Maya—Codices u. Einiger Altmexikanischer Bilderhandschriften.* Dresden.

Scully, Vincent. 1962. *The Earth, the Temple, and the Gods: Greek Sacred Architecture.* New Haven and London.

Scully, Vincent. 1975. *Pueblo, Mountain, Village, Dance.* New York.

Scully, Vincent. 1991. *Architecture: The Natural and the Manmade.* London.

Séjourné, Laurette. 1959. *Un palacio en la ciudad de los dioses; Teotihuacan.* Mexico City.

Seler, E. G.; 1914. "Uber die Sociale Stellung des Khapak Inca." *Gesammelte Abhandlungen zur Amerikanischen Sprach und Altertumskunde* 5. Berlin. Pp. 77–87.

Seler, E. G. 1902–28. *Gesammelte Abhandlungen....* 5 vols. Berlin.

Sharon, Douglas, and Christopher B. Donnan. 1977. "The Magic Cactus: Ethnoarchaeological Continuity in Peru." *Archaeology* 30, pp. 374–81.

Sherbondy, Jeanette E. 1982. "El regadió, los lagos, y los mitos de origen." *Allpanchis* 20, pp. 3–32.

Shimada, Izumi. 1987. "Horizontal and Vertical Dimensions of the Prehistoric States in North Peru." *The Origins and Development of the Andean State.* Edited by Jonathan Haas, Sheila Pozorski, and Thomas Pozorski. Cambridge, England. Pp. 130–44.

Shimada, Izumi, and Melody Shimada. 1985. "Prehistoric Llama Breeding and Herding on the North Coast of Peru." *American Antiquity* 50, pp. 3–26.

Silverman, Helaine I. 1986. "Cahuachi: An Andean Ceremonial Center." Ph.D. dissert., University of Texas, Austin.

Silverman, Helaine I. 1990. "Beyond the Pampa: The Geoglyphs in the Valleys of Nazca." *National Geographic Research* 6, pp. 435–56.

Sisson, Edward. 1983. "Recent Work on the Codex Borgia Group." *Current Anthropology* 24, pp. 653–56.

Skinner, Milica Dimitrijevic. 1986. "Three Textiles from Huaca Prieta, Chicama Valley, Peru." Rowe, 1986. Pp. 11–18.

Smith, Robert E. 1937. *A Study of Structure A-I Complex at Uaxactun, Peten, Guatemala.* Carnegie Institution of Washington Publication 456. Washington, D.C.

Sofaer, Anna, Rolf M. Sinclair, and Joey B. Donahue. 1990. "An Astronomical Regional Pattern Among the Major Buildings of the Chacoan Culture of New Mexico." *Proceedings of the Third International Congress of Archaeoastronomy.* Fife, Scotland.

Spence, Michael W. 1981. "Obsidian Production and the State in Teotihuacan." *American Antiquity* 46, pp. 769–88.

Spinden, H. J. 1913. "A Study of Maya Art, Its Subject Matter and Historical Development." *Memoirs of the Peabody Museum* 6.

Squier, E. George. 1877. *Peru: Incidents of Travel and Exploration in the Land of the Incas.* London.

Stein, John R., and Stephen H. Lekson. 1991. "Anasazi Ritual Landscapes." *Anasazi Regional Organization and the Chaco System.* Edited by David E. Doyel. *Maxwell Museum Papers in Anthropology.* Albuquerque.

Stephens, John L. 1963a. *Incidents of Travel in Central America, Chiapas, and Yucatan.* 2 vols. New York. First published New York: 1841.

Stephens, John L. 1963b. *Incidents of Travel in Yucatan.* 2 vols. New York. First published New York: 1843.

Stirling, Matthew W. 1940. "Great Stone Faces of the Mexican Jungle." *National Geographic Magazine* 88, pp. 309–34.

Stirling, Matthew W. 1955. *Stone Monuments of the Rio Chiquito, Veracruz, Mexico. Bureau of American Ethnology Bulletin* 157, *Anthropological Papers* 43. Washington, D.C.

Stone, Andrea. 1989. "Disconnection, Foreign Insignia, and Political Expansion: Teotihuacan and the Warrior Stelae of Piedras Negras." Diehl and Berlo, 1989. Pp. 153–72.

Stone, Rebecca R. 1986. "Color Patterning and the Huari Artist: The 'Lima Tapestry' Revisited." Rowe, 1986. Pp. 137–50.

Stone, Rebecca R. 1987. "Technique and Form in Huari-style Tapestry Tunics: The Andean Artist, A.D. 500–800." Ph.D. dissert., Yale University, New Haven.

Stone-Miller, Rebecca, and Gordon F. McEwan. 1990. "The Representation of the Wari State in Stone and Thread: A Comparison of Architecture and Tapestry Tunics." *RES* 19.

Stuart, David. 1987. *Ten Phonetic Syllables. Research Reports on Ancient Maya Writing* 14. Washington, D.C. Pp. 16–25.

Stuart, David. 1988. "Blood Symbolism in Maya Iconography." *Maya Iconography*. Edited by Elizabeth P. Benson and Gillett G. Griffin. Princeton. Pp. 175–221.

Taube, Karl A. 1985. "The Maya Maize God: A Reappraisal." *Fifth Palenque Round Table* 7. Edited by Merle Greene Robertson and Virginia Fields. San Francisco. Pp. 171–81.

Taube, Karl A. 1986. "The Teotihuacan Cave Origin: The Iconography and Architecture of Emergence Mythology in Mesoamerica and the American Southwest." *RES* 12, pp. 51–82.

Taube, Karl A. 1988a. "The Ancient Yucatec New Year Festival: The Liminal Period in Maya Ritual and Cosmology." Ph.D. dissert., Yale University, New Haven.

Taube, Karl A. 1988b. "Study of Classic Maya Scaffold Sacrifice." *Maya Iconography*. Edited by Elizabeth P. Benson and Gillett G. Griffin. Princeton. Pp. 331–51.

Taube, Karl A. 1992. "Schellhas Revisited: The Maya Gods." *Studies in Pre-Columbian Art and Archaeology* 32. Washington, D.C.

Taube, Karl A. N.d. "The Iconography of Mirrors at Classic Teotihuacan." *Art, Polity, and the City of Teotihuacan*. Washington, D.C., in press.

Taylor, Walter. 1948. *A Study of Archaeology. Memoirs of the American Anthropological Association* 69.

Tedlock, Barbara. 1982. *Time and the Highland Maya*. Albuquerque.

Tedlock, Dennis. 1985. *Popol Vuh: The Definitive Edition of the Mayan Book of the Dawn of Life and the Glories of God and Kings*. Edited and translated by Dennis Tedlock. New York.

Tello, Julio C. 1929. *Antiguo Perú: Primera época*. Lima.

Tello, Julio C. 1943. "Discovery of the Chavín Culture in Peru." *American Antiquity* 9, pp. 135–60.

Tello, Julio C. 1959. *Paracas, primera parte*. Lima, 1959.

Tello, Julio C. 1960. *Chavín: Cultura matriz de la civilización andina, primera parte*. Revised and edited by Toribio Mejia Xesspe. Lima.

Tello, Julio C., and Toribio Mejia Xesspe. 1979. *Paracas, segunda parte: Cavernas y necrópolis*. Lima.

Tezozomoc, Hernando Alvarado. 1944. *Crónica mexicana*. Edited by M. Orozco y Berra. Mexico City. First published Mexico City: 1878.

Thompson, J. Eric S. 1960. *Maya Hieroglyphic Writing*. Norman.

Thompson, J. Eric S. 1966. "Merchant Gods of Middle America." *Suma antropologica en homenaje a Roberto J. Weitlaner*. Edited by Antonio Pompa y Pompa. Mexico City. Pp. 159–72.

Thompson, J. Eric S. 1972. *A Commentary on the Dresden Codex*. Philadelphia.

Tobriner, Stephen. 1972. "The Fertile Mountain: An Investigation of Cerro Gordo's Importance to the Town Plan and Iconography of Teotihuacan." *Teotihuacan; Onceava Reunión de Mesa Redonda de Sociedad Mexicana de Antropología*. Mexico City.

Tomlinson, R. A. 1976. *Greek Sanctuaries*. London.

Topic, Theresa L. 1977. "Excavations at Moche." Ph.D. dissert., Harvard University, Cambridge, Massachusetts.

Torquemada, Juan de. 1943. *Monarquía indiana*. Mexico City.

Toscano, Salvador. 1944. *Arte precolombino de México y América Central*. Mexico City.

Townsend, Richard F. 1979. *State and Cosmos in the Art of Tenochtitlan. Studies in Pre-Columbian Art and Archaeology* 20. Washington, D.C.

Townsend, Richard F. 1982a. "Pyramid and Sacred Mountain." Aveni and Urton, 1982. Pp. 37–62.

Townsend, Richard F. 1982b. "Malinalco and the Lords of Tenochtitlan." *The Art and Iconography of Late Post-Classic Central Mexico*. Edited by Elizabeth H. Boone. Washington, D.C.

Townsend, Richard F. 1985. "Deciphering the Nazca World: Ceramic Images from Ancient Peru." *The Art Institute of Chicago Museum Studies* 11, 2, pp. 116–39.

Townsend, Richard F. 1986. "Coronation at Tenochtitlan." Boone, 1986. Pp. 371–410.

Townsend, Richard F. 1991. "The Mount Tlaloc Project." Carrasco, 1991.

Trik, Aubrey S. 1939. "Temple XXII at Copán." *Carnegie Institution of Washington, D.C. Contributions to American Anthropology and History* 5, 27. Washington, D.C. Pp. 87–103.

Uhle, Max. 1903. *Pachacamac; Report of the William Pepper MD, LL.D. Peruvian Expedition of 1896*. Pittsburgh.

Uhle, Max. 1913. "Die Ruinen von Moche." *Journal de la Société des Américanistes* 10.

Uhle, Max. 1927a. "Las antiguas civilizaciones esmeraldenas." *Anales de la Universidad Central* 38, pp. 107–36.

Uhle, Max. 1927b. "Estudios esmeraldenos." *Anales de la Universidad Central* 39, pp. 219–79.

Urbano, Enrique. 1981. *Wiracocha y Ayar; Héroes y funciones en las sociedades andinas*. Cuzco.

Urton, Gary. 1981. *At the Crossroads of the Earth and the Sky: An Andean Cosmology*. Austin.

Urton, Gary. 1982. "Astronomy and Calendrics on the Coast of Peru." Aveni and Urton, 1982. Pp. 231–47.

Urton, Gary. 1983. "Archaeological Fieldwork on the Coast of the Peru." *Calendars in Mesoamerica and Peru: Native American Computations of Time*. Edited by Anthony F. Aveni and Gordon Brotherston. *BAR International Series* 174. Oxford. Pp. 221–34.

Valdés, Juan Antonio. 1986. "Uaxactún: Recientes investigaciones." *Mexicon* 8, pp. 125–28.

Valdés, Juan Antonio. 1987. "Preclassic Grotesques of Uaxactún: The Case of Group H." *First World Symposium of Mayan Epigraphy, Tikal Association*. Guatemala City. Pp. 165–81.

Valdez, Francisco. 1987. *Proyecto arqueológico La Tolita*. Quito.

Valdez, Francisco. 1990. "El centro ceremonial La Tolita, factores que intervienen en su fomacion y consolidacion." *Cultura* 30.

Van de Guchte, Maarten. 1984. "El ciclo mítico andino de la Piedra Cansada." *Revista andina* 2, pp. 539–56.

Van de Guchte, Maarten. N.d. *Carving the World, Inca Monumental Sculpture and Landscape*. In press.

Van Haaften, Julia. 1980. *Egypt and the Holy Land in Historic Photographs. Seventy-Seven Views by Francis Firth*. Introduction by Julia Van Haaften. Selection and commentary by Jon E. Manchip White. New York.

Vázquez de Espinosa, A. 1948. *Compendio y descripción de las indias occidentales*. Washington, D.C.

Vidarte de Linares, Juan. 1968. "Teotihuacan, la ciudad del quinto sol." *Cuadernos americanos* 27, pp. 133–45.

Villacorta, J. A., and C. A. Villacorta. 1930. *Códices mayas reproducidos y desarrollados*. Guatemala City.

Vogt, Evon Z. 1964. "Ancient Maya Concepts in Contemporary Zinacantan Religion." *Sixième Congrès international des sciences anthropologiques et ethnologiques* 2. Paris. Pp. 497–502.

Vogt, Evon Z. 1969. *Zinacantan: A Maya Community in the Highlands of Chiapas.* Cambridge, Massachusetts.

Vogt, Evon Z. 1976. *Tortillas for the Gods: A Symbolic Analysis of Zinacanteco Rituals.* Cambridge, Massachusetts.

Vogt, Evon Z. 1981. "Some Aspects of the Sacred Geography of Highland Chiapas." *Mesoamerican Sites and World-Views.* Edited by Elizabeth P. Benson. Washington, D.C. Pp. 119–42.

Vogt, Evon Z. 1990. *The Zinacantecos of Mexico: A Modern Maya Way of Life.* Fort Worth.

Wafer, Lionel. 1934. *A New Voyage and Descriptions of the Isthmus of America.* Oxford.

Waisbard, Simone. 1981. "Enigmatic Messages of the Nazcas." *The World's Last Mysteries.* Pleasantville. Pp. 281–87.

Wassén, S. Henry. 1987. "'Ullucho' in Moche Iconography and Blood Ceremonies." *Göteborg Etnografiska Museum Annals 1985/86.* Gothenburg, pp. 59–85.

Watanabe, John M. 1989. "Elusive Essences: Souls and Social Identity in Two Highland Maya Communities." Bricker and Gossen, 1989. Pp. 263–74.

Webb, William, and Robert A. Weinstein. 1975. *Southwestern Indian Photographs of A. C. Vroman, 1895–1904.* New York.

Westheim, Paul. 1963. *Arte antiguo de Mexico.* Mexico.

Wheatley, Paul. 1971. *The Pivot of the Four Quarters: A Preliminary Enquiry into the Origin and Character of the Ancient Chinese City.* Chicago.

Wicke, Charles R. 1971. *Olmec: An Early Art Style of Precolumbian Mexico.* Tucson.

Willey, Gordon R. 1971. *An Introduction to American Archaeology* 2. *South America.* Englewood Cliffs.

Williams, León Carlos. 1980. "Complejos de pirámides con planta en U, patrón arquitectónico de la costa central." *Revista del Museo Nacional* 44, pp. 95–110.

Williams, León Carlos. 1985. "A Scheme for the Early Monumental Architecture of the Central Coast of Peru." Donnan, 1985. Pp. 227–40.

Yacovleff, Eugenio. 1931. "El vencejo (cypselus) en el arte decorativo de Nazca." *Wira Kocha* 1. Lima.

Yacovleff, Eugenio. 1932a. "La deidad primitiva de los Nasca." 1932b. "Las falcónidas en el arte y en las cerámicas de los antiguos peruanos." 1932c. "El mundo vegetal de los antiguos peruanos." *Revista Museo Nacional de Antropología y Arqueología* 1.

Zárate, Augustín. 1947. "Historia del descubrimiento y conquista del Perú." *Historiadores primitivos de Indias* 1. Madrid. Pp. 459–574.

Zuidema, R. Tom. 1964. *The Ceque System of Cuzco. The Social Organization of the Capital of the Inca.* Leiden.

Zuidema, R. Tom. 1977–78. "Shaft-tombs and the Inca Empire." *Prehistoric Contact between Mesoamerica and South America: New Data and Interpretations. Journal of the Steward Anthropological Society* 9.

Zuidema, R. Tom. 1979. "El Ushnu." *Economía y sociedad en los Andes y Mesoamérica. Revista de la universidad complutense* 28, pp. 317–62.

Zuidema, R. Tom. 1985. "The Lion in the City: Royal Symbols of Transition." *Animal Myths and Metaphors in South America.* Edited by Gary Urton. Salt Lake City. Pp. 183–250.

Zuidema, R. Tom. 1986. "The Inka Dynasty and Irrigation: Another Look at Andean Concepts of History." *Anthropological History of Andean Polities.* Edited by John V. Murra, Nathan Wachtel, and Jacques Revel. Cambridge, Massachusetts. Pp. 177–200.

Zuidema, R. Tom. 1989. *Reyes y guerreros.* Lima.

Zuidema, R. Tom. 1990. *Inca Civilization in Cuzco.* Translated by Jean Jacques Decoster. Austin.

Zurich, Kunsthaus. 1957. *Alt-peru aus Schweizer Sammlugen.* Zurich.

Zurich, Museum Rietberg. 1971. *American Indian Art: A Descriptive Catalogue.* Exhibition catalogue by Wolfgang Haberland. Zurich.

AUTHOR BIOGRAPHIES

Anthony F. Aveni is Charles A. Dana Professor of Astronomy and Anthropology at Colgate University, Hamilton, and author of *Skywatchers of Ancient Mexico* (1980) and *Empires of Time* (1989). He has been interested in problems of ancient calendars, timekeeping, and astronomy for more than two decades.

Elizabeth P. Benson, Research Associate of the Institute of Andean Studies and formerly Director of the Center for Pre-Columbian Studies, Dumbarton Oaks, Washington, D.C., is the author of *The Mochica: A Culture of Peru* (1972) and numerous articles on Moche art. She is currently working on a book on the symbolism of the animals in pre-Columbian art.

Elizabeth Hill Boone is the Director of the Center for Pre-Columbian Studies, Dumbarton Oaks, Washington, D.C.; author of *The Codex Magliabechiano and the Lost Prototype of the Magliabechiano Group* (1983) and *Incarnations of the Aztec Supernatural: The Image of Huitzilopochtli in Mexico and Europe* (1989); and editor of several works, including *The Aztec Templo Mayor* (1987).

J. J. Brody, Professor Emeritus of Art and Art History, and formerly Director of the Maxwell Museum of Anthropology, University of New Mexico, Albuquerque, is the author of numerous books and articles on the art of the Southwest United States, including *Mimbres Painted Pottery* (1977) and *Anasazi and Pueblo Painting before 1900* (1991).

Richard L. Burger, Professor of Anthropology at Yale University, New Haven, and Curator of South American Archaeology at the Peabody Museum, New Haven, wrote his doctoral dissertation for the University of California, Berkeley, on his 1975–76 excavations at Chavín de Huántar. He has since directed excavations at other early sites in Peru and has published articles and a book (1984) on Chavín. He has recently completed a general work on Chavín civilization, which is at press.

Beatriz de la Fuente was formerly Director of the Instituto de Investigaciones Estéticas, where she is currently Chief Researcher, as well as Professor of the History of Art at the Universidad Nacional Autónoma de México, Mexico City. She is the author of a number of books, including *Los hombres de piedra* (1977) and *Peldaños en la conciencia* (1985).

Mary W. Helms, Professor of Anthropology at the University of North Carolina, Greensboro, has published numerous articles and several books on native cultures of Central America and related topics. Her most recent book is *Ulysses' Sail: An Ethnographic Odyssey of Power, Knowledge, and Geographical Distance* (1988).

Alan Kolata is Professor of Anthropology at the University of Chicago. A graduate of Harvard University, Cambridge, Kolata has done extensive field work in Peru and Bolivia, where he has investigated the Tiwanaku culture. He is currently Field Director of the Tiwanaco Archaeological Project.

Stephen H. Lekson received his doctorate from the University of New Mexico, Albuquerque, in 1988. The author of a number of articles on the Chaco, Mimbres, and Hohokam cultures and of the book *Great Pueblo Architecture of Chaco Canyon* (1986), he is currently President of Crow Canyon Archaeological Center.

Miguel León-Portilla, Professor at the Instituto de Investigaciones Históricas at the Universidad Nacional Autónoma de México, Mexico City, is currently Mexican Ambassador to UNESCO. Among his numerous publications on Aztec and Colonial Mexican history are *Aztec Thought and Culture: A Study of the Ancient Náhuatl Mind* (1963) and *Pre-Columbian Literature of Mexico* (1969).

Colin McEwan, Special Exhibition Coordinator in the Department of Africa, Oceania, and the Americas at The Art Institute of Chicago, is completing his doctoral dissertation in South American archaeology at the University of Illinois, Champaign-Urbana. He directs the Agua Blanca Archaeological project on the coast of Ecuador, and has published articles on diverse topics in Andean archaeology.

Eduardo Matos Moctezuma, Director of the Museo del Templo Mayor, Mexico City, was in charge of the excavations at this site from 1978 on. Among his numerous publications on the Aztec peoples and the discoveries at the Templo Mayor is *The Great Temple of the Aztecs* (1988).

Mary Ellen Miller is Professor of the History of Art at Yale University, New Haven, where she received her doctorate in 1981. She is the author of *The Art of Mesoamerica* (1986), *The Murals of Bonampak* (1986), and, with Linda Schele, *The Blood of Kings: Ritual and Dynasty in Maya Art* (1986). She is currently working on a new book on Maya architecture.

Susan A. Niles received her doctorate in Anthropology from the University of California, Berkeley. Since 1981 she has taught at Lafayette College, where she is Associate Professor of Anthropology. She has written articles on Andean art and archaeology and is the author of *Callachaca: Style and Status in an Inca Community* (1987). She is currently studying the relationship between the Inca concept of history and the placement of Inca architecture.

Esther Pasztory received her doctorate from Columbia University, New York, where she is Professor of Art History and Archaeology. Most of her publications are on Teotihuacan and Aztec art. She is the author of *The Murals of Tepantitla, Teotihuacan* (1976) and *Aztec Art* (1983). She edited *Middle Classic Mesoamerica: A.D. 400–700* (1978) and was a major contributor to *Feathered Serpents and Flowering Trees: Reconstructing the Murals of Teotihuacan* (1988).

Anne Paul, Research Associate of the Institute of Andean Studies, Berkeley, is the author of *Paracas Ritual Attire: Symbols of Authority in Ancient Peru* (1990) and editor of *Paracas Art and Architecture: Object and Context in South Coastal Peru* (1991).

Carlos Ponce Sanginés is Director of the Centro de Estudios Antropológicos Tiwanaku. Formerly Director of the Instituto Nacional de Antropología de Bolivia, La Paz, and Minister of State, he has written numerous books and articles on Bolivian archaeology, anthropology, and Colonial history, including *Tiwanaku: Descripción del templete semi-subterráneo* (1969) and *Tiwanaku: espacio, tiempo y cultura. Ensayo de síntesis arqueológica* (1981).

Johan Reinhard, Research Associate, Department of Anthropology, The Field Museum of Natural History, Chicago, is the author of *The Nazca Lines: A New Perspective on Their Origin and Meaning* (1988).

Vincent Scully, Professor Emeritus of the History of Art at Yale University, New Haven, has written and lectured extensively on a wide field of subjects regarding architecture, ancient and modern, and the settings in which it evolved.

Rebecca Stone-Miller, a specialist in Huari textiles, received her doctorate from Yale University, New Haven. Now Assistant Professor of Art History at Emory University, Atlanta, she is also guest curator for the exhibition "To Weave for the Sun: Andean Textiles at the Museum of Fine Arts, Boston" (1992).

Richard F. Townsend, who received his doctorate from Harvard University, Cambridge, is Curator of the Department of Africa, Oceania, and the Americas at The Art Institute of Chicago. His many publications include *State and Cosmos in the Art of Tenochtitlan* (1979) and *The Aztecs* (1992).

Juan Antonio Valdés, of the Instituto Nacional de Antropología, Guatemala City, has worked at various Maya sites in Guatemala, notably Uaxactún. He is Professor of Anthropology at the Instituto de Antropología e Historia de Guatemala, Guatemala City.

Francisco Valdez received his doctorate from the Université de Paris (Nanterre). He has directed archaeological projects for the Museo del Banco Central, Quito; at La Tolita; and at Chobshi-Shabalula in the southern highlands of Ecuador. He is presently engaged in the Sayula Basin Archaeological Project in western Mexico.

Maarten Van de Guchte studied the history of art at the Rijksuniversiteit Amsterdam, and anthropology at the University of Illinois, Champaign-Urbana, where he received his doctorate. He has published on Inca sculpture, Colonial Peruvian art, and Amazonian art; forthcoming is his book, *Carving the World: Inca Monumental Sculpture and Landscape*. He is presently Curator at the Krannert Art Museum, University of Illinois, Champaign-Urbana.

Evan Z. Vogt, Professor Emeritus of Anthropology, and Curator Emeritus of Middle American Ethnology at Harvard University, Cambridge, also serves as Director of the Harvard Chiapas Project. He is the author of *Zinacantan: A Maya Community in the Highlands of Chiapas* (1969), *Tortillas for the Gods: A Symbolic Analysis of Zinacanteco Rituals* (1976), and *The Zinacantecos of Mexico: A Modern Maya Way of Life* (1990).

Tom Zuidema, who received his doctorate from the Rijksuniversiteit Leiden, the Netherlands, where he was also Curator at the Rijksmuseum voor Volkenkunde, is currently Professor of Anthropology at the University of Illinois, Champaign-Urbana. His interests include South American anthropology, the ethnohistory of Andean civilization, and the iconography of Andean art. His recent publications concern the Inca calendar and society, ritual, and myth in Cuzco; they include: *The Ceque System of Cuzco: the Social Organization of the Capital of the Inca* (1962), *Inca Civilization at Cuzco* (1991), and *Reyes y guerreros* (1991).

LIST OF LENDERS

BOLIVIA
Instituto Nacional de Arqueología,
La Paz

Museo de Metales Preciosos
Precolombinos, La Paz

Museo Nacional de Arqueología,
La Paz

Museo Arqueológico Regional
de Tiwanaku

CHILE
Museo Regional de Atacama

Museo Nacional de Historia Natural,
Santiago

COLOMBIA
Museo del Oro del Banco de la
República, Santa Fé de Bogotá

ECUADOR
Museo Antropológico del Banco
Central, Guayaquil

Museo Arqueológico del Banco
Central, Quito

GREAT BRITAIN
The Trustees of the British Museum,
London

GUATEMALA
Museo Nacional de Arqueología y
Etnología, Guatemala City

MEXICO
Museo Nacional de las Intervenciones,
Churubusco

Instituto Nacional de Antropología,
Mexico City

Museo Arqueológico de Teotihuacan

Museo del Templo Mayor, Mexico City

Museo Nacional de Antropología,
Mexico City

Museo de Antropología,
Universidad Veracruzana, Xalapa

PERU
Museo Arqueológico Bruning,
Lambayeque

Museo Amano, Lima

Museo Arqueológico Rafael Larco
Herrera, Lima

Museo Nacional de Antropología y
Arqueología, Lima

SWITZERLAND
Museum für Völkerkunde, Basel

UNITED STATES OF AMERICA

Maxwell Museum of Anthropology,
University of New Mexico,
Albuquerque

Logan Museum of Anthropology,
Beloit College

Museum of Fine Arts, Boston

University of Colorado Museum,
Boulder

The Brooklyn Museum

Robin B. Martin Collection, courtesy
of The Brooklyn Museum

Peabody Museum of Archaeology
and Ethnology, Harvard University,
Cambridge

Krannert Art Museum, University of
Illinois, Champaign-Urbana

The Art Institute of Chicago

The Field Museum of Natural History,
Chicago

The Cleveland Museum of Art

Dallas Museum of Art

The Dayton Art Institute

The Denver Art Museum

The Detroit Institute of Arts

Museum of Northern Arizona,
Flagstaff

Museum of Western Colorado,
Grand Junction

Alan Brown Gallery, Hartsdale

Bentley-Dillard Collection, Las Vegas

Fowler Museum of Cultural History,
University of California, Los Angeles

Los Angeles County Museum of Art

Southwest Museum, Los Angeles

Department of Anthropology,
University of Minnesota, Minneapolis

New Orleans Museum of Art

American Museum of Natural History,
New York

Arthur M. Sackler Collections,
New York

National Museum of the American
Indian, Smithsonian Institution,
New York

The Metropolitan Museum of Art,
New York

The Chrysler Museum, Norfolk

Philadelphia Museum of Art

The University Museum, The
University of Pennsylvania,
Philadelphia

Linde Collection, Phoenix

The Art Museum, Princeton
University

Virginia Museum of Fine Arts,
Richmond

Museum of Indian Arts and Culture,
Museum of New Mexico, Santa Fe

Collection of Tony Berlant,
Santa Monica

Henry Art Gallery, University
of Washington, Seattle

Seattle Art Museum

Munson-Williams-Proctor Institute,
Museum of Art, Utica

Department of Anthropology,
Smithsonian Institution,
Washington, D.C.

Dumbarton Oaks Research Library
and Collections, Washington, D.C.

James W. and Marilynn Alsdorf
Collection, Winnetka

Seven private collectors